MW00800705

ACCOUNTS AND IMAGES OF SIX KANNON IN JAPAN

*Published with the support of the School of Pacific and Asian Studies,
University of Hawaiʻi*

Accounts and Images of Six Kannon in Japan

SHERRY D. FOWLER

University of Hawai'i Press
Honolulu

Publication of this book has been assisted by a grant from the Kajiyama Publications Fund for Japanese History, Culture, and Literature, University of Hawai'i.

© 2016 University of Hawai'i Press
All rights reserved
Printed in the United States of America

21 20 19 18 17 16 6 5 4 3 2 1

Library of Congress Cataloging-in-Publication Data

Names: Fowler, Sherry D., author.
Title: Accounts and images of Six Kannon in Japan / Sherry D. Fowler.
Description: Honolulu : University of Hawai'i Press, [2016] | Includes bibliographical
 references and index.
Identifiers: LCCN 2016015392 | ISBN 9780824856229 (cloth ; alk. paper)
Subjects: LCSH: Avalokiteśvara (Buddhist deity)—Art. | Avalokiteśvara (Buddhist deity)—
 Cult—Japan. | Buddhist gods in art. | Buddhist art—Japan.
Classification: LCC N8193.3.A82 F69 2016 | DDC 700/.482943—dc23 LC record available at
 https://lccn.loc.gov/2016015392

University of Hawai'i Press books are printed on acid-free
paper and meet the guidelines for permanence and
durability of the Council on Library Resources.

Designed by Milenda Nan Ok Lee

For David

Contents

Color plates follow page 170

Illustrations

Color plates (following page 170)

Tables

Acknowledgments

LONG AGO, AT A TIME when I had little idea it would come to consume much of my life, the first glimmer of this book's topic appeared as a presentation on Six Kannon for the Rotary Club in Kyoto. Kannon is clearly the inspiration for the book, but the commitment to begin and then sustain this project arose out of many conversations, both substantial and casual. Years after my initial thoughts about the Six Kannon as a research theme, I was talking with my colleague Amy McNair at lunch one day about possible book topics. Her response ("Great idea!") to Six Kannon as a theme gave me the confidence to launch the project. After that I was often the happy beneficiary of her help in untangling knotty premodern text problems. Likewise, I am also grateful to Daniel Stevenson, who kindly shared his Buddhist-sutra text expertise. My other University of Kansas colleagues have also been especially supportive. Michiko Ito and Maki Kaneko have consistently offered excellent research support. Maki's mother, Yoshiko Kaneko, also graciously assisted with the daunting tasks of obtaining photographs and permissions. Mark Olson generously helped make the photographs suitable for publication. My past and present graduate students, Halle O'Neal, Hillary Pedersen, Yen-yi Chan, and Rachel Voorhies, applied their various talents and skills in assisting with parts of the book, for which I am very grateful.

In Japan, I benefited from the sage advice and expertise of Donohashi Akio, Saitō Kazuko, Kikuiri Ryōnyo, and Nedachi Kensuke. I received so much assistance from friends and colleagues, such as Catherine Ludvik, Patricia Fister, Melissa Rinne, Sarai Mai, and Yoshio Ōtsuka, that merely listing them feels inadequate. Masaaki Morishita provided precious assistance with many aspects of this project and was also a delightful travel companion throughout the mountains of Kyushu. The formidable Buddhist-text expert Michael Jamentz deserves special recognition for his generous assistance with my incessant questions. Melissa McCormick, Julie Davis, Matthew McKelway, John Carpenter, Andrew Watsky, Toshiko McCallum, and the late Helmut Brinker kindly helped with various parts of this project.

My word count is already too high to mention all the others who have supported this book in different ways. The anonymous readers of the manuscript deserve special acknowledgment for their probing questions and astute suggestions. I would also like to recognize University of Hawai'i Press editors Patricia Crosby for launching the project and Stephanie Chun for carrying it forward.

My graduate school colleagues and dear friends Yui Suzuki and Chari Pradel have offered insightful editorial suggestions as well as strong moral support for many years. I wish to offer special thanks to my former adviser, the late Donald McCallum, for commenting on early drafts of sections of the book and for being a constant source of support, inspiration, and encouragement. This book was certainly part of our last conversation and to my great regret, he was not able to see its completion. My husband, Dale Slusser, deserves the biggest heartfelt thanks because he showed unwavering support and patience throughout this long process. He also needs significant recognition for engaging in multiple rounds of painstaking editing. While acknowledging all the wonderful advice and assistance I have received from everyone, I must emphasize that I take full responsibility for any mistakes and blunders that have occurred.

Research for this book benefited from funding from a Japan Foundation Fellowship, Robert and Lisa Sainsbury Fellowship, Asian Cultural Council Asian Art and Religion Fellowship, Metropolitan Center for Far Eastern Art Studies Grant, Florence Tan Moeson Fellowship (Asian Division, Library of Congress), and Association for Asian Studies Japan Studies Research Travel Grant to Japan. From the University of Kansas, a Hall Center for the Humanities Fellowship, General Research Fund Program Grants, Center for East Asian Studies Travel Grants, Big XII Faculty Fellowship, and the International Travel Fund for Humanities Research offered support for the project.

ACCOUNTS AND IMAGES OF SIX KANNON IN JAPAN

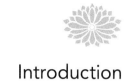

Introduction

BUDDHISTS AROUND THE WORLD widely celebrate the benefits of worshipping Kannon, a compassionate savior who is one of the most beloved deities in Buddhism. For maximum efficacy Kannon, known as Avalokiteśvara in Sanskrit and Guanyin in Chinese, appears in multiple manifestations—loving or fierce, male or female, mundane or otherworldly—and when they are grouped together the deity's magnificent powers are believed to reach even greater heights. The concept of multiples has generated important cults throughout history, and among the most significant is the cult of the Six Kannon, which began in Japan in the tenth century and remained strong through the sixteenth century. This book examines the development of the Japanese Six Kannon cult, its associated sculptures and paintings, and its transition to the still active Thirty-Three Kannon cult. By definition a cult is usually a system of veneration directed toward a particular figure, yet it should be noted that the subject of Kannon groups addresses multiple shifting associations that have expanded and contracted over the centuries.

From numerous written records we know that by the eleventh century the cult of Six Kannon had begun to flourish, but as the majority of the images have been lost or scattered, we are left with a fragmented impression of the phenomenon. However, one example that serves as an exemplar for Six Kannon images is the complete set of superlative life-size wooden sculptures housed at the Kyoto temple of Daihōonji. Discovered inside the images were several inscriptions and Buddhist texts dated 1224, the name of the female donor, and the identity of the sculptor. I closely analyze the history of this set of images, along with others, to consider the broader issue of how the cult's worship impacted Buddhist practice. With a diachronic approach, this book employs individual case studies beginning in the eleventh century to reinstate a context for the sets in order to clarify the former vibrancy, magnitude, and distribution of the cult and enhance knowledge of religious image making in Japan. While Kannon's role of assisting beings trapped in the six paths of transmigration is well documented, I argue that there are other significant themes at work in Six Kannon worship,

such as a focus on worldly concerns, strong ties between text and image, and the process of matching with groups of six kami. In the course of my investigation, I discovered that although many of its images are lost or underrepresented, Kyushu was an especially active site in the history of the Six Kannon cult. A great value in my work as an art historian is an emphasis on making the examples of these often fragmented sets of Kannon visible. As religious imagery is usually made to attract worshippers, the visual presentation of the Six Kannon was highly significant to the patrons, clergy, and worshippers involved, and their appearance can still entice contemporary audiences to learn more about the past.

Studies of the Six Kannon and Related Scholarship

In 1904 the Japanese monk and scholar Shaku Seitan (1871–1942) investigated the Six Kannon concept. Although this pioneering study was published in *Kokka,* Japan's most prominent art history journal of the day, it did not include a single photograph or even discuss any extant images. Shaku, who published widely as a Chinese poetry specialist with a focus on Buddhism, took a philological approach in his article, focusing on the origins of the names of the Six Kannon and how they connected to Chinese sources.[1] In 1914 he wrote a general scholarly study *Kannon no kenkyū* (Kannon research) to help readers understand the complexities of Kannon by including a few pages on each of the Six Kannon and a few paragraphs on the Thirty-Three Kannon and associated pilgrimage routes.[2] Since that time, the Six Kannon cult has mainly been analyzed in terms of Japanese religion, with the goal of untangling its origins, and few studies focusing on the range of its extant images have been published. As an art historian who has greatly benefited from research in other fields and acknowledges that disciplinary boundaries continue to shift and become less rigid, I privilege the visual and the material to reconstruct the Six Kannon cult. After all, the works themselves need careful scrutiny because text-based studies alone cannot account for their histories as attractive vessels of faith.

Given the popularity of the deity, it is impossible to survey all the publications devoted to Kannon. Scholars of religious studies who have published most of the in-depth research on the history of the Six Kannon cult include Gotō Daiyō (dates unknown), Hayami Tasuku (b. 1936), and Tomabechi Seiichi (b. 1952). Gotō's book, which grappled with the complex iconography of Kannon groups was first published in 1928, revised in 1958, and then republished in seven subsequent editions.[3] He laid the groundwork for the study of the iconographies of Kannon groups, but like Shaku, his books included no illustrations and were largely text-based. The eighth edition of this popu-

lar book was enlarged in 2005 to include black-and-white line drawings taken from a set of fifteenth-century Chinese prints that illustrated the *Lotus sūtra*'s Guanyin chapter.

Hayami Tasuku has been the most prolific writer on the Six Kannon cult to date. His first book, published in 1970, is a broad survey on Kannon worship and, like Gotō's work, it was revised and republished several times.[4] Hayami's research focused on how the cult developed under the two separate traditions, first within the Tendai School in the mid-tenth century and then within the Shingon School in the late tenth century. Nakano Genzō (1924–2014) also focused on the development of the Six Kannon within the Tendai tradition and emphasized the Six Kannon's roles in protecting the six paths (*rokudō*) of existence: hell, hungry ghosts, animals, asuras, humans, and heavenly beings. Nakano conducted pioneering research on paintings of the six paths (*rokudōe*), and as an art historian he was more focused on incorporating images into his work than his contemporary scholars in religious studies.[5] Tomabechi Seiichi built upon Hayami's and Nakano's studies, but instead of Tendai he concentrated on the Shingon School's role in the development of the Six Kannon cult. He devoted close attention to how the Six-Syllable ritual, along with its associated mandala, which is the subject of Chapter Four of the present volume, came to privilege the worldly concerns of the living over aid to the deceased in the six paths.[6]

Although art history scholars have been less engaged with the cult of Six Kannon as a whole than authors of religious studies, this book could not have been written without the pioneering works of the art historians who focused on specific individual sets of Six Kannon, such as Mizuno Keisaburō on the Daihōonji images, Maizawa Rei on the Hosomi Six Kannon paintings, and Itō Shirō on the Konkaikōmyōji Kannon images.

Studies that complement this book in a broad fashion include works on cult images by Yui Suzuki, Hank Glassman, and Kevin Carr; the role of icons in Japan by Robert Sharf and others; explorations of the Chinese transformation of Guanyin by Chün-fang Yü; and the investigation of Japanese pilgrimage by Ian Reader and Mark MacWilliams. These are but a few examples of related research. In the last two decades, authors of English-language scholarship have also become more interested in works of material culture that would not have been considered worthy of serious art-historical inquiry in the past. In general these encompass "non-art" artifacts that are crafted material objects, and their study involves their related ideas and practices. Karen Gerhart's investigation of funerary items in *The Material Culture of Death in Medieval Japan* includes unlikely objects, such as dragon-headed banners, coffins, and enclosures for cremation, that defy the former canon of acceptable subjects for Japanese art history.[7] Jan Mrázek and Morgan

Pitelka's volume *What's the Use of Art?* makes us reconsider the use of the term *art* in popular and scholarly constructions and how artworks function in relation to memory and movement.[8] Fabio Rambelli's book *Buddhist Materiality* addresses the religious status and power of items used by Buddhists in Japan, such as ritual objects and sacred texts, focusing on their material rather than "spiritual" or hermeneutical concerns.[9] Studies of material culture and materiality have contributed to the needed rupture of traditional art history–sanctioned foci, offering new and expanded opportunities for discourse on the accumulated layers of interpretation of objects.

Methods of Investigation

Although some of the works in this study have entered museums and the domain of "art," the majority still function within worship spaces. Even the most modest images, including those considered unattractive, can serve as Buddhist icons. I use the term *icon* throughout the book to refer to the image of a deity that is held sacred and usually functions as a central sculpture, and less frequently painting, at a Buddhist temple or ritual.[10] Throughout the investigation I stress the importance of the changing functions of these images within the context of evolving religious practice, an aspect of scholarship on these images that has been largely overlooked.

Indeed, the earliest dated set of Six Kannon in this study, which is from 1141, has been considered outside mainstream Japanese art history. Without doubt these Six Kannon were examined seriously in past Japanese scholarship, yet because they were incised on a bronze sutra box buried in the mountains of Kyushu, they have been treated more like the stuff of archaeology than as an object deserving art-historical consideration. Another example of how works in this study have been affected by shifting attitudes about Buddhist art surfaces in regard to the set of fourteenth-century Six Kannon paintings from the Hosomi Museum. Buddhist painting scholar Yanagisawa Taka (1926–2003) dismissively commented in 1973 that these significant paintings represent a decline in Buddhist art.[11] In the 1970s the standard attitude, unfortunately, was that most Buddhist painting and sculpture made after the thirteenth century, with the exception of some Zen paintings, was not worthy of serious study. Like others, I challenge the canon of works lauded by earlier scholarship. Maizawa Rei's article from 2009 rectifies the previous somewhat damning comments through a thoughtful and painstaking study of these paintings, demonstrating that the field of Japanese art history has evolved to accept later Buddhist works as worthy subjects of inquiry.[12] Although this introduction may be guilty of highlighting attractive examples, this book is full of modestly made

works, some from remote rural locations, that would have been ignored in the past, or perhaps would even have met with ridicule.

Although I previously stated that this study privileges objects over texts, texts are nonetheless key to this book. To find the roots of the Six Kannon cult, an investigation of Buddhist literature is essential. The Chinese text *Mohe zhiguan* (The great calming and contemplation, J. *Makashikan*) written by Zhiyi (538–597) has one of the earliest specific descriptions of six types of Guanyin images. This group was later touted in other important Chinese texts from the eleventh century. The Japanese prelate Ono no Ningai (951–1046) wrote of the equivalencies between the Chinese list from *Mohe zhiguan* and the Six Kannon images created in Japan. The names of the Six Kannon in Japan differ from the characters used in the Chinese sources, but Japanese monk-authors took great pains to elucidate the idea that their identities and functions are equivalent. Each of the Six Kannon helps to save beings along one of the six Buddhist paths of existence. Early sources on the cult include significant ritual manuals, such as *Kakuzenshō* and *Asabashō* from the twelfth and thirteenth centuries, which will be cited frequently in this book because they prescribe methods for constructing the images and record ritual events that demonstrate how the images were used in actual practice. Secular literature, such as the tenth-century *Pillow Book* (*Makura no sōshi*) by Sei Shonagon and the late eleventh-century *A Tale of Flowering Fortunes* (*Eiga monogatari*), is also essential to gain lay perspectives on the early worship of Six Kannon.

In the sixteenth century a transition took place between the Six and Thirty-Three Kannon cults as the Kannon pilgrimage routes, which were organized into groups of thirty-three temples, gained great popularity. In addition to close physical examination of extant works, I have mined the religious, historical, literary, and Internet sources from China and Japan to provide a broad context and history for the Six Kannon images and their transition to the significant living cults of Thirty-Three Kannon.

My methods of inquiry are somewhat like those of a detective or forensic investigator. But instead of cases involving missing persons, bodies, or properties, I seek missing sculptures, paintings, and buildings by pursuing their last known locations of temples and shrines to recover the histories of objects. Since I cannot interrogate the subjects and find few witnesses, most cases in the book are "cold." While following the trails, I consult contemporary texts and related images when possible, but also find rumors, legends, and fabricated stories useful to gain a picture of the lives of the images.

In the course of researching most cases, I was able to conduct firsthand investigations of many sculptures and paintings of the Six Kannon on site,

as in the associated temples of Buzaiin, Daihōonji, Dengenji, Tōmyōji, and Chōkyūji. I analyze the styles, related documents, sectarian affiliations, and evidence of ritual function. Some of the objects in the book have suffered from mistaken identity or loss of former context through cultural amnesia. In such cases as the painting now in Cologne of Six Kannon with an additional figure (discussed in Chapter Five), which was made for a forgotten ritual, I attempt to reconcile its past identity. Although the Daihōonji images (discussed in Chapter Three) survive in excellent condition, their provenance has to be pieced together, which contrasts with the Tōmyōji images that stayed in one place (with one exception), while the majority of their surroundings disappeared. Rather than a criminal court case document, the compilation of evidence in this book functions like a trial brief.

Six Kannon Not at Hōryūji

As I write this introduction I am fighting the temptation to investigate one more case, and I would like to explain it here in the event some readers wonder why an important group of Japanese sculptures that have historically been known as Six Kannon is not included in the main body of this text. The "set" in question consists of a group of six seventh-century bodhisattva sculptures from Hōryūji, made of wood and covered in lacquered gold leaf, which came to be known collectively as "Six Kannon." Even though I have included other sets of images in this book that were considered for a limited amount of time to be a group of Six Kannon, this particular set from Hōryūji has too little to recommend it as a case study for the cult since its designation as "Six Kannon" was probably never more than a popular appellation that appeared in the early twentieth-century formative stages of Japanese art history and somehow stuck.

The six Hōryūji images, which are registered as Important Cultural Properties, are still referred to as "Den Roku Kannon" (traditionally attributed as "Six Kannon"), meaning that they had been considered as a group of "Six Kannon," but now the title is questionable.[13] An eighteenth-century temple record explains that, rather than a single set of six, two pairs of images had been installed in the Hōryūji Kondō (Golden Hall) and one additional pair was previously in the Rectory (Jikidō). Even earlier, eleventh- and twelfth-century records of Hōryūji Kondō property list eight wooden images kept inside a tabernacle that had come from Tachibanadera. Since only six images remain now, there are rumors about where two of the statues might have been taken, but those are leads for a different investigation.[14]

In his 1923 book, Langdon Warner did not specifically call these images "Six Kannon" but stated the following about them:

Worthy of a group by themselves, and still preserved at Hōryūji Monastery, are six wooden figures of Bosatsu which have received all too little attention up to the present time from Japanese scholars. They are rarely seen together and the monastery traditions concerning them are scanty. . . . In all probability these six wooden figures were the attendant deities of three separate trinities from which the central figures have been lost. But they bear such striking likeness to one another that it needs not stretch the imagination to list them as the same generation and even the same atelier.[15]

In 1930 Aizu Yaichi proposed that the six images were originally inside a pagoda as part of a group of eight bodhisattva attendants that belonged to four triads of the Buddhas of the Four Directions.[16] He explained that the bodhisattva images came to be popularly called "Six Buddhas," and as he tracked the movements of the images through Hōryūji records, he found that the first mention of them as a group of six was from 1903.[17] Sometime before the book *Sōkan Hōryūji* (Pictorial encyclopedia of Hōryūji) was published in 1949, they began to be referred to as "Six Kannon."[18] Whether from respectful deference or timidity, even when widely acknowledged as incorrect, these images illustrate that once a name or identity has been assigned to a Japanese Buddhist image, it is not likely to change for a very long time.[19]

Of the six remaining bodhisattvas, one has a standing Buddha image in the crown, so it is a Kannon image, but the identities of most of the others are not clear, though they have been registered as Important Cultural Properties under different bodhisattva names (Fig. I.1).[20] Because the seventh century is hundreds of years before the tenth century,

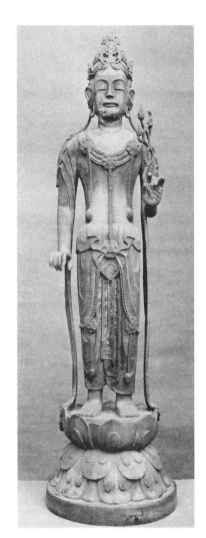

FIGURE I.1. Kannon, one of the Hōryūji "Six Kannon." Seventh century. Wood. 86.9 cm. Hōryūji, Nara.

when our story of the Six Kannon cult images begins in Japan, I must continue to resist the temptation to track down the complete history of these images. Nevertheless, here the fact that someone who worked with the Hōryūji sculptures, perhaps in the 1940s, thought to call this collection of six bodhisattva images "Six Kannon" is validation that the concept of Six Kannon was not only recognized as a significant, yet difficult to identify, phenomenon at the time but also points to its enduring tradition of power and significance.[21]

Creative Calculations in Buddhist Math: Do Numbers Lie?

In the process of researching the topic of this book, I have had to spend a great deal of time counting. Buddhist literature is rife with quantifications of concepts, such as the Four Noble Truths, the Five Precepts, and the Eight-Fold Path. Sacred geography in Japan (and certainly elsewhere in the world) has often used numbers to enhance sacrality, such as in the way the eight peaks of Mount Murō are counted to align with the petals of a lotus flower or the twenty-eight temples built throughout the mountains of the Kunisaki Peninsula are said to reflect the number of chapters in the *Lotus sūtra*.[22] Ishikawa Toshio authored a popular book on the Buddhist culture of numbers using the framework of organizing and illustrating major Buddhist concepts and deity groups in order of denomination from one to one million.[23] In Japan deities organized in numerical alliances are very familiar, especially Six Jizō, Seven Yakushi, and Nine Amida.[24] Moreover, the numerical ordering of sacred concepts is certainly not unique to Buddhism, as many religions have special sacred numbers. Christianity's Holy Trinity, Ten Commandments, and Twelve Apostles are but a few of a vast quantity of examples.[25]

Numerical structuring could serve practically as a memory aid, which was absolutely essential in premodern times in order to keep track of huge amounts of data. Organizing the abstract into numerical lists is a device to manage the enormity of the sacred word.[26] After all, before the sutras and commentaries were written they had to be transmitted orally. Buddhist math, if it is appropriate to call it so, is a powerful tool to help explain things that cannot be calculated, from the miniscule to the vast. Math historian Georges Ifrah discussed the early Indian passion for extreme numbers. Buddhist discussions of the minute describe how best to calculate the size of the tiniest of dust particles.[27] On the grand scale, there are numerous examples, one of which is at the beginning of the twenty-fourth chapter of the *Lotus sūtra*, "The Bodhisattva Wonderful Sound":

At that time Shakyamuni Buddha emitted a beam of bright light from the knob of flesh [on top of his head], one of the features of a great man, and

also emitted a beam of light from the tuft of a white hair between his eyebrows, illumining the Buddha worlds in the eastern direction equal to the sands of one hundred eighty thousand million nayutas of Ganges.[28]

The "number of sands in the Ganges River" is a commonly used trope in Buddhist literature to describe the infinite. While this seems mathematical on the surface, there is no consensus as to exactly how large a *nayuta* actually is.

Certain numbers have culturally constructed mystical resonance. Just consider how many people have emotional attachments to specific numbers, which may be lucky, unlucky, or need to be superstitiously avoided.[29] According to popular math author Alex Bellos's global survey of over 44,000 self-selected participants, seven came in first place as the world's favorite number.[30] Participants favored numbers under ten, which are likely dear because they can be counted on the fingers. Six, which figures as the main number in our study, finished in a disappointing thirteenth place in the contest, ranking lowest among all the numbers under ten.

One reason six is an especially significant number in Buddhist thought is that it refers to the six perfections or six *pāramitās* (J. *rokuharamitsu*), which are a set of bodhisattva practices that will lead to enlightenment if pursued with an attitude of detachment.[31] There are, of course, other significant sixes that appear in Buddhism, but of particular relevance to this study is the number of transmigratory paths of existence. Yet even that august principle is negotiable. Depending on the source, there are variations in the order of the paths, and in some cases the asuras (fighting spirits) are left out, thus leaving only five paths.[32] Nevertheless, in reference to Six Kannon I follow the order for the six paths used by Ono no Ningai and Zhiyi. The Six Kannon are often explained as being charged with helping beings trapped in the six paths, but their duties do not end there. Six is also significant as the number of syllables in the *Six-Syllable sūtra,* which focuses on a powerful magic spell that has six syllables. As will be discussed in Chapter Four, in some cases these potent syllables are aligned with Six Kannon and illustrated in the Six-Syllable mandala to prevent various catastrophes.

Thirty-three is the second most important number in this book. Kannon is believed to have the ability to appear in the guise that is best suited to lead a being to salvation. Because thirty-three is the number of different guises of Kannon listed in the *Lotus sūtra,* it is treated as a number with a special spiritual connection to Kannon. Of course, as seen in the plethora of images of Kannon all over the world, there are many more forms, but thirty-three comes to stand for the great number of variations Kannon can take. I use the word "guise" to refer to these different forms, but they can also be called transformed bodies (*keshin*) or manifestations (*ōke*). Accordingly, thirty-three came to be used as the appropriate number of temples organized

into pilgrimage routes dedicated to Kannon, the number of Kannon paintings in sets of prints and paintings called "Thirty-Three Kannon," and the number of figures in a set of Kannon images that was defined and widely transmitted in the text called *Butsuzō zui,* first published in the seventeenth century, which is discussed in Chapter Six.

As will become increasingly clear in this book, however, there are many instances when numbers with precious connections are not exact. Readers who find mathematics intimidating, such as myself, may find comfort in the fact that while many of the numbers used in Buddhism are impressive and meaningful, they are not necessarily stable. I am afraid that the question "How many heads does an Eleven-Headed Kannon have?" sounds like a joke, but indeed it just depends on how you count. Some images of the deity have ten smaller heads on top of a main head, and other images have eleven smaller heads arranged on top of a main head. Similarly, images of Thousand-Armed Kannon usually do not have a thousand arms because the number of arms may be abbreviated as dictated by convention, or miscalculated, or detached and lost.

For many of the examples in this study, there are slight value changes in the numbers. We will encounter creative calculations such as when six is represented by five or seven, or when thirty-three is represented by thirty-two or thirty-four, but the *idea* of the numerical values of six or thirty-three is maintained. Pious motivations commonly drove he faithful to augment a number to ensure maximum efficacy. In his massive tome on Buddhist mathematics, Brian Baumann discusses how premodern ideas about counting, numbers, and numbering were considered to be in the realm of divination and thus differ from modern mathematics.[33] This is certainly not to say that people did not know how to use numbers accurately. Magnificent feats of architecture prove that precise calculations were not only possible but also highly sophisticated in premodern Asia. From the seventeenth to the nineteenth century in Japan, long after the organization of most numerical deity groups were formed, wooden votive tablets inscribed with math problems and geometric symbols called *sangaku* were offered to shrines and temples (Fig. I.2). These abundant *sangaku*, which were offered in appreciation of the discovery of a theorem or as prayers for continued success in math, are demonstrations of a profound spiritual respect for the divine properties of math.[34]

Outline of the Chapters

Chapter One, "Reconstructing Six Kannon from the Tenth to the Twelfth Centuries," is an investigation and discussion of the origins and early func-

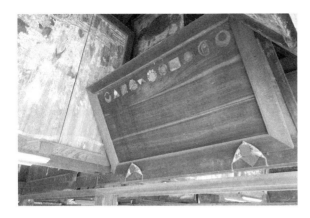

FIGURE I.2. *Sangaku.* 1879. Wood. 184×93 cm. Kitano Shrine, Kyoto.

tions of the six types of Guanyin in early Chinese texts, especially *Mohe zhiguan,* and the adoption and modification of these ideas into a cult in Japan in the tenth century, which was promoted by the Tendai and Shingon Schools of Buddhism. In general, I use the term *esoteric Buddhism* broadly throughout the book in a Japanese context to refer to the Buddhism referred to as *mikkyō,* secret teachings brought from China that were modified and promoted by these schools.[35] Many of the main sites that housed Six Kannon images in the Heian period (794–1185) are lost and known only through records, such as those from the Kyoto temples of Hosshōji and Hōjōji. This chapter will also examine rare early extant vestiges of former sets from this period, such as the images belonging to Buzaiin in Ishikawa and Konkaikōmyōji in Kyoto. These early Japanese images of Six Kannon and related records, such as iconographic manuals, diaries, and chronicles, allow us to gain a picture of the cult and images that flourished under elite patronage.

Chapter Two, "A Vision at Six Kannon Lake and Six Kannon/Six Kami in Kyushu," situates Six Kannon images within the parameters of the island of Kyushu, which has a high concentration of documentary and physical evidence of past Six Kannon practice. The miraculous story of the Six Kannon images that appeared at Six Kannon Lake in the Kirishima Mountains fueled the worship of the cult. The chapter includes a discussion of varied imagery from Kyushu, including the bronze sutra container from 1141 that had been buried in the mountains of Kunisaki, and the seventeenth-century set from Fumonji, which over centuries moved with a dual Buddhist–kami identity (as *honjibutsu*) between different temples and shrines in the Sagara domain. The geographic approach taken in this chapter makes clear that the strategy of matching Six Kannon with six kami, or six *gongen,* was a driving force in Kyushu religion.

Chapter Three, "Traveling Sets and Ritual Performance," examines the history, modifications, and movement of two well-documented wooden

sculpture sets of Six Kannon, the thirteenth-century set from Daihōonji and the fourteenth-century set from Tōmyōji. Copious inscriptions inside images in these sets reveal a great deal about diverse sponsorship, from an elite female patron in the former to a huge group of patrons from a variety of backgrounds in the latter. Within this chapter is an examination of thirteenth- to fifteenth-century written records on ritual procedures that focused on Six Kannon. The two sets provide the opportunity to learn how images functioned in response to different needs, such as assisting with the six paths, protecting the dharma, or bolstering sectarian heritage, throughout their changing circumstances.

In Chapter Four, "The Six-Syllable Sutra Ritual Mandala and the Six Kannon," I interpret why the images of Six Kannon appearing in paintings of the Six-Syllable mandala (Rokujikyōhō mandara), made from the thirteenth through the nineteenth century, look remarkably different from other sets of esoteric Six Kannon. The Six-Syllable mandalas include syllables, which are abbreviated forms of text called *bonji* based on Sanskrit letters, alongside Kannon images with body forms that recall earlier Chinese descriptions. As these mandalas served as the central focus of rituals performed to avert calamities, help with safe childbirth, and remove or redirect curses, they also demonstrate how the goals of Six Kannon worship came to emphasize practical, earthly concerns. Though the Six-Syllable sutra rituals were frequently performed, Six-Syllable mandalas that featured Six Kannon were not always used as the main focus of the rituals (J. *honzon*). Instead, especially in Tendai School rituals, paintings of other deities or groupings were used as alternate ritual foci. Consequently, this chapter locates and analyzes the rare surviving examples of Six-Syllable mandalas that include Six Kannon to show how textual evidence for the ritual practice was physically manifested.

Chapter Five, "Painting the Six Kannon," addresses extant iconic image sets of Six Kannon paintings made from the thirteenth century on. A centerpiece is the large fourteenth-century painting set from the Hosomi Museum in Kyoto, of which five of the original paintings survive. Within the discussion of paintings, this chapter examines the challenge of how unstable the number six can be in Six Kannon by considering the establishment of the Seven Kannon group. This phenomenon may occur when the alternate Kannon types used by Shingon and Tendai, respectively, are included within one group, such as in the scroll called *Sho Kannon zuzō* (Iconographic drawings of many Kannon), as well as with the images enshrined at the Kyoto temple called Shichi Kannon'in. In addition, the chapter uncovers groups of images misidentified as "Seven Kannon," which are actually Six Kannon joined by one Seishi (Skt. Mahāsthāmaprāpta) to explore the prac-

tice of the once popular but now almost unknown Edo-period ritual called Shichiyamachi (Seven Nights of Waiting). Paintings of Six Kannon, which were more portable than sculptures, had a significant role in the evolution of the Six Kannon cult and became a main avenue for the cult's subsequent transformation.

Chapter Six, "Bodies and Benefits: From Six to Thirty-Three Kannon," discusses the transition of the Six Kannon cult to the Thirty-Three Kannon cult or cults. The first location of transition, where Six Kannon image groups overlap with Thirty-Three Kannon image groups, may be found in painting sets, including a group of variations of Kannon transported to Japan from China in the fifteenth century. The second area of transition is in the fact that the main temple icons of the major Thirty-Three Kannon pilgrimage routes all feature one of the Six Kannon rather than any of the thirty-three images related to Kannon that are found in the *Lotus sūtra* grouping. Within the context of pilgrimage, a surprising area of transition between the cults is found in the imagery cast into large bronze bells used at Buddhist temples. Finally, beginning in the seventeenth century, the boundaries of the distribution of multiple Kannon imagery were pushed even further as publications of the printed iconographic manual *Butsuzō zui,* which clearly organized illustrations of groups of Seven and Thirty-Three Kannon, rapidly proliferated throughout Japan and then abroad, giving Kannon worldwide exposure.

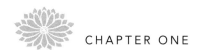

Reconstructing Six Kannon from the Tenth to the Twelfth Centuries

REPETITION IS A FUNDAMENTAL EXPRESSION in Buddhist piety, whether through chanting, ritual, or image making, and the idea of grouping multiple images of the same deity is common in Japanese religion. One of the most well-known examples is Kyoto's famous Sanjūsangendō (Hall of the thirty-three bays), with its one thousand images of Thousand-Armed Kannon made in the twelfth and thirteenth centuries. This chapter will discuss examples of Six Kannon images, which members differ from Sanjūsangendō in that they each have individual identities and roles that contribute to a synergistic power of the collective. The six types of Kannon included in the groups were more often enshrined individually at temples throughout Japan than as parts of sets.

Each one of the Kannon is so beloved and important individually that each warrants its own book, and indeed many books and articles have already been dedicated to them, from which this author has benefited greatly. Because the goal of this study is to address the images as a group, I will first address the cult's history in China and then describe the seven (six with one alternate) discrete types of Kannon to emphasize their distinctive features and roles within the Six Kannon scheme before moving on to consider how the Six Kannon function together. Next the chapter will address the formation of the cult in Japan and promotion by Shingon and Tendai School monks. Finally, the chapter provides evidence for sets of Six Kannon made in the Heian period (794–1185).

Formation of the Six Kannon Cult in China

Kannon is the bodhisattva of compassion whose image first appeared in India, but to find the roots of the Six Kannon cult we must rely on an investigation of Buddhist literature, not in India but in China. The sixth-century Chinese text *Mohe zhiguan* (J. *Makashikan*; The great calming and contemplation), written by Zhiyi (538–597), has one of the earliest specific descriptions of six types of Kannon (Ch. Guanyin).[1] Since this is one of the major

texts used by the School of Tientai Buddhism, or Tendai in Japanese, its significance throughout history must not be underestimated. In the section dedicated to the Six Guanyin in *Mohe zhiguan,* translated below, the focus is on the power to eliminate hindrances to good karma.

> The "*dhāraṇīs* of six-syllable phrases" [J. *rokujishōku darani,* Ch. *liuzi zhangju tuoluoni*] have the power to destroy the obstacles of passionate afflictions; without a doubt they purify [the senses of] the three poisons [of greed, anger, and delusion], and consummate the path of Buddhahood.
>
> The "six syllables" refer to the six [incarnations of] Avalokiteśvara, who have the power to destroy the three kinds of obstacles in the six [lower] destinies.

1. Avalokiteśvara as Great Compassion destroys the three obstacles in the destiny of hell. The suffering in this destiny is intense—therefore it is appropriate to apply great compassion.
2. Avalokiteśvara as Great Mercy destroys the three obstacles in the destiny of hungry ghosts. This destiny entails starvation and thirst—therefore it is appropriate to apply great mercy.
3. The Fearless Lion-like Avalokiteśvara destroys the three obstacles in the destiny of beasts. The king of beasts is majestic and fierce [and can thus face the untamed ferociousness of beasts]—therefore it is appropriate to apply fearlessness.
4. Avalokiteśvara of the Universally Shining Great Light destroys the three obstacles in the destiny of the asuras. This destiny entails envy and distrust—therefore it is appropriate to apply universal illumination.
5. Avalokiteśvara as the Divine Hero destroys the three obstacles in the destiny of human beings. The human destiny involves both mundane affairs and [the capacity to understand] the principle [of reality]. He is called "divine" because he uses mundane means to overcome [human] arrogance, and he is called a "hero" in [that he helps human beings understand] the principle [of reality], i.e., to perceive Buddha-nature.
6. Avalokiteśvara as Mahābrahmā the Profound destroys the three obstacles in the destiny of divine beings. Brahmā is the lord of divine beings—by indicating the lord, one includes the vassals as well.[2]

According to this text, the Six Guanyin are viewed as manifestations of a special Six-Syllable *dhāraṇī,* which is a powerful mystic formula distilled from esoteric texts believed to have apotropaic power.[3] Perhaps the association with these Guanyin gave the concept of *dhāraṇī* a more accessible presence than just that of imagining the power of a text. In *Mohe zhiguan*

each of the Six Guanyin helps to save beings in one of the six paths of existence: hell, hungry ghosts, animals, asuras, humans, and heavenly beings. The three obstacles that each Avalokiteśvara destroys refer to passionate afflictions, karma, and retribution.[4] According to Chinese Buddhist belief, after someone dies he or she is confronted by each of the Ten Kings (at intervals spaced out over a three-year period), who assess a list of the person's good and bad deeds during life to determine the next incarnation. The Ten Kings judge which of the six possibilities for the next incarnation are appropriate for the deceased.[5] Anxiety over this terrifying determination fueled enthusiasm for the Six Kannon to intercede on behalf of the dead.

Although I have not been able to find any images of the Six Guanyin in China, there are some fascinating textual sources. Centuries after the sixth-century *Mohe zhiguan,* stories such as those in the eleventh-century Chinese text *Sanbao ganying yaolüelu* (Essential record of the efficacy of the three jewels) illustrate the practical benefits of making images of the Six Guanyin. Chapter twenty-nine of the text tells the story of a man named Wenshi who was worried about his deceased parents because they had not followed the Buddhist way; he believed they were lost somewhere in the six paths. He decided to have paintings of Six Guanyin made in order to rescue his parents. The night before the paintings were to be finished, the Six Guanyin came to him in a dream to tell him his parents had been saved. One of the Guanyin had located his father in hell, and another had found his mother in the hungry ghost path. The other four Guanyin assured him that if his parents had been in any of the other four paths, they would have been rescued from those places as well. He awoke to find that the paintings had been finished and were emitting a divine light. Later, two heroes riding a purple cloud appeared and told him Guanyin had rescued them. All who heard the story believed the two heroes were his parents who had come to let him know they had been saved.[6]

Although not as explicit as chapter twenty-nine, chapter twenty-eight of the same text provides another story about the efficacy of making paintings of the Six Guanyin. A man named Xuqu from Liangzhou mourned his parents when he was young. Because he was worried about their fate, he made paintings of the Thousand-Eyed, Thousand-Armed Guanyin and the Six Guanyin for a memorial at his former home. A year and a half passed and he still did not know their fate. The next year, the voices of Xuqu's parents called to him out of the sky and told him that because of their bad karma they had been sent to suffer in the hells. But because he had the paintings made, they had the opportunity to leave hell and go to heaven. Xuqu told them he did not believe them, so they said that if he looked in a yellow box that was in storage he would receive one hundred gold coins. The

next day when he found the coins, he realized what they said was true. The narrator of the story adds that when viewing these paintings their elegance matches the story.[7]

These two stories are valuable not only because they substantiate that images of the Six Guanyin were considered efficacious in China, but also because they illustrate the significant role the Six Guanyin had in saving beings trapped in the worst of the six paths. These tales are important reminders that while the various types of Guanyin have the ability to rescue beings in the respective paths, the efforts made by the living are essential to activate the deities' powers to help the deceased. Regardless of these detailed textual explanations, I have not found any extant pictorial or sculptural images of Six Guanyin in China.

Introducing Six Kannon

Prior to the development of the cult of Six Kannon in Japan in the tenth century, specific types of Guanyin already operated independently in China, with significant established followings. Likewise in Japan, many Kannon already had specific cults that were tied to their geographic or temple locations. The following section will consider the individual types of Kannon that participated in the Six Kannon before moving on to consider how Japanese Buddhist leaders, with the patronage of the nobility, not only grouped Six Kannon by finessing matches with ideas in a distinguished Chinese source, but also with different types of Kannon that had significant powerful reputations of their own.

Shō Kannon

Shō Kannon (Skt. Ārya), or Noble Kannon, is the plain, humanlike form without extra heads, eyes, or arms, that takes the generic form of a bodhisattva modeled on the ideal of the Indian prince Siddhārtha before he left home and attained enlightenment to become Śākyamuni, the "Historical Buddha" who is said to have lived in the sixth century BCE. Sometimes an alternate character for Shō, meaning "correct" or "true," is substituted for the character of "noble," which has also been translated as "saintly" or "sacred." In a triad configuration, this is the form of Kannon that commonly flanks Amida (Skt. Amitābha) Buddha to represent compassion, along with Seishi Bosatsu (Skt. Mahāsthāmaprāpta Bodhisattva) to represent wisdom.

In this princely appearance, Kannon usually has a high topknot, elaborate jewelry, bare feet, a bare upper torso partially covered by a scarf, and wears a skirt (Fig. 1.1). Often the right arm is held down in the *varada mudrā*

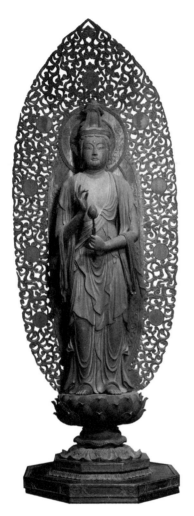

FIGURE 1.1. Shō Kannon. By Higo Jōkei. 1224. Wood. 178.0 cm. Daihōonji, Kyoto. Photograph by Sawada Naoyuki.

(J. *yoganin*) of giving and charity, although in some cases the hand may be raised with the thumb and second finger making a circle, in a variation of the *abhaya mudrā* (J. *semuiin*) or "freedom from fear" gesture. The left hand often holds a lotus bud. The lotus, which is one of the most widely used symbols in Buddhism and the most common attribute for Kannon images, symbolizes purity and perfection since this flower arises out of the mud to bloom immaculately. Within Shō Kannon's headdress, and indeed on most images of Kannon, there is usually a small figure of Amida Buddha (*kebutsu,* literally "transformed Buddha"), who is considered to be the special protector of Kannon.[8] The gentle, humanlike appearance of Shō Kannon is the most commonly represented manifestation of Kannon. There are some occasions, which will be discussed in Chapter Four, when Shō Kannon is represented alone to stand for the entire group of Six Kannon.

Thousand-Armed Kannon

With multiple appendages and eleven heads, the dramatic Thousand-Armed Kannon (J. Senju Kannon; Skt. Sahasrabhuja Avalokiteśvara) seems to be the opposite of the more subdued Shō Kannon. Images of multiarmed deities made in India served as sources of inspiration for Thousand-Armed Kannon. Indian monks translated several sutras with descriptions of Thousand-Armed Kannon from Sanskrit into Chinese in the seventh and eighth centuries.[9] Many of these images have eleven heads, like the Eleven-Headed Kannon, while others have twenty-seven heads (Fig. 1.2).

Through compassion, Thousand-Armed Kannon uses the extra heads, arms, and handheld objects to help save sentient beings (Plate 1). As explained in the sutra known by the abbreviated Chinese title *Qian shou jing* (Sutra of the thousand arms), which Bhagavaddharma translated into

Chinese in the seventh century, when the bodhisattva requested a thousand arms and a thousand eyes to save all sentient beings, they suddenly appeared on his body.[10] The sutra explains how the hands and the objects they hold can help with specific needs. For example, the jeweled bowl helps cure internal illnesses; the shield helps ward off tigers, wolves, and evil beasts; and the mirror helps attain great wisdom.[11]

The full number of one thousand arms is rarely depicted in sculptures, but there are a few examples such as the eighth-century sculptures from Fujiidera in Osaka and Tōshōdaiji in Nara. Sculptors faced with the challenge of making images with a thousand arms often created a fanlike configuration of smaller-sized arms radiating out around the image's body. Close scrutiny by modern conservators and art historians reveals that the number of arms does not always tally precisely to one thousand. More commonly, images of this deity have forty-two arms. The representation of forty-two arms, two of human proportions and forty smaller ones, is discussed

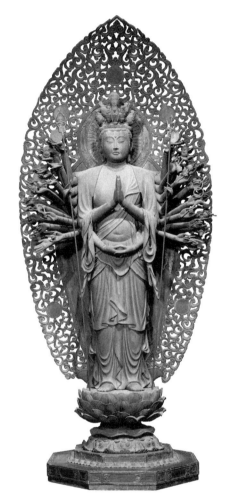

FIGURE 1.2. Thousand-Armed Kannon. By Higo Jōkei. 1224. Wood. 179.5 cm. Daihōonji, Kyoto. Photograph by Sawada Naoyuki.

in early texts and became a convention for this deity by the ninth century, as found in the one thousand images made in the twelfth to thirteenth century in the famous Sanjūsangendō in Kyoto. Usually the two principal arms form the gesture of prayer or adoration (Skt. *anjali mudrā;* J. *gasshōin*) in front of the chest, and below them is a smaller pair of arms holding a bowl. Each of the forty arms is said to save beings in one of the twenty-five states of existence (Skt. *pañca-viṃśati-bhava,* J. *nijūgou*), which consist of hell, hungry ghosts, animals, asuras, the four continents inhabited by humans, six heavens of desire, seven realms of the world of form, and four heavens of the formless world. Thus, one thousand arms are abbreviated to forty,

as forty times twenty-five equals one thousand.[12] The Thousand-Armed Kannon especially helps to ward off illnesses, aid longevity, and heal eye problems. Katia Triplett discussed the specific efficacy, lauded since the ninth century, of the Thousand-Armed Kannon icon of Tsubosakadera (Minamihokkeji) in Nara for aid with eye afflictions.[13] In some cases, depictions of this deity have eyes in the palm of each hand to help see all the sentient beings in need of salvation.

As seen in the exquisite thirteenth-century set of sculptures from Sanjūsangendō, Thousand-Armed Kannon may be accompanied by the Twenty-Eight Attendants (J. Nijūhachibushū), which include the Wind God (J. Fūjin), the Thunder God (J. Raijin), the old ascetic (J. Basu sennin), and the old woman (J. Mawaranyo).[14]

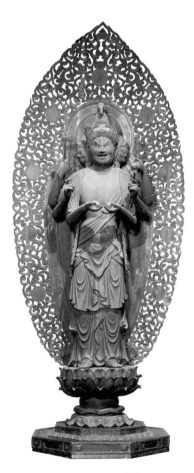

FIGURE 1.3. Horse-Headed Kannon. By Higo Jōkei. 1224. Wood. 175.2 cm. Daihōonji, Kyoto. Photograph by Sawada Naoyuki.

Horse-Headed Kannon

The manifestation of Horse-Headed Kannon, called Batō Kannon (Skt. Hayagrīva Avalokiteśvara), takes the name from his most characteristic attribute—the horse head on top of the topknot (Fig. 1.3). Horse-Headed Kannon possibly derived from a manifestation of the Hindu deity Vishnu, whose vehicle is a horse. There are sutras from as early as the eighth century and iconographic manuals with drawings from the thirteenth century that describe his main head as that of a horse, though this is rarely depicted in icons.[15] Instead, Horse-Headed Kannon has one or, more often, three faces, each with three eyes, angry scowls, fangs, hair flying up in a flame-like fashion, and a horse's head sitting above the topknot (Plate 2). Horse-Headed Kannon has a special hand gesture, called the "horse-mouth *mudrā*" (J. *bakōin*), with the pair of hands in front placed together and index fingers pointing out.[16] Horse-Headed's scowling face may seem somewhat surprising for a benevolent bodhisattva, but he is sometimes considered a Myōō (Skt. Vidyājrajā)

or Bright King, which is a class of deity that expresses wrath against evil. As Benedetta Lomi discussed, the Horse-Headed Kannon rituals that came to be practiced as a way to protect beloved horses among a wide swath of the populace in Edo-period (1615–1868) Japan had early roots. As early as the eighth century, texts auspiciously align Horse-Headed Kannon with the precious horse (Skt. *aśvaratna*) of a Chakravartin and then later in the thirteenth century with Kantaka, the trusty steed of Prince Siddhartha.[17]

As a significant early example, a bronze five-pronged *vajra* bell made in China in the eighth century, owned by the Nara National Museum, features Horse-Headed seated, with three faces, a horse's head on top of the main head, and four arms, as one in a group of four Myōō.[18] Images of Horse-Headed may have two, four, six, or eight arms, but six seems to be the most common. In keeping with his angry countenance, he carries weapons, such as an ax, a jeweled sword, and a jeweled staff. Images of this deity are often red in color and they may either stand or sit; if seated they are usually represented in the royal ease position, with one leg folded in and one knee raised.

As early documentary evidence in Japan, the temple record *Saidaiji shizai rukichō* (Record of Saidaiji temple property) from Saidaiji in Nara, dated to 780 (Hōki 11), indicates that a Horse-Headed Kannon image, no longer extant, was enshrined in its Yakushi Hall along with many other sculptures.[19] Significant freestanding sculptures in Japan include the large wooden image from the twelfth century from Kanzeonji in Fukuoka prefecture and the elegant and well-preserved image dated to 1241 (Ninji 2) from Jōruriji in Kyoto prefecture. The Museum of Fine Arts, Boston has a noteworthy painting on silk of this image from the twelfth century. From the seventeenth century onward, many modest sculptures of this deity made of stone were set up along roadsides to protect travelers and their horses. Especially in rural areas, Horse-Headed Kannon is regarded as a protector of animals, especially horses and cows. Accordingly, animal breeders pay great homage to him, and the Japan Racing Association sponsored a special exhibition of sculptures and paintings of this deity.[20] In addition to helping with the health and salvation of animals, Horse-Headed Kannon also helps control the passions in humans, which can be considered animal-like. In the Six Kannon group, Horse-Headed Kannon quite naturally offers salvation to beings in the animal path.

Eleven-Headed Kannon

In accordance with the sutras, such as *Ekadaśamukha dhāraṇī sūtra* (Ch. *Shiyimian Guanshiyin pusa shenzhou jing*; J. *Jūichimen Kanzeon Bosatsu jinjukyō*), that record the appearance of the deity, images of Eleven-Headed Kannon (Skt. Ekadaśamukha Avalokiteśvara; J. Jūichimen Kannon) usually have

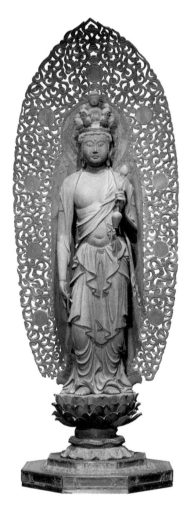

FIGURE 1.4. Eleven-Headed Kannon. By Higo Jōkei. 1224. Wood. 181.6 cm. Daihōonji, Kyoto. Photograph by Sawada Naoyuki.

ten small heads, plus a main head (Fig. 1.4, Plate 3).[21] Early textual sources for descriptions of the deity are found in sutras that were translated into Chinese by the sixth century. A common arrangement in sculptures is that seven of the small heads are placed in a circle around the diadem, two are placed above the front row of heads, and one is placed on top of the large topknot of hair. The head at the very back of the main head has a laughing face with an open mouth, and on top of the main head, balanced on the large topknot, is the head of a Buddha. In paintings, the heads are often arranged with two heads flanking the main head and then above in tiers so that all are visible to the viewers. Traditionally, in addition to the main head and the laughing face in the back, the smaller heads include three bodhisattva faces with kind expressions, three with tusks, and three others with angry expressions, but again the numbers can vary, so the images may have either eleven or twelve heads.[22] The heads express various emotions and are believed to help dispel delusions and assist sentient beings on the path to enlightenment. There are different theories about why the number eleven is significant for this figure, such as its relationship to the eleven stages on the path to enlightenment (Skt. *bhūmi*).[23] Ten is also important, and accordingly, sutras dedicated to Eleven-Headed Kannon, of which translations had arrived in Japan by the eighth and ninth centuries, proclaim ten benefits as a reward for proper devotion to the deity. As Samuel Morse succinctly explained,

Seven benefits relate to physical protection—against illness; evil enemies and threats; harm from the poison of insects of spells of demons; harm by swords or staffs; drowning; fire; and untimely death. Another benefit centers on the acquisition of riches—receiving wealth, jewels, clothing, and food in unlimited supplies. Two vows are more spiritual—receiving salvation from the myriad buddhas and words of praise from exalted beings.[24]

According to popular legend created to explain the heads, Kannon was so overwhelmed with despair after trying to save innumerable sentient beings that his head shattered into fragments. Amida (Skt. Amitābha) Buddha, Kannon's protector, came to the rescue by molding the fragments into new heads and placing them on top of Kannon's main head like a crown, adding a manifestation of his own head at the very top.[25] With all the extra eyes and brains, Kannon could extend his awareness and quest to save suffering sentient beings.

With two arms, Eleven-Headed Kannon typically holds a vase containing a lotus in the left hand while the right hand is held down in the *varada mudrā* of giving and charity. The palm of this hand may face inward or out to the side. The earliest sculpture of the Eleven-Headed Kannon found in Japan is a small bronze from the seventh or eighth century that was unearthed from the Nachi sutra mound within the Kumano Shrine complex in Wakayama prefecture.[26] Eleven-Headed Kannon was extremely popular in the ninth and tenth centuries. Morse discussed how at this time the cult of Eleven-Headed Kannon especially thrived in the area around Lake Biwa in Shiga prefecture and numerous temples, such as Kōgenji (or Dōganji) with its ninth-century sculpture, enshrined wooden images of this figure.[27] Sandalwood was considered the best material for an Eleven-Headed Kannon image, but because large pieces of this fragrant wood were not available, substitute woods were used and left unpainted.[28]

Juntei Kannon

Juntei Kannon (Skt. Cundī Avalokiteśvara), whose name means "pure," is the least likely of the Six Kannon to appear by herself as the independent object of a cult. Sutras that describe the deity, such as *Cundī dhārāṇi sūtra,* were translated from Sanskrit into Chinese in the eighth century (Fig. 1.5).[29] This deity is also named "Mother of the Seventy

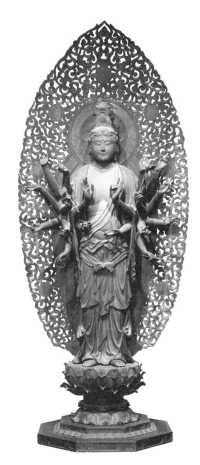

FIGURE 1.5. Juntei Kannon. By Higo Jōkei. 1224. Wood. 175.6 cm. Daihōonji, Kyoto. Photograph by Sawada Naoyuki.

Million Buddhas" (Skt. Saptakotibuddhamātr; J. Shichikutei Butsumo). The number eighteen has special significance for Kannon, and hence Juntei Kannon is most commonly depicted with eighteen arms that are said to represent the eighteen characteristics (Skt. *āveṇikadharmas*; J. *fugūhō*) exclusive to a Buddha as distinct from other beings (Plate 8).[30] Juntei Kannon is often represented as pale yellow or gold in color and with three eyes. The third eye is placed vertically in the middle of the forehead above the *ūrṇā*, the three white hairs that emit light, which, in contrast to the third eye, is a common iconographic feature for Buddhas and bodhisattvas. There are many variations in the attributes Juntei images hold to help with the salvation of sentient beings, including a *vajra,* a wheel, a lotus, and a conch shell. Often one of the hands makes the "freedom from fear" mudra and occasionally two of the deity's upper hands make the mudra of preaching. While Juntei is generally considered female, she usually looks like a bodhisattva of undetermined gender.

Images of Juntei appeared in the ninth and tenth centuries in Japan, such as the ninth- or tenth-century image at Kannonji in Shiga prefecture and another image dated to 970 (Tenroku 1), formerly owned by Shinyakushiji in Nara but now in the collection of the Tokiwayama Bunko in Kamakura.[31] Believers often address prayers specifically to Juntei Kannon in order to seek wisdom, victory in battle, cures for illnesses, easy childbirth, long life, and prayers for rain.

There is debate among various factions in Buddhism not only about whether Juntei is a Kannon, but also whether she is a bodhisattva at all. Within depictions of the Womb World mandala in the Genzu tradition, which maps out categories for esoteric images and is associated with Kūkai, she does not appear in the Kannon section, but as Butsumo in the section of Universal Knowledge (*henchi'in*) with the Buddhas. According to Elizabeth ten Grotenhuis, Butsumo are the aspects of knowledge that give birth to the Buddhas and the bodhisattvas.[32] In addition, images of Juntei often do not include a small Buddha image in the headdress, which is a common way to identify Kannon images. While Juntei is beloved as a Kannon by Daigoji and the Ono branch of Shingon Buddhism, the Hirosawa branch of Shingon, which has Ninnaji in Kyoto as its headquarters, does not recognize Juntei as a Kannon.[33] Moreover, the Tendai School does not usually recognize Juntei as a Kannon either. The Tendai monk Kōshū (1276–1350) noted in *Keiran shūyōshū* (A collection of leaves gathered from the stormy seas) that Tendai does not include Juntei in the group of Six Kannon because there is no Buddha in Juntei's crown.[34] Accordingly, when Juntei is included within a group of Six Kannon, there is often an association with the Ono branch of Shingon. As will be discussed, because Ono no Ningai (951–1046) of the Ono branch

was so active in promoting the Six Kannon cult, Juntei has a very prominent role in that lineage.

Fukūkenjaku Kannon

Fukūkenjaku Kannon (Skt. Amoghapāśa Avalokiteśvara) is named for his compassionate vow to save all beings with his unfailing lasso, literally the "Kannon whose lasso is never empty" or the "Rope-snaring Kannon." Because the translations for this name are not standardized, he will be referred to by his Japanese name. Fukūkenjaku Kannon compassionately uses the lasso (J. *kenjaku*) to ensnare deluded beings and pull them toward salvation. Images of this deity usually have eight arms, and in addition to the lasso attribute, they may hold a monk's staff, a lotus, or a flywhisk. One pair of arms is often held close to the body in prayer or adoration (Fig. 1.6). Another distinctive characteristic of Fukūkenjaku is that he usually has a third eye placed vertically between the eyebrows and above the *ūrṇa,* as in the previously discussed images of Juntei.

Sutras regarding this deity were translated into Chinese beginning in the sixth century.[35] In Japan, probably the most famous example of Fukūkenjaku Kannon is the imposing dry lacquer statue dated to 747 (Tenpyō 19) in Sangatsudō (Third Month Hall) at Tōdaiji in Nara. Fukūkenjaku Kannon was an especially significant deity to the Fujiwara clan, as demonstrated by their patronage of the image made by the sculptor Kōkei (fl. 1175–1200) in 1189 (Bunji 5) for the Nanendō (South Octagonal Hall) at Kōfukuji in Nara. This sculpture was made to replace an earlier Fukūkenjaku image from the eighth or ninth century that burned with the building during the Genpei War in 1180 (Jishō 4).

Since the deer is the clan symbol for the Fujiwara and Fukūkenjaku is said to love all beings like a doe loves her fawn, Fukūkenjaku is often pictured seated on a deer or with a deerskin cape covering his shoulders functioning as a monk's stole (J. *kesa*).[36] The earliest preserved description of Fukūkenjaku wearing a deerskin over one shoulder may be found in the text *Bukong juansuo zhou jing* (J. *Fukūkenjaku jukyō*), translated from Sanskrit into Chinese in the Sui dynasty (581–618).[37] The later Chinese text *Chimingzang yujia dajiao zunna pusa daming chenjiu yiqui jing* (J. *Jimyōzō yugadaikyō sonna bosatsu daimyōjōju gikikyō*), translated into Chinese by Faxian (d. 1001), describes Fukūkenjaku's deerskin as a scarf.[38] The deerskin as an attribute of Fukūkenjaku has a long history, and the Fujiwara clan may have promoted Fukūkenjaku's association with the deer not only because the deer was their clan symbol but also because of its association with Kasuga Shrine in Nara. Fukūkenjaku was considered the Buddhist counterpart (*honji*) of the main

FIGURE 1.6. Fukūkenjaku Kannon. Detail from *Sho Kannon zuzō*. Twelfth century. Ink on paper. 30.0 × 1064.3 cm. From *TZ* 12:21, no. 21.

shrine deity of Kasuga, called Kasuga Daimyōjin. Moreover, the kami named Takemikazuchi, resident of the first shrine at Kasuga, is said to have traveled there on a deer. Kasuga and Kōfukuji are part of the same religious complex that the Fujiwara clan controlled for centuries.[39]

In Tendai-School commissions of the Six Kannon grouping, Fukūkenjaku Kannon usually replaces Juntei Kannon to aid those in the human path.[40] As mentioned above, because Juntei is not always considered to be a Kannon by the Tendai School, Fukūkenjaku is substituted. Texts and extant image groups demonstrate that the Tendai and Shingon Schools, respectively, selected either Fukūkenjaku or Juntei for the Six Kannon assembly, but such protocol was not always strictly followed. The practice of using

these alternates within Six Kannon configurations will be discussed subsequently in regard to specific cases.

Nyoirin Kannon

Although images of Nyoirin Kannon (Skt. Cintāmaṇi Avalokiteśvara) have additional attributes, the name is derived from the wish-granting jewel (J. *nyoi*) and the wheel (J. *rin*) of dharma that he holds (Fig. 1.7). One other hand holds a Buddhist rosary while another holds a lotus flower. Another arm is raised with hand to chin in a contemplative gesture (Plate 4). Yet another arm is lowered, with the palm touching the rock base that represents Mount Potalaka (J. Kōmyōsan), the paradise where Kannon resides. Six-armed images of Nyoirin Kannon are usually represented as seated in the royal ease position (J. *rinnōza*), with one leg folded in and one knee up. However, there are rare standing examples of the six-armed Nyoirin Kannon, such as the twelfth-century sculpture from Nyoirinji in Fukuoka prefecture.[41] Nyoirin's six arms are said to explore the six paths, and through great compassion they can end many delusions and sufferings.

FIGURE 1.7. Nyoirin Kannon. By Higo Jōkei. 1224. Wood. 96.5 cm. Daihōonji, Kyoto. Photograph by Sawada Naoyuki.

One of the earliest texts on Nyoirin Kannon is *Cintāmaṇi dhāraṇī sūtra*, translated into Chinese in the early eighth century by the Indian monk Bodhiruchi, which describes the deity as emitting a great light and sitting on a lotus. The six-armed form of Nyoirin is not mentioned in this text. The earliest esoteric text that outlines the iconography for the form of this deity with six arms is known in Chinese as *Guanzizai Ruyilun Guanyin pusa yuqie fayao* (J. *Kanjizai Nyoirin Kannon Bosatsu yuga hōyō*; Service for meditation on Nyoirin Kannon who observes freely), which was reportedly translated into Chinese by the eighth-century Indian monk Vajrabodhi, said to be the fifth patriarch

in the Shingon tradition. This form of Nyoirin Kannon has a golden body, six arms, and wears a crown; it is further described as follows:

> The first hand is in the contemplating position because it shows mercy to sentient beings, the second hand holds the jewel that grants all desires, the third hand holds a rosary to save animals from suffering. On the left, the first hand rests on Mount Potalaka, unwavering in its fulfillment, the second is the hand that holds a lotus, purifying unlawfulness, and the third hand holds the wheel, which turns the supreme law.[42]

Knowledge of the six-armed Nyoirin Kannon form was transmitted to Japan in the early ninth century through Shingon connections, and in particular by Kūkai (774–835), who brought back many texts and paintings from China to enhance the transmission of Shingon (Ch. Zhenyan) Buddhism to Japan. Evidence for an earlier two-armed form of this deity is found at Ishiyamadera in Shiga prefecture. The eleventh-century representation of Nyoirin Kannon now enshrined there as the main image is said to retain the form of the original two-armed image from the eighth century that it replaced.[43] Within sets of Six Kannon, Nyoirin can appear with either two or six arms, as will be discussed in the subsequent examples.

Transition to Japan

Borrowing from Chinese sources, the Tendai monk Annen (841–ca. 898) wrote in the ninth century that the Six Kannon destroy the three obstacles in the six paths, but he did not describe any images.[44] By the eleventh century, the esteemed Japanese Shingon prelate Ono no Ningai (951–1046) explained the equivalencies between the traditional Chinese list from *Mohe zhiguan* and the images found in Japan, as well as which Kannon helps which path.[45] As shown in Table 1.1, although the characters for the names of the Six Guanyin in China differ from the Japanese sources on the Six Kannon, the message is the same. The original source for the text called *Ningai chūshinmon* (Report presented by Ningai) is unknown, but it was quoted in later Buddhist texts. The earliest is *Sanmairyū kudenshū* (Collection of the oral transmissions of Sanmai), compiled by Tendai monk Ryōyū, who was also known as Sanmai Ajari, in 1069–1072.[46] Other texts include *Hishō mondō* (Selections of secret questions and answers) by the monk Raiyu (1226–1304) and the Tendai ritual manual *Asabashō* (Notes on the Buddha [a], Lotus [sa], and Diamond [ba] sections [of the Womb World]), compiled by Shōchō (1205–1281).[47]

The fact that the earliest citation of *Ningai chūshinmon* was included in *Sanmairyū kudenshū,* a compilation made not too long after Ningai's death,

TABLE 1.1 Comparing Chinese Guanyin and Japanese Kannon

	CHINESE SIX GUANYIN IN *MOHE ZHIGUAN* 摩訶止観 (SIXTH CENTURY)	ROLE IN SIX PATHS 六道	JAPANESE SIX KANNON ACCORDING TO *NINGAI CHŪSHINMON* 仁海注進文 (ELEVENTH CENTURY)	*NINGAI CHŪSHINMON* EXPLANATION OF GUANYIN/KANNON EQUIVALANCE
1	大悲 Dabei (J. Daihi) (Great Compassion)	Saves denizens of hell 地獄道	聖 Shō (Noble) (Skt. Ārya)	Daci changes to Shō. *Ningai chūshinmon* reverses the order of Dabei and Daci
2	大慈 Daci (J. Daiji) (Great Mercy)	Saves hungry ghosts 餓鬼道	千手 Senju (Thousand-Armed) (Skt. Sahasrabhuja)	Dabei changes to Senju. *Ningai chūshinmon* reverses the order of Dabei and Daci
3	師子無畏 Shizi wuwei (J. Shishimui) (Fearless Lion)	Saves animals 畜生道	馬頭 Batō (Horse-Headed) (Skt. Hayagrīva)	Shizi wuwei changes to Batō
4	大光普照 Daguan puzhao (J. Daikōfushō) (Universal Light)	Saves asura (demigods) 修羅道	十一面 Jūichimen (Eleven-Headed) (Skt. Ekadaśamukha)	Daguan puzhao changes to Jūichimen
5	天人丈夫 Tianren zhangfu (J. Tenninjōfu) (Divine Hero)	Saves humans 人間道	准提 Juntei (Buddha Mother) (Skt. Cundī) (Note: 不空羂索 Fukūkenjaku [Rope-Snaring] [Skt. Amoghapāśa] is in this position in the Tendai tradition)	Tianren zhangfu changes to Juntei
6	大梵深遠 Dafan shenyuan (J. Daibonjin'on) (Omnipotent Brahma)	Saves heavenly beings 天道	如意輪 Nyoirin (Jewel-Holding) (Skt. Cintāmaṇicakra)	Dafan shenyuan changes to Nyoirin

and that the later quotations remain relatively consistent, gives the source more credibility. Furthermore, its repeated citation demonstrates a prolonged interest in the Chinese origins of the Six Kannon as well as explanations for how they functioned. Ono no Ningai's eleventh-century *Ningai chūshinmon* is quoted in *Sanmairyū kudenshū* as follows:

NOTES ON THE SIX KANNON

(1.) Avalokiteśvara as Great Mercy changes to Shō Kannon and saves those in the hell path. He has a light blue body. The left hand holds a blue lotus. Other examples have a [plain] lotus. The right hand makes the freedom from fear mudra.

(2.) Avalokiteśvara as Great Compassion changes to Thousand-Armed Kannon and saves those in the hungry ghost path. He has a yellow-gold body and six heads. The left hand holds a red lotus. The right makes the freedom from fear mudra.

(3.) The Fearless Lion-like Avalokiteśvara changes to the Horse-Headed Kannon and saves those in the animal path. His body is blue. The right hand holds a lotus, and on top of the lotus is a sutra box. The left hand makes the freedom from fear mudra.

(4.) Avalokiteśvara of the Universally Shining Great Light changes to Eleven-Headed Kannon and saves those in the asura path. His body is the color of [human] flesh. The right hand holds a red lotus, and on top of the flower stands a vase with a single-prong *vajra* emerging out of its mouth. The left hand makes the freedom from fear mudra.

(5.) Avalokiteśvara as the Divine Hero changes to Juntei Butsumo Kannon and saves humans. The body is dark blue. The right hand holds a blue lotus. The left hand makes the freedom from fear mudra.

(6.) Avalokiteśvara as Mahābrahmā changes to Nyoirin Kannon and saves those in the heavenly path. He has a white body. The left hand holds a red lotus, and on top of the flower stands a three-pronged *vajra*. The right hand makes the freedom from fear mudra.[48]

Ningai states that the preceding Six Kannon names and different transformations come from the sixth-century text *Mohe zhiguan*. However, he reversed the two positions of Dabei (J. Daihi, Great Compassion) and Daci (J. Daiji, Great Mercy) in his explanation; according to Ningai, Daci equals Shō, saving those in hell, and Dabei equals Senju, saving those in the hungry ghost path. While Ningai's acknowledgment of *Mohe zhiguan* as the source may have been an attempt to give a group of images appearing in Japan around the tenth century a more established pedigree, he explained that the additional description of the colors of the images and the attributes they hold was taken from the notes of "earlier masters" whom he does not name.

Perhaps the *Ningai chūshinmon* description may be closer to the appearance of the Chinese Six Guanyin, but because no Chinese examples have been located, this is speculation. Since each image described in the text has just two arms and only the Thousand-Armed Kannon has extra heads, these

are not the familiar esoteric images of the Six Kannon like those just described and at Daihōonji, which will be discussed in Chapter Three. Perhaps because by the eleventh century individual types of images of the Six Kannon had already been formed as the subjects of independent cults, sculpture groups with broad ritual functions were assembled using the more familiar esoteric images of the Kannon rather than the descriptions from Ningai's text. On the other hand, paintings of the Six-Syllable sutra mandala (Rokujikyōhō mandara) ritual contain images of the Six Kannon that do closely match Ningai's description.[49] Because these mandalas had their own specific ritual foci, I consider them as a distinct theme within the Six Kannon tradition and treat them separately in Chapter Four.

Before continuing, we should pause to consider that an alternative group of Six Kannon was formed in Japan that contrasts with the Six Kannon in *Chūshinmon* by including different individual Kannon. Purportedly, the Tendai prelate Enchin (814–891) presented his group of Six Kannon within the text *Nyūshingon monjū nyojitsuken kōen hokke ryakugi,* which is often referred to by the abbreviated title *Kōen hokkegi.*[50] Although the text is attributed to Enchin, who was in China from 853 to 858 before he founded the Jimon branch of Tendai and then served as abbot at Onjōji (Miidera) before becoming abbot of Enryakuji, the text was more likely a twelfth-century text written by a monk in his lineage. As we will see in the following text passage from *Kōen hokkegi,* the discussion of the *Kannon Chapter* (Universal Gateway or *Kannon sūtra*) of the *Lotus sūtra* emphasizes the Six Kannon, as well as explanations of their abilities, found in *Mahāvairocana Commentary* (J. *Dainichi sho*) from Yixing's (673–731) record of Śubhakarasiṃha's (637–735) commentary of *Mahāvairocana sūtra.*[51] The following is a translation of the *Kōen hokkegi* section on Six Kannon.

ABBREVIATED RITE FOR EXPOSITION OF THE LOTUS [BY WHICH ONE] ENTERS THE GATE OF THE TRUE WORD [SHINGON] OF REALITY AND ABIDES IN THE VIEW OF THINGS AS THEY TRULY ARE

Kanzeon Bodhisattva of the Universal Gate

　　Kannon is one who elevates humans and the Universal Gate exalts the dharma. This sutra lifts up both the dharma and humans. Therefore, it is called *Kannon Chapter of the Universal Gateway* and is correctly based on the gate of the true word [*shingon* or mantra]. This chapter instructs that the six kinds of Kannon remove one from suffering and manifestations of the Six Kannon dwell in the Universal Gateway. Therefore, it is called *Kannon Chapter of the Universal Gateway.* There are Six Kannon.

(1.) The first, Daihi [Great Compassion] Kannon,[52] as at the beginning of the text [*Kannon Chapter*]. *Mahāvairocana Commentary* states that he takes great compassion as his essence and whether body or mind, inside or outside, he purely takes compassion as his being.

(2.) The second, Daiseishi [Skt. Mahāsthāmaprāpta] Kannon. As the text [*Kannon Chapter*] states, if one enters a great fire, the fire will be unable to burn him or her because of this bodhisattva's majestic spiritual power. Therefore, *Mahāvairocana Commentary* states, born by the separation from the world and also born by the transcendence over suffering, he dwells in the wisdom of equality. (That which is just [written] above explains the text of Seishi Kannon's mantra). Fire and wisdom are fundamentally opposites. However, that [passage] concerns the ability for resolution. Thus, he is referred to as abiding in the wisdom of equality. This [passage] discusses the resolution and therefore it speaks of "great fire" [i.e., the fire of the burning house of *saṃsāra*].[53] The mundane and supra mundane differ, and that is all there is to it. Again, "born by the transcendence over suffering" refers to the fire of the mundane [birth and death], which agrees with this passage.

(3.) The third, Tara Kannon. As the text [*Kannon Chapter*] says, if one were adrift in a great flood, he or she would be taken to a shallow place right away. *Mahāvairocana Commentary* explains that Tara Kannon helps people cross over great rivers and places them onto the other shore.

(4.) The fourth, Bikuchi [Skt. Bhṛkuṭī] Kannon. As the text says when a person faces harm, he or she can be released. Rākṣasas and evil demons will not be able to see them with their evil gazes. *Mahāvairocana Commentary* explains that this deity makes all fears disperse.

(5.) The fifth, Byakusho. As the text explains, if a man or woman wishes to be reborn [they will be reborn] as a man or woman with fortune and wisdom at the proper level. *Mahāvairocana Commentary* says that this deity is born from the Buddha sphere. Namely, he is immediately able to give rise to the merits and virtues of many Buddhas and should be regarded as an adorned dharma body.

(6.) The Sixth, Horse-Headed [Batō]. As the text says, throughout life if one should chant the name of this bodhisattva 6,200,000,000 times (as numerous as the sands of the Ganges) or in the same way, another reverently offers the name of this Kannon bodhisattva once, the righteousness of these two people is the same. *Mahāvairocana Commentary* explains that this deity devours many obstacles and smashes these obstacles into tiny bits into the four [directions].

In this way, these six deities [Six Kannon] have thirty-three bodies that spread the ability to save suffering sentient beings throughout the whole world. Therefore, it is called *Kannon Chapter of the Universal Gateway.*

This group of Six Kannon—Daihi, Daiseishi, Tara, Bikuchi, Byakusho, and Horse-Headed—not only differs from those in *Mohe zhiguan* and those in *Ningai chūshinmon,* but also from those mentioned in the *Lotus sūtra.* There is no evidence that sets of these images were ever made, but if they were, this was not the grouping that captured the devotion, recognition, and replication that the groups of Kannon from *Mohe zhiguan* and *Ningai chūshinmon* achieved. The first, Daihi (Great Compassion) is the only Kannon in the group who also appears in *Mohe zhiguan.* Daiseishi is generally not considered a Kannon, and is not referred to as Kannon in *Mahāvairocana Commentary,* but does appear frequently as an attendant in an Amida triad along with Kannon.[54] This group also includes Tara and Bikuchi, who are regarded as female manifestations of Kannon. Tara, who was beloved as a goddess in South Asia, Tibet, and Nepal, appears again later in Japan as one of the Thirty-Three Kannon, which will be discussed in Chapter Six. Although one can find Bikuchi in the Kannon section of the Genzu mandala, like Tara, worship focused on her never took hold in Japan.[55] On the other hand, Byakusho is another name for Byakue (White-robed), which not only came to be a profoundly popular image of Kannon in East Asia by the fourteenth century but also was later included in the Thirty-Three Kannon group. The only overlap with Ningai's Kannon group is Horse-Headed Kannon.

Although not specifically quoting the *Lotus sūtra, Kōen hokkegi* justified the concept of Six Kannon with the statement that Kannon has thirty-three bodies to save suffering beings throughout the world. In contrast, Ningai associated his group of Six Kannon with *Mohe zhiguan.* Why did one group of Kannon become favored over another? The efficacious reputation of certain images as well as their promoters must have been important factors. In addition, perhaps the strategy of matching Six Kannon with six paths was more successful in capturing the attention of monks and patrons than the *Kōen hokkegi* scheme that did not emphasize the roles of the Six Kannon in helping navigate the six paths. This list proves that there were possibilities for variations in the types of Six Kannon in the Heian period.

Another group of six images that was also gaining currency in the twelfth century was Six Jizō (Skt. Kṣitigarbha). The three sets of Six Jizō present on the altar of the twelfth-century Konjikidō at Hiraizumi are the most recognized.[56] Hayami Tasuku examined textual evidence for the nobility's patronage of Six Jizō by from the eleventh to thirteenth century and found that

it paled in comparison to the support for Six Kannon.[57] As Hank Glassman has shown, the iconography for these groups was never set, as the names and attributes of the individual Jizō within these groups fluctuated greatly.[58] By the Edo period, Six Jizō began to appear with more regularity as modest images supported by nonelite society, as evidenced by the plentiful roadside and graveyard entrance stone sculptures of Six Jizō all over Japan. While beyond the scope of this chapter, the popularity of Six Jizō eventually outstripped Six Kannon because Jizō's reputation for rescuing people from hell gained widespread support from all levels of the populace. As we will see in Chapters Five and Six, by the Edo period, Kannon's notoriety shifts from groups of six to thirty-three.

In contrast to the idea of six relatively unknown generic types within Six Jizō, the Six Kannon were able to maintain their individual identities, although certainly with variety, while functioning within the group. The next section will outline the evidence for patronage of the groups of Six Kannon images that were made from the tenth to the twelfth centuries. Although only a few fragments of the actual sets survive, written records suggest that Six Kannon imagery and rituals thrived among the nobility during this period.

Documentary Evidence for Heian-Period Images of Six Kannon

In Japan the first recorded instance of the construction of Six Kannon images dates from 910 (Engi 10), when the Tendai prelate Sōō (831–918) had images of Amida (Skt. Amitābha) and the Six Kannon made at Mudōji on Mount Hiei in order to lead the living beings in the six paths to salvation.[59] Help with navigation along the six paths of transmigration seems to be the strongest motivation to make images of the Six Kannon in the early stages of the cult. In 985 (Eikan 3), Empress Shōshi (950–1000) sponsored the making of Six Kannon images for a temple complex named Kannon'in at the foot of Mount Hiei. "The Lecture Hall [kōdō] enshrines gold-colored images of the Six Kannon that lead sentient beings in the six paths and there are images of six devas that protect the Buddhist law."[60] The buildings of Kannon'in, like most old structures on Mount Hiei, were lost, but at least the images are known through records. As an indication of the cult's widespread recognition, *The Pillow Book* (*Makura no sōshi*), a reflection of court life written during the late tenth to early eleventh century by the well-known female author Sei Shōnagon, prominently lists the Six Kannon. *The Pillow Book* contains many lists, but only this account is of Buddhist deities: "Buddhas: Nyoirin, Thousand-Armed, and all the other Six Kannon, Yakushi Buddha, Shaka

Buddha, Miroku, Jizō, Monju, honorable Fudō, and Fugen."[61] Since she topped the list that she titled as "Buddhas" (*hotoke wa*) with two specific types of Kannon and subsequently acknowledged them as members of Six Kannon as a unit, she pointed toward the widespread notion of the Six Kannon cult at the time among her peers.

Members of the powerful Fujiwara family had significant sets of Six Kannon made during the tenth through the eleventh century. Even though they no longer survive, textual references testify to a trend of such prestigious commissions. The valuable record on Six Kannon rituals called *Roku Kannon gōgyō* in the thirteenth-century iconographic manual *Asabashō* lists seven examples of Six Kannon image sets with the comment that neither the arrangements nor the forms are set.[62] Indeed, when we consult evidence beyond the places mentioned in this text, this assessment continues to ring true. The following section of *Roku Kannon gōgyō* (Six Kannon procedures) in *Asabashō*, which is numbered three and titled "Forms of Six Kannon," discusses the examples with the types of Kannon and arrangements as follows. The translation of each passage is indented followed by brief explanatory comments.[63]

(1.) SAITŌ KANNON HALL [WEST PAGODA PRECINCT ON MOUNT HIEI]

First built by Fujiwara no Mototsune (836–891) when Empress Daigo was pregnant. First is Shō Kannon by itself in the east. Nyoirin has two arms. Thousand-Armed. Facing south is either Fukūkenjaku or Juntei, which are difficult to distinguish between. The hand of the right arm [of this image] is raised up with the thumb and middle finger touching. The left makes the giving mudra. Horse-Headed has two arms.

This passage refers to the Kannon Hall, which no longer exists, in the West Pagoda precinct of Enryakuji on Mount Hiei.[64] Empress Daigo likely refers to Fujiwara no Onshi (885–954), who was the daughter of Mototsune and consort of Daigo. Noteworthy in this passage is that the author Shōchō found the difference between Fukūkenjaku and Juntei difficult to determine.

(2.) YOKAWA ESHIN'IN [ON MOUNT HIEI]

Fujiwara no Morosuke (908–960), Kujōdono, built this when Empress Murakami was pregnant. Thousand-Armed [Kannon] surprisingly has forty-two arms, Fukūkenjaku has two arms. Shō Kannon, as usual, has two arms and holds a lotus. In the north is Dainichi making the meditation mudra. Eleven-Headed has two arms, one holding a vase and the other a

rosary. Nyoirin Kannon has six arms. Horse-Headed surprisingly has six arms. All of the above are life-size seated images.

Empress Murakami above may refer to Morosuke's daughter, Fujiwara no Anshi (or Yasuko) (927–964), who was empress-consort to Emperor Murakami, but which pregnancy this refers to is unclear. Elsewhere, conflicting records explain that instead of Morosuke, as in the passage above, according to his father's wishes and out of respect for the Tendai prelate Ryōgen, Morosuke's son Fujiwara no Kaneie (929–990) ordered the construction of Yokawa Eshin'in in 981 (Tengen 4) that was completed in 983 (Eigan 1).[65] *Enryakuji gokoku engi* (compiled in the Kamakura period [1185–1333]) notes that Six Kannon images "were perfectly made of wood and clay" at Eshin'in.[66] Whether or not the Six Kannon were in place before Morosuke's death in 960 remains a question. While acknowledging the contradictions, however, the records consistently assert that there was an important Fujiwara commission of Six Kannon images at Eshin'in in the tenth century.

(3.) HOSSHŌJI[a] KANNON HALL

Built by Fujiwara no Saneyori (900–970), who was also known as Ono no Miyadono. All Six Kannon are like images of Shō Kannon.

The now defunct Hosshōji[a] and its Kannon Hall were formerly located in southeast Kyoto in the Higashiyama area. Fujiwara no Tadahira (880–949) supported the building of Hosshōji[a] in 925 (Enchō 3).[67] By claiming that all the images were like Shō Kannon, this entry implies that the images were all two-armed and made in the way *Mohe zhiguan* describes. The text *Fusō ryakki* (Brief history of Japan) explains that Six Kannon colored gold were installed in the Hosshōji[a] Jeweled Pagoda (Tahotō) in Kyoto. While *Fusō ryakki* gives the year as 954 (Tenryaku 8), this is likely a mistake since other sources corroborate the event with the same month and day as above, but give the year as 945 (Tengyō 8).[68] An entry with the 945 date from *Honchō monzui* (Literary essence of our country) gives a detailed account of the Hosshōji[a] Six Kannon that aligns with the roles for saving beings in the six paths given in *Mohe zhiguan*.[69] Moreover, *Nihon kiryaku* also gives the date for the Hosshōji[a] pagoda dedication as 945.[70] Of special significance here is that both 945 and 954 predate any possible involvement by Ningai and therefore show that he was not single-handedly responsible for the cult of Six Kannon in Japan.

(4.) HŌJŌJI KANNON HALL

Fujiwara no Yorimichi [990–1074], also known as Ujidono, built this. Each of the Six Kannon images has a different form. This was at the time Master Ono no Ningai submitted his report [*Chūshinmon*]. I [referring to the author Shōchō] say that these names resemble those at the beginning [of the section].[71]

In this text, the second character used in Hōjōji is an alternate that was used to refer to Michinaga's impressive Hōjōji, which will be discussed later. The Six Kannon at Hōjōji that were dedicated in 1023 (Jian 3) were actually placed in a Yakushi Hall at the temple, rather than a Kannon Hall as mistakenly stated here. The *Asabashō* author Shōchō's inclusion of the Shingon prelate Ningai's text shows that these images were not thought of as exclusively Tendai and further accounts for the diversity by mentioning that each image was of a different type. Shōchō's note "I say that these names resemble those at the beginning" refers to a drawing in a rectangular frame of six circles that include abbreviated names of the Six Kannon and their *bonji* (Sanskrit seed syllables) at the beginning of this section of his own text. These names match those in Ningai's text.

(5.) SONSHŌJI KANNON HALL

Nyoirin, Fukūkenjaku, Eleven-headed, (North), Horse-Headed, Shō, Thousand-Armed.

Planning began through a vow made by Emperor Horikawa [r. 1087–1107] for Sonshōji around 1100 (Kowa 1).[72] The temple, now defunct, was located in Kyoto to the west and north of Hosshōji[b] in the Shirakawa area, near the area of Okazaki Park today.

(6.) *RICHIBŌ GAHON* [NINGEN'S ILLUSTRATED BOOK]

Nyoirin, Eleven-Headed, Shō, Thousand-Armed, Horse-Headed, Juntei.

Richibō refers to the Tendai prelate Ningen (1058–1109), who was a son of Fujiwara no Morozane (1042–1101). I do not know where this group of Kannon would have been located, or if they were ever made. Perhaps the wording "illustrated book" in this heading was used to indicate that the reference came from an iconographic manual compiled by Ningen. It is intriguing that

in his group the Tendai prelate chose to include Juntei, which is used in Shingon-School examples, but without the original source we cannot know what else was included or even discussed in the book.

(7.) HINO KANNON HALL [HŌKAIJI]

It is said that the "Ōhara Master" lived here. Fukūkenjaku with eighteen arms, Horse-Headed with eight arms, Thousand-Armed, north, Amida, Shō Kannon, Eleven-Headed, and Nyoirin with six arms. The above are all seated images.[73]

Hino Kannon Hall was built in 1081 (Eihō 1) on the grounds of the impressive Hōkaiji, a temple still extant south of Daigoji in Kyoto prefecture. Fujiwara no Sanetsuna (1012–1082) had the hall built for his daughter.[74] The "Ōhara Master" refers to the prelate Chōen (1016–1081), who was the founder of the Tendai Ōhara lineage, named for the area north of Kyoto called Ōhara, where he lived for a time.[75]

References to other sets of Six Kannon images from the same period that were not mentioned in *Asabashō* appear elsewhere. *Jimoku taiseishō* (Compilation of Jimoku court ceremonies) states that in 1003 (Chōho 5) at Shōrengein the life-size gold-colored Seven Yakushi and Six Kannon, for which a vow was made years before, were finished and now the Five Myōō have been dedicated.[76] Shōrengein likely refers to a subtemple in the West Pagoda precinct of Enryakuji.[77] *Shōyūki* (Fujiwara no Sanesuke's journal) explains that in 1018 (Kannin 2), fifth month, twenty-ninth day, there was a memorial service for Empress Dowager Fujiwara no Junshi (957–1017) on Tōnomine. "Recently a counselor of the first rank (Fujiwara no Kintō, 966–1041) said that a life-size set of Six Kannon was enshrined, but he still did not understand why there are [only] four now when there were two more before."[78] Tōnomine was a Tendai-affiliated institution in Nara prefecture. The prominent statesman Fujiwara no Yorimichi (992–1074) had a life-size set of Six Kannon with an Amida installed in the Jōgyōdō (Hall of constant practice) at Miidera in Shiga prefecture in 1040 (Chōraku 4).[79] *Chūyūki* (Fujiwara no Munetada's journal), which is the diary of Fujiwara no Munetada (1062–1141) covering the years 1087 to 1138, has at least six other references to Six Kannon images. Three of the entries refer to Six Kannon at the Kyoto temple Hosshōji[b], which was consecrated in 1077 (Jōraku 1).[80] Because these references represent a sample of the many Six Kannon sets commissioned by the nobility of Kyoto, it is not surprising that Fujiwara no Michinaga had a set installed at Hōjōji in 1023.

Hōjōji Six Kannon

The most legendary of all Six Kannon sets is that of Hōjōji, which was listed as the fourth entry in the aforementioned *Asabashō* section. Hōjōji was a magnificent temple complex with many halls and large-scale icons located in east Kyoto. Construction began around 1017 (Kannin 1). In front of its Kondō or main hall, built in 1022 (Jian 2), was a substantial pond with an island. West of the pond was an Amida Hall and to the east was a Yakushi Hall, where Six Kannon images were enshrined. Fujiwara no Michinaga's patronage of the complex ensured that it was outfitted in sumptuous style and made on a grand scale as a veritable paradise on earth.

The eleventh-century *A Tale of Flowering Fortunes* (*Eiga monogatari*) describes the splendor of Hōjōji in detail, with repeated references to its Six Kannon images. The first mention of the Six Kannon in the book is found in Chapter Fifteen. Although this chapter is dated to 1019 (Kannin 3), before Michinaga's Yakushi Hall was completed, the Six Kannon referred to are those made for the hall, which was finished in 1023.

> It would be impossible to describe all his activities at his own temples and private residences. Once he ordered images of the Six Kannon; at other times it was images of the Seven Healing Buddhas [Yakushi], or paintings of the Eight Events [the eight events in Śākyamuni's life], or nine images of Amitābha [Amida]. Or again he commissioned life-size statues of the buddhas and bodhisattvas of the Ten Days of Fasting, or 100 images of Śākyamuni, or a Thousand-armed Kannon, or 10,000 Fudō images. . . . [81]

This passage recognizes the importance of the numerical categories of deities by organizing them into groups of 6, 7, 8, 9, 10, 100, 1,000, 10,000, and so on. Six Kannon is significantly at the head of this list.

At Hōjōji, the Six Kannon had an important place among several substantial images in specifically numbered groups. In addition to the Nine Amida, mentioned above, for the Amida Hall directly west from the Yakushi Hall, the Godaidō (Hall of the Great Five Myōō) was directly to its north. In the same hall as the Six Kannon, the Seven Yakushi were attended by Twelve Guardian Kings. Yui Suzuki discusses the splendor of the Hōjōji buildings, some of the rituals that took place, and Michinaga's involvement in the grand project. As Suzuki put it, "Although there is no denying that Michinaga's Hōjōji was the culmination of his vast wealth and power, the temple was also a physical embodiment of his desires and anxieties towards the end of his illustrious life."[82]

Sections in Chapter Twenty-Two, which is dated to 1024 (Manju 1), in *A Tale of Flowering Fortunes* focus on the interior of the Yakushi Hall and its glittering images, including the Six Kannon. "There are *jōroku* [approx. 480 cm] Seven Yakushi all of gold, standing figures of Nikkō [Sunlight, Skt. Sūryaprabha] and Gakkō [Moonlight, Skt. Candraprabha], and the Six Kannon images are also *jōroku*. The way the robes flow over their lion pedestals looks extremely elegant."[83] The passage shows that in addition to the Seven Yakushi, which as the name of the hall indicates were considered the main focus for worship, the Six Kannon were also prominent in the hall. Another section in the same chapter explains, "[On] the pillar in front of the Six Kannon, all the verses from the *Lotus sūtra's* 'Kannon chapter' were written. One can only imagine the skill the Iimuro Master [En'en (d. 1040)] used to write them."[84] *A Tale of Flowering Fortunes* not only gives us an inside look at the hall's opulence, but also provides an example of the intimacy between the Six Kannon images and texts, especially the *Lotus sūtra*, which will be discussed as a theme in subsequent chapters.

Beyond the gorgeous impression, *A Tale of Flowering Fortunes* also specifically addresses the identities of the Six Kannon:

> The Six Kannon filled the worlds in the ten directions with innumerable rays of light, which manifested in their colors the bodhisattva resolve to benefit all living beings everywhere. The statues, similarly mounted on thrones made of different kinds of lotus blossoms, proceeded one after the other, from the Great Merciful One [Daihi] to the Great Brahmā-wisdom One [Daibonjin'on].[85]

In this section, the author chose to describe the Six Kannon by listing the first and last of them by their Chinese names used in *Mohe zhiguan*. In a later passage, the relationships between the *Mohe zhiguan* names and the commonly used names for the Six Kannon, as well as which path they help, are enumerated. "Furthermore, the purpose of the Six Kannon is to benefit all creatures in the six paths. How inspiring it is to recall their Original Pledge!"[86] The "Original Pledge" refers to the original vow (*honzei*) that every bodhisattva makes to save all beings. Following that statement, the author quotes an unknown text, which is likely *Ningai chūshinmon*, to give an abbreviated list of which of the Six Kannon takes care of which of the six paths.

Daihi [Great Compassion]/Thousand-Armed/hell
Daiji [Great Mercy]/Shō/hungry ghosts
Shishimui [Fearless Lion]/Horse-Headed/animals
Daikōfushō [Universal Light]/Eleven-Headed/asuras

Tenninjōfu [Divine Hero]/Juntei/humans
Daibonjin'on [Omnipotent Brahma]/Nyoirin/devas[87]

The section continues: "It is comforting to realize that we will never be sub-
ject to transmigration in the six paths if we worship with those names [of
each Kannon] constantly in mind. The contemplative air of the Prayer-
granting-wheel [Nyoirin] Kannon was especially moving."[88] The Six Kannon
must have been enlisted to contribute primarily to heal the ailing Michinaga,
but in the worst case they would be able to help him navigate the six paths
in the afterlife.

As previously pointed out in the text of *Asabashō,* and reinforced by *A
Tale of Flowering Fortunes,* the images of Hōjōji for the most part follow Nin-
gai's Shingon conception of the Six Kannon, except that the first two Kan-
non's associations with the hell and the hungry ghost paths are reversed and
thus follow *Mohe zhiguan.* The Shingon monk Raiyu (1226–1304), the com-
piler of the thirteenth-century text *Hishō mondō,* may not have noticed the
discrepancy, or was not troubled by it, and explicitly stated that the Hōjōji
Six Kannon were constructed for Michinaga in 1023 following the forms in
Ono no Ningai's *Chūshinmon.*[89] Raiyu noted in another text, *Shinzoku zakki
mondōshō* (Notes on dialogues of various sacred and profane records), that
the Juntei image that was made for Michinaga's Six Kannon group at Hōjōji,
which was made according to Ningai's protocol, was later transferred to the
Juntei Hall at Upper Daigoji in 1159 (Hōgen 4).[90] The Hōjōji Kannon images
were made in 1023 and were reportedly lost in the 1058 (Hōgen 3) fire that
burned down Hōjōji. Was the Juntei image able to escape the flames and gain
a new home as the main icon of its own hall at Daigoji? Though it is more
likely that Raiyu was merely perpetuating a rumor to enhance the promi-
nence of the Juntei image's provenance, the text reinforces the great sig-
nificance of the Hōjōji Six Kannon legacy. Daigoji's Juntei Hall, first built in
the ninth century, became a nexus of Juntei worship and an important Kan-
non pilgrimage site. Sadly, in 2008 the most recent iteration of the hall,
constructed in 1968, burned down. A new hall will be rebuilt.

When given, historical records show a variety of incentives for the com-
mission of Six Kannon images and rituals. One important motivation for
sponsorship was aid in childbirth. As mentioned earlier, the first two of
seven on the list of Six Kannon sets in *Roku Kannon gōgyō* in *Asabashō* above
indicate that they were constructed to aid in safe child delivery for the high-
est echelon: the Kannon Hall at the West Pagoda precinct on Mount Hiei
was constructed to help Empress Daigo, and Yokawa Eshin'in was built to
help Empress Murakami. An entry from 1178 (Jishō 2), tenth month, twenty-
seventh day, in *Sankaiki* (Record of mountains and locust trees), the diary

of Nakayama Tadachika (1131–1195), records that Taira no Shigemori (1138–1179) commissioned life-size colored images of Six Kannon images by the sculptor Myōen (d. 1199) and his five assistants.[91] This set, no longer extant, was made to pray for the safe childbirth of Shigemori's sister, Taira no Tokuko, later known as Kenreimon'in (1155–1213), who successfully gave birth to the future Emperor Antoku (1178–1185) about two weeks later.

The fictionalized account of the birth is much more well known than the above diary entry since it appears in the section on an imperial childbirth in the world-famous *The Tale of Heike,* a story of twelfth-century events compiled in thirteenth century. Again, Six Kannon are mentioned. The chapter describes how rituals of the Six Kannon and other Buddhist deities were performed for the imperial consort, but when the sutra of the Thousand-Armed Kannon was read, there was a sudden change and the prince was finally born.

> The abbot of Ninnaji performed
> the rite of the Peacock Sutra;
> the Tendai abbot Kakukai
> that of the Seven Medicine Kings;
> Cloistered Prince Enkei of Miidera
> undertook the rite of Kongō Dōji;
> in fact, every ritual that one could imagine—
> the Five Great Kokūzō, the Six Kannon,
> Ichiji Kinrin, the Five-Altar Rite,
> the Six-Letter Purification,
> the Eight-Letter Rite of Monju,
> yes, and the Life-Giving Fugen—
> every one of these was performed.[92]

The text goes on to describe the safe birth of Antoku to Kenreimon'in. Also noteworthy is that the second group of rituals listed includes "Six-Letter Purification," which is how Tyler translated "Rokuji karin," but I translate as Six-Syllable riverbank ritual. This ritual, which was known to be effective for warding off evil and reversing curses, and its connection to the Six Kannon cult will be discussed in detail in Chapter Four. In *Taiheiki,* another monumental tale in Japanese literature, there is a scene in which rituals were performed purportedly to help a princess give birth in 1332 (Genkō 2).[93] The list of rituals includes all the same as those mentioned above in *The Tale of the Heike* entry, including Six Kannon and Six-Syllable riverbank ritual, in addition to a few others. Since these are works of fiction, I do not include them as evidence of historical fact, but to show how the ritual for

Six Kannon was well recognized as an important ritual for successful birth.

Fragments from Late Heian-Period Six Kannon Sets

Given the documentation of Heian-period sets of Six Kannon just described, we should now turn to physical evidence. The only complete set of Six Kannon from the Heian period is on the bronze Chōanji sutra box, dated to 1141 (Hōen 7). Due to the special circumstances of its interment in Mount Ya in Ōita prefecture to preserve its sutras, a detailed discussion of it appears in Chapter Two in the context of Six Kannon images in Kyushu. The remainder of this chapter will focus on evidence of partial sets. Although unlikely, Raiyu's story of the transition of Hōjōji's Juntei image into the role of main image for a hall at Daigoji shows that the idea of repurposing icons was not extraordinary. Instead of Juntei, since *Asabashō* and other sources reference the relatively unusual image of Fukūkenjaku, clues related to this type of Kannon are more profitable in the search for former Six Kannon sets. Indeed, two matching seated Kannon images, one of Fukūkenjaku (Fig. 1.8) and the other of Eleven-Headed Kannon (Fig. 1.9), from the temple of Konkaikōmyōji located in the Kurodani area of east Kyoto, may have once been two members of a Heian-period set of Six Kannon once enshrined in a Kyoto temple.

After their conservation during 1996–1998, Asanuma Takashi wrote a detailed report introducing the Konkaikōmyōji Fukūkenjaku and Eleven-Headed Kannon images, now held by the Kyoto National Museum.[94] The images have relatively slim bodies, round faces, and youthful facial features carved in what is

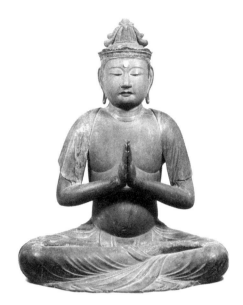

FIGURE 1.8. Fukūkenjaku Kannon. Late eleventh–twelfth century. Wood. 90.4 cm. Konkaikōmyōji, Kyoto.

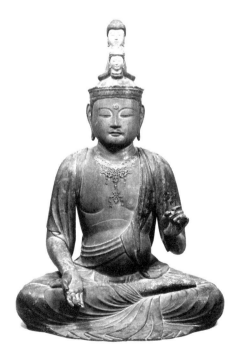

FIGURE 1.9. Eleven-Headed Kannon. Late eleventh–twelfth century. Wood. 90.8 cm. Konkaikōmyōji, Kyoto.

considered the Jōchō style, based on the famous master sculptor Jōchō (d. 1057), who was responsible for creating the now world-renowned Byōdōin Amida from 1053 (Tengi 1). The sculptors of the Konkaikōmyōji images used the technique of split-and-join construction (*warihagi zukuri*), in which a block of wood was split, hollowed out, and rejoined. Asanuma compared related extant works to propose that En School artists, who worked in a continuation of the Jōchō style, made these two similar Kannon images. Following Asanuma's appraisal based on the style and construction, these two works date from the late eleventh to twelfth century, which falls directly within the time frame of the references to the Six Kannon sets discussed above.[95]

One surprising thing about the Konkaikōmyōji Fukūkenjaku figure is that at some point it was reconfigured into a generic Kannon image. The image probably took a new identity as a different type of Kannon, with or without the company of other images. As discussed earlier, the most distinctive features of Fukūkenjaku are the eight arms, third eye, and deerskin cape. Traces of original additional arms, which have been removed, can be seen in the space under the deerskin cape and behind the two present arms that are held up in prayer. It is possible that this image may previously have had a small third eye, which would have been placed vertically in the center of the forehead, but now there is a glass or crystal *ūrṇā*.[96]

The Konkaikōmyōji Eleven-Headed Kannon image (Fig. 1.8) was also modified in that it now has only two of the extra heads, which are later replacements, on its topknot. It is possible that this image may previously have had all the original extra heads removed in order to change it into a generic Kannon. Seated images seem to have been rarer than standing images in sets of Six Kannon, yet the examples from Yokawa Eshin'in and from Hino Kannon Hall mentioned in the *Asabashō* passage above are evidence of the existence of Heian-period groups of seated images that included Fukūkenjaku. Nevertheless, I cannot suggest that the Konkaikōmyōji images came from either of these sets. The Eshin'in images were made in the tenth century, so they are too early, and although the date of late eleventh century matches the Hino Kannon Hall set, its Fukūkenjaku image was described as having eighteen arms. In my opinion, eighteen is too great a number to fit into the space of the former arms. A recent publication on Konkaikōmyōji proposed that its Fukūkenjaku image originally had either six or eight arms, which are more typical for this deity.[97]

Old records about the Konkaikōmyōji sculptures have been lost, so it is not known when they arrived at the temple. Konkaikōmyōji is a Pure Land School temple founded in the twelfth century, but its buildings were destroyed many times over, so although there is a possibility that the images

were there originally, it is not something that can be proved. Eighteenth-century records mention a Thousand-Armed Kannon image in the Kannon Hall, but this likely refers to the ninth- to tenth-century image that is enshrined there now.[98] Nineteenth-century government records of temple property list several images, but the sizes of the Kannon images recorded do not agree with these two figures.[99] In the grand old art-historical tradition, we must rely on analysis of their style, iconography, and construction to suggest that these two sculptures are precious fragments from one of the many former sets of Six Kannon from the eleventh and twelfth centuries in the Tendai tradition of Kyoto, like those reported in the literature.

Buzaiin, Six Kannon Outside the Capital

Since so many Six Kannon sets have been lost, partial sets farther afield from the capital must be examined to illuminate the beginnings of the cult in Japan and how its worship developed. Now located in a small temple called Buzaiin in Hakui City (Ishikawa prefecture), on Noto Peninsula near Kanazawa, three eleventh-century sculptures of Eleven-Headed, Horse-Headed, and Shō Kannon bear such a close resemblance to each other that they must have originally been a set of Six Kannon, especially since there is no known set of just these three Kannon (Fig. 1.10).

The three Kannon are all very sturdy images, standing straight upright, with stocky bodies and relatively thick features. Their drapery folds were executed in orderly, rhythmic, shallow cuts. They were made in the single-block technique (J. *ichiboku zukuri*), in which the heads and bodies were primarily carved from one block of wood, while extremities from different pieces were attached. As is common in this type of sculpture, each has a cavity hollowed out from the back and covered by a panel. If anything had been inside the images, that evidence is lost. The technique and style used in these images were established before the Jōchō style became popular in the capital, but continued to be used afterward, especially in outlying areas. The bulky proportions along with the flat carving of the drapery reveal a style consistent with images from the eleventh century.

After the images had been relocated several times before arriving at this temple during the seventeenth century, the Buzaiin Kannon were later safely installed in a concrete storehouse, just up the hill from the main hall of this small temple. At some point between moves, the other three members of the group must have become separated.[100] Furthermore, the Buzaiin images have shifted not only in function, but also in sectarian allegiance since they have landed in a Sōtō Zen temple. Because neither Fukūkenjaku nor Juntei are among the remaining three Kannon images, we cannot

FIGURE 1.10. Eleven-Headed Kannon, 167.6 cm. Shō Kannon, 169.1 cm. Horse-Headed Kannon. 173.6 cm. Eleventh century. Wood. Buzaiin, Ishikawa prefecture.

determine whether they might have been made within a Tendai or Shingon context. However, clues may be found in the following inscription (see Inscription 1.1 in the Appendix for the Japanese) found on the back of each image.

> This Kannon out of three, restored on an auspicious day of the third month of Genroku 1 [1688], was made by Kōbō Daishi.
> The patron Kanōya Yoheie offered them to the Hannya Hall at Buzaiin on Mount Hakuseki for the repose of Myōrin.
> Gekkan, present abbot [seal].[101]

We can discount the claim of attribution to Kūkai as pious fabrication, especially since he lived about two centuries before these were made. However, it is fascinating that Gekkan Gikō, who was responsible for restoring Buzaiin as a Zen School temple, seems eager to explain the transition of these images from a Shingon to a Zen context. Indeed, Gekkan's inscriptions in large characters written in red lacquer across the backs of the shoulders of each statue are hardly discreet. With Gekkan's prompting as a hint, I propose that the set was originally made in a Shingon context.

When Gekkan restored Buzaiin in the seventeenth century, it is possible that he may have intended the three Kannon to join the temple to protect the dharma. Buzaiin's other great treasure is the entire *Great Wisdom sūtra* (Skt. *Mahaprajñā paramitā sūtra;* J. *Daihannyagyō*), which was copied in blood from 1685 (Jōkyō 2) to 1696 (Genroku 9). According to temple records, Gekkan set about copying the six hundred volumes of the sutra in his own blood, and when he passed away twelve years later he had completed a little over half of them.[102] Local legends hold that Gekkan built the Kannon Hall to enshrine the three Kannon.[103] Kimura Takeshi, however, conjectured that the patron Kanōya Yoheie was so moved by Gekkan's efforts at copying the sutra that he sponsored restoring and moving the three Kannon images to the Hannya Hall at Buzaiin.[104] From the inscriptions we can see that the Kannon images were donated to the Hannya Hall, which was built to house Buzaiin's *Daihannyagyō.* Perhaps the three Kannon sculptures inspired Gekkan and his disciples as they successfully carried out his vow to finish copying the remaining half of the six hundred volumes in 1746 (Enkyō 3). Though the Hannya Hall is now gone, the Kannon sculptures still seem to stand guard over the sutra volumes that are installed beside them.

There are certainly many deities, such as the combination of Shaka and Tahō (Skt. Prabhūtaratna), as well as Monju (Skt. Mañjuśrī), who are better known for their dharma-protecting roles than the Six Kannon. Nevertheless, the proximity of the Hōjōji Six Kannon images to the written text of the *Lotus sūtra* on the pillars of the hall is a reminder of the intense relationship that they had with text. Later, more will be said about Six Kannon and texts. In the case of Buzaiin, the association of the Six Kannon with texts was probably never considered the main purpose. Yet the images could have had more than one function. The Buzaiin sculptures illustrate how, during the long lives of Buddhist images, the focus of worship can shift.

This chapter introduced the concept of how the worship of Six Kannon came to form a cult in Japan and evidence for its earliest images from the Heian period. Monks like Shōchō in *Asabashō* and Ningai in *Chūshinmon* went to great lengths to explain the circumstances of cult images of Six Kannon. Shōchō's list of Heian-period examples of Six Kannon sets, most of which are confirmed through other sources, clearly reveals how they were revered for the power to ensure the well-being of Heian aristocrats. Among them the most vivid descriptions were of Fujiwara no Michinaga's set at Hōjōji from 1023, which signals its important stature within the capital.

Although there is evidence through later Chinese stories that a cult of Six Guanyin had existed in China, we must rely on Ningai's statement in *Chūshinmon* that *Mohe zhiguan* is the authoritative basis for the Six Kannon cult in Japan. Whether the Six Guanyin, which were matched in *Chūshinmon*

with the Japanese names, were ever part of a thriving cult in China remains a question. It is clear, however, that many Japanese sources repeatedly cited *Mohe zhiguan* to bolster the authority of the Six Kannon cult in Japan. Though Ningai's role is the most well known in the formation of the cult in Japan, documentary evidence reveals the existence of prominent Six Kannon sets before Ningai also had an impact on their proliferation.

In regard to function, although the simple explanation that Six Kannon were made to aid beings in the six paths is accurate, many of the documented examples indicate that they were also made for a variety of practical this-worldly benefits, with safe childbirth as a priority. Physical evidence for the cult images of this early period is scarce, but the Fukūkenjaku and Eleven-Headed Kannon images from Konkaikōmyōji have the right profiles to have once been two members of a Heian-period Six Kannon set made in the capital and sponsored by the Tendai School. The three Buzaiin Kannon images, Horse-Headed, Eleven-Headed, and Shō, likely formed half of a Six Kannon set from the Shingon tradition made outside the capital. To further elicit the fragments of the history of the Six Kannon cult, the next chapter will proceed far to the south of Kyoto, to the island of Kyushu, with more examples from the Heian period before moving on to address the regional context of Six Kannon on the island.

A Vision at Six Kannon Lake and Six Kannon/Six Kami in Kyushu

AS A PLACE WITH SOME of the earliest references to images of Six Kannon, the island of Kyushu continues to be a site of activity for the cult. In this chapter, discussions of legends, documents, and extant sets of Six Kannon images are organized into a geographic framework. The map in Figure 2.1 gives the locations of Six Kannon sets in Kyushu. Legends begin in the tenth century with a miraculous vision of Six Kannon that took place in the centrally positioned "Six Kannon Lake" of Miyazaki prefecture. Although the sculptures that appeared in the vision do not exist, their story and subsequent history illustrates how the Six Kannon proliferated throughout Kyushu by creating dual or hybrid identities of six kami or *gongen*. Reckoning with the uneven survival of textual and physical evidence, this chapter will grapple with references to Six Kannon sets made in Kyushu from the twelfth through the eighteenth centuries.

The earliest dated images of Six Kannon in Japan are found on a bronze sutra container made in 1141 from Chōanji in the Kunisaki Peninsula. Because Kunisaki has a distinctive history as a special place for kami–Buddha confluence tied to mountain-ascetic practice, neighboring temples in Kunisaki that have relationships to Six Kannon are discussed in conjunction with Chōanji. Moving south to Kagoshima prefecture, we find a group of references, the earliest from the thirteenth century, to depictions of Six Kannon on mirrors. Mirrors have clear associations with shrine worship, and at Yamakuchi Shrine the alignment between the identities of the Six Kannon with specific kami is the most clearly delineated of all the examples in Japan. Next, the discussion will move to the west coast of Kyushu for the case of the Six Kannon at Dengenji in Karatsu. The unusual appearances and rich legends surrounding these images, most of which date from the twelfth century, make the group a worthy subject of investigation. Finally, the discussion returns to the central area in broad proximity to the Kirishima Mountains and Six Kannon Lake. Monuments from the sixteenth through the eighteenth centuries point to the variety of forms and functions of the Six Kannon cult images.

North: Chōanji and the Kunisaki temples

West: Dengenji in Karatsu

Central: Six Kannon Lake in the Kirishima Mountains

South: Shibushi and Sata

FIGURE 2.1. Map showing Six Kannon sites in Kyushu.

With the exception of the Chōanji sutra container, which is registered as an Important Cultural Property and widely acknowledged as a significant archaeological find, Six Kannon sets in Kyushu have had very little scholarly attention and fall outside the canonical works of Japanese art history. Each section in this chapter focuses on a geographic area with the images in a generalized chronological order. However, in order to comprehend the continuity of Six Kannon praxis in Kyushu, this approach will leap over the chronology of several Six Kannon images outside Kyushu presented in following chapters. Fueled by the activities of traveling Shugendō monks and combinatory shrine and temple practice, this examination of works in Kyushu demonstrates that the concept of Six Kannon had a widespread special significance that has not been previously recognized.

CENTRAL: KIRISHIMA MOUNTAINS

The Legend of Six Kannon Lake

Although much of Kyushu's history is undocumented, from the concentration of existing Six Kannon examples and related literary references, we can see that the cult revolves around Six Kannon Lake (Rokkannon no Miike)

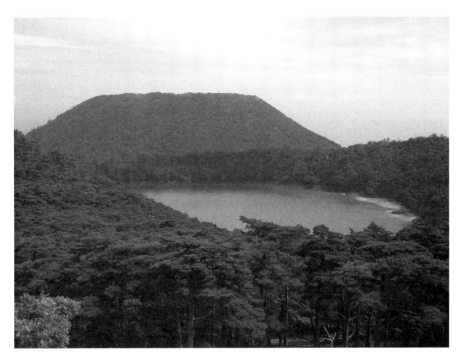

FIGURE 2.2. Six Kannon Lake (Rokkannon no Miike), Kirishima Mountains, Miyazaki prefecture. Photograph from Creative Commons, "Koshikidake Rokkannonmiike," by Ray_go.

in Miyazaki prefecture (Fig. 2.2). The lake, measuring about 400 meters in diameter, is one of forty-eight crater lakes formed by volcanic activity in the Kirishima mountain range, which straddles Miyazaki and Kagoshima prefectures. Once renowned as the site of numinous religious power, Six Kannon Lake is now celebrated for its beautiful blue-green color and as part of a popular hiking course in Mount Kirishima National Park.

The Kirishima mountain range is considered to be the site of Japan's creation myth. The kami Ninigi no mikoto, grandson of the Sun Goddess Amaterasu, is said to have descended to earth to establish the lineage of Japanese emperors on Kirishima's Takachiho peak.[1] Kirishima Shrine is mentioned in the highly significant eighth- and ninth-century texts *Engi shiki* (Procedures of the Engi era), *Shoku Nihon kōki* (Later chronicles of Japan continued), and *Sandai jitsuroku* (True history of three reigns of Japan).[2] The characters for Kirishima mean "Fog Island," likely so named because from a distance passing clouds make the peaks appear as if they were islands in the sea.[3] One of Kirishima's international claims to fame is that it appeared as the location for the villain's hidden rocket in the 1967 James Bond film *You Only Live Twice.* In 2011 the Kirishima peak named Shinmoedake, now off limits to tourists, had several volcanic eruptions that filled in its former

crater lake. Because the last eruption occurred two days before the Tōhoku earthquake and tsunami, coverage of the event was completely overshadowed.[4] Six Kannon Lake did not sustain damage and remains accessible.

A short version of the legend of Kirishima's Six Kannon Lake is posted on a large wooden sign located outside a small building near the shore of Six Kannon Lake.

SIX KANNON HALL

In the reign of Emperor Murakami [r. 947–967] when Saint Shōkū [d. 1007] was intoning the *Lotus sūtra* beside this Six Kannon Lake, suddenly an old, white-haired man appeared and said to Shōkū: "I am Yamato Takeru no mikoto. I transformed into a white bird and have been living in these mountains for a long time. By the virtue of your ascetic practice of sutra recitation I respond by appearing in this body." Because of this Shōkū was compelled to build a hall on the spot where Yamato Takeru no mikoto appeared and enshrined in it Six Kannon sculptures that he carved himself.

—MINISTRY OF THE ENVIRONMENT, MIYAZAKI PREFECTURE

While a sign in front of a monument should always be treated with caution as a historical document, this distilled version of the Six Kannon Lake story provides our investigation with a starting place.[5] Early records on Kyushu religion are relatively rare, and although this is an oft-repeated legend, the oldest dated source is in *Kirishima ryaku engi* (Abbreviated legends of Kirishima) from 1826 (Bunsei 9), written by the monk Unmo of Kerinmitsuji (Kerinji) in Kagoshima.

In order to worship the true form of the *honji* [Buddhist manifestations of kami] of this mountain [Kirishima], Saint Shōkū performed a fire ritual (*goma*) for seven days and nights at this lake. First, he felt he saw the Eleven-Headed Kannon on the surface of the water, and then all of the Six Kannon appeared. These were established as the correct *honji* of this sacred place. The place where the rituals took place is now called Gomadan [fire ritual altar]. Northwest of this lake about eight *chō* [872 m] is Tsuma-kirishima Shrine.[6]

Although this passage does not mention the Six Kannon as images, a later section of the text does say that Yamato Takeru no mikoto was the ancient *suijaku* (sacred trace) of Mount Shiratori, which is located about one *ri* (3.93 km) from Six Kannon Lake.[7] Indeed, Shiratori means "white bird," and the mountain was named after the manifestation of Yamato Takeru. In Japa-

nese mythology, in the fourth century Emperor Keikō sent his son Yamato Takeru to the area of modern Kumamoto to defend his clan. After he was killed Yamato Takeru was believed to have transformed into a white bird.[8]

One of the most significant sources for historical information on southern Kyushu geography is the gazetteer titled *Sangoku meishō zue* (Illustrated collection of famous places of the three countries), published in 1843 (Tenpō 14), just seventeen years after the previously cited document. A passage on Six Kannon Lake explains the following:

> Deep in the mountain forest in Masahara village on Mount Shiratori, there is a natural lake that measures about one *ri* [3.93 km]. Although its depth cannot be measured, it is also said that it is twenty fathoms deep. As one of the forty-eight lakes in the Kirishima Mountains, it has intensely blue water, which reflects the group of peaks. According to a record from Manzokuji on Mount Shiratori, when Saint Sumiyoshi Shōkū came to the bank of the lake and intoned the *Lotus sūtra,* Shiratori Gongen appeared. Therefore, Shōkū carved Six Kannon images with his own hands and built a Buddhist hall to enshrine them at the place where Shiratori Gongen appeared. Accordingly, he named it Six Kannon Lake, but it is also called Miike [honorable lake]. The Six Kannon are the *honji* [original manifestations] of the Six Gongen [provisional manifestations] of the six places [or shrines] in the Kirishima Mountains [Kirishimasan Rokusho Gongen].
>
> Now at the side of the lake there is a Buddhist hall where the Six Kannon images are enshrined. Moreover, a festival is held on the twenty-eighth day of the ninth month. On this day, the head priest of Manzokuji on Mount Shiratori leads the shrine priest and a number of people to Shiratori Shrine and offers a mirror that is a *shintai* [place for kami to reside]. Then the procession goes to the Six Kannon Hall where the festival is held.[9]

The gazetteer also includes an illustration of the lake that shows the small hall labeled "Roku Kannondō" (Six Kannon Hall) in the foreground (Fig. 2.3).[10]

These passages in *Sangoku* unearth the formerly close association between Buddhist and Shinto practice and also reflect the pervasive idea of the Six Kannon's relationship to Six Gongen. Since a *gongen* is a provisional manifestation of a Buddhist deity as a kami, who guides the Japanese to Buddhist salvation in the framework of the *honji-suijaku* system of matching, the Six Gongen reflect the Shinto part of a dual Buddhist/kami identity. The Six Kannon are the Six Gongen in Buddhist form.

The Buddhist protagonist of the Kirishima legends is the monk Shōkū, who by some accounts was born in Kyoto in 910 (Engi 10), studied with Ryōgen on Mount Hiei at age thirty-six, and then went to live in the Kirishima

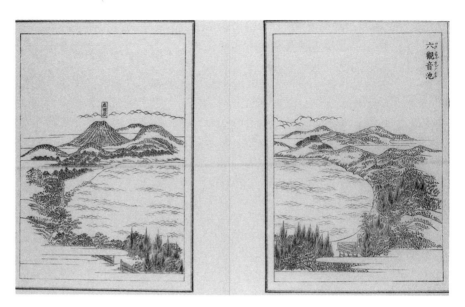

FIGURE 2.3. Six Kannon Lake (Rokkannon no Miike), Kirishima Mountains. 1905 (first published in 1843). Printed book pages. Height: 27 cm. From *Sangoku meishō zue*, vol. 53, pp. 2–3.

Mountains as a mountain ascetic until he died in 1007.[11] Shōkū's presence in Kirishima is mentioned in the fourteenth-century *Genkō shakusho* (History of Buddhism of the Genkō era), which predates sources on the Six Kannon Lake by centuries.[12] Shōkū's hagiography not only perpetuated the significance of the Kirishima Mountains as a site for Shugendō (mountain ascetic practice), but also the legendary vision and carving of Six Kannon, which extended far beyond the Kirishima Mountains. As one example, Mount Yufu (Yufudake), located in Ōita prefecture, is also known as a sacred space for Six Kannon associated with Shōkū. The eighteenth-century *Bungo kokushi* (History of Bungo province) claims that Shōkū carved Six Kannon in stone on Mount Yufu, but they were damaged and fell into the valley after an earthquake. The people of the village moved them to Bussanji.[13] Below the mountain in Yufuin, Bussanji was formerly linked to its tutelary shrine named Unagihime Jinja, which had the alternate name of Rokusho no Miya (Shrine of the Six Places). As will become clear, this is one example of a larger trend of matching Six Kannon with Six Gongen in the Kirishima tradition.[14] Shōkū, as a prominent early monk who was devoted to the *Lotus sūtra* as well as to Kannon, provides a pivotal Buddhist authority to match the Six Kannon and its lake with the local mountain kami, or *gongen*.

The Lake, the Hall, and the Animals

Most visitors to Six Kannon Lake today leave from the visitor's center at the Ebino plateau parking lot and hike around the three neighboring lakes,

Byakushi (White-Purple) Lake, Six Kannon Lake, and Fudō Lake. Walking at a comfortable pace on the most direct route to Six Kannon Lake may take about an hour from the visitor's center. Mount Shiratori is its closest peak to the east. During a visit to Six Kannon Lake in 2011, the name Kirishima "Fog Island" seemed particularly apt as I witnessed the lake repeatedly vanish and reappear in the drifting fog. Under such conditions, it is easy to imagine Shōkū having a vision of Six Kannon floating in the mist on the surface of the lake.

As hikers walk along the east bank of Six Kannon Lake, they come across a small hall, referred to as Six Kannon Hall (Roku Kannondō, or simply Kannondō) or Toyouke Shrine, where they may stop to say a prayer or rest on its benches (Fig. 2.4). This modestly constructed building still maintains its dual role as both Buddhist hall and Shinto shrine. A bright red *torii* gate, with the label Toyouke Shrine positioned between its horizontal beams, stands in front of the building.[15] However, just as the gazetteer *Sangoku* referred to it as Six Kannon Hall, this appellation also continues to be used. Inside the building, instead of Six Kannon, various pious visitors have deposited a variety of modern Buddhist images and items that do not align with Shōkū's vision.

FIGURE 2.4. Toyouke Shrine. Also called Roku Kannondō (Six Kannon Hall). Rokkannon no Miike, Kirishima Mountains, Miyazaki prefecture.

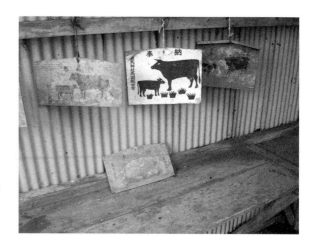

FIGURE 2.5. Animal *ema* at Toyouke Shrine. Rokkannon no Miike, Kirishima Mountains, Miyazaki prefecture.

Also inside the hall are votive plaques (*ema*) with pictures of cows, horses, and pigs that show its continuing role as a place for the protection of livestock (Fig. 2.5). Farmers who were profoundly invested in the health of their animals gravitated to the Six Kannon group because of the inclusion of Horse-Headed Kannon, known for his role as a savior of animals. Formerly, as mentioned in *Sangoku,* an annual Six Kannon festival was held at the hall, but now, at a lower elevation, it is held at a shrine on the southwest slope of the Kirishima Mountains.[16] This branch of Toyouke Shrine in Makizono-chō broke away from the shrine at Six Kannon Lake in 1913. As in the past, the main goal of the festival is to solicit the Six Kannon to assist with prayers for the well-being of horses and cows, but it now includes a local livestock fair and dance.

Beyond the small shrine at the side of the lake, another religious institution that has great significance in the story of Shōkū and Six Kannon Lake is Shiratori Shrine, which honors Yamato Takeru and was involved in the Six Kannon festival. A passage in *Sangoku* under the heading Shiratori Gongensha, the old name for Shiratori Shrine, states:

> The founding legend of this shrine holds that Saint Shōkū went to inspect a sacred cave in the Kirishima Mountains and saw a large lake. As he sat lakeside intoning the *Lotus sūtra,* an old man appeared suddenly and said to Shōkū, "I am Yamato Takeru no mikoto who transformed into a white bird and have been living in these mountains for a long time. By the virtue of your ascetic sutra-reading practice I respond by appearing in this body." Because of this Shōkū built the shrine and when he invoked Shiratori Gongen, Shō Kannon was the *honji.*[17]

In the sixteenth century the shrine and temple had the support of the Shimazu clan.[18] After its buildings were completely consumed in a fire, Shi-

ratori Shrine was rebuilt, purportedly in 1809 (Bunka 6).[19] Although the shrine was alternately called Rokusho Gongensha in the past and was highly significant to the legend of Six Kannon Lake, it was not usually included in the traditional grouping of Six Gongen shrines in the Kirishima mountain range. Shiratori Shrine is active today.

Gongen of the Six Shrines on Kirishima

Another reason for the pervasiveness of the Six Kannon cult is a powerful group of six shrines in the Kirishima Mountains that were collectively known as the Kirishima Rokusha or Kirishima Rokusha Gongen in the nineteenth century. As a provisional manifestation of a Buddhist deity as a kami, *gongen* were especially prevalent in mountain asceticism. In 1868, as part of the process of separating Buddhism and Shinto, the Meiji government wrote an edict that all *gongen* had to become kami and renounce Buddhist ties.[20] Hence, religious institutions like those on Kirishima were compelled to remove the word *gongen* from their names and add the words *jinja* or *jingū* to indicate the status of a Shinto shrine. In the case of Kirishima, the previously used term *gongen* seems to refer to the shrine as a site as well as the collective kami residing there. Since this coterie of Six Gongen, about which we will hear more, is also called Rokusho Gongen, or Gongen of the Six Places, it is clear that the land where they reside is significant. The most established list of six shrines in the Kirishima Mountains is in Table 2.1.[21] The corresponding tutelary Buddhist temples (referred to as *bettō*), which were located in adjoining buildings at the sites and affiliated with either Shingon or Tendai School Buddhism, were forced to close with the Meiji-period policy of *shinbutsu bunri* (separation of kami and Buddhas).

After the government ordered the removal of the word *gongen* from shrine names, the connections between the shrines weakened. When Hinamori was later consolidated with Kirishimamine in 1873, the numerical configuration of six shrines dissolved and afterward some of these shrines became quite small. The table includes the pre-Meiji *gongen* titles along with the modern designations. Six Gongen was a recurring idea in Japan, and even though the *gongen* titles were supposed to be abandoned, many place names maintained references to Gongen of the Six Places after the nineteenth century. Aside from Shiratori Shrine and the group of shrines in the table, at least two other Rokusho Gongen were in the Kirishima Mountains.[22]

The list of kami worshipped at each Rokusho Gongen site in Table 2.1 clearly shows that each shrine site has different kami groups as foci, with

TABLE 2.1 Kirishima Rokusho Gongen

	SHRINE NAME	NAME BEFORE MEIJI PERIOD	TEMPLE	LOCATION	KAMI	FOUNDER
1	Kirishima Jingū 霧島神宮	Nishigozaisho Kirishima Rokusho Gongen 西御在所霧島六所権現	Kerinji 華林寺 (Shingon)	Kagoshima prefecture, Kirishima City 鹿児島県霧島市	1. Ninigi, 2. Hikohohodemi, 3. Ugayafukiaezu, 4. Jinmu	Keiin 慶胤
2	Kirishimamine Jinja 霧島今神社	Kirishimayama Chūō Rokusho Gongen 霧島山中央六所権現	Setooji 瀬多尾寺 Later 瀬戸尾寺 (Tendai)	Miyazaki prefecture, Kobayashi City 宮崎県小林市	1. Ninigi, 2. Hikohohodemi, 3. Ugayafukiaezu, 4. Konohananosakuyabime, 5. Toyotama hime, 6. Tamayori hime	Shōkū 性空
3	Kirishimahigashi Jinja 霧島東神社	Kirishima Higashigozaisho Ryōsho Gongen 霧島東御在所両所権現	Shakujōin 錫杖院 (Shingon)	Miyazaki prefecture, Takahara-chō 宮崎県高原町	1. Izanagi, 2. Izanami, 3. Amaterasu, 4. Oshihomimi, 5. Ninigi	Shōkū 性空
4	Tsumakirishima Jinja 東霧島神社	Tsumakirishima Daigongen 東霧島権現	Choku-shōin 勅詔院 (Shingon)	Miyazaki prefecture, Miyakonojō City 宮崎県都城市	1. Izanami, 2. Ninigi, 3. Hikohohodemi, 4. Ugayafukiaezu, 5. Konohananosakuyabime, 6. Toyotama hime, 7. Tamayori hime	Shōkū 性空

Table 2.1 (continued)

	SHRINE NAME	NAME BEFORE MEIJI PERIOD	TEMPLE	LOCATION	KAMI	FOUNDER
5	Sano Jinja 狭野神社	Sano Daigongen 狭野大権現	Shintokuin 神徳院 (Tendai)	Miyazaki prefecture, Takahara-chō 宮崎県高原町	1. Ninigi, 2. Konohananosakuyabime, 3. Hikohohodemi, 4. Toyotamahime, 5. Ugayafukiaezu, 6. Tamayori hime, 7. Jinmu, 8. Ahiratsuhime	Keiin 慶胤
6	Hinamori Jinja 夷守神社	Hinamori Rokusho Gongen 夷守六所権現	Hōkōin 宝光院	Combined with Kirishimamine Jinja in Meiji period	1. Ninigi, 2. Konohananosakuyabime, 3. Hikohohodemi, 4. Toyotama hime, 5. Ugayafukiaezu, 6. Tamayori hime	Shōkū 性空

some overlap. Two shrines feature six kami, while the others enshrine four, five, seven, or eight kami. Unlike the more familiar image of the deity Zaō Gongen, who can be easily recognized by his flaming hair, fangs, and raised leg, the Kirishima Gongen do not usually align with individual kami that have identifiable forms.[23] However, in one specific case, *Sangoku* describes how at Kirishimamine Shrine its six kami—(1) Ninigi, (2) Hikohohodemi, (3) Fukiaezu, (4) Konohananosakuyabime, (5) Toyotama hime, and (6) Tamayori hime—take physical form. The text records that Shōkū carved six seated wooden images that each measured one *shaku,* five *sun* (45.5 cm).[24] Because Shōkū was famous for the set at Six Kannon Lake, we can speculate that these images took the Buddhist forms of the Six Kannon.

One theory as to why the kami of the Rokusho Gongen shrines do not always conform to the number six, presented in *Miyazaki-ken jinjashi,* explains that the kami have hierarchical rankings and more than one lower-ranking kami can occupy a single seat (*za*), or place.[25] The authors of *Miyazaki-ken jinjashi* made an effort to configure six kami for each shrine and at the same time conceded that it is difficult to determine when worship of these specific deities at the shrines began. In another attempt, a chart in the 1826 *Kirishima ryaku engi* (Abbreviated legends of Kirishima) gives six rankings or seats (*za*) to fifteen kami included in the Kirishimasan Rokugū Daigongen (Six shrines in the Kirishima Mountains), dividing them into four main kami, each with their own seat, and lower-ranking kami, with four sharing the fifth seat and seven sharing the sixth seat. Although this seems well organized, the *engi*'s chart does not neatly align with all the kami mentioned in *Sangoku* for the shrines as recorded in the table above.[26] Precise matching seems to be impossible. After all, counting kami, which are predominantly invisible, is not an exercise that can be precise. Perhaps in cases when the kami took physical form it was more important to have Six Gongen. I propose that the Six Gongen were numbered in relation to the shrine's land as a space and not necessarily matched with individual kami. According to *Jinja jiten* (Shrine dictionary), the definition of "Rokusho Jinja" may refer to either six kami worshipped together at one place or six shrines grouped together.[27] In the case of Kirishima, I propose the latter. The concept of Rokusho Gongen is found throughout Japan, and the close relationship between shrine and location is revealed in that the character *sho* (place) was often substituted by *sha* (shrine). Kikuchi Sansai proposed that the grouping of six kami found in the eighth-century text *Kogo shūi* (Classical gleanings), which is the historical record of the Inbe clan, refers to the kami of the four directions along with heaven and earth.[28] More explicitly, these six places mean all kami everywhere, which explains the prevalence of six kami through a reading that does not privilege Buddhism.

After the use of *gongen* as part of the name for a religious establishment was prohibited in 1868, interest in linking the Six Kannon and Six Gongen waned. In mainstream contemporary Kirishima Shrine worship today, the concept of the Six Gongen has largely been forgotten. Kirishima Jingū in Kirishima City, once considered one of the Six Gongen shrines under the name Nishigozaisho Kirishima Rokusho Gongen, has become the largest shrine in the Kirishima mountain range and is quite prosperous.[29] Its affiliation with Buddhism is long past.

Even though Six Kannon images are not physically present at the site of Six Kannon Lake, the legacy of these Six Kannon images has had a far-reaching impact that can be uncovered in the surrounding areas. In the sixteenth century the Sagara and Shimazu clans enforced a ban on Pure Land Buddhism of the Ikkō School. In contrast, the institutions of Shingon and Tendai, which in turn had a network of *shungedō* monks, were closely intertwined with the shrines and benefited from the clans' support.[30] While for the most part unseen, the reputation of the Six Gongen was pervasive and bolstered interest in the Six Kannon, even after the government tried to erase them. When the shrines needed a physical presence or a Buddhist identity, they were matched with the Six Kannon in order to appear as Buddhist deities, which usually had more concrete visual forms than kami.

NORTH (KUNISAKI)

Chōanji: The Earliest Dated Images of Six Kannon

The earliest dated pictorial images of the Six Kannon as a group are incised images on a bronze sutra container, dated Hōen 7 (1141) (Figs. 2.6–2.7), that hails from Chōanji in the Kunisaki Peninsula, Ōita prefecture, Kyushu (Fig. 2.8). This important object has the earliest inscribed date of any extant image group of Six Kannon and, like many examples from Kyushu, it has a significant connection to kami.[31] Formerly, the panels served as sides of a rectangular box that contained thirty-seven panels incised with the full text of the *Lotus sūtra*.[32] The panels of the box have detailed inscriptions that name Mount Ya as its location and state that the temples in the surrounding area of Rokugō, the six districts of the Bungo Takada Peninsula, donated funds to support the object's production. Since Mount Ya is the mountain where Chōanji is located, the panels are near their former site of interment. Beyond the local, this sutra box has significance that stretches not only all the way to the old capital (now Kyoto) but also far into the future.

In twelfth-century Japan it was believed that the age of *mappō* (end of the Buddhist law) had arrived, so sutra texts and other Buddhist objects

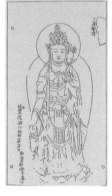

B

A

FIGURE 2.6.
Two sides of the
Chōanji sutra
box. 1141.
Bronze plates.
A side:
Eleven-Headed,
21.3 × 11.6 cm.
B side: Shō and
Thousand-
Armed,
21.3 × 18.7 cm.
Chōanji, Ōita
prefecture.

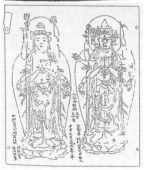

D

C

FIGURE 2.7. Two
sides of the
Chōanji sutra
box. 1141.
Bronze plates.
C side: Nyoirin,
21.4 × 11.7 cm.
D side:
Fukūkenjaku
and Horse-
Headed,
21.3 × 18.7 cm.
Chōanji, Ōita
prefecture.

FIGURE 2.8. Chōanji main hall on Mount Ya, Kunisaki Peninsula, Ōita prefecture, Kyushu, Japan.

were often buried in the ground in metal or stone containers to preserve the dharma for future generations and the coming of Maitreya, the Future Buddha. The most famous example and perhaps the oldest may be Fujiwara no Michinaga's (966–1028) 1007 (Kankō 4) sutra deposits in Yoshino on Mount Kinpu (Kinpusen) in Nara prefecture, but northern Kyushu, where Mount Ya is located, also had a particularly high percentage of these burials.[33] Most of the buried sutras were made of paper or silk and stored in cylindrical containers made of metal surrounded by an outer ceramic container.[34] The Chōanji example is rare and precious among buried sutra transcription projects because of its age, box shape, sophisticated Buddhist imagery, and lengthy engraved text on bronze plates. The box was unearthed in the Edo period, and then reassessed in 1926, but there is no information about an outer container or the circumstances of its excavation. In 1927, Tanaka Ichimatsu helped take the sides of the box, along with three original sutra plates, from Chōanji to Tokyo, where they were scrutinized closely by experts and stored at the Imperial Museum (former name of Tokyo National Museum).[35] Soon afterward the great significance of these works was recognized and they were registered as Important Cultural Properties.

Chōanji is one of a powerful group of temples in the Rokugō (six districts) mentioned in the inscription. These temples in the Kunisaki Peninsula were referred to collectively as "Rokugō Manzan" (all the temples in the mountains of the six districts) (Fig. 2.9).[36] According to legend, the monk Ninmon, who was not a historical person but considered a bodhisattva and an incarnation of Hachiman, founded the Rokugō temples in 718 (Yōrō 2).[37] The temples were under the sway of the monks of Mirokuji, the tutelary temple for the very powerful local Usa Hachiman Shrine, and steeped in the traditions of Shugendō mountain practice, Tendai Buddhism, and the combinatory practice of *honji-suijaku*. In the twelfth century there were

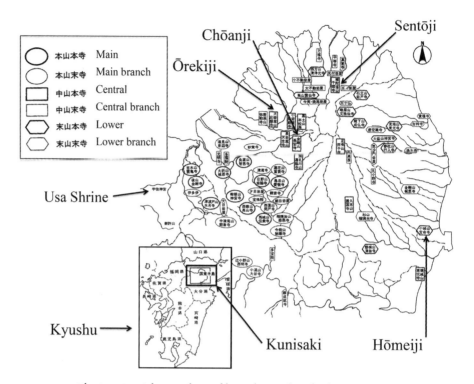

FIGURE 2.9. The twenty-eight temples and branch temples of Rokugō Manzan on Kunisaki Peninsula, Kyushu. Map modified from Kyushu Rekishi Shiryōkan, *Bungo Kunisaki Chōanji, Kyushu no jisha shirizu*, vol. 9, p. 18.

twenty-eight Rokugō temples, said to correspond to the number of chapters in the *Lotus sūtra*. The twenty-eight temples were organized into three groups: main (*motoyama*) with eight, central (*nakayama*) with ten, and lower (*sueyama*) with ten. This structure divided them by the following responsibilities: the main temples were in charge of the monks' educational training, sermon education, lectures, rituals, and the organization of the entire group; the central group focused on high-ranking *yamabushi* (mountain ascetics or *sendatsu*), record keeping, and administration of mountain-practice training; and the lower temples focused on monks' living arrangements and monks in the early stages of training.[38] In addition, below the twenty-eight main temples, thirty-seven branch temples (*sueji*) joined them, so the total number became sixty-five. Chōanji was one of eight temples in the central group (*nakayama*). In 1113 (Eikyū 1) the Rokugō Manzan temples were declared subsidiaries (*betsuin*) of Mudōji on Mount Hiei, and thus proclaimed Tendai School affiliation.[39]

The sides of the Chōanji sutra box have Six Kannon images inscribed on them; two larger panels have two images each and the two smaller panels each have single images. The diagram in Figure 2.10 illustrates how the Kan-

A

D

B

C

FIGURE 2.10. Reconstruction diagram of the Six Kannon sutra box. 1141. Bronze. Images faced exterior, text on interior. Top and bottom no longer extant. Chōanji, Ōita prefecture. Drawings after Kyushu Rekishi Shiryōkan, *Bungo Kunisaki Chōanji, Kyushu no jisha shirizu,* vol. 9, figs. 31, 34, 37, 40.

non images were arranged and how the now separate panels would have formed the original box.

The incising process used to create the outlines of the figures is called *keribori,* translated as "kick" line engraving, in which tiny wedge-shaped cuts were repeated contiguously with a chisel.[40] This process differs from *kebori,* hairline engraving that uses continuous lines. Because close examination is necessary to see the line quality, most sources mistakenly refer to the lines

TABLE 2.2 Organization of the Exterior of the Chōanji Sutra Box

PANEL A			
21.3 × 11.6 cm	1. Eleven-Headed	Holding rosary and lotus	Two arms
PANEL B			
21.3 × 18.7 cm	2. Thousand-Armed	Hands in prayer	Two arms
	3. Shō	Holding a lotus	Two arms
PANEL C			
21.4 × 11.7 cm	4. Nyoirin	Seated on a lotus on a rock base	Two arms
PANEL D			
21.3 × 18.7 cm	5. Horse-Headed	Horse-mouth mudra	Eight arms
	6. Fukūkenjaku	Various attributes	Eight arms

on these panels as *kebori.* The style of the figures is delicate yet sturdy, and is in keeping with twelfth-century Buddhist image traditions. Table 2.2 shows the organization of the images on the four exterior sides of the Chōanji box. The order of the Kannon images does not follow *Mohe zhiguan* or *Ningai chūshinmon* discussed in Chapter One.

The panel versos have a variety of text inscriptions, which are transcribed and translated below. Of particular interest is Panel D, which has a vertical line of six *bonji* characters that some scholars propose to be for the Six Kannon (Fig. 2.11). *Bonji* refers to Siddham script based on Sanskrit letters used in esoteric Buddhism to connote the sounds associated with certain deities; they are also called Sanskrit seed syllables (*shuji*). From top to bottom, the Japanese pronunciations and deity equivalents are as follows: *kiriiku*=Thousand-Armed Kannon, *bo*=Shō Kannon, *uun*=Horse-Headed Kannon, *kya*=Eleven-Headed Kannon, *bo*=Juntei, and *kiriku*=Nyoirin. There are a few variations in the *bonji* used to stand in for Six Kannon, and there are irregularities in their incised forms, but for the most part the characters agree with what are considered standard *bonji* for Six Kannon.[41] The *bonji* for the Eleven-Headed Kannon is unusual, but because the image depicted is recognizable by its distinctive heads and there is the inscription "Jūichimen Kannon" beside it, there is no question of identification. (This is the only one of the Six Kannon images that has the name inscribed next to it.) The character causing the greatest uncertainty is the fifth *bonji* from the top: where we might expect to see the *bonji* for Fukūkenjaku, which is *bo* or *mo,* we find one that looks more like the *bo* for Juntei. Visually, it is difficult to distinguish between the images of Juntei and Fukūkenjaku Kannon, but

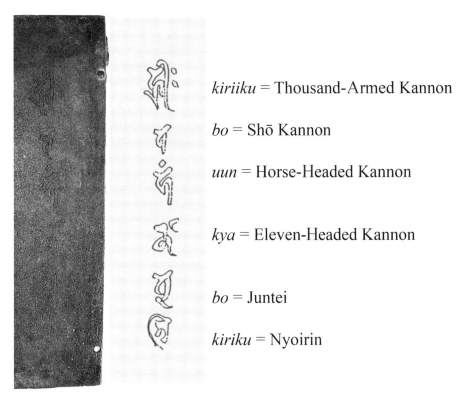

kiriiku = Thousand-Armed Kannon

bo = Shō Kannon

uun = Horse-Headed Kannon

kya = Eleven-Headed Kannon

bo = Juntei

kiriku = Nyoirin

FIGURE 2.11. *Bonji* characters representing Six Kannon on the Chōanji sutra box. Drawing after Kyushu Rekishi Shiryōkan, *Bungo Kunisaki Chōanji, Kyushu no jisha shirizu,* vol. 9 (Fukuoka-ken Dazaifu-shi: Kyushu Rekishi Shiryōkan, 1988), fig. 41, p. 15.

with one head and eight arms, two of which are in the mudra of adoration and one of which holds a long Buddhist staff (*shakujō*), the figure looks more like Fukūkenjaku than Juntei, who more commonly has eighteen arms. Although the iconography was not always set, since the norm is that Fukūkenjaku is the Tendai preference and Juntei is the Shingon preference, Fukūkenjaku seems a more appropriate identification, especially since Chōanji and the other nearby Rokugō temples were affiliated with Mount Hiei and the Tendai School. However, determining the image as Fukūkenjaku means that the *bonji* was either a mistake or an area of blurring between the identities of these two types of Kannon. As another iconographical variation, instead of the usual forty-two arms for a Thousand-Armed Kannon, the one on the box has only two arms placed together in the mudra of adoration.

The dedicatory inscription, which is dispersed in various places throughout the four panels, is quite significant because it includes the date, length of the dedication service, donor names, and location. Table 2.3 provides all parts of the inscription.

TABLE 2.3 Chōanji Text and Image Placement

	PANEL A
FRONT	Eleven-Headed Kannon image　　　　　十一面観音 勸進金剛佛子尊智 鎮西豊後國六郷御山屋山分也
TRANSLATION	[Text for Eleven-Headed Kannon image] Kongō Busshi Sonchi, fundraiser of the portion for the honored Mount Ya in the Rokugō Mountains in Bungo province in Chinzei (Kyushu)
VERSO (BOX INTERIOR)	[*bonji* clockwise from top right] *ka* = Jizō, *bo* = Kannon, *saku* = Seishi, *ba* = Ryūju 龍樹 (Skt. Nāgārjuna), and *kiriiku* = Amida, in the center

	PANEL B
FRONT	Thousand-Armed Kannon and Shō Kannon images
VERSO	[*bonji* clockwise from top right] *bai* = Bishamonten, *an* = Fugen, *man* = Monju, *kaan* = Fudō, and *baku* = Shaka in the center 金剛佛子神水・イトイミ・コイソ・クロ・犬子・コ子コ・僧嚴智・僧印嚴 僧弁仁・紀乙王・万才・今兒・惣一切衆生・大中巨大子・中子・比丘尼
TRANSLATION	[After *bonji*] Kongō Busshi Shinsui, Itoimi, Koiso, Kuro, Inuko, Koshiko, Monk Gonchi, Monk Ingon, Monk Ben'ni, Ki no Otoō, Mansai, Imaji, all sentient beings, elder sister of the Ōnakatomi clan, Nakako [middle child], nuns

	PANEL C
FRONT	Nyoirin Kannon image
VERSO	[*bonji* counterclockwise from top left] *aanku* = Taizōkai Dainichi, and *ban*, Kongōkai Dainichi *kaan* = Fudō Myōō 僧源增・紀重永作・紀長雅・秦氏四子
TRANSLATION	[*bonji*] Monk Genzō, Ki no Shigenaga the maker, Ki no Nagamasa, fourth child of the Hata clan

	PANEL D
FRONT	Horse-Headed Kannon and Fukūkenjaku Kannon images 六郷分鍒銅五百九十領・保延七年・歳次幸酉・四月廿八日始之 同年九月十四日供養畢 鍒銅六百八十領石清水・惣別當・僧暹意
TRANSLATION	The Rokugō [temples'] portion was 590 pieces of bronze. The dedication services began on the twenty-eighth day of the fourth month of Hōen 7 [1141] and concluded on the fourteenth day of the ninth month of the same year. Sen'i, 暹意, who was in charge of the entire Iwashimizu Hachiman Shrine complex [in Kyoto prefecture], donated 680 pieces of bronze.

Table 2.3 (continued)

VERSO	Six Kannon *bonji* [see text above and Fig. 2.11] *Bonji* for the five elements: *ken*=air, *kan*=wind, *ran*=fire, *ban*=water, and *an*=earth 太中巨六子同中子·太中巨子·藤原太子紀中子 太中巨久道·僧覺嚴·太中巨太子
TRANSLATION	Sixth child of the Ōnakatomi clan, and middle child of the same, [another] child of the Ōnakatomi, elder sister of Fujiwara clan, middle child of the Ki clan, Ōnakatomi Hisamichi, Monk Kakugon, elder sister of the Ōnakatomi clan

Note: · refers to a gap or space in the text.
The romanizations of all names are conjectures. I am grateful to Michael Jamentz's assistance with the inscriptions.

Beyond the highly technical sophistication of the metalwork, the project is impressive because it not only brings together the patronage of the Rokugō temples, but also support from over twenty individuals, many from the prominent Ōnakatomi and Ki clans, as well as several monks. Nakano Hatayoshi pointed out that members of the Ōnakatomi clan were officials for Usa Hachiman Shrine, and the Ki was the main family that supported Mirokuji, which demonstrates strong local support.[42] Of particular prominence was Sen'i, who was in charge of the entire Iwashimizu Hachiman Shrine complex in Kyoto prefecture, and whose involvement shows that the impact of this project reached far beyond Kyushu. Of course, since Iwashimizu Hachiman Shrine was linked to Usa Hachiman Shrine, which had a major impact on Kunisaki Peninsula temples such as Chōanji, it is not completely surprising.

On display today in Chōanji's storehouse along with the four box sides are a selection of the nineteen text plates that Chōanji still owns out of the original thirty-seven. When the top and bottom of the container were lost is unknown. Each text plate measures approximately 21.2 × 17.5 centimeters. Specialists have analyzed the extant text to conclude that there is evidence of at least five or six different writing styles.[43] In addition to the *Lotus sūtra,* on the thirty-seventh and last plate, which is now kept at the Tokyo National Museum, the *Heart sūtra* is repeated three times.[44] After the three repetitions of the *Heart sūtra* on the last plate is the following final dedication:

Completed in the hour of the sheep [between 1:00 p.m. and 3:00 p.m.] on the second day of the eighth month of Hōen 7 [1141].
Kongō Busshi Monk Sonchi
Kongō Busshi Monk Ryūgon
Monk Yōmyō[45] [see Inscription 2.1 in the Appendix]

The monk Sonchi is also mentioned in the inscription on the front of Panel A, so he may have been more involved than some of the other patrons who were only listed once. Other text plates are in various museums in Japan and in private collections, including the one formerly belonging to the Barnet and Burto Collection (Fig. 2.12) and the one belonging to the John C. Weber Collection.[46]

Remarkably, a similarly shaped sutra container of approximately the same size with incised images was discovered in the sixteenth century in northern Kyushu about 160 kilometers from Chōanji, in Fugen Cave on Mount Kubote (Kubotesan) in Buzen City, Fukuoka prefecture (Fig. 2.13). The container, which is still intact as a box, now belongs to Kunitama Jinja, located in this area. This box, of a size (22.5 cm in height) similar to Chōanji's, has an inscribed date of 1142 (Kōji 1), which is one year later than the inscription on the Chōanji box. There are thirty-three plates of sutra text, which includes the entire *Lotus sūtra* and repeats the *Heart sūtra* three times on the last plate.[47] These are the same texts in the same order as on the Chōanji box, except that here the *Heart sūtra* is written out in *bonji* characters, rather than regular script. The Mount Kubote box also has images incised on the exterior, but instead of Six Kannon images, the two smaller panels depict Fudō Myōō (Skt. Acala) on one and Bishamonten (Skt. Vaiśravaṇa) on the other, two deities who are significant to the protection of mountain practitioners. The two larger panels depict a Buddha triad on one face and two seated Buddhas together on the other.[48] Perhaps the deities on this box differ from Six Kannon because the relationship to Rokusho Gongen was not as strong on Mount Kubote as it was on Mount Ya.

Remarkably, some names in the Mount Kubote box inscription coincide with those on the Chōanji box, such as the makers Ki no Shigenaga and Ki no Nagamasa, and Ki and Hata clan patrons. Moreover, these names were also on yet another bronze box, which was buried on Mount Hiko (Hikosan) in Hizen (now Fukuoka prefecture) that was dated to 1145 (Kyūan 1).[49] Mount Hiko, also in north Kyushu, is about ninety-five kilometers from Chōanji. This box is only known through a detailed written description, so it may have been unearthed and lost or is still underground. *Hikosan ruki* (Mount Hiko register), written in 1213 (Kenpō 1), explains that a bronze box containing the inscribed text of the *Lotus sūtra* and *Heart sūtra* on gilt bronze was buried and dedicated to a shrine for Hachiman on Mount Hiko, and inscribed by the monk Gonson (the same name as on the Mount Kubote box) along with five other named monks in 1145. Since the Mount Hiko box lists six inscribers, this agrees with the analysis of the Chōanji sutra text noted above. The name of the metalworker Ki no Shigenaga, again the same as found on the Chōanji box, was given along with his title as administrator of Usa Hachiman Shrine.[50]

FIGURE 2.12. One of the thirty-seven text plates from the Chōanji sutra box. Bronze. 21.2 × 17.5 cm. Freer Gallery of Art, Smithsonian Institution, Washington, D.C.: Gift of Sylvan Barnet and William Burto, F2014.6.1a–d.

Clearly, Ki no Shigenaga and Ki no Nagamasa must have been the elite specialists in bronze sutra transcription in northern Kyushu during the mid-twelfth century. When considering other ways these sutra transcription projects were linked, we might place Mount Hiko in the center from which *yamabushi* traversed the areas around Mount Hiko, east to the Kunisaki Peninsula, where Chōanji is located, and west to the mountains that included Mount Kubote, which is eleven kilometers away. Moreover, another important hub between these places was Usa Shrine, centrally located at the southeastern foot of Mount Hiko and the northwestern edge of the Kunisaki Peninsula.[51]

FIGURE 2.13. Mount Kubote sutra box. 1142. Bronze. 22.5 cm. Kunitama Shrine, Fukuoka prefecture.

Gongen on Mount Ya

At Chōanji, beyond the main hall and storehouse, one may climb a fairly steep staircase to the tutelary shrine, which was formerly called Rokusho Gongen (Gongen of the Six Places), but is now known as Misosogi Shrine. Tutelary shrines are found all over Japan, and many other places in the Bungo area were known as Rokusho Gongen (and later Rokusho Gongen Jinja), just as were the six significant pre-1868 Rokusho Gongen shrines in the Kirishima Mountains. However, in contrast to the Rokugō Manzan temples, at Kirishima the shrines were larger than their corresponding tutelary temples.

Below Chōanji, near the road is the shrine's stone *torii* gate that dates from 1838 (Tenpō 9) and still bears the former title in its framed panel: "Sannō no Miya, Tarōtendō, Rokusho no Miya," which translates as "Mountain King Shrine, Tarō the Heavenly Boy, Shrine of Six Places."[52] Sannō refers to the pre-Meiji name of the mountain king guardian, or Gongen of Mount Hiei, indicating that this place was part of the "Tendai-Shinto" tradition related to Enryakuji. Tarō, the Heavenly Boy, was the local guardian and main *gongen* for the shrine, who, as will be discussed shortly, was also seen as a manifestation of the Rokusho Gongen. Perhaps for sake of size and readability, the term *gongen* was left off the shrine's *torii* plaque. Since the word *gongen* was not supposed to be used after 1868, its omission here made it unnecessary to change the plaque.

After 1868, to erase the *gongen* identity, the shrine name was changed to Misosogi Jinja, which means "shrine to purify the body" and was a generic shrine designation to replace the former Rokusho Gongen title. Although some Rokusho Gongen shrines in the Kunisaki area chose different new names, in addition to Chōanji, the tutelary shrines near Tennenji, Mudōji, and Reisenji and Jissōin were all renamed Misosogi Shrine. On the Chōanji Misosogi Shrine grounds are two buildings and several stone monuments cared for by a Shinto organization that does not involve Chōanji (Fig. 2.14).[53]

Why were *gongen* of the six places so prevalent in Kunisaki? There is no consensus, but some scholars have suggested that it may be because the number six is significant to the six Buddhist paths (*rokudō*) or because of the significance to Rokugō, the six districts.[54] One theory that has been proposed is that the Gongen of the Six Places in the Rokugō districts grew out of a relationship to Himegami worship at Usa Shrine. The main deity of Usa Shrine is the well-known hybrid Buddhist/Shinto figure Hachiman, who has

FIGURE 2.14. Rokusho Gongen Shrine, now called Misosogi Shrine. Above Chōanji, Kunisaki, Ōita prefecture.

alternate identities as Ninmon, the legendary founder of the Rokugō temples, and as the legendary Emperor Ōjin, said to have lived during the third and fourth centuries.[55] Hachiman's (or Ōjin's) cult was extended to include other kami as his family unit. The earliest relationship was with Himegami, who was considered to be his wife or female companion, and the second was Jingū Kōgō, who is considered to be his mother. After four Wakamiya (young princes), who were the legendary offspring of Emperor Ōjin, joined the group, these attendants or family members numbered six.[56] As in the Kirishima Mountains, the transferring and overlapping of identity was common in the Usa area, where the various names of kami worshipped at Rokusho shrines were also inconsistent. There is early evidence for the existence of Rokusho Gongen shrines, some of which were rock grottos (*iwaya*). The 1228 (Antei 2) text *Rokugōzan shogongyō tō mokuroku* (Various records of diligent practice on Mount Rokugō) recorded that rituals were regularly performed in front of sixteen different Rokusho shrines at Kunisaki, including the one on Mount Ya.[57] Among the offerings to the one at Mount Ya were the *Lotus sūtra, Heart sūtra*, and specifically the *Kannon Chapter* of the *Lotus sūtra*.

Tarōten, the Heavenly Boy

In addition to the box, Chōanji's other twelfth-century treasure is an unusual wooden sculpture known as Tarōten (Fig. 2.15). Tarō is a generic name for a boy and *ten* is a designation for a heavenly being.[58] The sculpture is in the form of a youth wearing shoes, a long-sleeve robe of several layers, and with his hair fixed in buns on each side of his head, similar to some images of the youthful Prince Shōtoku. In general, the figure of a youth in the context of Japanese religious imagery is referred to as a *dōji* or divine boy. Figures of such youths are plentiful in Japanese religious imagery,

but in addition to its uncommon name of Tarōten, this image has other atypical features.[59] In the right hand, Tarōten holds a staff topped by a fan with a jewel at the tip, and in the left hand he holds a branch with three long leaves.[60]

The sculptor created the image by splitting a log, hollowing it out, and rejoining it by the *warihagi zukuri* (split-and-join) technique.[61] The cavity inside the body of the sculpture is filled with ink inscriptions, covering the back of the head, one shoulder, most of the front, and almost the entire back, which name over a hundred donors, give information on the circumstances of production, and explain that the sculpture was made in 1130 (Daiji 5). From the names listed inside the image, scholars have presented different theories about the possible identity of the sculptor or sculptors. Among the candidates is the name Kakugi, who appears in the phrase "hōzōnin Kakugi toshi nijūichi" (Kakugi, age twenty-one, offered the construction). Sculptors' names were not as common in the early twelfth century as they came to be in the following centuries, so this name was more likely a patron or someone important who had the construction of the work offered in his name.[62] The donor names include numerous Tendai monks and members of the Fujiwara, Ki, and Usa clans, but none of the specific donor names were duplicated on the Chōanji box, which was produced eleven years later. One person, however, listed as a fifty-four-year-old monk of Ajari status named Keishun, may be the same person as Keishun (with a similar first character) who was the main fundraiser for Chōanji's bell in 1150 (Kyūan 6).[63] Local support must have been strong for these projects, and it is possible that the monk Keishun (with a slight variation in the first character) at age seventy-four still played an important role in the

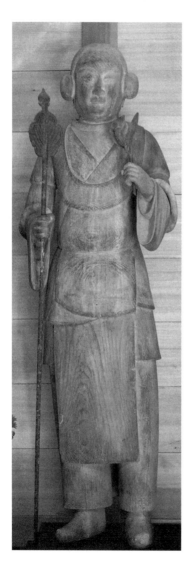

FIGURE 2.15. Tarōten. 1130. Wood. 161 cm. Chōanji, Kunisaki, Ōita prefecture.

support of Yayamadera (Temple of Mount Ya), the previous name for Chōanji.

"Tarō from Mount Ya," as he is named in the inscription, is accompanied by two smaller youthful figures: one boy (h. 97.5 cm) who looks like a gentle, smaller-scale version of Tarōten, and a youthful demon (*oni*) figure (h. 96.5 cm) with a big frown, bushy eyebrows, flaming hair, bare feet, and a skirt. No other such triad is known, but these delightful "naughty and nice" figures should remind us of the child attendants, Seitaka (Skt. Ceṭaka) and Kongara (Skt. Kiṃkara), who often accompany Fudō Myōō (Fig. 2.16). Indeed, the interior inscription explains that Tarōten is a manifestation of Fudō, and the image includes the text for the Nineteen Visualizations of Fudō (*Fudōson saku jūkyū kan*), which was recorded by the ninth-century Mount Hiei monk Annen.[64] The *Nineteen Visualizations* are a step-by-step iconographical description of Fudō, which lists features such as his portly physique, dark blue color, sword and rope attributes, wrathful expression, and two acolytes. Those who conceived the Tarōten project must have felt that *Nineteen Visu-*

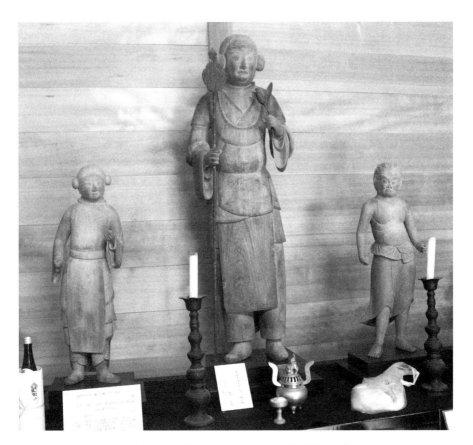

FIGURE 2.16. Tarōten triad. 1130. Wood. 161 cm. Kunisaki, Chōanji, Ōita prefecture.

alizations verified the sculpture's connection to Fudō since Tarōten bears no resemblance to typical images of the deity.

There must have been considerable overlap and exchange between Chōanji and its protecting shrine. A temple record from circa 1244 (Kangen 2) lists Tarōtendō (Tarō the Heavenly Boy) along with a lecture hall, Buddhist image hall, rock cave, and Gongen. If the word Gongen referred to Rokusho Shrine, then it is possible that the Tarōten image had its own specific hall in this period.[65] Tarōten appears periodically in eighteenth-century temple records: one noted that Chōanji had a bell cast as a dedication to him in 1724 (Kyōhō 9).[66] Although Tarōten was considered the main image for Rokusho Gongen Shrine, after the separation of shrines and temples in 1868, the Heavenly Boy no longer had a place at the shrine and was sent down the mountain into Chōanji's care.[67]

FIGURE 2.17. Tarōten from Tarōten Cave. Possibly fifteenth–sixteenth century. Stone. 49 cm. Sentōji, Kunisaki, Ōita prefecture.

Tarōten is a local deity whose rare presence is also found at another Kunisaki temple named Sentōji (Fig. 2.17). A cave named Tarōten Iwaya in the steep mountains to the west of Sentōji previously enshrined a stone image of Tarōten (h. 49 cm), perhaps from the fifteenth or sixteenth century, which moved into the temple's main hall for protection.[68] Local tradition holds that Tarōten was a manifestation of a *tengu,* a hybrid bird-human who protected *yamabushi* during mountain excursions. Certainly Sentōji's winged stone image, which looks more like a *tengu* than the Chōanji sculpture, also functioned as a mountain protector.[69] Yet the idea of Tarōten as a local mountain protector is consistent.[70] Sentōji also had a Rokusho Gongen Shrine, which is mentioned in thirteenth-century records and is now marked by a sign at the former site.[71] Another nearby cave, called Shiritsuki Iwaya, located just off the main road on

the way up to Tarōten Iwaya and south of present-day Sentōji, houses a building that enshrines Six Kannon images made of wood, now too weathered to see well or determine when they were made.[72] These Six Kannon images were at one time likely meant to reflect manifestations of the Rokusho Gongen.

Rather than match the Rokusho Gongen with Six Kannon images, the patrons chose to have the protector manifested as Tarōten, with an alternate identity as Fudō Myōō, in this unusual group of three figures.[73] Other than with images of Fudō, two similar child attendants named Otomaru and Wakamaru sometimes accompany the legendary tenth-century monk Shōkū, who had the vision of the Six Kannon at the lake and traversed the mountains throughout Japan before arriving in Kyushu.[74] Unlike the clothing in depictions of Shōkū, Tarōten is not wearing a standard monk's robe, nor does he have a shaved head.[75] Instead, Tarōten wears shoes and a garment with a high collar, over which is a tunic wrapped over the left shoulder. The figure also wears layered sleeves, a split skirt (*hakama*) over which is a flat cloth panel covering the front of the legs and another cloth panel that falls down over the back of the legs, and a *wagesa,* which is a flat band around the neck that serves as an abbreviated circular monk's stole. Rather than a cumbersome monk's robe, this unusual outfit is more appropriate for a practitioner who travels through the mountains. Thus, as Kondō Yuzuru has suggested, Tarōten's image may express the role of a mountain protector in the guise of a premodern traveling Tendai monk (*shugenja*).[76]

Thinking Outside the Box: Unearthing the Chōanji Sutra Transcription Project

Returning to the Chōanji box, its sophisticated production, which was clearly a costly and impressive technical feat, must have been thought to hold considerable karmic merit for the patrons. The Kunisaki Peninsula, and northern Kyushu in general, was an important site for burying sutras, but this project reaches far beyond Kyushu through the patronage of the Iwashimizu Hachiman Shrine near Kyoto by creating a mutually beneficial long-distance network. The selection of the Six Kannon images was likely devised because of the association with the Rokusho Gongen. Rokusho Gongen were being supplicated on Mount Ya in the thirteenth century, and one of the sutras read before them was the *Lotus sūtra*'s *Kannon Chapter*. Because that text discusses all the different forms Kannon can take, it may have been considered particularly efficacious within the context of matching the Six Kannon to the Six Gongen.

Numerical equivalents can be important, yet they were not strictly applied, and a range of images can be matched with Rokusho Gongen that are not always linked to six figures. The pervasive but often invisible Rokusho Gongen can be associated with the Six Kannon, as was likely the reason for their depiction on the sutra box, but there are also other possibilities for physical form, such as Tarōten with his two attendants. One of the challenges of investigating the correspondences between deities is that they are irregular, and forms of kami are even less standardized than Buddhist images. Opening the sutra box reveals the vision that Rokusho Gongen manifested as Six Kannon on Mount Ya.

Reconstructing Six Kannon at Hōmeiji

A key site on the Kunisaki Peninsula that continues to promote its worship of Six Kannon is Hōmeiji, located on Mount Ogi in Kunisaki City, Musashi-machi, three kilometers from the Ōita Airport (and about 30 kilometers from Chōanji). Hōmeiji was a branch temple (*sueyama*) in the previously discussed Rokugō Manzan system, and the aforementioned record *Rokugōzan shogongyō tō mokuroku* from 1228 reports that the main images (*honzon*) for Ogidera, the old name for Hōmeiji, were Six Kannon.[77] Throughout the history of Hōmeiji, the Six Kannon images appear to have been replaced several times, most recently in 1984. Hōmeiji, like Chōanji and many other Kunisaki Peninsula temples, was accompanied by a Rokusho Gongen Shrine. Here too, even though the term *gongen* was outlawed in 1868, not all traces have vanished.

A copperplate print precinct picture titled *Hōmeiji keidai zenkei no zu* (Illustrated panoramic view of Hōmeiji precinct) published in 1897 illustrates the temple layout with all the buildings, including the Kannon Hall (Fig. 2.18). The tutelary shrine, Rokusho Gongen, which had closed before that time, is not included in the print, but the print's cartouche gives the history of Hōmeiji and its Six Kannon images.

> The forty-fourth generation Empress Genshō established Hōmeiji on the first month, fifth day of 717 [Yōrō 1]. The Bodhisattva Ninmon carved Six Kannon images in order to vanquish strange enemies and one hundred demons and vowed to remove suffering and confer peace. According to an old record, the Ōtomo clan burned down the hall, and although there are few details, it was rebuilt in 1572 (Genki 3).[78]

The attribution of Ninmon, the legendary founder of the Rokugō Manzan temples, as the maker of the images, is common in this area. More-

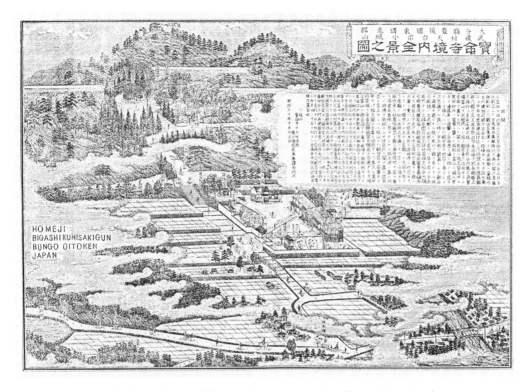

FIGURE 2.18. *Hōmeiji keidai zenkei no zu* (Illustrated panoramic view of Hōmeiji precinct). 1897. Copperplate print. From Ueda, *Ōita-ken shaji meishō zuroku*, p. 113.

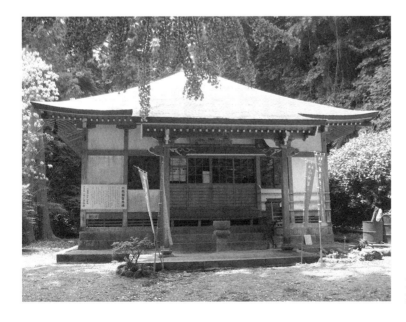

FIGURE 2.19. Hōmeiji Kannon Hall. 1984. Kunisaki, Ōita prefecture.

over, ritual effort to subdue foreign enemies was also a fairly common theme in Kyushu. Kyushu's closer proximity to Korea and China made this a greater concern in comparison to many other parts of Japan. Because the images are emphasized at the beginning of the print's cartouche, they were considered important to the temple, and we should assume that there were actual images in the hall at the time the print was conceived.

Sadly, the Kannon Hall and its images burned down in 1982, but funds were raised quickly, with contributions from over 2,000 people, and the hall and images were rebuilt in 1984 (Fig. 2.19).[79] The replacement images, all of unpainted wood with gold leaf, include Horse-Headed, Shō, Eleven-Headed, a standing Nyoirin, Fukūkenjaku, and Thousand-Armed Kannon. The *yamabushi* protectors Bishamonten and Fudō Myōō stand to each side as attendants. Usually the hall is open, but the images are treated as secret images (*hibutsu*), locked behind doors that enclose the rear altar.[80] As an exception, during the second weekend in February there is an opening with rituals performed in front of the images. It is clear that the set of Six Kannon images mentioned in the thirteenth-century *Rokugōzan shogongyō tō mokuroku* were lost centuries ago, and although I have not been able to determine when the previous set of images destroyed in the 1982 fire was made, the Edo period is likely.[81] I speculate that the images were remade at the time the hall was rebuilt in 1788 (Tenmei 8) and that the print from 1897 refers to those images.[82] If they had been eighteenth-century images, they may have garnered little scholarly interest and so never had a published assessment. Nevertheless, the images were dear enough to worshippers to support the considerable cost of replacement in 1984.

The connection with the Rokusho Gongen was a likely reason for the initial construction of the Six Kannon at Hōmeiji. Significantly, since the 1228 record *Rokugōzan shogongyō tō mokuroku* mentions both that rituals to Rokusho Gongen at Hōmeiji (Ogidera) were conducted and that the main images were Six Kannon, it is an important demonstration of the connection between the Six Kannon and the Six Gongen in the thirteenth century. These records, as well as others, show a trajectory of mediation between Hōmeiji and its tutelary shrine, which may have helped preserve the Six Kannon/ Six Gongen images through numerous iterations of dual-purpose Buddhist/ Shinto practice.[83]

The building arrangement in the nineteenth-century precinct print is much the same as it is at present. While the main hall and other more frequently used buildings are at the lower elevation, the Kannon Hall is located up the mountain, and access is by a steep old stone staircase or a newly paved access road. Continuing up beyond the Kannon Hall leads to Ogi Kannon

Park, which commands an impressive view of the coastline and the sea beyond. Perhaps this visual proximity to the ocean inspired the belief that the Six Kannon were efficacious for seafaring safety, which is of great concern to the inhabitants of the Kyushu coast.[84]

Cliff Carvings of Six Kannon Near Ōrekiji

Before moving beyond the Kunisaki area, we should visit two different rock carvings in the vicinity of the temple Ōrekiji. Like Chōanji and Hōmeiji, Ōrekiji was also one of the twenty-eight temples in the Rokugō Manzan group that had an adjacent Rokusho Gongen Shrine for protection. Located about ten kilometers from Chōanji, behind Ōrekiji's main hall is a cliff face with a group of stone relief-carved Buddhist images, among which we find Six Kannon (Fig. 2.20).

From the Heian through the Muromachi periods, Ōrekiji flourished within the Rokugō Manzan as a central (*nakayama*) temple that focused on high-ranking *yamabushi* (mountain ascetics, or *sendatsu*) and mountain practice training. The record *Rokugōzan shogongyō tō mokuroku* from 1228 confirms that sutras, including the *Kannon Chapter* of the *Lotus sūtra,* were regularly read at Ōiwaya (Great rock grotto), which is the name of the area behind Ōrekiji.[85] Ōrekiji is said to have been consumed in a fire at some time during the fifteenth to sixteenth century, declined in the early seventeenth, and then rebuilt in its present location in 1695 (Genroku 8).[86]

Above the main grounds of Ōrekiji about halfway up the path leading to Rokusho Gongen Shrine is a cliff carving known as Dō no sako magaibutsu (Cliff-carved Buddhas of the hall in the valley). The figures in this unusual relief carving are arranged in a row within a long rectangular space, which measures approximately 105 × 525 centimeters. From right to left the figures are thought to be the following: a standing Shiroku (Officer of records, who

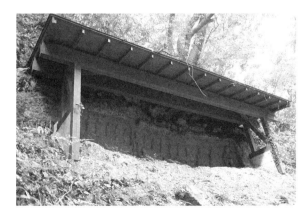

FIGURE 2.20. Dō no sako cliff carving, near Ōrekiji. Circa fifteenth century. Stone. 105 × 525 cm. Kunisaki, Ōita prefecture.

records human deeds as King Enma's attendant) writing with a brush; a seated female dressed as a nun with a head covering; a seated male dressed as a monk; a group of standing Six Jizō figures; a standing image of King Enma; and a group of standing Six Kannon images.[87] Each of the Kannon images, which measure about forty centimeters in height and are eroded, appear to have two arms; two of the figures have hands held up in prayer and the four others hold stemmed lotuses. These images are located high on the cliff above the path, with no access. The Matamamachi Board of Education dates the carvings to the early Muromachi period (1337–1573) and proposes a reasonable theory that the monk and nun represent husband and wife donors who prayed to receive a favorable judgment from Enma that would lead to paradise.[88]

Further up the mountain on the path from these images is Ōrekiji's Rokusho Gongen Shrine. Its stone *torii* gate, dated to 1819 (Bunsei 2), bears a plaque with the words "Rokusho Dai Gongen" carved in stone. Unlike the shrine at Chōanji and several elsewhere, this location was able to maintain its Gongen title after 1868. I suggest that the Six Kannon carved in stone were once again linked to the Rokusho Gongen, Gongen of the Six Places. Here they are part of an assemblage of images that bolsters the donor couple's chances to escape the six paths and directly go to paradise. The patrons sought maximum efficacy not only by enlisting the help of Six Kannon, but also from the accompanying Six Jizō.

About a five-minute drive from Ōrekiji is another set of Six Kannon images that belong to a large constellation of images, known as Fukuma magaibutsu (Cliff-carved Buddhas of Fukuma). This area is also called Shiō Gongen (Gongen of the Four Kings) because it once enshrined images of the Four Guardian Kings (Shitennō), now long gone. The record *Rokugōzan sho-gongyō tō mokuroku* from 1228 refers to the place as Shiō Ishiya (Rock cave of the Four Kings), without mention of Ōrekiji, and notes that sutras were ritually read at the site for the Four Guardian Kings as its main images (*honzon*).[89] The record also explains that texts and rituals offered at Shiō Ishiya focused on Bishamonten, who is the guardian of the north direction among the Four Guardian Kings, instead of Kannon as carried out at Chōanji (Mount Ya), Hōmeiji (Mount Ogi), and Ōiwaya (Dō no sako).

To get to the Fukuma cliff carvings site from the road, one must walk through fields, untie a roped fence (with an inviting sign), cross over a stream by a bridge, and then pass through a stone *torii* gate with a plaque that reads "Roku sho" in small characters above larger characters reading "Dai Gongen," showing that this place was also considered a Rokusho Gongen Shrine. Twenty meters beyond the *torii* and up a flight of stairs is a roofed, three-bay stone structure built in 1857 (Ansei 4) to protect the carvings (Fig. 2.21).[90]

FIGURE 2.21. *Torii* and entrance to Fukuma cliff carving (Ōiwaya). Circa fifteenth century. Stone. 160×460 cm. Kunisaki, Ōita prefecture.

From right to left, the images carved in relief into the stone are as follows: a Womb World mandala made up of Sanskrit seed syllables (*shūji*), a standing image of Fudō Myōō, a group of seated Six Kannon, Five Buddhas (seated) of the Diamond World (with Dainichi in the center), a group of seated Six Jizō, and a standing image of Bishamonten.

As at Dō no sako, here too Six Kannon are included in a larger group that also include Six Jizō and are in direct proximity to a Rokusho Gongen Shrine. In contrast, the Six Kannon in the Fukuma cliff carvings are easier to view and in better condition. These Kannon, each measuring approximately thirty-four centimeters, are seated on lotus pedestals and arranged in two horizontal rows (Fig. 2.22). In the lower row from right to left, the Kannon appear to be Shō holding a lotus, Eleven-Headed with two arms holding a lotus, and a two-armed Nyoirin in a contemplating pose. In the upper row is perhaps Fūkukenjaku with multiple arms holding what seems to be a rope in a front hand, Horse-Headed with three faces and six arms, and Thousand-Armed, with the most erosion, appears to have many surrounding arms. Assorted publications give a likely date of production as between the fourteenth and sixteenth centuries. Although the style and iconography of these two sets of images differ, they appear to have been made at roughly the same time period as the carvings from Dō no sako.[91]

The entire arrangement of Fukuma cliff carvings does not follow a known program, so we must consider the various elements of the composition individually. Bishamonten was important to the site as one of the Four Guardians from which Shiō Gongen took its name. As mentioned in regard to their appearance on the Mount Kubote bronze sutra box from 1142 discussed above, Bishamonten and Fudō Myōō together were protectors of *yamabushi* during mountain excursions, which is also highly significant to the Kunisaki area. The mandala and Five Buddhas give the group an esoteric Buddhist character. Finally, here again, the Six Kannon and the Six Jizō could

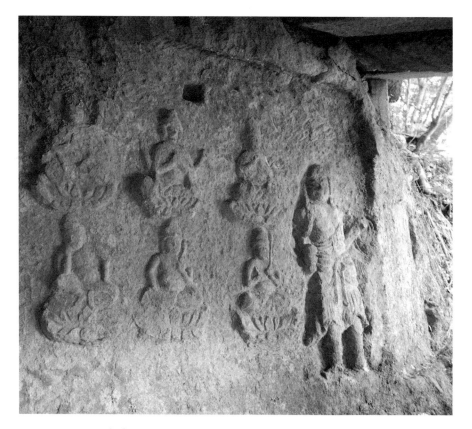

FIGURE 2.22. Detail of Six Kannon and Fudō at Fukuma cliff carving (Ōiwaya). Circa fifteenth century. Stone. 160×460 cm. Kunisaki, Ōita prefecture.

provide the layered benefits of helping navigate the six paths, for the donors in the future or their departed loved ones, and make a link to the Rokusho Gongen.

SOUTH (SHIBUSHI AND SATA)

Six Mirrors, Shrines, Kami, and Kannon

Moving to southern Kyushu, the earliest evidence related to the Six Kannon cult in this area is from Yamakuchi Shrine in Shibushi, Kagoshima prefecture. Unlike most amorphous cases involving the matching of Six Kannon with kami, this example provides explicitly detailed relationships between the Six Kannon cult and kami. The gazetteer *Sangoku meishō zue* from 1843 reports that six mirrors of Six Kannon were kept inside the Honjidō (hall for Buddhist deities in a shrine context), which was located at Yamakuchi Shrine.[92] Each of the six mirrors had an image of Kannon on its face and

an inscription with the date of 1267 (Bunei 4) on the back. The mirrors were considered to be *shintai,* which are objects in which the kami reside.

The Yamakuchi Shrine kami all have close ties to Emperor Tenji (or Tenchi; 626–671), and the relationships between the Six Kannon and their kami equivalents are carefully recorded as the following: (1) Shō Kannon is Emperor Tenji; (2) Thousand-Armed Kannon is Princess Oto (Tenji's oldest daughter); (3) Nyoirin Kannon is Prince Ōtomo (Tenji's son and successor, also known as Emperor Kōbun [648–672]); (4) Eleven-Headed Kannon is Emperor Jitō (645–702); (5) Horse-Headed Kannon is Princess Tamayori (who according to local legend was a love of Tenji); and (6) Juntei Kannon is Princess Yamato (Tenji's queen).[93] *Sangoku meishō zue* has an illustration of Yamakuchi Shrine with a Kannon Hall on the grounds, but does not show an image of the Honjidō, which was probably long gone by the time this gazetteer was published.[94] The whereabouts of the actual Six Kannon mirrors are unknown. These mirrors, now lost, may have burned, been repurposed for their metal, or removed from the shrine in 1868 when the practice of separating temples and shrines took place.

Just before the Meiji-period separations, *Jinja Keiōshū* (Collection of shrines from the Keiō era [1865–1867]), recorded the details on the mirrors in 1859 (Ansei 6).[95] The back of each mirror states that it was made for Yamakuchi Shrine located in Kūniin (the area of modern Shibushi), the monk in charge of all the donations was Ryōkei, the date is 1267 (Bunei 4), and the sculptor's name was Eison.[96] Each mirror had a different main patron's name and different monk's name.[97] Since Eison was referred to as a Great Buddhist sculptor (Dai Busshi), the images were likely three-dimensional and attached to the mirrors as *kakebotoke,* literally "hanging Buddha," which refers to a mirror made to suspend inside a shrine or temple hall, often adorned on the back with separately cast Buddhist images.[98]

According to legend, the six shrines of Yamakuchi were consolidated in 807 (Daidō 2) as a group and correspond to the following: 1. Emperor Tenji = Yamamiya Jinja; 2. Prince Ōtomo = Yamakuchi Jinja; 3. Yamato hime = Jitsubo (or Shizume) Jinja; 4. Tamayori hime = Yasura Jinja; 5. Emperor Jitō = Wakamiya Jinja; 6. Otohime = Biro Jinja.[99] Around 1868 the six shrines were consolidated into Tanoura Yamamiya Jinja in Shibushi City, Kagoshima.[100] As *shintai,* each mirror must have been precious to its associated shrine. Today the consolidated shrine also functions under the name Yasura Jinja.

Although legendary, Shibushi is thought of as a place Emperor Tenji had visited, so the merging of the imperial kami connected to Tenji with the Six Kannon was a way for the locals to enjoy maximum protection simultaneously from Buddhist and Shinto deities with a significant imperial pedigree. The representation of Yamakuchi Shrine's Six Kannon on mirrors

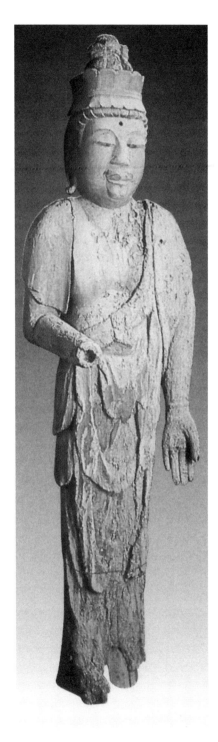

FIGURE 2.23. Shō Kannon. Muromachi period (1337–1573). Wood. 205 cm. Dengenji. Karatsu, Saga prefecture.

should remind us of the role the mirror had in the Six Kannon festival at Six Kannon Lake, where a mirror was offered at Shiratori Shrine before the procession went to the Six Kannon Hall next to the lake. As at Kirishima, shrines in six different locations were conceptually linked together. Yet here the group of six mirrors served as a physical device to bond the six shrines as a collective. It should also be noted that Princess Tamayori is a generic female kami name, who is also included in four of the Six Gongen shrines at Kirishima.

At Mount Misaki, located at the southernmost tip of Kyushu, in what is now called Cape Sata, Kagoshima, there is a much later mirror with a Six Kannon/Six Gongen connection.[101] In this case, six kami were enshrined together at a place called Chikatsu no Miya. Chikatsu no Miya held a single mirror with a date of 1677 (Enpō 5), with Sanskrit seed syllables (*shūji, bonji*) for the Six Kannon together. The inscription states that the Lords Taigen and Kanyō dedicated the mirror to increase fortune and stop calamity.[102] *Sangoku* also states that to the left of the main shrine is a three-bay Honjidō that enshrines Six Kannon.[103] Whether this building held the mirror from 1677 or a different set of images is unclear, but it substantiates the pervasiveness of the Six Kannon merged with the Rokusho Gongen in the vicinity of Kirishima.

As a related example, Tashirofumoto at Kitao Rokusho Gongen, about forty kilometers north of Sata, held a

mirror with one Kannon image on the front and Six Kannon inscribed on the back.[104] The previously mentioned Lord Taigen donated four pieces of white silver to this shrine in 1693 (Genroku 6), perhaps with the intention that the silver would be used to make other mirrors with Six Kannon. Such mirrors from southern Kyushu embodied the Six Kannon and Six Gongen connection in a tangible form.

WEST (KARATSU)

Kannon Images from Dengenji

Returning to the Heian period, on the west coast of Kyushu in the countryside of Saga prefecture outside Karatsu City is a small hall on the grounds of Kawakami Jinja with a set of Six Kannon sculptures, of which most date from the twelfth century. Within this area in Saga prefecture, more specifically called Hamatama-chō or Higashi Matsuura, Kawakami Jinja is a functioning shrine, but even though the small building referred to as Dengenji on its grounds is no longer an active temple, local people still offer incense and flowers there. Based on

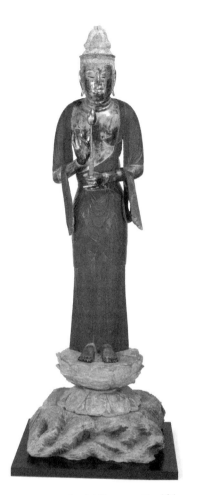

FIGURE 2.24. Juntei Kannon. Twelfth century. Wood. 148 cm. Dengenji. Karatsu, Saga prefecture.

the work of Tanabe Takao, the images have been named Shō (Fig. 2.23), Juntei (Fig. 2.24), Nyoirin (Fig. 2.25), Eleven-Headed (Fig. 2.26), Thousand-Armed (Fig. 2.27), and Horse-Headed (Fig. 2.28) and were given the designation of Important Prefectural Property in 1976.[105] With some similar stylistic features, these images are referred to as a Six Kannon group and appear to be a set. Building a solid case for all six sculptures present in the hall as a historical Six Kannon group is not possible, but it is worth considering that part of the group may have comprised a set of Six Kannon at one time.[106]

Inside the Dengenji hall, three images stand to the right and two stand to the left of the closed *zushi,* which enshrines a secret image that is only opened once in fifty or sixty years.[107] This hidden Shō Kannon, which was made in the Muromachi period (1392–1573), is considered to be the main image

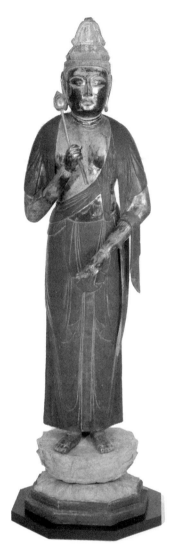

FIGURE 2.25. Nyoirin Kannon. Twelfth century. Wood. 172.3 cm. Dengenji. Karatsu, Saga prefecture.

(Fig. 2.23). The body was made of a single block of wood to which the arms were attached. Its lower left side is quite damaged from weathering and insects, and the right hand and left foot are missing. One cannot help but surmise that the reason this image is kept locked in a box is not only because of the condition but also its large square head, wide facial features, and awkward appearance are not attractive. Yet among the images, this Shō Kannon has the most colorful ties to Dengenji's past.

According to the 1628 (Kanei 5) Dengenji *Engi*, as recounted in *Higashi Matsuragunshi*, in the time of Emperor Kinmei (c. 539–571 CE), the counselor Ōtomo Sadehiko was sent to the Matsuura area in Hizen to await dispatch to Korea.[108] At that time Sadehiko and the Matsuura princess Sayohime fell in love. After Sadehiko's ship set sail to Korea, Sayohime rushed to the top of a mountain to wave farewell with her scarf. She became so distraught over her lover's departure that she died on the spot. Afterward a large camellia tree, which had been at her home, was carved into her likeness to become a miraculous Kannon image. The *Engi* continues that the image, known as "Tree Root (*negi*) Kannon," measures five *shaku* and is enshrined in a hall called Dengenji on Mount Kawakami.[109]

The well-known legend of Sadehiko and Sayohime is found in the oldest collection of poems in Japan, the eighth-century *Man'yōshū*, which explains that Sadehiko was sent on a mission to support the small Japanese military outpost of Mimana on the tip of the Korean peninsula.[110] After their battles against Silla forces were successful, Sadehiko returned to find Sayohime had died. The image of Sayohime waving her scarf at Sadehiko's departing ship became a famous Japanese poetic trope.

Perhaps the Shō Kannon was been given the name "Tree Root Kannon" because its rough surface corresponds to the significance of the wood in the legend. The image is made of *hinoki*, Japanese cypress, rather than camellia.

TABLE 2.4 Dengenji Kannon Images

TYPE	KANNON NAME	SIZE	ALTERNATE NAME	TECHNIQUE	DATE	NUMBER OF ARMS
Type 1	Shō Kannon	205 cm	Tree Root Kannon	Single-block	Muromachi period	Two
Type 2	Juntei	148 cm	Shō in 1714 inscription	Single-block	Twelfth century	Two
Type 3	Eleven-Headed	170 cm	—	Single-block	Twelfth century	Two
	Thousand-Armed	165 cm	—	Multi-block	Twelfth century	Four or more
	Horse-Headed	178 cm	—	Single-block	Twelfth century	Eight
	Nyoirin	172.3 cm	Shō?	Single-block	Twelfth century	Two

Visually it relates to the concept of *tachiki butsu* or Buddhist images carved from a standing tree, in which the sculptors maintained recognition of the original tree by using cylindrical forms with roughly carved surfaces and unfinished lower areas near the roots.[111] The large wooden signboard posted on the Dengenji grounds in 2003 explains that the hall was built for Sayohime's repose and the Tree Root Kannon is a miraculous image that unceasingly responds to prayers for easy childbirth, finding marriage partners, and preventing children from crying at night. The image's relationship to Princess Sayohime inspires prayers that are of special concern to women.

Analysis of the Images in the Group

To compare the images of the Dengenji Six Kannon, it is best to consult the work of Tanabe Takao, who examined them in the 1970s and proposed that they formed three types.[112] Table 2.4 outlines the factors that divide the three groups based on construction techniques and dates.

Shō Kannon (the main image with the Sayohime connection), which is Type 1, is clearly the odd one in the group. The other five in Types 2 and 3 each display some differences in technique, but they are similar in style and were likely made by the same workshop. These five appear to have been made in the twelfth century, with red lacquer on the robes and gilding on the skin that was added at a later time.

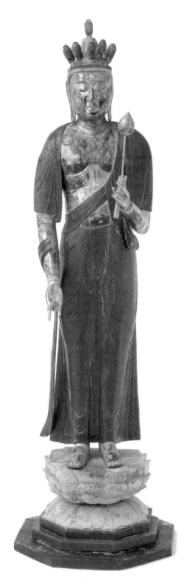

FIGURE 2.26. Eleven-Headed Kannon. Twelfth century. Wood. 170 cm. Dengenji. Karatsu, Saga prefecture.

The image that Tanabe named Juntei in Type 2 is smaller (148 cm), more slender, and has crisper carving compared to the other five Kannon. It holds a lotus and has only two arms. The only inscription discovered inside the Dengenji images was found on a wooden board inside this image. "The middle image Shō Kannon was restored by the [following] patrons... 1714 [Shōtoku 4], eighth month, eighteenth day, Buddhist sculptor Katsumoto Hisahachi of Karatsu Katana-machi, Mount Kawakami Dengenji" (see Inscription 2.2 in the Appendix). This inscription clarifies that the image was considered to be Shō Kannon in the Edo period and therefore refutes the identification as Juntei.[113] While it does not claim that the figure was part of a Six Kannon set, the inscription describes it as a middle image (*chūson*), indicating that it was part of a group, and also confirming that it belonged to Dengenji in 1714 and was repaired by a local Buddhist sculptor.

Type 3 includes an image that has been named Nyoirin Kannon with two arms, one raised to hold something now missing and the other lowered with palm open. Images of two-armed Nyoirin Kannon are less common than six-armed. The Thousand-Armed Kannon image only has four arms, but as it has spaces in back where additional arms would have been inserted, it was likely made originally to be a Thousand-Armed Kannon. According to Tanabe, there are some variations in the construction of the four images in Type 3, and he surmised that a different artist made each one.[114] The Thousand-Armed Kannon is the most divergent in the group in that it was made in the multi-block technique, whereas the other four were made in the single-block technique with hollowing out to prevent cracking. Both techniques were often used in the twelfth century. The Horse-Headed Kannon has three heads, three eyes on the main face,

fangs, and eight arms (the top left is a replacement), and because it dons a large horse-head on top of the head, placed between two upright clumps of flaming hair, one cannot mistake this Kannon for any other.[115] The consistent stylistic features, such as the cylindrical bodies, flat carving of the drapery folds, and shallow carving of the facial features indicate that these four images were likely made by the same workshop in the twelfth century.[116]

History of Dengenji

Early historical evidence for Dengenji is found in the document *Hōrengein mandokoro kudashibumi* (Hōrengein administrative orders) from 1222 (Jōō 1), which records a case submitted to Hōrengein a dispute between a monk from Kagami Jingūji and a monk named Genjitsu who later became the head of Dengenji, proving that a temple by the name of Dengenji existed at that time.[117] That Dengenji's location of the Matsuura estate was a territory of Saishōkōin in Kyoto from 1173 (Jōan 3) until the latter burned down in 1226 (Kajō 2), indicates a period when exchanges between this area and the capital took place.[118]

During a battle for control over land in Matsuura in 1574, when the army of the monk Ryūshin of Ryūzōji attacked the castle of Kusano Shizunaga, Dengenji at Hana no Mine burned along

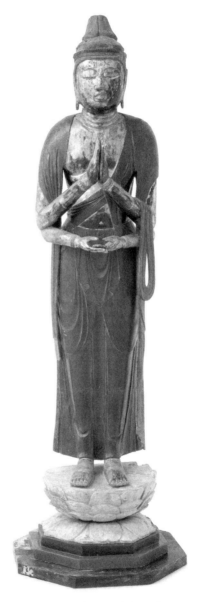

FIGURE 2.27. Thousand-Armed Kannon. Twelfth century. Wood. 165 cm. Dengenji. Karatsu, Saga prefecture.

with the surrounding area of Hirabara. Afterward, legend has it the Buddhist images that survived were taken to a corner of Kawakami Shrine where a new Dengenji was built. As a reference to the conflagration, a few charred Buddhist images believed to have been in this fire are kept in the hall now.[119] The largest of the burned images is of a height similar to the Kannon images, so it is possible that it was an image of Juntei (or even

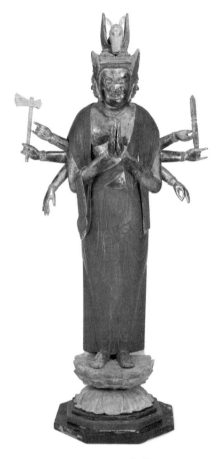

FIGURE 2.28. Horse-Headed Kannon.
Twelfth century. Wood. 178 cm.
Dengenji. Karatsu, Saga prefecture.

Fukūkenjaku) that was retired from the group of Six Kannon after being burned beyond recognition. In such a scenario, the four images in Type 3 escaped the fire, a charred Juntei remains, and a Nyoirin Kannon was completely lost.

Matsuura kojiki (Matsuura old records) compiled in 1789 (Kansei 1), has an entry for Sayohime Jinja, which repeats the sad story of Sayohime and Sadehiko with an intriguing embellishment about the Tree Root Kannon. A Korean monk named Don'e from Paekche (also spelled Baekje; J. Kudara), who came to Japan on the same ship that brought Sadehiko back, carved the Shō Kannon image and established a temple in honor of Sayohime, along with fellow Korean monk Shintan.[120] The attribution of Don'e as the sculptor of Tree Root Kannon enhances the prestige of the image as this Korean monk is linked to the Sayohime narrative as well as the introduction of Buddhism to Japan. While inaccurate, the unusual legends surrounding this image offer reasons to viewers as to why Tree Root Kannon looks so odd, even though few would have had the opportunity to see it.

Were They a Group of Six?

Because of the differences between the images, Tanabe proposed that the present Dengenji group was not originally a group of Six Kannon.[121] However, another theory is that a local sculpture studio made all four images in Type 3 above as part of a set of Six Kannon. The smaller Juntei image may have been made by the same studio as the others, but for a different group of images. Over the centuries two of the images may have been lost from the group, with the possibility that a different Juntei or Fukūkenjaku was charred in the 1574 fire and a Nyoirin was lost. In any case, the fact that four twelfth-century images that were likely made in the area, and perhaps the same studio, are still

together suggests a high probability that they were part of a group of Six Kannon. As I will argue in the case of the fourteenth-century images of Tōmyōji in Chapter Three, to have four of the requisite Kannon images out of a group of six is sufficient to propose a group of Six Kannon.

CENTRAL: RETURN TO THE PROXIMITY OF THE KIRISHIMA MOUNTAINS

The Six Kannon Stone Monument of Ōsumi Kokubunji

The hunt for images of Six Kannon in Kyushu will now make a great leap in time and take a detour to Tokyo before returning to Kyushu and the vicinity of the Kirishima Mountains. The first clues were some stone rubbings from the 1930s, housed at Waseda University Library in Tokyo. The library titled the rubbings "Ōsuminokuni Kokubunji rokukannon sekizō mei" (Inscription of a Six Kannon stone monument from Ōsumi Kokubunji) and noted its date of 1562 (Eiroku 5).[122] Other than a few general sentences about the location, the library had no other information. After examining the rubbings, I never expected that the actual monument would still survive, much less that I could find it, but ultimately with the aid of the Internet, maps, and a GPS, I tracked down the actual stone in Kirishima City, next to a parking lot.

This stone monument is from the former Ōsumi Kokubunji in southeastern Kagoshima prefecture, and although not in the most aesthetically pleasing condition, this relief carving of Six Kannon yields valuable evidence for the fervent devotion to Six Kannon during a difficult period in history. On the front face of the rectangular monument (107 × 110 cm) are six seated Kannon images (each approximately 18 cm tall) with prominent mandorlas carved in relief, in two stacked horizontal rows of three each (Fig. 2.29). The

FIGURE 2.29. Six Kannon monument. 1562. Stone. 107 cm. Site of former Ōsumi Kokubunji, Kirishima City, Kagoshima prefecture.

damaged condition of the stone makes identification challenging. A possible arrangement of the Kannon is proposed as follows.

Eleven-Headed	Nyoirin	Juntei?
Horse-Headed	Thousand-Armed Kannon	Shō?

The most easily identifiable figure in the group is in the center of the bottom row; its multiple arms make it clear that it is an image of Thousand-Armed Kannon (Fig. 2.30). Two of the images have the right knee raised. Since the bottom left one of these seems to have flaming hair and two arms pressed together in front of the chest, it is Horse-Headed Kannon. As the top middle image not only has the right knee raised, but also leans toward the right hand raised against its cheek, it is Nyoirin. The crown on the head of the top right image is exceptionally large, with what seems

FIGURE 2.30. Thousand-Armed Kannon detail, Six Kannon monument. 1562. Stone. 107 cm. Site of former Kokubunji, Kirishima City, Kagoshima prefecture.

to be multiple heads, so it must be Eleven-Headed Kannon. The bottom right image appears to be holding a lotus in the right hand, so it is possibly Shō. Such a configuration leads to the possibility that the upper left image is Juntei (or perhaps Fukūkenjaku), but it is badly eroded.

On the two sides and back of the monument is the lengthy incised inscription from which the Waseda Library rubbings were made. Though many areas of the monument are illegible, it is still possible to get a sense of the inscription, which is summarized below.[123]

KOKUBUNJI SIX KANNON RESTORATION MONUMENT

The accurate images of Kannon that formerly stood next to the great Kannon Hall at Kokubunji were broken in the middle and destroyed. They were left this way for many years, but because the local laymen and laywomen could not live without them for such a long time, they were all encouraged to become donors and have the six images recarved in stone. The patrons prayed that this good deed would give them blessings and keep them safe. . . . The main patrons are Kintaku sō (the elder) Tōkai, Fuchiwaki Anjun, the lay-monk Jōgyō, and about thirty other people. The monk Eiga [?, the second character is damaged] respectfully wrote the inscription on a good day in spring in Eiroku 5 (1562).

Ōsumi Kokubunji was founded in the eighth century as one of the temples in the Kokubunji system, of which Tōdaiji in Nara was the head temple. In response to famine and plagues of the time, Emperor Shōmu (701–756) had one official temple, referred to as Kokubunji, built in each of the sixty-seven provinces in 741 (Tenpyō 3) as a prayer for the peace and prosperity of the state. Ōsumi is located in what is now called Aira-gun in Kagoshima. The Kokubunji in Ōsumi province was dismantled in the late nineteenth century, but in addition to our Six Kannon monument discussed above, there are a few other fragments of stone and clay remaining from its past. A great number of roof tiles survive in this area as vestiges of numerous lost temple buildings.[124]

Today the Ōsumi Kokubunji site is about a ten-minute walk from Kokubu train station, Kirishima City, Kagoshima prefecture. The city was reorganized and renamed to Kirishima City in 2005, which makes a stronger connection to the mountains where Six Kannon Lake is located. (Formerly this area was called Kokubu, which was named after Kokubunji.) The site of the stone stele is fairly desolate except for the few stone monuments from the old temple, including two undated broken Buddhist guardians (Fig. 2.31).

The most well-known monument from Kokubunji in Ōsumi is a six-story stone pagoda, which has an inscription carved into one side of the second

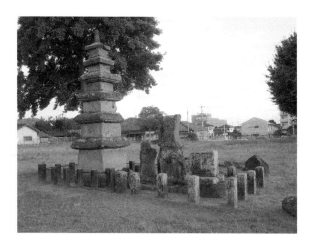

FIGURE 2.31. Monuments including stone pagoda (1142) and stone Niō figures (dates unknown). Site of former Ōsumi Kokubunji, Kirishima City, Kagoshima prefecture.

story, from 1142 (Kōji 1). Six-story pagodas were not common, and local officials who carefully measured every part determined from the proportions that there were alternations and that it had been either five or seven stories originally.[125] The Kyushu gazetteer *Sangoku meishō zue* from 1843 mentions this stone pagoda, which is identified by its 1142 date, as having only five stories.[126]

While working on a local sewer in 1962, a road crew unearthed another inscribed stone monument from Ōsumi Kokubunji, made twenty years after the Six Kannon monument.[127] In contrast, this monument (88 × 56 cm) has only one Kannon image on the top front. Its inscription states that Kokubunji was restored in 1582 (Tenshō 10) by Fuchiwaki Nyūdō, who was saddened by the condition of the once-great temple that Anjun had tried to restore that previously had seven halls, a great gate, and a bell tower.[128]

Like Fuchiwaki Nyūdō's monument above, the Six Kannon monument made twenty years earlier, which had Anjun (a different member of the Fuchiwaki family) as a patron, also references the former glory of the temple. The monument's purpose was to restore earlier images of Six Kannon of an unknown date that were damaged. A monk, whose name was perhaps Eiga, seems to have been in charge of the project and led three main patrons and over thirty others in the creation of the Six Kannon relief sculptures. Not long after these monuments were made, Toyotomi Hideyoshi (1536?–1598) took over Kyushu in 1587 (Tenshō 15), and the Ōsumi area came under the localized control of the Satsuma clan, who maintained it until the end of Edo.[129] The donors must have wanted the help and comfort that they believed Six Kannon could provide during a stressful period.

According to *Kokubu kyōdoshi,* the first patron listed in the Six Kannon monument's inscription named Kintaku was the thirteenth-generation head

of Ryōgonji in nearby Kiyomizu-mura.[130] *Sangoku meishō zue* explained that Kokubunji was revived as subtemple of Ryōgonji in the Tenbun era (1532–1554). In this period Emperor Gonara (r. 1526–1557) donated handwritten copies of the *Heart sūtra* in gold on blue paper to all the Kokubunji temples on behalf of the sixth-century (semilegendary) Emperor Annei. An imperial messenger arrived in Hyūga in 1542 (Tenbun 11) with the sutra, but because of extensive warfare in the area it had to pass through several different channels before presentation to the temple.[131]

The *Sangoku meishō zue* entry on Ōsumi Kokubunji gives some indication of the local instability of the area at the time and also confirms that Kokubunji had greatly downsized. Twenty years after Emperor Gonara's sutra was presented to Kokubunji in 1542, Kintaku had the Six Kannon stone monument made in 1562, and then twenty years after that in 1582, Fuchiwaki Nyūdō had the other monument with a single Kannon image made. *Sangoku meishō zue* continues with a bit more information about Kokubunji in the Edo period and then states that "now" (meaning the Tenpō era 1830–1843) there was one monk and a small hall, but people still made pilgrimages there, and to the left of the Kannon Hall was a five-story stone pagoda dated to 1142.[132]

The anxiety of this time, shifting alliances, and perhaps the new influx of foreign contact, which included the Portuguese Jesuits and their subsequent expulsion, must have contributed to the donors' desire to re-create a Six Kannon monument. The known efficacy of the Six Kannon and their affiliated Six Gongen in the nearby Kirishima Mountains made it an appropriate choice for Kokubunji.

Another local monument dedicated to the Six Kannon may be found at the site of the former temple of Kongōji, which is about a ten-minute walk from the site of Ōsumi Kokubunji at the entrance to Shiroyama Park. This monument is now cemented into a space with seventeen other stone monuments from Kongōji, including graves of the former head monks (Fig. 2.32). Next to the space is the mausoleum, which includes a stone chamber, made for the tenth-generation Kongōji head monk Shinō (1610–1689), who is said to have invoked the power of the Kirishima deities.[133] Many of sites' stone monuments date from the seventeenth and eighteenth centuries, so although this one does not have a date, it is likely from the same period. The stone monument, which measures 130 centimeters in height, is in the shape of six-sided pillar topped by a jewel sitting on a base. Each side bears the name of one of the Six Kannon, with the corresponding seed syllable above. Below the one for Horse-Headed, which interestingly is referred to as a Myōō, is the name Keijirō of Ogawa, which was a village near the now-defunct Kongōji. Presumably Keijirō's relatives, or Keijirō himself while alive, chose this as his gravestone in order to invoke the Six Kannon to help navigate the six paths, and especially to avoid a bad path after death.

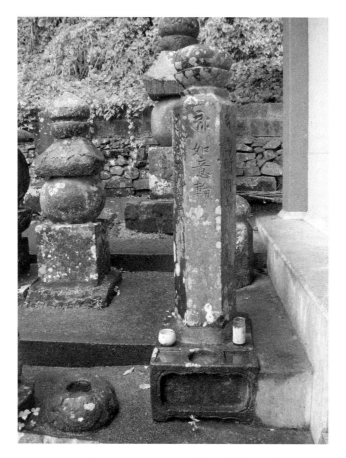

FIGURE 2.32. Six Kannon monument formerly located at Kongōji. Seventeenth or eighteenth century. Stone. 130 cm. Kirishima City, Kagoshima prefecture.

Returning to Ōsumi no Kokubunji, in the early Meiji period the temple was dismantled because of the separation of shrines and temples and the area became a cemetery. The six-story pagoda, guardians, and other monuments were designated as important properties in 1921. After the Pacific War was over in 1945, the cemetery was moved and the area became a park.[134] Formerly, there was a Kōminkan (People's hall) at the site, but that building was torn down sometime in the 1990s.[135] Now that it is gone the stone monuments stand in a vacant area, waiting for their next recontextualization.

The Six Kannon of Chōkyūji and Shukuin Busshi

Moving east from the Kirishima Mountains, we find a significant surviving group of Six Kannon images at Chōkyūji, which were made in 1562, just ten years after the Kokubunji stone monument. The detailed interior inscriptions

FIGURE 2.33. Shō Kannon. By Shukuin Busshi. 1562. Wood.
36.5 cm. Chōkyūji, Miyazaki prefecture.

by the artists make them a particularly intriguing example that offers a window into the production of a complete set of Six Kannon. The Shingon temple Chōkyūji, located in the Ōtsuka area of Miyazaki prefecture, is one of only a few temples to have Six Kannon sculptures featured as main icons (*honzon*). These sixteenth-century seated Six Kannon images were made in the multi-block technique (*yosegi zukuri*), have crystal inserts for the eyes and *urna*, and range in size from thirty-two to thirty-seven centimeters. Some of the images have missing appendages and much of the color has worn away, yet their delicate features are still apparent. The Shō Kannon has an inscription declaring it was repaired in 1713 (Shōtoku 3), so it is likely that the whole group was refurbished at that time (Fig. 2.33).[136] All but two of the sculptures' bases

FIGURE 2.34. Altar of main hall at Chōkyūji, Miyazaki City, Miyazaki prefecture.

have been replaced, and in the course of repair and reassembly, parts of the bases for each image were inadvertently interchanged.[137]

While Miyazaki is a large city, once off the main roads the outlying areas quickly turn to a mixture of suburban and rural landscape. There are many dwellings in the area of Chōkyūji, but just after crossing the large road from the nearest bus stop, suddenly one will notice the sounds of cows lowing and the smell of fertilizer from the small fields interspersed between houses. Chōkyūji is built on the side of a hill with a cemetery that stretches around its north side. The main hall, located up the stairs from the temple entrance, is a twentieth-century white concrete building with a substantial *tatami* floor space for groups. At the back of the hall is a fairly large, stepped altar where five of the Six Kannon images are arranged (Figs. 2.34, 2.36). One is left out because of its condition (Fig. 2.35). In 2009, the head priest Kobayashi Kōjun explained that he felt each Kannon's role in helping beings along the six paths was very important, but a specific order on the altar was unnecessary. Indeed, a photo from 1998 shows them in different positions.[138]

The reason the image of Nyoirin Kannon cannot be displayed is that it was dismantled. Kobayashi's father Kobayashi Honkō had been an amateur sculptor and had repaired the Six Kannon at various times because he felt it inappropriate to leave them in poor condition.[139] Honkō has since passed

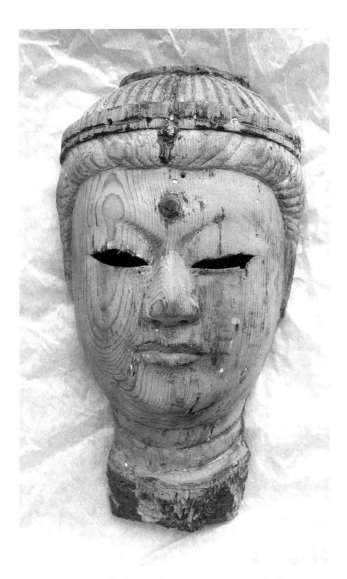

FIGURE 2.35. Detached face of Nyoirin Kannon. By Shukuin Busshi. 1562. Wood. Chōkyūji, Miyazaki City, Miyazaki prefecture.

away and his son Kōjun worries that having the images professionally re-stored would be a costly endeavor, so the sixth Kannon remains in a box. While the situation may be unsatisfactory for worshippers, from a technical as well as a historical perspective the dismantled state of the Nyoirin image is fascinating to examine.

In 1949 Kobayashi Honkō found that the images were full of inked inscriptions covering the majority of their interior cavity walls as well as the various pieces of wood that make up their bases (Fig. 2.37). Kobayashi later

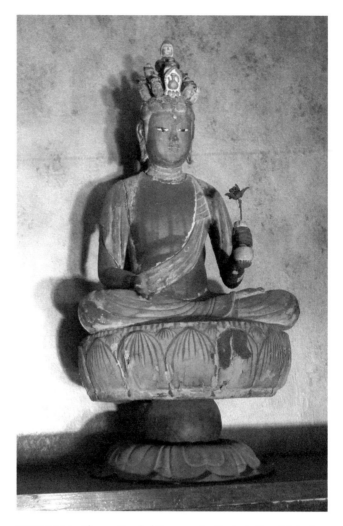

FIGURE 2.36. Eleven-Headed Kannon. By Shukuin Busshi. 1562.
Wood. 37.7 cm. Miyazaki City, Chōkyūji, Miyazaki prefecture.

alerted Miyazaki prefecture officials, who scrutinized, assessed, and re-
corded all these notations.[140] From them we learn the Chōkyūji images
were made in 1562–1563 (Eiroku 5–6) by artists named Genji, Genshirō,
Gengorō, and Ryōshō, who belonged to a group of Buddhist sculptors called
Shukuin Busshi. The name Shukuin comes from the location of Shukuin-chō,
which was the name of the area in Nara just north of Kōfukuji, where the
sculptors worked. The first generation of these artists were considered car-
penters (banjō) who made various wooden objects in the fifteenth century,
but by the early sixteenth century the subsequent generation of artists came
to be Buddhist sculpture specialists.[141] Over seventy works by the very pro-
lific Shukuin Busshi are known today. In contrast to the Chōkyūji Six Kan-

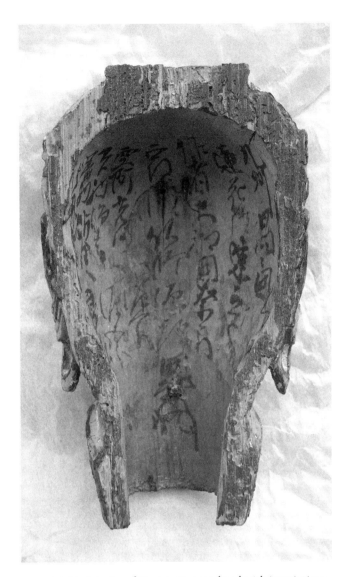

FIGURE 2.37. Interior of Nyoirin Kannon head with inscriptions.
By Shukuin Busshi. 1562. Wood. Chōkyūji, Miyazaki City,
Miyazaki prefecture.

non, most of the works have a recognizable style that displays slightly rough
carving that is visible on unpainted surfaces.

Various records of the Shukuin Busshi group indicate that Genji, also
known by the longer name Genemon no jō, was the head of the studio and
that he worked with his sons Genshirō (second son), Gengorō (third son), and
Ryōshō (fourth son) at the time the Chōkyūji images were made.[142] Genzaburō,
Genji's oldest son, is not mentioned in the Chōkyūji inscription, but he is
known to have worked with the group previously, and by 1563 he was

independently executing many Buddhist sculptures elsewhere.[143] An inscription found inside the Juntei Kannon records that Gengorō was sixteen years old when he made the image.[144]

In *Hyūgaki* (Records of Hyūga), which records the history of the powerful Itō clan in Miyazaki, there is an entry stating that Itō Yoshisuke (1512–1582), who was a lord in the Hyūga area (now called Miyazaki), commissioned the Nara sculptors Gengorō and his brothers to make a colossal Birushana (Skt. Vairocana) Buddha triad in 1551 (Tenbun 20) for Kinpakuji. The images and the hall that enshrined them no longer exist.[145] The successful completion of this large project likely enhanced the reputation of the Shukuin Busshi sculptors in the Miyazaki area and may have influenced the patrons' decision to commission them to make the Chōkyūji Kannon. However, within the group there is a historical inconsistency with the names of the artists. Since Gengorō was sixteen years old in 1563 when he worked on the Chōkyūji images, in 1551 when the colossal Birushana triad was made, he would have been only four years old. Shukuin Busshi artists reused established names throughout their history, as in the different generations of Genji and Genjirō, but there are no records with the name of a Gengorō artist of an earlier generation.[146] Gengorō is listed as one of the makers of an image in 1555 (Kōji 1) when he would have been age eight.[147] It is possible that an eight-year-old boy could have assisted with menial tasks at the studio, but a four-year-old's help certainly sounds like a safety hazard. Since the *Hyūgaki* entry names the makers of the images as Nara Buddhist sculptors Gengorō and his brothers, "Nanto no Busshi Gengorō kyōdai," we should interpret that "the brothers of Gengorō" worked without him and that the boy Gengorō was positioned to become a respected member of the Shukuin Busshi group in the future, and would later work on the Chōkyūji Kannon.

Within our study of Chōkyūji, another confusing instance of double naming concerns the appellation of the temple itself. A different temple named Chōkyūji with the same characters is in Nichinan City, also in Miyazaki prefecture. This Chōkyūji is a Tendai temple, whose history seems to be unrelated to the Chōkyūji in Miyazaki City, yet it has a sculpture of Kokūzō Bosatsu (Skt. Ākāśagharba) that was also made by Genji, Genshirō, Gengorō, and Ryōshō in 1571 (Genki 1).[148] We should note that in this case the timeline matches the Gengorō who worked on the Chōkyūji images, so he should be the same person. Gengorō would have been twenty-four at that time.

The Shukuin Busshi inscriptions inside the Chōkyūji works include numerous pieces of information, including the artists' names, the identities of each image, and the dates each work was made. Contrary to expectation, the names of specific patrons were not included. The name "Kūa" is also included, which was a shortened version of the dharma name (*hōmyō*) "Kū

Amida Butsu" that Genji used within his works.[149] Shukuin Busshi did not assume the familiar Buddhist ranking titles, such as Hokkyō (Bridge of the Law), Hōgen (Eye of the Law), and Hōin (Seal of the Law), which were typical for earlier Buddhist sculptors. However, because of the idea that Buddhist images required special treatment, Genji's dharma name of Kūa respectfully associates him with Amida Buddha and perhaps helped provide the Buddhist authority needed to handle sacred images.

The Chōkyūji images' inscriptions also include the name of the location where they would be enshrined, given as "Renge'in Hyūga no kuni."[150] Renge'in is an older name for the temple and Hyūga is the former name for Miyazaki prefecture. The prelate Gyokuyū, who was the thirty-eighth head of Imafukuji, founded Chōkyūji as a Shingon temple in 1562, just a year before the Six Kannon images are dated.[151] Gyokuyū was known to have been close with Itō Yoshisuke, and temple tradition suggests that Yoshisuke may have been its main patron. If this is the case, it is another link between Chōkyūji's choice to employ the Shukuin Busshi, since Itō Yoshisuke supported Gengorō's colossal Birushana Buddha triad in 1551. Chōkyūji was one of twelve subtemples belonging to Imafukuji, which is also located in Miyazaki City. Although much of the history of both Imafukuji and Chōkyūji is obscure, we know that during the years 1870–1871 Imafukuji and its subtemples were all shut down and most of their property was dispersed because of anti-Buddhist sentiment. Beginning in 1870 the abandoned temple was referred to as Imafukuji and then after it was revived, its name changed back to Chōkyūji sometime before 1925.[152]

Back inside the main hall of Chōkyūji today, to the right of the Kannon images on the altar is a wooden image of Kūkai, measuring eighty-one centimeters, which was also made in 1563 by the same group of Shukuin Busshi artists: Genji, Genshirō, Gengorō, and Ryōshō. This seated image is crisply carved with white paint on the skin areas and red on the robe (see right side of Fig. 2.34). The image was restored and color was added in 1714 (Shōtoku 4), one year after the repair of the Shō Kannon. The inscription records Ōtsuka-mura, which is the location of Chōkyūji, indicating that it was there at the time.[153] The presence of the Kūkai sculpture reveals additional evidence for the link between the Nara Shukuin Busshi artists and Chōkyūji.

There are two theories about where the Six Kannon images might have been made. One is that they were made in Nara at the Shukuin Busshi studio and then taken to Chōkyūji by boat. The other possibility is that the artists worked on site in Kyushu. Since the four artists had an active business in Nara, it is very plausible that the images were constructed at the studio in Nara. Furthermore, since they are relatively small, the images would not have been difficult to transport. In contrast, the Shukuin Busshi would have had to construct the previously mentioned colossal Birushana triad on site.

In light of the inscriptions, the Six Kannon sculptures are significant to the origin of Chōkyūji in 1562 and likely have stayed at the same temple since the time they were made. Although unstated, the patrons likely chose Six Kannon because they were aware of their legend in the Kirishima Mountains. About fifteen kilometers away, in an area called Kunitomi-chō Tajiri, also in Miyazaki prefecture, are some images that were carved in relief on a cliff face at the bank of the Honjō River. The configuration of these Six Kannon, along with a large Yakushi (5.8 meters) they surround, is known as Honjō no sekibutsu. The images have been attributed to the late Kamakura period (fourteenth century), but today they are so eroded that they are almost impossible to discern.[154] Since the Six Kannon images at Honjō are situated between the Kirishima Mountains and Chōkyūji's former site of Imafukuji, these images also participated in the localized awareness of the efficacy of the Six Kannon in the area of the Kirishima Mountains. Yet another legend of Six Kannon matched with Six Gongen is from Udo Jingū, about forty kilometers south from Chōkyūji on the Nichinan coast, which purportedly has images of Six Kannon that are no longer seen enshrined in one of its nearby caves.[155]

Two Six Kannon Temples on the Sagara Kannon Pilgrimage Route

Two temples in Kumamoto prefecture feature Six Kannon sets as main icons. Both are stops on a Thirty-Three Kannon pilgrimage route that was named for the powerful Sagara clan, who controlled the area from the twelfth to the nineteenth century. During the spring and fall equinoxes (March 20/21 and September 22/23) all thirty-three temples along the route are open so the featured Kannon images can be viewed, to the delight of pilgrims and tourists.[156] The theme of thirty-three temple Kannon pilgrimages will be discussed in Chapter Six with a focus on the larger and more famous routes, such as Saigoku. Of special interest for the present chapter is the more localized Sagara route as Temple Number 32, Shingūji, has a set of life-size Six Kannon sculptures dating from the sixteenth to the seventeenth centuries and Temple Number 25, a Kannon Hall from the now defunct Fumonji, has a smaller set of Six Kannon made in the seventeenth century. This section will explore how these sets originated and how the cult of Six Kannon functioned within the Sagara area.

The Sagara Thirty-Three Kannon pilgrimage route developed in the seventeenth century. Iguchi Bishin (1762–1803), a member of the Sagara clan who lived at Nakayamadera (Number 28) in his later years, compiled the first known records on this pilgrimage in 1794 (Kansei 6). The records consist of two sets of poems (goeika) written about each temple along the route, which

are precious evidence of how pilgrims engaged with the sites aside from of-
fering prayers. Bishin wrote one set of poems himself and recorded an-
other set written earlier by his relative Mushin (1626–1690). Takada Motoji
proposed that because Mushin was involved in the support of other temples
on the route in 1677 (Enpō 5), he wrote the poems at that time, and hence it
was likely the beginning of the pilgrimage.[157]

In 1935–1936 the American anthropologist John Embree, who studied Sue
village, discussed this pilgrimage, which did not have many participants at
the time, in his study of local customs that brought the small village to inter-
national attention.[158] Statistics for participation are difficult to access, but in
autumn 2011 the local newspaper reported that among the many people
who joined, one walking group boasted 244 members of all ages and that the
route was divided into three-, five-, and ten-kilometer courses.[159] Over the
years the pilgrimage has adapted to the changing needs of the community.

Shingūji Six Kannon

Number 32 on the Sagara route, in the rural area of Nishiki-machi, Nishi-
mura in Kuma district, Kumamoto prefecture, is a special hall made to house
Six Kannon at the Ōbaku School temple of Shingūji. Inside its hall Six

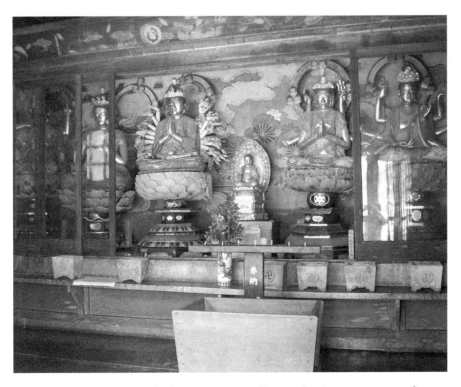

FIGURE 2.38. Six Kannon inside Shingūji Kannon Hall. Kuma district, Kumamoto prefecture.

Kannon images are protected by a large glass case with sliding doors across the far wall (Fig. 2.38). The hall and other buildings are accessible up a steep set of stairs on a hillside. On the far side of the parking lot and some fields, a golf course and restaurant were recently built below the temple. As urbanization creeps closer and the rural identity of the temple diminishes, local devotion to Kannon still remains strong.

Shingūji was named for the Shingū clan, who founded it in 1405 (Ōei 12).[160] Various donors are given credit for the commission of an original group of Six Kannon sculptures at the temple, but no source provides a date.[161] However, almost all references agree that the temple was destroyed by fire in 1576 (Tenshō 4). Versions of the following miraculous story are often repeated about the next stage in the temple's history. After the 1576 fire, the temple master was surprised when he discovered something in the ashes that shone brilliantly gold in all directions. Upon picking it up, he found it was a pure, unburned image of a saint (*hijiri*), measuring three *sun* (nine centimeters), with a crown and a scarf. Sagara Yoshihi (1544–1581) had faith that this was true, and so the Six Kannon images were remade after the fire.[162]

The most extensive history of the area, called *Kumagunshi* (History of the Kuma district), compiled in 1941, includes a copy of the undated *Shingūsō dayū chōsho* (Records by the head of the Shingū estate), which has a less fantastic and more detailed account of the Six Kannon images at Shingūji. In this version, Sagara Yoshihi's great patron Kiyohara Yoritada donated the funds for the restoration of the Six Kannon images in 1577 (Tenshō 5), the year after the fire. The Nyoirin Kannon image (Fig. 2.39) was made by Kaigetsu from Ōsumi in 1578 (Tenshō 6), the Thousand-Armed Kannon image (Fig. 2.40) was made by Hidaka Shibu Hideei in 1578, the Shō Kannon was made in 1579 (Tenshō 7) by an unknown artist, the Juntei was made in 1586 (Tenshō 14) by Kinsaku, and the Horse-Headed (Fig. 2.41) was made in 1630 (Kan'ei 7) by Ogata Daigaku from Uemura in Kuma. In short, different sculptors individually made these images over a span of fifty-four years, from 1578 to 1630.[163] Accordingly, this is an excellent documented example that shows Kannon images in sets of six were not always constructed at the same time.

The history of Shingūji continues when the Ōbaku master Tenzui Dō'on (1627–1688) revived the temple in 1673 (Kanbun 13). One year later a terrible typhoon hit and damaged the halls and images again.[164] Tenzui, along with another monk named Kanshū from Satsuma, helped rebuild the temple again in 1674 (Enpō 2). Shingūji appears to have had an Ōbaku School affiliation at least since the time of Tenzui's involvement.[165] Sometime before 1941 it became a subtemple of the Ōbaku headquarters Manpukuji in Uji.[166]

A study by the local cultural preservation agency recorded that a copy of the Shingūji Kannon Hall ridge plaque dates the former hall to 1676

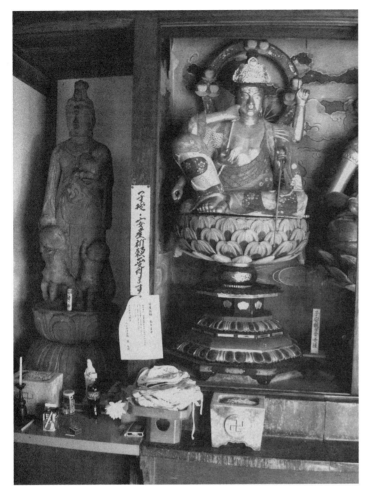

FIGURE 2.39. Shingūji
Kannon Hall interior.
Left: Kannon with children,
Date unknown (modern).
Stone. Right: Nyoirin
Kannon. By Kaigetsu. 1578.
Wood. Kuma district,
Kumamoto prefecture.

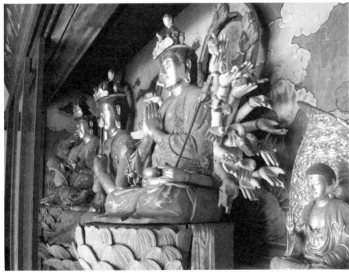

FIGURE 2.40. Thousand-
Armed Kannon. By Hidaka
Shibu Hideei. 1578. Wood.
Shingūji, Kuma district,
Kumamoto prefecture.

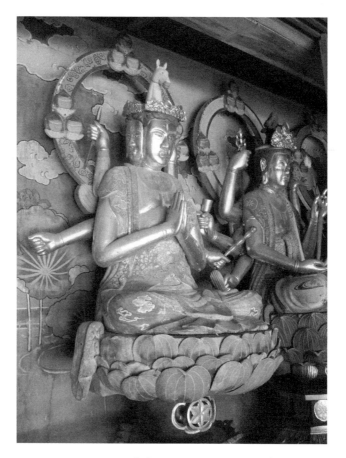

FIGURE 2.41. Horse-Headed Kannon. By Ogata Daigaku. 1630.
Wood. Shingūji, Nishiki-machi, Kuma district, Kumamoto
prefecture.

(Enpō 4), which is a year after Tenzui and Kanshū's rebuilding.[167] Parts of
the old structure may have been recycled into the building when it was
reconstructed and moved up the hill in 1937. As appropriate for Six Kan-
non images, the large wooden plaque hanging above the front door reads
"Daijikaku" (Pavilion of Great Compassion).

Shingūji Kannon, Safe Childbirth, and Animal Fertility

Aside from interest in going to the Shingūji Kannon Hall as a stop on the
Sagara Thirty-Three temple pilgrimage route, another reason to visit is for
prayers for safe childbirth. To one side of the large glass case that encloses
the Six Kannon images is a modern life-size standing stone image of Kan-
non that holds one child in her arms while two others try to climb her skirt
(see Fig. 2.39). In the past, when Shingūji was surrounded by farms, there

had been a stronger emphasis on the safe birth of cows and horses. An old photograph of a prize steer and a small clay sculpture inscribed as "Gyūba Kannon" (Cow-Horse Kannon) remain as evidence in the hall.[168] As noted earlier in reference to the Toyouke Shrine at Six Kannon Lake, believers made offerings to Six Kannon images for the production of healthy livestock because of the presence of Horse-Headed Kannon, who is responsible for the animal path. Embree noted in his 1930s study of the area that Horse-Headed Kannon was annually worshipped by "wagoners and horse-brokers" on the seventeenth and eighteenth days of the sixth month.[169]

As local cattle farming diminished, the emphasis shifted away from animals toward the safe delivery of human babies. Formerly, the temple had exchanged special protective sashes for pregnancy (haraobi), which were traditionally worn by mothers beginning in the fifth month of pregnancy, but today only one or two are left hanging from the bell in front of the Kannon Hall in reference to the older practice. Although the medical benefits are usually no longer touted, these sashes were a way to wrap the fetus in religiously charged protection.[170] Now at Shingūji it is customary to write prayers for safe delivery or messages of appreciation for a successful birth on commercially produced bibs and leave them in a tray in front of the stone Kannon (see Fig. 2.39).

Evidence that the Six Kannon were considered efficacious for aid in human childbirth is in the previously mentioned record Shingūsō dayū chōsho, which specifically mentions that Nyoirin is a Kannon who aids easy childbirth. This record also explains that in 1578 (Tenshō 6) the Nyoirin image was made for Lord Yoshihi and Kamechiyomaru, the great female patron, and her daughter (named Hōen) in order to stop calamity as well as bring about long life, strong minds and bodies, prosperity, bountiful harvests for the three districts, and happiness to many people. Kamechiyomaru also commissioned the Thousand-Armed Kannon image for the same types of protection for herself, her daughter, and Yoshihi (presumably the girl's father) in the same year.[171] Nyoirin's role in childbirth protection is significant here, and we should also note the patronage by a female donor to care for her daughter. Moreover, the informative twelve-meter-long illustrated scroll of the Kuma area, known as Kumaezu and dated 1773 (An'ei 2), includes an illustration of the temple showing two halls, next to which is a note stating that prayers for easy childbirth are made to Shingūji's Six Kannon.[172]

The local 1916 history Kumagun kyōdoshi claims that in 1673 (Kanbun 13) Tenzui began the annual Kannon service that is held on March seventeenth.[173] The temple still holds this annual rite emphasizing safe human childbirth. Embree reported that Kannon was regarded as the protector of pregnant women in Kuma County, and women desiring children visited

Kannon halls.[174] Requests for Kannon's assistance for easy childbirth are not unusual, as we find rituals and prayers addressed to Kannon to help with childbirth by the twelfth century in Japan. Shingūji's emphasis on, first, the birth of humans, then animals, and then again human birth, was bolstered by local necessity.

Kumagunshi, from 1941, also records that the images were restored and painted at the time the hall was rebuilt in 1937.[175] The original appearance of the Six Kannon images, which are all life size, has been obscured by the addition of ostentatious new coloring, such as the electric blue hair, shiny gold skin, and colorful customized designs on the robes and bases seen today. A close investigation with a flashlight reveals that the name of the artist, Ogata Daigaku, is visible through an opening to the inner structure of the base for the Horse-Headed Kannon image. Considering all the damage and destruction the temple suffered over the centuries, it is fortuitous that this group of Six Kannon survives intact and continues to be the focus of active worship.

Six Kannon Hall at the Former Fumonji

About an hour's drive from Shingūji is a small hall, which serves as a vestige of the former Fumonji in Yunomae (Kumamoto prefecture) with another set of Six Kannon (Fig. 2.42). In this case, the images all date to 1652 (Jōō 1), but since the Eleven-Headed Kannon image is missing, there are now only five.[176] While Fumonji no longer functions as a fully operational temple, local farmers take turns caring for the hall during the year and preparing for the openings held during the pilgrimage events that take place during the equinoxes. Fumonji is Number 25 in the Sagara Thirty-Three Kannon pilgrimage.

Fumonji appears much more frequently in local histories than the previously mentioned Shingūji. From one of the oldest sources, *Fumonji ryakki* (Abbreviated record of Fumonji) in *Kumagun jinjaki* from 1699 (Genroku 12), we learn that it was first a small shrine for mountain practitioners on Mount Yu in Mizukami-mura, where Ichifusa Shrine was located.[177] All histories of the area are heavily inscribed with the activities of the powerful Sagara clan. In the early Eishō period (1504–1520), during the time of Sagara Nagatsune (1469–1518), who was Sagara Yoshihi's second son, the temple was moved from Mount Yu to Iwano, east of the area that would become Shōzenin.[178] More specifically, Fumonji was built in 1506 (Eishō 3) as a Shingon-School tutelary temple for Ichifusa Shrine.[179] Eison, who formerly lived at Tōkōji in nearby Kurohiji-mura, is considered the first generation of the Fumonji lineage of head monks.[180]

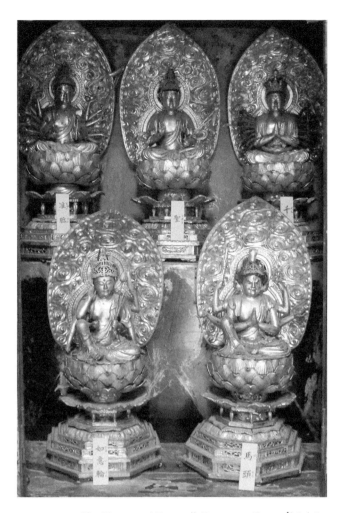

FIGURE 2.42. Five Kannon at Fumonji. Yunomae, Kuma district, Kumamoto prefecture.

The most well-known story of Fumonji is not about Kannon but its fifth-generation head monk named Seiyo. In 1582 (Tenshō 10) Seiyo was falsely accused of treason for purportedly making plans to oppose Sagara Yorisada (b. 1544) and was executed. Some versions of the story say that the devout Seiyo engaged in daily practice of the Six Kannon ritual (Roku Kannon hōji) and was in the midst of chanting the *Kannon sūtra* when he was executed.[181] According to local legends, after this occurred Seiyo's outraged mother Kugetsu vowed to avenge his death. Kugetsu hid at Ichifusa Shrine with her beloved cat Tamatare and starved herself as she prayed for revenge. There are many variations of this story, but in one the dying Kugetsu cut her fingers so Tamatare could drink her blood in order to survive and take revenge. After Kugetsu died, it came to light that Seiyo was innocent and had been

executed unjustly. Local inhabitants suspected that the ghost of the angry cat was haunting the area. In 1625 (Kan'ei 2) the Sagara clan built Shōzenin near the ruins of the old Fumonji site to appease the angry spirits of Seiyo, his mother, and her cat. Kugetsu and Tamatare have graves beside the Kannon Hall at Shōzenin. Because this story is so well known, the temple maintains the nickname "Nekodera" (cat temple) and capitalizes on this history by selling a variety of cat-related talismans.[182] Along with Seiyo and his mother, might Fumonji's commission of the Six Kannon images, which includes Horse-Headed Kannon as a savior of animals, have been considered helpful to appease the spirit of the angry cat? Based on the tenacity of the legend and that the Six Kannon images were made only twenty years after Shōzenin was built, it is an intriguing possibility.

After Seiyo's posthumous exoneration, Fumonji was revived in 1604 (Keichō 9) and moved to Yunomae, where its Kannon Hall stands now. The temple land is on the site of the former castle, called Yunomae Furujō, where the military leader Higashi Naomasa lived until 1559 (Eiroku 2). In 1604 this land became the property of Fumonji.[183] The illustrated handscroll *Kumaezu* from 1773, mentioned earlier, contains an illustration of Fumonji that consists of two gates and four or five buildings at the old castle site. Below the picture of the temple is the text abbreviated from *Fumonji ryakki* mentioned above.[184] The scroll also includes an illustration of Shōzenin with accompanying text about the Seiyo–Nekodera incident and a notation to the east of the temple to mark the former site of Fumonji nearby.

From the shrine perspective, *Kumagunshi* states that Ichifusa Shrine built a *yohaijō*, which is a place to worship kami of another location, in Yunomae in 1600 (Keichō 5).[185] Ichifusa Shrine had been a remote site high in the mountains for *shugenja*. Since the kami were on such a steep mountain, the new spot became more convenient for worshippers. In 1604, when Fumonji was moved to this location, it became the tutelary temple for the shrine. In 1872 (Meiji 5), because of the separation of Buddhist deities and kami, it was simply renamed Yohaijō, and then a great fire burned the temple in 1883 (Meiji 16).[186] In the 1930s Ichifusa Shrine was reconfigured into three locations. Satomiya (literally village shrine, and considered the lower shrine) was built in 1934 just up the hill from the present Fumonji Kannon Hall, standing at the former locations of both the earlier castle and the subsequent structures of Fumonji.

From records we find that Fumonji was consolidated with Shōzenin in the early Meiji period.[187] The 1941 *Kumagunshi* states that the Six Kannon images were housed in a hall at Shōzenin at that time.[188] Just outside the present Fumonji building, a stone maker records that the roof was repaired in

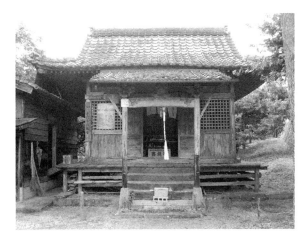

FIGURE 2.43. Kannon Hall. Early twentieth century. Fumonji, Yunomae, Kuma district, Kumamoto prefecture.

1926 and names it a Kannon Hall. This small hall, which is constructed of wood with a hip-and-gable tile roof, was built before 1926, left empty, and then restored at some point before 1978 (Fig. 2.43).[189]

Monchūdosha narabi daidai senshi (Lineage of temple and shrine masters), a lineage history of the area's religious institutions compiled in 1860 (Man'en 1) now owned by Shōzenin, states that the images of the Honjidō are the Six Kannon, specifically Shō, Thousand-Armed, Horse-Headed, Eleven-Headed, Juntei, and Nyoirin, and were made by the deities themselves.[190] As inhabitants of the Honjidō, the images were matched with kami and functioned in the combinatory *honji-suijaku* practice that was so prevalent in Kyushu. The record likely reflects the circumstances of 1860, just before Fumonji closed and was combined with Shōzenin. *Rekidai shisei dokushūran* (Single collection of the successive generations [of the Sagara clan]; compiled in the Bunsei era, 1818–1830, dated 1853) states the Six Kannon arrived at Fumonji in 1654 (Jōō 3) and a service for the new images was officiated on the eighteenth day of the tenth month by the monk Kakunin of Ganjōji in Hitoyoshi.[191] Another record, *Nantō manmenroku* (Records of the thriving Nantō [Sagara] Clan), compiled in the Bunka era (1804–1817), confirms the service for the new images at this time and states that Shōtatsu, the twentieth-generation head of Ganjōji, also officiated.[192] A wooden ridge plaque that records Kakunin's dedication of the images in 1654 is stored in the hall next to the images' tabernacle.[193]

Each seated Kannon image is gilt with small, delicate facial features and thin tubular limbs. The drapery is naturalistically formed, with relatively active folds. The carving is sophisticated, and although the artists' names are unrecorded, some sources say that they were made in Kyoto and brought to Fumonji.[194] They are housed in a black lacquer tabernacle (*zushi*), with

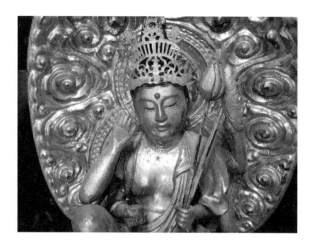

FIGURE 2.44. Nyoirin Kannon, detail. 1652. Wood. 21.5 cm. Fumonji, Yunomae, Kuma district, Kumamoto prefecture.

three images on the upper shelf and two below. Beginning clockwise from the top center, the Kannon images are Shō, Thousand-Armed, Horse-Headed (Plate 5), Nyoirin (Fig. 2.44), and Juntei.[195] The Eleven-Headed Kannon is missing. The tabernacle, which is considered to be original to the images, is auspiciously adorned with paintings of a peacock with red and white chrysanthemums on one door interior and a phoenix with red and white peonies on the other (Plate 6). A larger outer tabernacle constructed of plain wood with a pitched roof, columns, and lattice doors was made to encase the black lacquer tabernacle.

Although the section on Ichifusa Shrine in *Kumagun kyōdoshi* from 1916 does not mention Fumonji, it notes that Ichifusa Shrine was a local shrine built to protect the mountains and valleys, and significantly one of its kami, named Hikohohodemi no mikoto, is worshipped at the Kirishima Gongen shrines.[196] In an earlier entry dated to 1511 (Eishō 8), *Nantō manmenroku* claims that the kami at Ichifusa Shrine are the same, literally the same body (*dōtai*), as those at Kirishima.[197] Moreover, Sagara family documents from 1517 (Eishō 12) refer to Ichifusa Shrine as "Ichifusa Rokusho Gongen."[198] The previously mentioned ridge plaque says the images were dedicated to Ichifusa Rokusho Gongen, firmly tying the Six Kannon and Six Gongen together. At the beginning of the Meiji period in 1868, when shrine and temple worship were officially separated by order of the government, the Six Kannon images were temporarily housed at Shōzenin and lost their shrine affiliation.[199]

At some point before 1978, the images were moved away from Shōzenin into their present hall, back in proximity to Ichifusa Shrine, which is on the hill just above the hall. Inside the hall we find a votive tablet (*ema*) with a three-dimensional horse and jockey as an offering for successful horse

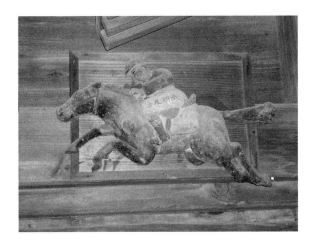

FIGURE 2.45. Racehorse *ema*. 1906. Wood. Fumonji, Yunomae, Kuma district, Kumamoto prefecture.

racing in 1906 (Meiji 39) (Fig. 2.45). Such a specific, animal-related dedication was likely directed toward the powers of Horse-Headed Kannon and perhaps brought with the Six Kannon from Shōzenin, where it might have been initially inspired by its tradition of concern for animals.

The likely main reason for the commission of these Six Kannon images at Fumonji was to match them with the six kami of the Kirishima Mountains. The Kirishima connection was reiterated in the 1860 record *Monchūdosha narabi daidai sen* mentioned earlier, which states that the kami were summoned to Ichifusa Shrine from the Kirishima Mountains in 708 (Daidō 2). The companion or tutelary temple (*bettō*) was Fumonji, and the shrine was referred to as Ichifusa Rokusha Dai Gongen, which should remind us of the former shrine titles at Kirishima.[200] Indeed, in the sixteenth century the Sagara family called Ichifusa Shrine "Ichifusa Rokusho Gongen." Just as the writers of these sources were likely well aware of the powerful Kirishima Gongen, those associated with the commission of the Six Kannon must have selected them within the *honji-suijaku* framework, linking them to the Kirishima Gongen in the same area of Higo.

Kyushu Six Kannon

This chapter mapped extant Six Kannon images and framed them within the geographic areas of Kyushu, first by addressing the centrally located Kirishima Mountains, then moving north, south, west, and finally eastward back to the general vicinity of Kirishima. The map in Figure 2.1 shows the high concentration of evidence for Six Kannon images in Kyushu. As the Six Kannon have a variety of individual fortes, it stands to reason that as a group they would not merely serve a single purpose. Their well-known efficacy in

helping beings navigate the six paths was important in stone imagery, such as the Kongōji memorial for Keijirō in Kirishima City and perhaps the sixteenth-century Ōsumi Kokubunji monument.[201] We should also recall that the Six Kannon in the Dō no sako cliff carvings in Kunisaki were carved alongside Enma and his assistant to help donors avoid the unhappy judgment of rebirth into an evil path.

A recurring theme that emerged within Six Kannon belief was the focus on prayers for animal health, well-being, and fertility. The Toyouke Shrine at Six Kannon Lake has an emphasis on aid for animals, and the tradition continues in the Horse-Headed Kannon festival and livestock fair in Makizono. In the Kuma district, emphasis on prayers for the safe birth of cows and horses emerged through the rites for safe human birth, which resurged again later and are still practiced at Shingūji. The Six Kannon may also have been enlisted to help appease the ghost of the angry cat when the Fumonji images were located at Shōzenin (Nekodera).

The relationship between the Six Kannon and the Six Gongen undeniably had a powerful impact on Kyushu's related shrines and temples. I began with the assumption that the Six Kannon cult in Kyushu revolved around the powerful story of the tenth-century monk Shōkū's carving of Six Kannon images, which came to be the namesake for Six Kannon Lake in the Kirishima Mountains. If we only consider the legend in terms of extant documentation, the story of Six Kannon Lake does not appear in writing until the nineteenth century. Nevertheless, though apocryphal, the legend of the story of Shōkū's life in Kirishima is found in the fourteenth-century Buddhist history *Genkō shakusho*. From the references discussed in Chapter One, it is clear that Six Kannon images existed in Japan in the tenth century, which at least coincides with the temporal setting for Shōkū's story. In the Edo period, while the Six Gongen shrines in the Kirishima Mountains became increasingly powerful, they exploited their Buddhist affiliation with Six Kannon before *gongen* went out of favor. The fact that the mid-seventeenth-century Six Kannon images at Fumonji were matched with the Six Gongen of Ichifusa—who are said to be the same as those on Kirishima—is evidence that predates the written narratives of the Kirishima Buddhist avatars. Stories of the Six Kannon are part of a legendary fabric woven over the course of centuries.

Returning to the earliest dated extant set of Six Kannon images at Chōanji from 1141, the likely motivation for the selection of this imagery was the belief in the Six Kannon's efficacy in helping negotiate the six paths. Yet by considering the surrounding geography, we find the related phenomenon of Six Gongen thrived. Images of the Six Kannon could be matched with the Six Gongen in Rokusho shrines, as the Chōanji sutra box and the legacy of

the Hōmeiji Six Kannon demonstrate. Documentary evidence confirms that there were many active Six Gongen shrines in the area in the thirteenth century. The description of the thirteenth-century mirrors from Yamaku-chi Shrine reveals explicit matching of the Six Kannon with Six Gongen, which in this case aligned with the family of Emperor Tenji. The strategy of matching Buddhist Six Kannon to make their elusive kami counterparts vis-ible and tangible was a driving force in the religion of Kyushu.

CHAPTER THREE

Traveling Sets and Ritual Performance

BUDDHIST ICONS ARE OFTEN IDENTIFIED closely with the specific place where they are housed, yet we find that they are not always fixed permanently in a single location and can travel. This chapter will track two significant sets of Six Kannon images made during the thirteenth and fourteenth centuries that are now protected in fireproof concrete storehouses at their respective sites. Following the path of the Daihōonji images as they moved from one location to another contrasts with the Tōmyōji images, which have largely stayed in place even as parts of their temple home moved away piece by piece. In addition to their movements, through their inscriptions, related documents, and environments, these two sets provide an opportunity to see how images respond to the changing circumstances of location, patronage, schools of Buddhism, ritual practice, and even identity reassignment.

HISTORY OF DAIHŌONJI AND ITS ICONS

Although relatively unfamiliar to scholars, students, and tourists, the Kyoto temple of Daihōonji houses a complete set of superlative life-size wooden sculptures of Six Kannon from the thirteenth century (Plate 7), which serves as the strongest extant visual evidence of the Six Kannon cult. Moreover, its main hall is the oldest surviving wooden building in Kyoto (Fig. 3.1).[1] Senbon Street is one of the main thoroughfares running north–south on the west side of the city, and although the temple is close to this busy street, it is surrounded by homes in a densely packed neighborhood.[2] While the formal name of this temple is Daihōonji, most people know it by its popular name, "Senbon Shakadō," which is taken from the location name and the main hall, or Shaka Hall that enshrines an image of Shaka Nyorai.[3] In the fourteenth century, the well-known author and monk Yoshida Kenkō (1282?–1350) describes going out at night to worship at the "Temple of Senbon" in his *Essays in Idleness*.[4]

Hantōkō (Part ceramic and straw), compiled circa the 1480s, contains the earliest narrative on Daihōonji history, which explains that the Tendai

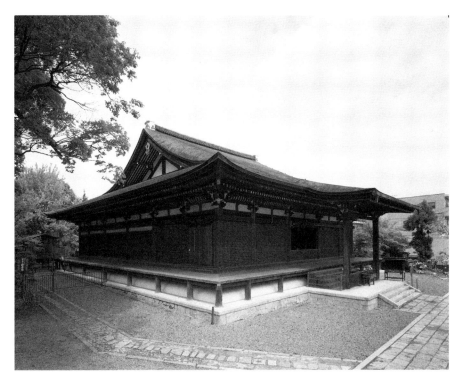

FIGURE 3.1. Main hall (Shakadō). 1227. Daihōonji, Kyoto.

prelate Gikū (grandson of Fujiwara no Hidehira [d. 1187]) established
Daihōonji in the Senbon area in 1221 (Jōkyū 3) and enshrined images of a
Buddha and the Ten Great Disciples in a small temporary hall. In 1223 (Jōō
2), Gikū commissioned the main hall, the completion of which was made
possible by an offering received from a lumber merchant in Amagasaki who
had a miraculous dream that convinced him to donate the needed wood.[5]

During the time of the 1951–1954 restoration of the Daihōonji main hall,
workers discovered an inscription on an interior ridge beam bearing the
date of 1227 (Antei 1) and Gikū's name, written as "Tendai Myōhokkeshū
Shakushi Gikū" (Buddhist Gikū of the Tendai Lotus School). The inscription
also states that there were images of Shaka, the Ten Great Disciples, Miroku,
and Monju in the hall.[6] The Shaka refers to the thirteenth-century image
of Shaka made by the sculptor Gyōkai (fl. early thirteenth century), which
is considered the main image of Daihōonji.[7] Today the Shaka is kept in a
closed tabernacle (*zushi*) inside the hall that is only opened a few times a
year. Unlike the Six Kannon, various records attest that this sculpture of
Shaka has been kept in the hall since the time it was built.

The temple belongs to the Shingon School today, but temple histories
claim that in 1235 (Katei 1), several years after its founding, Daihōonji was

considered a divine site from which to spread the Buddhist faith of three schools: Kusha, Tendai, and Shingon.[8] Although the founder (Gikū) was a Tendai monk and Edo-period records claim that the temple had previously been Tendai, when it became a subtemple of Chishakuin in 1619 (Genna 5), it officially registered as a Shingon School temple.[9]

Inscriptions found inside two of the cavities of the Six Kannon icons provide 1224 (Jōō 3) as a date, but no location for the images is given. A likely scenario is that the images were commissioned in 1223, at the same time as the Daihōonji main hall, and were finished in 1224, before the main hall was completed in 1227.[10] Thus the images were ready to be enshrined at the celebration for the completion of the hall.[11] The main icon of Shaka was finished before the main hall, installed in a temporary hall in either 1220 or 1221 (Jōkyū 1–2), and then moved to the main hall when the building was completed.[12] Although the Six Kannon were not acknowledged as central icons, evidence to support their presence in the main hall in 1227 is as follows: the date the Six Kannon were finished (1224) falls within the period of the main hall's commission and construction; like the hall, a Fujiwara patron sponsored the images; and the images were in known proximity to Daihōonji. If indeed the Six Kannon had been in the hall originally, they might have been placed to one side of the hall and not included within the hall's central altar arrangement.

Surprisingly, the earliest recorded location for the Six Kannon images is not at Daihōonji. According to the temple record *Rakuhoku Senbon Daihōonji engi* (Legends of Daihōonji in Senbon, north Kyoto), which dates from around the mid-eighteenth century, they were in a sutra hall on the grounds of nearby Kitano Shrine.[13] Since that hall was built in 1401 (Ōei 8), and therefore postdates the Six Kannon by almost two centuries, we must then consider why they would have been moved to this location.

Rakuhoku Senbon Daihōonji engi contains a section about the sutra hall, or Kyōōdō, also called Kitano Ganjōjuji, referring to a building that previously stood south of Kitano Shrine, about a ten-minute walk from Daihōonji.[14] The building, no longer extant, was originally built by Shōgun Ashikaga Yoshimitsu (1358–1408) because he was worried about the spirit of the former Daimyo Yamana Ujikiyo (1345–1392), who had opposed him when he attacked Kyoto in 1391 during the Meitoku uprising, also known as the Yamana rebellion. Ujikiyo died in battle in 1392 in the area of Uchino, the site of the former imperial palace, north of Kitano Shrine, and according to *Rakuhoku Senbon Daihōonji engi,* his head was buried in Uchino. A year after his death, a service that included the reading of *sutras* and a large offering to the hungry ghosts was held in Uchino, with a thousand monks participating. A few years later, in 1401, Ashikaga Yoshimitsu had the

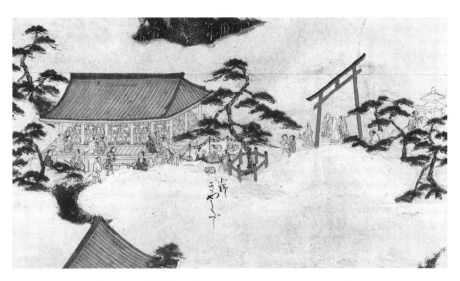

FIGURE 3.2. Detail of sutra hall from the Uesugi screens. By Kano Eitoku. Circa 1565. Panel: 160.0×364.0 cm. Uesugi Museum. Yonezawa City, Yamagata prefecture. Photograph courtesy of Matthew McKelway.

sutra hall finished at Kitano, where the service came to be held annually. *Rakuhoku Senbon Daihōonji engi* explains that the Six Kannon sculptures were enshrined in this building.

The relationship between the "Uchino sutra hall named Ganjōjuji" and Daihōonji is spelled out in *Daihōonji ryō shōen denbaku tō mokuroku* (Catalogue of Daihōonji's possessions of landed estates, rice fields, etc.), dated 1399 (Ōei 6) and written by the monk Fuson; it lists the sutra hall as one of Daihōonji's twenty holdings.[15] Since the date given in this record predates the construction of the hall at Kitano in 1401, the record may refer to a temporary hall or the proposed site of the building before it was finished. After that time the sutra hall must have functioned as a possession under Daihōonji's authority.

The former sutra hall was a popular site to include in painted scenes of Kyoto. The famous Uesugi screens, painted circa 1565 (Eiroku 8) by Kano Eitoku (1543–1590), show the the hall packed full of monks during the sutra-reading service that came to be known as the Manbukyōe, which is a reading of "all parts" (*manbu*) of the *Lotus sūtra* (Fig. 3.2).[16] Though we know from records that the former sutra hall was modified throughout history, one must question the accuracy of its depictions since the number of bays in the building differs from painting to painting.[17]

Because of the great cost involved in hosting an annual sutra reading for a thousand monks, when it was built in 1401 the hall may have turned to the nearby parent temple Daihōonji to borrow some ready-made icons

FIGURE 3.3. Sutra hall (Taishidō). Built 1951–1954 with wood from the earlier Kitano sutra hall. Daihōonji, Kyoto.

suitable to the mission of the sutra hall. Umezawa Akiko demonstrates that the number of monks participating in the Manbukyōe was tied to the finances and power of the Muromachi shogunate and that the service eventually became too much of a burden to support.[18] The sutra hall may have later suffered the same fate.

According to the section on the sutra hall in *Rakuhoku Senbon Daihōonji engi,* "After the Keichō era [1596–1615], in the Kanbun era [1661–1673] some sixty years ago . . . the great [sutra] hall (thirty bays long and twenty-five bays wide) fell into ruin and images of the Six Kannon and a Jizō were moved to the Kondō [fundamental hall] of the main temple. The altar was moved to Chishakuin."[19] The Kondō mentioned in *Rakuhoku Senbon Daihōonji engi* refers to the main hall of Daihōonji; it was the temple that had been in charge of the sutra hall since the fourteenth century and there is a ridgepole plaque inscription that confirms the Kannon were in the hall in 1670 (Kanbun 10).[20] Sculptures were not the only things to be moved. Even some of the wood and tiles from the old sutra hall were repurposed into the Daihōonji main hall, which was undergoing repairs at the time.[21] When the sutra hall could no longer function and became dilapidated, Daihōonji had the responsibility of finding a new home for the Six Kannon images and chose to enshrine them in their main hall.

A new sutra hall that was built in 1951–1954 now stands southwest of the main hall on the grounds of Daihōonji (Fig. 3.3). According to Ōmori Kenji, the new hall was constructed during the main hall's restoration from a mixture of wood from the old sutra hall and wood from the additions made to the main hall during and after the Edo period.[22] A stone marker dedicated to Yamana Ujikiyo, which dates from 1680 (Enpō 5) and was moved from Kitano Shrine, stands in front of the new sutra hall.[23] This monument

continues to memorialize the legacy of Ujikyo at Daihōonji (Fig. 3.4).

Inside the Daihōonji main hall, a series of four inscriptions on the *munafuda,* or ridgepole tablets, describe the repairs to the building and state that the Six Kannon were safely enshrined there beginning in 1670, and continuing in 1714, 1743, and 1897.[24] A photograph taken around 1951 shows them installed inside the hall, lined up inside cabinets, three on each side of the altar.[25] When the building was restored in 1951–1954, however, the restoration specialists removed the cabinets because they were not original and recycled them to construct the altar in the new sutra hall.[26] Except for trips to exhibitions, the images remained in the main

FIGURE 3.4. Marker dedicated to Yamana Ujikiyo (1345–1392). 1680. Stone. Daihōonji, Kyoto.

hall until they were deposited in a storehouse in 1966. The Six Kannon relocated again into a newer and safer storehouse next door in 1984.[27]

The Six Kannon Images of Daihōonji

As the sculptures from Daihōonji are such fine examples and are in excellent condition, they were used as models to discuss Six Kannon iconography in Chapter One (Figs. 1.1–1.5, 1.7, and Plates 1–4, 7–8). These elegant works were made in the tradition of *danzō,* or sandalwood images, which were unpainted so that the natural state of the wood could be appreciated. As sandalwood is scarce in Japan and generally not very large, substitute woods are used.[28] The Daihōonji Six Kannon have been judged to be made of *kaya* (*torreya nucifera*), or Japanese nutmeg, and were carved in a style, popular in the thirteenth century in Japan, said to borrow features from Chinese Song-dynasty (960–1279) images, such as the extremely tall topknots, elongated bodies, long fingernails, and elaborate, fluttering drapery with folds carved in high relief. The high degree of realism in these works is further exemplified by the eyes, which are made of inserted crystal (*gyokugan*) to give them an extra lifelike sparkle. The sculptures were all made by a technique using multiple blocks of wood (*yosegi zukuri*), which allowed for substantial interior cavities that could hold not only inscriptions, but also precious deposits, such as the texts of sutras and *dhāraṇī.*

Daihōonji Juntei

Within the group of Daihōonji images, the Juntei stands out with its more massive body, rounder face, and fuller cheeks (Fig. 1.5, Plate 8). The extra flourishes of hair wound around the diadem and the prominent bow tied in front of the skirt also differ from the others. Although the distinctive fluttering folds in the skirt are present in all six, they are more dramatic in the Juntei. Another significant feature of the Juntei sculpture is an ink inscription in the interior cavity: "This Juntei Kannon was made by the artist Higo Jōkei of *bettō* [supervisor] rank, Jōō 3 [1224], fifth month, fourth day."[29] (See Inscription 3.1 in the Appendix.)

Nishikawa Shinji was perhaps the first to propose that because the artist Higo Jōkei (1184–after 1256) wrote "*This* Juntei" in the inscription, he was making a distinction between this statue and the other images in the group. Several authors have closely examined the stylistic features of each image in the set and concluded that Jōkei made the Juntei but not the other images. The collaborative nature of sculpture studios makes it difficult to distinguish a personal style. Even if Higo Jōkei made only the Juntei image, the other statues were certainly made under his supervision, as his status as workshop supervisor (*bettō*) indicates.[30] Shiozawa Hiroki has shown that Jōkei's rank as a sculptor was later raised to higher levels.[31]

Higo Jōkei was a member of the well-respected Kei School of sculptors, but the few known details are complicated by the fact that there are at least two other sculptors named Jōkei who used the same characters for their names. Since he refers to himself by adding the name of the location Higo (in modern Kumamoto prefecture) in Kyushu, we can distinguish him from the Jōkei who made the thirteenth-century images for the East Golden Hall at Kōfukuji in Nara.[32] Aside from the Six Kannon, Higo Jōkei made at least eight other works. Among them the image of Bishamonten (Skt. Vaiśravaṇa), dated 1224 (Jōō 3), now owned by Tokyo Geijutsu Daigaku (Tokyo University of the Arts), and Shō Kannon, dated 1226 (Karoku 2), from Kuramadera in Kyoto, are the closest in date to those from Daihōonji. The Kuramadera Shō Kannon was made in the same elegant Song style as the Daihōonji images, but instead of *danzō* it was elaborately painted (Fig. 3.5).[33]

The origin of Jōkei's distinctive style of bodhisattvas has become a topic of recent scholarship. Art historians have long considered Song-dynasty Buddhist painting as the source for the elongated, fluid imagery with fluttering drapery in the so-called "Song style" (*sōfū*), of which Jōkei was a champion. Yamaguchi Ryūsuke and others have argued that there are other important sources for this style, such as the late works of the renowned sculptor Unkei (d. 1224), which have high topknots and similar

drapery.[34] Although it is beyond the scope of this chapter, there is a theory that Higo Jōkei was actually Unkei's second son Kōun (dates unknown).[35] Nevertheless, the character *kei* in his name declares an affiliation with the prominent Kei School of sculptors.

In order to include Higo as part of his name, Jōkei had a relationship of some kind to the area of Higo. Whether or not he lived in the area is unknown, but we do know the patron of the Daihōonji Six Kannon images did have ties to Higo. In Higo (Kumamoto prefecture, Kumagun, Yunomae), remaining in their original hall on the grounds of Myōdōji, is an Amida flanked by Kannon (Fig. 3.6) and Seishi, dated to 1229 (Kangi 1), which features the same thin Song-style bodhisattva images that scholars attribute to Jōkei.[36] Although no one claims that the Myōdōji images are actually by Jōkei, many acknowledge how close the style features are to Jōkei's work.[37] Jōkei's known works are found in Kyoto, Gifu, and Kamakura, demonstrating a wide sphere of patronage. Shiozawa Hiroki has shown the link between the Sagara clan, who controlled the area of Higo where the Myōdōji images are located, and the Bakufu in Kamakura, who patronized this style of image, as one ave-

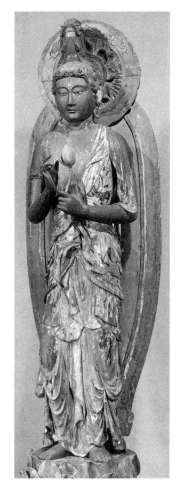

FIGURE 3.5. Shō Kannon. By Higo Jōkei. 1226. Wood. 176.7 cm. Kuramadera, Kyoto.

nue for the long reach of Jōkei's style.[38] The selection of a set of Six Kannon images as a commission to the Jōkei who has a link to Higo, reveals another geographic connection between the Six Kannon cult and Kyushu. Was it a coincidence that Higo is near the Kyushu locations of Six Kannon Lake and the two later sets of Six Kannon images from Shingūji and Fumonji (close to Myōdōji above) discussed in Chapter Two? Perhaps Higo Jōkei or his patron selected Six Kannon because of the Higo connection.

Functions of the Set: Six Kannon for Six Paths

Using the Daihōonji set as a model to investigate the cult of the Six Kannon, three significant themes related to the functions of these images emerge.

First of all, as described in Chinese records and later explained by Ningai and others in Japan, the most well-known function of the Six Kannon was to help beings navigate the six paths. The inscription mentioned earlier that was found on the postscript of the text titled *Batō nenju giki* (Ritual commentary on Horse-Headed Kannon recitations) that was inserted inside the Horse-Headed Kannon image states:

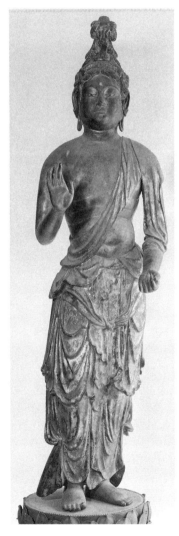

In 1224, fourth month, twenty-ninth day, the great patron Fujiwara no Mochihisa's daughter, of the great Fujiwara patrons, offered these sutras placed inside the Six Kannon [that she had] constructed and installed. These are for the benefit of various sentient beings in the dharma worlds to be led with excellence to the highest form of enlightenment. I write this expressing her whole-hearted sincerity. Written by the monk Myōzō. (Inscription 3.2)

Although the inscription does not say "six paths" explicitly, it may be implied from the phrase about guiding various sentient beings in the dharma paths to supreme enlightenment. While this inscription is rather general about who will benefit from the Six Kannon, the role of the Daihōonji images seems to have shifted to a more specific purpose in the fifteenth century when they were moved to the sutra hall. There the role of the Six Kannon was likely to ease the suffering of Ujikiyo and the spirits of the other victims of war to prevent them from becoming vengeful ghosts. The Kannon could save beings trapped in the six paths, and they could also protect the living from malevolent spirits and possibly ease the consciences of those who felt responsible for their deaths. Since the sutra hall was next to Kitano Shrine, it should bring to mind that this shrine was constructed

FIGURE 3.6. Kannon. 1229. Wood. 103.5 cm. Located in original hall on the grounds of Myōdōji, Kuma district, Kumamoto prefecture. Owned by Yunomae, Kuma district, Kumamoto prefecture. Photograph courtesy of Nara National Museum.

to honor Sugawara Michizane (845–903), who had been exiled from Kyoto for a suspected plot to dethrone the emperor. Twenty years after Michizane's death, his reputation was restored and the shrine was dedicated to him in order to appease his spirit. Nakano Genzō pointed out that *Kitano tenjin engi* (Illustrated legends of Kitano Shrine), from circa 1221 (Jōkyū 3), includes dramatic scenes of the six paths.[39] Since this important scroll was made just a few years before the Daihōonji Kannon, it demonstrates a timely localized concern to help potentially angry ghosts successfully navigate the six paths.

In Ujikiyo's case, *Meitokuki* (Record of the Meitoku era [1390–1394]) reports that a large service (offering to the hungry ghosts) with a thousand monks was held so that Ujikiyo—who formerly controlled Mutsu—as well as those who died in the war, the sentient beings of the six paths, the three worlds, and the 10,000 souls would all be able to attain salvation.[40] This service was first performed at a temporary hall in Uchino, but the sutra hall was built at Kitano Shrine nine years later to take over this function. While the statement in *Meitokuki* is meant to focus upon Ujikiyo, it also emphasizes that a goal for the service was to help those in the six paths. Once the Six Kannon images were installed in the sutra hall, they could join in the effort to save Ujikiyo and other unfortunate beings.

Textual evidence for the role that other Six Kannon image sets played in aiding in the six paths is plentiful. As discussed in Chapter One, the first recorded instance of the construction of Six Kannon images in Japan was in 910 when Sōō had images of Amida and the Six Kannon made in order to lead living beings on the six paths to salvation.[41] *A Tale of Flowering Fortunes,* from the late eleventh century, relates that the function of the Six Kannon images enshrined at Hōjōji in 1023 was to help beings navigate the six paths of transmigration. Each Kannon's role in assisting a specific path is clearly stated in *A Tale of Flowering Fortunes,* which can be traced to *Mohe zhiguan.* With a general purpose of helping all beings, Michinaga was the more direct concern for the Hōjōji images in the same way that Ujikiyo became the focus of the Six Kannon within the sutra hall.

Salvation for Women

Examining the records of the Daihōonji images and the literature about other sets, it becomes apparent that the Six Kannon cult was of particular interest to women, targeting their salvation as well as worldly benefits. A woman, Fujiwara no Mochihisa's daughter, was the main patron of the Daihōonji Six Kannon images, as stated on an inscription inside the Horse-Headed Kannon image and reiterated on a *dhāraṇī sūtra* that was inserted inside the Nyoirin image as follows:

This [text] was copied in 1224, fourth month, twenty-fifth day, for the patron, the former provincial governor of Higo Fujiwara no Mochihisa's daughter, of the great Fujiwara patrons. Written by Myōzō.[42] (Inscription 3.3)

The patron's father, Mochihisa, was the son of the military leader Fujiwara no Tokinaga (dates unknown) and the nephew of Saitō Tokiyori (dates unknown), who was a retainer to Taira no Shigemori (1138–1179). In 1221, Mochihisa was in temporary control of the area of Higo, which was part of present-day Kumamoto prefecture in Kyushu.[43] This may be the explanation for why the sculptor Higo Jōkei, who was named after the Higo area, was commissioned to make the sculptures.

When the Daihōonji main hall was restored in the 1950s, an inscription discovered on one of the original ceiling beams was found to bear the names, likely including the original patrons of the hall, of at least fifteen women, six of whom were nuns. Among the names of the women are daughters of the Ki, Minamoto, and Fujiwara families.[44] Was one of the two Fujiwara daughters in the inscription the same person who donated the Six Kannon? The apparent interest by Fujiwara women, as well as other women, in the construction of the Daihōonji main hall is another clue that strengthens the possibility that the Six Kannon sculptures were originally in the main hall.

To consider reasons why Mochihisa's daughter may have chosen to commission the Six Kannon images, or at least had them selected for her, there are several literary sources that reveal interest among women in the Six Kannon cult during the tenth through fifteenth centuries, such as Sei Shōnagon's inclusion of Six Kannon in *The Pillow Book,* written during the late tenth to early eleventh century. Many cases of Six Kannon image making discussed in Chapter One relate to women's patronage or as the motivation for the vow. For example, Empress Shōshi sponsored the making of Six Kannon images for a temple complex named Kannon'in, which until its destruction in 985 was located at the foot of Mount Hiei. More specifically related to women's interests, in the Heian period Six Kannon were important players in rituals to assist childbirth, which is of course of special concern to women. In addition to the classic fictionalized accounts in *The Tale of Heike* and *Taiheiki,* many instances of the sponsorship of Six Kannon images for aid in imperial childbirth are recorded in diaries and ritual manuals.[45]

Rituals for Six Kannon

Before continuing the discussion on the functions of Six Kannon, it is important to address the procedures of Six Kannon rituals. Section four of *Roku Kannon gōgyō* (the preceding section three was discussed in Chapter One) in the early thirteenth-century *Asabashō* gives a short description of the *dōjō* (practice place) for a Six Kannon rite, stating that there should be a flower vase in front of each of the Six Kannon sculptures and that the space should possess the appropriate ritual food, drink, and water offerings.[46] Following that, section five of the text gives information about ritual protocol; a basic outline follows.[47]

First, the opening rituals are performed with chanting and bowing. Then the name of Kannon is chanted in Sanskrit, followed by chanting the names of each of the Six Kannon in Sanskrit. (The sounds of the Sanskrit names are approximated through phonetic readings of Chinese characters.) Afterward, the particular vows made by the ritual's patron are initiated.

The next phase of the ritual is a contemplation of each of the six syllables, or *bonji,* for the Six Kannon. First the *bonji* appear one by one, sitting on top of a pure moon disc, and then they individually transform into different apposite symbols (attributes of the images) before transforming into the specific Kannon they represent. First, the *bonji* for Shō Kannon changes into a lotus, then, in sequence, the *bonji* for Thousand-Armed Kannon changes into an open lotus, the *bonji* for Horse-Headed changes into a white horse head, the *bonji* for Eleven-Headed Kannon changes into a vase, the *bonji* for Fukūkenjaku changes into a rope, and finally the *bonji* for Nyoirin changes into a jewel. Each one is contemplated as inside a moon disc with a lotus base, surrounded by the entourage of the lotus section. After a few more offerings are made, the next significant section is on the mudras. Monks carrying out the ritual have the option to perform just the mudra for Shō Kannon or they may perform the specific mudra for each Kannon. The positions of the fingers are described for each of the Six Kannon. Following the mudras, various offerings are made, such as the five offerings, universal offerings, praises, water, bell ringing, releasing the power of magic words, bowing, the respectful send-off, practices of the bodhisattvas, five repentances, and transfer of merit. Then the practitioner should get up from his or her seat, bow, and leave the hall. In the following section (number six), the *goma* or fire ritual offering, which must take place elsewhere, is briefly described.

Some of the components of the ritual appear to be fairly generic, but calling the names in Sanskrit and the contemplations of the individual *bonji* are specific to the Six Kannon. Key in the ritual is the close relationship between the Six Kannon and the six syllables, which transform into the Kannon

attributes before becoming the Kannon.[48] These are the same *bonji* written on the sides of the Chōanji sutra container discussed in Chapter Two.

Near the beginning, the text indicates when the vows should be initiated, but the purpose is unstated because it needs to be supplied for the specific occasion. Three other Six Kannon ritual texts from the thirteenth century are owned by the Tendai temple Shōren'in in Kyoto. Prince Sonjo (1217–1291), who was abbot of Shōren'in and son of Emperor Tsuchimikado (r. 1198–1210), wrote the one dated to 1236 (Katei 2). All three texts have missing and blurred parts, so if the motivations for the rituals had been included, they are not clear now.[49] A section of the Tendai compilation *Keiran shūyōshū* (A collection of leaves gathered from the stormy seas), called "Roku Kannon hōji" (Rites for Six Kannon) and dated to 1318 (Bunpō 2), is thick with description of the six types of Kannon individually, but relatively thin on the procedures used within the specific rites.[50] The Mount Hiei monk Kōshū (1276–1350) compiled this text based on notes about various traditions, which he organized into sections on each type of Kannon, with Thousand-Armed Kannon as the first and longest.

Two different fifteenth-century records called *Roku Kannon gōgyōki* (Record of the Six Kannon procedures) describe the details of specific events dedicated to Six Kannon. Each text explains how the ritual was carried out, how the altar was arranged, where the paintings of the Six Kannon were placed, which monks participated, and what they chanted. The names of the monks, locations, and the inclusion of Fukūkenjaku Kannon attest to the fact that both of these rituals were held in Kyoto and were affiliated with the Tendai School. These two rituals followed some of the same protocols as the *Asabashō* description, but instead of sculptures they used paintings for the icons.

For all the detail in both these records, again the goals for the services are not clearly stated. Could the purposes have been considered too personal or too obvious to write down? Just as in the Daihōonji set, the rituals have female patrons. *Roku Kannon gōgyōki* from Kyoto University (dated 1474 [Bunmei 6], eleventh month, twenty-sixth day) gives the main donor as "great female patron" [*nyodai seshu*].[51] *Roku Kannon gōgyōki* in *Monyōki* (dated 1474 [Bunmei 6], ninth month, twenty-first day) identifies its three patrons as a mother, father, and son.[52] Returning to the theme of women's interest in Six Kannon, like the many rituals performed for safe child delivery, the targets for these two rituals were also women and those close to them.

Text Connections

Beyond the roles of aiding women and restless spirits in the six paths, the Six Kannon also had a close relationship to Buddhist texts. As mentioned earlier, sacred texts were placed inside the cavities of each one of these

sculptures at the time of their construction. Buddhist images of the thirteenth century often had items installed inside them, but the relationships between the type of image and its contents are often not as closely linked as they are in the Daihōonji images.[53]

A detailed survey carried out in 1990 recorded that two to three Buddhist texts, many of which are *dhāraṇī sūtras* directly related to their specific Kannon host, were installed inside each one of the Daihōonji images.[54] If we recall the explanation in *Mohe zhiguan,* the Six Guanyin (Six Kannon) have an intimate relationship to text because they were considered manifestations of the Six-Syllable *dhāraṇī,* which has the power to destroy the obstacles to good karma. Since the Daihōonji images physically contain written *dhāraṇī,* vestiges of the concept of them *as dhāraṇī* carried over into their later relationships to text in Japan.[55] The detailed contemplation of the six syllables transforming into the Six Kannon just described in ritual is evidence of the unseen dimensions of the text–image relationship at work in the Six Kannon.

During the fifteenth through seventeenth centuries, when the Six Kannon set was enshrined at the sutra hall, the group likely performed another function, namely to protect the dharma text in a broad sense. The very name of the building as a sutra hall proclaims its purpose. After this building fell into disrepair and the Six Kannon were moved, the sutra hall was rebuilt and the old Six Kannon group was replaced by a new set of images with a stronger dharma-protection role.[56] The gazetteer *Miyako meisho zue* (Famous views of the capital) from 1780 (An'ei 9) states that the main images in the sutra hall were two Buddhas: Shaka and Tahō (Skt. Prabūtaratna).[57] The very presence of these two together signifies the *Lotus sūtra* since they vowed to appear whenever this sutra was preached. Itō Shirō proposed that two fifteenth-century Buddha sculptures closely resembling each other, now in the collection of Daihōonji, are the former main images of the sutra hall that remained on the grounds of Kitano Shrine until it became defunct in 1870.[58] At that time laws enacted to separate Buddhist temples from Shinto shrines forced Kitano Shrine to send the sutra hall's property to Daihōonji.[59]

The sutra hall's precious entire canon of sutras (*issaikyō*) made in 1412 (Ōei 19) was also sent to Daihōonji around 1870.[60] A pre-1960s diagram of the Daihōonji main hall interior shows the Six Kannon, with three on each side of the altar, east of a chamber for the *issaikyō.* Once again the Six Kannon seemed to protect the sutras. Today the Six Kannon images are again near the sutras in Daihōonji's storehouse.

If we search beyond the Daihōonji set to consider the Six Kannon's strong connections with texts, we can find evidence of other images and documents related to the cult that have the role of dharma protection. At the Hōjōji Medicine Buddha Hall, built in 1023, all the verses from the *Lotus*

sūtra's Kannon Chapter were written on the pillar in front of the Six Kannon images, where they visibly reinforced the power of the Kannon from the outside, in contrast to the way the Chōanji images from 1141 protected the contents of their sutra container or the way the written dharma vivified the interiors of the images in the Daihōonji Six Kannon. The association of the Six Kannon with texts was strongest when they were thought of as manifestations of the six syllables and *dhāraṇī*.

Movements of the Daihōonji Kannon

To investigate the functions of the Six Kannon images in Japan, we tracked the movements and changing religious functions of the Daihōonji sculptures, aspects about images that traditionally were overlooked in art-historical scholarship. A consideration of how religious images "live" and how their circumstances change over time is crucial to understanding the roles Buddhist icons play over time. As Richard Davis has observed with regard to Hindu images, it is important to overcome the temptation to limit inquiry to the origins of images and to expand it to consider how they can move and gain new and layered functions.[61] In the preceding, three different themes emerge related to the functions of the Six Kannon in reference to the Daihōonji images—specifically, the role of assisting beings in the six paths, associations with women, and relationships to texts. These themes will continue to surface in regard to our next example, as well as other Kannon image groups in the pages that follow. In 2007 the Daihōonji Juntei Kannon traveled to Museum Rietberg in Zürich for a substantial exhibition on Kannon images.[62] Standing at the entrance to the exhibition, Juntei brought along her history, but also took on a new role as a cultural ambassador for Japan.

SIX KANNON AT TŌMYŌJI AND THE DEVOLUTION OF A TEMPLE

In the rural region of Kamo, in southwestern Kyoto prefecture, five images of Kannon made in the fourteenth century can be found arranged inside a storehouse at the site of Tōmyōji (Fig. 3.7).[63] The building was once surrounded by farmland and untended fields, but new houses and other buildings now encroach upon the area, which is east of the Kizu River, about a fifteen-minute walk from the small Kamo train station. En route from the station a few small, infrequent signs point the way to the stone steps leading to Goryō Jinja. While this shrine, which shares the grounds with the Tōmyōji site, is still active, Tōmyōji no longer functions as a temple.

FIGURE 3.7. Five Kannon inside the storehouse at the former location of Tōmyōji. Kamo, Kyoto prefecture. From left to right: Horse-Headed Kannon, "Nyoirin" Kannon, Thousand-Armed Kannon, Eleven-Headed Kannon, Shō Kannon. Ippan Zaidanhōjin Kawai Kyōto Bukkyō Bijutsu Zaidan.

Because the majority of Tōmyōji's main buildings have been torn down or moved elsewhere, a storehouse built in 1985 serves as an archive to offer a glimpse into the former life and worship of the temple. Inside the storehouse five Kannon sculptures, which I argue made up a set of six in the past, are prominently lined up across an altar-like stage. Only open once a year or by special permission, the building displays to the public photographs, models, and items originally belonging to the temple.

Although the once-active phenomenon of the Six Kannon cult is difficult to trace, since many of the sets of Six Kannon have dispersed, in the case of the five Tōmyōji sculptures a journey through the devolution of the temple and trail of additions and subtractions to the set reveal the adaptable nature of the Six Kannon.[64] Unlike the investigations of the Daihōonji Kannon that were moved from their home (and other images that are relocated to a museum), in this case it is the images that have remained and the temple buildings and the majority of the material culture that defined the context for the site that have moved away.

Pilgrimage records claim that the temple's main image (*honzon*) belonged to a group of Six Kannon at Tōmyōji in 1713, 1756, and again in 1835 and 1836.

The Kannon images at the former Tōmyōji site correspond to five out of a group of Six Kannon. Since other records from the seventeenth and eighteenth centuries claim that there were five, there is a discrepancy as to when or if they were ever a fully realized group of Six Kannon. How can we conceive of these images as a group of six with one missing? In spite of the fact that the Tōmyōji Kannon set has experienced reconfigurations, changes in identity, and the removal of almost every piece of evidence around it, I will demonstrate how the images connect to the Six Kannon cult.

The Five Kannon Images of Tōmyōji

During a repair and restoration of the five Kannon images that was carried out during 1974–1976, pieces of paper filled with inscriptions, which include the date of 1308 (Tokuji 3), first month, eleventh day, were discovered inside one of the images. Tanaka Junichirō, who analyzed the statue's interior documents, counted a total of 624 patron names in about seventy groups, and because the papers have damaged and illegible sections, there were likely even more people involved. The practice is called *hōkakechien kyōmyō* (offering of names to establish a connection), where people can associate their names with a Buddhist deity to form a bond or karmic connection for either future salvation or this-worldly benefit. From the names listed it is clear that many of the supporters were monks, and a significant number of others were nuns and laywomen. The temple traditionally dubbed this statue that held the inscriptions as "Nyoirin," but I will argue subsequently that it was in fact Fukūkenjaku Kannon (Fig. 3.8).[65] Although awkward, I will use the "Nyoirin" designation, until I explain why Fukūkenjaku is more appropriate, because it acknowledges the image's identity change.

The Tōmyōji "Nyoirin" image is mostly unpainted, with chisel marks visible on the surface, and should be considered as a *danzō* image, but unlike the Daihōonji Kannon images, its surface is much less finished. Appropriately for an image in the *danzō* tradition, it had color on the hair, eyes, and lips. Recent repainting is apparent. The sculpture has a tall topknot, fairly full face, short neck, and broad body with sloping shoulders. The drapery is relatively three-dimensional, and the end of the skirt falls down between the legs and covers the tops of the feet. These stylistic features of the body and drapery are consistent with the date of the early fourteenth-century inscription.[66] This image is quite close in style, construction, and size to the Tōmyōji Eleven-Headed Kannon image (Fig. 3.9), so it is likely that they were constructed to match around the same time. Two other images in the group, Horse-Headed (Fig. 3.10) and Shō (Fig. 3.11), seem to form a second pair as they resemble each other in style and in size, both approximately 110 centimeters, in comparison to the taller, approximately 180 centimeters, first two. All four images appear

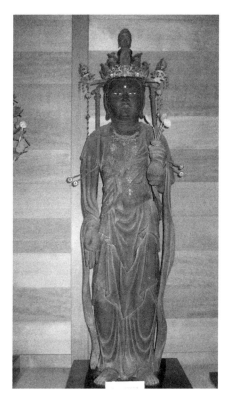

FIGURE 3.8. "Nyoirin" Kannon (Fukūkenjaku Kannon). 1308. Wood. 180 cm. Former Tōmyōji site, Kamo in Kyoto prefecture. Ippan Zaidanhōjin Kawai Kyōto Bukkyō Bijutsu Zaidan.

FIGURE 3.9. Eleven-Headed Kannon. Fourteenth century. Wood. 182 cm. Former Tōmyōji site, Kamo in Kyoto prefecture. Ippan Zaidanhōjin Kawai Kyōto Bukkyō Bijutsu Zaidan.

to have been made about the same time and have a general family likeness, but the smaller Horse-Headed and Shō are slightly more delicately carved than the two larger images. In regard to style, the figures' tall topknots, relatively slender frames, and three-dimensional carving of the drapery also display the Song style, but these are more modestly carved than those made by Higo Jōkei or in his style. Although the sculptors of the Tōmyōji images worked in the fourteenth century, the slightly rough carving of their unpainted surfaces resembles the work made by the later group of Nara sculptors called Shukuin Busshi, discussed in Chapter Two, who did not start working until the fifteenth century.[67] Indeed, before the inscriptions were discovered, the Tōmyōji images were considered Muromachi-period (1333–1573) works.[68]

Returning to the cache of inscriptions, at least five of the statements have the phrase "ichinichi zō" (one-day construction) or "ichinichi butsu" (one-day Buddha) and two more include the specific date of 1308 (Tokuji 3), first month, eleventh day.[69] Oku Takeo investigated the seemingly implausible

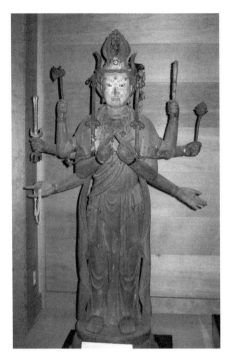

FIGURE 3.10. Horse-Headed Kannon. Fourteenth century. Wood. 111 cm. Former Tōmyōji site, Kamo in Kyoto prefecture. Ippan Zaidanhōjin Kawai Kyōto Bukkyō Bijutsu Zaidan.

FIGURE 3.11. Shō Kannon. Fourteenth century. Wood. 109 cm. Former Tōmyōji site, Kamo in Kyoto prefecture. Ippan Zaidanhōjin Kawai Kyōto Bukkyō Bijutsu Zaidan.

concept of "ichinichi zōritsu butsu" (Buddha constructed in one day) to argue that the Tōmyōji Fukūkenjaku ("Nyoirin") image really was made in one day, from the time the wood for the image (*misogi*) was selected until it was consecrated with an eye-opening ceremony. Oku argues that the rough finish and relatively simple features of the Tōmyōji Fukūkenjaku make it an exemplar of the "One-Day Buddha" type. This practice seems to have been based on the legend of King Udayana's miraculous portrait of the Buddha that was made in one day and is referred to in eleventh- and twelfth-century diaries.[70] As confirmation of the practice, *Asabashō* has a section on how to abbreviate the rituals for image making when it is necessary to finish them in one day.[71] Other shortcuts were likely taken to conform to the concept, but whether they were actually completed in one day is a subject for debate elsewhere. Nevertheless, patrons of the Tōmyōji image showed their commitment to a "One-Day Buddha" plan because the phrase appears in five of the petitions that were inside the image.[72]

An important early source for Tōmyōji sculpture history is found in *Tōmyōji engi* (Origins of Tōmyōji), written in 1696 (Genroku 9) by the monk Nissei.[73] At the end of the document is the following passage:

FIVE KANNON IMAGES

The central image of Thousand-Armed Kannon was made by Saint Shingyō. One figure each of Eleven-Headed, Horse-Headed, Nyoirin, and Shō were said to have been made by the Kasuga sculptors.[74] (Inscription 3.4)

The four images in *Tōmyōji engi* must refer to the four Kannon images just mentioned. In addition to these four, center stage in the Tōmyōji storehouse today is a Thousand-Armed Kannon that looks quite different from the others. Since neither five nor four is a usual grouping for Kannon images, and other records refer to them as a set of six, we must consider that even though they are not a perfectly matched group like that of Daihōonji, they likely made up, or were once intended to make up, part of a set of Six Kannon.

A challenge to the consideration of these images as a unit is that a group of Six Kannon images at a single temple made in different sizes is rare.[75] Since Tōmyōji had more limited means than a place like Daihōonji, with its support by a Fujiwara patron, a possible explanation is that economic factors were considered in the timing of the construction, and the subsequent images were made on a smaller scale. Another possibility is that the remaining two, including the present Thousand-Armed Kannon, may have been brought in from elsewhere. Perhaps a different Nyoirin Kannon image than the one so called in the current group formed a third stylistic pair with the Thousand-Armed Kannon.

The Thousand-Armed Kannon image is close to the same size (172 cm) as the images of "Nyoirin" (180 cm) and Eleven-Headed Kannon (182 cm); however, it differs greatly from the unpainted images since the surface was covered by a layer of lacquer that was in turn covered in a layer of gold leaf, now wearing thin (Fig. 3.12).

FIGURE 3.12. Thousand-Armed Kannon. Fourteenth century. Wood covered with lacquer and gold. 172 cm. Former Tōmyōji site, Kamo in Kyoto prefecture. Ippan Zaidanhōjin Kawai Kyōto Bukkyō Bijutsu Zaidan.

The head is relatively small and has crystal eyes.[76] The lower half of the body seems to swell out in comparison to the upper body, which was made narrower to compensate for the span of the forty-two arms. Though the image itself is shorter in comparison to the two larger Kannon images, with its attached lotus-petal base, this one looks the most substantial. Its stylistic features are in keeping with the fourteenth century, placing its date of production around the same general time frame as the 1308 inscriptions.

One of the inscriptions inside the 1308 "Nyoirin" image mentions a Thousand-Armed Kannon constructed in one day.[77] Were the donors mistaken about the identity of the image? Or does this refer to the Thousand-Armed Kannon image now in the hall? Since the Thousand-Armed Kannon looks different from the others and obviously had a very complicated construction, it does not appear to be a "one-day image." However, this inscription points to the possibility that the patronage may have extended beyond this image to Six Kannon, or at least to the Eleven-Headed Kannon image that so closely resembles the "Nyoirin."[78]

As *Tōmyōji engi* attests, the Thousand-Armed Kannon came to be known as the main image at the temple before the end of the seventeenth century.[79] *Tōmyōji jūmotsuchō* (Treasures of Tōmyōji) from 1779 (An'ei 8) also describes it as the main image.[80] The status of the image is also suggested in a temple record called *Engi kazaritsuke furetsu hei kaichō chū shoki* (Records on the origins of the adornment and display) from 1810 (Bunka 7), which states that the main image of Thousand-Armed Kannon was displayed once every thirty-three years along with temple treasures.[81]

Six Kannon at Tōmyōji on a Thirty-Three Kannon Pilgrimage Route

Tōmyōji is the third stop along the route of the thirty-three sites of the Kannon pilgrimage of the Minamiyamashiro area in southern Kyoto prefecture.[82] In the Jōkyō era (1684–1688), the monk Johan, who resided at Kaijūsenji, organized his temple, Tōmyōji, and neighboring temples into a pilgrimage route with thirty-three stops based on the famous Kannon pilgrimage routes of Saikoku, Bandō, and Chichibu, which will be discussed in Chapter Six.

The earliest known record of this pilgrimage is *Minamiyamashiro sanjūsansho junrei* (Minamiyamashiro Thirty-Three Kannon pilgrimage route), written by Johan in 1713 (Shōtoku 3) in commemoration of the five-hundredth anniversary of the death of the renowned monk Jōkei (1155–1213), a devout follower of Kannon who lived at Kaijūsenji.[83] Johan began each entry for

all thirty-three temples with the number, location, sectarian affiliation, temple name, and name and size of its main image and finished the entry with a poem. For the Tōmyōji heading Johan wrote, "Number Three, Kamo, Nichiren School, Tōmyōji, Thousand-Armed, or Six Kannon, six *shaku*."[84]

After a period of decline in interest, in 1835 (Tenpō 6) a local religious association made efforts to revive the pilgrimage set up by Johan. The group, called Ide Tamamizu no Tachibana kō (Tachibana confraternity of the Ide and Tamamizu areas), slightly revised Johan's short passage and accompanying poem about each temple to create a new record of *Minamiyamashiro sanjūsansho junrei.* The following year the group made a wooden plaque for each temple along the route with corresponding passages and poems.[85] The passage and poem for Tōmyōji are as follows:

Kamo, Number Three, Tōmyōji.
The main image of the Six Kannon measures six *shaku.*
From here it is eight *chō* to Jōnenji.[86]

In the garden of the temple
shining in the east [Tōmyōji],
dewdrops on leaves of grass
have been scattered like jewels
by gusts of autumn wind.[87] (Inscription 3.5)

These pilgrimage records claim that the main image belongs to the "Six Kannon" at the temple. In 1713 Johan acknowledged that the Thousand-Armed Kannon was part of a Six Kannon group. Then his entire text was copied in a Kaijūsenji record in 1756 (Hōreki 6), and after that a later statement about the Six Kannon appears in the revised 1835 pilgrimage record, which was then copied onto the plaque in 1836. Since the earlier *Tōmyōji engi* from 1696 and *Tōmyōji jūmotsuchō* from 1779 only describe five Kannon, an additional Kannon might have been in the building for a time and then later left the site. Did Johan actually see an additional Kannon image in the early eighteenth century? Even if there had been only five in 1713, Johan, seemingly untroubled by a mismatched group of Kannon images, may have thought there should be six because he was aware of the significance of the Six Kannon as a cult. At the very least his statement and those that followed demonstrate the cult was so significant that the authors expected to see a group of Six Kannon.

History of Tōmyōji

Archaeological evidence unearthed around the Tōmyōji site indicates settlements were there from the fourth through eighth centuries.[88] With several gaps, temple records and other published sources offer a general idea about the dramatic shifts in sectarian allegiance during its history.[89] *Tōmyōji kakochō* (Tōmyōji death register) from 1695 (Genroku 8), proclaims that the semilegendary figure Gyōki founded the temple under the name Kannonji (Temple of Kannon) in 784 (Enryaku 3), indicating a long purported association with Kannon. Then in 863 (Jōgan 5) Shingyō, a disciple of the Shingon master Kūkai (774–835), revived the temple.[90] More reliably, the oldest known reference to use the name Tōmyōji is in a sutra dedication from 1225 (Karoku 1), proving that the temple was in existence by that time.[91] Roof tiles, a stone pagoda, and an impressive stone lantern provide evidence of fourteenth-century activity at the temple.[92]

Tōmyōji is listed as a Kōfukuji subtemple with five halls in the record *Kōfukuji kanmuchōso* (Kōfukuji official comments) from 1441 (Kakitsu 1).[93] According to *Tōmyōji engi* from 1696, the Enryakuji monk Ninzen reestablished Tōmyōji as a Tendai School temple in 1457 (Kōshō 3).[94] The pagoda and main hall (*hondō*) were built during this period. Many clay roof tiles from this time stamped with the characters "Tōmyōji" (Eastern-Light-Temple) were discovered at the site. Then in 1663 (Kanbun 3), when the monk Nichiben from Honkokuji in Yamashiro took over as head, Tōmyōji became a Nichiren School temple.[95] North of the temple in a small cemetery, Nichiben's gravestone stands along with those of members of the powerful Tōdō clan who controlled the area in the seventeenth century.[96] In 1688 (Jōkyō 5) the third head, Nisshin, led the campaign to finance Tōmyōji's large bronze bell (*bonshō*), which remains at the site.[97]

Nissei, who wrote *Tōmyōji engi*, took over the temple in 1695 as the fourth in a continuous lineage of twenty Nichiren School monks in which Nichiben, who became head in 1663, was the first and Nikkan (or Nichikan), who passed away in 1889, was the last.[98] In the eighteenth century, documents appear using alternate characters with the same pronunciation for the name Tōmyōji (from Tōmyōji = Eastern-Light-Temple to Tōmyōji = Lantern-Light-Temple), perhaps in an effort to dissolve the former association with the Shingon temple Saimyōji (Western-Light-Temple), which is not far to the west of Tōmyōji at the foot of Mount Ōno.[99] In *Tōmyōji engi* Nissei accentuated the temple's history of shifting sectarian identities, from Shingon to Tendai and then to Nichiren School. Shingyō, who was Kūkai's disciple, is cited as the reviver of the temple and also as the maker of the Thousand-Armed Kannon. Since Shingyō lived in the ninth century and

the Thousand-Armed Kannon was made in the fourteenth century, this bit of pious fabrication was meant to promote an illustrious history that connected to a Shingon past. In 1457, Ninzen reestablished Tōmyōji as a Tendai School temple.

Moving Buildings and Financial Difficulties for Tōmyōji

The landscape of Tōmyōji has been vastly altered over the centuries, but to consider where the Kannon sculptures had been located we can examine some of the actual structures, as well as illustrations, to gain a sense of the temple's layout at different times. The main building for neighboring Goryō Jinja, which continues to function as a shrine in its original location, was built in the fifteenth century. Also remaining on the site is the monk's living quarters (*kuri*), built in 1672 (Kanbun 12).[100] A printed book illustration from 1787 (Tenmei 7) shows four main structures—the main hall, pagoda, monk's quarters, and the shrine building, along with the lantern (Fig. 3.13).[101]

What happens to the buildings when a temple goes defunct? After the Nichiren School abbot Nikkan passed away in 1899, no one succeeded him

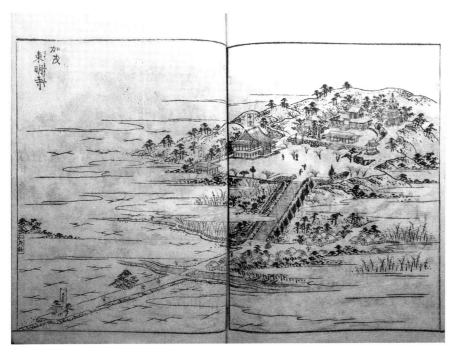

FIGURE 3.13. Kamo Tōmyōji. 1787. Woodblock-printed book pages. From *Shūi miyako meisho zue*. Height: 27 cm (DS897.K84 A663 1787). Courtesy of the Library of Congress, Asian Division, Japanese Collection.

FIGURE 3.14. Former Tōmyōji pagoda. Fifteenth century. Relocated to Sankeien Garden in Yokohama in 1914.

immediately. As with many Buddhist temples at the end of the nineteenth century, Tōmyōji had a difficult time financially. In 1901, a Yokohama man named Kawai Yoshijirō (1857–1939), who was in the trading business and also a Nichiren School monk, rescued Tōmyōji by assuming its considerable debt of about 16,000 yen.[102] Under the monk name Nichien, Kawai had previously established the temple of Sengōji in Yokohama. Tōmyōji became its subtemple.[103]

In 1914, perhaps to raise needed funds, Kawai sold the fifteenth-century pagoda to the silk industrialist Hara Tomitarō, also known as Hara Sankei (1868–1939), who had the pagoda reconstructed on a hill on his property in Yokohama (Fig. 3.14). In 1906 Hara opened to the public a garden he later named Sankeien. After surviving the 1923 earthquake and later bombing during the Pacific War, the pagoda now stands as one of the oldest structures in the Kanto region. Although he let go of the pagoda, in 1919 Kawai established a foundation to protect the objects from Tōmyōji, including the Kannon sculptures.[104] After Kawai Genmyō passed away in 1934, Tōmyōji was left without a head for many years. Throughout the 1930s the main hall remained in place but it badly needed repair. Then in 1948 the hall was severely damaged by a typhoon.[105] Kawai's foundation dissolved in the late 1940s.

In the aftermath of the Pacific War, restoration had to be postponed, and internal temple disputes about how to repair the main hall continued for decades. Even in its dilapidated state, in 1950 the building was declared a National Treasure under the old system and was later redesignated an Important Cultural Property. The temple was shut down in 1952.[106] In 1981 Ōzawa Genzui, who was the head of the temple at the time, proposed to donate the building to Sankeien Garden. The disputes were resolved when the pieces of the hall were moved to join the pagoda in Yokohama in 1982, and its rebuilding was completed in 1987.[107] Through the stewardship of Kawai's family, in 1989 a new foundation called Kawai Yoshijirō Kinen Kyoto Bukkyō Bijutsu Hozon Zaidan (Kawai Yoshijirō memorial Buddhist art preservation foundation) was created to honor Yoshijirō's wishes to care for Tōmyōji property and preserve other forms of Buddhist art.[108]

FIGURE 3.15. Former Tōmyōji main hall. Fifteenth century. Relocated to Sankeien Garden in Yokohama in 1987.

While the storehouse now stands on the site of the former main hall with the Kannon sculptures and other temple items, the main hall (Fig. 3.15), which no longer functions as a religious structure, stands at Sankeien with more than seventeen other historic buildings.[109] Since the park's structures are individually rented out for various occasions, such as weddings, performance art pieces, and concerts, the main hall is no longer a religious structure, but has acquired a new secular life.

The original construction of the main hall in the fifteenth century post-dates the inscription found in the "Nyoirin" Kannon by about 150 years, but the building was likely built with the accommodation of the Kannon sculptures in mind.[110] At Sankeien Garden the hall maintains a relationship to Kannon since it houses a replica of the Tōmyōji Eleven-Headed Kannon inside its reconstructed tabernacle.[111] The replica, which was made in 1988 by a company that specializes in making human anatomical parts for medical simulators, is so convincing that we have to wonder which image, the original or the replica, functions more like a Buddhist icon. Is it the original, which is locked away in the Tōmyōji storehouse and rarely seen, or the resin replica on public view inside a former Buddhist hall?

The Tōmyōji *zushi* (or tabernacle) made to house images was originally constructed as a three-bay structure, but in the Kan'en era (1748–1750) it was remodeled and one of the three bays was removed.[112] This structure was also badly damaged during the period of the main hall's neglect. When the main hall was moved in the 1980s, the *zushi* was also taken to Sankeien for installation in the hall. There it was carefully restored to its three-bay state to reflect its earlier size and style. The *zushi* may have been original to the hall, but even though the report on the reconstruction and relocation of the *zushi* to Yokohama is extremely detailed, the author only intimates that it was made in the fifteenth century.[113] An inventory of Tōmyōji property from 1883 has one entry for five Kannon images with heights that

approximately correspond to our images—three measuring five *shaku* (151.5 cm) and two measuring three *shaku* (90.9 cm), all inside a single *zushi*.[114] While this reference shows that the images had all fit together inside the *zushi*, this situation could not reflect their original presentation since they predate the *zushi*. Nevertheless, the replica of the Eleven-Headed Kannon standing inside the *zushi* functions as a link between the building, its icons, and their former existence at Tōmyōji.

A Case of Mistaken Identity

In considering how the Six Kannon might have functioned in Tōmyōji's changing sectarian environment, we should revisit the question of the identity of the "Nyoirin" Kannon image with the 1308 inscription. While four out of the five images listed in *Tōmyōji engi* are easily identifiable, the "Nyoirin" Kannon image, which contained the inscriptions, alone raises identification problems. This image has eight arms, two of which have hands placed together in front of the chest. Between the brows is a third eye placed vertically. In contrast, images of Nyoirin Kannon are usually seated, with six arms and two eyes, as in the one in the Daihōonji set. Although a few images of standing Nyoirin Kannon exist, examples of the deity with eight arms appear only in iconographic manuals.[115] Therefore, this was not originally an image of Nyoirin Kannon and the "Nyoirin" designation that appears in *Tōmyōji engi* is not appropriate.

The statue in question was instead made to be an image of Fukūkenjaku Kannon. Though it is damaged, one of the pages among those stored inside the image refers to the making of a "Fu—Kannon." After the character for "fu," the next three characters, undoubtedly "kū-ken-jaku," are blurred (especially the kū), but this is still a solid indication that the patrons considered it to be an image of Fukūkenjaku.[116] As is typical for this deity in Japan, the Tōmyōji figure has three eyes, eight arms, and one set of hands pressed together in front of the chest forming the mudra of prayer or adoration. Twelfth- and thirteenth-century iconographic texts explain that in groups of Six Kannon supported by the Tendai School, Fukūkenjaku replaces the Shingon School preference for Juntei Kannon, who usually has eighteen arms and only two eyes.[117]

The handheld attributes, as well as Fukūkenjaku's distinctive rope, were replaced long ago in the Tōmyōji image, so they cannot be used for identification. Yet as another particular indication of Fukūkenjaku, the Tōmyōji sculpture was intentionally made without the sash (*jōhaku*) that crosses in front of the chest, which most images of Kannon wear. Indeed, all the other Tōmyōji Kannon images have this sash. Asai Kazuharu suggests that the

Tōmyōji sculpture was one of several images made to match the form of the present Kōfukuji Nan'endō Fukūkenjaku image from 1189 (Bunji 5), which is without a sash.[118] Furthermore, like the Tōdaiji and Nan'endō images, another special feature of Fukūkenjaku is a deerskin worn over the shoulder. The earliest preserved description of Fukūkenjaku wearing a deerskin over one shoulder may be found in the text *Bukong juansuo zhou jing* (J. *Fukūkenjaku jukyō*), translated from Sanskrit into Chinese in the Sui dynasty (581–618).[119] The later Chinese text, *Foshuo chimingzang yujia dajiao zunna pusa daming chenjiu yiqui jing* (J. *Bussetsu jimyōzō yugadaikyō sonna bosatsu daimyōjoju gikikyō*), translated into Chinese before 1000, describes Fukūkenjaku's deerskin as a scarf.[120] As the deerskin attribute of Fukūkenjaku has a long history, Kōfukuji may have promoted this association because the deer was a symbol of the Fujiwara clan, who supported the temple and its partner shrine Kasuga.[121] Consequently, the wide, cape-like part of the scarf covering the shoulders of the Tōmyōji image was made to resemble a deerskin.

The image in question was originally Fukūkenjaku, but its identity was reassigned as Nyoirin by the time the 1696 *Tōmyōji engi* was written. Although Nissei, the author of the *engi,* was a Nichiren School monk, he was promoting a Shingon history for the temple by claiming Kūkai's disciple Shingyō as the reviver of the temple. Perhaps Nissei considered Nyoirin to be a more suitable identity for the image because sets of Six Kannon made for Shingon affiliations did not include Fukūkenjaku. It is also possible that Nissei simply took the Nyoirin attribution from an earlier source or that he did not know that Fukūkenjaku could be part of a set of Six Kannon, and assigned the name of Nyoirin to the image. Although we can find many descriptions in texts, extant examples of Fukūkenjaku images that are part of a Six Kannon set are rare. In comparison, Chapter One discussed the possibility that the Konkaikōmyōji Kannon image had once been in a Six Kannon set as a Fukūkenjaku image before having its identity changed through the more radical removal of extra arms (Fig. 1.8).

Tōmyōji's securely documented Tendai connections do not appear until 150 years after the images were made, when the Enryakuji monk Ninzen resurrected the temple in 1457, but there may have been earlier connections to Tendai. Moreover, though the previously mentioned temple record *Tōmyōji jūmotsuchō* from 1779 describes this image as Fukūkenjaku, the identity of Nyoirin as written in the *engi* took precedence and was preserved at the storehouse and in Tōmyōji literature.[122] Although its identity had already been questioned and essentially reassigned by me and others, until recently the designation as Nyoirin remained, perhaps out of deference to temple tradition. The 2012 publication by Oku Takeo and the foundation's current website reassert the image's identity as Fukūkenjaku without hesitation.[123]

Fukūkenjaku has a strong association with Kōfukuji. As early as the eighth century, Kōfukuji made special efforts to revere Fukūkenjaku, as the history of the extremely important worship site at the Kōfukuji Nan'endō shows.[124] Moreover, one page of the 1308 image's inscriptions states that "Bechie goshi" (special group of five masters) were among the sponsors of the Tōmyōji image's construction. The officials in this elite group were high-ranking Kōfukuji prelates whose main duty was to organize the large On Matsuri festival dedicated to the Kasuga deity for the Wakamiya Shrine at Kasuga.[125] Moreover, many of the other donors listed in the 1308 petition papers were from Kōfukuji subtemples.

The 1308 inscriptions list eight participating Kōfukuji subtemples, including Shion'in. Oku determined from one of the inscriptions, in spite of its damage, that the sculpture was actually made at Shion'in.[126] This subtemple, which is now defunct, was located west of Kōfukuji and east of Kasuga Shrine in Nara. Shion'in was built in 1215 (Kenpō 3), suffered a great fire in 1479 (Bunmei 11), and closed after it burned down again in the Meiwa era (1764–1772).[127] Given that it was closely connected to Kasuga Shrine throughout its history, perhaps Nissei's statement in *Tōmyōji engi* that the images were made by the Kasuga sculptors refers to Shion'in's relationship to Kasuga. Moreover, Tōmyōji itself had a significant relationship with Kōfukuji as a subtemple in 1441.[128]

After the Tōmyōji image was initially created as a Fukūkenjaku Kannon, there may have been a scheme to add five other Kannon images to form the concept of the Six Kannon that reflected Tendai, as well as Kōfukuji, interests at the temple. The framework of the One-Day Buddha concept points to a pattern of making images one by one under individual fundraising campaigns. The Eleven-Headed Kannon, which most resembles the Fukūkenjaku, was likely made closest in time. *Kōfukuji ryaku nendaiki* (An abridged chronicle of Kōfukuji), compiled in the eighteenth century based on earlier sources, mentions a life-size Eleven-Headed Kannon image that was made in one day during the fifth month of 1306 (Tokuji 1) for rain prayers.[129] It is possible that this refers to the Tōmyōji Eleven-Headed Kannon, which could have been made three years before the dated petitions found inside the Fukūkenjaku image. Obtaining necessary funding for the subsequent images of Shō and Horse-Headed might have become more difficult, which might account for their smaller sizes. The Thousand-Armed Kannon now with the group, along with a missing Nyoirin Kannon, may have made up a full set of Six Kannon. Finally, in the eighteenth and nineteenth centuries, did the monk-authors who recorded their pilgrimages see a now-lost sixth Kannon as they proclaimed? Although we cannot have the experience of actually seeing the images in their former main hall, with the aid of archival

and physical evidence available, we too can imagine a group of Six Kannon together again at Tōmyōji.

Two Tales of Survival

Through the twists of fate from fire, war, weather, and financial or political problems, many sets of Six Kannon are now only known in literature. The two groups of Six Kannon from Tōmyōji and Daihōonji tell different stories about how images adapt to achieve long-term survival. Tracing their movements through fragments of evidence, both physical and textual, reveals the complex networks that make up their changing histories. Once in the light, texts hidden inside their bodies offer clues about initial patronage to show the offering of names that establishes a significant bond between the donors and the deities. Reading those names provides strong evidence of women's patronage, from elite women to a large group-sponsored endeavor that included laywomen and nuns. Documentary evidence of sponsorship of other sets and rituals corroborates women's interest in the Six Kannon cult. Safe childbirth was a special focus of Six Kannon, but by no means the only concern. The Tōmyōji and Daihōonji images show how Six Kannon could meet various needs by having more than one function simultaneously, such as aiding with the six paths, appeasing angry ghosts, protecting the dharma, creating personal bonds, bolstering sectarian heritage, or as the focus of a pilgrimage.

The Six-Syllable Sutra Ritual Mandala and the Six Kannon

WITHIN THE STUDY OF SIX KANNON is the fascinating theme of the Six-Syllable sutra ritual (Rokujikyōhō), a Japanese esoteric Buddhist ritual performed to avert calamity and promote healing. The central focus of the ritual can be a painted mandala, which contains images of the Six Kannon surrounding a central Buddha image. Most sources refer to them as Rokujikyō mandara, or Rokujikyōhō mandara, and I will use the corresponding translation of Six-Syllable mandala. Beginning in the eleventh century, several manuals have described this mandala in use, but the earliest extant paintings of this type date from the thirteenth century. The six syllables are abbreviations for the Six Kannon: Shō, Thousand-Armed, Horse-Headed, Eleven-Headed, Juntei, and Nyoirin. Accordingly, the paintings may include Sanskrit seed syllables, or *shuji,* alongside images of the Six Kannon. The topic of this chapter is a departure from our study of the Six Kannon cult, as the Six Kannon images found in the Six-Syllable mandala are related to, but different in form from the more familiar Japanese esoteric identities favored by the Shingon and Tendai Schools that have been discussed thus far.

With an emphasis on the Six Kannon within the historical development and ritual context of the Six-Syllable mandala, the known paintings will be examined in a loose chronological framework. The related rituals and role the prelate Ono no Ningai took in the construction and promotion of this style of mandala will also be addressed. Although this important ritual has been studied, surprisingly, other than catalogue entries and short sections in books there have to date been no significant art-historical studies devoted to the extant paintings of the Six-Syllable mandala. Paintings of the Six Kannon in a group that align more closely with the images in previous chapters that are not in the Six-Syllable mandala format will be treated separately in Chapter Five.

The roots of the Six Kannon in the Six-Syllable mandala are found in the sixth-century Chinese text *Mohe zhiguan.* As discussed in Chapter One, in the eleventh century the esteemed prelate Ningai, founder of the Ono lin-

eage of Shingon, was credited with developing the equivalencies between the Chinese Guanyin listed in *Mohe zhiguan* and the Kannon images in Japan. Early commentaries on the Six Kannon in Japanese esoteric texts almost always cite Ningai, yet the textual descriptions do not reflect the usual esoteric forms of these Six Kannon with multiple heads and arms, either separately or as part of a group in paintings and sculpture. Since Ningai was an established Buddhist prelate with access to numerous Buddhist images, how should we account for these unusual choices? As we will see, the description of the older alternate Chinese Guanyin in *Ningai chūshinmon* matches the Kannon depicted in the Six-Syllable mandala. The translation of the relevant passage given in Chapter One and Table 4.1

TABLE 4.1 Comparing Six Kannon in *Ningai chūshinmon* with Japanese Esoteric Kannon

	SIX KANNON IN *NINGAI CHŪSHINMON*	JAPANESE ESOTERIC KANNON
1	大慈 Daiji (Great Mercy) Light blue body; left hand: holds a blue lotus; right hand: *semuiin* ("fear not" mudra)	聖 Shō (Noble) One head, two arms, often holds a lotus in one hand
2	大悲 Daihi (Great Compassion) Yellow-gold body; six heads, right hand: *semuiin;* left hand: holds a red lotus	千手 Senju (Thousand-Armed) Eleven heads, forty-two arms, holds numerous objects
3	師子無畏 Shishimui (Fearless Lion) Blue body; right hand: holds a lotus with a sutra box on top; left hand: *semuiin*	馬頭 Batō (Horse-Headed) One or three heads, four, six, or eight arms, often has red body, holds several objects
4	大光普照 Daikōfushō (Universal Light) Body color of human flesh; right hand: holds a red lotus, on top of which is a vase with a single-pronged *vajra*; left hand: *semuiin*	十一面 Jūichimen (Eleven-Headed) Eleven heads, two arms, often holds a lotus in one hand
5	天人丈夫 Tenninjōfu (Divine Hero) Dark blue body; right hand: holds a blue lotus; left hand: *semuiin*	准提 Juntei (Buddha Mother) One head, eighteen arms, holds numerous objects
6	大梵深遠 Daibonjin'on (Omnipotent Brahmā) White body; right hand: *semuiin*; left hand: holds a red lotus with a standing three-pronged *vajra* on top	如意輪 Nyoirin (Jewel-Holding) One head, six arms, sits with one knee raised, holds several objects

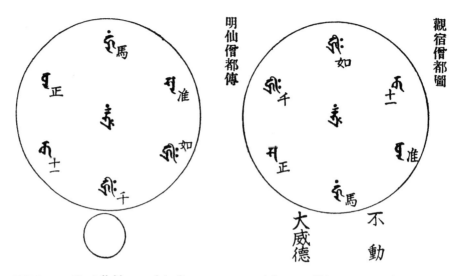

FIGURE 4.1. Six-Syllable mandala diagrams. Original from twelfth century. Left: Myōsen tradition. Right: Kanshuku tradition. From *Shoson yōshō, T* 78:296c.

provides a succinct comparison of the main identifying features of the Kannon in *Ningai chūshinmon* that were used in the Six-Syllable mandala with the usual features of the esoteric Six Kannon images.

In comparing just two pairs of matching manifestations in Table 4.1, (2) Daihi (Great Compassion) in the Six-Syllable mandala has only two arms and six heads in contrast to the esoteric form of Thousand-Armed Kannon with eleven heads and the typical abbreviated number of forty-two arms. Both manifestations save beings in the hungry ghost path. In contrast to Daibonjin'on (6), or Omnipotent Brahmā, who has two arms (the left holds a red lotus blossom with a vajra on top and the right makes the gesture of calming or "fear not," with the hand raised and palm held up flat), the equivalent is an esoteric Nyoirin Kannon that has six arms with various attributes and sits with one knee raised. The Kannon of the Six-Syllable mandala are always depicted together in a single painted or graphic image and never made in a series of individual paintings.

Iconographic manuals and ritual texts from the Heian and Kamakura periods describe the evolution of the Six-Syllable mandala, along with Ningai's role in its development in the following way. The two monks Myōsen and Kanshuku are responsible for two separate Six-Syllable mandala traditions. Myōsen (c. 788–868) was a monk from the Tendai lineage of Enchin (814–891). A diagram of the Myōsen tradition (left side of Fig. 4.1) shows that the mandala consists simply of Shaka Kinrin Buddha in the center surrounded by the Six Kannon (clockwise from the twelve o'clock position: Horse-Headed, Juntei, Nyoirin, Thousand-Armed, Eleven-Headed, and Shō)

and a plain circle below.[1] None of the known extant mandalas follow this form.

The monk Kanshuku (844–928), who was from the Shingon lineage of Daigoji, created the second tradition (right side of Fig. 4.1). Kanshuku's central arrangement is basically the same as Myōsen's, except that the order of the Kannon differs (clockwise from the twelve o'clock position are Nyoirin, Eleven-Headed, Juntei, Horse-Headed, Shō, and Thousand-Armed). Fudō Myōō (Skt. Acala) and Daiitoku Myōō (Skt. Yamāntaka) are below the large circle. Some of the manual illustrations have abbreviated notations for the deities that are represented by the first characters of their names and their Sanskrit seed syllables. Below is a moon disc or mirror perched on top of a rock base. Most iconographic manuals that discuss Six-Syllable mandala state that Ono no Ningai completed the main design of the mandala by embellishing the Kanshuku-style mandala.

Before continuing, I should note that "mandala" is a general term that developed in India as a Buddhist diagram with a geometric composition, used as a way to delimit a centered sacred area for ritual that is set apart from the mundane. In Japan the term *mandala*, transliterated as *mandara* in Japanese, is used fairly loosely for Buddhist paintings of different types that display deities in an organized system. The most famous type of mandalas in Japan are the extremely complex Mandalas of the Two Worlds, which work in tandem to present organized depictions focused on the Buddha Dainichi (Skt. Mahāvairocana). Mandalas such as these can be considered as sacred territories with a vast array of figures that express the relationships between various powers. Mandala studies categorize Six-Syllable mandalas as *besson mandara* (individual deity mandalas), because they were made to invoke specific deities for specific purposes.[2]

The fact that twelfth- and thirteenth-century iconographic compendia contain over thirty illustrated examples of Six-Syllable mandalas, which were in turn copied many times, makes it clear that many paintings used for this significant ritual must have existed in the past.[3] Although I have located only twelve examples of actual paintings, surely others will surface in the future. In addition to the paintings, two detailed drawings that were used as models will also be considered. Rather than introduce each extant mandala in strict chronological order, I will begin the discussion with a description of the lavish fourteenth-century color mandala from Sanbōin, Daigoji. Although it is not the earliest, the Sanbōin mandala is better preserved than the earlier examples, and its form was copied many times. Using the Sanbōin painting as a rubric, I will examine known examples of Six-Syllable mandalas that I have identified by types in rough chronological order. Table 4.2 provides an overview of the examples and

TABLE 4.2 Features of Extant Six-Syllable Mandala

LOCATION	CENTURY OR YEAR	KANNON ORDER AND FORMS	SHUJI	COLOR	JUSOJIN	FUDŌ/ DAIITOKU PLACEMENT
1. Kyoto National Museum (Plate 10)	Thirteenth	*Ningai chūshinmon* order, Eleven-Headed Kannon has eleven heads	No *shuji*	Color	No names	Seated water buffalo
2. Nara National Museum (Plate 11)	Thirteenth	*Ningai chūshinmon* order, Eleven-Headed Kannon has eleven heads	No *shuji*	Color	No names	Seated water buffalo
3. Daigoji Sanbōin (Plate 9)	Fourteenth	*Ningai chūshinmon* order	*Shuji*	Color	No names	Standing water buffalo
4. Daigoji Hōonin (Plate 12)	Fourteenth	*Ningai chūshinmon* order	*Shuji*	Blue and gold	Three have *bonji* names	Standing water buffalo
5. Yamato Bunkakan (Figure 4.3)	Fourteenth–fifteenth	*Ningai chūshinmon* order	No *shuji*	Color	No names	Seated water buffalo
6. Kangiji (Figure 4.4)	Fifteenth–sixteenth	*Ningai chūshinmon* order, Kannon on a pink lotus-flower background	No *shuji*	Color	No names	Geometric shapes, seated water buffalo
7. Rokujizōji (Figure 4.6)	Late sixteenth	Kanshuku order with esoteric images	*Shuji*	Color	No names, flying above the mirror	Geometric shapes, seated water buffalo
8. Hasedera	1660	*Ningai chūshinmon* order	*Shuji*	Blue and gold	Three have *bonji* names	Standing water buffalo
9. Hōkokuji	Seventeenth–eighteenth	*Ningai chūshinmon* order	No *shuji*, empty circles	Blue and gold	No names	Standing water buffalo
10. Kisshōin (Figure 4.7)	Late sixteenth–seventeenth	Kanshuku order with esoteric images	No *shuji*	Color	No names, standing on lotus-petal bases	Geometric shapes with positions reversed

Table 4.2 (continued)

LOCATION	CENTURY OR YEAR	KANNON ORDER AND FORMS	SHUJI	COLOR	JUSOJIN	FUDŌ/ DAIITOKU PLACEMENT
11. Uesugi Museum (Figure 4.8)	Eighteenth– nineteenth	Kanshuku order, Nyoirin has one knee raised and Eleven-headed Kannon has eleven heads	No shuji	Color	No names, flying beside the mirror	Standing water buffalo
12. Chōhōji (Figure 4.10)	1857	Ningai chūshinmon order	Shuji	Line drawing	Three have bonji names	Water buffalo about to stand
13. Chōhōji (Figure 4.9)	Nineteenth	Ningai chūshinmon order	Shuji	Line drawing	Three have bonji names	Water buffalo about to stand
14. MFA Boston (Plate 13)	Nineteenth	Ningai chūshinmon order	No shuji, empty circles	Color	No names	Standing water buffalo

their significant features. After introducing the mandalas and the rituals associated with them, I will return to a discussion of Ningai and his relationship to the paintings.

A Rubric for Six-Syllable Mandala: Sanbōin, Daigoji, Kyoto, Fourteenth Century

One of the most gorgeous and well-known examples of the Six-Syllable mandala is the fourteenth-century painting, which measures 127.4 × 83.6 centimeters, in the collection of the Daigoji subtemple Sanbōin in Kyoto (Plate 9).[4] Beginning at the top of the painting, there is a group of clouds flanked by two flying heavenly beings (devas) that wear flowing green scarves and hold bowls of offerings. Such lower-ranking beings who honor central figures are a fairly standard feature in Japanese Buddhist painting. Between them is a curling multicolored cloud, below which is a large white circle centered on Shaka Kinrin, or Śākyamuni of the Golden Wheel, who is wearing a red robe adorned with a pattern of gold flowers, holding one wheel in his lap and framed by seven other wheels, arranged within his double mandorla. Shaka Kinrin is a Buddha who symbolizes the supreme wisdom of the Historical Buddha and is one of the Kinrin Butchō deities (Golden Wheel Cranial Protrusion Deities) celebrated in Japanese esoteric Buddhism.[5] The wheel,

one of the most significant Buddhist symbols, represents the Buddhist law, or dharma, and the power of a universal ruler whose authority extends without boundaries.[6] Shaka Kinrin's wheel refers to his limitless power moving in all directions.

Surrounding the Buddha are images of the Six Kannon, each seated within a circle. Starting with the twelve o'clock position and moving clockwise, the Kannon are Eleven-Headed, Juntei, Nyoirin, Shō, Thousand-Armed, and Horse-Headed. This arrangement, which differs from those of Kanshuku and Myōsen, is found in numerous iconographic drawings included in manuals such as the twelfth-century manuals *Zuzōshō* (Collection of iconographic drawings) (Fig. 4.2) and *Besson zakki* (Miscellaneous record of classified sacred images).[7] If we begin at the three o'clock position and move clockwise, this order follows that found in *Ningai chūshinmon*.[8] Accordingly, I will refer to this as the *Ningai chūshinmon* order, which is most commonly used in Six-Syllable mandalas. However, because the body of each image in the Sanbōin mandala is a shade of cream or white, it does not follow the color descriptions in *Ningai chūshinmon*. The images' double halos, consisting of concentric bands of lively gradient color, are surrounded by flames and embellished by three groups of outer flames on each side that seem to leap off the edges. Between each pair of circles are smaller circles that contain abbreviated gold forms of Sanskrit syllables, or *shuji*, that refer to each of the Six Kannon represented. These are the "six syllables" from which the mandala takes its name.

In the lower area, centered below this concentration of deities, is a smaller white disc resting on a rock that rises above the water. This white disc has been described as a mirror that is so formidable when evil beasts see themselves reflected in it, the evil in their hearts naturally disappears.[9] This explanation demonstrates the idea of the mandala's power to repel harmful forces. The rock represents Mount Sumeru, which is the highest mountain in Buddhist cosmology, emerging from the center of the world. With legs submerged in the sea, six figures that look like heavenly beings wearing crowns and scarves make the gesture of adoration as they surround the rock. Texts about the mandala say these six unusual beings, who are specific to this mandala type, are a group of Jusojin, or magical spirits, who participate in the removal of curses and illnesses.[10] Their special role in the function of Six-Syllable mandala will be discussed later in the chapter.

In contrast to this benign-looking group of deities, two wrathful blue images with scowling faces and flaming halos, are shown protecting the lower corners of the painting. These two Myōō (Skt. Vidyārāja), who are kings of light and wisdom, are shown together in many other mandalas in this configuration to ward off enemies.[11] On the right, Fudō Myōō, which means the "unmovable one," is surrounded by flames while standing on his rock that

FIGURE 4.2. Six-Syllable mandala diagram. Original from twelfth century. From *Zuzōshō, TZ* 3:no. 21.

rises up from the sea, with his head slightly turned back toward the mirror. In his right hand he holds a sword to cut through all delusions, and in his left he holds a rope to bind enemies.

In the lower left of the Sanbōin painting is Daiitoku Myōō riding a water buffalo and surrounded by flames. He uses his six heads, six legs, and six arms to remove poisons, fight pain, and help subjugate enemies. Daiitoku's relationship to the number six makes him a particularly appropriate choice for the Six-Syllable mandala.[12] In two of his hands he holds a bow and arrow drawn and aimed toward the mirror. His other hands hold a baton, vajra sword, vajra pole, and a rope. Daiitoku's water buffalo is green with a red belly and two-toned horns. Since the water buffalo is usually seated, especially when he appears in the group of Five Myōō (Godai Myōō), his standing pose is a distinctive feature of this mandala.[13] As a reference, Daigoji has a tenth-century wooden sculpture of Daiitoku astride a standing water buffalo in a set of Five Myōō.[14]

Through stylistic and technical analysis, the Sanbōin painting is considered to date from the fourteenth century. A piece of its former mounting that bears an inscription describing its repair in 1410 (Ōei 17) is stored with the painting. Although the specific date the painting was produced is unknown, it likely would have been made at least a few decades before it needed repair, thus pushing its date of production back into the fourteenth century. Temple tradition asserts that the painting has been in the collection of the subtemple Sanbōin at Daigoji for generations. As temple records also indicate that Six-Syllable rituals were performed regularly at Daigoji during the fourteenth century, this may well have been the very painting used.[15]

Earliest Six-Syllable Mandalas from the Thirteenth Century

Kyoto National Museum owns one of the oldest extant Six-Syllable mandalas, measuring 72.1 × 39.0 centimeters, which is considered to date from the thirteenth century (Plate 10).[16] The background of the painting has faded to a soft, murky brown, and while some details are difficult to discern, it has a delicacy of line and color that can be observed at close range. A small, elegant canopy of hanging flowers appears in the top center. The two devas, with separated outstretched hands, fly downward toward the main circle. In comparison to the Sanbōin example, the circles surrounding the Six Kannon images more closely crowd into the center circle that contains Shaka Kinrin. There are no *shuji* in the painting, and the only wheel is the one found in Shaka Kinrin's lap. The lines of the circles appear to be made in *kirikane* (cut gold). Both Fudō and Daiitoku's water buffalo are seated. The water has disappeared for the most part, but the feet of the six Jusojin seem to be submerged. The Kannon are arranged as in the *Ningai chūshinmon,* yet a surprising difference between these paintings and the Sanbōin rubric is that the Kannon in the topmost (twelve o'clock) position, Daikōfusho (Avalokiteśvara of the Universally Shining Great Light; Ch. Daguan puzhao), whose equivalent is Eleven-Headed Kannon, actually has eleven heads as well as a small figure of an Amida Buddha in the crown. Later examples of this image in the Six-Syllable mandala do not have eleven heads unless all the Kannon are in esoteric form.

The other early Six-Syllable mandala considered to date from the thirteenth century is kept by the Nara National Museum (Plate 11).[17] This painting measures 79.7 × 38.6 centimeters and, like the Kyoto National Museum painting, is relatively small. Although the gold paint and cut gold are still vibrant, the background silk has changed to a darker brown and much of the pigment has worn away. Both these museum examples should be con-

sidered as the early form of the mandala, which is small in size and has delicate painted features with fewer details. Also characteristic of this early form are the lack of *shuji*, seated images of Fudō and Daiitoku Myōō's water buffalo, and most distinctively, the Eleven-Headed Kannon actually has eleven heads.

Blue and Gold Six-Syllable Mandalas

Daigoji, one of the most significant of all Shingon temples in Japan, not only has the magnificent fourteenth-century color Six-Syllable mandala from Sanbōin described earlier; it also has an excellent example painted in gold on an indigo silk background, measuring 145.5 × 77.7 centimeters (Plate 12). This blue painting came from the Daigoji subtemple known as Hōonin, where Ono no Ningai, who will be discussed in more depth later, served as the fifteenth-generation head.[18] A slip of paper stored with this painting gives a date of repair as 1440 (Eikyō 12). And, like the Sanbōin mandala, this has been dated to the fourteenth century based on stylistic and technical grounds. This painting may likely have been used in rituals recorded at Hōonin in the mid-fourteenth century.[19] The use of gold paint on a blue background is a luxurious form traditionally used for copying sutras and Buddhist paintings that accompany sacred texts.

A thin, gold line encloses the edges of the rectangular form of the Hōonin painting, but the vestiges of a double frame with flowers can be seen upon close inspection. Aside from its gold and blue color, other special features include three vertical inscriptions of Sanskrit syllables, depicted next to three of the Jusojin figures. These lines of text, to be discussed later, which are not usually shown in the color versions of this mandala, are of great interest. In addition, the main image of Shaka Kinrin displays his prominent corresponding *shuji* of "*boron*" (Skt. *bhruṃ*) on his chest.

Later paintings closely followed this significant painting as a model. Hasedera in Nara owns a Six-Syllable mandala painted in gold on blue silk, which is similar in form and style to the fourteenth-century Hōonin blue painting. Hasedera in Nara is a major center of Shingon Buddhism as well as Kannon worship. An inscription on the Hasedera scroll states that the monk Hōzōbō Kōyū (a.k.a. Shinkai, 1635–1688), who was a high-ranking monk from Iwashimizu Hachimangū in Yamashiro (Kyoto), sincerely prayed at the eye-opening ceremony of the painting, thus implying that he sponsored its commission.[20] The inscription continues, stating that Kanzei (1596–1663), the head priest and chief administrator (Chōja hōmu) of Tōji, ordered the painter Tosa Hironobu (specific dates unknown) to copy it from an old painting and had it consecrated in 1660 (Manji 3).[21] Before Kanzei became

the head of Tōji, he trained at the Daigoji subtemple of Hōonin and eventually became its sixteenth-generation head.[22] Considering Kanzei's connection to Hōonin, he must have seen Hōonin's blue Six-Syllable mandala, which was likely the "old painting" that Tosa Hironobu referred to in the inscription. Tosa Hironobu seems to have had an excellent reputation as an artist who received commissions from the Shingon School.[23]

The inscriptions on the painting's box track its arrival at Hasedera. The underside of its box lid states that the highly ranked Hasedera monk Tsūzei (dates unknown), the forty-ninth generation of Koikebō at Hasedera, donated the painting to Hasedera in 1863 (Bunkyū 3). Furthermore, the top of the box lid bears a warning that it should not be removed from the Hasedera main hall.[24] Might this admonition have meant that it should remain in the hall to use for rituals?

Hōkokuji in Kamakura owns another Six-Syllable mandala that was painted in gold on blue silk, like the painting from Hasedera discussed above. The painting is precise, and from the type of silk and handling of the paint, it appears to date from the seventeenth to the eighteenth century, in the Edo period.[25] The Hōkokuji mandala also closely resembles the fourteenth-century blue mandala from Hōonin. Because of slight variations in some details, such as the hand positions of the flying figures and level of the water, it is clear that the painting was closely copied without tracing. The most striking difference between the other two blue mandalas is that the characters were left out of the Hōkokuji mandala. The small circles next to the Kannon images, which contain *shuji* in the other blue mandalas, are empty and there are no vertical inscriptions of Sanskrit syllables next to the Jusojin. Was it unfinished or copied from a manual that omitted the *shuji*? When the painting entered the temple collection is unknown, and since Hōkokuji is a Rinzai Zen temple, it is unlikely that the painting was used for rituals there. Instead, it must have been created for a Shingon temple, perhaps with a relationship to Daigoji.

Six-Syllable Mandalas and Rokuji Myōō

The Museum Yamato Bunkakan in Nara has a well-preserved Six-Syllable mandala, which dates to the early Muromachi period (late fourteenth to early fifteenth century) (Fig. 4.3).[26] In comparison to the Sanbōin painting, the positions of the Daiitoku and Fudō in the painting are higher than the mirror, but this is something also seen in the thirteenth-century mandala. The two Myōō and the mirror are each depicted on tall, rock-shaped bases that are strikingly striped green and yellow with spots to indicate lichen. Two of the Jusojin are between each Myōō and the mirror, and the other four

Jusojin are positioned in the lowest part of the painting. In the center, Shaka Kinrin, is wearing a gold robe and has nine wheels surrounding the double mandorla, rather than seven. Although unusual, as a precedent a drawing of the Six-Syllable mandala with nine wheels is in the twelfth-century manual *Zuzōshō*.[27] The painting has some gold paint in the raised areas, such as in the crowns, and all the thin lines are rendered in *kirikane*. The body colors in shades of blue, white, and gold match those given in *Ningai chūshinmon*, as outlined in Table 4.2.

The back of the scroll has a somewhat perplexing inscription that reads "Rokuji Myōō" (Six-Syllable Bright King) on top, and below it is a little worn and blurry, but a possible reading is "Ryōshōin Denshō kyū" (Requested by Denshō of Ryōshōin). The painting is obviously not an image of Rokuji Myōō, who is a deity with a distinctive form that will be discussed subsequently, but is related because paintings of this deity were often used in rituals in place of the Six-Syllable mandala. As for the other part of the inscription, Ryōshōin is a fairly popular temple name and Denshō appears elsewhere as a monk name, so it is possible that a monk named Denshō who had an association with a temple named Ryōshōin requested the painting.

FIGURE 4.3. Six-Syllable mandala. Fourteenth–fifteenth century. Color on silk. 97.5 × 50.8 cm. Museum Yamato Bunkakan, Nara.

Another Six-Syllable mandala considered to be from the Muromachi period (1337–1573) hails from Kangiji located in Sōma City in Fukushima prefecture (Fig. 4.4).[28] In this mandala, Daiitoku is framed in a half circle and Fudō is framed in a triangle on the right; both these forms are full of flames, which appear in other mandalas, and relate to the five elements; that is, the triangle is a symbol for fire and the half circle is the symbol for wind. Instead of the usual circle containing the Six Kannon and Shaka Kinrin, the images are set against a pink, six-petal, open lotus flower with the three prongs of a vajra end protruding between petals.

FIGURE 4.4. Six-Syllable mandala. Fourteenth–sixteenth century. Color on silk. 89.6 × 36.3 cm. Kangiji, Sōma City in Fukushima prefecture.

Although Sōma was one of the areas hard hit by the 2011 tsunami, fortunately Kangiji survived and is restoring its damaged buildings.[29] The presence of a Six-Syllable mandala at this temple is not surprising because Kangiji has a long history of worshipping Myōken, the Pole Star deity who looks similar to, and was often conflated with, Rokuji Myōō (Six-Syllable Myōō) (Fig. 4.5). Myōken (Skt. Sudṛṣti; Ch. Miaojian) was originally a deification of the Pole Star, but later also was regarded as a deification of the Big Dipper.[30] Since Myōken was the tutelary deity of the Chiba clan, who controlled the surrounding area, the temple owns several other images of this figure.[31]

Kanshuku-Style Mandalas

The Shingon temple Rokujizōji in Mito, Ibaraki, has a mandala painted on silk that may date to the sixteenth century (late Muromachi period) (Fig. 4.6).[32] Ibaraki prefecture declared the painting an Important Prefectural Property in 1975. The painting has several unusual features. First of all, the Kannon are not in the order of the Sanbōin mandala; instead, starting at the twelve o'clock position and moving clockwise, they are Nyoirin, Eleven-Headed, Juntei, Horse-Headed, Shō, and Thousand-Armed. This is the order of Kannon in the Kanshuku-style mandala discussed earlier, which iconographic manuals cited as an earlier form of the mandala. Even more surprising, the Kannon are distinctively recognizable as the familiar esoteric Kannon instead of the forms described in *Ningai chūshinmon* or depicted in the Sanbōin mandala. Horse-Headed and Eleven-Headed Kannon both have red bodies. All of the Kannon images have blue body halos and green head halos.

Although Fudō on the right and Daiitoku on the left are in their usual positions, the flaming triangle and half-circle shapes that encase them are reversed. This switch is not a complete anomaly since the Sonshō mandala (Mandala of Supreme Victory), which is a mandala with features similar to the Six-Syllable mandala that was used in rituals for longevity and the absolution of sins, has a half circle on the right and a triangle on the left. While Fudō is in his triangle, Sonshō mandala has a Gōzanze Myōō (Skt. Trailokyavijaya) instead of a Daiitoku Myōō in the half circle.[33] In the Rokujizōji painting, there are no heavenly beings at the top of the painting; instead, they appear to be conflated into the Jusojin six images, with three on each side flying below the main circle that holds the Six Kannon and above the large mirror. The image theoretically of Shaka Kinrin has a crown, so instead of the usual Buddha form as in all the other mandalas, this one looks like a bodhisattva or an image of Dainichi Buddha. Although the iconographic variations raise questions about authenticity, with so few surviving examples, it is best to keep an open mind.

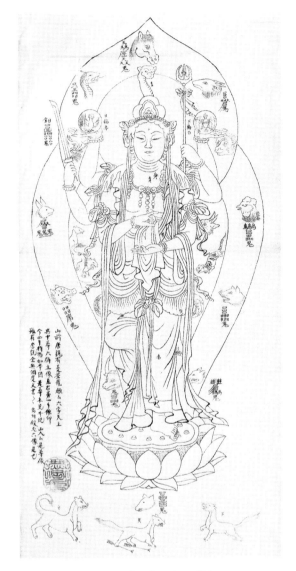

FIGURE 4.5. Iconographic drawing of Six-Syllable Myōō (no. 1150). Nineteenth century. 171.0 × 28.2 cm (including two other drawings). Ink on paper. Kyoto Shiritsu Geijutsu Daigaku.

Kisshōin in the Setagaya ward of Tokyo also has a remarkable Six-Syllable mandala that has a mixture of features and is in the Kanshuku configuration. Fascinating inscriptions that date from the eighteenth century accompany the painting.[34] Uchida Keiichi judged the mandala, which is painted in color and gold on silk, to be from the early sixteenth century (Muromachi period), but some of its features suggest a later date (Fig. 4.7).

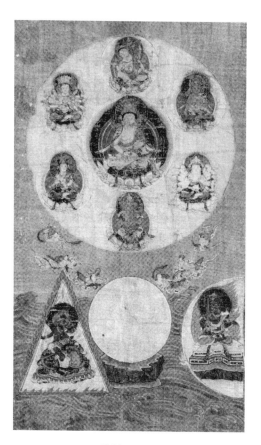

FIGURE 4.6. Six-Syllable mandala. Sixteenth century. Color on silk. 74.8 × 37.4 cm. Rokujizōji, Mito, Ibaraki prefecture.

Since the eighteenth century, this mandala has been stored in the same box as a scroll of a painting of Kūkai, known as *Nichirin Kōbō Daishi* (Sun-Wheel Kōbō Daishi) because the figure of Kūkai has a sun above his head and a wheel beneath his lotus seat. The box lid has an inscription, written by the monk Unjōbō Shuban from Kisshōin, stating that both paintings were displayed at an opening of temple treasures (*kaichō*) held at Eidaiji in Fukugawa, Edo, in the third month of 1767 (Meiwa 4), at which time a new box was made to hold both paintings.[35] An inscription on the back of the Kūkai painting explains that later that year, in the seventh month, Hashimoto Kichijirō of Hachimonjiya in Hachiman-chō, Fukagawa, Edo, donated the funds to have the painting remounted. This inscription, also written by Shuban, confirms that the paintings were temple treasures of Kisshōin, Jizōji, in Setagaya, Tama City, in Musashi.

As proof of their early pairing, the two paintings are also listed in three important records dating from the eighteenth to the early twentieth centuries. However, they refer to the Six-Syllable mandala as a "Seven Kannon image," indicating that whoever wrote the record may have been unfamiliar with the iconography and mistook the middle image of Shaka Kinrin for another Kannon. In Chapter Five, I will discuss other instances of mistaken, as well as correct, identifications of Seven Kannon, which becomes a significant phenomenon by the Edo period. The gazetteer *Edo meisho zue* (Guide to famous Edo sites), which the editor Saitō Chōshū (1737–1799) and others began writing in 1791 (Kansei 3) and then published in 1834–1836 (Tenpō 5–7), provides the following apocryphal information.

> Gyōki founded Kisshōin in 740 (Tenpyō 12). It has a painting of "Seven Kannon" by Kōkyō Daishi, another name for the Shingon Prelate Kakuban (1095–1143). At that time Kisshōin was a subtemple of Ninnaji in Kyoto. In 1148 (Kyūan 4) Prince Shukaku (1150–1202), son of Gomizunoo, went to this

area to escape an enemy rebellion and stayed from midsummer to early fall. During this period he stayed at the temple and donated the painting. The temple also has a painting of Kūkai painted by his own hand.[36]

The entry in *Shinpen musashi fudoki kō* (Newly edited records of Musashi local history), compiled in 1835 (Bunsei 8), has a similar story and also states that two of the temple treasures are a "Seven Kannon" painting by Kōkyō Daishi (Kakuban) and a self-portrait of Kūkai.[37] *Setagaya kikō* (Setagaya travelogue), written by Oyamada Tomokiyo (1783–1847) and published in 1904, reports that the temple's *engi* lists a Seven Kannon painting by Kōkyō Daishi and a self-portrait of Kūkai and adds a comment about how fortunate it is that the ancient color remains on these two paintings.[38]

While we must discount the overly optimistic attributions of dating and artists, the various texts' acknowledgment of the paintings as important treasures at the temple indicates that they were highly respected works stored there together. Since Shuban, the monk who facilitated the remounting, uses the same unusual character of "ban" in his name as the purported artist Kakuban, the painting maintained a relationship with Ninnaji and the Shingi Shingon lineage, which Kakuban disciple's Raiyu founded.

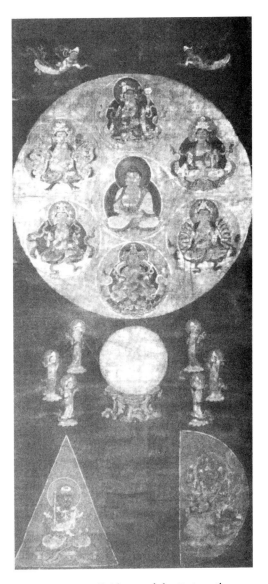

FIGURE 4.7. Six-Syllable mandala. Sixteenth-seventeenth century. Color on silk. 84.8 × 37.7 cm. Kisshōin, Setagaya, Tokyo.

Compared to all other Six-Syllable mandalas, with the exception of Rokujizōji, the Kisshōin painting has more unusual features. Some of the paint is flaking, especially the white of the mirror and the large disc behind the Six Kannon. Here too the Kannon are in the order of the Kanshuku mandala, with Nyoirin in the twelve o'clock position. Also like the

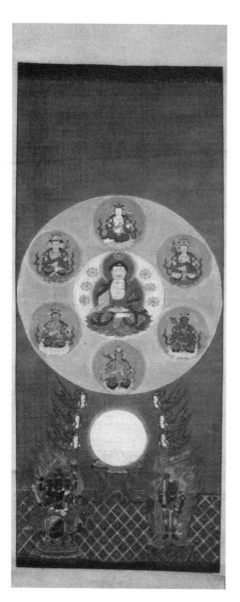

FIGURE 4.8. Six-Syllable mandala. Eighteenth–nineteenth century. Color on silk. 88.5 × 38.0 cm. Uesugi Museum, Yonezawa, Yamagata prefecture.

Rokujizōji mandala, the Kisshōin painting includes recognizable esoteric Kannon instead of the forms described in *Ningai chūshinmon*. The Jusojin are standing on lotus petals instead of in water, so their legs are shown. Like the Kangiji mandala, the two Myōō in a half circle and a triangle are different from most Six-Syllable mandalas but similar to the Sonshō mandala. As another special feature, Daiitoku usually aims his bow toward the mirror, but in this case his bow points out of the painting and is not drawn.

The painting certainly predates its inscriptions and remounting, but how much earlier is it? Uchida dates the mandala to the early sixteenth century.[39] Because the unusual iconography is not seen elsewhere, I will more cautiously use the span of late sixteenth to seventeenth century for dating because a greater variety in iconography occurred in later periods. Both the paintings from Rokujizōji and Kisshōin demonstrate an impressive blending between the Six-Syllable mandala Kannon and the Six Kannon cult, which is of special interest for the present study.

Later Iterations of Six-Syllable Mandala

The Yonezawa Uesugi Museum owns a later painting that has the basic layout of a Six-Syllable mandala but uses formalized lines and textures in contrast with earlier images of this subject (Fig. 4.8).[40] The museum has not determined a date for the painting, but I propose that it was made in the late Edo period, in the eighteenth or nineteenth century. In comparison to the Sanbōin painting, there are many variations in iconography. The flying devas and Jusojin appear to be conflated into six images depicted symmetrically, three on each side of the mirror and stacked above each other in repetitive horizontal flying poses. The usual area of water has been replaced by a grid pattern of tile diamond shapes created

in gold lines on a blue ground. The Kannon are arranged in the Kanshuku order, as in the two previous examples. In addition, there seems to be some more mixing of the iconography between the *Ningai chūshinmon* forms of Kannon and esoteric images, such as the seated position of the Nyoirin Kannon, with one knee raised and the other leg folded down, which is at the top, and the eleven heads of the Eleven-Headed Kannon in the upper right. Abundant anomalous features combined with flat, bright colors and thick outlines indicate an eighteenth- or nineteenth-century painting.

In addition to paintings, two detailed iconographic drawings of Six-Syllable mandalas from the mid-nineteenth century that formerly belonged to the Kyoto Shingon temple Rokkakudō Nōmanin (Chōhōji) and now in the collection of Kyoto City University of the Arts are worthy of inclusion.[41] Assembled before the temple's fire in 1864 (Genshi 1), the drawings, numbered 1150 (Fig. 4.9) and 1151 (Fig. 4.10), were part of a substantial collection of drawings of

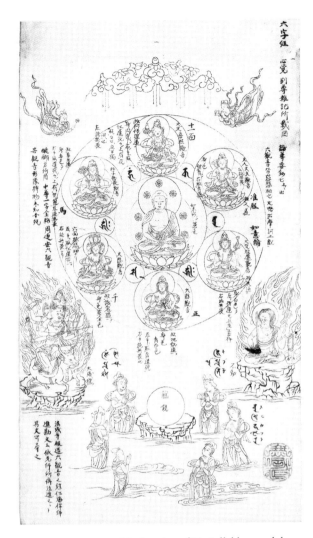

FIGURE 4.9. Iconographic drawing of Six-Syllable mandala (no. 1150). Nineteenth century. 171.0×28.2 cm (includes two other drawings). Ink on paper. Kyoto Shiritsu Geijutsu Daigaku.

Buddhist images made for copying (*funpon*) to guide artists and clerics in the intricacies of the complex forms of Buddhist painting. While in operation, the Nōmanin Buddhist painting studio used the drawings, but after the school disbanded in 1870, the monk Tamura Sōryū, who was also a painting teacher at the forerunner of the university, took custody of the works, which his relatives later donated to the school.[42] There are other extant iconographic drawings of Six-Syllable mandalas, but those from Nōmanin have especially detailed annotations that show the artists' awareness of history, the mandala's relationship to the texts *Mohe zhiguan*

FIGURE 4.10. Iconographic drawing of
Six-Syllable mandala (no. 1151). 1857.
97.0 × 49.7 cm. Ink on paper. Kyoto Shiritsu
Geijutsu Daigaku.

and *Shoson yōshō* (Essential notes on various deities), compiled by Jichiun (1105–1160), and connection to Daigoji. The depictions in each of the drawings are almost the same, except for differences in the canopies and the placements of flames around the central image.

Number 1550, which is undated, measuring 171.0 × 28.2 centimeters in its entirety, also includes two other drawings of Six-Syllable Myōō (Rokuji Myōō), one of which is shown in Figure 4.5. In contrast to Number 1551, its text claims that the Six Kannon were made according to *Ningai chūshinmon,* which used detailed records transmitted from earlier masters. The other drawing in the compendium, Number 1551 (97.0 × 49.7 cm), bears a date of 1857 (Ansei 4) and describes some of the same things, but also includes annotations that state that the mandala appeared in the twelfth-century iconographic manual *Besson zakki,* the Six Kannon follow the same order of the six syllables as the one from the Jōganji storehouse, and the original explanation for the forms and attributes of the Six Kannon is unknown. The text does not mention Ningai but instead cites the twelfth-century text *Genpishō* (Deep secret records) in regard to two of the Jusojin's names, Shibusemu (Shifusen) and Kibune, a point that acknowledges that the enigmatic Jusojin names were worthy of comment.[43]

In both drawings, the order of the Kannon follows that of *Ningai chūshinmon*. The drawings also label each figure and give instructions for the application of color, including the specific body colors for each Kannon. The color instructions are consistent with those in *Ningai chūshinmon,* except that the body of Horse-Headed Kannon (Shishimui/Fearless Lion) should be painted in red. Red is the preferred body color for Horse-Headed Kannon in esoteric form, but *Ningai chūshinmon* instructs that he be blue. Because there is one copy of *Shoson yōshō* that says that the image should be red, the artists must have used that particular copy as the source for this note.[44] The level of precision of these drawings is an indication of their high esteem and practical value.

Our last Six-Syllable mandala is located in the Museum of Fine Arts, Boston (Plate 13).[45] This relatively large painting, measuring 123.2 × 78.4 centimeters, is slightly smaller than the Sanbōin painting. The Boston painting follows the main patterns of the Sanbōin mandala, including the *Ningai chūshinmon* arrangement, but unlike the Sanbōin mandala the body colors follow the *Ningai chūshinmon* description. Another difference is that the only wheel is the one Shaka Kinrin holds in his lap, and there are no others adorning his mandorla. This feature is also found in a drawing in the twelfth- to thirteenth-century iconographic manual *Kakuzenshō*, but that drawing does not match the Boston painting in other ways.[46] The Boston painting has no *shuji*, but strangely there are empty circles outlined in red where one would expect to see the characters. Could it be unfinished? The only other painting where we have encountered empty circles is the seventeenth-eighteenth century blue mandala from Hōkokuji.

With so few of these mandalas surviving, readers must wonder how this one came to be in the United States. Due to the efforts of Ernest Fenollosa (1853–1908), William Sturgis Bigelow (1850–1926), Okakura Kakuzō (1862–1913), and others, the Museum of Fine Arts, Boston, has a distinguished history of collecting Japanese Buddhist art.[47] Records show that the painting was donated in 1919 and came into the collection as a "Gift of Mrs. Albertine W. F. Valentine, residuary legatee under the will of Hervey E. Wetzel," and was listed simply as "Japanese Buddhist painting" in a 1919 issue of *Museum of Fine Arts Bulletin*.[48] Edward W. Forbes, director of the Fogg Art Museum at Harvard University, wrote the following about Mr. Wetzel and his generous gifts in 1919:

> The Museum and the community suffered a great loss in the death of Hervey Edward Wetzel, Class of 1911, one of the young graduates trained in the Division of Fine Arts, who in only a few years had developed into one of the ablest collectors of works of Oriental art in the country, and who was associated with the Museum of Fine Arts in Boston. Mr. Wetzel lost his life in the service of the American Red Cross in France. He left to the Fogg Art Museum a bequest of $100,000, which was to be used for the purchase of important works of art of rare beauty. Also, in accordance with the expressed wish of Mr. Wetzel, his relative Mrs. Valentine gave to the Museum of Fine Arts and the Fogg Art Museum in approximately equal amounts, a large number of the works of art that he had collected.[49]

Mr. Wetzel's substantial collection of Asian art consisted mainly of ceramics, textiles, and sculptures.[50] The lid of the wooden box that accompanies the painting has the following characters painted in gold: "Fujiwara jidai

Rokuji Kannon sonzō" (Six-Syllable Kannon image from the Fujiwara period). Whoever wrote the inscription on the box may have known that iconographic manuals that depict Six-Syllable mandalas date from the twelfth century of late Heian (951–1185), or the so-called Fujiwara period, but not that no other paintings of this subject from that time survive. Because of the style and color we can easily dismiss the date on the box as too early. In any case, the title "Rokuji Kannon" on the box was fortunate as few at the turn of the twentieth century would have been able to identify such a rare work. Until 2012 the painting remained in the collection without a date until the present study prompted its reexamination.

Some parts of the painting show wear, especially in the upper right corner, and there is evidence of some repainting of the outlines in places. Some precise lines show adept handling of gold paint, and Shaka Kinrin and the Kannon have been carefully painted, but the lower-ranking deities, such as the flying devas and Jusojin, have thicker lines and were executed with less attention. While the painting looks old, its lines are not as sharp and controlled as the Daigoji examples. Could it be the work of a clever forger?

With a mixture of styles and features, we are left with questions about its authenticity. Why would such a painting have been made in the nineteenth century? Was it to be used for ritual during that time? Or was the sale to an unsuspecting foreigner its goal? As Patricia Graham commented in regard to nineteenth-century forgeries, "when Buddhist persecution and impoverishment of temples in the Meiji period left professional Buddhist painters unemployed, some turned to producing forgeries for prosperous, unsuspecting foreign buyers."[51] It is possible that Mr. Wetzel could have been deceived, but he also may not have been the first owner. In any case, a Six-Syllable mandala would be an unusual choice for an intentional forgery.

Alternatively, could the mandala have been used as a way to train students to study old Buddhist paintings through copying? It is possible that it might have been a study painting of a type that was more complete than the drawings used by the Nōmanin studio. As Victoria Weston has discussed, copying Buddhist painting was an important part of the curriculum at the Tokyo School of Fine Arts in the nineteenth century.[52] Undoubtedly, Buddhist paintings were routinely copied for different purposes over the centuries.

Summary of Extant Six-Syllable Mandala

Considering all known extant Six-Syllable mandalas, as outlined above and in Table 4.2, I have been able to ascertain the following. The arrangement of the Kannon within the paintings generally follows the Sanbōin mandala and

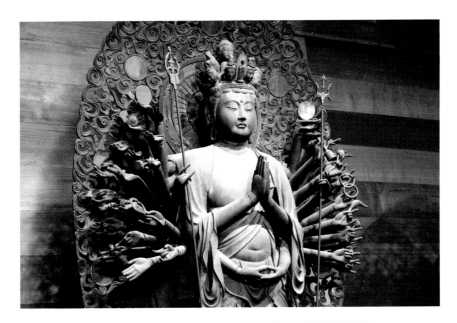

PLATE 1. (*top*) Thousand-Armed Kannon detail.
By Higo Jōkei. 1224. Wood. 179.5 cm. Daihōonji, Kyoto. Photograph by Sawada Naoyuki.

PLATE 2. (*bottom*) Horse-Headed Kannon detail.
By Higo Jōkei. 1224. Wood. 175.2 cm. Daihōonji, Kyoto. Photograph by Sawada Naoyuki.

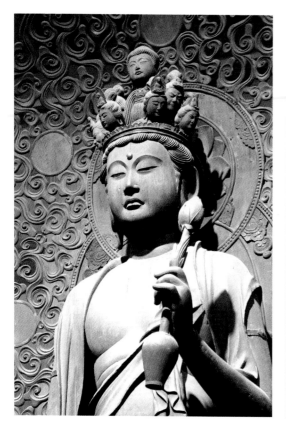
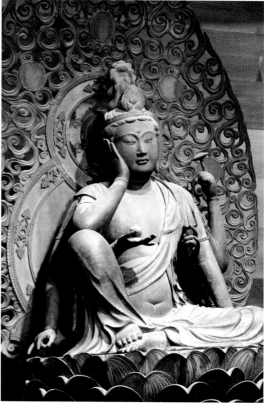

PLATE 3. (*left*) Eleven-Headed Kannon detail.
By Higo Jōkei. 1224. Wood. 181.6 cm. Daihōonji, Kyoto. Photograph by Sawada Naoyuki.

PLATE 4. (*right*) Nyoirin Kannon detail.
By Higo Jōkei. 1224. Wood. 96.5 cm. Daihōonji, Kyoto. Photograph by Sawada Naoyuki.

PLATE 5. (*top*) Horse-Headed Kannon.
1652. Wood. 21.5 cm. Fumonji, Yunomae, Kuma district, Kumamoto prefecture.

PLATE 6. (*bottom*) Five Kannon inside black lacquer tabernacle (*zushi*).
Fumonji, Yunomae, Kuma district, Kumamoto prefecture.

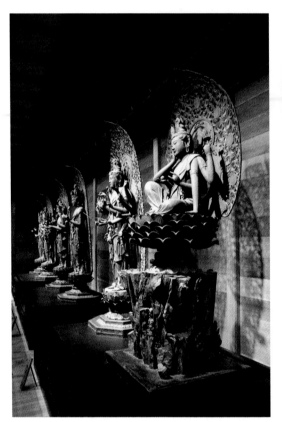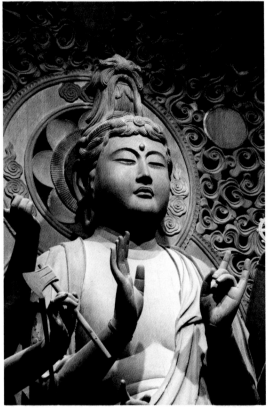

PLATE 7. (*left*) Six Kannon inside storehouse at Daihōonji, Kyoto.
Photograph by Sawada Naoyuki.

PLATE 8. (*right*) Juntei Kannon detail.
By Higo Jōkei. 1224. Wood. 179.5 cm. Daihōonji, Kyoto. Photograph by Sawada Naoyuki.

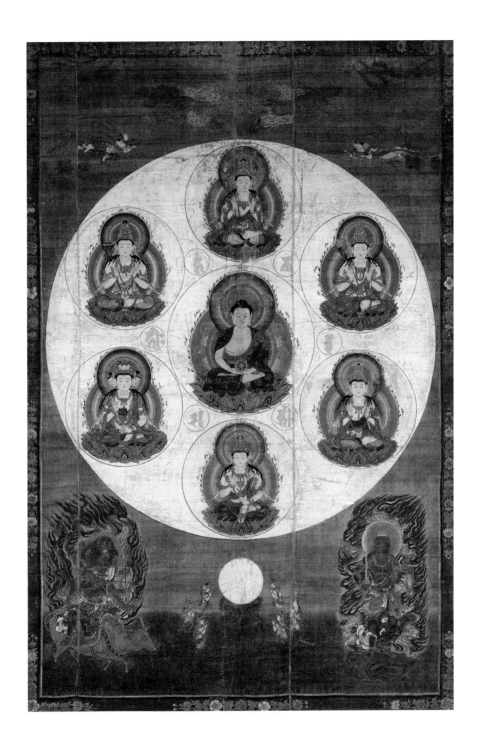

PLATE 9. Six-Syllable mandala.
Fourteenth century. Color on silk. 127.4 × 83.8 cm. Sanbōin, Daigoji, Kyoto.

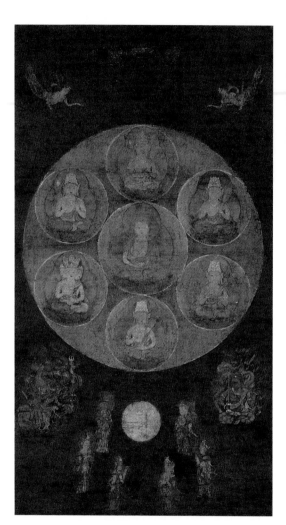

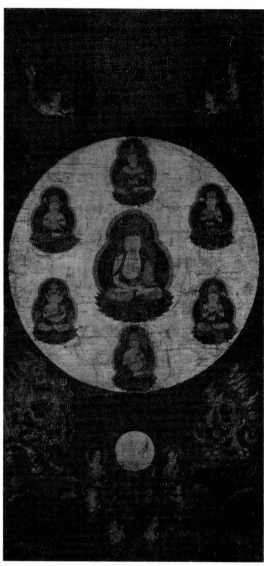

PLATE 10. (*left*) Six-Syllable mandala.
Thirteenth century. Color on silk. 72.1 × 39.0. Kyoto National Museum.

PLATE 11. (*right*) Six-Syllable mandala.
Thirteenth century. Color on silk. 79.7 × 38.6. Nara National Museum.

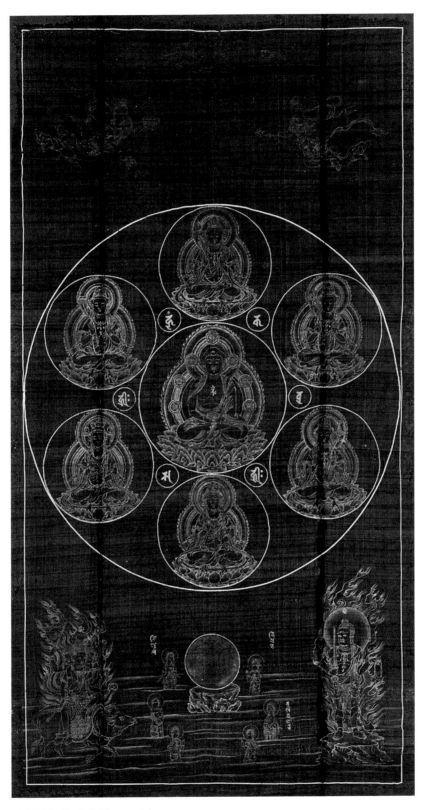

PLATE 12. Six-Syllable mandala.
Fourteenth century. Gold on indigo dyed silk. 145.5 × 77.7 cm. Hōonin, Daigoji, Kyoto.

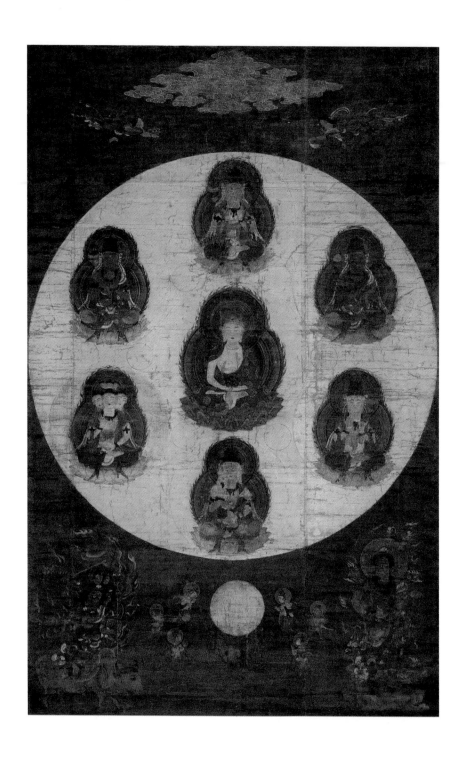

PLATE 13. Six-Syllable mandala.
Nineteenth century. Color on silk. 123.2×78.4 cm. Museum of Fine Arts, Boston.

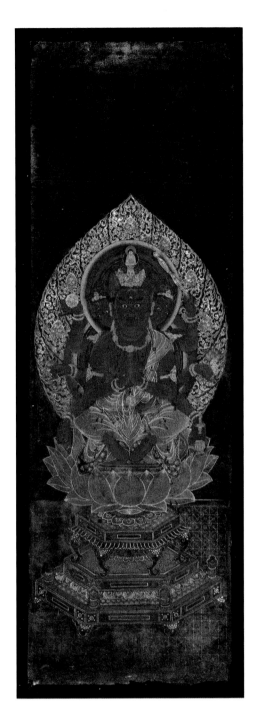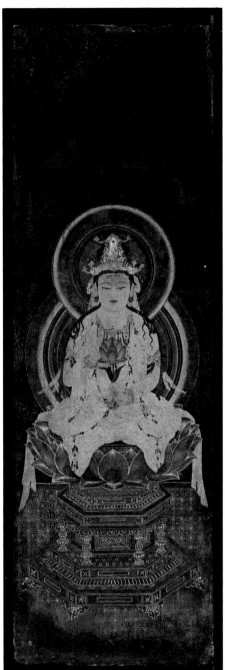

PLATE 14. (*left*) Horse-Headed Kannon.
Fourteenth century. Color and gold on lacquered wood panel. 63.1 × 20.9 cm. Museum of Fine Arts, Boston. William Sturgis Bigelow Collection.

PLATE 15. (*right*) Shō Kannon.
Fourteenth century. Color and gold on lacquered wood panel. 63.4 × 20.7 cm. Museum of Fine Arts, Boston. William Sturgis Bigelow Collection.

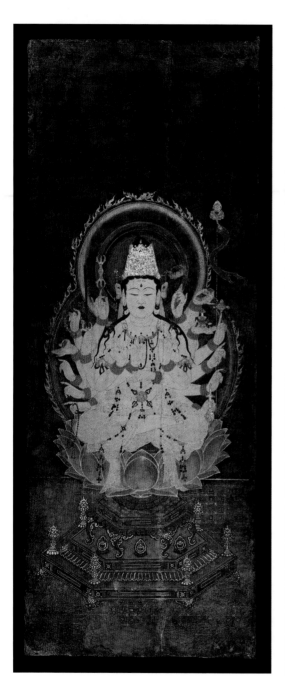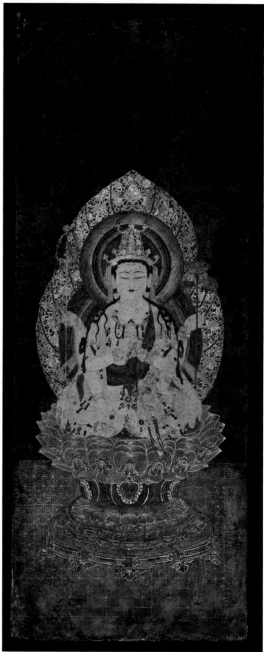

PLATE 16. (*left*) Juntei Kannon.
Fourteenth century. Color and gold on lacquered wood panel. 63.2 × 25.0 cm. Museum of Fine Arts, Boston. William Sturgis Bigelow Collection.

PLATE 17. (*right*) Fukūkenjaku Kannon.
Fourteenth century. Color and gold on lacquered wood panel. 63.2 × 25.0 cm. Museum of Fine Arts, Boston. William Sturgis Bigelow Collection.

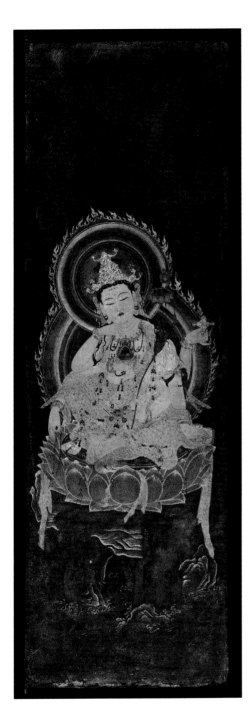 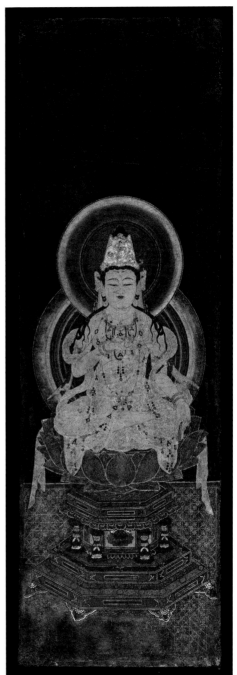

PLATE 18. (*left*) Nyoirin Kannon.
Fourteenth century. Color and gold on lacquered wood panel. 63.3 × 20.8 cm. Museum of Fine Arts, Boston. William Sturgis Bigelow Collection.

PLATE 19. (*right*) Byakue Kannon.
Fourteenth century. Color and gold on lacquered wood panel. 63.2 × 20.8 cm. Museum of Fine Arts, Boston. William Sturgis Bigelow Collection.

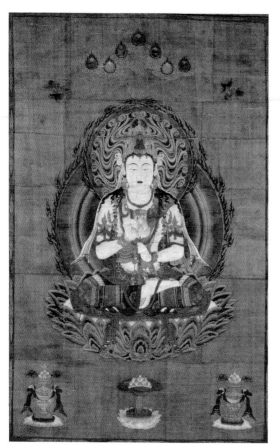 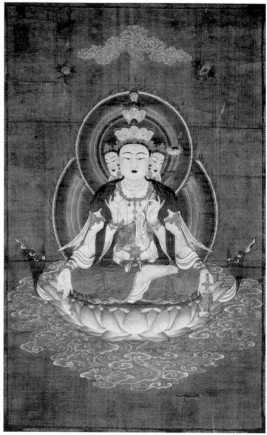

PLATE 20. (*left*) Shō Kannon.
Fourteenth century. Color on silk. 147.9 cm. Hosomi Museum, Kyoto.

PLATE 21. (*right*) Eleven-Headed Kannon.
Fourteenth century. Color on silk. 147.9 cm. Hosomi Museum, Kyoto.

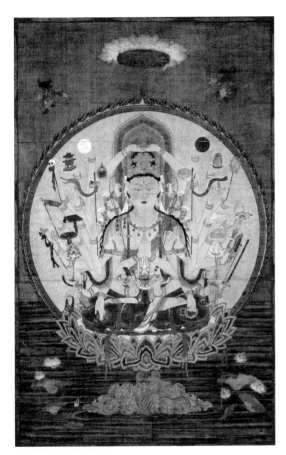 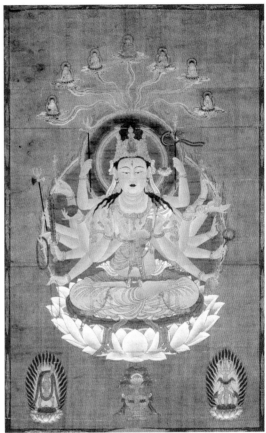

PLATE 22. (*left*) Thousand-Armed Kannon.
Fourteenth century. Color on silk. 147.9 cm. Hosomi Museum, Kyoto.

PLATE 23. (*right*) Juntei Kannon.
Fourteenth century. Color on silk. 147.9 cm. Hosomi Museum, Kyoto.

PLATE 24. Nyoirin Kannon.
Fourteenth century. Color on silk. 147.9 cm. Hosomi Museum, Kyoto.

PLATE 25. *Kannon Mandala: Seven Buddhist Deities.*
Eighteenth century. Color on paper. 39.5 × 27.8 cm. Museum für Ostasiatische Kunst Köln.

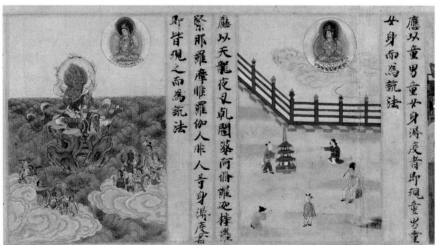

PLATE 26. (*top*) Horse-Headed Kannon with scene of animal path.
Sixteenth century. One in a set of Thirty-Three Kannon paintings. Color on silk. 93.7 × 44.2 cm.
Shō Bijutsukan, Kōdaiji, Kyoto.

PLATE 27. (*bottom*) "Universal Gate," Chapter 25 from the *Lotus sūtra* (Illustrated sūtra of
The Miracles of Kannon).
1257. Text by Sugawara no Mitsushige. Ink, color and gold on paper, handscroll. 23.9 × 934.9 cm.
The Metropolitan Museum of Art, New York.

is described in *Ningai chūshinmon*. This order, with the Eleven-Headed Kannon in the twelve o'clock position, appears in most of the iconographic manuals. As alternatives, the most unusual examples in the group, from Kisshōin, Rokujizōji, and Uesugi Museum, follow the arrangement attributed to the ninth- to tenth-century monk Kanshuku. They also differ from most of the paintings because their body colors follow those described in *Ningai chūshinmon*.

Given the importance of the six syllables to the ritual, it is surprising that only four of the mandalas include *shuji* next to the Kannon. The Nōmanin iconographic drawings, which have considerable detail for study, also include them. These drawings also supply the *bonji* readings that name three of the Jusojin, which will be discussed subsequently. These names, which were often debated among Heian period monk-authors, appear in only two of the extant blue and gold mandalas.

There is some variety in the positions of the images of Fudō and Daiitoku Myōō, but of most interest is whether or not the water buffalo is standing or seated. If standing, the painting indicates a connection to Daigoji, as with the Sanbōin and Hōonin mandalas. Since the iconographic drawings from Nōmanin, which do reference Daigoji, show the animal's front legs out and the back legs down as if it were in the midst of standing, this posture might have been some sort of compromise.

There are two approximate sizes. The smaller paintings range from 72 to 89 centimeters in height. The two earliest paintings from the thirteenth century, in Kyoto National Museum (72 cm) and Nara National Museum (79 cm), are of the small size. The larger paintings measure from 123 to 153 centimeters in height. The Sanbōin mandala falls in this group, at 127 centimeters.

The earliest paintings from the thirteenth century are smaller and have more delicate painting with fewer details. The Sanbōin and Hōonin paintings from the fourteenth century were important and served as models for later sources that were at times copied faithfully. In contrast, some of the later paintings, such as those from Kisshōin and Uesugi Museum, show a variety and complexity of forms of a hybrid type that merge images from the esoteric Six Kannon tradition with the Six-Syllable mandala framework. In examining all of the mandalas, we see that none of them follow textual sources exactly, which thus reveals a negotiation between texts, practice, and the reputation of the Six Kannon.

Development of the Six-Syllable Mandala in Japan

The eleventh-century text *Ningai chūshinmon* explains the equivalencies between the traditional Chinese list from *Mohe zhiguan* and the Six Kannon images in Japan, which again is outlined in Table 4.1. Although these

descriptions closely match the Kannon images in the Six-Syllable mandala, there is no direct mention of Six-Syllable mandalas in this text.[53] In the Sanbōin mandala, beginning with Daiji (Shō Kannon) in the six o'clock position, the images can be aligned with the table by moving clockwise around the circle.

Ningai chūshinmon acknowledged that *Mohe zhiguan* was the source for the Six Kannon, but the roles of the first two Kannon were reversed and more detailed descriptions for the body colors and hand positions were added. Interestingly, Ningai, or the editor, claimed that the information was taken from the notes of "earlier masters," but did not identify them. As I have discussed in Chapter One, I have only located stories about the efficacy of the Six Guanyin images in China, but have not found any extant Chinese sculptures or paintings. Since such stories do not describe how the images appeared, it is possible that the *Ningai chūshinmon* descriptions matched the appearance of the Chinese Six Guanyin.[54] Yet rather than part of long-standing continuing tradition of visual imagery, available evidence indicates that Japanese monks reinvented and reinterpreted the forms based upon *Mohe zhiguan.*

Ningai's Relationship to Six-Syllable Mandala

Ono no Ningai, the monk who is most often recorded in connection to bridging the gap between Six Kannon belief in China and Japan, also played a part in the development of the Six-Syllable mandala. Ningai was a very prominent eleventh-century Japanese Buddhist prelate who was the founder of the Ono branch of Shingon Buddhism. This branch is distinct from Hirosawa, the other significant branch of Shingon, which was promoted by Ninnaji in Kyoto and patronized by the imperial family. Although the Ono branch had fewer imperial connections, it had significant patronage from the wealthy Fujiwara family. The basic teachings of the two branches do not differ significantly in doctrine, but in general Ono emphasizes oral transmission while Hirosawa emphasizes texts. Indeed, Ningai and other members of the Ono School often cited oral traditions, called *kuden,* as sources within their written works.[55] Ningai trained on Mount Kōya, where he studied Siddham (J. *shittan*) script, which is the abbreviated form of Sanskrit referred to as seed syllables or *shuji.* Again, these appear in the Daigoji Sanbōin mandala, and most others, in the smaller circles next to the Kannon images and are very important to its theme.[56] The specialized knowledge of Siddham script that was especially important for monks was well beyond most laypeople. Ningai studied under the high-ranking monk Gengō at Daigoji in Kyoto and later served as head of several major Kyoto temples. In 1023, which was incidentally the year the Hōjōji Six Kannon were finished, Ningai was awarded the rank of Sōjō, one of the highest positions a monk could receive at the time.[57]

Mandalas were particularly significant to Ningai, who was the founder of a temple called Mandaraji, later known as Zuishin'in, which was built in the Ono, or Yamashina area of Kyoto, not far from Daigoji. Mandaraji, literally "Temple of the Mandala," took its name from a type of mandala different from the Six-Syllable type. According to the temple's founding legend, Ningai saw that his mother had been reborn as a red cow in a dream. When he awakened, he searched and located the red cow and took care of her as his filial duty. When the cow died, Ningai had the cow skinned and the Mandalas of the Two Worlds depicted on her hide. Legend has it that these leather mandalas were used as the central focus for worship at Mandaraji.[58]

Ningai was best known as an effective rainmaker and thus earned the name "Ame no Sōjō," or the Rainmaking Prelate.[59] During his lifetime, rainmaking rituals were considered to be extremely important since they were a means to control the weather to produce healthy crops. In times of drought, professional rainmakers such as Ningai could direct rituals to start rain, and in times of flooding they could direct rituals to stop rain. Consequently, rainmaking rituals were conducted more often than Six-Syllable rituals. Ningai is recorded as performing the second earliest Six-Syllable ritual in the year 1008 (Kankō 5) after the palace burned as a result of a lightning strike. Because Prince Atsuhira, who later became Emperor Goichijō (1008–1036), was born while the ritual was taking place, the ritual gained an exalted and efficacious reputation.[60]

Six-Syllable Ritual

The first specifically recorded occurrence of the performance of a Six-Syllable ritual was in 999 (Chōhō 1) by the monk Kōkei (977–1049) in the province of Iyo (old name for Ehime in Shikoku) for Fujiwara no Tomoakira (dates unknown), who was lord of Iyo province.[61] As mentioned above, the second ritual to be documented was performed by Ningai in 1008. Six-Syllable rituals are recorded fairly frequently in Japan from the eleventh until the fifteenth century. In his extensively researched article, Tsuda Tetsuei documents ninety-three instances of the ritual from 999 to 1178.[62] Significantly, *Rokuji hōki* (Record of the Six-Syllable rite) from 1284 (Kōan 7) provides a detailed description of a ritual, including drawings of the altar configurations, conducted by Kenjun (1258–1308), who was head of Hōonin, for the well-being of retired Emperor Kameyama (1249–1305).[63] After that, forty-two different rites were recorded in the diary of Mansai (1378–1435), *Mansai jugō nikki*.[64] Another text, *Gohachi daiki* (Records of forty [5×8] generations) lists ten rites performed by Kenshun (1299–1357), who was the twenty-ninth-generation head of Hōonin, from 1345 to 1351 (Kōei 4–Kanō 2).[65]

佉
知
佉
注
佉
毘
知
緘
壽
く
く
多
知
波
知

眞
言

FIGURE 4.11.
Six-Syllable ritual
mantra (*shingon*).
Original from
twelfth–thirteenth
century. From
Kakuzenshō, TZ 4:354c.

We should recall that Hōonin owns the important fourteenth-century blue Six-Syllable mandala. Extant Edo-period paintings indicate that the Six-Syllable ritual continued to be performed into the eighteenth century, but it seems to have fallen out of favor in the nineteenth century, and I have found no evidence that it is conducted today.[66] The published misidentifications of the Kisshōin Six-Syllable mandala as a "Seven Kannon" painting point to the confusion about the subject in the nineteenth century.

The purpose of the Six-Syllable ritual, which usually lasted a week, focused mainly on personal worldly matters, such as safe childbirth and protection from illness, differs from the use of Kannon as guides to help the deceased to the higher realms initially presented in *Mohe zhiguan* and *Ningai chūshinmon*. Benedetta Lomi has discussed how the choreography of the Six-Syllable ritual contributed to purification and healing.[67] Another important benefit of the ritual was that an individual could not only remove a curse but could also reverse its effects by sending it back to its originator.[68] In this way, the ritual does not fit the stereotype of Buddhist practice as always selfless and benevolent, but instead reveals its crucial role of confronting fearful situations.

To consider how the Six-Syllable ritual was deployed to combat evil forces, we should look to the *Six-Syllable sūtra* from which it takes its name. Originally the sutra was not related to the mandala. There are two extant Chinese versions of the *Six-Syllable sūtra*. The oldest, *Rokuji juōkyō* (Ch. *Liuzi zhouwang jing*), was translated from an Indian language into Chinese in the Eastern Jin dynasty (317–420). The premise of this sutra is that Śākyamuni's disciple Ananda was bewitched by a demon in the guise of a woman belonging to a low caste who handled meat. To remedy the problem, the Buddha taught Ananda a special formula of six syllables to break the spell.[69]

In Japanese, the magic formula (*shingon*), or mantra, to get rid of curses is pronounced "kya-chi-kya-chū-kya-bi-chi-kamu-shu-kamu-shu-ta-chi-ba-chi" (Fig. 4.11).[70] Rather than be frustrated because there are more than six syllables in this incantation and a literal translation is impossible, it is necessary to keep in mind that the Chinese characters used to record this

formula were transliterated from the Sanskrit seed syllable *dharani,* which is a potent distillation of an esoteric text made for chanting as a special formula that is not to be read grammatically. Japanese monks adopted the sutra as a powerful tool to remove curses, conduct exorcism, and avert disasters because it gives advice about how the formula can break various spells. While the sutra mentions that Kannon (Guanyin) can be of additional help, it does not state the connection between the Six Kannon and the six syllables. Lomi discusses the complexities of how Tendai and Shingon lineages competed to lay claim to the origins of the ritual.[71] Although which lineage was actually first is buried in the debates, it is safe to assume that the mandala is a Japanese invention and a ninth- or tenth-century Japanese monk or monks within these factions made the associations between the Six Kannon syllables in *Mohe zhiguan* and the six syllables in the sutra. With a Shingon-lineage agenda, *Ningai chūshinmon* promoted this association as initiated by the unnamed earlier masters, which was converted into an awesome visual manifestation seen in the paintings of the Six-Syllable mandala.[72]

Several manuals explain how to conduct the Six-Syllable ritual. An outline of the ritual based on the description found in *Kakuzenshō* (Kakuzen's notes) compiled by the monk Kakuzen (1143–1217), who belonged to Ningai's Ono lineage, helps determine the function of the painting, particularly because of its detail. The entry titled "Rokuji" (Six syllables) is divided into sections that pertain to various aspects of the ritual.[73] First, the head monk (*ajari*) and his assistants set up a fire altar, called *goma,* for the patron with an arrangement of weapons, including arrows, bows, and swords pointing in the six directions (Fig. 4.12). (Note that there is a wide variety in the arrangements in other illustrations that differ from the one pictured.) The monks, usually six in number, read the *Six-Syllable sūtra,* perform special hand gestures, or mudras, and chant the six-syllable formula from the sutra. As chanting takes place, one of the monks knots a ritual rope, called *kessen,* which seems to be a figurative way to tie elements of the ritual together. Another monk bangs a gong and another sprinkles water on the patron.

A crucial part of the ritual employs three types of pictures, called "three kinds of forms" (*sanruikei*): a person, a bird, and a fox. There are numerous illustrations of these in iconographic manuals and ritual texts, which perhaps served as models to show how the images should be depicted. Figure 4.13 shows pictures from the twelfth-century manual called *Hizōkonpōshō* (Secret collection of fundamental writings).[74] In the various manuals, the pictures are similar, and notably the human figure is almost always female. Beginning in the thirteenth century, some texts refer to these as three types of foxes, as a human fox (*ninko*), a heavenly fox (*tenko*) referring to the bird, and an earthly fox (*chiko*). These three forms are

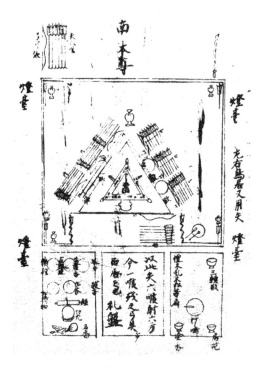

FIGURE 4.12. Six-Syllable ritual altar. Original from twelfth–thirteenth century. From *Kakuzenshō, TZ* 4:357a.

FIGURE 4.13. Three forms used in the Six-Syllable ritual. Original from twelfth century. From *Hizōkonpōshō, T* 78:340c.

said to represent the three poisons—the person is greed, the bird is anger, and the fox is stupidity—which were brought on by the family who initiated the curse.[75] Another explanation is that these forms represent the various disasters brought about by the heavens, the land, and humans.[76] The commentary *Ono ruihishō* (Various secret notes of Ono), written by Kanjin (1084–1153), claims that once during a successful Six-Syllable ritual performance a fox cry was heard. It also mentions that when Ningai was performing the ritual in 1008 at Tōbokuin (northeast of Hōjōji in Kyoto) a fox came out from the altar and that ritual was successful.[77] From these texts, it is not clear if the fox was the reason for the effective results of these rituals, but the presence of a fox was certainly of great import. Since the ninth century in Japan the fox has been considered a potent symbol of change, and thus fox imagery represented the animal's perceived magical powers of transformation.[78] The name of the enemy family who initiated the curse may be written on the three forms.[79] During the ritual the pictures of the three forms are burned and then the patron drinks their ashes, which are said to represent the heart of the enemy.[80] On some occasions seven images of each form were used.[81] Today some shrines still engage

in the practice of using simple paper figures of people, called *hitogata*, as a way to dispel defilement and eradicate problems.

As the central focus of worship, a Six-Syllable mandala could be hung on the south side of the altar to assist the monks in invoking the deities pictured. However, this was not the only kind of image that could be used in this ritual. The fact that a variety of types of images were used in this popular rite helps explain why, in contrast to the numerous textual descriptions of the ritual, so few actual Six-Syllable mandalas remain.

Typology of the Main Images Used in the Six-Syllable Ritual

In addition to the Six-Syllable mandala, some twelfth-century iconographic manuals list four other types of paintings that were used as the main image for the Six-Syllable ritual. The typology from *Zuzōshō*, the earliest of the iconographic manuals, compiled circa 1135 (Hōen 1), is summarized as follows.[82]

1. The <u>first</u> is the type used by Daigoji with Ichiji Kinrin in the center surrounded by Six Kannon. These Six Kannon were made for Hōjōji. According to *Ningai chūshinmon* the Six Kannon were handed down from earlier masters. The monk Seison (1012–1074) copied them from an original in the Jōganji storehouse that had the six corresponding *shuji*. Previously there were no Myōō, moon disc or heavenly beings (*ten*).
2. The <u>second</u> is a Shō Kannon mandala, which has the *shuji* character of Shō Kannon surrounded by other *shuji* for images from the lotus court of the Taizōkai mandala.
3. The <u>third</u> is an image of the six syllables with the Five Great Myōō.
4. The <u>fourth</u> features Enmantokuka [an alternate name for Daiitoku Myōō] with six heads, arms and legs. This is used for making angry enemies surrender and for removing curses.
5. Finally, the <u>fifth</u> type centers on a standing Six-syllable (Rokuji) Tennō with six arms.

The first type, which is the subject of this chapter, appears to have been used most often at the time. The comment about copying an original from Jōganji, a defunct temple that was part of Kashōji in Fushimi and founded by Kūkai's brother and disciple Shinga (801–879), makes a strong connection to the Shingon lineage. Because the Jōganji mandala consisted of *shuji* without Myōō, moon disc (or mirror), or heavenly beings, it references a precursor to the Kanshuku and Myōsen versions discussed earlier. Several other manuals mention Jōganji as the source for the mandala. Seison was

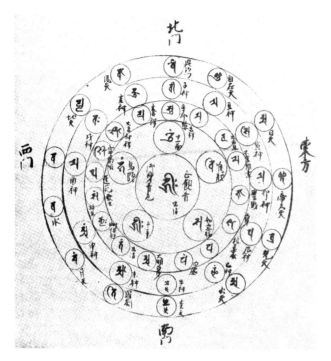

FIGURE 4.14. Shō Kannon mandala. Original from twelfth–thirteenth century. From *Kakuzenshō*, *TZ* 4:353, fig. 111.

a disciple of Ningai's and sixteenth generation of Hōonin, which is the provenance for the fourteenth-century blue mandala.

Options two through four are almost unknown, but part of the issue may be that they were multipurpose objects that were difficult to recognize as related to the ritual. The iconographic manual *Kakuzenshō* includes a drawing of the second type (Fig. 4.14).[83] Moreover, a related variation of this type is that Shō Kannon can be depicted alone to stand in for the group of Six Kannon.[84] The mid-twelfth-century text *Gyōrinshō* (Collection of rituals) reported that a life-size sculpture of Shō Kannon was used as the main image for the Six-Syllable ritual.[85] The topic of the Shō Kannon mandala's use as a substitute for the Six Kannon will be taken up in Chapter Five in regard to Six Kannon paintings.

In regard to the fifth type, the Six-Syllable Myōō is the most common alternative image to the Six-Syllable mandala. Six-Syllable Myōō, which was referred to previously in the sections on the Yamato Bunkakan and Kangiji paintings, is another name for Six-Syllable Tennō (heavenly king). This deity, who is not a bodhisattva like Kannon, is a Myōō, or bright king, who holds various attributes, stands on one foot, and is surrounded by the twelve animals from the Asian calendar. When scholars such as Tsuda Tetsuei, Kamikawa Michio, and Nakamura Teiri discussed the topic of the main image of the Six-Syllable ritual, they directed their attention to how the Six-Syllable Myōō eventually came to be more prevalent than the Six-Syllable mandala. According to Tsuda, the earliest reference to this image in Japan is from the tenth century.[86] Many Six-Syllable Myōō images made centuries later survive, and an early example is the thirteenth-century color painting of this deity standing on one foot surrounded by animals from Hōjuin in Wakayama.[87] One of the nineteenth-century iconographic drawings from Nōmanin discussed above provides two clear illustrations of the deity be-

low another drawing of the Six-Syllable mandala (Number 1550).[88] Figure 4.5 shows one of these Six-Syllable Myōō figures with three foxes below.

Water Matters: Six-Syllable Riverbank Ritual and Jusojin

Rokuji karinhō, or Six-Syllable riverbank ritual, is similar to the Six-Syllable ritual just described, but often on the night of the sixth day the ritual was moved to an altar in a boat on a river. Smaller accompanying boats carry torches for illumination (Fig. 4.15). The elaborate arrangement and ritual equipment needed are explained in several manuals, but few mention anything about the main image, except to note that it faces the altar.[89] As an exception, *Rokuji karinhō,* dated 1088 (Kanji 2), describes the main image simply as a "hanging Kannon."[90] Other texts say it is an image of Shō Kannon or a Six-Syllable Tennō. Since these were hung, we can be confident that they were all paintings.

Another distinctive feature of the Six-Syllable riverbank ritual is that the patron, who joins the monks on the main boat or in a smaller accompanying boat, casts straw rings and dolls into the river during the service in order to lead evil away. The ritual must have been a loud torchlit spectacle to those on the riverbank who witnessed monks in the boat hitting gongs, beating drums, blowing conch shells, and chanting. Six-Syllable riverbank rituals were conducted at various rivers in the Kansai area, including the Katsura and Ōi rivers.[91] As mentioned in Chapter One, both *The Tale of Heike* and *Taiheiki* list the Six-Syllable riverbank ritual as one of the rites used to bring about successful childbirth.

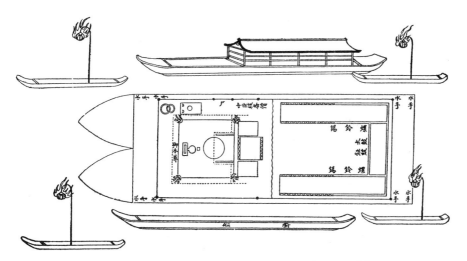

FIGURE 4.15. Diagram of boat for Six-Syllable riverbank ritual. Original from 1088. From *Rokuji karinhō, ZGR* 26, pt. 1:56.

Ono no Ningai is given credit for completing the main design of the Six-Syllable mandala by adding on to the Kanshuku-style mandala. Ningai purportedly added the six Jusojin surrounding a mirror on the base of Mount Sumeru. The six Jusojin, who look like heavenly beings, make the gesture of adoration. Textual descriptions do not give specific reasons why Ningai enhanced the Six-Syllable mandala, but by adding these six figures shown standing in water, we can imagine that as a prominent rainmaker he would have been well equipped to exploit the mandala's relationship to water. After all, Ningai's first performance of the ritual, in 1008, took place in the context of disaster prevention rituals done after a storm that caused lightning to strike and burn the palace.

In the two previously discussed blue mandalas from Hōonin and Hasedera, and in the Nōmanin iconographic drawings, three of the six figures are named with Siddham script placed next to them, while the three others do not have names. The name of the one on the upper right can be transliterated from the Siddham script into Japanese as Kibune, which refers to an area north of Kyoto known for its river of pure water and as a place for rainmaking rituals.[92] A vestige of this practice is still held there annually on March ninth, mainly for the nearby inns and restaurants who rely on the excellent reputation of the Kibune River's water for successful business.[93] During the small festival, shrine priests make offerings and burn tablets inscribed with patrons' wishes.

The transliteration of the second named Jusojin figure is Kinpusen. Mount Kinpu is known as a sacred mountain in Yoshino that is an important Buddhist pilgrimage site, with temples all over the mountain. The third and last name, in the lower right, may be transliterated into Japanese as Suikazura or Suhikazura, which is again one of the deities at Kibune Shrine.[94] The identities of the other three Jusojin without written names were the subject of debate between twelfth- and thirteenth-century monk-authors. *Byakuhōshō, Genpishō, Hishō mondō,* and other sources name them as Yamao, Kawao, and Okufuka, which are also deities at Kibune Shrine, the place known for its pure river.[95] Moreover, a poem in *Ryōjin hishō* (Songs to make the dust dance), edited by Emperor Goshirakawa (1127–1192), confirms their identities as kami of Kibune, specifically Yamao, Kawao, Okufuka, and Suikazura.[96] As water spirits from Kibune, their power may have been either magnified or cleansed by the riverbank ritual, which takes place on water, to help cure illness, avert calamity, assist with childbirth, conduct exorcism, or remove nasty curses. Though the mysterious six Jusojin figures were often referred to as devas (*ten*) or kami and have the appearance of gentle nature spirits, they were also regarded as vengeful poisons that needed to be supplicated in the ritual.[97]

The thirteenth-century monk Raiyu commented in *Hishō mondō* that another master said that the three unnamed figures were not set and instead

were tutelary deities (*ujigami*) of the ritual patron's clan or land-protecting kami (*ufusuna*) of the officiant's homeland.[98] Under such a strategy, the names could be supplied at the time of the ritual according to the patron, and a Six-Syllable mandala kept by a temple could be used for different patrons at different times. Because this is the Six-Syllable mandala, Ningai, or earlier masters who initiated the idea, likely considered that *six* was an auspicious number of Jusojin figures to include. The nonspecific identities of the six figures provided the opportunity for practitioners to strengthen and localize a powerful ritual by identifying some of them with an impressive Japanese mountain, river, or kami of personal protection.

Of Mandalas and Syllables

This chapter surveyed the history of the Six-Syllable mandala as well as extant examples in order to consider its relationship to the broader cult of the Six Kannon. The tradition of the mandalas, with a distinctive purpose for use in the Six-Syllable ritual, should be viewed as a phenomenon that is independent from the images of the Six Kannon cult. Nevertheless, the Kannon depicted in the mandala share roots with the Six Kannon cult images featured as the main subject of this book. The texts *Mohe zhiguan* and *Ningai chūshinmon* are as central to the history of the Six-Syllable mandala as they are to the Six Kannon cult images. With syllables of text as its foundation, it should not be surprising that the Six-Syllable mandala adheres to the description in *Ningai chūshinmon* more faithfully than the esoteric Six Kannon images. Yet when comparing the texts with the paintings it is clear that they do not slavishly follow the written descriptions.

Based on the iconography of the images and the texts that discuss them, ample sharing took place between the Six-Syllable mandala and Six Kannon traditions. In the early Six-Syllable mandalas, the Eleven-Headed Kannon images actually have eleven heads, as they do in their esoteric guise. Although these extra heads disappear for the most part after the thirteenth century, later mandalas, such as in the Kisshōin and Rokujizōji examples, have apparent areas of blurring where the esoteric forms completely replace those described in *Ningai chūshinmon.*

The monk Ningai is credited with making the connections to Chinese sources and had an integral place in developing the Six-Syllable mandala, but what exactly was his role? Ningai's purported addition of the Jusojin figures, which could take on the names of Japanese landscape features and kami, solidly grounds the mandala within Japanese religion. Writers of the twelfth- and thirteenth-century ritual manuals evoke Ningai's presence in their texts

to make the connection from China to Japan and thus enhance the historical and practical prestige of the Six-Syllable tradition. Ningai did not simply bring a Chinese form to Japan, but his citation of *Mohe zhiguan* links the two cultures. *Ningai chūshinmon*'s claim that the Six Kannon were transmitted by unnamed earlier masters further bolsters the foundation of the cult by providing another way to bridge the long time span between the sixth-century *Mohe zhiguan* and the Six-Syllable mandalas used centuries afterward.

Painting the Six Kannon

SOURCES FROM THE THIRTEENTH CENTURY and earlier declare that many paintings were made for Six Kannon rituals, yet surprisingly few survive. The likely reason is that, like sculptures, if individual pieces within a set became separated, they might never again have the possibility of being recognized as part of a unit. Fortunately, the fourteenth-century painting set of Six Kannon from the Hosomi Museum is a substantial example that shows how, though one painting has gone astray, it is still recognizable as a Six Kannon group. On the other hand, the fifteenth-century painting of Six Kannon owned by Ryōsenji in Nara provides a significant example of one hanging scroll that neatly includes all Six Kannon. Its worn condition indicates that it was well used and thus demonstrates a high probability that similar paintings were made and retired.

This chapter will examine a diverse group of examples of Six Kannon paintings along with related works to argue that many more paintings once existed and have since been lost. In addition, we will consider the first significant expansion of Six Kannon into a group of seven. Finally, a set of sixteenth-century paintings from Kōdaiji in Kyoto will serve as a bridge between images of the Six and Thirty-Three Kannon cults.

An Early Iconographic Scroll with Six Kannon:
Sho Kannon zuzō

Before turning full attention to the early colorful extant Buddhist paintings of Six Kannon, an iconographic scroll painted only in black ink, which is owned by the Nara National Museum and known as *Sho Kannon zuzō* (Iconographic drawings of many Kannon), is worthy of consideration as an early source for Six Kannon imagery (Fig. 5.1, and see Fig. 1.6). The scroll, which was formerly owned by the Tanaka family, includes several varieties of illustrations of each type of Kannon (the number follows in parentheses) in the following order: Shō (5), Thousand-Armed (5), Horse-Headed (9), Fukūkenjaku (7), Byakue (4), and Nyoirin (15).[1] Oddly, the scroll does not

FIGURE 5.1. *Sho Kannon zuzō,* detail of Nyoirin Kannon section. Twelfth century. Ink on paper. 30.0×1,064.3 cm. Nara National Museum.

include Eleven-Headed Kannon, which became a standard member of the Six Kannon group in later years. The beginning title as well as the first heading for the Shō Kannon images is missing, but a postscript clarifies the scroll theme as Six Kannon and as such reveals the period's varied possibilities for Six Kannon.[2]

Although the first postscript states: "The monk Jōshin from Kiyomizu-dera in Kyoto wrote this brief record to propagate the Buddhist law in Jōryaku 2 [1078]" (Inscription 5.1 in the Appendix), specialists believe that because of the painting's style, line quality, and historical clues, this scroll is a copy produced in the late twelfth century. A second postscript states that it was copied in the second year of Ōho, which corresponds to 1162, but the dates below, "ki no tora" (wood-tiger) in the sexagenary cycle, do not match that year. More appropriately, the "wood-tiger year" corresponds to the second year of Ōtoku (1085), a word that begins with the same character of "Ō." It appears that the copyist mistakenly wrote a similar second character that reflects a more recent date. Therefore, the existing scroll is likely a copy made in the years after 1162 of an original work that dated from 1085.[3]

In the two postscripts Jōshin provides clues that this scroll represents the Six Kannon. He repeatedly states that in *Mohe zhiguan* each of the Six Kannon corresponds to one of the six paths of transmigration, and in reference to Nyoirin he reiterates that the six arms have the ability to save beings on the six paths.[4] Nyoirin, who is most often depicted with six arms, seems to have been particularly important to Jōshin since the scroll has fifteen representations of Nyoirin, including in three mandalas, which is a greater number than any other type of Kannon represented.

A feature of the Nara scroll that is of great value to our study is that Byakue Kannon is given as one of the Six Kannon, and one of its representations holds a rope in the left hand and a sutra box in the right with accompanying text that describes the attributes. The same type of image appears in the iconographic manuals *Zuzōshō* from the twelfth century and *Besson zakki* from the thirteenth century.[5] If we accept that an earlier scroll existed with a date corresponding to 1078, upon which the Nara scroll was based, the images in *Sho Kannon zuzō* are all the more significant because they predate all well-known iconographical sources. Byakue as a member of the Six Kannon never became very popular, but we will encounter this phenomenon later.[6] Although without pictures, if we refer back to the Tendai School text *Nyūshingon monjū nyojitsuken kōen hokke ryakugi* (Abbreviated rite for exposition of the lotus), discussed in Chapter One, which includes Byakusho (an alternate name for Byakue) as one of the Six Kannon, Byakue's presence in Jōshin's scroll should not be a complete surprise.[7] Moreover, the fact that there is a fourteenth-century copy of this scroll in the Arthur M. Sackler Museum at Harvard demonstrates its circulation.[8]

By definition, an iconographic manual is a work to be copied, and accordingly in the related scroll *Shoson zuzōshū* (Iconographic scroll of various deities) owned by the Museum of Fine Arts, Boston, we find some of the very same images. This scroll appears to be by the hand of more than one artist and dates from the twelfth to thirteenth century. The Kannon images represented do not follow the same order, but *Shoson zuzōshū* includes many identical illustrations of Kannon with some of the same portions of descriptive text and so may have had the same original source as the Nara National Museum scroll.[9] The Boston scroll does not focus exclusively on Kannon iconography, as it includes many additional deities, yet the images in common with the Nara scroll are remarkable. Among them, the similar images of Byakue with a rope and sutra box in each scroll are of particular import. The iconography in the scrolls from Boston and Nara will serve as possible sources in the following section.

Six Kannon Panel Paintings in Boston

The exquisite panels decorated with seated images of Six Kannon at the Museum of Fine Arts, Boston, are painted in brilliant color and embellished with gold on lacquered wood (Plates 14–19). While vastly different in technical execution and media, like the Chōanji sutra box panels discussed in Chapter Two the Boston panels also served as the sides of a container. Without solving the mystery definitively, I will frame the evidence to propose possibilities for its original form. The Museum of Fine Arts assessed the

panels' date of production as the fourteenth century by examining the materials and painting style.[10] Indeed, the precise lines, vibrant colors, and use of cut gold (*kirikane*) are comparable to dated Buddhist paintings on lacquer of the period.

The artist (or artists) made attempts to individualize the colors and designs of the halos and the various parts of the bases for each Kannon image, yet the bluish-gray lacquer background in the upper section and the style and proportion of the images show an overall uniformity. Each panel has the remnants of hinges on one side, demonstrating its former function as a door. The panels formed a *zushi*, or tabernacle, that contained something precious. In general, a small-scale *zushi*, also referred to as a portable shrine, is a container that was used for private devotion, differing from a large-scale *zushi* used to house a full-size Buddhist sculpture within a Buddhist hall. According to museum records, when the panels were conserved in the 1970s, Masonite backings were added to each for stability. Therefore, the reverse, which was likely plain black lacquer, is now covered and unavailable for examination.

William Sturgis Bigelow (1850–1926), who went to Japan in 1882 and stayed for seven years, was one of the founders of the Asian art collection at the Museum of Fine Arts, Boston, and the panels represent a tiny fraction of the more than 3,500 paintings he donated to the museum. Bigelow probably purchased the Six Kannon paintings in Japan as individual flat painted panels after their disassembly from a three-dimensional tabernacle.

Many such lacquer doors painted with individual Buddhist deities may be found on *zushi* made from the fourteenth to the sixteenth centuries. Comparable hinged door pairs that are designed to meet in the center and can be folded back when open are called *kannonbiraki tobira*, literally "Kannon-opening doors," which is a term derived from the fact that many *zushi* with this door style house images of Kannon. Although most small-size *zushi* have four doors, six doors (three pairs) on the sides of some enhance the visibility of the interior, which in some cases enshrine small jewel-shaped reliquaries.[11] Since most *zushi* were rectangular, if there were six doors (each with one Kannon), a possible door arrangement would be to have two doors on the front and two on each side, with a back panel that does not open.[12] Descriptive data about the Six Kannon on the door panels has been catalogued by the museum with the identities described in Table 5.1. Also refer to my reconstruction diagram in Figure 5.2.

The images of Shō, Horse-Headed, and Nyoirin are easily recognizable, with no possible alternative identities for the latter two. Surprisingly, although sets of Six Kannon usually include Thousand-Armed and Eleven-Headed, they do not appear in these panels.

TABLE 5.1 Information on the Museum of Fine Arts, Boston, Six Kannon Panel Paintings

MFAB ACCESSION # SIZE PLATE NUMBER	KANNON NAME	ATTRIBUTES	COLOR OF BODY	COLOR OF ROBE	NUMBER OF ARMS
11.6224 63.1×20.9 cm Plate 14	Horse-Headed	Horse-head in crown, baton, blue lotus, water bottle, wheel, ax-key, three heads, horse-mouth mudra	Red	Red skirt and gold scarf	Eight
11.6225 63.4×20.7 cm Plate 15	Shō	Red lotus, freedom from fear mudra	White	Gold	Two
11.6226 63.2×25.0 cm Plate 16	Juntei	Lotus, jewel on pole, sutra, conch shell, wheel, flower vase, water vase, vajra, sword, flower wreath, axe, fruit, key, rosary, wheel-turning mudra, freedom from fear mudra	Gold	Gold	Eighteen
11.6227 63.2×25 cm Plate 17	Fukūkenjaku	Lotus, hands in prayer, noose, giving mudra monk's staff, flywhisk, deerskin scarf with attached deer head	Gold	Gold, green scarf	Eight
11.6228 63.3×20.8 cm Plate 18	Nyoirin	Wheel, rosary, red lotus, jewel, rock submerged in water under lotus base	Gold	Gold	Six
11.6229 63.2×20.8 cm Plate 19	Byakue (White-Robed)	Sutra box, rope	Gold	Gold	Two

The table confirms the distinctive iconography for both the Fukūkenjaku and Juntei images: especially because of the characteristic deerskin scarf on Fukūkenjaku and the eighteen arms with specific attributes for Juntei, there is no likely possibility of different identifications. As discussed in Chapter One, within sets of Six Kannon the Shingon preference is for Juntei and the Tendai preference is for Fukūkenjaku, so to have Fukūkenjaku and Juntei in the same painting group is surprising at this early date. Some

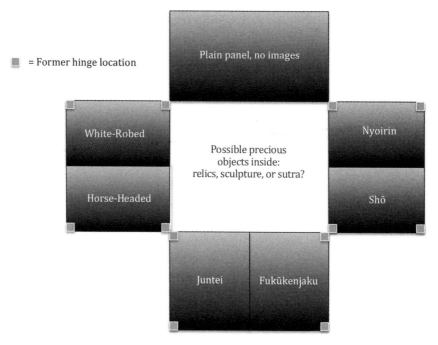

FIGURE 5.2. Reconstruction of possible configuration of Six Kannon tabernacle. From Museum of Fine Arts, Boston. Images faced the interior with the doors opening out. Top and bottom no longer extant.

iconographic studies, however, which were done to explain the complexities of Buddhist imagery, show these two together and of equal stature, such as the aforementioned *Shoson zuzōshū* that originated in 1078.[13]

Within the group of panel paintings, the image identified as Byakue, holding a sutra box and rope, is the most unusual, but it resonates with the images in the iconographic scrolls from Nara and Boston just discussed. Interestingly, although Byakue means "white-robed," the one in the panel has a robe of gold. From the fifteenth century on, Byakue becomes a popular subject for independent paintings of Kannon, especially in monochrome ink for the Zen School. Again, as further confirmation that the inclusion of Byakue is not an anomaly, the previously discussed scrolls *Sho Kannon zuzō* from Nara National Museum and *Shoson zuzōshū* from Boston include among their Six Kannon an image labeled Byakue with the same pose, crown shape, rope, and sutra box.[14] Therefore, such an iconographic source could have been used as justification to have one in the Boston panel paintings' group of six.

Given that the panels appear to be from the same set, a likely *zushi* design for the fourteenth century would be one with door pairs on three sides and a plain, stationary back. The two doors with Juntei and Fukūkenjaku

would have stood next to each other on the front, as they are the same wider width (25 cm), the hinges are on opposite sides, and the tile designs of the floor have a matching pattern, a grid of gold lines on a green ground. The images of Horse-Headed and Byakue were likely next to each other because they both have the same width (20.8 cm), hinges on opposite sides, and matching floor tile designs that differ from the above pair. Finally, Nyoirin and Shō have the same width (20.8 cm) and the hinges are on opposite sides. Because Nyoirin has the customary rock base submerged in water instead of a tile floor pattern, it does not match its corresponding door. A comparable *zushi,* dating from the fourteenth to fifteenth century from Kōfukuji, has two door pairs with matching tile patterns that differ between pairs.[15]

What might have been enshrined inside the tabernacle? The concept at work in this type of glorious container is that of *shōgon,* or ritual adornment, in which patrons received karmic merit for adorning Buddhist objects, as they would for sponsoring an image or copying a Buddhist text. If an image had been enshrined inside the *zushi,* it was likely a Buddha.[16] However, many such *zushi* enshrined sutras. Because of the strong connection between Kannon and the *Lotus sūtra,* and more specifically with Six Kannon as evidenced by the Chōanji sutra container, veneration of this sutra in the proposed tabernacle is a distinct possibility.[17]

Large-Scale Six Kannon Paintings at the Hosomi Museum

Of all the painted Six Kannon images, the large-scale set from the Hosomi Museum in Kyoto is the most grandiose. The museum, which was founded in 1998 based on the collection of the Osaka industrialist Hosomi Ryō (1901–1978), owns five of an original set of six large-scale, richly colored individual paintings of Kannon made in the fourteenth century that are in excellent condition (Plates 20–24).[18] The painting of the Horse-Headed Kannon, which would complete a Six Kannon set, is missing. As with the Boston paintings just discussed, these paintings have individualized features, but share a uniformity of size and style, so their appearance as a group is unmistakable. This section will address theories about the paintings' history, dating, iconography, and past functions.

With large areas of flat, vivid colors contrasted with strong, steady lines, the paintings have a consistency of style found in fourteenth-century Japanese Buddhist painting.[19] At the center of each painting is a single image of Kannon seated on a lotus base and backed by a mandorla surrounded by red flames. The paintings have relatively flat backgrounds, with a variety of objects placed above and below the figures, and are framed by a red border with the design of surrounding single-pronged golden vajras. While the

Kannon images of Shō (Plate 20) and Eleven-Headed (Plate 21) have white bodies with red shading and gray lines, Thousand-Armed (Plate 22) and Nyo-irin (Plate 24) have yellow bodies with red lines, and Juntei (Plate 23) has a yellow body with gray lines. In some of the ritual objects and jewelry, the *urahaku* technique was used, in which gold foil is applied to the back of the silk to show subtly through the front surface. There is no apparent cut gold. The artist or artists gave the works consistency to make them recognizable as a set, but also created lively variety in the paintings by changing the colors, patterns, and surrounding attributes in each. In regard to construction, the paintings are so large that three pieces of silk were needed to construct each one. The organization of the silk pieces as horizontal, rather than a more typical vertical placement, is a feature of the fourteenth century.[20]

While most publications on the Hosomi set agree that the paintings are significant fourteenth-century works, the level of enthusiasm for them has grown over the years. In 1973 the noted Buddhist painting specialist Yanagi-sawa Taka dated the Hosomi set to the mid-fourteenth century, but did not comment on the style in the most flattering terms. She opined that the paintings were properly painted in traditional technique with uniformly thin lines, but that the immature flatness and limited color harmony were representative of the "period of decline" in Buddhist painting.[21] In the land-mark 1981 exhibition catalogue on Kannon, Kawahara Yoshio repeated some of Yanagisawa's language on style, but in general he was much more positive about the works.[22] Later publications about the paintings are more flattering, especially those published by the Hosomi Museum.[23] To date Maizawa Rei has written the most in-depth article on the Hosomi Six Kannon paintings, to which I am indebted and from which I draw for the discussion below. To place these attitudes in context, we must consider that the brilliant painting scholar Yanagisawa belonged to an era when it was commonplace to privilege Buddhist art made before the end of the Ka-makura period and denigrate that which came afterward. Maizawa's ex-cellent article on the paintings in a major art history journal demonstrates that the field of Japanese art history has grown to accept a wider range of later Buddhist works as worthy subjects of study.

Almost all scholars seem to agree that the Hosomi paintings date from the fourteenth century. Yanagisawa dated them to the mid-fourteenth century, but Maizawa countered that they may have been made in the early fourteenth century. She selected some early fourteenth-century paintings to show similarities to works from this time while acknowledging that few appropriate comparisons exist.[24] Since the distinction between an early or mid-fourteenth century cannot be proved, I interpret the date as the first half of the fourteenth century.

The Hosomi paintings are a paragon of a Six Kannon painting set and the best model to extrapolate the appearance of lost painting sets. For the most part, the iconography of the Hosomi set was based on the images in Genzu mandara, literally "current-depiction mandala," which refers to the final version of the Womb World mandala that Kūkai brought back from China and considered standard for the Shingon School.[25] A discussion of distinctive features of the individual works in the Hosomi paintings will precede their consideration as a set.

1. Shō. (Plate 20) Compared to the other images in the Hosomi group, the figure of Shō Kannon has the most unusual features, setting it apart from most depictions of this deity. In particular, the figure's head halo is painted in a pattern of wavy multicolored rays curled at the ends, which is often found in esoteric paintings of Buddha images, such as Dainichi and Ichiji Kinrin.[26] Another surprising feature is that above the figure's halo are seven jewels floating on clouds, which are linked to the seven stars of the Big Dipper, *hokuto shichisei*. This special feature is associated with the subject known as "Hasshūron Dainichi" (Dainichi of the Treatise on the Eight Schools), which is an episode of Kūkai's life story. Purportedly when the ninth-century Shingon patriarch was debating religious theory with monks from eight different schools (the six older schools of Nara Buddhism along with Tendai and Shingon) at the emperor's residence within the Imperial Palace, Kūkai manifested himself as Dainichi in order to demonstrate the concept that one can become a Buddha in one's very body.[27] Authors who have discussed this painting recognize the subject by the seven stars, but are uncertain why the stars are depicted here. Maizawa makes a case that the stars, as well as the patterned halo, give the Hosomi Shō Kannon a special Buddha-like status.

2. Eleven-Headed. (Plate 21) Eleven-Headed Kannon images usually have two arms, but in this case the image has four. One of the right hands is held down in the gesture of giving and charity and the other holds a Buddhist rosary. On the left side, one hand holds a lotus and the other holds a water container.

3. Thousand-Armed. (Plate 22) This majestic Thousand-Armed Kannon has two of its hands held up over the crown, together supporting a small Buddha image, which is a feature of the "Kiyomizudera style" because the secret image of this deity at Kiyomizudera in Kyoto is believed to make this distinctive gesture. These two hands and the small standing Buddha are framed by a boat-shaped head halo that differs from the other paintings in the set. The image's forty-two arms are a common abbreviation for the number of arms in a Japanese Thousand-Armed Kannon image,

yet the background of this image's round golden mandorla is a more emphatic reference to the thousand in that it is completely filled with tiny hands depicted in light gray outlines. Maizawa noticed that this figure also contrasts with the others in the set because of its Chinese flavor, especially apparent in the long fingernails, which Japanese Buddhist artists depicted to indicate a style associated with Song-dynasty (960–1279) China.[28] By contrast, the figures in the other paintings have short, clipped fingernails. This painting also differs from the others in that water is represented in the lower section of the painting and the lotus base appears to be balanced on waves or a plantlike configuration.

4. Juntei. (Plate 23) As discussed in the first chapter, the inclusion of Juntei Kannon in the Hosomi Museum set indicates that it was most likely made for Shingon School use. Below the Juntei figure is a two-pronged vajra on the left and a three-pronged vajra on the right that sit upon lotus bases and are surrounded by flames. When fitted together the two vajras make up a special split five-pronged vajra, or *warigokosho*.[29] Although single, three-, and five-pronged vajras are ubiquitous in esoteric Buddhist art, the *warigokosho* is an uncommon ritual object and rarely found in paintings. The previously discussed iconographic scroll *Shoson zuzōshū* from the twelfth- to thirteenth-century in the Museum of Fine Arts, Boston, has a Juntei image with most of the same features, including the *warigokosho* separated between the flower vase at the bottom and the relatively unusual feature of seven Buddha images emanating from the top of Juntei's head.[30] The seven-Buddha configuration echoes the seven stars in the set's Shō Kannon image.

5. Nyoirin. (Plate 24) The six-armed image of Nyoirin follows the style and iconography that is standard for an esoteric image of the deity in this period. Floating above the image is a blue lotus canopy with a single-pronged vajra across its center. Below the image is a border of patterned rectangles, which might represent the edge of a table for ritual objects.

Provenance of the Paintings

Traditionally, the Hosomi set of paintings is thought to have come from Tōji, the major Shingon Buddhist temple in Kyoto, because there is a reference to a set of Six Kannon paintings in *Tōbōki* (Record of treasures from Tōji).[31] Lists of temple property, which vary in accuracy and amount of detail, are valuable sources of information for Buddhist art provenance. *Tōbōki* is a highly significant fourteenth-century compilation of Tōji-related texts, assembled mainly by the Tōji prelate Gōhō (1306–1382). The ostensible reference to the Hosomi paintings is found at the beginning of the *Tōbōki* section

bearing the title *Saiin anchi honzon shōgyōtō tsuika mokuroku* (Supplemental catalogue of images, ritual texts, and other items enshrined at Saiin [west precinct]), referred to as *Tsuika mokuroku*.[32] Gōhō's disciple Kenbō (1333–1398) from Kanchiin (a subtemple of Tōji) made additions to *Tōbōki* in this supplement during 1396–1398 (Ōei 3–5). Specifically, the painting reference is in the *Tsuika mokuroku* section on the Mieidō (Founder's portrait hall), which is a highly significant building in Tōji's west precinct (Saiin) that houses a substantial collection of objects. Sadly, it burned in 1379 (Kenryaku 1) but was rebuilt the following year. The entry in question, titled "Roku Kannon zō roku ho" (Six Kannon images, six paintings), clearly identifies a set of six individual paintings. However, there was room for doubt as to whether this referred to the Hosomi set because the description stated that the set was in the Koryō-period (918–1392) style of Korean painting and that the painting of Nyoirin Kannon was missing (instead of Horse-Headed as in the Hosomi Museum group).[33]

Possibly the author, Kenbō, may not have been able to recognize the difference between Korean and Japanese styles of painting and was simply mistaken about which painting was missing. Recently however, Niimi Yasuko carefully researched and compared the different Tōji property records and found more convincing evidence.[34] Kenbō appended *Tōbōki* about twenty years after the 1379 (Eiwa 5) Mieidō fire and around the same time, in 1396–1403 (Ōei 3–10), Kōju, who was a monk from Hōgonin (a subtemple of Tōji), compiled another Tōji Mieidō property record called *Saiin Mieidō naigejin gusoku mokurokuan* (Record of the west precinct founder's hall inner and outer sanctuary possessions), which states that sometime after 1379 a certain person donated five paintings from a set of Six Kannon images with a missing Horse-Headed Kannon.[35] Because this record states that the Horse-Headed Kannon is missing, rather than Nyoirin, and all of its other entries match the *Tsuika mokuroku* list, it seems that Kōju corrected the error about the missing painting, and therefore both lists do indeed refer to the Hosomi set. Furthermore, as corroboration by omission, Kenbō's previous list of Saiin treasures from 1364 (Jōji 3) and the even earlier list made in 1277 (Kenji 3) did not include Six Kannon paintings, so they must have arrived after the fire.[36] Moreover, the underside of the lid of the box that formerly held the painting set has an inscription dated to 1753 (Hōreki 3), stating that it held Six Kannon with one missing, and thus provides further evidence that the set belonged to Tōji and continued to be kept there long after the fourteenth century.[37]

If we accept that the paintings were made before the late fourteenth century, as Yanagisawa, Maizawa, and others have argued, they were likely elsewhere before the Mieidō. If the set had come into the Mieidō with one painting missing, it was likely neither brand new nor made as a specific

commission for the building's collection, but came from one of the major Shingon establishments active in the fourteenth century.[38]

The Hosomi Shō Kannon Painting and the Six-Syllable Mandala

In her examination of the Hosomi paintings, Maizawa argued that the distinctive Shō Kannon painting shows a relationship to one type of main image used in the Six-Syllable ritual (Rokujihō). As discussed in Chapter Four, according to the twelfth- and thirteenth-century manuals *Zuzōshō* and *Besson zakki,* the Six-Syllable ritual had five different options for main images.[39] Again, the first type is the Six-Syllable mandala that Kanshuku created and Ningai enhanced, illustrated by the fourteenth-century examples owned by Daigoji (see Plates 9, 12), and the second type is a Shō Kannon mandala (Fig. 4.14).[40] *Shinzoku zakki mondōshō,* written in 1260–1282, states: "Even though the different explanations of the main images among the branches have complicated roots, the various branches at Daigoji make Shō Kannon the main image. Sanmon (Enryakuji) makes Six Kannon the main image. Kajūji and Ninnaji do the same. Nowadays the Kanshuku mandala is made as the main image."[41] (Inscription 5.2 in the Appendix.) Hayashi interpreted this statement to mean that the branches of Buddhism associated with Daigoji previously used the Shō Kannon mandala for the Six-Syllable ritual before the Kanshuku type became the dominant form.[42]

That the Shō Kannon has the most lavish coloring within the Hosomi set suggests that it had a more prominent role in the ritual than the other paintings. Maizawa found that the Hosomi Shō Kannon painting's relationship to the Six-Syllable mandala is revealed by its distinctive head halo. As mentioned previously, this style of multicolored halo is most often used for a Buddha image, such as Ichiji Kinrin or Dainichi.[43] Some esoteric Buddhist texts say that Shō Kannon and Ichiji Kinrin have the same body.[44] Others, such as *Shiku* (Spoken word of the masters), compiled by Yōzen (1172–1259), explain that Shō Kannon can be used instead of Ichiji Kinrin in a Rokuji ritual.[45] Moreover, as discussed above, the iconography of the seven stars in the Hosomi Shō Kannon relates to Dainichi Buddha. Since the painting of Shō Kannon takes the features of a Buddha like Dainichi, who is the supreme Buddha in the Shingon School, or Ichiji Kinrin, who is at the center of the Kanshuku-style Six-Syllable mandala, the image is distinctive and seems to have a higher status than usual. Indeed, the images of Shō Kannon in the previously discussed Boston door paintings and in the Ryōsenji painting to be discussed next, do not have these Buddha-like features.[46]

As another indication of Shō Kannon's privileged position, the text *Roku Kannon gōgyōki* (Record of the Six Kannon procedures), dated Bunmei 6 (1474)

and found in *Monyōki,* gives one arrangement but specifies that within the group of Six Kannon paintings, Shō Kannon should be in the center facing south, and while Shō should face front, there is nothing set about the others.[47] The thirteenth-century record *Roku Kannon gōgyō shiki* (Personal record of Six Kannon procedures), from Shōrenin and dated 1236 (Katei 2), includes two diagrams of configurations for Six Kannon with the names for each marked by a *shuji,* or seed syllable, as well as abbreviated characters. The upper diagram has Shō Kannon in the center, and clockwise from the one o'clock position, the surrounding images are Fukūkenjaku, Nyoirin, Thousand-Armed, Horse-Headed, and Eleven-Headed.[48] The long rectangular diagram below shows the Kannon images in a line from right to left in the following order: Fukūkenjaku, Shō, Nyoirin, Thousand-Armed, Horse-Headed, and Eleven-Headed. The upper diagram seems to show an option to display Six Kannon featuring Shō in a single mandala, while the lower diagram shows a possible arrangement for Six Kannon images lined up across a single wall. *Asabashō* from 1252 includes a diagram similar to the upper one, with a following sentence that claims there is no single standard for the forms or setups of Six Kannon.[49] Thus, ritualists had options for arrangements depending on the types of images and ritual spaces available.

The only known documented Shō Kannon mandala is the above-mentioned diagram consisting of *shuji* in *Kakuzenshō.*[50] In the center is Shō surrounded by the other five Kannon, beyond which are various lower-ranking deities organized in concentric rings (Fig. 4.14). As a related work, Hayashi On argues that a fourteenth-century painting from Chōjuji in Shiga prefecture depicts a Shō Kannon mandala that was used as a main image for the Six-Syllable ritual.[51] The work in question is an unusual triad, with Shō Kannon seated on a dais positioned above two flanking figures, Fudō Myōō on the right and Daiitoku Myōō on the left. Although it too differs from the *Zuzōshō* and *Kakuzenshō* descriptions of Shō Kannon mandalas, the Chōjuji painting has several shared features with the Kanshuku mandala, the most familiar main image for the Six-Syllable ritual, such as the duo of Myōō in the same position. Endowed with related iconography, the Chōjuji painting is a more persuasive candidate for a Shō Kannon mandala than the Hosomi Shō Kannon. Without asserting that the Hosomi Shō Kannon painting was actually ever used in a Six-Syllable ritual, Maizawa's analysis furthers the discussion for more flexible interpretations of these works. Taking a step further, it is possible that the creators of the Hosomi set assumed that individual paintings from the set would occasionally be employed for different ritual purposes. After all, thirteenth-century texts claim that Shō Kannon can stand alone in the Six-Syllable ritual in place of all Six Kannon.[52]

As we see in the Hosomi group, and in many other examples in this book, images from Six Kannon sets have gone missing. Returning to *Roku Kannon gōgyōki,* found in *Monyōki* from 1474, the *ajari* brought only five scrolls (paintings) of Shō Kannon, Thousand-Armed, Eleven-Headed, Nyoirin, and Fukūkenjaku to use for the ritual, but neither the patron nor the *ajari* had one of "Batō Myōō" (Horse-Headed Bright King), here referred to by the alternate name for Horse-Headed Kannon. For that occasion the patron requested an artist named Onki to make a new one.[53] Instead of commissioning an entirely new set, this passage shows how monks and patrons were able to modify an incomplete group of paintings by adding one. In comparing the *Monyōki* record to the Hosomi painting set, we see another instance of a missing Horse-Headed Kannon painting. As tempting as it would be to suggest this might be the same set, because the *Monyōki* is a Tendai record with the inclusion of Fukūkenjaku Kannon, it does not refer to the Hosomi set. Were Horse-Headed Kannon paintings so desirable or scarce that they were used for other rituals and not returned? The *Monyōki* passage demonstrates that ritual practitioners could take practical actions to make modifications when necessary. After all, paintings were expensive to commission, and those responsible must have wanted to make the most of their investments.

Six Kannon in One Painting from Ryōsenji

A little-studied painting from Nara is a precious depiction of all Six Kannon on a single hanging scroll. This fifteenth-century painting on silk owned by Ryōsenji, a Shingon School temple located west of Nara City that has numerous treasures of Buddhist art and architecture.[54] This painting (measuring 108.2 × 39.7 cm) appears to be exquisite, but its muted brown color and patchy surface from centuries of wear make details difficult to see (Fig. 5.3). The background appears plain for the most part, but thin gold lines to suggest clouds remain faintly at the top edge of the painting. Despite the fact that all Six Kannon are depicted in a circular pattern, the figures differ significantly in iconography from those found in the Six-Syllable mandala. Instead, we find the more familiar Shingon esoteric Six Kannon images. Moreover, they are not in the order of either the Myōsen or Kanshuku traditions, nor of the ritual diagrams discussed above. Beginning at the top position and moving clockwise, the images are in the following order: a seated six-armed Nyoirin (on a rock base below a red lotus with a round mandorla), a standing Thousand-Armed Kannon, a standing Horse-Headed Kannon (with a red body, three heads, two arms, and the front of the left foot raised) (Fig. 5.4, detail of 5.3), a standing Eleven-Headed Kannon, a stand-

ing eighteen-armed Juntei, and a standing Shō Kannon holding a red lotus.

The few published sources claim that according to unspecified "old records," the painting is considered to have been painted in the Ōan era (1368–1375) by the Buddhist painter Yūgen, who attained the rank of Hōgen in the official Nara painting studios.[55] The back of the painting has an inscription stating that it was repaired in 1541 (Tenbun 10). We should consider that the painting was made between fifty and a hundred years before the repair because the techniques used in the painting are representative of the fifteenth century.[56] The painting has accents in gold paint as well as some cut gold on the edges of the mandorlas. The care and expense taken to create the painting extends to the process of using gold foil applied to the back of the painting (*urahaku*) for the Thousand-Armed Kannon and the process of reverse painting (*urazaishiki*) in the other images, where pigments were applied on the reverse side of the silk. Both techniques show through the silk to enhance the brilliance of the front surface. Lavishly executed as this painting was, it would have been less costly than the commission of six individual paintings.[57] Surely similar works with Six Kannon together in a single hanging scroll were produced but no longer survive.

Seven Kannon Instead of Six

Throughout this book the flexibility in the concept of Six Kannon is apparent as the number of images in the groups expands and contracts. Though never as widespread as Six Kannon, Seven Kannon worship became a significant phenomenon in its own right. While the earliest references are found in the thirteenth

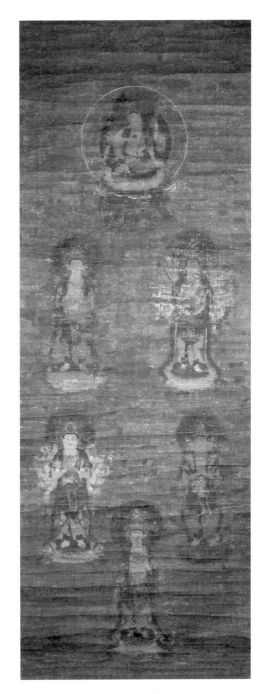

FIGURE 5.3. Six Kannon. Fifteenth century. Color on silk. 108.2 × 39.7 cm. Ryōsenji, Nara.

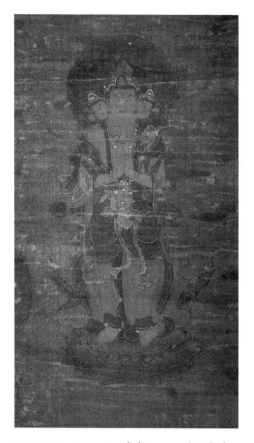

FIGURE 5.4. Horse-Headed Kannon, detail of Six Kannon painting. Fifteenth century. Color on silk. 108.2×39.7 cm. Ryōsenji, Nara.

century, evidence for Seven Kannon groups appears with greater frequency in the Edo period. The chronicle *Azuma kagami* (Mirror of the east) explains that Hōjō Masako (1157–1255) dedicated paintings of Seven Kannon in 1204 (Genkyū 1) to establish a relationship between the deities and the shōgun's family.[58] The same text explains that in 1250 (Kenchō 2) Tokiyori's wife dedicated a sutra reading at a Seven Kannon Hall.[59] The specific identities of the Kannon cannot be determined, but these entries reveal the early presence of Seven Kannon. In the late twelfth century and continuing into the sixteenth, Kyoto nobles participated in a Seven Kannon pilgrimage, Shichi Kannon mōde, in which each temple featured an important Kannon icon.[60]

The most famous place connected to Seven Kannon images as a group is the temple Shichi Kannon'in in Kyoto. The text *Roku Kannon Hachidai Kannon no koto,* published in 1705 (Hōei 2), explains that when Fukūkenjaku is added to a group of Six Kannon, laypeople define it as "Seven Kannon" because of the reputation of the Seven Kannon enshrined at Shichi Kannon'in.[61] Shichi Kannon'in, literally a temple for Seven Kannon, is located on the east side of the city in the neighborhood below the western slope of Kiyomizudera, southwest of Kōdaiji and the Yasaka pagoda. Today the main hall is visible from the side street, but there is no sign on its front gate and it is not open to the public. While its present circumstances remain a mystery, numerous historical sources discuss the group of Seven Kannon images from Shichi Kannon'in in detail as significant Kyoto icons, and the name appeared frequently on Edo-period maps.[62]

The following description summarizes the entry on Shichi Kannon'in from the gazetteer *Sanshū meisekishi* (Yamashiro record of famous traces) from 1711 (Shōtoku 1), which has a particularly detailed description. Shichi Kannon'in is a Shingon School temple with a gate and hall that face east. In the hall the center image of Nyoirin is seated and measures two *shaku* (60.6 cm). Horse-Headed and Fukūkenjaku are seated images that each mea-

sure one *shaku* (30.3 cm) and Shō, Thousand-Armed, and Juntei are standing images that each measure about one *shaku*, two or three *sun* (36.5–36.9 cm). Kūkai made the central image of Nyoirin and the Kasuga sculptors made the other six images that surround it. Beginning with the central image, they belonged to Emperor Takakura (who reigned 1168 through 1180) and were enshrined in the palace. By imperial order a temple was built to enshrine them as protecting images and was thus called Gojiin for peace and protection in the world. Later, after the other Six Kannon images made by the Kasuga sculptors were brought in, it was renamed Shichi Kannon'in for the Seven Kannon. The temple was first located in Higashiyama, then moved to central Kyoto in the area now called Karasuma Shichikannon-chō. Later it moved east of the palace and after that it moved to its present location.[63]

Other gazetteers fill out the details of the history and resurrections of the temple, but they do not always agree.[64] Some explain how Shichikannon-chō (Seven Kannon district), the former site of the temple located southwest of Rokkakudō across the now very busy Karasuma thoroughfare, was named after these images. The city of Kyoto still maintains the place name Shichikannon-chō in addresses and local signage.

Kyōhabutae (Silks of the capital) from 1685 (Jōkyō 2) refers to the temple Shichi Kannon'in as "Seven Kannon in front of Kōdaiji" and states that it was number eight in the Kyoto Rakuyō (Eastern Kyoto) Thirty-Three Kannon Pilgrimage.[65] Its reputation as an important center for Kannon veneration and the significance of its images were further promoted in the chronicle *Getsudō kenmonshū* (Getsudō's collection of things seen or heard), which proclaims that the images were shown in a public unveiling that lasted over a month in 1727 (Kyōho 12).[66]

Without having the Seven Kannon images available to analyze, we can consider how the Shichi Kannon'in images might have been perceived in the Edo period based on written documents, which is a direct contrast to the many examples in this book of extant Kannon images with little or no historical documentation. Most descriptions of Shichi Kannon'in single out the image of Nyoirin Kannon as the largest and earliest image, to which six were added to form the group of seven. *Sanshū meisekishi*'s discussion of their differences in size, positions of sitting or standing, and creators makes it possible to imagine them as a sanctioned mismatched group.

The claim that Kūkai made the Nyoirin image is not surprising, as images were often overzealously attributed to him, but the less fantastic attribution to the Kasuga sculptors, who worked in the Nara area, is more unexpected.[67] The government temple record called *Kyōtoshi jiin meisaichō* (Kyoto City temples detailed records) from 1884 repeats much of the same information found in the Edo-period documents, but it enhances the temple's imperial

connection.[68] Shichijōin (1157–1228), who was the mother of Emperor Gotōba (r. 1183–1198), had a dream that told of the Seven Kannon. Kūkai made the Nyoirin, which was the main image, and the Kasuga Myōjin deity made the six other Kannon: Shō, Thousand-Armed, Horse-Headed, Eleven-Headed, Juntei, and Fukūkenjaku. The story raises the images' spiritual capital by relating that the Kasuga deity made the six images, instead of the Kasuga sculptors.

Did a group of Seven Kannon images actually exist in the twelfth century and form the legacy for Shichi Kannon'in? Since the temple purportedly burned down several times, if there had been earlier images they are likely long gone. One possibility is that a new grouping of older images of different sizes from different places was assembled when the temple moved to its last location in the seventeenth century. The repeated specificity of the images' identities in the Edo-period texts reveals a strong interest in asserting this constellation of Kannon identities as a group. The examples from iconographic manuals and the Boston painted panels discussed previously notwithstanding, what is highly relevant to our study is that this is the earliest known written evidence for Fukūkenjaku and Juntei as part of the same sculptural icon group, as well as a set of Kannon in different sizes and positions.

Seven Kannon in *Butsuzō zui*

We now turn our attention to how groups of Seven Kannon became more prominent after the seventeenth century. As the quantity of published materials grew exponentially in seventeenth-century Japan, Buddhist material culture became accessible to a more diverse audience through the woodblock-printed iconographic manual titled *Butsuzō zui* (Collection of Buddhist image illustrations), which was the most widely distributed source for information on religious images. *Butsuzō zui* was originally published in three volumes in 1690 (Genroku 3) and then was expanded and republished in five volumes in 1783 (Tenmei 3).[69] Every few decades up into the early twentieth century, new publishers continued to rerelease the enlarged version to eager audiences.[70]

Butsuzō zui categorizes and organizes deities by framing their printed illustrations in black outline into grids across the book's pages. Of all the deities in this expansive work, Kannon was most frequently depicted. There are three different groups of Kannon in the manual. The first group of Kannon in the book is a set of Seven Kannon (Fig. 5.5), followed by the second, which is a group of Thirty-Three Kannon (Fig. 5.6), which was gaining popularity in Japan in the seventeenth century at the time *Butsuzō zui*

emerged. The third group of Kannon, which appears in a later section of the second edition of the book, consists of a group of Kannon icons from the Saigoku Thirty-Three Kannon pilgrimage route. The two latter groups will be discussed in the Chapter Six. The particular focus of this section is to consider the role *Butsuzō zui* had in the distribution of images of Six and Seven Kannon, and I contend that its wide distribution was instrumental in the recognition of Seven Kannon as a group.

Butsuzō zui was part of the seventeenth-century wave of publications created to categorize and organize knowledge. Mary Beth Berry discusses the myriad types of encyclopedic publications that were born in the Edo period.[71] For the most part, these secular comprehensive publications steered clear of religious matters, except for gazetteers, which discussed religious institutions.

As an iconographic compendium, *Butsuzō zui* contains illustrations of all forms of Buddhist imagery including Buddhas, bodhisattvas, heavenly beings, ritual equipment, and Buddhist patriarchs, as well as numerous unusual beings that could be categorized as hybrid Shinto–Buddhist deities. Again, in the first and second editions of *Butsuzō zui,* which have 713 and 824 illustrations, Kannon—with respectively 42 and 49 illustrations—appears most frequently of all the deities. An impressive list consisting of eighty-six sacred and secular texts that were consulted as references appears after the preface. Because the publication hails from a time before these images were considered art works and before the early Meiji period official separation of Buddhism and Shinto, it is a particularly rich source for Edo-period religion.

Early evidence for the practice of making iconographic manuals for religious images in Japan may be found in the eleventh and twelfth centuries, such as *Sho Kannon zuzō,* discussed at the beginning of this chapter. In general, *zuzō,* which functioned as commentaries on sacred texts and guides for image making, were stored by temples as precious documents and hidden away from the public. In the early part of the twentieth century, many iconographic texts were gathered together and published as part of *Taishō Tripiṭaka,* the Chinese Buddhist canon and Japanese commentaries assembled in the Taishō era (1912–1226), which could be consulted for ritual and scholarly purposes by anyone with access to a holding library.[72] In contrast, even though *Butsuzō zui* had a major impact on spreading knowledge of Buddhism for centuries, as a relatively inexpensive popular encyclopedic work that included popular Japanese religion, it was not revered as a sacred text, not included in the Taishō Buddhist canon, not considered gorgeous, and with a few exceptions never attracted much attention from scholars other than as a resource.

FIGURE 5.5. Seven Kannon with Willow Branch Kannon. 1752 (first published 1690).
Woodblock printed book pages. 23×28 cm. From *Shoshū Butsuzō zui*. (BQ4630.B89 1752).
Courtesy of the Library of Congress, Asian Division, Japanese Collection.

Given the large circulation and numerous times *Butsuzō zui* was reprinted, surprisingly little is known about its authors and illustrators. The first edition of *Butsuzō zui,* with three volumes consisting of illustrations and one of an index, was published in Kyoto in 1690. The preface explains the author's pious motivation to make a guide to holy images available to everyone. He states, "Anyone even a novice can learn the names and tell the similarities and differences."[73] The postscript gives the author's name as Gizan, but there is debate about his identity, especially because sectarian partiality is not apparent in the manual.[74]

The preface and postscript to the first edition (1690) of *Butsuzō zui* were retained in the second (1783). An additional new preface describes how the new author and illustrator Ki no Hidenobu of the Tosa School, also with the desire to help ordinary people understand Buddhism, reprinted the book because the woodblocks were worn out and he also wished to expand the volume.[75] Although we know that Tosa School artists were active in publishing illustrated books in the seventeenth century, there is nothing known about Hidenobu's identity.[76] Because of the wide breadth of coverage,

FIGURE 5.6. First two pages of Thirty-Three Kannon section. 1752 (first published 1690). Woodblock printed book pages. 23×28 cm. From *Shoshū Butsuzō zui*. (BQ4630.B89 1752). Courtesy of the Library of Congress, Asian Division, Japanese Collection.

rather than any single monk or artist, it is more likely that a bookshop or publisher compiled the information for both editions. Instead of piety as the prologues proclaim, the main motivation for the production was commercial success.

Group Pictures of Kannon

The first place to find Kannon in *Butsuzō zui* is in the second volume under the heading "Seven Kannon" (Fig. 5.5). As we have already seen, five of the Six Kannon include Shō, Thousand-Armed, Eleven-Headed, Horse-Headed, and Nyoirin. The additional Kannon image seems to differ depending upon sectarian preference.

Without sectarian bias or explanation for the two images, *Butsuzō zui* takes a comprehensive approach by presenting both alternates, Juntei and Fukūkenjaku, with equal stature in the group and titling it "Seven Kannon," and the expanded grouping provided artists with an updated model to copy. With few sources to draw from, the renowned Buddhist sculptor Takamura

Kōun (1852–1934) may have had *Butsuzō zui* in mind when he carved a large ensemble of Seven Kannon images for Daienji in Tokyo in 1930. Sadly, these sculptures were destroyed during a Pacific War bombing, but miniature images of each Kannon that had been kept inside them were saved.[77] Another surviving example of a Seven Kannon sculpture group from the nineteenth century may be found in a small tabernacle at The Field Museum in Chicago.[78]

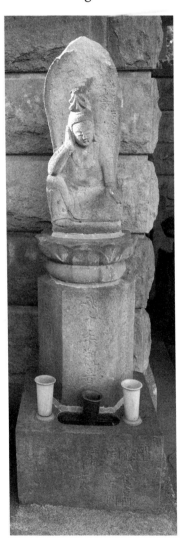

FIGURE 5.7. Seven Kannon monument (Nyoirin Kannon is on top with other Six Kannon in incised seed syllables below). 1811. Stone. 96 cm. Enkōin, Nerima, Tokyo.

The text included with each *Butsuzō zui* illustration in the Seven Kannon section gives the name, the corresponding Sanskrit seed syllable (*shuji*), and a short description of what the image holds or how it functions. Interestingly, it also provides each of the alternate identity names given in the highly respected sixth-century Chinese text *Mohe zhiguan*.[79] *Butsuzō zui*'s text on the Juntei Kannon claims to quote *Mohe zhiguan,* and indeed some parts of the text are accurate, such as Juntei's ability to destroy the three obstacles as well as pride, but the text is not an exact quote. That *Mohe zhiguan* does not say anything specifically about "concentration of the illusory body" (J. *nyogen sanmai*; Skt. *maya-upamā-samādhi*) as claimed in *Butsuzō zui*'s text on Juntei, demonstrates that editorializing embellishment took place in the book. Hattori Hōshō, one of the few authors to write about *Butsuzō zui*, critically cites its mistakes and use of apocryphal sources.[80] Misattribution and imaginative quoting aside, while *Butsuzō zui* cites the classics of the past to provide sacred authority for the illustrations, most readers would not have been able to check the facts.[81]

The adjacent two pages in *Butsuzō zui* with the heading of "Seven Kannon" (Shichi Kannon) have eight spaces of Kannon images rather than seven. The next page has the heading "Thirty-Three Kannon Bodies" (Sanjūsantai Kannon), with thirty-two images of Kannon follow-

ing. The first of the Thirty-Three, which is actually positioned on the previous page with the Seven Kannon, is the Willow Branch Kannon, one of the most well known of all the Thirty-Three Kannon. The creators of the book must have wanted to maximize the space to fit in the illustrations, so this image became the bridge between the pages for the Seven Kannon and the Thirty-Three Kannon. The text accompanying Willow Branch Kannon says: "It is said that because the willow branch waves as if it were in a spring breeze, it blesses all of the Six Kannon." (Inscription 5.3 in the Appendix.) Notably, this passage refers to the older idea of the grouping of Six Kannon rather than seven. Although many other praises could have been added to the Willow Branch Kannon illustration, the author chose to emphasize a felicitous connection between the two Kannon groups.

As will become even more explicit in the sections on Thirty-Three Kannon in the next chapter, *Butsuzō zui* circulated so widely that, even with its faults, it became the most accessible resource for artists and lay enthusiasts to consult for information on Kannon. At Enkōin in the Nerima ward of Tokyo there is a monument that literally sets the relationship of Willow Branch Kannon with Six Kannon in stone (Fig. 5.7). A six-sided stone banner (*sekidō*) from 1811 (Bunka 8), with a three-dimensional carving of a two-

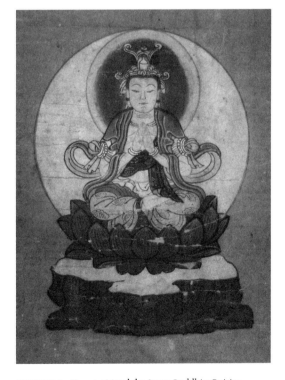

armed Nyoirin Kannon on top, has the corresponding Sanskrit seed syllables and names in characters for five of the other Six Kannon (including Juntei) to make up Six Kannon. In addition, on the sixth side of the pillar is the corresponding seed syllable and name in characters for Willow Branch Kannon.[82] This is but one example among many of how the presentation of Seven Kannon in *Butsuzō zui* may have aided in expanding the notion of Six Kannon to seven.

The Seven Nights of Waiting Ritual and a Painting in Cologne

A painting in the collection of Museum of East Asian Art, Cologne (Museum für Ostasiatische Kunst Köln), Germany, poses an interesting problem to study variations of Kannon groups (Fig. 5.8, Plate 25). Over the last century, Mu-

FIGURE 5.8. *Kannon Mandala: Seven Buddhist Deities,* detail of Seishi. Eighteenth century. Color on paper. 39.5 × 27.8 cm. Museum für Ostasiatische Kunst Köln.

seum records have titled it "Seven Deities," "Kannon Mandala," "Seven Manifestations of Kannon," or both together.[83] With a group of figures organized into three horizontal rows, the painting on paper, measuring 39.5 × 27.8 centimeters, was likely mounted as a hanging scroll before it came to the museum in 1913.[84] Like many exported paintings at the turn of the twentieth century, this one was remounted on a type of cardboard backing and framed. At some point the frame was removed and now the green-patterned backing paper remains visible around the edges. The figures in the painting are arranged as follows, with the body colors in parentheses.

	Thousand-Armed Kannon (gold)	
Eleven-Headed Kannon (gold)	Horse-Headed Kannon (red)	Shō Kannon (white)
Seishi Bosatsu (white)	Nyoirin Kannon (gold)	Juntei Kannon (white)

While the painting on the figures is in relatively good condition, the background paper is a faded tan color, with some damage from flaking paint and water stains. Each deity sits on a rock formation with a flat white top surface and craggy green sides. In the center position, Horse-Headed Kannon stands out, with a red body and round red mandorla embellished with gold flames. The other images have round white mandorlas outlined in red. The figures' lotus-petal bases, scarves, and skirts are painted in variations of red, white, blue, brown, and green. Each figure also includes some gold paint in different places on the crowns and accessories, and in the case of the Thousand-Armed, Eleven-Headed, and Nyoirin figures, the bodies are painted gold. A steady hand executed the thin, precise outlines of each image. With its uniformity, flat color, and sharp outline, the work is consistent with eighteenth-century Japanese Buddhist painting.

The configuration of the seven figures of Six Kannon with Seishi Bosatsu (Skt. Mahāsthāmaprāpta Bodhisattva) in the painting is relatively rare, and I propose that it reflects the commemoration of a ritual known as Shichiyamachi, "Seven Nights of Waiting," that was practiced in Japan beginning in the sixteenth century. Before returning to the Cologne painting and its role in the ritual, I will elucidate this now-lost practice. As evidenced by surviving stones in situ that were erected outdoors to commemorate Shichiyamachi, the ritual was most popular in Tokyo, Saitama, and Kanagawa in the eighteenth century. Shichiyamachi is a longer version of the broader phenomenon called Tsukimachi, "Waiting for the Moon," in which groups of people, often women, participated in all-night gatherings for eating, drinking, and prayer on one specific night. The seven nights from the seventeenth to the twenty-third in a lunar month were particularly favored because the moon takes the

longest to rise. While these are the seven nights in Shichiyamachi, in the single-night practice of Tsukimachi, other nights could be singled out. Iida Yūsen and others suggest that the character "*machi*" (to wait) was conflated with "*matsuri*" (festival) because of their similar pronunciation and because the atmosphere was so celebratory.[85] An illustration of a Tsukimachi held at Yushima in Edo in 1838 (Tenpō 9) depicts such a festive environment.[86]

Sakaguchi Kazuko consulted diaries and other written records to determine that Tsukimachi gatherings, the broader category to which Shichiyamachi belongs, suddenly became popular with women's groups in the Edo period, and noted that their prayers often targeted safe childbirth and child-rearing.[87] Since the practice fell between shrine and temple worship, it died out after the Meiji-period laws separating Buddhism and Shinto, which also denounced folk practices, were enacted.[88] The ritual is similar to Himachi, or Nichimachi (Waiting for the Sun), in which people stay up all night waiting to worship at dawn.[89] The most well-known of the "waiting" rituals are the gatherings held by members of the Kōshin cult, which have origins in Chinese Daoism. On days and nights designated as Kōshin, beginning on the fifty-seventh day of the sixty-day calendar cycle, people would gather to stay awake all night and perform rituals.[90] This cult, which flourished from the seventeenth to the nineteenth century in Japan, continues today; a functioning Kōshin hall is located one block south of the previously mentioned Shichi Kannon'in in Kyoto.

For Tsukimachi, different groups celebrated different nights, and some groups erected commemorative stone monuments identified only by an inscription of the ordinal number for the night. Specific deities selected for worship on the individual nights vary, such as Seishi on the twenty-third night. Seishi (Skt. Mahāsthāmaprāpta) is a bodhisattva most often encountered with Kannon in an Amida triad, but his role in Tsukimachi is more central. Prints that commemorate the ritual for the twenty-third night depict Seishi.[91] Seishi usually has hands pressed together in prayer in front of his chest and a water bottle in his crown, as in the Cologne painting (Fig. 5.8), but he is also shown holding a stemmed lotus.

During the seven nights of Shichiyamachi, a monk or ascetic practitioner (*yamabushi*) led rituals during the vigils.[92] In the mid-sixteenth century, the ritual was conducted at Tamon'in, a subtemple of Kōfukuji in Nara, at least seven times.[93] Later sources more specifically explain that each night was aligned with a worship focus on one of the Shingon Six Kannon and Seishi. Although not technically correct, since Seishi is not a Kannon, in some cases these groups have been labeled "Seven Kannon," thus obscuring the affiliation with Shichiyamachi. The deities corresponding to the nights in the Shichiyamachi ritual are ordinarily as follows: seventeenth = Thousand-Armed

Kannon, eighteenth = Shō Kannon, nineteenth = Horse-Headed Kannon, twentieth = Eleven-Headed Kannon, twenty-first = Juntei Kannon, twenty-second = Nyoirin Kannon, and twenty-third = Seishi Bosatsu.[94]

Seventeenth- and eighteenth-century texts explain the relationships between the nights, deities, mantras, and mudras in Shichiyamachi rituals. *Shichiyamachi no daiji* (Seven-night waiting essentials) was compiled by a monk named Ryūyo (1653–1711) of the Buzan branch of Shingon associated with Hasedera.[95] This list of deities matches the images in the Cologne painting if we begin from the top with Thousand-Armed Kannon and move down the rows from right to left, with Seishi in the last position. An alternate tradition is described in the source *Nanayamachi no daiji* (Seven-night waiting essentials), compiled by Shōnyo (active 1684–1688) of the Chizan branch of Shingon that is associated with Chishakuin.[96] This text, which has a postscript explaining that Shōnyo received it from his master in 1656 (Meireki 2), differs from the former in that the first two positions, Thousand-Armed and Shō, are reversed and there are some differences in the mudras and the mantras. For example, the image of Seishi in Ryūyo's text has hands in prayer, while in Shōnyo's text one hand holds a flower. In considering the slightly different traditions between the two branches of Buzan and Chizan, we should place the Cologne painting within the Buzan/Hasedera tradition because Ryūyo's text begins with Thousand-Armed Kannon and the iconography of the Seishi image matches.

According to the texts, the Seven Nights of Waiting ritual consists of the following parts: first a ritual for body protection (*goshinhō*), then, in sequence, mudras and mantras appropriate for the deity, offering of the *Kannon sūtra,* the spell (*ju*) for the deity enacted one hundred times, the spell for the moon and heaven done one hundred times, and finally the desired prayers.[97] Another record called *Shichiyamachi sahō*

FIGURE 5.9. Eight-sided stone banner with incised seed syllables for Six Kannon and Seishi. 1796. Stone. 130 cm. Chōmeiji, Nerima, Tokyo.

(Procedures for Seven-Night Waiting), which has some variations on the former sequence, proclaims that upon reciting the first set of mudras and mantras, the seven fortunes will immediately arise and the seven misfortunes will immediately vanish.[98] Thus, this record makes more significant associations with the number seven.

Stone monuments called Shichiyamachi kuyōtō commemorating the ritual of the seven nights together offer the most solid evidence of the former practice. Two well-preserved examples are located in the Nerima ward of Tokyo (near the previously mentioned Enkōin Seven Kannon pillar). The first is a parasol-topped eight-sided stone banner (sekidō) with no images from Chōmeiji, measuring 130 centimeters. Seven of its sides have names in characters for the Six Kannon and Seishi Bosatsu, with corresponding Sanskrit seed syllables in circles above. The eighth side bears a date of 1796 (Kansei 8) (Fig. 5.9).[99] The

FIGURE 5.10. Seven-sided stone banner with images of Six Kannon and Seishi in relief. 1740. Stone. 250 cm. Nakamura, Nerima, Tokyo. Formerly located nearby at Nanzōin.

second, measuring 250 centimeters, with a curved lantern-like roof topped by a jewel, has the seven bodhisattva images carved in low relief on each side. In addition to the date of 1740 (Genbun 5), the inscriptions on each side give information on the individual donors, the number of people in two confraternities, and the location as well as directional position of Nakamura in Nerima (Fig. 5.10). Formerly, the monument was located at the nearby Shingon temple of Nanzōin, but it was moved to a small park in the Nakamura Nerima neighborhood.[100] Other commemorations of Shichiyamachi consist of seven independent stone figures, such as the group from Tōkōji in Hanō City, Saitama, from the Kansei (1789–1801) era. One of its images has hands in prayer, which is standard for Seishi, but because it appears to have a Buddha in the crown, it has been identified as a two-armed image of Juntei, and thus the group has been called "Seven Kannon."[101] Stone images tend to have a great deal of iconographical variation, and as with other

groups of Seven Kannon stone images made in the Edo period, it is sometimes difficult to confirm whether the seventh image is Kannon or Seishi.[102] In contrast, the Seishi image in the Cologne painting clearly illustrates the hands in prayer and a water bottle in the crown, so there is no question of its identity (Fig. 5.8).

The Cologne painting commemorates the Shichiyamachi ritual with the same imagery used in the explanatory texts and the stone monuments, which were at their peak of production in the eighteenth century, and judging by the style, the painting was likely made in this period. By contrast, the parallel but more popular Kōshin tradition had a prolific practice of making commemorative paintings in addition to prints and stone monuments.[103] Other paintings of Shichiyamachi gatherings likely exist, but because so much of popular Edo-period Buddhist material culture is undocumented, such works may not yet be recognized.[104] Since the Cologne painting was exported to Germany and appreciated as an unusual piece of Japanese art, it has been preserved as a rare example of the painted Shichiyamachi tradition that might have otherwise have been lost.

A Transitional Set of Paintings from Kōdaiji

An assembly of unusual sixteenth-century paintings owned by Kōdaiji in Kyoto sets the stage for the transition between the Six and Thirty-Three Kannon cults.[105] Each painting in this set of thirty-three works depicts a Kannon image with a prominent halo above clouds or a rock base. Painted in vibrant colors, each figure stands out against the background landscape, largely done in monochrome ink. While six individual

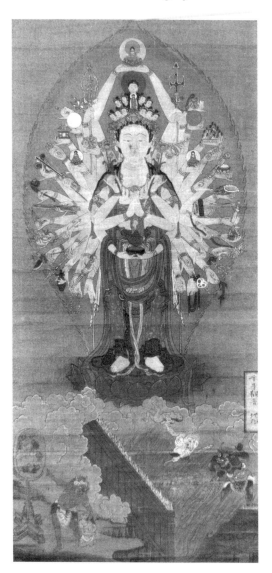

FIGURE 5.11. Thousand-Armed Kannon with scene of hell path. Sixteenth century. One in a set of Thirty-Three Kannon paintings. Color on silk. 93.7 × 44.2 cm. Shō Bijutsukan, Kōdaiji, Kyoto.

paintings in the set feature one of the Six Kannon each, in the other twenty-seven paintings most of the Kannon images look like variations of White-Robed Kannon (Byakue).[106] The lower sections of the twenty-seven paintings have illustrations that correspond to *Lotus sūtra* passages, in contrast to the Six Kannon paintings that clearly show the six paths of Buddhist transmigration (*rokudō*), with scenes illustrating the path the particular Kannon aids. Although no text helps identify the patron or artist of this set, the paintings are highly significant as they blend images of Kannon from the *Lotus sūtra* with esoteric Buddhist imagery from the Six Kannon cult.[107]

In each of the Kōdaiji Six Kannon paintings a cartouche explains the name of the Kannon and the corresponding path.[108] Beginning with the lowest path, Thousand-Armed Kannon (Fig. 5.11) serves as an intercessor to save those in hell. The scene below the standing Thousand-Armed Kannon is divided by a wall topped by ominous jagged spikes. To the left of the wall, a red demon holds a bound person by the hair and forces him to look into the karma mirror, which reveals his past sins of theft and brutality, and to the right of the wall is a fiery pit of hell, which is this sinner's likely fate. While a white horse-headed demon throws one

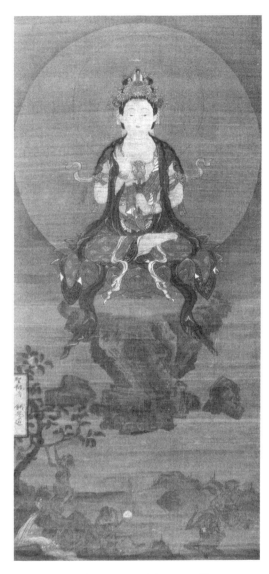

FIGURE 5.12. Shō Kannon with scene of hungry ghost path. Sixteenth century. One in a set of Thirty-Three Kannon paintings. Color on silk. 93.7 × 44.2 cm. Shō Bijutsukan, Kōdaiji, Kyoto.

person in, a green cow-headed demon stirs the mass of writhing bodies inside the pit.

The painting of Shō Kannon (Fig. 5.12), who saves beings in the hungry ghost path, depicts this figure sitting upon a blue lotus dais holding a red lotus. Below, in an ink-painted landscape, are five hungry ghosts, who because of sins of greed during life are condemned to suffer the fate of eternal hunger and thirst. Among the many different types of hungry

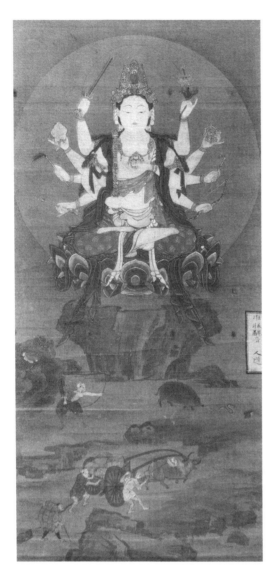

FIGURE 5.13. Juntei Kannon with scene of human path. Sixteenth century. One in a set of Thirty-Three Kannon paintings. Color on silk. 93.7 × 44.2 cm. Shō Bijutsukan, Kōdaiji, Kyoto.

ghosts, those illustrated are five images with specific problems related to the inability to satiate themselves. From left to right they are as follows: one who is so starved she eats the five children she gives birth to every day, one who cuts open his own skull and eats his brain because of starvation, one who is eternally hungry because all food turns to fire, and another who is eternally thirsty because all drink turns to fire. The final figure, with a huge distended belly, grasps the flaming branch of a tree.[109]

The painting of Horse-Headed Kannon (Plate 26) includes an eight-armed figure seated on a green lotus base astride three kneeling white horses. In the foreground, two horses run away from a green-skinned, red-haired ogre who wears a tiger skin and holds a white dog by the fur in one hand and a human by the hair in the other. Since Horse-Headed Kannon takes care of the animal path, he will rescue the animals and perhaps the human in the accompanying landscape.[110] The painting of Juntei (Fig. 5.13) features a ten-armed, seated image of the deity above a progression of figures moving to the right. A red, horned demon on a black cloud armed with a spear stalks a hunter with bow drawn on an unsuspecting wild boar, which in turn follows a snake that follows a frog. Below, two men force an ox to pull a heavy cart uphill. Juntei, who saves humans, will be able to help people overcome their sins of participating in the carnivorous food chain as well as their cruelty to animals.[111]

Another painting depicts an Eleven-Headed Kannon (Fig. 5.14), who saves beings in the asura path. Since the figure stands on a platform and holds a ringed monk's staff in the right hand and a lotus in the left, it appears to be

a Hasedera-style Kannon. Beneath is a group of figures including Indra (J. Taishakuten) riding on his white elephant, attacking a group of asura below. The red-skinned, six-armed Rāhu asura (J. Rago Ashura) fights back with weapons as he plunges diagonally downward on black clouds. Although some asura are benevolent and support Buddhism, many are fond of fighting and are said to be in constant battle with Indra.

Finally, in the last of the Six Kannon paintings, a six-armed Nyoirin Kannon (Fig. 5.15) sits above a scene featuring a square altar adorned with bowls of gleaming offerings, flower vases, and a Chinese-style bronze incense burner. As one figure in Chinese dress approaches with another bowl of offerings, a white-skinned heavenly being stands to the side of the altar with hands raised in front of the chest in reverence. The serenity of the scene below the Nyoirin Kannon, who rescues those in the deva path, is a stark contrast to the torments represented in the other five paths. Those who live in the deva path know great gratification, but when that comes to an end their suffering from pleasure lost is extreme.[112]

Cult images of the Six Kannon are not normally combined with scenes of the different paths; in fact, I have not located any similar paintings. Possible

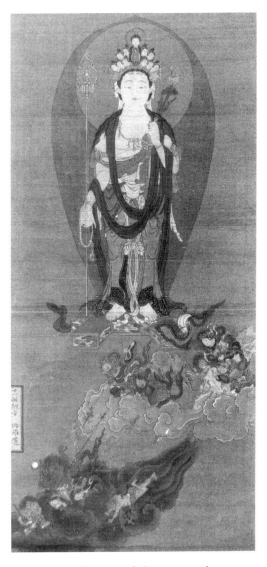

FIGURE 5.14. Eleven-Headed Kannon with scene of asura path. Sixteenth century. One in a set of Thirty-Three Kannon paintings. Color on silk. 93.7 × 44.2 cm. Shō Bijutsukan, Kōdaiji, Kyoto.

sources for the scenes in the Kōdaiji set are paintings of the six paths (*rokudōe*), such as the thirteenth-century Chinese paintings made in Ningbo, now owned by Shinchion'in in Shiga prefecture, in which each scroll has a distinctive scene depicting an illustration from one of the six paths.[113] Scholars have proposed that these paintings were used during the Water and Land ritual (Ch. *shuilu*) in China, which is an elaborate rite for the salvation of the numerous creatures of water and land.[114] The rite is related

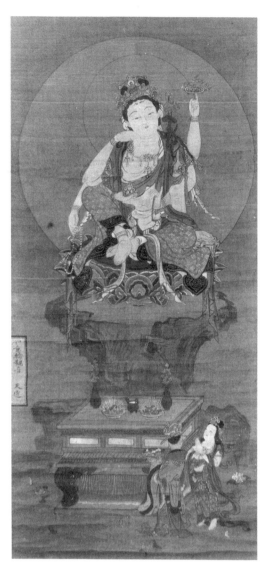

FIGURE 5.15. Nyoirin Kannon with scene of deva path. Sixteenth century. One in a set of Thirty-Three Kannon paintings. Color on silk. 93.7×44.2 cm. Shō Bijutsukan, Kōdaiji, Kyoto.

to the ritual feeding of hungry ghosts (J. *segaki*) in Japan, held during Obon to appease the spirits of the dead. Another source for the Kōdaiji paintings is the famous thirteenth-century Shōjuraigōji *rokudoe* set of paintings, which were mainly based on the text *Ōjō yoshū* (Essentials of rebirth), written by Genshin (942–1017) in 985 (Kanna 1). Although most of the scenes differ between the two sets, several of the individual figures within the paintings bear close resemblance.[115]

Aside from the Six Kannon, the other twenty-seven paintings in the Kōdaiji set have cartouches that refer to the guises and the perils in the *Lotus sūtra*. This precious painting set is referred to as "Sanjūsan Kannon zu" (Thirty-Three Kannon illustrations) by the Shō Art Museum (Shō Bijutsukan) at Kōdaiji, where it is housed. Within the total of thirty-three paintings, the types of Kannon are as follows: six paintings are the images of the Six Kannon just described, twenty are images of White-Robed Kannon, and the remaining Seven Kannon have a variety of colored robes, scarves, and jewelry. Some of the paintings have scenes below the Kannon images from the *Lotus sūtra* that are doubled or tripled up and have two explanatory cartouches in order to make the total paintings conform with the magical number of thirty-three. Aside from the Six Kannon paintings, the other twenty-seven fit into the development of the well-established Thirty-Three Kannon painting theme, which will be discussed in the next chapter. The combination of imagery in the Kōdaiji set should be viewed as the embodiment of the transition between the cults of the Six and Thirty-Three Kannon.

Image Diversity

Painted examples from this chapter reflect the great diversity of size, shape, material, and function of Six Kannon paintings. The *Sho Kannon zuzō* iconography scroll, which originated in the eleventh century, offers an early model to consider the flexibility in the iconography of the Six Kannon cult images. From the beginning, we see that artists were grappling with the muddy issue of when to use either Juntei or Fukūkenjaku in a group, and we find both in the *Sho Kannon zuzō* scroll. The fourteenth-century Six Kannon lacquer doors from a disassembled tabernacle in the Museum of Fine Arts, Boston, offer the opportunity to imagine further diversity of material and format. The fourteenth-century Hosomi set and the fifteenth-century Ryōsenji scroll show two different models for Six Kannon image scrolls, the former consisting of six individual paintings and the latter of a single scroll.

Evidence for a new Seven Kannon group emerges in thirteenth-century texts, and later Seven Kannon as a concept was invigorated in the Edo period through stories of the Shichi Kannon'in images and the widely distributed publication *Butsuzō zui.* The idea of Six Kannon was also reconfigured into a new group of seven images that included Seishi to form a focus for the Shichiyamachi ritual, as illustrated in the Cologne painting from the eighteenth century. These groups of seven show that even the number six in the Six Kannon is unstable. Finally, the sixteenth-century Six Kannon paintings at Kōdaiji that belong to a group of Thirty-Three Kannon paintings, of a type that will be explored in the next chapter, reveal a turning point in the expansion of the number and diversity of Kannon groups, which continued to proliferate long afterward.

Bodies and Benefits

From Six to Thirty-Three Kannon

THIRTY-THREE KANNON CAME TO SUPERSEDE Six Kannon as the latter group faded in popularity. As demonstrated in the previous chapter in regard to how Six Kannon could sometimes be seven, mathematical accuracy was far less important than the maximization of benefit. Thirty-three, of course, has significance as the number of guises Kannon can take in the *Lotus sūtra,* which emphasizes the teaching of Buddhist law through skillful means. This chapter will focus on how the Six Kannon cult was eclipsed by Thirty-Three Kannon, which was not a simple and tidy addition to a group of six.

In order to make sense of the shift, the standard visual representations for Thirty-Three Kannon groups will first be outlined. The bubble chart in Figure 6.1 gives a relative visual sense of the areas that make up the imagery of the cults and how they intersect. The first section of this chapter will treat paintings and sculpture created as manifestations of Kannon in the *Lotus sūtra* in Japan, following which will be a consideration of the separate development of painted sets of Thirty-Three Kannon.

Another materialization of the Thirty-Three Kannon that will be considered is the phenomenon of thirty-three-stop pilgrimages, in which by the fifteenth century many temples in Japan with a central icon of Kannon organized themselves. If we consider the identities of each Kannon icon along the major Kannon pilgrimage routes, they do not match any of the *Lotus sūtra* guises or those in Thirty-Three Kannon painting sets. Instead, we find that each is one of the Six Kannon. At the time the cult of the Six Kannon began to fade in the fifteenth century, the Thirty-Three Kannon pilgrimage cults began to flourish and new alliances for Kannon worship were formed through the use of old images. As faith in Kannon gained new followers, it expanded from an elite to a popular practice through the physical movement of pilgrims within a unified geographic sphere, as well as the spread of inexpensively produced printed Buddhist imagery. A subcategory that reveals an area of intersection between the Six and Thirty-Three Kannon cults in the arena of pilgrimage is, surprisingly, in the form of large bronze bells.

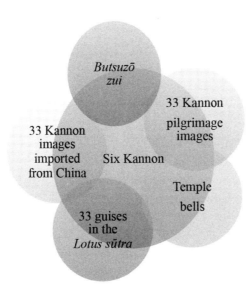

FIGURE 6.1. Intersections between the cults of the Six and Thirty-Three Kannon.

Finally, as fostered by the Kannon pilgrimage routes and the new boom in printed literature, the accessibility of Kannon imagery exploded beginning in the seventeenth century. The widely distributed printed iconographic manual called *Butsuzō zui* pushed the boundaries of the expansion of knowledge of the Kannon cult and its forays far beyond Asia.

Typology for the Thirty-Three Kannon

The great significance of thirty-three as the special number for Kannon is manifested in several ways. Although the relationship between the number thirty-three and Kannon may be found in the *Lotus sūtra*, the images of Kannon described in the sutra were not commonly represented. In exploring how the various groups of Thirty-Three Kannon that did achieve more attention developed in Japan, we will see that some of the images come from India, some from China, and others are of unknown, perhaps domestic, origin. This discussion will include a particular subfocus on the female manifestations in the group, which were important in bringing the message of Kannon's benevolence to an expanding audience. After investigating the roots of the Thirty-Three Kannon as a concept, an inquiry into the various groups of Thirty-Three Kannon in Japan will follow. While many of the areas overlap, images of the Thirty-Three Kannon in this essay have been organized into a general typology with four categories.

1. Thirty-three guises in the *Lotus sūtra*
2. Thirty-three Kannon images that originated in painted and printed sets imported from China
3. Thirty-three Kannon icons from pilgrimage routes
4. Thirty-three Kannon images found in the printed manual *Butsuzō zui*

Thirty-Three Guises in the *Lotus Sūtra*

The *Lotus sūtra* is the first place to look for hints of the origin of the organization of Thirty-Three Kannon as a constellation. Parts of the *Lotus sūtra* were written in India in the first century CE, and after the sutra evolved into many chapters, translations from Sanskrit into Chinese were made beginning in the third century CE, which then made their way to Japan by the seventh century.[1] The "Universal Gateway Chapter" (J. *Fumonbon;* Skt. *Saddharma-pundarīka-sūtra*) is the twenty-fifth chapter of the *Lotus sūtra,* which came to be known as the *"Kannon sūtra"* (Ch. *Guanyinjing;* J. *Kannongyō*) because it was used separately to focus on that deity. The first section describes how believers in Kannon can be saved from various perils, such as fire, flooding, shipwrecks, and robbers. In the following section, Kannon takes an appropriate guise, one of the so-called "Thirty-Three bodies" (*sanjūsanshin*), or transformed bodies (*keshin*), or manifestations (*ōke*), which include Buddhas, monks, children, dragons, officials, or other deities, to preach the dharma in order to save various beings.[2] Then the sutra repeats the ways that believers may be saved from various perils in *gatha,* or verse form. Table 6.1 offers a list of the standard forms from the *Kannon sūtra.* Notably, seven of the guises included are female.

There are many more forms of Kannon than the guises listed, so the number thirty-three came to stand for the concept of Kannon's ability to attain any state of being, from divinities to humans to nonhumans, in order to preach the dharma most effectively. In visual representations, such as in sets of paintings, there is great flexibility in how the guises are arranged, from one guise per painting to several guises in one scene. Moreover, in some cases thirty-two Kannon are represented instead of thirty-three. An alternative of thirty-two developed from Kannon's transformation into thirty-two bodies to liberate all beings from suffering as found, not in the *Lotus sūtra,* but in *Śūraṅgama sūtra* (Ch. *Shoulengyan jing;* J. *Shuryōgonkyō*), which came to be favored by Chan and Zen Buddhists.[3] Nevertheless, Kannon's relationship to the number thirty-three stands as the most pervasive throughout history, which raises the question as to why the number thirty-three in particular was used in the *Lotus sūtra.*

TABLE 6.1 Types of the Thirty-Three Guises from the *Lotus Sūtra*

1.	Busshin	仏身	Buddha
2.	Byakushibusshin	辟支仏身	Pratyekabuddha
3.	Shōmonshin	声聞身	Voice-hearer, Śrāvaka
4.	Daibonōshin	大梵王身	King Brahmā
5.	Taishakushin	帝釈身	Indra
6.	Jizaitenshin	自在天身	Heavenly Being Freedom, Īśvaradeva
7.	Daijizaitenshin	大自在天身	Heavenly Being Great Freedom, Mahêśvara
8.	Tendaishōgunshin	天大将軍身	Great General of Heaven
9.	Bishamontenshin	毘沙門身	Vaiśravana
10.	Shōōshin	小王身	Prince
11.	Chōjashin	長者身	Rich man, elder
12.	Kōjishin	居士身	Householder
13.	Saikanshin	宰官身	Chief minister
14.	Baramonshin	婆羅門身	Brahman
15.	Bikushin	比丘身	Monk
16.	Bikunishin	比丘尼身	Nun
17.	Ubasokushin	優婆塞身	Layman believer
18.	Ubaishin	優婆夷身	Laywoman believer
19.	Chōjafujoshin	長者婦女身	Wife of an elder
20.	Kōjifunyoshin	居士婦女身	Wife of a householder
21.	Saikanfunyoshin	宰官婦女身	Wife of a minister
22.	Baramonfunyoshin	婆羅門婦女身	Wife of a Brahman
23.	Dōnanshin	童男身	Young boy
24.	Dōnyoshin	童女身	Young girl
25.	Tenshin	天身	Heavenly being
26.	Ryūshin	龍身	Nāga (dragon)
27.	Yashashin	夜叉身	Yakṣa
28.	Kendatsubashin	乾闥婆身	Gandharva
29.	Ashurashin	阿修羅身	Asura
30.	Karurashin	迦樓羅身	Garuḍa
31.	Kinarashin	緊那羅身	Kiṃnara
32.	Magorakashin	摩睺羅迦身	Mahōraga
33.	Shūkongōshin	執金剛身	Vajrāpani

The number was likely adopted from traditional concepts of the Hindu or Vedic pantheon, which consists of thirty-three different gods, evenly divided into three groups of eleven. These groups preside over three different categories of responsibility: atmospheric, terrestrial, and celestial.[4] Thus, the number thirty-three was an auspicious choice for the number of guises as a representative of a large powerful assembly. The number is also associated

with the Heaven of the Thirty-Three Gods (J. Tōriten; Skt. Trāyastriṃśa), which according to Buddhist cosmology, is on the peak of Mount Sumeru, where the Vedic and Hindu gods who converted to Buddhism live.[5] Since there are an infinite number of Kannon manifestations and an infinite number of deities who live on the peak of Mount Sumeru, the number thirty-three seems to stand for the *idea* of a great number with venerable roots in earlier Hindu or Vedic cosmology, rather than an accurate calculation. Other numbers that often stand in for "a lot" are 100 or 10,000 and 84,000, but they do not have the special resonance that thirty-three has with Kannon.

Illustrations from the *Lotus sūtra* that emphasize the Guanyin chapter in China appear as early as the fifth century and became increasingly popular afterward, with many made throughout the Tang dynasty (618–907).[6] One of the earliest Chinese portable examples in which the guises appear is the painted booklet (10 × 18 cm) of the *Guanyinjing* (*Kannon sūtra*) made in the late ninth to tenth century and found at Dunhuang. This booklet, which is part of the Stein Collection (S. 6983) now kept at the British Library, consists of simple black outline pictures with accents of orange and red above the accompanying sutra text.[7] To further abbreviate, the artist grouped some of the guises together on a single page. In Figure 6.2 the text on the right page may be translated as "If they need a chief minister to be saved, immediately he becomes a chief minister and preaches the Law for them."[8] The illustration shows a minister preaching to two others. On the left page the text states, "If they need a Brahman to be saved, immediately he becomes a Brahman and preaches the Law for them. If they need a monk, a nun, a layman believer, or a laywoman believer to be saved, immediately he

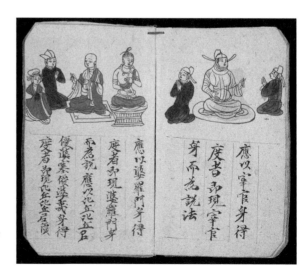

FIGURE 6.2. *Guanyin sūtra* (J. *Kannongyō*) found at Dunhuang. Ninth–tenth century. Illustrated manuscript bound as a booklet. Ink and color on paper. 8 × 10 cm. © The British Library Board, Or.8210/S.6983.

becomes a monk, a nun, a layman believer, or a laywoman believer and preaches the Law for them."[9] The scene shows a monk preaching to a layman and laywoman, and next to him is a Brahman facing the other way, who seems to be preaching to a minister on the facing page. Such simple booklets could easily have made their way to Japan as an avenue of iconographic transmission.

The earliest known sculptures of the thirty-three guises in Japan are on the mandorla of the main seated Thousand-Armed Kannon image (h. 334.8 cm) at the famous Sanjūsangendō. The magnificent "Hall of the Thirty-Three Bays" at Rengeō'in (also called Myōhōin) in Kyoto houses one main image of Kannon along with a thousand other standing images of Thousand-Armed Kannon.[10] The main image and its mandorla with attached carvings of the guises were made by the master Buddhist sculptor Tankei (1173–1256) and his workshop in 1254 (Kenchō 6) as part of a major restoration. Each figure of a guise (approximately 36 centimeters in height) is organized around the mandorla concentrically, with a seated Buddha image at the very top.[11] A similar configuration of sculptures of the thirty-three guises is attached to the mandorla of the twelfth- to thirteenth-century secret image of the Thousand-Armed Kannon at Kiyomizudera Okunoin, so there were likely other such mandorlas made at this time.[12] The thirty-three guises of Kannon were included because of the *Lotus sūtra's* reputation, but their visual representations were not widely known in sculpture since they did not serve as main icons.

In Japan, the earliest extant painting featuring Thirty-Three Kannon is the luxurious *Illustrated Sūtra of the Miracles of Kannon,* or *Kannongyō emaki,* from 1257 (Shōka 1), now in the collection of the Metropolitan Museum of Art (Plate 27).[13] The illustrations in the scroll are interspersed between text passages that follow the sutra; the first and third sections show scenes of Kannon rescuing people from various perils, and the second section has scenes in which a golden Kannon floats in a circle above one of the guises, who preaches the dharma to a small group. In one vignette (shown on the right side of Plate 27), the text to the right of the painted scene translates as "If they need a young boy or young girl to be saved, immediately he becomes a young boy or young girl and preaches the Law for them." The scene shows a golden Kannon holding a small white lotus and seated on a lotus dais, encased in a circle floating on clouds in the sky above. Below, a few children play around a small three-story pagoda. In the next scene (depicted on the left side of Plate 27), the text to the right is, "If they need a heavenly being, a dragon, a yaksha, a gandarva, an asura, a garuda, a kimara, a mahoraga, a human or a nonhuman being to be saved, immediately he becomes all of these and preaches the Law for them." On the other side of the scene

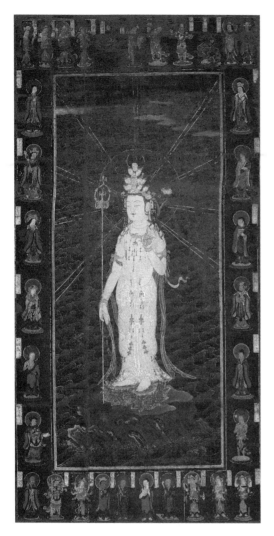

FIGURE 6.3. Hasedera Kannon with thirty-three guises. Fourteenth century. Ink and color on silk. 116.6 × 58.8 cm. Nōmanin, Nara.

the text is "If they need a vajra-bearing god to be saved, immediately he becomes a vajra-bearing god and preaches the Law for them."[14] The artist of the painting has combined the two passages into one scene in which a fierce-looking red vajra-bearing deity (Vajrāpani) is seated on a small rocky island in the sea, while the figures of the other beings mentioned previously are divided into two groups that ride golden clouds above the blue and green waves. The same type of Kannon as in the previous scene floats above in a circle. The scroll continues by combining other guises with text passages.

According to the scroll's inscription, by Sugawara no Mitsushige, the painting was modeled after an earlier printed version from China dated to 1208 (Jiading 1).[15] The printed source from 1208 is no longer extant, but several later illustrated Chinese printed sets that follow the format of this scroll survive from the fourteenth to the seventeenth centuries.[16] Because of Kannon's large following, less extravagant illustrated print versions of the sutra were widely produced, circulated, and exchanged between Japan and China from the thirteenth century on.[17]

In a different format, a fourteenth-century painting from Nōmanin, a subtemple of the significant Buddhist temple of Hasedera in Nara prefecture, depicts a standing image of Kannon framed by individually labeled vignettes of the thirty-three guises from the *Kannon sūtra* in an orderly, chart-like configuration without narrative scenes on a dark blue background (Fig. 6.3). The vignette labeled number one with a Buddha image is positioned in the center of the lower edge. The numbered guises alternate right and left as they move upward, with the last figure (number 33) of Shūkongōshin in the top center position.[18] The central image of Kannon is gold with rays of light emanating from his body and stands on a double

lotus on top of a rock that represents Kannon's Potalaka paradise in the sea.[19] With a lotus in the left hand and a monk's staff (*shakujō*) in the right, this is clearly the beloved Eleven-Headed Kannon of Hasedera. Hasedera was a stronghold of Kannon worship through the centuries, and its main image has this readily recognizable iconography.[20]

According to temple legend, the original Kannon icon of Hasedera was from the eighth century, but the temple suffered several fires. An enormous replacement sculpture that measures over ten meters in height, from 1538 (Tenbun 7), is enshrined in the main hall inside a specially built tabernacle (*zushi*). On the tabernacle's interior wooden door panels are paintings of the thirty-three guises of Kannon, which were painted in 1603 (Keichō 8). Above the head of the image in each painting is the Sanskrit seed syllable "ka" (or "kya"), which stands for the Eleven-Headed Kannon.[21] In addition, the *zushi* was surrounded by seventeenth-century sculptures of the thirty-three guises.[22] Similar extant examples of sculptures of the thirty-three guises made during the fifteenth and sixteenth centuries indicate the likelihood that many more sculpture sets of this type existed in the past.[23]

If we use documents to delve further, the earliest reference for the representation of the assembly of guises is found in an entry from 900 (Shōtai 3) in *Hasedera genki* (Miraculous tales of the Hasedera Kannon), compiled in 1587 (Tenshō 15), which states that Emperor Uda (r. 887–897) made a vow to have images of the thirty-three guises made at Hasedera.[24] *Hasedera genki* includes many stories about the benefits of making offerings to the Hasedera Kannon by all classes of people. But with imperial sanction, Emperor Uda's gift added a layer of prestige to Hasedera's strong association of the thirty-three guises and Kannon. Later, when Hasedera joined the Saigoku Thirty-Three Kannon pilgrimage route, the relationship between this temple, Kannon, and the number thirty-three was further reinforced.

Painting Sets of Thirty-Three Kannon

The most famous of all Thirty-Three Kannon Japanese painting sets is purportedly by the artist Minchō (1352–1431), painted in 1412 (Ōei 19) and owned by Tōfukuji in Kyoto.[25] Minchō was legendary for his ink painting skill and was the head of a leading painting workshop located at Tōfukuji. Kano Ikkei's (1599–1662) biography of Japanese painters, *Tansei jakubokushū* (Collection of young saplings of painting), compiled circa 1650 and published in 1662, includes a reference to the Tōfukuji Thirty-Three Kannon paintings, which thus attests to the set's historical significance.[26] Two of the paintings are later replacements by Kano Sansetsu (1589–1651) from 1647 (Shōhō 4).[27] Although this significant set inspired many subsequent works, it should

not be touted as the origin of this group of Thirty-Three Kannon, since there are examples of earlier prints with similar motifs from China.

In the upper half of each of the Tōfukuji paintings is either a standing or sitting image of a White-Robed Kannon suspended inside a circle, which resembles the moon emerging from clouds that trail down into the scene below (Fig. 6.4). The lower half of each painting includes a scene that corresponds to the *Kannon sūtra*. In a sense, the format of this set and its numerous copies is a blend of the *Kannon sūtra* thirty-three guises along with a group of thirty-three images of Kannon (or Guanyin) imported from China.[28] Paintings and prints in this format made in Ming- and Qing-dynasty China (fourteenth to early twentieth centuries) were sent to Japan and copied.[29] After careful comparisons, Igarashi Kōichi proposed that the Tōfukuji paintings were likely based on a Chinese set of prints published in 1395 (Hongwu 28).[30] Many of the details are very close, yet in the Tōfukuji paintings all the multiarmed esoteric Guanyin figures in the Chinese prints have been exchanged for images of two-armed Kannon images, which are mostly White-Robed.[31]

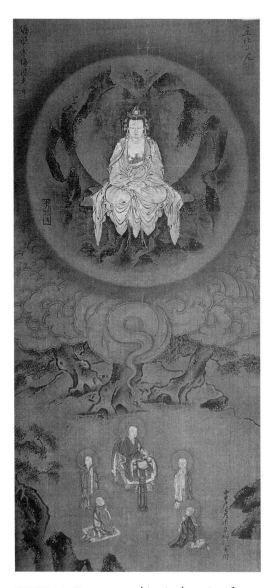

FIGURE 6.4. Kannon preaching in the guise of a monk, from a set of Thirty-Three Kannon paintings. Attributed to Minchō. 1412. Color on silk. 118.3 × 54.5.6 cm. Tōfukuji, Kyoto.

Sesshū's Lost Set of Thirty-Three Kannon

As an indication of the acclaim of this new style of Thirty-Three Kannon imagery, the renowned ink painter Sesshū Tōyō (1420–1506) made a set of Thirty-Three Kannon paintings in a format somewhat similar to the set attributed to Minchō. Sesshū, perhaps the most lauded of all fifteenth-century Zen-priest painters, worked on landscapes and figure paintings, many of which were religious subjects. Although most

of the set is missing, Hata Yasunori located nine possible visual references to different paintings in the set, including two originals.[32] In the lower left of each painting is an inscription stating that it was painted when Sesshū was sixty-seven years old, which, if accurate, dates the paintings to 1486 (Bunmei 18).[33] At the top of each Kannon painting are verses written in gold ink from the *Kannon sūtra*. One of the possible originals was formerly owned by Mōri Motoakira (1865–1938). At present the location of the painting is unknown, but the 1909 volume *Sesshū gashū* (Paintings of Sesshū) published a photograph of the painting (Fig. 6.5). The top of the painting has a verse from the *Kannon sūtra,* "If one were washed away by a great flood and called upon his name, one would immediately find himself in a shallow place," and it is signed, "Sesshū in his sixty-seventh year," in the lower right.[34] The central figure is an image of Kannon holding a willow branch in one hand and a bowl in the other. Although the painting has features similar to the aforementioned two works, such as the clouds, waves, and the depiction of the faces, it differs from the other paintings in that its verse is in two character lines (as opposed to five, which is more common) and this Kannon figure is standing, while the others are seated.[35] Another painting in the purported set, now at Kyushu National Museum, depicts a Kannon above with hands in the meditation mudra seated on a grass mat inside a disc. Below, a well-dressed person outside a building vomits off the side of a railing into the water. The verse from the *Kannon sūtra* written in gold at the top translates as "Suppose with curses and various poisonous herbs someone should try and injure you. Think on the power of that Perceiver of Sounds [Kannon] and the injury will rebound upon the originator."[36] Although the painting shows the man in distress, we know that Kannon's power will not only save him but also return the curse to the person responsible.[37] This scene is not included in the Tōfukuji paintings, but is found in Chinese prints of the same period.[38]

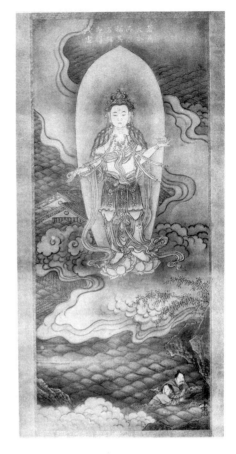

FIGURE 6.5. Kannon rescuing people from a flood. Attributed to Sesshū Tōyō. 1486. Ink and color on paper. 104.2×45.7 cm. Present whereabouts unknown. From Tajima Shi'ichi, ed. *Sesshū gashū*. Tokyo: Shinbi Shoin, 1909, n.p.

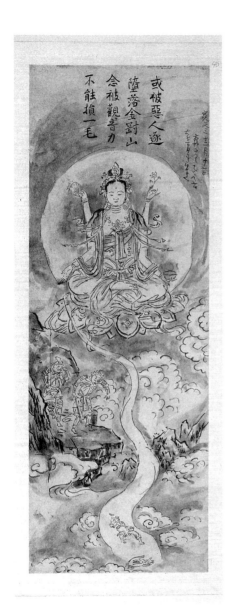

或被惡人逐
墮落金剛山
念彼觀音力
不能損一毛

FIGURE 6.6. Kano Tan'yū: Album of Playful Brushstrokes (*Hitsuen itsuyū*). Detail of Kannon rescuing a man falling off a mountain. Ink on paper, 36.3 x 13.4 cm. Edo period, ca. 1661–1673, this detail: 1663. © Staatliche Museen zu Berlin, Museum für Asiatische Kunst, Inv. No. 792–40, photography: Jürgen Liepe.

As more evidence for an original series, there are at least three later paintings with the same format that claim to have copied Sesshū's work, including his signature and age as sixty-seven. Two are by Kano Tsunenobu (1636–1713), one from 1674 (Enpō 2) and another from 1677 (Enpō 5).[39] A third copy, owned by Tokyo Geijutsu Daigaku (Tokyo University of the Arts), was made by Yamamoto Shōgetsu (dates unknown) in 1900 (Meiji 33) that has an accompanying inscription claiming that Yamamoto copied the work from a painting dated to 1826 (Bunsei 9) that belonged to a Yoshiwara resident.[40] This work, painted in ink, light color, and gold pigment on paper, depicts a seated Kannon holding various attributes in its twelve arms in a circle above a scene of the manifestation of a minister preaching the dharma to a few others. Although this copy of the painting has the signature of Sesshū at age sixty-seven and style features similar to the others just mentioned, there may have been several iterations between it and a lost original.

In his practice of authenticating paintings, the renowned painter Kano Tanyū (1602–1674) made thousands of sketches, which have become very valuable as historical resources. A volume attributed to him that belongs to the Museum of East Asian Art in Berlin (Staatliche Museen zu Berlin, Museum für Asiatische Kunst) contains a sketch of one of the paintings from the putative Sesshū set (Fig. 6.6).[41] The top section of the painting shows a four-armed Kannon in the sky sitting on a lotus seat in front of a moon disc. Below the Kannon, two people stand on a cliff looking down at another person who has fallen off, but at the bottom of the painting a large hand reaches up to save him. The text written at the very top translates as "Suppose you are pursued by evil men, who wish to throw you down from a diamond mountain. Think on the power of the Perceiver of Sounds and they cannot harm a hair of you!"[42] Tanyū dated his sketch to

1663 (Kanbun 3) and said that the work he copied was from Sesshū's true brush. Interestingly, Kano Tsunenobu, who worked with Tanyū on making the numerous small-scale sketches called *shukuzu*, later made copies of two of the Sesshū Kannon works in 1674, so this set was certainly well respected and circulating among artists at the time.

With the evidence available thus far, it seems very likely that a complete original set of Thirty-Three Kannon paintings made in Sesshū's name existed. Yet since Sesshū's paintings are so rare, Tanyū's judgment notwithstanding, we cannot be certain it was by his hand. In contrast to this set that includes the multiarmed images of Kannon, another painting of the Thirty-Three Kannon theme, which was attributed to Sesshū in the past, does not include any of the multiarmed images like the Minchō set. This privately owned handscroll with the seal of Sesshū includes the *Kannon sūtra* text above roundels containing Thirty-Three Kannon images plus three additional final images of a triad of Amida, Kannon, and Seishi.[43] Though this handscroll is not actually by Sesshū's hand, it is nevertheless another testament to the prominence of Sesshū's link to the Thirty-Three Kannon theme as well as the diversity of iconographic choices within sets.

Several later sets of Thirty-Three Kannon paintings closely resemble the fifteenth-century Tōfukuji set, especially in the preference for White-Robed Kannon without extra arms. There are many other sets of similarly related Thirty-Three Kannon paintings. The Ōbaku monk painter Takuhō Dōshū (1652–1714), who studied under the previously mentioned Kano Tanyū, painted a set in 1677 (Enpō 5) that formerly belonged to Bukkokuji in Kyoto, but is now held by Tokyo National Museum.[44] Takuhō may have had the opportunity to see either Sesshū's Kannon paintings or the sketches of them made by his teacher Tanyū in 1663. Another Ōbaku monk-painter, Kakushū Reikō (ca. 1641–ca. 1730), also seems to have modeled his sets after that of Tōfukuji.[45] Kakushū was a member of the Sumiyoshi School of painters, which was an offshoot of the Tosa School that took its name from Sumiyoshi Shrine in Osaka. As the second son of the well-known painter Sumiyoshi Jokei (1559–1670) and brother of Sumiyoshi Gukei (1631–1705), Kakushū worked for the shogunate on Sumiyoshi School projects with his family. After he lost his hearing, he retired as an official painter and became an Ōbaku monk at Kōchiji. In 1688 (Genroku 1) Kakushū accepted an offer to become a painter for the Matsudaira clan in Takamatsu in Shikoku, and later painted at least two additional sets of the Thirty-Three Kannon theme, including one for Hōnenji in Takamatsu and another for the Shingon temple of Gokokuji in Tokyo.[46]

The Kyoto artist Hara Zaichū (1750–1837) painted a set of Thirty-Three Kannon paintings in 1793 (Kansei 5) for the Zen temple of Shūon'an Ikkyūji in southern Kyoto prefecture (Fig. 6.7).[47] As a measure of this set's significance,

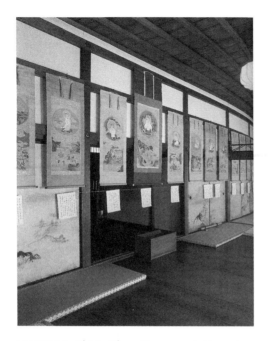

FIGURE 6.7. Thirty-Three Kannon painting set on display at Ikkyūji. By Hara Zaichū. 1793. Ikkyūji, Tanabe, Kyoto prefecture.

the central painting in the group has the seal of Daiten Kenjō (1719–1801), the great art patron and Zen abbot of Shōkokuji.[48] As well-respected artists who all worked in the Kyoto area, Kakushū, Takuhō, and Hara would likely have been able to access the Tōfukuji set as a resource to create similar paintings of Thirty-Three Kannon.[49]

Thirty-Two Monochrome Ink Kannon Paintings from Kenchōji

The elegantly painted set of Thirty-Two Kannon paintings on silk from the Zen monastery Kenchōji in Kamakura differs from others because it consists of monochrome ink images of Kannon within a landscape setting without inscriptions or narrative references to the *Kannon sūtra* (Fig. 6.8). Moreover, because this set consists of thirty-two paintings, there is a question as to whether one is missing or whether it refers to the thirty-two guises in *Śuraṅgama sūtra* instead of the thirty-three in the *Lotus sūtra*.[50] With a few exceptions, most paintings within sets of Thirty-Three Kannon consist of a double depiction of a variation of the White-Robed Kannon in a circle above and a narrative scene from the *Kannon sūtra* below. At Kenchōji, although the forms of Water-Moon, Waterfall-Watching, Dragon-Headed and White-Robed guises of Kannon are repeated, they are not furnished with the distinctive names or identities of the Thirty-Three Kannon that came to be codified in the following centuries.[51]

Historic Kenchōji records attribute the works to the monk-artist Shōkei (a.k.a. Keishoki, fl. ca. 1487–1506), who practiced at Kenchōji, and give a provenance of Sairaian, located in the western section of Kenchōji. However, few scholars accept the Shōkei attribution because there is lack of consistency in the paintings' brushwork. A variety of hands likely made these paintings, which appear to be consistent with other fifteenth-century works that reference Chinese Song-dynasty ink painting style and were made in the Kamakura area.[52] Whether they were actually conceived as a set of Thirty-Three Kannon paintings from inception remains a question, but since the box lids as well as seventeenth- to nineteenth-

century temple records label them as "Thirty-Two Kannon paintings," they have been considered as such for centuries.[53] Takahashi Shinsaku, however, argued that Kenchōji used this set in the fifteenth century in rituals that required Thirty-Three Kannon paintings and that the additional one might have been a painting in a different style, or even a sculpture.[54] The problem of thirty-two or thirty-three paintings resonates with the theme of flexible numbers discussed in this book.

Aside from sets, surviving individual paintings of White-Robed Kannon that have historic ties to Zen temples are plentiful. As one of the deities from the traditional Buddhist pantheon that Zen schools favored, why was White-Robed Kannon in particular so prominent in Zen contexts? Chan and Zen monks as well as scholar-officials may have found the subject of the White-Robed Kannon meditating alone in nature especially appealing as a model for both meditation practice and the reclusive ideal.[55]

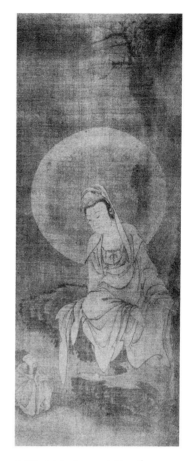

FIGURE 6.8. One painting from a set of Thirty-Two Kannon. Fifteenth century. Ink on silk. Kenchōji, Kamakura. From *Nihon bijutsu gahō*, vol. 3, no. 6 (November 1896), n.p.

Functions and Benefits of Thirty-Three Kannon Paintings

Why and when were paintings of Thirty-Three Kannon used? The motivations and functions that were so precious to donors were not always recorded or articulated. Traditionally, Shōgun Ashikaga Yoshimochi (1386–1428) was thought to have commissioned Minchō to make the Thirty-Three Kannon paintings, but Igarashi has argued convincingly that there is not enough proof for this assertion.[56] Nevertheless, a source from some fifty years later significantly makes an Ashikaga family connection that sheds light on how the paintings were used. A diary entry from 1466 (Bunshō 1), second month, records that the eighth Shōgun Ashikaga Yoshimasa (1435–1490) visited the Zen monastery Tōfukuji for a repentance ritual (*senpō*), where he offered incense in front of the Thirty-Three Kannon paintings by Minchō that were hung in the abbot's quarters (Hōjō).[57] In this ritual, also known as *keka*, participants petition Kannon to annul their own sins or those of others. This ritual was highly significant in the fifteenth century, especially in Zen monasteries. Tatehata Atsuko has discussed the context for this

1466 repentance ritual at Tōfukuji and noted its grand scale, with 318 attendees.[58] Elsewhere Takahashi argued that the Kannon repentance ritual had likely been held at Kenchōji since the early fourteenth century (late Kamakura period), but the earliest dated record of the ritual he found at the monastery was from 1470 (Bunmei 2). Furthermore, within Kenchōji's records on the ritual, the earliest indication of the use of thirty-three paintings, which likely refers to the set of thirty-two paintings discussed previously, is from 1496 (Bunmei 12).[59]

Returning to the paintings in the set attributed to Minchō, inscriptions on the reverse include donor names, many of whom are Buddhist nuns. These inscriptions do not date from the time the paintings were originally made, but were added sometime before the early seventeenth century when they were repaired or remounted.[60] An inscription on the back of one of the paintings records a *gyakushu* (antemortem mortuary rite) for a Zen nun named Myōchin from Ōmi (modern Shiga prefecture). *Gyakushu* are rites that are performed while the person is alive to help that person attain merit after death. As Quitman Phillips and Karen Gerhart have noted, merit generated before death was thought to be much stronger than efforts made by the living on behalf of the dead.[61] By supporting the repair of the paintings, Myōchin was in a sense taking out an insurance policy for her afterlife.

Ichijōin, a Shingon temple on Mount Kōya, owns two sets of Thirty-Three Kannon paintings with documented multiple functions. In a colophon that described the production circumstances of the two sets, Ichijōin Abbot Seii (dates unknown) overzealously claimed that the original painting set was made by the renowned thirteenth-century Chinese artist Mu Qi. Seii was so concerned that this precious set might be lost that he had it copied in 1686 (Jōkyō 3).[62] Seii explained that Osen (1557–1673), the wife of Naoe Kanetsugu (1560–1619), who had been lord or Yamashiro, donated the original set from which the copies were made to Ichijōin at the time its abbot Seiyū (1574–1631) passed away and the new abbot Ken'yū (d. 1656) received the title Hōtō (Transmission of the Lamp). Osen's dual-purpose donation of the paintings to the temple served to transfer merit (*ekō*) to the deceased former abbot, with whom she was close, and at the same time also celebrated the new abbot's promotion.[63]

Yukio Lippit has investigated surprising connections between sets of Thirty-Three Kannon paintings and the series of paintings *Colorful Realm of Living Beings* (*Dōshokusaie*), made between 1757 and 1765 by Itō Jakuchū (1716–1800). Although *Colorful Realm* does not include any images of Kannon, it is a luxurious set of thirty-three paintings of birds, flowers, fish, insects, and a Buddha triad that was used repeatedly in the Kannon repentance rituals held at the prominent Kyoto Zen temple of Shōkokuji. According to Lippit,

Jakuchū likely made the paintings in memory of his father and recently deceased brother, but also as *gyakushu*. Moreover, he would have been well aware of the Thirty-Three Kannon paintings from Tōfukuji and could easily have seen the benefit of an additional use for his paintings in the Kannon repentance ritual.[64]

At the Zen temple of Ikkyūji, located in southern Kyoto prefecture, the set made by Hara Zaichū in 1793, discussed earlier, is displayed every year for an airing (*mushiboshi* or *bakuryō*) during the Obon festival on August fifteenth and sixteenth, at which time the *Kannon sūtra* is read in remembrance of the temple's founding patrons (Fig. 6.7).[65] Although we do not know when this practice began at the temple, more specific information about the earlier functions of these works is recorded directly on the paintings themselves. Sixteen of the thirty-three Ikkyūji paintings have inscriptions on their backs that give the date, the scroll mounter's name and location, the name of the donor who funded the mountings, the patron's names, and their particular prayers. From all the different names and prayers, which include safety at home, safety in town, safety at sea, salvation of all beings, wish fulfillment, and memorial services, we can determine that there was a campaign, involving the efforts of many different patrons with a variety of goals, to produce the entire set.[66]

From these examples it is clear that Thirty-Three Kannon paintings served multiple purposes and were not used exclusively in Zen. Certainly Zen establishments actively held Kannon repentance rituals in which Thirty-Three Kannon paintings were used, but as Lippit noted, the Kannon repentance ritual expanded to include other purposes beyond the expiation of sins, such as aiding rain prayers, protection of the nation, prayers for the emperor's health, and the commemoration of important personages.[67] Their use in antemortem *gyakushu* rites was also significant. Moreover, although certainly important to the Zen tradition, other Buddhist institutions, such as the Shingon temples of Ichijōin and Gokokuji as well as the Pure Land temple of Hōnenji, sponsored painting sets of Thirty-Three Kannon. Accordingly, Thirty-Three Kannon paintings were treated in the same way that the *Lotus sūtra* was revered far and wide across sectarian divisions and utilized for different occasions.

Thirty-Three Kannon Pilgrimages

By the sixteenth century there was a great upsurge in the popularity of Thirty-Three Kannon pilgrimage routes, especially the most traveled Thirty-Three Temples of Kannon: Saigoku in the western provinces, Bandō in eastern Japan, and Chichibu northwest of Tokyo in Saitama prefecture.

Modeled after these major routes, elsewhere all over Japan temples arranged themselves into shorter and more localized routes. Chapter Two discussed two temples that feature Six Kannon images as part of the local Sagara Thirty-Three Kannon pilgrimage that developed in the seventeenth century and similarly, Chapter Three discussed how Tōmyōji became part of the region's Minamiyamashiro Thirty-Three Kannon pilgrimage route in the seventeenth century. Moreover, at the same time Tōmyōji's Thousand-Armed Kannon was considered the main image of the temple, some pilgrims commented that it belonged to a group of six and that together they served as the main images. In contrast to the larger Kannon pilgrimage routes such as Saigoku, the abovementioned temples on local routes display more overlap between the Six and Thirty-Three Kannon cults.

Returning to Kannon's significance to thirty-three, this became the appropriate number of destinations along the routes. The temples along the three major Kannon pilgrimage routes do not feature any of the White-Robed Kannon found in the Thirty-Three Kannon sets of paintings or any of the *Lotus sūtra* manifestations as a main icon. Instead, depending on preference, each temple has one of the Six Kannon, or seven if we include the alternate guises of both Juntei and Fukūkenjaku, as its worship focus. Thus, the temples used their older and more traditionally revered images of one of the Six Kannon to band together to form pilgrimage routes using the esteemed number of thirty-three for its stations as a geographic unit. The pilgrimage experience became a physically engaging way to fuel pious enthusiasm for the benefits of worshipping a specific Kannon at a specific place, and in turn grouping the different Kannon together magnified their individual benefits.[68]

Miniaturized Sets of the Pilgrimage Routes

Beyond the actual icons installed in the temples, many small sets replicating the images of the main Thirty-Three Kannon routes have been painted or printed, or constructed of stone or wood, and thus function as miniature pilgrimages. Viewing or sponsoring such images could function as a way to obtain merit through virtual pilgrimages for those unable to travel. The oldest extant Japanese pilgrimage painting is from the fourteenth century; it is known as *Kannon Mandara* and is from Kegonji in Gifu.[69] Within the painting, images from the temples of the Saigoku route are not arranged in their modern numerical sequence, and they have no identifying labels. In the center a Buddha image, possibly Amida, sits on a six-sided base. The Hasedera Eleven-Headed Kannon, with its distinctive monk's staff, appears in the top right,

in the first position, and the sequence zigzags down to the Mimurodoji Thousand-Armed Kannon in the last position at the bottom left. Since this route follows the path described in the record *Jimon kōsōki* (Record of the high monks of the Jimon branch), which was edited in the thirteenth century, the painting commemorates pilgrimages made by Tendai monks of the Jimon branch that is based at Mi-idera in Shiga.[70]

On a more modest scale, cheaper printed versions of this type of scroll began to be made in the fifteenth century. This type of print became increasingly popular by the nine-teenth century as pilgrimages and traveling became more and more accessible.[71] In some cases, pilgrims collected small prints from each temple and mounted them together as commemorative hanging scrolls. Figure 6.9 shows a scroll from a pri-vate collection, made up of individ-ual prints from the Saigoku pilgrim-age that a filial son had mounted in memory of his father in 1897 (Meiji 30). An inscription on the back of the scroll explains that the father had collected the pilgrimage prints and intended to mount them on a scroll, but he passed away from a sudden illness before he had the chance. Other nineteenth-century examples show the icons of the Saigoku Thirty-Three Kannon pilgrimage all printed together.[72]

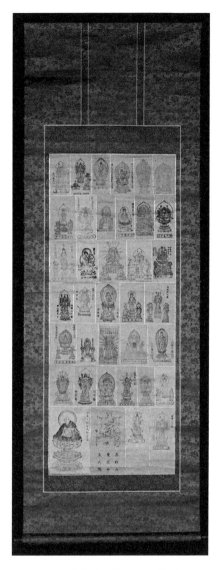

FIGURE 6.9. Saigoku Kannon pilgrimage print scroll. 1897. Woodblock prints affixed to a hanging scroll. Dimensions of scroll, including mounting: 148 × 57 cm. Private collection. Photographed by Chip Porter, Frances Lehman Loeb Art Center.

In addition to two-dimensional images, in the Edo period numerous groups of Thirty-Three Kannon images were carved into separate stones or onto the face of a single upright stone.[73] Many temples, such as Ishiya-madera (number 13) and Chōhōji (number 18) on the Saigoku route, have

buildings to house the smaller images that can serve as a contained virtual pilgrimage. As another variation of the phenomenon, small sets of individual sculptures could be carried along on a pilgrimage in a case as a way to simulate a pilgrimage in an abbreviated trip.[74] These small-scale image replications not only offer intimate connections between worshipper and icon not always possible with originals; they also shrink the enormity of Kannon's omnipresent identities into a mentally manageable size.

Bells with Kannon Imagery

As an important step in the pilgrimage process, worshippers who physically visit a site will often ring the temple bell. Old Buddhist bells have a fairly standard form and usually lack depictions of deities, but by the seventeenth century new variations appeared, among which were bells cast with images of the Six Kannon.[75] Surprisingly, bells, which are rarely included in art historical inquiry, are significant sites of convergence between the imagery of the Six and Thirty-Three Kannon cults. One attraction of the Six Kannon cult is that the Six Kannon can alleviate the suffering of beings in the six paths, and in a similar role, the sound of the bell is also said to ease the pain of the dead, especially those in hell. Kannon's name, after all, has been interpreted to mean one who perceives the sounds of suffering throughout the world. This section will examine five bells adorned with depictions of Kannon as evidence of the intermingling between the Six and Thirty-Three Kannon cults, temple bells, and the pilgrimage process.

Large bronze bells (*bonshō*) that developed in China and Korea have been used by temples since the inception of Buddhism in Japan. The earliest extant Chinese example, dated to 575 (Taijian 7), is kept by the Nara National Museum, and the earliest extant Japanese example, with an inscription dating to 698 (Monmu 2), belongs to Myōshinji in Kyoto.[76] Most Japanese temples have a large bell hanging outdoors that can be rung daily to announce time or be used to enhance certain rituals. During the Pacific War, as well as at other times during Japanese history, many temple bells were melted down for metal to support military efforts, so each surviving old bell has an additional tale of escape from such a fate.

Before looking at the bells with Kannon, let us first consider the features of a more typical temple bell. Temple bells usually have a fairly consistent barrel-like form that widens at the bottom. Vertical and horizontal bands adorn the surface of the body, punctuated by the design of two open lotus flowers, called *tsukiza:* one at the place where the wooden striker (*shumoku*) hits the bell and the other on the opposite side. Crowning the bell is a jewel shape poised atop two facing dragon heads that form a loop from which to suspend the bell. The upper sections around the bell's body contain protrud-

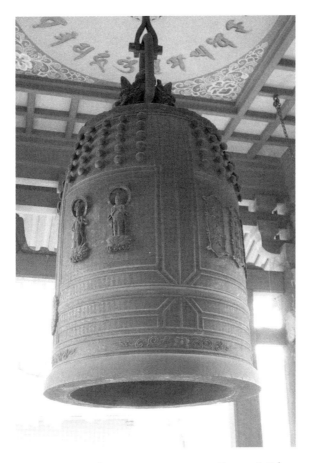

FIGURE 6.10. *Bonshō*. 1657. Bronze. 184 cm. Honsenji, Tokyo.

ing bosses, or nipples (*chi*), which usually number 100 or 108 in total, but can vary. These bells are often between 120 and 150 centimenters tall, fairly thick, and can weigh several tons.

Honsenji: The Long Journey Back Home

Honsenji, located in Tokyo's Shinagawa district, from which it takes the characters of its name, is home to the oldest bell adorned with Six Kannon images, which dates to 1657 (Fig. 6.10). This bell is significant not only for its Six Kannon, but also because it has a fascinating and internationally relevant life story. This large bell, measuring 184 centimeters, displays the Six Kannon organized into three pairs: Shō and Eleven-Headed, Horse-Headed and Thousand-Armed, and Nyoirin and Juntei (Fig. 6.11). Along with its head halo, each Kannon stands (or sits in the case of Nyoirin) on a lotus on top of clouds, measures approximately seventeen centimeters, and protrudes out from the surface of the bell in relatively high relief.

FIGURE 6.11. Detail of *bonshō* showing one of the three pairs of Kannon. 1657. Bronze. Left: Juntei Kannon, 17 cm tall. Right: Nyoirin Kannon, 14.6 cm tall. Honsenji, Tokyo.

As temple bells often contain inscriptions that include dates and names of patrons and artists, they can offer a more direct opportunity to learn about the context than is often possible with sculptures or other objects of temple property. This bell's inscription gives the date as 1657 (Meireki 3), the location as Fumonin at Honsenji, and the name of the maker of the bell as Ōnishi Gorōzaemon no jō Fujiwara Sonchō of the Sanjō (Third Avenue) Foundry in Kyoto. It also states that the Six Kannon were made separately by Kōsai, who was head of the venerable Shichijō Bussho (Seventh Avenue Buddhist Sculpture Atelier) in Kyoto.[77] Three separate cartouches, which are about the same size as the Kannon (approximately 23 centimeters), bear the posthumous names of the first three Tokugawa shōgun Tōshōgū, who is Ieyasu (1543–1616); Taitokuin, who is Hidetada (1579–1632); and Taiyuin, who is Iemitsu (1604–1651). The subsequent shōgun, Ietsuna (1651–1663), had the bell made under the supervision of the monk Kōson for the repose of his three Tokugawa predecessors. Under Ietsuna's patronage, Kōson, who had previously restored Honsenji in 1652 (Kanbun 1), wrote the inscription for the bell and possibly copied the sutra text cast on the bell.

The Honsenji bell has a dramatic history of mystery and movement. In the mid-nineteenth century, Honsenji was abandoned and burned. During that time the bell mysteriously disappeared from the temple and presumably went to the international exposition in Paris in 1867, and then on to Austria's international exposition in Vienna in 1873.[78] The Asian art connoisseur Gustave Revilliod (1817–1890) discovered the bell while it was being repaired at the prominent Rüetschi bell foundry in Aarau, Switzerland. Revilliod acquired the bell and had it installed in Geneva in the garden of Musée Ariana, a museum dedicated to ceramics and glass that he founded and then bequeathed to the city of Geneva in 1884. When a Japanese student visited Geneva in 1919, he noticed that the bell was from Honsenji. After authentication and negotiation, local officials agreed to have the bell returned to Honsenji in 1929. In 1930, after the bell arrived at Yokohama, it was taken to Hibiya Park in Tokyo for a grand celebration and then the next day was proudly paraded through the streets of Shinagawa in an oxcart as it returned home to the temple. The bell then became a noteworthy symbol for Tokyo's international community. In 1934 a reporter from the English newspaper *The Japan Times & Mail* wrote the following, noting that there were still struggles for the bell after its relocation.

During the troubled days of the Restoration the bell was taken abroad and exhibited at the museum in Geneva, but later was returned to its home at Honsenji after an absence of sixty years. Although it has come home it has been neglected and left without shelter, exposed to the weather. But definite steps have now been taken to preserve the bell and to construct a suitable tower in which it may hang.[79]

Indeed, a new bell tower was built for it in 1937. As a sign of recognition almost sixty years after its return, Honsenji offered Geneva a replica of this famous bell, which the city had installed in a small pavilion in the park at Musée Ariana in 1991, where it became a symbol of

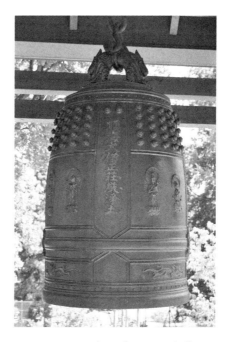

FIGURE 6.12. Replica of Honsenji bell. 1991. Bronze. 184 cm. Musée Ariana, Geneva. Photograph by Daniel Pradel.

friendship between Japan and Switzerland (Fig. 6.12).[80] The Six Kannon on the new bell are not exact replicas; they are in lower relief and their individual iconographies are more recognizable. In Japan the temple now shows pride in the bell's international history at one of its buildings through displays of various clippings and photographs of the events surrounding the bell's return.

Honsenji is a Shingon School temple where Kannon belief is emphasized, as noted by its alternate name, Fumonin, which was taken from the *Fumonbon* "Universal Gateway" chapter of the *Lotus sūtra,* also known as the *Kannon sūtra.* Accordingly, the sutra text is cast into the bell around the horizontal registers just below the Kannon images.

The focus of worship at Honsenji is not the bell, but its two main Kannon sculptures. One is a Water-Moon Kannon, which was purportedly the personal image (*nenjibutsu*) of Kūkai, and the other is a Shō Kannon, which was purportedly the personal image of the Shōgun Ōta Dōkan (1432–1486), who brought it with him from his homeland when he moved to Edo castle.[81] Both of these images are kept hidden from view at the temple, but in contrast, a large bronze Jizō image, of 275 centimeters and made in 1708 (Hōei 5), is very visible on the temple grounds. Beside the main gate it sits as one of the six large Jizō images of Edo, made to protect the six entrances to the city (now Tokyo). Like the Six Kannon, the Six Jizō protected the six paths of existence. In this case these large bronze Jizō were adapted to suit the times by shifting the meaning of the six paths of transmigration to the six main roads for human travel in Edo. The people of Edo might also have believed that the Six Kannon on the Honsenji bell could help the six paths of the living as well as the dead.[82]

Honsenji is featured in the gazetteer *Edo meisho zue* (Guide to famous Edo sites), which the editor Saitō Chōshū (1737–1799) began writing in 1791 (Kansei 3) and was initially published by his grandson Gesshin in 1834–1836 (Tenpō 5–7). The gazetteer's text explains Honsenji's history as a popular place for tourists and pilgrims, and its accompanying illustration prominently shows the bell inside its belfry, to the left front of the main hall, and the large bronze Jizō image (Fig. 6.13).[83]

At present, Honsenji is regarded as number 31 in a newer Thirty-Three Kannon pilgrimage route of Edo Kannon temples. Here again, these temples were organized into a local pilgrimage route with thirty-three stops based on the older routes.[84] A modern guidebook (*Shōwa shinsen Edo sanjūsansho Kannon junrei* [Thirty-Three Kannon pilgrimage sites of Edo selected in the Shōwa period] [1926–1988]) to the temples along this pilgrimage route provides a nine-step explanation of how to worship properly at each temple as outlined below.

FIGURE 6.13. Honsenji. 1893 (first published 1836). Height: 26 cm. Woodblock printed book pages. From *Edo meisho zue* (DS896.3 .S29 1834). Courtesy of the Library of Congress, Asian Division, Japanese Collection.

1. Bow in front of the gate.
2. Purify one's hands and mouth with water.
3. Ring the bell twice slowly. The guidebook cautions that if the bell is rung *after* praying, the pilgrim will *lose* merit.
4. Light incense and candles.
5. Place a slip of paper (*nōsatsu* or *osamefuda*) as an offering in the box provided.[85]
6. Place some coins in the offering box.
7. Place hands together, bow, and recite appropriate Buddhist texts in front of the main image (*honzon*).
8. Collect the temple's seal (*nōkyō*).
9. Bow in front of the temple gate before leaving.[86]

The third procedure in this process is to ring the bell, which contrasts with monasteries where bells often mark time throughout the day. Temples on pilgrimage routes usually have bells that are freely accessible for ringing,

but at Honsenji there is a sign and a rope prohibiting people to climb the steps up to the bell, either for the safety of the visitors or that of the bell.

Ongakuji: Six Kannon at the Temple of Music

A Six Kannon bell found at Ongakuji, located along the side of a mountain outside of Chichibu City, is ready and waiting to be rung by visitors. Ongakuji is temple number 23 along the Chichibu Kannon pilgrimage route, which continues to thrive today. Legends about this route of Kannon temples, located in the Chichibu area northwest of Tokyo in Saitama prefecture, claim that it began in the thirteenth century, but more likely it began in the fifteenth century. Ongakuji's bell, measuring 120 centimeters, is similar in form to Honsenji, except that it has a total of 108 bosses instead of 100 (Fig. 6.14). Without any handheld attributes, the Six Kannon images are each positioned atop lotus petals on clouds in low relief and spaced evenly along the lower registers (Fig. 6.15). Above the lip of the bell is a frieze pattern of dragons.[87]

The text cast into the surface states that the bell was made in 1768 (Meiwa 5) for Ongakuji on Mount Shōfū and inscribed by the monk Gikai. Ōgawa Tarōbee Tōshi Kanpū and three others are listed as responsible for recasting the bell.[88] According to the text on the bell, the sound was considered to be inadequate, so the twelfth abbot, with the support of Chichibu residents and a man from Edo who donated part of his fortune, tried to have it recast, but they were unsuccessful. The thirteenth abbot also tried to have the bell recast, but he became ill and died before it could happen. Finally, the fourteenth abbot was able to realize their dreams and have the bell recast in 1768. Whether the story is accurate or not, it represents the extreme difficulties faced in achieving a visually and audibly successful casting.

The characters of the temple's name Ongakuji, literally "temple of music," and its mountain name Shōfū, "wind in the pines," come from the legend of

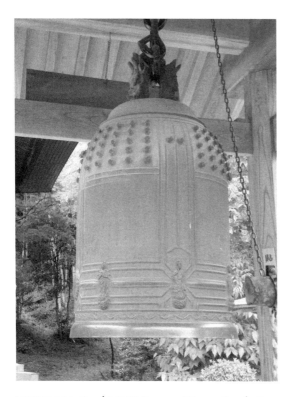

FIGURE 6.14. *Bonshō.* 1768. Bronze. 120 cm. Ongakuji, Chichibu.

the thirteen founders of the Chichibu pilgrimage route, who believed that the sound of the wind in the pines on the mountain resembled the music made by the heavenly entourage that comes down with Amida Buddha to greet a dying aspirant before returning with that person to paradise.[89] Sound is clearly an important focus here, and musicians represent some of Ongakuji's most famous pilgrims. Appropriately, Ongakuji has a superior temple bell on its grounds.[90]

At Ongakuji the pilgrims cannot see the main Kannon image, which is inside a closed tabernacle or *zushi*. The main image is a Shō Kannon, which has a legendary attribution to Ennin (794–864), the revered Tendai School prelate and purported founder of the temple. The veracity of this bit of pious fabrication, which enhances temple lore, does not appear to be cause for worshippers' concern. Other sources claim that the image

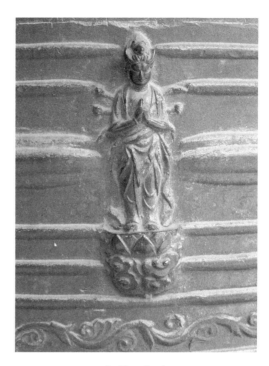

FIGURE 6.15. Detail of *bonshō* showing Horse-Headed Kannon. 1768. Bronze. Height of image: approx. 9 cm. Ongakuji, Chichibu.

dates from the Muromachi period (1333–1573).[91] As is common in many temples, the front opening of the hall is faced with a wooden grid preventing entrance. If pilgrims peer through the grid, they can see an image of lesser status that stands in front of the main image's tabernacle. This alternate image is called a *maedachi,* literally "standing in front," and the pilgrims have to take it on faith that the main image of Kannon is enshrined inside the box. In contrast, the bell inside its belfry in front of the hall may be easily viewed, touched, and rung.

Meanings for Ringing

The practice of ringing a temple bell is common, but explanations of the meaning of this action are not. In Japanese-language scholarship, Tsuboi Ryōhei provided valuable analysis of the forms and texts of countless specific bells, but did not discuss their broader social history. Temple bells have different functions, but they are perhaps best known in Japan for the custom of ringing at the end of the year (*joya no gane*). Just before midnight on the last day of the year, all over Japan, temple bells are struck 108 times as

a way to purify the 108 defilements (Skt. *kleśa;* J. *bonnō*) before the new year begins.[92] (The number 108 should remind us of the usual number of bosses on the surface of the bells.) At many monasteries, temple bells are also used to announce times of day and calls for devotions.[93] It is not surprising that, given their temple settings, bells also have a memorial function, and bell inscriptions often testify to the fact that that they were made for the repose of an honored or loved one.

Buddhist literature sources proclaim that the sound of the bell can alleviate the sufferings of the dead trapped in the lower paths.[94] In the seventh-century Chinese text *Shimen jiseng guidu tu jing* (Illustrated scripture on the procedures and models for the assembly of the *sangha* in Buddhism), attributed to the Vinaya Master Daoxuan (596–667), the techniques and functions of bell ringing are explained. For example, the most effective method for striking the bell before an assembly is three short sequences to call the assembly and then a number of long sequences that total 108 in order to alleviate the suffering in the lowest paths (animals, hungry ghosts, and hell).[95] An eleventh-century text, *Chanyuan qinggui* (Rules of purity of the Chan monastery), notes that before ringing the big bell, the attending monk should recite a verse about the bell relieving the sufferings of beings trapped in the three lower paths and the eight difficulties (J. *hachinan*).[96] These are eight circumstances in which sentient beings cannot see or hear the Buddha. This verse references a story about King Kaniṣka (fl. second century CE) of the Kushan dynasty, who because of bad karma in a previous life had been reborn as a thousand-headed fish, whose heads were continually severed by a wheel of knives. The wheel stopped when the sound of the bell was heard, so Kaniṣka requested that the monks continually strike the bell to alleviate his pain.[97] The biography of Zhixing (586–630), found in the seventh-century *Xu Gaoseng zhuan* (Further biographies of eminent monks), attributed to Daoxuan, relates that because the sound of the temple bell vibrates into hell it can relieve those suffering there.[98] Though unstated in the inscriptions of the bells with Six Kannon imagery, the likely connection between Six Kannon and bells is the similarity that both the bell, through its reverberation, and Kannon, through boundless compassion, can alleviate the suffering of beings trapped in the most difficult places.

Through the transmission of Buddhist texts and monks who traveled from China to Japan, the salvific power of the bell's sound was perpetuated in Japanese Buddhism.[99] Inscriptions cast into some fourteenth-century Japanese bells attest that their sounds could reach into hell and alleviate the sufferings of the dead. As examples, a bell dated to 1379 (Kōryaku 1) from Injōji (Senbon Enmadō) in Kyoto states that striking the bell once is a prayer that reaches all beings in the three worlds and releases them from suffering; another, from Dōjōji in Wakayama, dated to 1362 (Shōhei 17), states that

hearing the sound of the bell will lessen defilements and release beings from the fiery pit in hell.[100] Also in the fourteenth century the temple Rokudō Chinkōji in eastern Kyoto had the custom of letting laypeople ring its bell before the Obon festival to welcome the spirits of the dead. This annual event continues to be held. The area of Kyoto where the temple is located is called Rokudō no Tsuji (Crossroads of the six paths) because historically it was a burial site at the edge of Kyoto.[101] In contrast, Yatadera has a centuries-old custom of ringing its bell to send the spirits of the dead back to rest peacefully in what is called "*okurigane*" (sending-off bell).[102] While in all these cases proclaim the bell's sound is a comfort to the dead, it in turn comforts the living.

Another Buddhist concept associated with the bell is the idea of impermanence. In seventh-century China the monastery gong, referred to as the "bell of impermanence" (Ch. *wuchang qing*; J. *mujō kei*) was rung at the moment a monk died as a signal of passing into the next world.[103] One of the most familiar bell references in Japanese literature is the first line of the classic *Tale of the Heike:* "The sound of the Gion Shōja bells echoes the impermanence of all things."[104] Gion Shōja refers to the monastery in Jetavana grove, where the Buddha Shakyamuni taught. In *Tale of the Heike,* the sound of these bells sets the stage for the twelfth-century events surrounding the rise and fall of the great Heike clan in Japan. The last chapter of the book, "Death of the Imperial Lady," describes the final days of the former Empress Kenreimon'in, who had survived many tragic events before becoming a Buddhist nun and taking refuge at the temple of Jakkōin in Ōhara outside Kyoto. This final chapter opens with a passage about the Jakkōin temple bell announcing nightfall as the evening sun sinks into the west.[105] The image of the bell offers symmetry to the tale as well as signaling impermanence, as Kenreimon'in is about to pass away and go on to the Pure Land in the west. In the early fourteenth-century Japanese literary classic *Essays in Idleness,* the author Yoshida Kenkō remarks about the various tones of temple bells and how a good tone evokes impermanence and should be compared to the bells of Gion Shōja.[106] Since he could not have heard these bells in ancient India, he is alluding to the reference in *Tale of the Heike* and perpetuating the idea of the tone of the Gion Shōja bells as the pinnacle of all Buddhist bells.

Kōbaiin: Four Kannon, Two Dragons, and Two Turtles

At Kōbaiin, a subtemple of Myōshinji in Kyoto, there is a very intriguing bell that was dedicated to the mother of the temple's sixth abbot in 1672 (Kanbun 12) (Fig. 6.16). While the bell is suspended from the usual loop of double dragon heads, the body of this bell, which at ninety-three centimeters is smaller than the others discussed in this section, is designed in an unusual

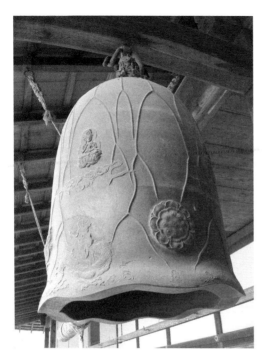

FIGURE 6.16. *Bonshō.* 1672. Bronze. 93 cm. Kōbaiin, Kyoto.

form of inverted lotus leaves, with none of the typical intersecting bands or bosses.

Around the center section are images of four of the Six Kannon—Shō, Eleven-Headed, Horse-Headed, and Nyoirin—seated on lotus pedestals floating on clouds. Since four of the Six Kannon are on the bell, I believe the designers likely intended to reference the cult of the Six Kannon. There are no canonical groupings of just four Kannon. Why were two of the Six Kannon images (Thousand-Armed and either Juntei or Fukūkenjaku) left off the bell? Within this study of Six Kannon it can be challenging to discern how many images were originally in a set. Unlike the members of a sculpture group that can be subtracted and added, however, images on a cast object such as the bell are set, so there is no debate that there were ever two additional Kannon images. Since the artist could have incorporated two more Kannon onto the eight lotus petals if desired, perhaps to have just these four Kannon there was an intentional but now unknown personal meaning for the temple or patron. Because the form and design of this bell breaks all conventions, we should consider that the convention of Six Kannon has been broken here as well. As possible sources of inspiration for the design, there are many examples of Korean bells from the Joseon dynasty (1392–1910) that have images of four bodhisattvas, not designated as Kannon, adorning their sides.[107]

Another unusual feature of this bell is that the inscription is cast in the interior rather than on the exterior as in most cases. Few indeed would have had the opportunity to read that the sixth generation abbot of Kōbaiin, Myōdō, offered the bell for the repose of his late mother, Keishun, who was a lady in waiting for Tōfukumonin (1607–1678). Tōfukumonin was the consort of retired Emperor Gomizunoo and daughter of the second Shōgun Tokugawa Hidetada, who was mentioned earlier in the Honsenji bell inscription. The inscription further explains that Rikuoku Daijō Tōshi Ietsugu made the bell at the Rokujō (Sixth Avenue) foundry in Kyoto in 1762 (Kanbun 10).

Returning to the imagery on the Kōbaiin bell, we can see that below the Kannon images, the two strike plates, designed as open lotus flowers, are

placed on opposite sides between alternating images of dragons with turtles (two each). A pattern of linear waves embellishes the bell around its undulating bottom edge.[108] The association of bells with water imagery will be addressed in the next example.

Ōmidō: Kannon and Hydropower

At Ōmidō (great hall) in Tsukuba in present-day Ibaraki prefecture, we can find another link to Six Kannon and bells. This is temple number 25 along the Bandō pilgrimage route for the Thirty-Three Kannon in eastern Japan.[109] The book *Bandō junrei sanjūsansho mokuroku* (Catalogue of the Bandō thirty-three temple pilgrimage) from 1882 explains that Mount Tsukuba has been a spiritual land since the time heaven and earth were created (Fig. 6.17). It continues, stating that the Hossō School monk Tokuitsu (781?–842?) founded the mountain site in the eighth century and the Shingon prelate Kūkai (774–835) carved the temple's main image of Kannon. Long ago, a dragon spirit

(*ryūjin*) brought a bell to the mountain with Six Kannon images cast on it and offered it to the local kami of the six places, "Rokusho Myōjin." When the bell was struck, the tide rose to the base of the mountain. People were afraid of drowning and referred to this bell as Tide-Calling Bell (Shioyobi no kane). Because the mountain deities stopped the bell from ringing and because the dragon deity was worshipped in the guise of Benzaiten (Skt. Sarasvatī), the base of the mountain remained in peace.[110]

The lower portion of the image in the Ōmidō print shows what happened, or what can happen, in a less peaceful time as a man and woman flee from rushing water while another man falls down in a panic. In contrast, the upper section of the print shows an uneventful scene of the temple grounds, with the main hall featured as the largest building. The print caption on the right titles it as "Bandō Number 25." The bell is

FIGURE 6.17. Ōmidō, Tsukuba. Illustrated by Umedō Kunimasa. 1882. Temple number 25 in Hattori Ōga, ed., *Bandō junrei sanjūsansho mokuroku*. Woodblock printed book page. Height: 18 cm. Nichibunken Library, Kyoto.

FIGURE 6.18. Ōmidō, Tsukuba. 1903. Temple number 25 in *Bandō Saikoku Chichibu hyaku Kanzeon reijōki,* 26. Copperplate printed book page. Height: 19 cm. (BQ6450.J3 B36 1903). Courtesy of the Library of Congress, Asian Division, Japanese Collection.

not depicted in the print, but eighteenth- and nineteenth-century maps of the temple show a bell tower in the foreground of the precinct.[111]

A similar print in the 1903 book *Bandō Saigoku Chichibu hyaku Kanzeon reijōki* (Record of one hundred sacred sites of Bandō Saigoku Chichibu) also includes a cartouche on the lower right with a temple verse (*goeika*) that features the bell (Fig. 6.18). In contrast, the image of the bell in the verse is one of nostalgia that does not match the adjacent illustration of people desperately trying to outrun raging water.

At Ōmidō the bell
stands on a Tsukuba cliff
at dusk
longing for the country.[112]
(Inscription 6.1 in the Appendix)

Strangely, though in most tales that accompany images in Kannon pilgrimage print series we read about how people are saved by the miraculous power of Kannon, this story lacks reference to Kannon's compassion, and instead the bell adorned with Six Kannon seems to be something frightening. Furthermore, since one of Kannon's roles in the *Lotus sūtra* is to save people from flooding, there may have been some idea of Kannon's efficacy against floods in the temple's history that is unstated in the print. Ōmidō was previously part of the temple Chisokuin Chūzenji, but in 1872, due to anti-Buddhist sentiment, it was dismantled and most of the Buddhist furnishings were removed as it was merged with Tsukuba Shrine. Later, in 1930, only Ōmidō was rebuilt and reestablished as a Buddhist institution.

The story is a good illustration of how local kami and Buddhist deities were worshipped together for greater efficacy before the Meiji period. Indeed, there was a shrine in the area called Rokusho Jinja (Shrine of the six places) prior to 1910 that enshrined six kami of Mount Tsukuba.[113] This amalgamation recalls the numerous references to the matching of Six Kannon

and Six Gongen in Kyushu, discussed in Chapter Two. The text of *Bandō jun-rei sanjūsansho mokuroku* abbreviates the narrative of the Tide-Calling Bell from an older and longer version of the story. And yet the fact that this spare text includes both the Six Kannon and the local deities of the six places (Rokusho Myōjin) on Tsukuba Mountain, and matches them together in a way, indicates their strong ties to the location and to each other.[114]

Since the dragon is known as a deity who controls water in Asia, it is fitting that in this case she, as the female deity Benzaiten, functions as an agent who uses the bell to link the powers of the local deities with Kannon. In Japanese literature there are many fantastic stories of dragons, women, and bells, such as the Noh plays of Dōjōji and Miidera, so such a trope was likely not lost on readers of this print.[115] Returning to the physical features of bells, we should remember that most Japanese bells are suspended by a double-headed dragon loop. The specific dragon imagery on the previously discussed Ongakuji and Kōbaiin bells also demonstrates the pervasive strength of the association between bells and dragons.[116] People of the Tsukuba region must have felt that the enhanced supernatural reinforcements, such as the Six Kannon, the six local kami, and the dragon, were needed to quell the threat of flooding that was such a grave concern for the area.[117]

The location has suffered a great deal of damage over the centuries. And indeed in 1938 a landslide destroyed the temple. Now a hall built in 1961 stands at the site, welcoming pilgrims and tourists to worship Kannon. As appropriate for a pilgrimage temple, a bell is suspended inside its tower at the site. This bell was cast in 2001 and does not have Six Kannon cast onto its sides so the former tie to Six Kannon has been broken.[118] In previous times, because the awesome sound of the bell was thought to cause flooding, we can infer that if the dragon deity was worshipped properly in the form of Benzaiten, the power of the six local kami aligned with the Six Kannon could literally help to turn the tide.

Jōrinji: One Hundred Kannon and Three Pilgrimage Routes

The bell at Jōrinji, also known by its more familiar name, Hayashidera, greatly expands the parameters of Kannon worship beyond even one pilgrimage route, as it includes one hundred images of Kannon depicted on its surface (Fig. 6.19). This bell shows that the cults of the Thirty-Three Kannon temple pilgrimages had definitely superseded the cult of the Six Kannon by the eighteenth century. The surface of the bell includes the temple name, the accompanying verse (*goeika*), and a relief sculpture of the main Kannon image for each temple along the three major Kannon pilgrimage routes in Japan. The aforementioned routes of Chichibu, Bandō, and Saigoku each

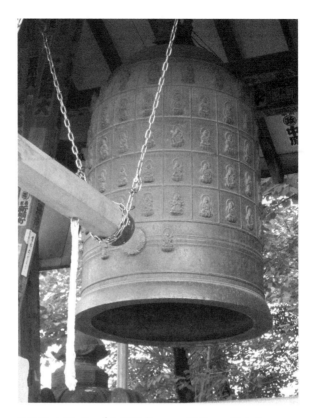

FIGURE 6.19. *Bonshō.* 1758. Bronze. 137.9 cm. Jōrinji, Chichibu.

have thirty-three temples that feature Kannon. Since the Chichibu pilgrimage actually includes one extra temple on its route, the Kannon images on this bell total one hundred.[119] The Jōrinji bell, measuring 137.9 centimeters in height, has images set in a grid pattern around its body, with four Kannon placed off the grid around the lowest level.

The depiction of Jōrinji's own Eleven-Headed Kannon is in the privileged position to the left of the long inscription and to the right of the *tsukiza*, the open lotus where the striker hits the bell (Fig. 6.20). Curiously, the figure shown is a seated image, in contrast to the temple's main image, which is standing and has also been traditionally described as such. Either there have been some changes in the main icon or the physical description of the image was not important to those involved in creating the bell.[120] In recent years an inscription was discovered inside Jōrinji's main Eleven-Headed Kannon sculpture that dated its initial dedication to 1593 (Tenshō 22), so it predates the bell.[121] Moreover, *Chichibu engi reigenki entsūden* (The Entsū tradition of miraculous origin tales of Chichibu), compiled in 1744 (Enkyō 1), describes Jōrinji's main image as a miraculous *standing* Eleven-Headed Kan-

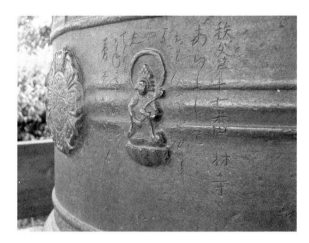

FIGURE 6.20. Detail of Eleven-Headed Kannon and verse on Jōrinji *bonshō*. 1758. Bronze. Height of Kannon image: approx. 9 cm. Jōrinji, Chichibu.

non that measures 1 *shaku*, 6 *sun* (48.48 cm).[122] Therefore, the makers of the bell likely did not see the main image and probably had very little information about it.

Jōrinji is number 17 on the Chichibu Kannon pilgrimage route. To travel to Jōrinji, pilgrims take main roads as well as paths though working fields. At the site, the raised bell tower and small hall are adjacent to fields used for small-scale farming. Jōrinji is listed as belonging to the Rinzai School of Buddhism, but it has not had an abbot for decades and is managed by the neighboring houses.

According to temple tradition, a previous bell was made for the temple in the early Edo period, but it was lost in a fire along with the hall. The present bell was cast in 1758 (Hōreki 8).[123] Unfortunately, the earlier bell was not described in records, so whether or not the original bell had the same design of one hundred Kannon is unknown.

One legend associating the temple's main Kannon image with the bell is about a woman who was pregnant while making the Chichibu pilgrimage. Even though she had the baby near Jōrinji, she still desperately wanted to complete the pilgrimage, so she wrapped the baby in a cloth and threw it in a nearby pond. When the woman returned home after finishing the pilgrimage she found the baby on the mud floor at her house. At the same spot in the house she pulled a print (*osugata,* literally "honored form") of the Jōrinji Kannon out of the mud.[124] The mother regretted her actions so intensely that she had a bell donated to the temple in atonement. From this and other stories, the temple became associated with helping children.[125] As mentioned earlier, prints with images of the temple's main icons were significant souvenirs at pilgrimage temples. Jōrinji's contemporary prints featuring a standing image of the Eleven-Headed Kannon, in either blue or white, may be purchased at the temple for about a dollar or two each

FIGURE 6.21. Votive print of Eleven-Headed Kannon at Jōrinji. Circa 2008. Printed black ink on white paper. 15.5×9 cm. Collection of author.

(Fig. 6.21). Most of the individual Kannon images on the bell (see Fig. 6.19) are framed by a grid pattern that may reference the rectangular shape, size, and significance of souvenir temple prints. The verse (*goeika*) for Jōrinji, which is cast onto the surface of the bell around its own Kannon image, features its bell:

Thinking about what might be,
my mind settled on the temple in the woods
Hayashidera—
though I still hear its bell toll,
I've awakened from my dreams.[126] (Inscription 6.2 in the Appendix)

Obviously the Jōrinji bell was, and still is, one of the temple's main treasures and in a sense seems to have overshadowed the main icon. In keeping with the pilgrim's guidelines mentioned earlier, a sign on the Jōrinji bell tower, rebuilt in 1963, reminds people that they should ring the bell *before* praying. Anyone making a pilgrimage along the route may ring the bell, but proper protocol should be observed.

Temples may use bells to announce time or place emphasis on certain rituals, but as part of the pilgrimage process, ringing a temple bell is understood to be advantageous to oneself or the departed. One can imagine that upon properly ringing a bell enhanced with Six Kannon the pilgrim will receive the benefits not only from one Kannon, but from all Six Kannon at once. In the case of the Jōrinji bell, the ringer of the bell can receive the multiple benefits of all the Kannon from the three major pilgrimage routes simultaneously. Here the number one hundred supersedes the power of thirty-three, which is another expansion of Kannon's enumeration. In this way, along with a multiplicity of Kannon who can perceive the sounds of suffering, the bell's deep voice makes a sound that can penetrate the worst of the paths and rescue beings in the greatest peril, which sometimes might be on earth.

Butsuzō zui and the Multiplications of Kannon

The illustrated manual *Butsuzō zui* (Collection of Buddhist image illustrations) is the best place to find the organization of Kannon imagery, from

six, seven, or thirty-three, which was newly established in the seventeenth century. As introduced in Chapter Five, *Butsuzō zui* was originally published in 1690 in three volumes and then expanded into five in 1783.[127] Stretching across the two pages of the section of *Butsuzō zui* with the heading of "Seven Kannon" (Shichi Kannon), as discussed in Chapter Five, are actually eight spaces of Kannon images rather than seven (Fig. 5.5). The title "Thirty-Three Kannon Bodies" (Sanjūsantai Kannon) that appears at the top of the next page is followed by thirty-two images of Kannon (Fig. 5.6). On the previous page Willow Branch Kannon (Yōryū), which is one of the most frequently depicted paintings among all the images of Thirty-Three Kannon, serves as a bridge between the two groups of Seven Kannon and Thirty-Three Kannon. As noted in Chapter Five, the stone monument from Enkōin (Fig. 5.7), made in 1811, is an example that shows Willow Branch Kannon as one within a group of Seven Kannon. Kannon usually makes use of the willow branch as an attribute for healing. However, because the *Butsuzō zui* text accompanying Willow Branch Kannon says: "It is said that because the willow branch waves as if it were in a spring breeze, it blesses all of the Six Kannon" (Fig. 5.5, lower right), the plant functions like the branches that are used in purification rituals and thus Kannon wields it to sanction the relationship between each of the Kannon groups.

As an iconographic compendium with 824 images, *Butsuzō zui* curiously does not include images of Kannon's thirty-three guises listed in the *Lotus sūtra* that are in Table 6.2. The images surrounding the Hasedera Kannon painting held by Nōmanin (Fig. 6.3) that were organized into boxes would have been perfect to copy into *Butsuzō zui,* but no such images appear. By the seventeenth century these guises may not have been considered significant enough to include as individual illustrations. Nevertheless, as I will demonstrate later, references to the *Lotus sūtra* and connections to the Kannon guises do appear in the text accompanying some of the *Butsuzō zui* Thirty-Three Kannon images.

What Is the Butsuzō zui *Group of Thirty-Three Kannon?*

Just at the time *Butsuzō zui* was circulating in the seventeenth century, sets of Thirty-Three Kannon gained popularity in Japanese painting, such as those mentioned earlier by Kakushū and Takuhō. Because this group was not in earlier iconographic manuals, *Butsuzō zui* was even more significant as a reference for their representation and identification. Like the preceding Seven Kannon section in *Butsuzō zui,* each of the Thirty-Three Kannon images includes a name, a drawing, and some lines of text. A few of these

TABLE 6.2 Thirty-Three Kannon in *Butsuzō zui*

1.	Yōryū	楊柳	Willow Branch
2.	Ryūzu	龍頭	Dragon-Headed
3.	Jikyō	持経	Sutra-Holding
4.	Enkō	円光	Radiant Light
5.	Yūge	遊戯	Joyful
6.	Byakue	白衣	White-Robed
7.	Renga	蓮臥	Lotus-Reclining
8.	Takimi	滝見	Waterfall-Watching
9.	Seraku	施楽	Joy-Bestowing
10.	Gyoran	魚籃	Fish-Basket
11.	Tokuō	徳王	King of Virtue
12.	Suigetsu	水月	Water Moon
13.	Ichiyō	一葉	Single Leaf
14.	Seitsu	青頭	Blue-Headed
15.	Itoku	威徳	Majestic Virtue
16.	Enmei	延命	Long Life
17.	Shūhō	衆宝	Many Jewels
18.	Iwato	岩戸	Rock Door
19.	Nōjō	能静	Tranquil Ability
20.	Anoku	阿耨	Anavatapata
21.	Amadai	阿摩提	Amati
22.	Yōe	葉衣	Leaf-Robed
23.	Ruri	瑠璃	Lapis Lazuli
24.	Tarason	多羅尊	Goddess Tara
25.	Kōri	蛤蜊	Clam Shell
26.	Rokuji	六時	Six Hours
27.	Fuhi	普悲	Universal Compassion
28.	Merōfu	馬郎婦	Wife of Mr. Ma
29.	Gasshō	合掌	Adoration
30.	Ichinyo	一如	Oneness
31.	Funi	不二	Unequaled
32.	Jiren	持蓮	Lotus Holder
33.	Shasui	灑水	Water-Sprinkling

Kannon, such as White-Robed and Water-Moon, are well known and have individual histories, but most of them are rarely represented alone, and in earlier Japanese iconographic manuals when some of them do appear in proximity to other Kannon images, they are not tied together as a unit.[128] Most have a relatively generic appearance and look like variations of the White-Robed Kannon, like those in the Minchō set. Within the *Butsuzō zui*, however, there is information to indicate that some of the Kannon are from India and based on Buddhist scripture, and some are from popular Chinese stories. Others have more descriptive identity titles, such as "Sutra-Holding"

and "Waterfall-Watching." Table 6.2 provides the names. The three that are specifically gendered female will be highlighted in the discussion as part of the new organization.

Gendered Images of Kannon

The gender of Kannon is often the source of confusion. Although Kannon was regarded as a male bodhisattva in canonical Buddhist literature, by the eleventh century the deity also came to be regarded as female in China through stories and painted and sculpted images.[129] Though it is not clear how each of the Thirty-Three Kannon images was selected to be in *Butsuzō zui,* it must have become necessary to include the increasingly popular female forms in this semiofficial version of the Thirty-Three Kannon. Moreover, the standard form of the White-Robed Kannon appears to be female, but often sports a mustache. Merely by observation, we may get a vague impression that the White-Robed Kannon and its variations are female, but Chün-fang Yü has clearly argued that popular notions of Guanyin as female were firmly rooted in Chinese culture. These ideas were happily brought to Japan. In the Thirty-Three Kannon, as in the table above, the three images that are specifically gendered female are Wife of Mr. Ma, Fish-Basket, and Tara.

Before proceeding to the decidedly female manifestations of Kannon, we should make a detour that shows a bizarre twist on the specific gendering of Kannon images. As part of a seventeenth-century series made in China known as the *Fifty-Three Manifestations of Guanyin Bodhisattva* (*Guanyin dashi wushisan xianxiang*), there is a surprising image of Kannon (Fig. 6.22).[130] Amid this series of monochrome prints of the usual variations of the deity, including many White-Robed Guanyin, we find one showing that in an extraordinary effort to save beings from suffering, Kannon has taken on the astonishing form of a foreign man that resembles a European portrait, possibly of a Dutchman, or at least a man in a foreign outfit. Although we know that Kannon can have a mustache, the more familiar attributes are the willow branch in a vase on the man's right, representing healing properties of the deity, the boy Sudhana who visits Kannon in the *Avataṃsaka sūtra* (J. *Kegongyō*), and the white parrot who made a vow never to part from the deity.[131] Unfortunately, there is no documentation to accompany the prints except for an attached slip of paper with the aforementioned title and the claim that it was printed in the Ming dynasty.[132] This unusual print series seems to merge the concept of the fifty-three teachers (of which Avalokiteśvara is one) that the boy Sudana visits in *Avataṃsaka sūtra,* with the idea of worshipping of multiples of Kannon.[133] The image of Kannon as a foreign man is an

FIGURE 6.22. Foreign Male Guanyin. Seventeenth century, China. From the series *Fifty-Three Manifestations of Guanyin*. Woodblock print. 27.5 × 28.9 cm. Machida Shiritsu Kokusai Hanga Bijutsukan, Machida City, Japan.

example of a guise that was perhaps experimental, since it did not become popular in China and was not reproduced in Japan. Perhaps antiforeign sentiment in seventeenth-century Japan was reason enough to exclude him as an image among the various manifestations of Kannon. After all, actual foreign men were not welcome in Japan in this period.

In contrast to the strange foreign male figure, one of the most well-known images in the group of Thirty-Three Kannon is Wife of Mr. Ma (J. Merōfu Kannon; Ch. Malangfu Guanyin). Her legend comes from a Tang-dynasty story about a laywoman who was very beautiful. Many men wanted to marry her, so in order to winnow the competition, she asked her suitors to memorize the *Kannon sūtra* in one night. Twenty succeeded, so she then asked them

to memorize the *Diamond sūtra*, which half of them were able to do. Finally, she asked that they memorize the entire *Lotus sūtra* in three days. A man from the Ma family was the only one who could accomplish this feat, so she agreed to marry him. However, she died right after the wedding ceremony and her body quickly decomposed. Later, when a monk asked Mr. Ma if he could view her remains, he found that her bones were linked together by a golden chain, which was the sign of a holy person. Wife of Mr. Ma thus used her beauty as a means to teach men Buddhist doctrine. Although the men were motivated by desire, they were compelled to learn the dharma by memorizing the sutras. Since Wife of Mr. Ma died before consummating her marriage, she was able to maintain a state of saintly purity.

The usual form for Wife of Mr. Ma is a laywoman in Chinese dress holding a scroll of the *Lotus sūtra*.[134] However, in the *Butsuzō zui* illustration (Fig. 6.23, top right), she is in Chinese garb, wears a crown, and is empty-handed. This is a case where an extra line of text next to the image was included to bolster the authority of the entry

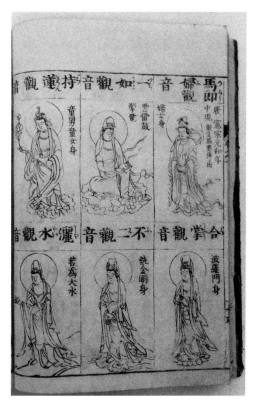

FIGURE 6.23. One page of Thirty-Three Kannon section; including Wife of Mr. Ma, top right. 1752 (first published 1690). Woodblock printed book page. 23 × 14 cm. From *Shoshū Butsuzō zui* (BQ4630.B89 1752). Courtesy of the Library of Congress, Asian Division, Japanese Collection.

stating: "The manifestation from the Yuanhe Era [805–820] of Tang Emperor Xianzong, taken from *Guanyin gan ying zhuan* [Record of Guanyin's Manifestations]." Although this specific text no longer exists, there are Chinese chronicles as early as the twelfth century that tell her story.[135]

Patricia Fister has shown that seventeenth-century Japanese Buddhist nuns were especially drawn to Wife of Mr. Ma as a model of female piety. Devoted nuns not only supported images of Wife of Mr. Ma in painting and sculpture, but also made them in *oshie*, pictures constructed of recycled fabric pasted onto wood. In the mid-seventeenth century, Empress Tōfukumon'in (1607–1678), who had by this time become a nun, made an *oshie* image of Wife of Mr. Ma and donated it to Eigenji in Shiga prefecture.[136] By crafting *oshie* themselves, these nuns created a bond with Kannon that was more personal than commissioning an image from a professional.

Curiously, another of the female Thirty-Three Kannon images has a similar story that was sometimes conflated with Wife of Mr. Ma. The story of Fish-Basket Kannon, or Gyoran Kannon, has the same premise of a woman who bribed men to memorize the *Lotus sūtra* in exchange for the possibility of marriage, but in this version she is the daughter of a fishmonger.[137] Fish-Basket Kannon was much more popular, and independent images of her are more plentiful than those of Wife of Mr. Ma. Moreover, in the Mita district of Tokyo there is a temple named after her called Gyoranji, which features a wooden sculpture of Fish-Basket Kannon as a main image.[138] The early nineteenth-century gazetteer *Edo meisho zue* illustrates the temple as a former bustling worship site.[139] Although Fish-Basket and Wife of Mr. Ma have intertwined histories, they are treated as two separate manifestations of Kannon that each earned a place within the Thirty-Three Kannon group.[140]

The figure of a woman holding a basket of fish is certainly recognizable as the main iconography for Fish-Basket Kannon, and it is the most common form of her in independent representations. Yet *Butsuzō zui* (Fig. 6.24,

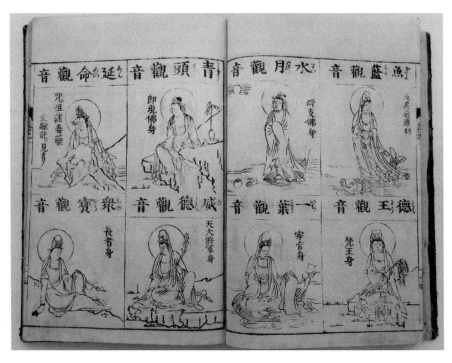

FIGURE 6.24. Two pages of Thirty-Three Kannon section; including Gyoran Kannon (top right, right page) and Enmei Kannon (top left, left page). 1752 (first published 1690). Woodblock printed book pages. 23×28 cm. From *Shoshū Butsuzō zui* (BQ4630.B89 1752). Courtesy of the Library of Congress, Asian Division, Japanese Collection.

top right), shows her as a White-Robed Kannon standing on the back of a large fish with the phrase from the *Kannon sūtra,* translating as "Suppose you encounter evil rakshasas [evil demons]." This tradition of the oversized fish seems to have been embedded in the connection to Thirty-Three Kannon imagery and appears in painted sets.

One other image within the Thirty-Three Kannon who is specifically female is Tara, a female deity who was popular in India, Bhutan, Tibet, and Nepal, but not in China, Korea, or Japan. Tara is regarded as having the power to help quell the Eight Great Fears: lions, elephants, fire, snakes, thieves, drowning, captivity, and evil spirits. Images of her made as early as the eighth century show her in conjunction with narrative scenes of these perils.[141] There are many stories of the origin of Tara in India; one is that she came from a vow made by Amitābha (J. Amida), and another is that she arose from a blue lotus that grew out of a pond created by the tears Avalokiteśvara (Kannon) wept out of compassion for suffering beings.[142] Tara has indeed had a long-standing relationship with Kannon. In her earliest appearance, as a stone relief sculpture from the late sixth century at Khanheri, she is an attendant of Avalokiteśvara, surrounded by images of the perils.[143] Chün-fang Yü contends that the Chinese always maintained a clear distinction between Tara and Guanyin.[144] In Japan, however, Tara diminished in stature and was merged with Kannon. Some Buddhist texts and iconographic compendia describe her as a Kannon and even name her "Tara Kannon."[145] In the twelfth- to thirteenth-century iconographic manual *Kakuzenshō,* she is described as a middle-aged female with one head and two hands held up in reverence, holding a flower in between.[146]

One close connection between Tara and Kannon in Japan is that Tara is found in the Womb World Mandala's Kannon section, which embodies various aspects of compassion.[147] Within this section, Tara is in the position of the fourth bodhisattva from the top in the inside row, closest to the mandala's central lotus configuration. Her form is of a cross-legged, crowned bodhisattva holding a lotus. In *Butsuzō zui* (Fig. 6.25, top middle of left page) she appears wearing a crown and robe that covers her right hand while she stands on a floating cloud. The accompanying line of text from the *Kannon sūtra* next to the Tara image translates as "Suppose you are surrounded by evil-hearted bandits," meaning that Tara Kannon will protect you from this fate. Notably, one of the eight fears that Tara can quell is that of thieves. Moreover, the other seven fears are remarkably similar to the other perils from which Kannon can save beings in the *Kannon sūtra.* Perhaps these wondrous powers in common convinced people to continue the long-term relationship between Tara and Kannon, which secured her a place within the Thirty-Three Kannon group.

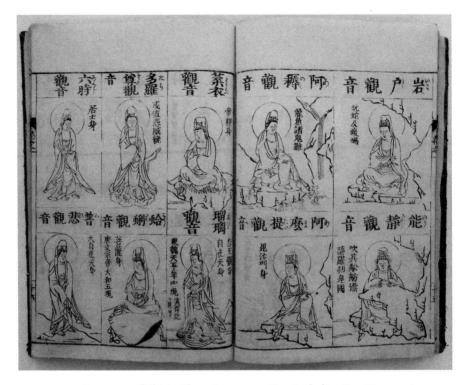

FIGURE 6.25. Two pages of Thirty-Three Kannon section; including Tara Kannon, top middle, left page. 1752 (first published 1690). Woodblock printed book pages. 23×28 cm. From *Shoshū Butsuzō zui*. (BQ4630.B89 1752). Courtesy of the Library of Congress, Asian Division, Japanese Collection.

In the Japanese group of thirty-three, there are many images with blurred identities and ambiguous genders, but three where gender is part of the message. Tara has a long history throughout Asia that identifies her as female. Wife of Mr. Ma and Fish-Basket have stories that utilize their sex appeal to further the cause of the Buddhist teachings. Moreover, beyond the popularity of the female images, I suggest that a significant reason to include Fish-Basket and Wife of Mr. Ma within the Thirty-Three Kannon is their legacy of great advocacy for the *Lotus sūtra*. While I certainly cannot offer all the answers, at least *Butsuzō zui*'s organization helps to change the age-old question of "*Is* Kannon female?" to "*When* is Kannon female?"

Butsuzō zui *as a Copybook*

Several sets of Thirty-Three Kannon paintings made in the Edo period reference the fifteenth-century Tōfukuji set, yet within them the individual identities of the Kannon were not standardized in Japan until *Butsuzō zui* was published in 1690. The images of Thirty-Three Kannon in *Butsuzō zui* come to be a composite that abbreviates selections taken from different

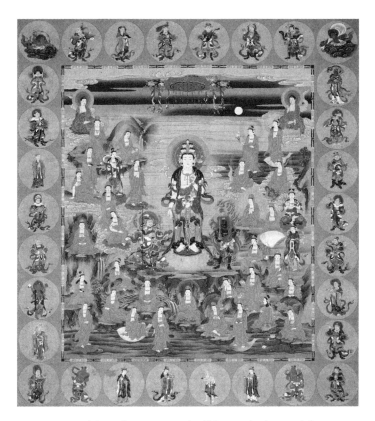

FIGURE 6.26. Thirty-Three Kannon bodhisattva body mandala. By Kanda Sōtei Yōshin. Nineteenth century. Color on silk. 163.7 × 149.9 cm. Hiratsukashi City Museum, Hiratsuka.

painting sets, and unlike the paintings, each frame includes a title. By 1793, when Hara Zaichū produced the set owned by Shūon'an Ikkyūji, artists like him could consult *Butsuzō zui* in addition to using painted sets as models.[148] Could *Butsuzō zui* have been considered an Edo-period "Wikipedia" for religious imagery in Japan, which served as a handy reference but should have its sources verified? Because *Butsuzō zui* was so accessible, many artists easily appropriated its images, as in the nineteenth-century *Thirty-Three Kannon Bodhisattva Body Mandala* (*Kanzeon Bosatsu sanjūsanshin mandara*), painted by Kanda Sōtei Yōshin (1826–1875), now in Hiratsuka City Museum (Fig. 6.26).[149] Yōshin was the ninth-generation head of the well-established Buddhist painting academy at Kaneiji in Tokyo, which the first-generation artist Kanda Sōtei (1590–1662) began.[150] Another example that copies *Butsuzō zui* is the ink and light color painting of Thirty-Three Kannon from Seisuiji in Fukuoka from 1835 (Tenpō 6).[151] The most famous artist to draw on *Butsuzō zui* imagery was Katsushika Hokusai (1760–1849). Instead of the common representation of Fish-Basket Kannon as a woman holding a basket of fish, the curvilinear image of this deity standing on the back of a large S-shaped

FIGURE 6.27. Fish-Basket Kannon in *Hokusai manga*, vol. 13. By Katsushika Hokusai. 1849. Printed book pages. 29.5 × 24 cm.

carp included in a two-page spread in *Hokusai manga* (Fig. 6.27) follows the image in *Butsuzō zui* (Fig. 6.24).[152] This form is not surprising given that images of other deities in *Hokusai manga* were appropriated from *Butsuzō zui*.[153]

Beyond painting, other artists used *Butsuzō zui* images as models for the Thirty-Three Kannon in stone. Most artists did not plagiarize the entire set, but chose to borrow selectively, as in the group of Thirty-Three Kannon made in 1835 from Entsūji in Saitama. This set of Thirty-Three Kannon is carved in relief on three separate stone steles, bearing eleven Kannon each. Within the same set, references to some of the *Butsuzō zui* Kannon images are close copies, others are reversed, and others only pick out a few of the same features.[154]

Within the frames of the Kannon images of *Butsuzō zui* we can find references to the *Lotus sūtra*. Nineteen of the thirty-three frames have an extra line of text that corresponds to the guises in the *Kannon sūtra*. For example, Wife of Mr. Ma is aligned with women (*fujoshin*), and White-Robed (Byakue) is aligned with monks and nuns (Fig. 5.6, top right of left page). There is no one-to-one match between each of the *Lotus sūtra* guises and a specific Kannon in *Butsuzō zui*. In ten of the other frames is a line of text from the *Lotus sūtra,* such as "spells and various poisonous herbs" next to Long Life Kannon (Enmei), meaning that if one is subjected to these things and calls the name of Kannon, that person will be saved (Fig. 6.24, top left of left page). Next to Waterfall-Watching Kannon (Takimi) is the line "a pit of fire is transformed into a lake," meaning that Kannon can save those subjected to fire (Fig. 5.6, top left of left page). The bits of text included do not follow the order of the *Lotus sūtra,* and the relationship to a particular Kannon image is not necessarily obvious. Like the two previous examples, it appears that while the author, or authors, was making a distinctive taxonomy for these images, snippets of *Lotus sūtra* text were added to maintain the strong relationship between the sutra and this group of Thirty-Three Kannon.

Five Icons from the Saigoku Thirty-Three Kannon Pilgrimage

The final section dedicated to Kannon in *Butsuzō zui,* spread over two pages in the fourth volume of the expanded second edition from 1783, displays five of the images from the popular Saigoku Thirty-Three Kannon pilgrimage.

As discussed previously, simple printed images of Kannon were distributed to pilgrims who could not always gaze directly upon the temple's main icon of Kannon. As one example, the eleventh-century image of Nyoirin Kannon at Ishiyamadera in Shiga (see below), which is kept hidden, was primarily known through its reproduction in souvenir temple prints and the *Butsuzō zui* illustration.

Instead of an encyclopedic enumeration of each of the Thirty-Three Kannon icons from the entire Saigoku route, only five were selected for *Butsuzō zui*. The accompanying text is minimal, only giving the temple name and province. Although unnumbered, they are arranged in order: Number 7 (Nyoirin), Okadera in Nara; Number 10 (Thousand-Armed), Mimurodoji in Uji, Jōshū [Yamashiro]; Number 13 (Nyoirin), Ishiyamadera in Kōshū [Shiga]; Number 24 (Eleven-Headed), Nakayamadera in Sesshū [near Osaka in Hyōgo]; and Number 26 (Shō), Hokkesan (Ichijōji) in Banshū [Hyōgo]. Figure 6.28 shows the page with the first four images, starting at the top right. The image of Hokkesan is on the other side of this folded page. Based upon my observation of a Saigoku pilgrimage route map, the author seems to have selected images from temples in different districts at relatively regular spatial intervals, in a clockwise fashion to give an abbreviated sense of the whole route. In 1886 Kajikawa Tatsuji published the third edition of the book called *Meiji zōho shoshū Butsuzō zui* (Meiji-era enlarged edition encompassing various schools of the illustrated compendium of Buddhist images), which maintained the previous group of five images from Saigoku in the former position of the 1783 edition, but added thirty-three new images, one for each temple, at the end of the book.[155] Figure 6.29 shows the last two pages of this section. The inclusion of the new images may have been considered a bonus feature of the new volumes—the Saigoku pilgrimage images had become too important as a cultural phenomenon to leave only in abbreviated form.

FIGURE 6.28. Four of the Saigoku Thirty-Three Kannon pilgrimage icons. 1796 (first published in 1783). Woodblock printed book page. 22.5 × 14 cm. From *Zōho shoshū Butsuzō zui*. Kislak Center for Special Collections, Rare Books and Manuscripts, University of Pennsylvania.

FIGURE 6.29. Last two pages of *Meiji zōho shoshū Butsuzō zui,* including Nichienji Shō Kannon (lower left). 1886. Printed book pages. 22 × 28 cm. Kislak Center for Special Collections, Rare Books and Manuscripts, University of Pennsylvania.

Since many of the Kannon are secret images and not likely to be seen even by a pilgrim on site, we must ask where the representations used in *Butsuzō zui* originated. Pilgrimage temples routinely provided printed paper souvenirs of their main icons, called *osugata* or *ofuda* (talismans) to pilgrims, such as in Figure 6.21. These commemorate the pilgrimage and also create a personal connection to the deity, as in those collected and mounted on the previously mentioned scroll from 1897 (Fig. 6.9). On the last page of *Meiji zōho shoshū butsuzō zui,* the text next to the final and additional Kannon pilgrimage image, from a supernumerary temple outside the main route called Nichienji in Ayabe, explains, "Because this Kannon is a truly remarkable manifestation, it is printed on paper so that sentient beings can establish a connection [*kechien*] with it."[156] This is the lower left image in Figure 6.29.[157]

Pilgrimage prints are usually modest, simplified representations that emphasize recognizable features of the icons. For example, the Eleven-Headed Kannon from Nakayamadera has an unusual lotus-leaf mandorla that is similarly depicted both in the pilgrimage prints (Fig. 6.30) and in the *Butsuzō zui* image (Fig. 6.28, lower left).[158] Although the sculpture was made in the tenth century, it is the unusual mandorla (the kind of accessory scholars tend to overlook) made in 1702 (Genroku 15) that became the defining feature of this

image for public consumption.[159] The expanded *Meiji zōho shoshū butsuzō zui* from 1886 also includes this prominent mandorla in the illustration.

The Kannon icon from the pilgrimage temple Mimurodoji in Uji is a secret image of Thousand-Armed Kannon, which is rarely shown. This hidden image is represented and known through its anachronistic wooden sculpture that stands in front (*maedachi*) of the closed tabernacle that holds the secret image, possibly dating from the Edo period. *Butsuzō zui* from 1783 shows it as a two-armed Kannon image with one palm resting on the other across the chest and wearing a scarf with distinctive sawtooth-style folds (Fig. 6.28, lower right). Although two-armed versions of this deity exist, because this figure does not have any extra appendages, it certainly does not look like a typical Thousand-Armed Kannon. Moreover, its unusual form refers to a seventh-century style commonly seen in small bronzes.[160] *Meiji zōho shoshū butsuzō zui* from 1886 lists it as a Thousand-Armed Kannon, but the illustration follows the earlier *Butsuzō zui* illustration from 1783.[161] The accompanying text says it is a bronze image measuring

FIGURE 6.30. Eleven-Headed Kannon pilgrimage print from Nakayamadera. Nineteenth century. Woodblock print. 10.5 × 19.5 cm. Collection of author.

eight *sun,* two *bu* (24.8 cm). Temple legend proclaims that this Thousand-Armed Kannon icon is a bronze that was taken out of a deep pond beneath a waterfall and has been kept as a secret image shown only once every thirty-three years since the Enryaku era (781–806).[162] The Mimurodoji Kannon image is another demonstration that the Kannon images from Saigoku pilgrimage reproduced in *Butsuzō zui* are not exact replicas. Instead, they highlight certain features, likely culled from pilgrimage prints and written descriptions, which like a portrait, give a sense of the identity of a specific icon. As the preface of *Butsuzō zui* makes clear, its purpose was to help the untrained learn to identify Japanese religious images. The distinctive visual cues of the icons help accomplish this. While I argue for *Butsuzō zui*'s role in the codification of the broad categories of Kannon imagery, such as the

Thirty-Three Kannon pilgrimage images, and groups of seven and thirty-three, we should bear in mind that the volumes were also used piecemeal as a resource to be mined for iconographic details that were replicated long afterward.

Kannon Goes Worldwide

As *Butsuzō zui* circulated, the various representations of Kannon depicted within moved beyond Japan as they were introduced to new audiences throughout the world. The German doctor Philipp Franz von Siebold (1796–1866), who had the rare experience of being a European living in Japan for over eight years, published the first foreign-language version of the work in 1852 within the fifth volume, entitled "Das Buddha-Pantheon von Nippon," of his monumental book *Nippon*.[163] Siebold was aided by the German scholar of philology and Asian philosophy Johann Joseph Hoffmann (1805–1878), who translated parts of *Butsuzō zui* for *Nippon*.[164] This large-size, seven-section work was published in installments beginning in 1832 and sold by subscription. Because the parts were assembled later, often into two large volumes, various bound volumes often have different contents. In many cases, the sheets with text from "Das Buddha-Pantheon von Nippon" were bound separately from the sheets with the images.[165] The artists copied the *Butsuzō zui* illustrations in thin lines and accurately captured the iconographical features. In the process of rearranging, Siebold gave each image of Kannon within the groups of seven, thirty-three, and the pilgrimage icons, a number that corresponded to an explanatory text, but jumbled the images together in the pages. Figure 6.31 shows the page titled "Shichi Kannon" (Seven Kannon) with eight images, which includes six images copied from the *Butsuzō zui* group of Seven Kannon along with one Willow Branch Kannon (lower left) and an image of the Nakayamadera Eleven-Headed Kannon image with its distinctive lotus-leaf mandorla (upper left). Figure 6.32 shows another page with twelve of the Thirty-Three Kannon images.[166]

In the nineteenth century, foreigners such as Émile Guimet (1836–1918), who founded Musée Guimet in Paris, were eager to learn about the mysterious religions in Japan and greeted *Butsuzō zui* with enthusiasm. Guimet owned a copy of *Butsuzō zui*, as well as Hoffmann's translation, which must have aided him in assembling his vast collection of Buddhist images that included many of the more unusual Kannon forms illustrated in *Butsuzō zui*'s pages.[167] Indeed, Guimet was keenly interested in collecting Buddhist images as manifestations of religion rather than as art, so he was attracted to works different from those that interested others.

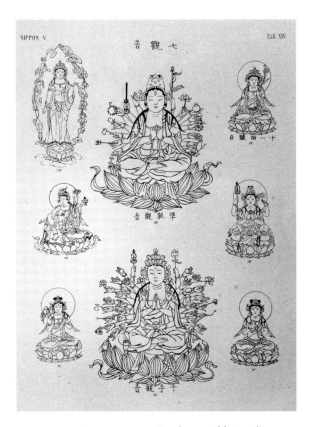

FIGURE 6.31. "Seven Kannon" with two additional Kannon. 1832–1852. Printed book page. 35×56 cm. From Siebold, *Nippon,* Tab. XIV (DS809. S55). Courtesy of the Library of Congress.

William Anderson (1842–1900), a doctor and art enthusiast who had lived in Japan, included several illustrations from *Butsuzō zui* in his 1886 catalogue of Chinese and Japanese paintings from the British Museum.[168] In his section on Kannon, titled "Kwanyin," he opted to reproduce only two images: the Thousand-Armed Kannon from the Seven Kannon group and Anoku Kannon from the group of Thirty-Three Kannon. In 1908, when Henri Joly published *Legend in Japanese Art,* a time-honored resource for popular Japanese iconography, he did not include illustrations but extensively quoted translations of *Butsuzō zui* that reference Kannon. Perhaps because he could not read the titles and misunderstood the pictorial organization, he concluded wrongly that instead of seven and thirty-three, there were groups of eight Kannon and thirty-two Kannon in *Butsuzō zui.*[169] Joly may have appropriated the use of thirty-two Kannon from *Nippon,* which places Willow Branch Kannon in with Seven Kannon and lists thirty-two instead of

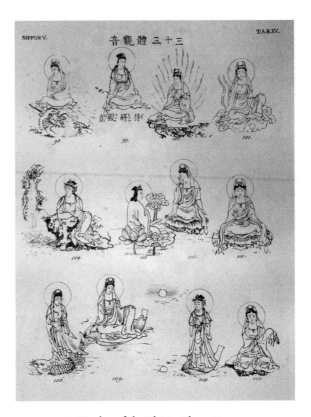

FIGURE 6.32. Twelve of the Thirty-Three Kannon. 1832–1852. Printed book page. 35 × 56 cm. From Siebold, *Nippon*, Tab. XIV. (DS809. S55). Courtesy of the Library of Congress.

thirty-three. In 1914, Alice Getty wrote in her classic *The Gods of Northern Buddhism* that *Butsuzō zui* was the best source available for Japanese Buddhist iconography but explained the hesitation in the book's reception. "The Japanese Buddhist priests do not look upon the *Butsuzō Zui* [*sic*] as an absolute authority on Japanese Buddhism; but until another manual is compiled, the Western student must continue to refer to this Japanese manual of Buddhist divinities, especially as, in so many respects, it has been found to be perfectly reliable." Following her own advice, she cited it repeatedly in her book's section on the various types of Kannon.[170]

For many outside Japan, these references to *Butsuzō zui* were the first point of contact with Buddhism and Japanese religion. As this new audience, few of whom could read the original text, explored the wonders of an unknown culture, they came to rely on *Butsuzō zui* illustrations of Kannon as a primary resource for identification, and thus new codifications of Kannon were formed without much concern that they came from a popular, noncanonical source.

Butsuzō zui has occupied an awkward position in Japanese studies scholarship. Although it has been, and still is, quoted extensively in written and visual sources, it was not sanctioned as a specific religious text. Perhaps the nebulous information about its authors, illustrators, and compilers was a deliberate marketing strategy. Although readers might have been impressed by the pious motives explained in the different prefaces of the first and second editions, rather than distribution by religious institution it was actually the bookstores and publishers that drove the prolific production of this for-profit venture. The plethora of images in the pages, which were not limited to any school of Buddhism or shrine complex, had broad appeal without alienating any group. *Butsuzō zui*'s mass production made it the "go-to" source in a period before most people had access to the Buddhist canon that now inhabits libraries worldwide as well as the Internet. The simply titled, black-and-white images of *Butsuzō zui* spread across the pages were appealingly accessible when they were made and remain so today.

Conclusion

Kannon is an immensely popular deity who has the ability to appear in countless forms. Accordingly, without a context the term "Thirty-Three Kannon" is open to multiple, and sometimes confusing, interpretations. Chapter Five ended with the set of sixteenth-century Kannon paintings from Kōdaiji that includes not only six individual paintings featuring Six Kannon with scenes of the six paths, but also twenty-seven other paintings of Kannon with narrative scenes from the *Lotus sūtra*. Its total number of thirty-three resonates with sets of Thirty-Three Kannon paintings, and indeed the unusual format of the Six Kannon paintings with the scenes below follows the organization of most painted sets of Thirty-Three Kannon, such as that from Tōfukuji. The Kōdaiji set of paintings is an exemplar that demonstrates how the visual imagery of Kannon worship expanded by overlapping Six and Thirty-Three Kannon together.

As I began this area of research, I assumed that information on the images of the Thirty-Three Kannon would be easily obtainable, but to my surprise, other than studies on individual sets, relatively little has been written on this topic. One likely reason is that most of the images were made after the fifteenth century and therefore were considered outside the canon of Buddhist art. Another reason is that the relationship between Kannon and thirty-three has such diverse components.

Unwieldy as they may be, the images of the Thirty-Three Kannon in this chapter were organized in a general typology, which has components that refer to the transition of the older Six Kannon cult. The first type is

represented by the images of the guises taken by Kannon in order to best preach the dharma in the different situations that are found in the *Kannon sūtra,* such as monks, children, dragons, officials, and women. When represented in sculpture and painting they serve to enhance the efficacy of a main icon of Kannon, such as the thirteenth-century sculptures in the mandorla of the main Kannon image at Sanjūsangendō and the seventeenth-century paintings on the tabernacle doors for the huge Eleven-Headed Kannon sculpture at Hasedera.

The second type is a portrayal of Thirty-Three Kannon in painted and printed sets, where the image of Kannon (predominantly White-Robed) floats in a circle of light above a narrative scene of the perils or the guises from the *Kannon sūtra.* While the 1257 handscroll in the Metropolitan Museum of Art is the earliest of Japanese *Kannon sūtra* images that contains these elements, it is the format of the fifteenth-century hanging scroll set from Tōfukuji purportedly by Minchō that captivated the attention of patrons and artists as a prototype for later works. Yet while making this claim I must acknowledge that its format was based on Chinese prints of a sort that continued to be consulted in Japan long after the fifteenth century.

A third type of Thirty-Three Kannon group is made up of sculptures, and their secondary replications, that function as the main image from each temple along the Kannon pilgrimage routes and have identities tied to their geographic settings. Within this type, the subset of Kannon imagery on bells provides a focused platform within a pilgrimage context that reveals the transition between the Six and Thirty-Three Kannon cults.

The fourth and final type is a group of Thirty-Three Kannon that was codified in the iconographic manual known as *Butsuzō zui,* first published in 1690. In these representations, although the images are specifically named and the narrative scenes disappear, we still find abbreviated textual references to the *Kannon sūtra.* Since this manual was widely accessible, it became a standard reference from which artists like Hokusai could borrow templates to create Kannon images, both individually and as a group, in order to grasp hold of the giant slippery concept of Thirty-Three Kannon.

Epilogue

Searching for Stones in the Unstable Landscape of Kannon

A TWENTY-MINUTE WALK FROM THE crowded Great Buddha Hall in Nara Park will take you to a very odd granite sculpture that few will ever venture out to see. Following the main road in front of the Nara National Museum east to the south slope of Mount Wakakusa you will find a small, unmarked forested area where stands a six-sided pillar with Six Kannon carved in relief, one on each side, and a Buddha's head on top (Figs. 7.1, 7.2). How should we approach such a strange thing? One purpose of this book is to confront images that are outside the canon of Japanese art history and recognize their role within the Six Kannon cult. The idea for this book began with such lofty images as the sculptor Higo Jōkei's superlative wooden set from Daihōonji from 1224 and the statesman Fujiwara no Michinaga's set of Six Kannon at Hōjōji from 1023, now lost but known through written descriptions of its splendor. Along the way, through the twists and turns of history, and beyond their affiliation with a numbered grouping of Kannon, it becomes clear that many of the works that remain from the cults are unconventional. This book not only broadens our horizons and expectations about works of Six Kannon imagery but also pushes possibilities for the vast extent of multifarious Kannon cult images even further.

Yet even after sifting through all the images treated in the pages of this book, the head on top of the pillar is

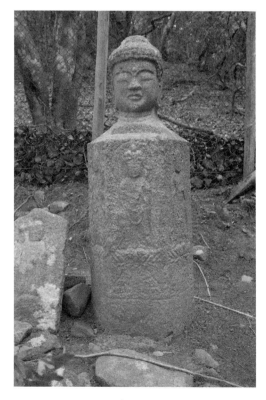

FIGURE 7.1. Hora Head monument. 1520. Stone. 107 cm. Hora, Mount Wakakusa, Nara.

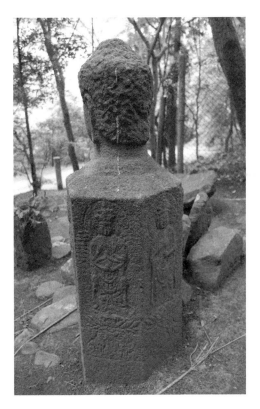

FIGURE 7.2. Hora Head monument, back showing Thousand-Armed Kannon and Shō Kannon in relief. 1520. Stone. 107 cm. Hora, Mount Wakakusa, Nara.

still strange. This monument, known as "Hora no buttōseki" (Stone Buddha head in the grotto), takes its name from an area located west of Kasuga Shrine called Hora, which, although the name literally means "grotto," is not obvious as such today.[1] I will refer to this unusual monument as the Hora Head.

Although stone sculpture is a vast resource for variations in Buddhist form and is often located in accessible outdoor natural and unrestricted settings, in Japanese art history it has been treated in isolation, marginalized as ethnographic material or folk art, or just dismissed altogether. While I have tapped into this great resource for some of the examples in this book, such as the monument at hand, there are so many more images that could be accounted for, so many more that are waiting to be discovered, and so many more that will be posted on the Internet in the future by dedicated bloggers. Accordingly, these images will reach new audiences who cannot necessarily access the physical sites or who might never consider looking for old photographs of stones in libraries. Indeed, if it were not for the numerous image-posting enthusiasts, who often even include excellent directions, I would never have located several of the works made in stone, or in other materials for that matter, discussed in this study. In the interest of obtaining more expansive archives of pictures of their subjects, I urge scholars who have not already done so to take advantage of the amateur bloggers' and local authorities' vast access to valuable resources. Discovering something outside the walls of a museum or a sanctioned temple space is, after all, a special reward akin to finding buried (or often in these cases semi-buried) treasure. Such finds are the disappearing fragments of culture, which appear to have been left undisturbed in nature, solidly planted in the earth. Yet if we examine stone images closely, like most of the Buddhist images discussed in this book, we find that they too may be moved, modified, stabilized, repaired, and enhanced.

Returning to the mysterious Hora Head, including the head and pillar base, the entire sculpture measures approximately 107 centimeters in

height. In front of the Buddha's neck is an oblong indentation to hold offertory water. Six Kannon were carved in relief on the surfaces of the six sides; beginning with the image on the front, in line with the direction of the head, they are as follows: Eleven-Headed Kannon holding a lotus, Juntei Kannon with eight arms, Thousand-Armed Kannon with what appears to be forty-two arms, Shō Kannon holding a lotus in one of its two hands, Nyoirin Kannon seated in a pensive pose with six arms, and Horse-Headed Kannon with two arms. As with many of the Six Kannon images, the identifications are not completely clear, and due to this flexibility it is possible that the identities of the Juntei and Horse-Headed Kannon images may be reversed.[2] Below each image's lotus pedestal is a pair of facing seated lion-dogs (*komainu*), like the three-dimensional stone figures that often guard the entrances to shrines.

The Buddha head may be an Amida. If we return to Chapter One to consider the recorded sets of Six Kannon that were enshrined with a Buddha image, such as those from Mudōji from 910, Hino Kannondō at Hōkaiji from 1081, and Jōgyōdō at Miidera from 1040, Amida is the most likely choice for a Buddha to accompany Six Kannon. Although different in main concept from our monument, it is worth considering that Amida figures may appear abbreviated in scenes known as "Amida Coming over the Mountains" (Yamagoshi raigō), in which Amida's body is obscured by mountains as he approaches an aspirant.[3]

In regard to images of Six Kannon in stone, Chapter Two discussed a stone stele with Six Kannon images from Ōsumi Kokubunji in Kyushu, made in 1562 (Figs. 2.29, 2.30), which offers a comparison made within fifty years of the Hora Head and that is also the same height (both measure 107 centimeters). This rectangular monument with Six Kannon carved in relief was commissioned by a group of local donors wishing for blessings and safety. Close by, also in Kirishima City, is a related but somewhat later monument, possibly made in the seventeenth or eighteenth century at the former location of Kongōji (Fig. 2.32). This is a six-sided stone banner (*sekidō*) with the names and corresponding seed syllables of Six Kannon on each side, but instead of a Buddha head, there is a sacred jewel crowning the top. As discussed in Chapter Five, three other examples with similar forms, one from Chōmeiji (Fig. 5.9), one from Nanzōin now in Nakamura (Fig. 5.10), and one from Enkōin (Fig. 5.7), which are all from Nerima ward in Tokyo, indicate that the faceted stone banner type that included Six Kannon became popular in the Edo period.

An inscription on the surface with Eleven-Headed Kannon on the Hora Head stone banner reads "Prelate Kakuhen Mokujiki, Eishō 17 [1520], a day in the second month" (Daisōzu Kakuhen Mokujiki, Eishō jūnana nen kōshin [konoetatsu] nigatsu nichi).[4] On another side, an additional inscription had

the name of a saint (*shōnin*), which is quite eroded, but was possibly read as either Engen or Enkū. The inscription with Kakuken's name is barely visible now, and the other name has disappeared, but fortunately these were recorded decades ago when they were more legible.[5]

The prelate Kakuhen Mokujiki named in the inscription is not the famously prolific sculptor of smiling curvilinear wooden images named Mokujiki, who lived from 1718 to 1810. Similar to that artist, however, this Mokujiki (or Kakuhen) also took the Buddhist vow to be a "wood-eater" (*mokujiki*), which refers to someone who abstains not only from meat and fish but also from grains. An outdoor monument seems appropriate for someone who took such a serious Buddhist vow to revere the natural environment.

In 1943, Nishimura Tei, who could see the inscriptions better than anyone today, proposed that the monk names refer to two former Kōfukuji abbots (*bettō*) who were in the lineage of the widely respected Hossō prelate Jōkei (1155–1213). Engen (b. 1175) was the fifty-seventh abbot of Kōfukuji, and Kakuhen (1175–1258) was the sixty-second.[6] Significant monks were often commemorated long after death, and the proximity of the Hora Head to Kōfukuji, which belonged to the same religious complex as Kasuga Shrine, makes this theory an attractive possibility.

No specific motivation for the monument's creation is given in the inscription, but we might assume that the Six Kannon were included as a way to help those named on the pillar, whether the thirteenth-century Kōfukuji monks or others, navigate the six paths of transmigration. The oblong indentation for offertory water (*mizubachi*) in front of the Buddha's neck is indeed a common feature of Japanese gravestones. The additional presence of Amida may have been a prayer to elude the six paths and go directly to paradise. Or, as many of the works in this book have shown, it was also possible that the donors could enlist Amida and the Six Kannon for help with more worldly concerns of the present. During the Eishō era (1504–1521) when the monument was made, the civil wars in Japan must have intensified anxiety over the future.

Mystery will continue to surround the Hora Head, which is definitely off the beaten path of Buddhist imagery, but at least we can consider comparisons. Although this image is certainly not a template for Six Kannon imagery, a consideration of the Hora Buddha Head with Six Kannon is a useful rubric for how to consult this book to reconstruct the history of an image with connections to Six, Seven, or Thirty-Three Kannon.

As the investigation of the Hora Head exemplifies, tracking the numerous modestly carved stone Kannon sculptures left out in the open is one method to consider how the Six Kannon cult image groups shifted over time from an elite to a nonelite patronage. In addition, the fact that such an eccentric object is the focus for the conclusion of this book is a deliberate strat-

egy to illustrate the art historical shift in progress to recognize alternative images as worthy of study. Continuing with the examination of the Hora Head as a platform for the conclusion, the following revisits the major themes of the book.

Landscape and Sacred Geography

To be sure, Nara is one of the most prominent locations for Buddhist art in the world and because of all the other major works in this area, it is easy to overlook a stone sculpture like the Hora Head, which is in a remote location, no longer attached to a temple, nor adjacent to a larger group of images. Although it does not appear to have been modified and looks quite stable, it is unlikely that the stone was originally in its present position or location. Nishimura Tei wrote in 1943 that it had recently been moved from a nearby area called Tobihino, which is closer to Kasuga Shrine.[7] Three other stones that feature carvings of Jizō, one dated to 1254 (Kenchō 6), are in the same clearing, but they do not seem to have any relationship to the Hora Head. As Hank Glassman has shown in regard to Jizō and other stone images in Japan, abandoned gravestones were often relocated into new groupings in an effort to appease the unconnected dead.[8] The haphazard placement of the three Jizō stones makes it seem as if they were moved here without fixed plans for worship or display. Since they are heavy, we can at least assume that they did not travel far. Although no place name is given in the inscription of the Hora Head, possibly because it seemed unnecessary at the time, one clue might be the unusual depiction of the pair of lion-dogs below each Kannon image. As lion-dogs are a common fixture of shrines, perhaps this connotes a relationship to nearby Kasuga Shrine. As discussed in Chapter Two, numerous examples of Six Kannon, especially in regard to the Rokusho Gongen shrines in Kyushu, were matched with kami that were tied to specific geographic locations.

Indeed, discussions in this book about sacred geography and landscape are primarily focused on the island of Kyushu, where we find the highest concentration of documentary and physical evidence for past belief in Six Kannon. In the Kirishima Mountains of Kyushu, Six Kannon images are said to have appeared on the surface of a lake, later named Six Kannon Lake (Rokkannon no Miike), which contributed to the authority of matching Six Kannon with six kami (Figs. 2.2–2.4). The earliest dated set of Six Kannon on the incised bronze sutra container dated to 1141 from Chōanji in Kunisaki Peninsula has an extremely strong relationship to the earth since it was buried within Kyushu's Mount Ya for several centuries (Figs. 2.6, 2.7). Stone cliff images that are still physically attached to their environs, such as the Dō no sako cliff (Fig. 2.20) and Fukuma cliff (Fig. 2.22) carvings in Kunisaki

Peninsula made in the Muromachi period (like the Hora Head), demonstrate how Six Kannon could operate in an outdoor setting in tandem with other deities, such as Six Jizō and Enma, in an effort to maximize benefits for future rebirth.

When thirty-three temples joined together by virtue of their proximity and the enshrinement of a significant Kannon icon at each stop, new regions for Kannon cults that converged with the landscape were born. Because of the sheer numbers of Kannon pilgrimage routes and images, an extensive treatment of this subject was not possible in the present volume. Instead, Chapter Six offers a more focused discussion of areas where the images of the Six and Thirty-Three Kannon cults overlap. The geography of Kannon cult images greatly expanded as the Six Kannon cult came to be overshadowed by the Kannon pilgrimage routes, which created vast territories dedicated to Kannon through the movement of pilgrims, who traveled throughout the country to areas beyond their home horizons.

Text and Image Relationships

The strong relationship between text and image is another important theme that surfaces throughout this book. In order to reconstruct the history of the Six Kannon cult in Japan, whenever possible written documents from historical and religious sources about a work and its environment were consulted. The Hora Head has no known associated premodern secondary literature, but it does have a text that is more direct. In contrast to the copious inscriptions found concealed in the interiors the thirteenth-century set from Daihōonji and one in the fourteenth-century set from Tōmyōji (Fig. 3.8), discussed in Chapter Three, the Hora Head has the rare and fortunate circumstance of an inscription recorded right on its surface, with a date and patron name. Yet matching the inscription now to what was recorded in descriptions of the monument some seventy years earlier proves a great challenge. One price of being out in the open is that exposure to the elements is causing the inscription to disappear before our eyes.

As few images survive from the earliest period of the Six Kannon, we must use textual sources as the primary loci of information. From the outset, the sixth-century Chinese Buddhist text *Mohe zhiguan* explains that the Six Guanyin *are* texts, as they are viewed as manifestations of an especially powerful Six-Syllable phrase or *dhāraṇī*. Early Japanese monk-authors who promoted the Six Kannon cult repeated the idea. Ono no Ningai, who is associated with the development of the theory that matches the Japanese Six Kannon with the Chinese concept in the eleventh century, is also touted for his role in completing one of the Six-Syllable mandala (Rokujikyōhō mandara) painting

types, examples of which date from the thirteenth through the nineteenth centuries. Six-Syllable mandalas, discussed in Chapter Four, make the most direct connections between Six Kannon and text because they include syllables called *bonji* as abbreviated forms of Sanskrit text that reference the sounds of each of the Six Kannon, alongside their corresponding figurative images. Although images dominate the visual expression of the Six Kannon cult, on some occasions throughout its history, as seen in iconographic manuals, figurative images of Six Kannon were exchanged for such textual representations. Additionally, in the three Edo-period stone banners from Kongōji, Chōmeiji, and Enkōin (Figs. 2.32, 5.9, 5.7), just mentioned as comparisons to the Hora Head, incised names of the Six Kannon were doubled up with Sanskrit seed syllables to stand in place of images. The distilled *bonji* can concentrate the essence of the deities in powerful and recognizable esoteric shorthand.

The Six Kannon's significant relationship with texts arises in diverse ways. Buddhist text itself has an intrinsic sacrality and, as became apparent during the period when the Daihōonji images were enshrined in the Sutra Hall at Kitano Shrine, Six Kannon also had a role in protecting the written dharma—by empowering the location where all the sutras were stored and also read aloud by monks for special services.

Even beyond sacred texts and the records kept by temples essential for the success of Buddhist institutions, illustrated iconographic manuals with written explanations are also crucial for this study. From the twelfth-century *Zuzōshō* to Philipp Franz von Siebold's nineteenth-century book *Nippon,* which had Kannon images derived from the seventeenth-century manual *Butsuzō zui,* we can track not only how texts were used as sources, both textual and figural, for Kannon groups, but also how they functioned to proliferate great numbers of Kannon images throughout the world.

Ritual Practice/Ritual Life of the Object

What kind of ritual would have been performed in conjunction with the Hora Head? It is not probable that the ritual would have been group-oriented like the once-popular Shichiyamachi (Seven Nights of Waiting) that is commemorated by the stone banners from Nerima at Chōmeiji (Fig. 5.9) and the "Seven-faced stone banner with Six Kannon and Seishi" in Nakamura, Nerima (Fig. 5.10), which were cited as comparisons earlier. Perhaps a ritual like *Roku Kannon gōgyō,* which is described in thirteenth-century sources, would have been more appropriate to consecrate the Hora Head because it focused on calling the names of the Six Kannon to invoke them into service. If indeed it is a memorial for past Kōfukuji abbots, the ritual may have had a particular local character that interfaced with Kasuga Shrine.

A highly significant motivation for making Six Kannon images was their performativity. Textual descriptions of related rituals crystallize their function, and in some cases, long after the images were lost, the transcription of the ritual is the only evidence of their existence. Procedural records discussed in Chapter Three that focused on Six Kannon ritual, such as *Roku Kannon gōgyō* in the thirteenth-century iconographic manual *Asabashō*, explain general protocol for Six Kannon rituals, while the fifteenth-century texts called *Roku Kannon gōgyōki* each give the details of a different time-specific rite that took place. These texts not only provided templates for monks to conduct similar rituals, but also captured, insofar as it is possible, the ephemeral nature of a past ritual event.

Texts, such as the fifteenth-century diary of the prelate Mansai, who kept track of the number of times the Six-Syllable sutra ritual was performed, document the ritual's prominence and demonstrate what was considered effective. From the extensive surviving documentation, we know more about the Six-Syllable sutra ritual, which by the fourteenth century seems to have been more frequently performed than Six Kannon rituals such as *Roku Kannon gōgyō*. Six-Syllable mandalas served as the central focus of rituals performed to avert calamities, help with safe childbirth, remove or redirect curses, and practice exorcism. Over time the goals for Six Kannon worship came to emphasize practical, earthly concerns.

Some of the ritual lives and functions of the Kannon images in this book are more obvious than others. For example, Chapter Six has a section on how bells function within Buddhist ritual and how Kannon imagery cast onto them enhanced their purposes. Cases such as the Honsenji bell from 1657 (Fig. 6.10) have ample text cast directly on the bell, as well as secondary literature with which to examine the history and changes in function from its inception as a memorial for three deceased Tokugawa shōgun to its role as a "peace bell" to strengthen international relations between Japan and Switzerland beginning in the early twentieth century. The images discussed in the book that have survived over a long period of time repeatedly demonstrate the resiliency of ritual and cultural strategies.

Numbers of Kannon

In the process of researching partially surviving sets of images from the Six Kannon cult, several case studies built an argument for the existence of a former set with evidence from the remaining two (Konkaikōmyōji in Kyoto), three (Buzaiin in Ishikawa), or five (Tōmyōji, Fumonji, and Hosomi Museum in Kyoto). While the Hora Head monument has a stable group of six on one stone, it also manifests the concept of expansion or augmentation if we con-

sider that it has more than just Six Kannon. The Buddha head on the top represents an additional dimension and offers up the synergistic possibility of doing more than what was expected from a set of Six Kannon alone. Although the idea of a bodiless head atop a pillar may look odd and incomplete, the serene expression on the Buddha's face in conjunction with the comfort Amida's welcoming descent could provide, must have appeared less startling to the faithful of earlier centuries.

The concept of Six Kannon stretched into seven when some groups included both Fukūkenjaku and Juntei Kannon, usually considered alternatives, such as the scroll *Sho Kannon zuzō* (Figs. 5.1 and 1.6) and the sculptures from the Kyoto temple Shichi Kannon'in. Because the *Lotus sūtra* lists thirty-three different forms of Kannon, this number comes to be highly significant to Kannon, yet it too was not necessarily stable. Painted and printed sets of Thirty-Three Kannon contain images that often do not strictly add up to thirty-three; moreover, the types of Kannon depicted are not fixed. Thirty-three temples grouped together into pilgrimage routes dedicated to Kannon commonly include supernumerary temples and in the case of the Chichibu Kannon pilgrimage a thirty-fourth temple was officially added. When we consider how the 1758 Jōrinji bell from the Chichibu pilgrimage route depicts images of all the Kannon icons from all three major Kannon pilgrimage routes, Kannon's number expands to a hundred (Fig. 6.19). One strike of the bell may summon all the Kannon at once.

The purpose of calculating concepts and deities in Buddhism is about trying to grasp hold of the ethereal and contain it in some way. Image making is similar to quantification in that it attempts to capture the form of an idea. Rather than concentrate on the shrinking numbers of surviving Kannon images, this book clarifies that the numbers of Kannon keep expanding, which, given the propensity to categorize concepts in Buddhism numerically, is not at all surprising. Multiplication of bodies is especially fundamental to the identity of Kannon. As the *Lotus sūtra* explains, in order to most expediently save a sentient being Kannon can assume any kind of body. As humans asked more from Kannon, they counted on getting greater responses by making more images and increasing the numbers of Kannon. Yet Kannon's power seems to defy mathematical calculation as well as the limitation of a fixed image, or even a set of images, as the numbers of bodies and varieties of images are in flux. By writing this book, I too have participated in the effort to account for, count on, and conjure up the multifarious and uncanny groups of Kannon.

Inscription 1.1

三觀音之内　元禄元年戊辰三月吉日
奉再興
弘法大師御作
為妙林菩提也　施主加能屋与兵衛
白石山　豊財院　般若台　現住
月澗 判

Inscription 2.1

保延七年八月二日未時打了
金剛佛子僧尊智
金剛佛子僧隆嚴
僧永明

Inscription 2.2

中尊聖観音再興施主 . . .
正徳四甲午歳八月十八日
唐津刀町佛師　勝本久八
川上山傳源寺 . . .

Inscription 3.1

此准提觀音者
造佛師肥後別當定慶
貞應参年五月二二日

Inscription 3.2

貞應三年四月廿九日大檀那
藤原以久女大施主藤
氏六觀音造立之中
奉納此經為利法界之
郡類導無上菩提抽
殊丹誠所書寫如件
執筆僧明増

Inscription 3.3

貞應三年四月廿五日書寫　願主
肥後前司藤原以久女大施主藤氏
執筆明増

Inscription 3.4

觀音之像五躰
中尊ハ千手　真暁上人造
十一面一躰　馬頭一躰　如意輪一躰
　聖觀音一躰
右春日ノ作也云云

Inscription 3.5

かも　三番　とうみやうじ
本尊六くはん(観)音御長六尺
是よりぢやうねんじへ八丁
あき風にひがしの
あくるてらのにわ
くさばのつゆは
わけし　たまかも

Inscription 5.1

洛東清水僧定深爲興法署記之于時
承暦二年六月而已

Inscription 5.2

本尊ノ異説諸流雖多端ナリト。醍醐
ノ諸流ハ正觀音ヲ爲本尊ト。山門ニ
ハ六觀音ヲ爲本尊ト。勸修寺。仁和
寺同之。今觀宿ノ曼荼羅ヲ爲本尊ト。

Inscription 5.3

楊柳ノ春風ニ靡クガ如シ故ニ総シテ
六觀音ニ亘ル

Inscription 6.1

Ōmidō kane wa
Tsukuba no mine ni tate
katayūgure ni
kunizo koishiki
大御堂かねは
つくばの峯にたて
かた夕ぐれに
くにぞ恋しき

Inscription 6.2

aramashi o
omoisadameshi
Hayashidera
kane kikiaezu
yume zo samekeru
あらましを
おもひさためし
はやしてら
かねきゝあへす
夢そさめける

Abbreviations

DNBZ	*Dai Nihon Bukkyō zensho*
KT	*Shintei zōho kokushi taikei*
SMZ	*Sangoku meishō zue*
SKS	*Shinshū Kyoto sōsho*
T	*Taishō shinshu daizōkyō*
TZ	*Taishō shinshu daizōkyō zuzō*
ZGR	*Zoku gunsho ruijū*

Notes

Introduction

1. Shaku Seitan, "Roku Kannon to Rokuji shōku," *Kokka* 166 (March 1904): 207–218.
2. Shaku Seitan, *Kannon no kenkyū* (Tokyo: Ōshima Seishindō, 1914). The book contains only two photographs.
3. The first edition was Gotō Daiyō, *Kanzeon Bosatsu no kenkyū* (Suginami-chō, Tokyo: Hōshidō, 1928) and the most recent is the eighth edition: Gotō Daiyō, *Zukai Kannonkyō tsuki Kanzeon Bosatsu no kenkyū* (Tokyo: Sankibō Shorin, 2005). In the 1950s and long afterward, one of the most widely used sources for iconography on Kannon was Mochizuki Shinkō, *Mochizuki Bukkyō daijiten* (Tokyo: Sekai Seiten Kankō Kyōkai, 1954–1958).
4. Hayami Tasuku, *Kannon shinkō* (Tokyo: Hanawa Shobō, 1970).
5. Nakano Genzō, *Rokudōe no kenkyū* (Kyoto: Tankōsha, 1989), 70–79. Nakano published prolifically on Six Kannon, and the following is another good example: Nakano Genzō, *Nihon no butsuzō, Kannon* (Kyoto: Tankōsha, 1982), 123–125.
6. Tomabechi Seiichi, "Heian jidai no roku Kannon zō to '*Makashikan*': Roku Kannon shinkō no seiritsu o megutte (1)," in *Tada Kōshō hakushi koki kinen ronshū, Bukkyō to bunka,* ed. Tada Kōshō hakushi koki kinen ronshū kankōkai (Tokyo: Sankibō Busshorin, 2008), 655–674; Tomabechi Seiichi, "Rokujikyōhō to mikkyō no roku Kannon: Roku Kannon shinkō no seiritsu o megutte (2)," in *Shingon mikkyō to nihon bunka: Katō Seiichi hakushi koki kinen ronbunshū* (Tokyo: Nonburu, 2007), 323–389.
7. Karen Gerhart, *The Material Culture of Death in Medieval Japan* (Honolulu: University of Hawai'i Press, 2009), 2–5.
8. Jan Mrázek and Morgan Pitelka, eds., *What's the Use of Art?: Asian Visual and Material Culture in Context* (Honolulu: University of Hawai'i Press, 2008), 2–3.
9. Fabio Rambelli, *Buddhist Materiality: A Cultural History of Objects in Japanese Buddhism* (Stanford, Calif.: Stanford University Press, 2007).
10. For a recent overview discussion of the term icon and its relationship to Buddhist art, see Charles Lachman, "Buddhism—Image as Icon, Image as Art," in *The Oxford Handbook of Religion and the Arts,* ed. Frank Burch Brown (New York: Oxford University Press, 2014), 372–376.

11. Yanagisawa Taka, in Mochizuki Shinjō, ed., *Nihon Bukkyō bijutsu hihō: Shoka aizō* (Tokyo: Sansaisha, 1973), 242.

12. Maizawa Rei, "Hosomi Bijutsukan shozō roku Kannon zō kō," *Bijutsushi* 166 (March 2009): 324–339.

13. http://ja.wikipedia.org/wiki/%E6%B3%95%E9%9A%86%E5%AF%BA (accessed April 23, 2014). On the list of images on the website above, next to each bodhisattva pair is the alternate name "Den Roku Kannon." The images from each of the three former triads are now kept in Daihōzōin at Hōryūji.

14. *Nara rokudaiji taikan, Hōryūji*, vol. 4 (Tokyo: Iwanami Shoten, 1971), 18. See also Aizu Yaichi, "Hōryūji rokutai butsu narabi ni byakudan Jizō zō no denrai o ronjitte futatabi Shitennō zō no kondō inyū ni oyobu," *Tōyō bijutsu* 5 (1930): 1–4.

15. Langdon Warner, *Japanese Sculpture of the Suiko Period* (New Haven, Conn.: Yale University Press, 1923), 37.

16. Aizu, "Hōryūji rokutai butsu," 6–7.

17. Ibid., 1–3.

18. Kinki Nihon Tetsudō, ed., *Sōkan Hōryūji* (Kyoto: Kawahara Shoten, 1949), 122–123. Mochizuki Shinjō, who wrote the entry, refers to them as "Six Kannon" but explains that this is a popular name and with the exception of one, the images actually represent bodhisattvas other than Kannon.

19. This is discussed in Chapter Three in relation to the identity of the Fukūkenjaku image from Tōmyōji that had been formerly called Nyoirin.

20. One other image in this group has a bottle in the crown, which is likely Seishi, but aside from the Kannon image, the others have empty crowns and cannot be securely identified.

21. Penelope Mason, *History of Japanese Art* (Upper Saddle River, N.J.: Pearson Prentice Hall, 2005), fig. 98, p. 80, discusses the six Hōryūji bodhisattva images and includes one of the images in a photograph. Perhaps because of the "Six Kannon" title, the image, which does not have a Buddha image in the headdress, was misidentified as Kannon in the caption. The caption also misdated the seventh-century statue to 711.

22. Sherry Fowler, *Murōji: Rearranging Art and History at a Japanese Buddhist Temple* (Honolulu: University of Hawai'i Press, 2005), 10–12, and Allan Grapard, "The Textualized Mountain—Enmountained Text: The *Lotus Sutra* in Kunisaki," in *The Lotus Sutra in Japanese Culture*, George J. Tanabe, Jr. and Willa Jane Tanabe, eds. (Honolulu: University of Hawai'i Press, 1989), 172. See Chapter Two of the present book about Kunisaki.

23. Ishikawa Toshio, *Sūji de wakaru Bukkyō bunkazai no meishō* (Kyoto: Tankōsha, 2013). This book is very general and includes sections on the Six Kannon, 81–82, and Thirty-Three Kannon, 102–105.

24. For Six Jizō, who like Six Kannon also aid beings in the six paths, see Françoise Wang-Toutain, *Le bodhisattva Kṣitigarbha en Chine du Ve au XIIIe siècle* (Paris: Presses de l'École française d'Extrême-Orient, 1998), 279–280; Hank Glassman, *The Face of Jizō: Image and Cult in Medieval Japanese Buddhism* (Hono-

lulu: University of Hawai'i Press, 2012), 27–29. About Nine Amida who represent the nine degrees of rebirth according to the Pure Land scriptures, see Mimi Yiengpruksawan, *Hiraizumi: Buddhist Art and Regional Politics in Twelfth-Century Japan* (Cambridge, Mass.: Harvard University Asia Center, 1998), 53, 55; about Six Jizō, see p. 138. About Seven Yakushi, see Yui Suzuki, *Medicine Master Buddha: The Iconic Worship of Yakushi in Heian Japan* (Leiden: Brill, 2012).

25. See the popular website http://mysticalnumbers.com (accessed May 3, 2014).

26. Popular websites that address Buddhist numbers are as follows: http://viewonbuddhism.org/resources/Buddhist-Book-of-Numbers.htm, http://www.urbandharma.org/udharma7/numbers.html, and http://www.thezensite.com/ZenEssays/Miscellaneous/Buddhism_by_Numbers.html (accessed April 21, 2014).

27. Georges Ifrah, *The Universal History of Numbers: From Prehistory to the Invention of the Computer,* David Bellos, trans. (New York: J. Wiley, 2000), 421–426. See also Alex Bellos, *Here's Looking at Euclid: A Surprising Excursion through the Astonishing World of Math* (New York: Free Press, 2010), 73–75.

28. Burton Watson, trans., *The Lotus Sutra* (New York: Columbia University Press, 1993), 290. See also Thich Nhat Hanh, *Awakening of the Heart: Essential Buddhist Sutras and Commentaries* (Berkeley, Calif.: Parallax Press, 2012), 367, for a similar reference in the *Diamond sūtra.*

29. For a discussion of Japanese superstitions about certain numbers see Ifrah, *The Universal History of Numbers,* 275–276.

30. Alex Bellos, *The Grapes of Math: How Life Reflects Numbers and Numbers Reflect Life* (New York: Simon & Schuster, 2014), 13–24. See also article "'Seven' Triumphs in Poll to Discover World's Favorite Number," http://www.theguardian.com/science/alexs-adventures-in-numberland/2014/apr/08/seven-worlds-favourite-number-online-survey, and "FAVORITE NUMBER.NET," http://pages.bloomsbury.com/favouritenumber (accessed April 20, 2014).

31. I have not found a direct connection between the Six Kannon and the six perfections. In general they are generosity, proper conduct, renunciation, wisdom, diligence, and forbearance, but there are variations and additions to this list.

32. Neil Schmid, "Revisioning the Buddhist Cosmos: Shifting Paths of Rebirth in Medieval Chinese Buddhist Art," *Cahiers d'Extrême-Asie* 17 (2008): 293–325.

33. Brian Baumann, *Divine Knowledge: Buddhist Mathematics According to the Anonymous Manual of Mongolian Astrology and Divination* (Leiden: Brill, 2008), 16–17.

34. Hidetoshi Fukagawa and Tony Rothman, *Sacred Mathematics: Japanese Temple Geometry* (Princeton, N.J.: Princeton University Press, 2008), 7–9, and see plates 4–13 for photographs of *sangaku.* The website "Wasan no kan," http://www.wasan.jp/ (accessed April 27, 2014) has a large collection of photographs of *sangaku* from various temples and shrines throughout Japan. Since *sangaku* were hung outside and exposed to the elements, many have disintegrated, and those that survive are often deteriorated.

35. For a recent detailed discussion of the wide-ranging definitions of esoteric Buddhism, see Charles D. Orzech, Henrik H. Sørensen, and Richard K. Payne, *Esoteric Buddhism and the Tantras in East Asia* (Leiden: Brill, 2011), 2–18.

Chapter One: Reconstructing Six Kannon from the Tenth to the Twelfth Centuries

1. *Mohe zhiguan*, in *Taishō shinshu daizōkyō* (hereafter cited as *T*), eds. Takakusu Junjirō, Watanabe Kaigyoku, et al. (Tokyo: Taishō Issaikyō Kankōkai, 1934), 46:15ab. About a possible source for the Six Guanyin, see Paul L. Swanson, trans., *The Great Cessation and Contemplation (Mo-ho chih-kuan)*, compact disc (Tokyo: Kosei Publishing Co., provisional edition, 2004), 195–196. Swanson cites a list of five similar Guanyin found in a *dhāraṇī* text—*Qifo bapusa suo shuo da tuoluoni shenzhou jing;* J. *Shichibutsu hachibosatsu shosetsu dai darani jinjukyō,* translated into Chinese during the Eastern Jin period (317–420)— that he believes may have been the source for the *Mohe zhiguan* group. See also Hayami Tasuku, *Kannon shinkō jiten* (Tokyo: Ebisu Kōshō Shuppan, 2000), 284. For original text of the *dhāraṇī*, see *T* 21:541b8–10. Out of the standard Six Guanyin, only Great Compassion (Ch. Dabei; J. Daihi) is missing in this *dhāraṇī*.

2. Swanson, *The Great Cessation,* 196. Although I quote Swanson's translation, an equally good one, also with excellent annotation, is in Neal Donner and Daniel B. Stevenson, *The Great Calming and Contemplation* (Honolulu: University of Hawai'i Press, 1993), 283–285. See Table 1.1 in the present book for transliteration of Chinese names.

3. For a good definition of *dhāraṇī* in general, see Ryūichi Abe, *The Weaving of Mantra* (New York: Columbia University Press, 1999), 5–6. The meaning of the "six syllables" appears to be a mystery and the sutra itself does not explain it. Both Swanson, *The Great Cessation,* 195, n. 340, and Donner, *The Great Calming,* 283, n. 285, agree that although theories about their meaning have been proposed, none seems satisfactory.

4. Donner, *The Great Calming,* 282.

5. On the Ten Kings, see Stephen F. Teiser, *The Scripture on the Ten Kings and the Making of Purgatory in Medieval Chinese Buddhism* (Honolulu: University of Hawai'i Press, 1994), 171–179, 223. On the six paths in Japan see William LaFleur, *The Karma of Words: Buddhism and the Literary Arts in Medieval Japan* (Berkeley: University of California Press, 1983), 27–29, 49–51, 118–119. For a more general discussion of the six paths in Asia, see Paul Mus, *La lumière sur les six voies* (Paris: Institut d'ethnologie, 1939), 153–183, and Stephen F. Teiser, *Reinventing the Wheel: Paintings of Rebirth in Medieval Buddhist Temples* (Seattle: University of Washington Press, 2006), 3–49. There are variations in the order of the paths, and asuras are sometimes omitted, thus leaving five paths. See Neil Schmid, "Revisioning the Buddhist Cosmos: Shifting Paths of Rebirth in Medieval Chinese Buddhist Art," *Cahiers d'Extrême-Asie* 17 (2008): 293–325.

6. I have summarized the story based upon the Chinese text in the *Taishō* canon, an English translation by Amy McNair, and a Japanese translation in *Kokuyaku issaikyō wakan senjutsu bu, shiden bu* (Tokyo: Daitō Shuppansha, 1988), vol. 12, 274–275. The Chinese text is in *Sanbao ganying yaolüelu* and was written by the Liao Buddhist historian Feizhuo (d. 1063). *T* 51:853b–c.

7. *Sanbao ganying yaolüelu, T* 51:853b. I also used the Japanese translation in *Kokuyaku issaikyō,* 12:274 with assistance from Amy McNair. All translations in this book are my own unless otherwise indicated.

8. On the relationship between Amitābha and Avalokiteśvara, see Chün-fang Yü, *Kuan-yin: The Chinese Transformation of Avalokiteśvara* (New York: Columbia University Press, 2001), 36. In this case, *kebutsu* (Skt. *nirmana-buddha*) refers to the way a Buddha can transform into another body, such as Kannon.

9. See Angela F. Howard, *Summit of Treasures: Buddhist Cave Art of Dazu, China* (Trumbull, Conn.: Weatherhill, 2001), 15–16. For a discussion of the early sutras see, Emily Sano, "The Twenty-Eight Bushū of Sanjusangendō" (PhD diss., Columbia University, 1983), 37–39.

10. See *Qianshou qianyan guanshiyin pusa dabeixin tuoluoni jing* (J. *Senju sengen Kanzeon bosatsu daihishin daranikyō;* Dhāraṇī of the bodhisattva with a thousand hands and eyes who regards the world's sounds and feels vast, complete, unimpeded great compassion) by Bhagavaddharma (Ch. Qiefandamo), *T* 20:106c. Sano, "The Twenty-Eight Bushū," 32, led me to the source above.

11. *T* 20:111ab. For an English translation of the sutra see Hsüan Hua and Heng Yin, *The Dharani Sutra: The Sutra of the Vast, Great, Perfect, Full, Unimpeded Great Compassion Heart Dharani of the Thousand-Handed, Thousand-Eyed Bodhisattva Who Regards the World's Sounds* (San Francisco: The Society, 1976). The section about the hands is on pp. 124–125. See also Yü, *Kuan-yin,* 63–65, for this section.

12. For a good diagram of the forty attributes, see Ikawa Kazuko, "Kannon zō," *Nihon no bijutsu* 166 (March 1980): 48–49.

13. Katja Triplett, "Esoteric Buddhist Eye-Healing Rituals in Japan and the Promotion of Benefits," in *Grammars and Morphologies of Ritual Practices in Asia,* ed. Axel Michaels et al. (Wiesbaden: Harrassowitz, 2010), 485–499.

14. See Sano, "The Twenty-Eight Bushū."

15. Inoue Kazutoshi, "Nyoirin Kannon zō, Batō Kannon zō," *Nihon no bijutsu* 312 (May 1992): 54–55.

16. See *Mikkyō daijiten* (1983), s.v. "Batō Kannon," for details on the mudra, which is also called the "fundamental Horse-Headed mudra" (J. *Batō konponin*).

17. Benedetta Lomi, "The Iconography of Ritual Images, Texts and Beliefs in the Batō Kannon Fire Offering," in *Grammars and Morphologies of Ritual Practices in Asia,* ed. Axel Michaels et al. (Wiesbaden: Harrassowitz, 2010), 568–569.

18. Negishi Keiba Kinen Kōen and Baji Bunka Zaidan, *Batō Kannon shinkō no hirogari: Shūki tokubetsuten* (Yokohama: Uma no Hakubutsukan, 1992), cat. no. 3, p. 5, 18.

19. *Saidaiji shizai rukichō,* in *Zoku gunsho ruijū* (hereafter cited as *ZGR*), vol. 27, pt. 2 (Tokyo: Zoku Gunsho Ruijū Kanseikai, 1984), 140.

20. Negishi Keiba Kinen Kōen and Baji Bunka Zaidan, *Batō Kannon shinkō no hiro-gari*. For a related exhibition see Japan Art Centre, ed., *Horses and Humanity in Japan* (Tokyo: Japan Association for International Horse Racing, 1999).

21. See Donald A. Wood, "Eleven Faces of the Bodhisattva" (PhD diss., University of Kansas, 1985), 368, for an English translation of the description of the heads in *Buddhavacana Ekadaśamukha dhāraṇī sūtra*, translated into Chinese by Yasogupta in the sixth century. For Chinese, see *T* 46:150c. Wood also discusses the various translations of the sutra; see 10–14. For a diagram of the heads, see Mizuno Keisaburō, ed., *Nihon chōkokushi kiso shiryō shūsei: Kamakura jidai: zōzō meiki hen*, vol. 3 (Tokyo: Chūō Kōron Bijutsu Shuppan, 2003), text vol., p. 193.

22. Wood, "Eleven Faces," 29.

23. See Tove Neville, *Eleven-Headed Avalokiteśvara, Chenresigs, Kuan-yin or Kannon Bodhisattva: Its Origin and Development* (New Delhi: Munshiram Manoharlal Publishers, 1999), 5–8, for a discussion of the significance of the number eleven.

24. Samuel C. Morse, "The Buddhist Transformation in the Ninth Century: The Case of Eleven-Headed Kannon," in *Heian Japan, Centers and Peripheries*, Mikael Adolphson, ed. (Honolulu: University of Hawai'i Press, 2007), 159.

25. Neville, *Eleven-Headed Avalokiteśvara*, 4, unpacks the legend.

26. See Soejima Hiromichi, "Jūichimen Kannon zō, Senju Kannon zō," *Nihon no bijutsu* 311 (April 1992): fig. 3, p. 2, for a picture of the Eleven-Headed Kannon from Nachi.

27. Morse, "The Buddhist Transformation," 153–176.

28. Ibid., 167–171, discusses the sutras and other sources that proclaim sandalwood is the best material from which to make an Eleven-Headed Kannon image. Christian Boehm, *The Concept of Danzō: 'Sandalwood Images' in Japanese Buddhist Sculpture of the 8th to 14th Centuries* (London: Saffron Books, 2012), 187–191.

29. For a list of sutras relating to Juntei, see Asai Kazuharu, "Fukūkenjaku, Juntei Kannon zō," *Nihon no bijutsu* 382 (March 1998): 68–69.

30. Robert Gimello, "Icon and Incantation: The Goddess Zhunti and the Role of Images in the Occult Buddhism of China," in *Images in Asian Religions: Texts and Contexts*, ed. Phyllis Granoff (Vancouver: University of British Columbia Press, 2004), 247.

31. Asai, "Fukūkenjaku," 70–71. Kannonji refers to its image as a Thousand-Armed Kannon.

32. See http://www.aisf.or.jp/~jaanus/deta/g/genzumandara.htm (accessed December 4, 2013). See Elizabeth ten Grotenhuis, *Japanese Mandalas: Representations of Sacred Geography* (Honolulu: University of Hawai'i Press, 1999), 61–62.

33. Matsuura Kiyoshi, "Ni ryūō ga rengeza o hōji suru Juntei Kannon ni tsuite," *Osaka Shiritsu Hakubutsukan kiyō* 22 (1990): 7.

34. *Keiran shūyōshū*, in *T* 76: 584c.

35. Dorothy Wong, "The Case of Amoghapāśa," *Journal of Inner Asian Art and Archaeology* 2 (2007): 151.

36. See Susan Tyler, *The Cult of Kasuga Seen through Its Art* (Ann Arbor: Center for Japanese Studies, University of Michigan, 1992), 91.

37. See *T* 20:402a. The earlier text from which this was translated does not survive.

38. *T* 20:685a. See Asai Kazuharu, "Okayama Ōtsūji no Fukūkenjaku Bosatsu zazō," *Bukkyō geijutsu* 246 (1999): 80–81. Wong, "The Case of Amoghapāśa," 152, mentions a seventh-century Chinese description of the deity with a deerskin. See *Zan Guanshiyin pusa song* (J. *San Kanzeon bosatsu ju*), in *T* 20:67b. Asai, "Okayama Ōtsūji no Fukūkenjaku Bosatsu zazō," 80–81, as well as Ito, "Fukukenjaku," 25, list other later Buddhist texts that mention Fukūkenjaku's deerskin.

39. See Richard Bowring, *The Religious Traditions of Japan, 500–1600* (Cambridge: Cambridge University Press, 2005), 180–182, 275.

40. *Roku Kannon gōgyō,* dated to 1252, in *Asabashō,* in *Taishō shinshu daizōkyō zuzō* (hereafter cited as *TZ*), eds. Takakusu Junjirō, Watanabe Kaigyoku, et al., vol. 9 (Tokyo: Taishō Issaikyō Kankōkai, 1934), 223a–224a.

41. See Inoue, "Nyoirin Kannon zō, Batō Kannon zō," fig. 53, p. 40, for a picture of the standing Nyoirin Kannon image from Nyoirinji.

42. *Kanjizai Nyoirin Kannon Bosatsu yuga hōyō,* in *T* 20:213b.

43. Ishiyamadera's secret image of Nyoirin Kannon was on display in 2016. See temple website http://www.ishiyamadera.or.jp/ishiyamadera/gyouji/gokaihi/ (accessed April 10, 2016).

44. See *Taizōkongō bodaishingi ryakumondō shō, T* 75:482b no. 2397. See also Hayami, *Kannon shinkō jiten,* 285.

45. See Hayami, *Kannon shinkō,* 189, and Hayami, *Kannon shinkō jiten,* 296.

46. See *Sanmairyū kudenshū,* in *T* 77:28ab, no. 2411.

47. *Hishō mondō,* in *T* 79:424bc, no. 2536; and *Asabashō, TZ* 9:149–157.

48. *Sanmairyū kudenshū,* in *T* 77:28ab.

49. For two excellent fourteenth-century examples from Daigoji, see Sawa Ryūken, ed., *Daigoji; Hihō* (Tokyo: Kōdansha, 1976), 8:108–109, 334, figs. 110–111. In these and other paintings, the body colors do not match Ningai's description. In *Zuzōshō* (also called *Jikkanshō*), *TZ* 3:11c, compiled by Ejū in 1135, we see that Ningai's text was followed by an explanation of how the Six Kannon images in Six-Syllable mandala should look. See Chapter Four of the present book.

50. *Nyūshingon monjū nyojitsuken kōen hokke ryakugi, T* 56: 200ab, and in *Dai Nihon Bukkyō zensho* (hereafter cited as *DNBZ*), vol. 27 (Tokyo: Meicho Fukyūkai, 1978–1983), 936. There are slight differences between the two texts. See Hayami, *Kannon shinkō jiten,* 284b. I am grateful for help with the translation from Amy McNair, Michael Jamentz, and Daniel Stevenson and Kamaeyama Takahiko for the text date.

51. See "Enchin" in *Digital Dictionary of Buddhism* (accessed December 7, 2013). *Dainichi sho* is *The Great Commentary on the Mahāvairocana Scripture* expounded by Śubhakrasiṃha (637–735) and written down by his disciple Yixing (683–727). The longer title is (J. *Daibirushana jōbutsu kyō sho,* Ch. *Dapiiu zhena cheng fo jing su*). See *T* 39:632.

52. The *Taishō* version of the text uses Kanzeon (Perceiving the sounds of the world), which is another name for Kannon, but the *DNBZ* version of this text uses Kannon.

53. The parable of the burning house, which is discussed in Chapter Three of the *Lotus sūtra,* is about using expedient means to save others from *saṃsāra,* the cycle of birth and death. See Burton Watson, trans., *The Lotus Sutra* (New York: Columbia University Press, 1993), 47–79.

54. It should be noted Daiseishi (Seishi) is in the Kannon section of the Genzu mandala. For more on Seishi, see the section on Shichiyamachi ritual in Chapter Five. When Seishi appears with Six Kannon in the Edo period, the group is sometimes called "Seven Kannon."

55. Mallar Ghosh, *Development of Buddhist Iconography in Eastern India: A Study of Tārā, Prajñās of Five Tathāgatas and Bhrikuṭī* (New Delhi: Munshiram Manoharlal, 1980), 145–174. See also Louis-Frédéric and Nissim Marshall, *Buddhism* (Paris: Flammarion, 1995), 175–176.

56. See Mimi Yiengpruksawan, *Hiraizumi: Buddhist Art and Regional Politics in Twelfth-Century Japan* (Cambridge, Mass.: Harvard University Asia Center, 1998), 138. For early Six Jizō images and history, see Matsushima Ken, "Jizō Bosatsu zō," *Nihon no bijutsu* 239 (April 1986): 48–52.

57. Hayami Tasuku, *Jizō shinkō* (Tokyo: Hanawa Shobō, 1975), 70–71.

58. Hank Glassman, *The Face of Jizō: Image and Cult in Medieval Japanese Buddhism* (Honolulu: University of Hawai'i Press, 2012), 27–29.

59. *Tendai nanzan Mudōji konryū oshō den,* in *Gunsho ruijū,* vol. 5 (Tokyo: Gunsho Ruijū Kankōkai, 1960), 551. The text is abbreviated as *Konryū oshō den.* See also M. W. de Visser, *Ancient Buddhism in Japan: Sūtras and Ceremonies in Use in the Seventh and Eighth Centuries A.D. and Their History in Later Times* (Leiden: Brill, 1935), 388.

60. *Fusō ryakki,* by Kōen (d. 1169), in *Shintei zōho kokushi taikei* (hereafter cited as *KT*), vol. 12 (Tokyo: Kokushi Taikei Kankōkai, 1965), 255. See also Paul Groner, *Ryōgen and Mount Hiei Japanese Tendai in the Tenth Century* (Honolulu: University of Hawai'i Press, 2002), 227 and 428, n. 21. *Onjōji denki, DNBZ* 127:67, is a similar source about Kannon'in, but it is abbreviated and does not mention the Six Kannon.

61. See Toki Takeji, "*Makura no sōshi* 'subete Roku Kannon' no saiginmi," *Hanazono Daigaku kenkyū kiyō* 11 (March 1980): 1–25. See the list section in *Makura no sōshi,* by Sei Shōnagon (b. ca. 967), in *Shinpen Nihon koten bungaku koten zenshū,* vol. 18 (Tokyo: Shōgakkan, 1997), 336.

62. *Asabashō, TZ* 9:224c–225a.

63. The following section is in *Asabashō, TZ* 9:224b–225a.

64. See *Asabashō, TZ* 9:770a, for another reference to Mototsune installing Six Kannon in the hall.

65. Groner, *Ryōgen,* 172. *Sanmon dōshaki,* in *Gunsho ruijū,* vol. 24 (Tokyo: Gunsho Ruijū Kankōkai, 1960), 501, confirms the Six Kannon were in place at the ceremony in 983.

66. *Enryakuji gokoku engi, DNBZ* 126:26. See also Hayami Takusu, *Kannon shinkō jiten* (Tokyo: Ebisu Kōshō Shuppan, 2000), 285.

67. Joan R. Piggott et al., *Teishinkōki: The Year 939 in the Journal of Regent Fujiwara no Tadahira* (Ithaca, N.Y.: East Asia Program, Cornell University, 2008), 33–34. See also Groner, *Ryōgen*, 40.

68. *Fusō ryakki, KT* 12:226. I am grateful to Heather Blair for calling this to my attention.

69. *Honchō bunshū, KT* 30:158–159. *Honchō bunshū* was compiled in the eleventh century by Fujiwara no Akihira (989–1066).

70. *Nihon kiryaku, KT* 11:44.

71. The abbreviated character for the author's name, which is translated here as "I" is glossed on the first page of *Asabashō, TZ* 9:1c.

72. *Kyoto Yamashiro jiin jinja daijiten* (Tokyo: Heibonsha, 1997), 428–429. See also Cary Shinji Takagaki, "The Rokushō-ji: The Six 'Superiority' Temples of Heian Japan" (PhD diss., University of Toronto, 1999), 112–113.

73. *Asabashō, TZ* 9:225a.

74. "Hōkaiji" in *Nihon rekishi chimei taikei* (accessed November 5, 2013). Hōkaiji is known for its architecture and images of Amida and Yakushi.

75. Chōen's disciple was Ryōyū, who founded the Sanmai lineage, mentioned previously as one who recorded *Ningai chūshinmon* in his text *Sanmairyū kudenshū, T* 77:28ab.

76. *Jimoku taiseishō* (also known as *Ōma naribumi shō*), in *Shintei zōho shiseki shūran*, vol. 1 (*bekkan*) (Kyoto: Rinsen Shoten, 1973), 554. See also Hayami, *Kannon shinkō jiten,* 285.

77. "Saitō" in *Nihon rekishi chimei taikei* (accessed November 7, 2013).

78. *Shōyūki*, by Fujiwara no Sanesuke (957–1046), in *Dai Nihon kokiroku* 10 (Tokyo: Iwanami Shoten, 1959–1986), vol. 3, pt. 5, p. 36. See also Hayami, *Kannon shinkō jiten,* 285–286.

79. *Fusō ryakki, KT* 12:285. See also *Onjōji denki, DNBZ* 127:67, for a similar entry that does not specifically mention Six Kannon.

80. See *Chūyūki*, in *Zōho shiryō taisei,* vol. 9 (Kyoto: Rinsen Shoten, 1965), 291 (1095.9.24); vol. 10, p. 193 (1102.6.29); vol. 11, p. 109 (1106.4.6), p. 227 (1107.7.8); vol. 13, p. 291 (1127.3.6); vol. 14, p. 97 (1129.7.22). Hosshōji[b] belonged to Rokushōji, the so-called Six "Superiority" Temples, in Kyoto because they all had the character *shō* in their names. See Takagaki, "The Rokushō-ji," 91–107, and Yiengpruksawan, *Hiraizumi*, 52–54.

81. Helen Craig McCullough, *A Tale of Flowering Fortunes: Annals of Japanese Aristocratic Life in the Heian Period* (Stanford, Calif.: Stanford University Press, 1980), 513–514, for this translation. See also *Eiga monogatari,* ed. Yamanaka Yutaka (Tokyo: Shōgakkan, 1995–1998), vol. 2, 198–199.

82. Yui Suzuki, *Medicine Master Buddha: The Iconic Worship of Yakushi in Heian Japan* (Leiden: Brill, 2012), 113–116.

83. Michinaga erected a Yakushi Hall east of the Golden Hall at Hōjōji. See *Eiga monogatari*, vol. 2, 402, 410–411. For a different English translation, see McCullough, *A Tale of Flowering Fortunes*, 622.

84. McCullough, *A Tale of Flowering Fortunes,* 627–628, translated this and the rest of the passage as follows:

> The Sixth Month soon came, and on the Twenty-sixth the Healing Buddha Hall was dedicated amid ceremonies of indescribable grandeur. As usual, the hall dazzled the eye: one could scarcely make anything out. Shōshi and Rinshi occupied rooms on the north side, where blinds had been hung along the eavechambers. The architectural plan, the dog barricade, and all the other details were exactly the same as in the Western Hall [Amidadō]. Representations of the Twelve Great Vows were painted on the inner pillars in the front of the Healing Buddhas, and other paintings depicting verses from the "Kannon" chapter decorated the pillars facing the six images of Kannon. The reader may imagine the skill with which they were executed by the Iimuro Holy Teacher En'en.

See also *Eiga monogatari,* vol. 2, 411.

85. McCullough, *A Tale of Flowering Fortunes*, 623; *Eiga monogatari*, vol. 2, 403.

86. McCullough, *A Tale of Flowering Fortunes*, 629; *Eiga monogatari*, vol. 2, 412.

87. I chose not to use McCullough's translation for this part because she uses different terms for the Kannon names.

88. See McCullough, *A Tale of Flowering Fortunes,* 629 and notes on 783–784. For the original, see *Eiga monogatari,* vol. 2, 412.

89. *Hishō mondō,* in *T* 79:424c.

90. *Shinzoku zakki mondōshō,* in *Shingonshū zenshū,* vol. 37 (Mt. Kōya: Shingonshū Zensho Kankōkai, 1933–1939), 366. I am grateful to Michael Jamentz for giving me this reference.

91. *Sankaiki,* in *Zōho shiryō taisei* (Kyoto: Rinsen Shoten, 1965), vol. 27, 155–157. See also Nedachi Kensuke, ed., "Kamakura zenki chōkoku ni okeru Kyoto," *KURENAI* (2004): 75, 111. http://repository.kulib.kyoto-u.ac.jp/dspace/handle/2433/85127 (accessed February 6, 2014).

92. Royall Tyler, trans., *The Tale of the Heike* (New York: Viking, 2012), 142–143. For an earlier translation see Helen Craig McCullough, trans., *The Tale of the Heike* (Stanford, Calif.: Stanford University Press, 1988), 101–102.

93. Helen Craig McCullough, trans., *The Taiheiki: A Chronicle of Medieval Japan* (Rutland, Vt.: C. E. Tuttle, 1979), 12–13. One of the monks performing the rituals was Enkan from Hosshōji[b], another major temple in east Kyoto. See also *Taiheiki,* in *Shinpen Nihon koten bungaku zenshū* (Tokyo: Shōgakkan, 1994), vol. 54, 30–31.

94. Asanuma Takashi, "Mokuzō Fukūkenjaku Kannon zazō, mokuzō Jūichimen Kannon zazō, Kyoto Konkaikōmyōji zō," *Gakusō* 29 (2007): 77–83. For the initial report see Kyoto Kokuritsu Hakubutsukan, *Kyoto shaji chōsa hōkoku* 17 (Kyoto: Dōhosha, 1996), 8, 20.

95. Asanuma, "Mokuzō Fukūkenjaku," 81. Asanuma proposed that Chōsei (1010–1091) might have made the Fukūkenjaku and Ensei (d. 1135) might have made the Eleven-Headed Kannon image.

96. Kyoto Kokuritsu Hakubutsukan, *Kyoto shaji chōsa hōkoku* 17, p. 20. Asanuma, "Mokuzō Fukūkenjaku," 77 and 83, n. 4, was not positive, but considered the possibility that the image never had a third eye. This image is also discussed in Asai, "Fukūkenjaku," 55–56.

97. Konkai Kōmyōji, *Daihonzan Kurotani Konkai Kōmyōji hōmotsu sōran* (Kyoto: Shibunkaku Shuppan, 2011), 67.

98. See *Miyako meisho zue*, ed. Akisato Ritō (fl. 1780–1814), first published in 1780 (An'ei 9). See http://www.nichibun.ac.jp/meisyozue/kyoto/jpg/jpg3/km_01_03_061.jpg (accessed May 22, 2015).

99. See *Kyōtofū jishikō* (Kyoto prefectural temple records) from 1892, which is held at the Kyoto Prefectural Library and Archives Special Collections.

100. Before the images were donated to Buzaiin and moved in 1688 (Genroku 1) by Gekkan Gikō, a disciple of Jōtsū, they were located in the Kannon Hall of Hakui-gun Yada village, Shikamachi. See Kuno Takeshi, *Kannon sōkan* (Tokyo: Shin Jinbutsu Ōraisha, 1986), 274, and Fujimori Takeshi, *Nihon no kannon zō* (Tokyo: Shōgakkan, 2003), 189.

101. Kimura Takeshi, "Hakusekisan Buzaiin Notoshi ni okeru Sōtoshū to Ōbaku to no kakawari," *Ōbaku bunka* 121 (2000–2001): 182–183. See also Hakuishi Bunkazai Kyōiku Iinkai, *Hakuishi no bunkazai* (Hakui: Hakuishi Bunkazai Kyōiku Iinkai, 1968), 7. Much of the lower areas on all three images have been restored. See also Hakuishi Shihensan Iinkai, *Hakuishishi: Chūsei shaji hen* (Hakuishi Shihensan Iinkai, 1975), 492–495.

102. Kimura, "Hakusekisan," 183. There is also an image of Amida painted in blood by the monk Dokutan from Manpukuji, which was made around the same time as the sutras. See Kimura, "Hakusekisan," 184–185, fig. 4, and Arakawa Hirokazu, "Aki no Buzaiin," *Museum* 130 (January 1962): 33. The color of the text of the sutra is now reddish brown. When I asked the resident temple caretaker about the blood, she told me that according to temple legend, the monks used red ink to supplement the blood.

103. "Buzaiin kessho *Hanyashingyō*," in *Hakui no mukashibanashi*, ed. Hakui no Mukashibanashi Chōsa Jikkō Iinkai (Hakui: Hakui no Mukashibanashi Chōsa Jikkō Iinkai, 2006), vol. 1, 68.

104. Kimura, "Hakusekisan," 183.

Chapter Two: A Vision at Six Kannon Lake and Six Kannon/Six Kami in Kyushu

1. Andrew Cobbing, *Kyushu, Gateway to Japan* (Folkestone, U.K.: Global Oriental, 2009), 16–18. Cobbing discusses the debate over which of the two places named Takachiho is supposed to be the site where the kami descended to earth.

2. See Felicia Bock, *Engi-shiki: Procedures of the Engi Era* (Tokyo: Sophia University, 1970), 162. *Nihon sandai jitsuroku, KT* 4:7, under the date Tenan 2 (858). For *Shoku Nihon kōki* entry, see Jōwa 4 (837), eighth month, first day, http://www.j-texts

.com/chuko/shokukouki.html (accessed January 19, 2014). See Nakamura Chishirō, *Kirishimayama* (Tokyo: Hōbundō, 1943), 91.

3. Nakamura, *Kirishimayama,* 39; *Sangoku meishō zue,* eds. Godai Hidetaka and Hashiguchi Kenpei, vol. 53 (Tokyo: Yamamoto Morihide, 1905), 1–2. For easier access, see newer version published by Seichōsha, 1982, vol. 4, pp. 787–788. Hereafter, I will cite both editions of *SMZ.*

4. Helen Kennedy, "Hundreds Flee in Japan after Shinmoedake Volcano Begins Spewing Ash, Boulders," *New York Daily News* (March 13, 2011), http://www .nydailynews.com/news/world/hundreds-flee-japan-shinmoedake-volcano -begins-spewing-ash-boulders-article-1.123827 (accessed April 7, 2012).

5. http://kanto2525ohta.blog122.fc2.com/blog-entry-110.html (accessed June 30, 2014).

6. *Kirishima ryaku engi* in *Hizen, Higo, Hyūga, Satsuma, Ōsumi no kuni, Shintō taikei, jinja hen,* eds. Kudō Keiichi and Matsumoto Sumio, vol. 45 (Tokyo: Shinto Taikei Henzankai, 1987), 672.

7. *Kirishima ryaku engi,* 673.

8. Ivan Morris, *The Nobility of Failure: Tragic Heroes in the History of Japan* (Rutland, Vt.: Charles E. Tuttle, 1975), 1–13. About the prohibition on killing white birds in the area, see Morita Kiyomi, *Kakure nenbutsu to sukui: Nonosan no fushigi, Kirishima sanroku no minzoku no shugen* (Miyazaki: Kōmyakusha, 2008), 236–238, and also *SMZ* (1905) 53:5 / (1982) 4:417.

9. *SMZ* (1905) 58:1–2 / (1982) 4:787–788. And see entries "Rokkannon ike" and "Manzokuji ato" in *Nihon rekishi chimei taikei* (accessed December 29, 2010).

10. *SMZ* (1905) 53:2–3 / (1982) 4:412–413.

11. Sawa Ryūken, *Mikkyō jiten* (Kyoto: Hōzōkan, 1975), s.v. "Shōkū." According to legend, Shōkū followed an auspicious cloud to Mount Shosha, where he carved a Kannon image from a living tree, which he later enshrined at Enkyōji in Himeiji. See *Banshū Shoshasan engi* (dated 1644 [Kan'ei 21]), *DNBZ* 117:258–259; see also Jean Holm, ed., *Sacred Place* (London: Pinter Publishers, 1994), 194. Morita, *Kakure nenbutsu to sukui,* 230.

12. *Genkō shakusho, DNBZ* 10:136–137.

13. Karahashi Seisai (1736–1801), *Bungo kokushi: Tsuketari senshaku Bungo fudoki* (Tokyo: Hōbundō, 1975 [reprint]), 54. For the section on the Six Gongen of Unagihime Shrine, see p. 47.

14. "Bussanji" in *Nihon rekishi chimei taikei* (accessed July, 19 2012); Yufuin-chō, *Chōshi Yufuin* (Yufuin-chō Ōitaken: Yufuinchō-shi Kankō Kiseikai, 1989), 1194–1201.

15. Miyazaki-ken Jinjachō, *Miyazaki-ken jinjashi* (Miyazaki-shi: Miyazaki-ken Jinjachō, 1988), 332, shows a very rustic *torii* gate that predates the one in place now. Toyouke (bringing prosperity) is a generic shrine name.

16. Miyazaki-ken Jinjachō, 332. See also Miyazaki-ken, *Miyazaki-ken shiseki chōsa,* vol. 3 (Miyazaki-ken, 1928), 31. The entry on Six Kannon Lake "Rokkannon no ike" says that a young horse and *ema* are offered at the festival. http://blog .livedoor.jp/wacky_kirishima_1/archives/55043378.html (accessed June 3,

2015). Perhaps because of the emphasis on animals, the shrine is sometimes referred to as "Batō Kannon." http://www.city-kirishima.jp/modules/page004/index.php?id=53 (accessed June 3, 2015).

17. *SMZ* (1905) 53:4–6 / (1982) 4:415–419. Instead of the Six Kannon, here it only mentions Shō Kannon.

18. Miyazaki-ken Jinjachō, 347.

19. http://www.pmiyazaki.com/siratori_j/ (Accessed April 23, 2012.)

20. See Sarah Thal, *Rearranging the Landscape of the Gods* (Chicago: University of Chicago Press, 2005), 47, 130, 283.

21. Nakamura, *Kirishimayama,* 93. The chart is also reproduced with modifications in Miyazaki-ken Jinjachō, 20. *Bettō* can refer to a specific person as head of the temple, but at Kirishima it is used as a designation for the accompanying or tutelary temples.

22. Miyazaki-ken Jinjachō, 19, 140, 321. See *SMZ* (1905) 58:16 / (1982) 4:817, for Yasuwara (now Sedarashi Shrine) in Miyakonojō, which says that the six shrines of Kirishima had Six Kannon as *honji.* See *SMZ* (1905) 58:13 / (1982) 4:811 about Hanamai (now Yamada Shrine) in Yamada.

23. See Heather Blair, "Zaō Gongen: From Mountain Icon to National Treasure," *Monumenta Nipponica* 66, no. 1 (2011): 1–47. Blair, pp. 23–24, explains the problems of identifying Zaō Gongen as either Buddhist or Shinto in the nineteenth century.

24. *SMZ* (1905) 54:6 / (1982) 4:499.

25. Miyazaki-ken Jinjachō, 19.

26. *Kirishima ryaku engi,* 670. Miyazaki-ken Jinjachō does not give this *engi* as a source for the rankings of the kami.

27. Shirai Eiji and Toki Masanori, *Jinja jiten* (Tokyo: Tōkyōdō Shuppan, 1979), 354.

28. Fuchū Shishi Hensan Iinkai, *Fuchū shishi shiryōshū,* vol. 11 (Fuchū [Tokyo]: Fuchū Shishi Hensan Iinkai, 1966), 1921–1922. The prevalence of *rokusho* in Kyushu is also mentioned on page 1839.

29. The main shrine building on the site now dates from the eighteenth century. A survey of local material culture noted over thirty stone monuments, of which the earliest was from 1600 (Keichō 5) in the graveyard at the site of the former temple Kerinji, which was formerly affiliated with Kirishima Jingū. Mitsumori Masashi, *Bukkyō bijutsu no kenkyū* (Kyoto: Jishōsha, 1999), 84–87. For two maps of Kirishima Jingū from 1759–1760 (Horeki 9–10), see Kokuritsu Rekishi Minzoku Hakubutsukan, *Shaji keidaizu shiryō shūsei* (Chiba-ken, Sakura-shi: Kokuritsu Rekishi Minzoku Hakubutsukan, 2001), 473–474.

30. Cobbing, *Kyushu,* 185. The clans also supported Zen institutions.

31. This section has been revised from Sherry Fowler, "Containers of Sacred Text and Image at Twelfth-Century Chōanji in Kyushu," *Artibus Asiae* 74, no. 1 (2014): 43–73.

32. Kyushu Rekishi Shiryōkan, *Bungo Kunisaki Chōanji,* vol. 9 of *Kyushu no jisha shirizu,* (Fukuoka-ken Dazaifu-shi: Kyushu Rekishi Shiryōkan, 1988), 11–16, figs. 28–39; Taguchi Eiichi, "Dōban *Hokekyō,* tsuketari dō hakoita," *Kokka* 957

(May 1973): 44–52; *Bungo Takadashi shitsūshi* (Ōita, Usa: Bungo Takadashi, 1998), 799–803.

33. See D. Max Moerman, "The Archeology of Anxiety: An Underground History of Heian Religion," in *Heian Japan, Centers and Peripheries,* ed. Mikael Adolphson (Honolulu: University of Hawai'i Press, 2007), 245–271, and specifically 254.

34. Seki Hideo, "Kyōzuka to sono ibutsu," *Nihon no bijutsu* 292 (September 1990): dedicated issue.

35. Tanaka Ichimatsu, "Ōita-ken hakken no dōban *Hokekyō* ni tsuite," *Kōkogaku zasshi* 18 (January 1928): 9–11. The article shows that in the 1920s scholars were aware of the resemblance between the Chōanji and Kubote sutra boxes.

36. Although the number expanded later, the original six districts were Kunawa, Imi, Kunisaki, Musashi, Anki, and Tashibu.

37. Allan Grapard, "Lotus in the Mountain, Mountain in the Lotus: Rokugō Kaizan Nimmon Daibosatsu Hongi," *Monumenta Nipponica* 41, no. 1 (Spring 1986): 40–42.

38. Sakai Tomizō, *Kunisaki hantō no Rokugō manzan* (Tokyo: Daiichi Hōki Shuppan, 1976), 24–27.

39. This is confirmed in *Yayama kankei nendaiki* (Chronology of records related to Mount Ya), compiled in 1857 (Ansei 4). See Kyushu Rekishi Shiryōkan, *Kyushu Rekishi Shiryōkan kenkyū ronshū,* vol. 13 (Dazaifu-machi [Fukuoka-ken]: Kyushu Rekishi Shiryōkan, 1988), 88.

40. Kumamoto Kenritsu Bijutsukan, *Heian jidai no bijutsu: Kyushu no chōkoku o chūshin ni* (Kumamoto: Kumamoto Kenritsu Bijutsukan, 1999), 117.

41. Kyushu Rekishi Shiryōkan, *Bungo Kunisaki Chōanji,* 15, identifies them as the Six Kannon *bonji,* with the fifth character as Juntei. *Bungo Takadashi shitsūshi,* 802, identifies the fifth character, naming it *bo,* for Juntei. In his detailed article, Taguchi, "Dōban *Hokekyō,*" 48, said that he could not read the line of *bonji.* It is not an exact match because the second character for Shō is usually *sa,* so the use of *bo* is different.

42. Nakano Hatayoshi, *Hachiman shinkō shi no kenkyū* (Tokyo: Yoshikawa Kōbunkan, 1967), 706–707.

43. Taguchi, "Dōban *Hokekyō,*" 44.

44. Kyushu Rekishi Shiryōkan, *Bungo Kunisaki Chōanji,* 16.

45. Taguchi, "Dōban *Hokekyō,*" 44.

46. Melanie Trede, ed., *Arts of Japan: The John C. Weber Collection* (Berlin: Museum für Ostasiatische Kunst, Staatliche Museen zu Berlin, 2006), 44–45. According to the catalogue essay by Max Moerman, p. 44, all but two of the bronze plates of text are accounted for. See also Moerman, "The Archeology of Anxiety," 260, 263. The panel from the Barnet and Burto collection was donated to Freer Gallery of Art in 2014.

47. Ichiba Chōjirō, "Kubotesan dōbankyō zuzō shikō," *Kōkogaku zasshi* 40, no. 3 (1954): 12.

48. While the images of Fudō and Bishamonten are clearly identifiable, Ichiba, "Kubotesan," 18–23, has determined the identities of the other figures to be a

triad of Amida flanked by Kannon and Seishi on one side, and the two seated
Buddhas to be Shaka and Yakushi on another. There are several other theo-
ries about the identities.

49. *Bungo Takadashi shitsūshi,* 802. Fukuoka-ken Kyōiku Iinkai, *Kyushu no bukkyō
bijutsu ten* (Fukuoka-ken Bunka Kaikan, 1969), 25, 85. Taguchi, "Dōban *Hokekyō,*"
48–49. See Chikushi Yutaka, "Hikosan shinkō no bijutsu," *Bukkyō geijutsu* 81
(August 1971): 144.

50. *Bungo Takadashi shitsūshi,* 803. Ki no Shigenaga's title is *Oumadokoro kengyō.*

51. Allan Grapard, "Geotyping Sacred Space: The Case of Mount Hiko in Japan,"
in *Sacred Space: Shrine, City, Land,* eds. Benjamin Z. Kedar and R. J. Zwi Werblow-
sky (New York: New York University Press, 1998), 216–218.

52. Kyushu Rekishi Shiryōkan, *Bungo Kunisaki Chōanji,* 20, 56. The *torii* also bears
names of several donors and the stonemasons. Ōitaken Rekishi Hakubutsu-
kan, *Rokugōsan jiin ikō kakunin chōsa hōkokusho,* vol. 9 (Usa: Usa Fudoki no Oka
Rekishi Minzoku Shiryōkan, 2001), 20. The framed panel, also called a *gaku-
tsuka,* is located on the center strut between the two lintels of the *torii.* Each
of the three phrases is in a different line of text.

53. There is a distinctive fourteenth-century Kunisaki-style stone stupa (h.
270 cm) on the grounds. Kyushu Rekishi Shiryōkan, *Bungo Kunisaki Chōanji,*
19–20. In the late nineteenth to early twentieth century, Amanuma Shun'ichi
claimed it had a Kamakura-period inscription, which is no longer legible.

54. Sakai, *Kunisaki hantō,* 32.

55. See Christine Guth, *Shinzō: Hachiman Imagery and Its Development* (Cambridge,
Mass.: Harvard University Press, 1985), 35, 38.

56. The princes are Hayabusawake, Ōbae, Kobae, and Metori. See *Kunisaki chōshi*
(Ōita-ken: Kunisaki Chōshi Kankōkai, 1973), 229–300; Sakai, *Kunisaki hantō,* 33;
Ōita-ken, *Ōita kenshi, Kodai hen,* vol. 2 (Ōita: Ōita-ken, 1984), 481–482. See *Dazai
kannai shi,* ed. Itō Tsunetaru (1774–1858), (Tokyo: Bunken Shuppan, 1989), vol. 2,
p. 225. This is in vol. 8 of the Bungo section. This source also gives alternative
identities as Emperor Chūai, Jingū Kōgō, Emperor Ōjin, Himegami, Emperor
Nintoku, and Ujinowakairatsuko for the six.

57. Ōita-ken, *Ōita kenshi, Kodai hen,* vol. 2, 477–478. See also Kyushu Rekishi
Shiryōkan, *Bungo Kunisaki Chōanji,* 43–45. The temple is called Yayamadera in
the record.

58. The suffix "*rō*" in Tarō is commonly used in given names for Japanese males.
Oku Takeo, "Garanjin no shōrai no juyō," in *Zuzō kaishakugaku: kenryoku to tasha,*
ed. Kasuya Makoto (Tokyo: Chikurinsha, 2013), 371, pointed out that this suffix
was often seen in China from the Tang to the Song dynasties (approximately
seventh through thirteenth century) in the names of land-protecting spirits.

59. For general discussions on *dōji* images see Christine Guth, "The Divine Boy in
Japanese Art," *Monumenta Nipponica* 42, no. 1 (Spring 1987): 1–23; Hikonejō
Hakubutsukan, *Bijutsu no naka no dōji* (Hikone: Hikone-shi Kyōiku Iinkai, 2000);
and Tsuda Tetsuei, "Chūsei no dōjigyō," *Nihon no bijutsu* 442 (March 2003): ded-
icated issue.

60. According to Nishikawa Shinji, "Chōanji zō, Tarōten oyobi nidōji zō," *Bijutsu-shi* 12 (March 1963): 125 and Maruo Shōzaburō, ed., *Nihon chōkoku shi kiso shiryō shūsei: Heian jidai*, vol. 3 (Tokyo: Chūō Kōron Bijutsu Shuppan, 1967), text volume, 10–11, the pole of the staff in the right hand is a replacement, but the branch with three leaves in the left hand has some of its old color remaining.

61. Guth, *Shinzō*, 22, 68. Kyushu Rekishi Shiryōkan, *Bungo Kunisaki Chōanji*, 8, 65, claims that Tarōten was repaired in 1789 (Kansei 1) by a local sculptor and that people were aware of the twelfth-century inscriptions then. See also Nakano, *Hachiman shinkō shi*, 280. For details on construction see Kyushu Rekishi Shiryōkan, *Bungo Kunisaki Chōanji*, 4–10, and Maruo, *Nihon chōkoku shi kiso shiryō shūsei, Heian jidai*, vol. 3, 7–11.

62. See Kondō Yuzuru, "Nyohōkyō shinkō to Ōita, Chōanji Tarōten zō," *Bukkyō Daigaku ajia shūkyō bunka jōhō kenkyūjo kenkyū kiyō* 3 (2007): 36–37. Guth names Kakuji as the sculptor in *Shinzō*, 68.

63. See *Yayama kankei nendaiki* in *Kyushu Rekishi Shiryōkan kenkyū ronshū*, vol. 13, pp. 60, 89. And see Kondō, "Nyohōkyō shinkō," 36.

64. Kyushu Rekishi Shiryōkan, *Bungo Kunisaki Chōanji*, 7–8. Soon after, the text was recorded by Shunyū (890–953) from Ishiyamadera whose text is found in *Yōson dōjō kan, T* 78:43–44. For a translation of the visualizations see Karen Mack, "The Function and Context of Fudō Imagery from the Ninth to the Fourteenth Century in Japan" (Ph.D. diss., University of Kansas, 2006), 32.

65. Oku, "Garanjin," 370, 375, n. 34. Oku cites this passage from the document named *Yayama jiin jūsō Ōnin ni oite bun'an* in *Dōkyōji monjo*. This document, which was discovered in 1987, is transcribed and discussed in detail in Iinuma Kenji, "Bungo no kuni Rokugōsan *Dōkyōji monjo* no shōtai," *Ōita Kenritsu Usa Fudoki no Oka Rekishi Minzoku Shiryōkan kenkyū kiyō* 6 (1989): 47–48, 53, 59–61. Iinuma dates it as early Kamakura period (p. 53) and proposed that it may date more specifically to 1244 (Kangen 2). Note that the character "dō" in Tarōtendō means "boy" or "youth" and not "hall."

66. See Kyushu Rekishi Shiryōkan, *Bungo Kunisaki Chōanji*, 65. Tarōten was repaired in 1789 (Kansei 1), and at that time its date of construction 1130 (Daiji 5) was noted. For the bell, see *Yayama kankei nendaiki* in *Kyushu Rekishi Shiryōkan kenkyū ronshū*, vol. 13, pp. 64, 102. Kyushu Rekishi Shiryōkan, *Bungo Kunisaki Chōanji*, 55, 65, fig. 73.

67. See Kondō, "Nyohōkyō shinkō," 21–73. In 1832 (Tenpō 3) records show that "Tarōtendō, Rokusho no Miya," and "Sannō no Miya" were painted. See *Yayama kankei nendaiki* in *Kyushu Rekishi Shiryōkan kenkyū ronshū*, vol. 13, pp. 65, 103. *Dazai kannai shi* (Dazai jurisdiction record) from 1841 (Tenpō 12) notes a "Tarōten shrine" (Tarōten no yashiro) above the grounds of Chōanji. See *Dazai kannai shi*, vol. 2, p. 248, which is in vol. 9 of the Bungo section. Tarōten is also mentioned in vol. 2, p. 227, which is in vol. 8 of the Bungo section.

68. Watanabe Nobuyuki, *Kunisaki hantō no sekibutsu* (Tokyo: Mokujisha, 1971), fig. 60 shows a photograph of the stone Tarōten image *in situ*. Tarōten Iwaya is in *Dazai kannai shi*, vol. 2, p. 229. Watanabe, p. 151, proposes the Muromachi-period

date for the image, but I have not been able to confirm this elsewhere. Mr. Ima-
kuma Gōshō, current head of Sentōji, said he thought his father, who was the
former head of the temple, removed the image from the cave to protect it (per-
sonal interview, May 17, 2014). I would like to thank Mr. Imakuma for allow-
ing me to view and photograph the image.

69. Watanabe Katsumi, *Kunisaki Rokugō Manzan reijō meguri* (Ōita: BookWay, 2012),
111–112. For a photograph, see http://web.city.kunisaki.oita.jp/htmldoc
/bunkazai/11kunimi/n05home/n05home.html#nc0507 (accessed July 19,
2012). See also Watanabe Katsumi, *Kunisaki koji junrei* (Ōita-shi: Sōrinsha, 1986),
83–84. Watanabe implies that Tarōten is a conflation of the monk Tarō (Tarōbō)
and a *tengu*. See also and Kunimi Chōshi Henshū Iinkai, *Kunimi chōshi* (Ōita,
Kunimi-chō, 1993), 470–472. The figure seems to hold a fan made of feathers,
which is an iconographical feature of a *tengu* and might relate to the fan held
by the Chōanji figure. Mount Kubote, which is where one of the buried sutra
boxes was found, is also said to have a Tarōten. See Shigematsu Toshimi,
"Kubotesan shinkō to bijutsu," *Bukkyō geijutsu* (August 1971): 142; http://kubote
-historical-museum.com/hotoke.html (accessed April 18, 2016); and Tengu
mandara painting in Shigematsu Toshimi, *Yamabushi mandara: Kubotesan shu-
gen iseki ni miru* (Tokyo: Nihon Hōsō Shuppan Kyōkai, 1986), color photo insert
between pages 96 and 97.

70. Elsewhere, and beyond the scope of this investigation, Tarōbō was a protec-
tor *gongen* of Chōmeiji in Shiga, which has "Rokusho Gongen" rocks behind
its main hall that enshrines three Kannon images as *honzon*, showing such a
phenomenon was not limited to Kyushu. See http://ja.wikipedia.org/wiki
/%E9%95%B7%E5%91%BD%E5%AF%BA (accessed June 8, 2015).

71. Ōita-ken, *Ōita kenshi, Kodai hen*, vol. 2, 478, 481. See also Kyushu Rekishi
Shiryōkan, *Bungo Kunisaki Chōanji*, 43–47. There is a drawing of the Rokusho
Gongen hall in a copperplate print precinct picture of Sentōji from the late
nineteenth century. See Ueda Ensei, ed., *Ōita-ken shaji meishō zuroku* (Kuma-
moto: Seichōsha, 1983), 107.

72. *Kunimi chōshi*, 471. The Six Kannon are enshrined with a Yakushi image. This
cave is near the highway, on the path to Tarōten Iwaya, about one kilometer
from the present location of Sentōji. For a photograph see http://kazesasou
.com/hotoke9/hotoke_32_siritukiiwaya.html (accessed September 29, 2013).

73. Indeed, the only triad that looks somewhat similar is the Fudō Myōō triad
from Kisshōji in Wakayama prefecture, which consists of a youthful central
figure wearing a pointed hat with two attendant youths with the double-bun
hairstyle. This central image does, however, have fangs, so he looks more like
Fudō than Tarōten. See Wakayama Kenritsu Hakubutsukan, *Idōsuru butsuzō:
Aridagawa-chō no jūyō bunkazai o chūshin ni* (Wakayama-shi: Wakayama Kenritsu
Hakubutsukan, 2010), 20. See also Hikonejō, *Bijutsu no naka no dōji*, 32–33.

74. For information about the relationship between Shōkū and his child atten-
dants, see Hikonejō, *Bijutsu no naka no dōji*, 36, 100–101, Tsuda, "Chūsei no
dōjigyō," 96–98, and Melissa McCormick, *Tosa Mitsunobu and the Small Scroll in*

Medieval Japan (Seattle: University of Washington Press, 2009), 200–201. I am grateful to Melissa McCormick for pointing me to the passage on the boys in Koyama Satoko, *Gohō dōji shinkō no kenkyū* (Kyoto: Jishōsha Shuppan, 2003), 122–130. Koyama discusses Kyushu and Kirishima specifically on page 129.

75. A fourteenth-century painting from Danzan Jinja in Nara and a fifteenth-century painting from Nezu Bijutuskan in Tokyo are two examples of paintings of Shōkū with his two attendants. See Hikonejō, *Bijutsu no naka no dōji*, 36.

76. See Kondō, "Nyohōkyō shinkō," 23, 67.

77. Kyushu Rekishi Shiryōkan, *Bungo Kunisaki Chōanji*, 45. The entire record is transcribed on 43–47.

78. Ueda, *Ōita-ken shaji meishō zuroku*, 113.

79. http://blogs.yahoo.co.jp/mikey0505jp/archive/2011/2/15 (accessed April 17, 2016). The photographs on the blog show the opening of the images in the Kannon Hall, and include a Horse-Headed Kannon, a standing Nyoirin Kannon, a Thousand-Armed Kannon, a Fudō Myōō, and a Bishamonten, all unpainted with gold leaf.

80. Watanabe, *Kunisaki Rokugō*, 92. Unfortunately, the local authorities who hold the key (not the temple) were not willing to unlock the doors at any other time.

81. Sakai, *Kunisaki hantō,* 170, which was published before the fire in 1976, mentions that the Six Kannon are the temple's main images, but does not say anything more about them.

82. After the 1572 fire, the temple was rebuilt again in 1648 (Keian 1) after another fire. In 1774 (An'ei 3) an Amida image was dedicated and in 1788 the Kannon Hall was reconstructed. Usa Fudoki no Oka Rekishi Minzoku Shiryōkan, *Rokugōsan jiin ikō kakunin chōsa hōkokusho*, vol. 3 (Usa: Usa Fudoki no Oka Rekishi Minzoku Shiryōkan, 1995), 57–58. The source given is a record called *Eidaichō*, which dates to 1802 (Kyōwa 2) and is owned by the temple. This volume, p. 62, has a photograph of the hall and reports a stone lantern near it dated 1721 (Kyōhō 6), but does not offer a date for the previous Kannon Hall.

83. Rokusho Gongen Shrine is documented in 1776 (An'ei 5), demonstrating that the shrine was in operation before the Kannon Hall was rebuilt in 1788. See Usa Fudoki no Oka, *Rokugōsan jiin*, 3:57.

84. Watanabe, *Kunisaki Rokugō Manzan reijō meguri*, 92.

85. *Dazai kannai shi* from 1841 refers to the place as Ōishiya Gongen (Gongen of the great grotto) near Ōrekiji and confirms ritual readings of the *Kannon Chapter* took place there. See Kyushu Rekishi Shiryōkan, *Bungo Kunisaki Chōanji*, 44.

86. Watanabe, *Kunisaki Rokugō*, 62. Previously the temple had been located about four hundred meters below its present location.

87. For photographs see Watanabe, *Kunisaki to sekibutsu*, 123; Satō Sōtarō, *Sekibutsu no bi*, vol. 2 (Tokyo: Mokujisha, 1968), 24, fig. 37; and http://kunisakikaze.photo-web.cc/sub-a-bunkazai/bungotakada-matama/b/matama-b-03.html (accessed June 12, 2014). Shiroku is usually accompanied by Shimei but not here.

88. Usa Fudoki no Oka Rekishi Minzoku Shiryōkan, *Rokugōsan jiin ikō kakunin chōsa hōkokusho,* vol. 2 (Usa: Usa Fudoki no Oka Rekishi Minzoku Shiryōkan, 1994), 61. This source suggests the carvings were made in late Nanbokuchō period (1334–1392). See also sign posted at the site.

89. Kyushu Rekishi Shiryōkan, *Bungo Kunisaki Chōanji,* 44.

90. http://kunisakikaze.photo-web.cc/sub-a-bunkazai/bungotakada-matama/a /matama-a-04.html (accessed June 13, 2014); Satō, *Sekibutsu no bi,* vol. 2, p. 24, fig. 36. The three-bay structure measures 160×460 centimeters.

91. Usa Fudoki no Oka, *Rokugōsan jiin,* 2:62.

92. *SMZ* (1905) 60:14–17 / (1982) 4:1024–1030. The picture of the shrine is in *SMZ* (1905) 60:14–15 / (1982) 4:1026–27. Note that it includes a Kannon Hall.

93. Shibushi-chō, *Shibushi chōshi* (Kagoshima: Shibushi-chō, 1972), vol. 1, pp. 383–384.

94. *SMZ* (1905) 60:16–17 / (1982) 4:1029–1030.

95. See Yamahata Toshihiro, ed., *Jinja Keiōshū* (Shibushi-chō: Shibushi-chō Kyōiku Iinkai, 1998), 16–18. See p. 3 for a chart on the separation of Shinto and Buddhist deities in the area.

96. Kagoshima-ken Rekishi Shiryō Sentā Reimeikan, *Inori no katachi: Chūsei Minami Kyushu no hotoke to kami* (Kagoshima-shi: Kagoshima-ken Rekishi Shiryō Sentā Reimeikan, 2005), 188. See also p. 196, note 8 about the location of the record *Jinja Keiōshū.*

97. See Shibushi-chō, *Shibushi chōshi,* vol. 1, pp. 383–384.

98. See Naniwada Tōru, "Kyōzō to kakebotoke," *Nihon no bijutsu* 284 (January 1990): dedicated issue.

99. See "Yamamiya Jinja" in *Nihon rekishi chimei taikei* (accessed December 27, 2010).

100. See http://blogs.yahoo.co.jp/yan1123jp/archive/2010/12/2 (accessed December 27, 2010). See also "Yamamiya Jinja" in *Nihon rekishi chimei taikei* (accessed March 19, 2012).

101. *SMZ* (1905) 46:12–16 / (1982) 3:1106–1111. One theory says there were only three *gongen* at the shrine.

102. *SMZ* (1905) 46:13 / (1982) 3:1107.

103. *SMZ* (1905) 46:16 / (1982) 3:1115. For a drawing of the building, see *SMZ* (1905) 46:15 / (1982) 3:1110.

104. *SMZ* (1905) 46:8 / (1982) 3:1097. The Rokusho Gongen name was changed in 1779 (An'ei 8) to Kitao Daigongensha and then again to Kitao Shrine, which it maintains today.

105. Tanabe Takao, "Dengenji no Roku Kannon zō," *Nishi Nihon no bunka* 115 (1975): 16–21. See http://www.k-tanbou.com/pdf/rekishi/dengenjinorokukannonzou .pdf (accessed June 4, 2015).

106. Kumamoto Kenritsu Bijutsukan, *Kannon Bosatsu to Jizō Bosatsu* (Kumamoto: Kumamoto Kenritsu Bijutsukan, 1997), 38–39.

107. The signboard outside the hall "Dengenji no yurai," written in 2003, says that the *zushi* is opened once every fifty years. When Mr. Shingo Kenta formerly of the Karatsu City Hamatama Office of Education (Karatsushi Hamatama

Shijo Kyōikuka), showed me the Dengenji images in 2006, he told me that he was not allowed to open the *zushi* for Tree Root Kannon, but he showed me a photograph.

108. See http://www.geocities.jp/tamatorijisi/higasimatuuragunsi.html#090209 (accessed July 16, 2014). First published in Matsushiro Matsutarō, ed. *Higashi Matsuuragunshi* (Higashimatsuura-gun: Kyōikukai Hakkō, 1915). Also in *Matsuuraki shūsei*, compiled in 1934, in Yoshimura Shigesaburō, *Matsuura sōsho: Kyōdo shiryō* (Tokyo: Meicho Shuppan, 1974), vol. 2, p. 235. About Sadehiko see http://www.asahi-net.or.jp/~sg2h-ymst/sadehiko.html (accessed July 16, 2014).

109. For a photo of the image, see Hamatama-chō Kyōiku Iinkai, *Hamatama-chō no bunkazai* (Hamatama-chō: Hamatama-chō Kyōiku Iinkai, 1996), 10.

110. Ian Hideo Levy, *The Ten Thousand Leaves: A Translation of the Man'yōshū, Japan's Premier Anthology of Classical Poetry* (Princeton, N.J.: Princeton University Press, 1981), vol. 1, p. 381.

111. Hamatama-chō Kyōiku Iinkai, *Hamatama chōshi* (Saga: Hamatama-chō Kyōiku Iinkai, 1989), vol. 1, p. 688. Although wood identification can be difficult from visual analysis, the use of camellia wood for Buddhist images is highly unusual and unlikely. Tanabe does not specify the wood types in his article. About *tachiki butsu* see Kuno Takeshi, "Tachiki ni tsuite," *Bijutsu kenkyū* 217 (July 1961): 43–58.

112. Tanabe, "Dengenji," 17.

113. Hamatama-chō Kyōiku Iinkai, *Hamatama chōshi*, vol. 1, p. 692. Tanabe, "Dengenji," 21.

114. Tanabe, "Dengenji," 18; Hamatama-chō Kyōiku Iinkai, *Hamatama chōshi,* vol. 1, p. 696.

115. Instead of the special mudra for Horse-Headed Kannon (*bakōin*) with the hands pressed together and the index fingers bent as is usually present, this image has two hands placed in front of the chest in the mudra of reverence.

116. According to the Board of Education, the Dengenji images employ various sculpture techniques that are similar to those used by Kyoto and Nara sculptors, but they also have characteristics of provincial sculpture. See Hamatama-chō Kyōiku Iinkai, *Hamatama chōshi*, vol. 2, p. 681.

117. Tanabe, "Dengenji," 21. *Hōrengein mandokoro kudashibumi* is quoted in "Dengenji ato" in *Nihon rekishi chimei taikei* (accessed April 26, 2009). The original is at Kyoto University. See also Hamatama-chō Kyōiku Iinkai, *Hamatama chōshi*, vol. 1, p. 696.

118. Kumamoto Kenritsu Bijutsukan, *Kannon Bosatsu to Jizō Bosatsu,* 39. See also "Dengenji ato" and "Matsuuranoshō" in *Nihon rekishi chimei taikei* (accessed May 5, 2009). This site also claims that Dengenji flourished as a site for *shūgendō* in the Kamakura period, but does not offer a source for the information. Saishōkōin was part of the Kyoto Tendai Hōjūji complex, south of the present site of Kyoto National Museum and east of Sanjūsangendō. Later the territory was transferred to Tōji. Kokushi Daijiten Henshū Iinkai hen, *Kokushi daijiten* (Tokyo: Yoshikawa Kōbunkan, 1979), vol. 6, pp. 167–168.

119. The signboard "Dengenji no yurai" (written in 2003) explains that these images were brought there from the fire. When I visited in 2006, Shingo Kenta opened this *zushi* for my viewing.

120. Yoshimura Shigesaburō, *Matsuura sōsho: Kyōdo shiryō*, vol. 1, pp. 81–84.

121. Tanabe, "Dengenji," 17.

122. See the Waseda Library database, http://archive.wul.waseda.ac.jp/kosho/i04 /i04_03153/i04_03153_b082/ (accessed June 4, 2015), for digital photographs of the three rubbings through the library website. The three rubbings (measuring 64.8×32.2 cm, 64.5×66.5 cm, 65×32.4 cm) were made in the 1930s by Ogino Minahiko (1904–1992), a premodern Japanese literature specialist and former director of the Waseda Library. The rubbings on paper were subsequently mounted into three separate hanging scrolls and donated to the library in 1998.

123. I am grateful to Amy McNair for helping me read the text from the rubbings on November 2, 2010. The authors of *Kokubu kyōdoshi* (Kokubu local history records) were able to read more of the inscription. Kokubu Kyōdoshi Henzan Iinkai, *Kokubu kyōdoshi: Shiryōhen* (Kokubu: Kokubushi, 1997), 882; fig. 216 has a small photograph.

124. Kagoshima-ken Rekishi Shiryō Sentā Reimeikan, *Bukkyō bunka no denrai: Satsuma Kokubunji e no michi* (Kagoshima-shi: Kagoshima-ken Rekishi Shiryō Sentā Reimeikan, 1990), 74–75.

125. *Kokubu kyōdoshi*, 244–248.

126. *SMZ* (1905) 31:39 / (1982) 3:80. The Six Kannon monument is not mentioned. Although the pagoda is not shown, the volume has an illustration of Kokubunji shrouded in misty clouds with the Kannon Hall labeled as the most prominent place in the picture. *SMZ* (1905) 31:37–38 / (1982) 3:79.

127. *Kokubu kyōdoshi*, 248–249.

128. Haraguchi Torao, *Kagoshimaken no rekishi, Kenshi shirīzu* vol. 46 (Tokyo: Yamakawa Shuppansha, 1971), 65–66. See also *Kokubu kyōdoshi*, 4, 248, 873. The stone is kept in the city, but not at the site of former Kokubunji, where the Six Kannon monument and pagoda are located. From the photograph in the latter volume, it seems to have been at the same site as the others, so it must have been moved sometime after the book was published in 1997. I was unable to find it when in the area.

129. Mary Elizabeth Berry, *Hideyoshi* (Cambridge, Mass.: Harvard University Press, 1982), 90.

130. *Kokubu kyōdoshi*, 248. I have not been able to confirm elsewhere that Kintaku was from Ryōgonji.

131. The story about the *Heart sūtras* comes from *SMZ* (1905) 31:38 / (1982) 3:78. For an example of a *Heart sūtra* written by Gonara in 1540, see the Iwase Bunko Library site: http://www.city.nishio.aichi.jp/nishio/kaforuda/40iwase/kikaku /42sinnisio/sinnisio.html (accessed December 26, 2011). The sutra dedications are known as one of his main accomplishments. See also Tokyo Kokuritsu Hakubutsukan, *Kokuhō Daigoji ten: Yama kara orita honzon* (Tokyo: Nihon Keizai Shinbunsha, 2001), 148–149, fig. 77.

132. *Kokubu kyōdoshi*, 249.

133. See http://www.city-kirishima.jp/modules/page045/index.php?id=3#14 (accessed July 1, 2014).

134. *Kokubu kyōdoshi*, 249.

135. See http://www.geocities.jp/kawai5510/kagosima-kokubunjiato-soutou.html (accessed July 14, 2014). Mr. Shigehisa Junichi from the Kirishima Kyōiku Iinkai (Kirishima Board of Education) provided the source *Kokubu kyōdoshi*, 882. I am grateful to Maki Kaneko for calling him on November 18, 2010. The local history museum displays a reproduction of a Taishō-period photograph of the group of monuments together.

136. Nara-ken Kyōiku Iinkai, *Shukuin busshi* (Nara: Nara-ken Kyōiku Iinkai, 1998), 225.

137. Nara-ken Kyōiku Iinkai, *Shukuin*, 227, 229, 230.

138. Miyazaki-ken, *Miyazaki kenshi tsūshihen* (Miyazaki-ken, 1998), 733. I interviewed Kobayshi Kōjun on July 12, 2009 when he showed me the images.

139. I noticed that the Eleven-Headed Kannon's crown had been repaired and there is a water bottle as the front crown ornament, perhaps in imitation of the water bottle in the image's hand, instead of the more iconographically appropriate figure of Amida in the crown.

140. Kobayashi Honkō, "Chōkyūji no kaiki to butsuzō," *Miyazaki hibi shinbun*," June 7, 1963.

141. See Nara Kokuritsu Hakubutsukan, *Shukuin busshi: Sengoku jidai no Nara busshi* (Nara: Nara Kokuritsu Hakubutsukan, 2005), 8, for a lineage chart and pp. 63–66 for a timeline. For a map of Shukuin-chō see Nara-ken Kyōiku Iinkai, *Shukuin*, 1.

142. Nara-ken Kyōiku Iinkai, *Shukuin*, 734–735.

143. Genzaburō made works from 1573 to 1582. See Nara Kokuritsu Hakubutsukan, *Shukuin busshi*, 11, and Suzuki Yoshihiro, "Shukuin busshi," *Nihon no bijutsu* 487 (December 2006): 52, 72–79.

144. Suzuki, "Shukuin," 64, and Nara-ken Kyōiku Iinkai, *Shukuin*, 229.

145. Miyazaki-ken, *Miyazaki kenshi sōsho Hyūgaki* (Miyazaki-ken, 1999), 155. The remains of Kinpakuji are in the area now called Sadowara-chō in Miyazaki. See also p. 156 about the bell Itō Yoshisuke (1512–1585) had cast for Kinpakuji the following year.

146. Nara-ken Kyōiku Iinkai, *Shukuin,* 139.

147. Ibid., 124. The image is the Dainichi from Takeda Jinja in Kashiwara City. See Nara Kokuritsu Hakubutsukan, *Shukuin busshi*, 35, 56.

148. Kai Tsuneoki, "Shukuin busshi no shinshutsurei Chōkyūji no mokuzō Kokūzō Bosatsu zazō ni tsuite," *Shiseki to bijutsu* 767 (August 2006): 274–278. The inscriptions in this image were discovered after the 2005 exhibition at the Nara National Museum on Shukuin Busshi took place, so it was not included in the most significant exhibition ever held on this theme.

149. Nara-ken Kyōiku Iinkai, *Shukuin,* 128–130.

150. For full inscriptions see ibid., 224–230.

151. Kobayashi, "Chōkyūji," n.p.

152. Saeki Etatsu, *Haibutsu kishaku hyakunen: Shiitagerare tsuzuketa hotoketachi* (Miyazaki-shi: Kōmyakusha, 1988), 188–192. See also "Imafukuji" and "Ōtsukamura" in *Nihon rekishi chimei taikei* (accessed August 11, 2009). According to the latter source, the temple was restored in 1884. Also related to temple history, Chōkyūji owns a few stone monuments from the sixteenth and seventeenth centuries, including a stone pillar with Six Jizō dated to 1587 (Tenshō 15). Hirabe Kyōnan (1815–1890), *Hyūga chishi* (Kumamoto: Seichōsha, 1976), 111 and 125, documents how Chōkyūji merged with Imafukuji in 1870. Hirabe compiled *Hyūga chishi* (History of the Hyūga area) in 1879–1884.

153. Suzuki, "Shukuin," 64, fig. 63; Nara-ken Kyōiku Iinkai, *Shukuin*, 82, 232–233.

154. Kobayashi Kōjun told me that he went to see them, but could barely make them out. See "Honjō no sekibutsu" in *Nihon rekishi chimei taikei* (accessed November 28, 2010), and for photographs see http://mpv21hiro.blog75.fc2.com /blog-entry-397.html (accessed June 4, 2015), and http://shogo33333.ninja-web .net/miyazaki-kourakuti/honjyouishibotoke/honjyouishibotoke.html for directions and details on the site (accessed June 4, 2015). A shelter was built to cover the Honjō images, and in 1989 a group of stone-Buddha enthusiasts sponsored a wooden relief carving inspired by the images, which includes the Six Kannon, on display in a glass case at the site.

155. *SMZ* (1905) 46:7–8 / (1982) 3:1096–1097. See also http://www.udojingu.com /goyuisyo/ (accessed July 16, 2014).

156. http://www.hitoyoshikuma.com/kankou/kannon.html and http://www .hitoyoshi-hikari.com/rensai_kannon/vol32/all.html (accessed August 6, 2011). See also "Sagara sanjūsan Kannon," *Asahi shinbun, Kumamoto-ken* (March 22, 2008): 30.

157. Takada Motoji, *Sagara sanjūsan Kannon meguri* (Hitoyoshi: Hitoyoshi Kuma Bunkazai Hogo Kyōiku Iinkai, 1978), 59. Takada clarifies that there are three versions of the pilgrimage record with the same date (Kansei 6 [1794], fifth month) and he confirmed Bishin and Mushin's dates from their graves. In accordance with Takada's theory, Mushin's poem about Shingūji refers to the six paths, so it was likely written after the Six Kannon set was finished in 1630. See also p. 46.

158. John F. Embree, *Suye Mura: A Japanese Village* (Chicago: University of Chicago Press, 1939), 116–117. Embree reported that every village in Kuma district had two or three Kannon halls on the route and noted that participation in the pilgrimage was on the wane in 1935.

159. " 'Rōjaku danjo 244 nin ga sanka' Sagara sanjūsan Kannon uōkingu Hitoyoshi," *Hitoyoshi shinbun* (September 24, 2011). http://www.hitoyoshi-press.com (accessed September 26, 2011).

160. Takada, *Sagara*, 54–55. See also "Nishi machi" in *Nihon rekishi chimei taikei* (accessed December 29, 2010) and Uemura Shigeji, *Kyushu Sagara no jiin shiryō* (Kumamoto: Seichōsha, 1968), 55.

161. Takada, *Sagara*, 54, claims that the twenty-third-generation head of the Shingū clan, named Torimune, enshrined Six Kannon images. Uemura, *Kyushu Sagara*, 55, reports that Shingū Yoritsuna, who was the head of the district, rebuilt it in 1534 (Tenbun 3). Kumagun Kyōikushikai, *Kumagunshi*, 557, and *Kumagun kyōdoshi*, ed. Kumamoto-ken kyōikukai Kumagunshikai (Kumagun Kumamoto-ken, 1916), 92, say that long ago the Zen Master Jinkō Hōshū enshrined the Six Kannon and built the halls for the temple. I have not been able to confirm dates or alternate names for these people.

162. Kumagun Kyōikushikai, *Kumagunshi*, 557. A shorter version of the legend is in *Kumagun kyōdoshi*, 92–93.

163. Kumagun Kyōikushikai, *Kumagunshi*, 558, says it was copied from *Shingusō dayū chōsho*, but no date is given. Because of the language it appears to be an Edo-period source. The record has a dedicated heading on a page separate from the entry on Shingūji. The large sign posted in 1993 in front of the temple quotes the information, but the characters for the name of the text vary. Many sources, including Takada, *Sagara*, 55, repeat that the Eleven-Headed Kannon image was made in 1577 (Tenshō 5) by Kaigetsu from Ōsumi, but it is not in *Kumagunshi*'s version of the record and I do not know the source. See also http://yumeko2.otemo-yan.net/e360077.html (accessed September 15, 2015). All readings for the sculptor's names are speculation.

164. *Kumagunshi* and *Kumagun kyōdoshi* repeat this. It is also found in Uemura, *Kyushu Sagara*, 55. Eigaku Kōichi, "Tenzui Dō'on no kenkyū," *Komazawa Daigaku gakuhō* 2 (1953): 33. Tenzui was also called second generation Dentō Oshō of Tōrinji.

165. Unoki Eiji, *Higo no kuni Kumagun sonshi* (Kumamoto: Kumamoto Joshi Daigaku Rekishigaku Kenkyūbu, 1976), 94. In 1875 Shingūji was a subtemple of Tōrinji.

166. Kumagun Kyōikushikai, *Kumagunshi*, 557.

167. Gotō Osamu, "Kakureta chiiki no bunkazai isan: Kumamoto-ken Hitoyoshi, Kuma-gun no shaji kenchiku chōsa kara," *Gekkan bunkazai* 344 (May 1992): 7. Eigaku, "Tenzui," 33, mentions that Tenzui wrote this plaque. *Kumagun kyōdoshi*, 93, a source from 1916, states that the building dates from the 1676 rebuilding.

168. The temple caretaker confirmed this former practice (personal interview, July 16, 2011).

169. Embree, *Suye Mura*, 282. On Horse-Headed Kannon in relation to memorials, rather than fertility, see Barbara Ambros, *Bones of Contention: Animals and Religion in Contemporary Japan* (Honolulu: University of Hawai'i Press, 2012), 63–64.

170. See William R. Lindsey, *Fertility and Pleasure: Ritual and Sexual Values in Tokugawa Japan* (Honolulu: University of Hawai'i Press, 2007), 123–127; Ian Reader and George Tanabe, *Practically Religious: Worldly Benefits and the Common Religion of Japan* (Honolulu: University of Hawai'i Press, 1998), 317.

171. Kumagun Kyōikushikai, *Kumagunshi*, 558. I appreciate Chang Qing's help reading this document.

172. The location of the original scroll is unknown, but two copies exist. Most of the scroll is unpublished, but the local history museum has a large replica of one copy on view, with the characters transcribed for easier reading. See http://www.city.hitoyoshi.lg.jp/q/aview/95/249.html (accessed August 9, 2011). For one section, see Masakama Tashiro et al, *Shin'yaku Kuma gaishi* (Kumamoto: Seichōsha, 1972), front page.

173. *Kumagun kyōdoshi*, 93.

174. Embree, *Suye Mura*, 183, 252, 245, 259.

175. Kumagun Kyōikushikai, *Kumagunshi*, 557.

176. http://pmon.exblog.jp/13280404/ (accessed July 23, 2012); see this blog for a photograph.

177. *Fumonji ryakki* is reprinted in Kumagun Kyōikushikai, *Kumagunshi*, 503; *Kumagun jinjaki*, in *Hizen, Higo, Hyūga, Satsuma, Ōsumi no kuni, Shintō taikei, jinja hen*, eds. Kudō Keiichi and Matsumoto Sumio, vol. 45 (Tokyo: Shinto Taikei Henzankai, 1987), 299–300; and Dohi Ken'ichirō, *Kumagun jinjaki* (Kamimura [Kumamoto-ken]: Kuma Sōsho Kankōkai, 1919), 110. I am grateful to Maki Kaneko for obtaining the latter record for me at the National Diet Library. See also *Rekidai shisei dokushūran,* by Umeyama Muikken (1755–1828), (Kumamoto-ken, Kuma-gun, Sagara-mura, 1995), 65.

178. Shōzenin was built at the location later in 1625.

179. *Nantō manmenroku,* by Umeyama Muikken (1755–1828), (Kumamoto: Seichōsha, 1977), 57. This document is a history of the Sagara domain from 1675–1720. The text, which was compiled in the Bunka era (1804–1818), also appears in *Rekidai shisei dokushūran*, 65.

180. *Rekidai shisei dokushūran,* 65. An 1876 copy of the record *Fumonji daidai senshi* of the forty-one generations of the Fumonji lineage is reproduced in Uemura, *Kyushu Sagara,* 61–63, and see p. 14 about dating. The record states that the dates for Eison are unknown, and interestingly the page that would have included the infamous fifth-generation Seiyo was left out.

181. *Rekidai shisei dokushūran,* 174; Takada Motoji, *Yunomae chōshi* (Yunomae-machi, 1968), 132–133.

182. Kumagun Kyōikushikai, *Kumagunshi* (Hitoyoshi-chō, Kumamoto-ken: 1941), 575–577, and Uemura, *Kyushu Sagara,* 61. The episode is referred as the "Nekodera incident." For a version of the story in English see Atsushi Shibuya and Nobuyuki Takaki, *A Comprehensive Guide to Hitoyoshi City and Kuma County* (Hitoyoshi: Hitoyoshi Tourist Club, 1977), 13. See also Takada, *Yunomae chōshi,* 129–134 and Embree, *Suye Mura,* 276–277.

183. Kumagun Kyōikushikai, *Kumagunshi,* 503. See also Takada Motoji, ed., *Shinyaku Kuma gaishi* (Kumamoto: Seichōsha, 1972), 177, 203, 227. Masakama Tashiro (1790–1869) originally compiled the latter text in 1853.

184. Kumagun Kyōikushikai, *Kumagunshi,* 574.

185. Kumagun Kyōikushikai, *Kumagunshi,* 502. This was taken from the passage on Ichifusa Shrine and is repeated on the wooden sign that stands outside the shrine today.

186. The site http://5.pro.tok2.com/~niemon/kumamoto/yunomae/dotyu/fumonji .html (accessed April 18, 2016) claims the Kannon Hall survived the 1883 fire. *Kumagun kyōdoshi* does not mention Fumonji, although it covers the other temples discussed in this section, such as Shingūji and Shōzenin.

187. Takada, *Sagara,* 46.

188. Kumagun Kyōikushikai, *Kumagunshi,* 577.

189. Hanging inside the hall, and suffering from the elements, is a 1978 photograph of a group of people celebrating an anniversary of the rebuilding of the hall. Takada, *Sagara,* 46–47, includes a photograph of the images as part of the pilgrimage in 1977.

190. Uemura, *Kyushu Sagara,* 10, 213. *Monchūdosha narabi daidai senshi* is reproduced in this book.

191. *Rekidai shisei dokushūran,* 259, and Hitoyoshi Shishi Hensan Kyōgikai, *Hitoyoshi shishi* (Hitoyoshi-shi: Hitoyoshi-shi Kyōiku Iinkai, 1981), 561. See also Takada, *Sagara,* 46, and "Fumonji ato" in *Nihon rekishi chimei taikei* (accessed November 13, 2011). *Rekidai shisei dokushūran,* 523, also mentions a service of two nights and three days held for the *honji,* which likely refers to the Six Kannon images, at Ichifusa in 1749 (Kan'en 2).

192. *Nantō manmenroku* 277.

193. The plaque lists Kakunin as giving prayers, but I was unable to photograph its entire text that might include Shōtatsu and other details.

194. Uemura, *Kyushu Sagara,* 86; "Fumonji ato" in *Nihon rekishi chimei taikei;* and Takada, *Yunomae chōshi,* 784. The latter text quotes *Gotōke bunsho* as the source of this information, but I have been unable to find this text.

195. The measurements of the Kannon images are as follows: Shō (55.5 cm total height with base, 22.5 cm image only); Juntei (54.0 cm total height with base, 21.5 cm image only); Thousand-Armed (56.5 cm total height with base, 22.0 cm image only); Horse-Headed (55.0 cm total height with base, 21.5 cm image only); and Nyoirin (53.0 cm total height with base, 22.5 cm image only).

196. *Kumagun kyōdoshi,* 76. Hikohohodemi no mikoto was worshipped at five out of the six Kirishima Gongen shrines.

197. *Nantō manmenroku,* 57.

198. Tokyo Daigaku Shiryō Hensanjo, *Dai Nihon komonjo; Iewake,* vol. 5, *Sagara-ke monjo,* pt. 2 (Tokyo: Tokyo Teikoku Daigaku, 1917–1918), 332, 336.

199. Kumagun Kyōikushikai, *Kumagunshi,* 577.

200. Uemura, *Kyushu Sagara,* 10.

201. Scattered around Kyushu, and too numerous to include in this book, are even more Six Kannon stone monuments, such as those in Saga prefecture from the sixteenth century. See http://www.city.saga.lg.jp/contents.jsp?id=11461 for a Muromachi-period example and http://www.city.saga.lg.jp/contents .jspid=3479 for one dated 1518 (Eishō 15) (accessed July 24, 2012). See also "Shimotetsuki (Imari-shi) Roku Kannon sekidō ni tsuite," *Matsuro no kuni* 167 (2006): 18–20, for an example from 1580 (Tensho 8).

Chapter Three: Traveling Sets and Ritual Performance

1. Sawada Naoyuki of Tansei Institute and Daihōonji were especially kind to allow me to use Sawada's photographs of the Daihōonji images. The first section on Daihōonji in this chapter has been modified and updated from an earlier article, Sherry Fowler, "Travels of the Daihōonji Six Kannon Sculptures," *Ars Orientalis* 36 (2006): 178–214.

2. Iwai Taketoshi, *Nihon kokenchiku seika* (Tokyo: Benridō, 1919), vol. 1, p. 18. The photo shows the former (not original) tile roof of the building and the area before neighborhood development. See Fowler, "Travels of the Daihōonji Six Kannon Sculptures," fig. 3, p. 181.

3. For a discussion of the architectural features of the hall in English, see Jiro Murata, "The Main Hall of the Daihoonji Temple," *Japan Architect* 37, part 1 (June 1962): 78–83 and part 2 (July 1962): 80–85.

4. See Murai Jun, ed., *Jōen-bon Tsurezuregusa kaishaku to kenkyū* (Tokyo: Ofūsha, 1967), 460, and Donald Keene, trans., *Essays in Idleness: The Tsurezuregusa of Kenkō,* (New York: Columbia University Press, 1967), 196.

5. *Hantōkō,* written by the monk Genryō (1458–1491), is quoted in "Daihōonji" in *Nihon rekishi chimei taikei* (accessed February 26, 2007). This section of *Hantōkō* is also in *Shinshū Kyoto sōsho* (hereafter cited as *SKS),* vol. 18 (Kyoto: Rinsen Shoten, 1976), 135–136. Other records give the temple an older pedigree by making the unlikely claim that it was built by Emperor Yōmei (r. 585–587) and later restored by the monk Gikū. The earliest record (untitled) to mention Yōmei building the temple is from 1615 (Genna 1). See Kyōtofu Kyōikuchō Bunkazai Hogoka, *Kokuhō kenzōbutsu Daihōonji Hondō shūri koji hōkokusho* (Kyoto: Kyōtofu Kyōikuchō Bunkazai Hogoka, 1954), 118.

6. For the inscription, see Kyōtofu, *Kokuhō,* 111, and Itō Shirō, *Senbon Shakadō Daihōonji no bijutsu to rekishi* (Kyoto: Yanagihara Shuppan, 2008), 186. The Ten Great Disciples, made by the famous sculptor Kaikei circa 1208–1220 were also continuously enshrined in the hall until they were placed in a storehouse along with the Six Kannon in the 1960s. See Mizuno Keisaburō, ed., *Nihon chōkokushi kiso shiryō shūsei: Kamakura jidai: zōzō meiki hen,* vol. 3, text vol., 91–113; plate vol., 98–134, no. 88.

7. Kyōtofu, *Kokuhō,* 118 and Itō, *Senbon,* 103. The whereabouts of the Miroku and Monju are unknown.

8. See *Daihōonji engiki* in Kyōtofu, *Kokuhō,* 119, and Itō, *Senbon,* 189. This document is one of two *engi* that belong to the temple. It has a postscript on an attached piece of paper dated 1803 (Kyōwa 3) but is considered to have been compiled earlier. Shimosaka Mamoru in Itō, *Senbon,* 76, proposes that the writing of this *engi* began in the fourteenth century. Kyōtofu, *Kokuhō,* 119, posits that it was made after the Muromachi period (1392–1573).

9. See an untitled document in Kyōtofu, *Kokuhō,* 118, and also *Kyōuchi mairi,* compiled 1708 (Hōei 5), *SKS* 5:454–455.

10. Mōri Hisashi in *Senbon Shakadō Daihōonji,* ed. Kikuiri Tonnyo (Kyoto: Benridō, 1956), 16–17; Mizuno, *Nihon chōkokushi,* vol. 3, text vol., 191.

11. "Daihōonji Hondō," *Asahi hyakka Nihon no kokuhō* 7, no. 61 (1999): 22. The Six Kannon set from Hōjōji is an example of another set made earlier than the building in which they were ultimately housed. See Helen Craig McCullough, *A Tale of Flowering Fortunes: Annals of Japanese Aristocratic Life in the Heian Period* (Stanford, Calif.: Stanford University Press, 1980), 622–623. A ritual was held to transfer them to the Yakushi Hall in 1023. For the original text, see *Eiga monogatari,* ed. Yamanaka Yutaka (Tokyo: Shōgakkan, 1995–1998), vol. 2, p. 402.

12. For a description of the Shaka and the Ten Disciples, which claims they were in the temporary hall in 1220, see *Daihōonji engiki* in Kyōtofu, *Kokuhō,* 119. See *Hantōkō.* This is also repeated in an untitled temple record from 1615 (Genna 1). See Kyōtofu, *Kokuhō,* 118.

13. *Rakuhoku Senbon Daihōonji engi* in Kyōtofu, *Kokuhō,* 119–122; Itō, *Senbon,* 192.

14. There are several examples of folding screens of *Rakuchū rakugaizu* (Pictures in and around the capital) that include the sutra hall with an inconsistent number of bays. See Kyōtofu, *Kokuhō,* 132, fig. 46. See also Matthew P. McKelway, *Capitalscapes: Folding Screens and Political Imagination in Late Medieval Kyoto* (Honolulu: University of Hawai'i Press, 2006), 40–41, and Matthew P. McKelway, "Kitano Kyōōdō to Suwa no shinji: Muromachi jidai senmen zu no ba to kioku" (Kitano sūtra hall and archery at Suwa Shrine: Muromachi fan paintings and shogunal memory) in *Fūzoku kaiga no bunkagaku: Toshi o utsusu media,* ed. Matsumoto Ikuyo (Kyoto: Shibunkaku Shuppan, 2009), 78–96. McKelway discusses various pictures of the sutra hall (fig. 2.19, p. 40 in *Capitalscapes,* and color plate 2 in "Kitano").

15. Kyōtofu, *Kokuhō,* 117–118 and 121. The record also lists the revolving sutra storage formerly near the sutra hall at Kitano, which was modified and moved in 1871 to Zuiōji in Ehime prefecture. See Itō, *Senbon,* 54, 134–136, 193.

16. On the Manbukyōe, see Umezawa Akiko, "Muromachi jidai no Kitano Manbukyōe," *Nihon Joshi Daigakuin bungaku kenkyū kiyō* 8 (2002): 93–116. For a painting of the hall that bears a seal of Kano Motohide (1551–1601), see Kyoto Kokuritsu Hakubutsukan, *Rakuchū rakugaizu* (Kyoto: Kyoto National Museum, 1997), 259, fig. 278, and for the detail that depicts the building in the Uesugi screens, see p. 56, panel 3.

17. As the most extreme description of the hall, which may likely be an exaggeration, according to *Rakuhoku Senbon Daihōonji engi,* the hall measured thirty by twenty-nine bays at one time. See Itō, *Senbon,* 192, and Kyōtofu, *Kokuhō,* 121. See also Usui Nobuyoshi, "Kitanosha issaikyō to Kyōōdō," *Nihon Bukkyō* 3 (October 1959): 43.

18. Umezawa, "Muromachi jidai," 93–116.

19. *Rakuhoku Senbon Daihōonji engi* in Kyōtofu, *Kokuhō,* 121, and Itō, *Senbon,* 140, 192. Itō, 142–143, also proposes that the Kamakura-period Jizō (164.5 cm) at Daihōonji today is not only the Jizō image that was transferred from the sutra hall along with the Six Kannon, but also was originally made to accompany the Six Kannon.

20. For an inscription that records the Six Kannon in the Daihōonji main hall in 1670, see Kyōtofu, *Kokuhō*, 114. Mizuno, *Nihon chōkokushi*, vol. 3, text vol., 197.

21. Kyōtofu, *Kokuhō*, 121–122, and Itō, *Senbon*, 93, 96, 136–137.

22. For a discussion of the constructions of the new and old sutra halls, see Ōmori Kenji in Kikuiri, *Senbon Shakadō*, 9–12. The new sutra hall, which is seldom used and usually closed to the public, now bears the name Taishidō in honor of Shōtoku Taishi (573–621). See this hall's main image in Itō, *Senbon*, 33, 110.

23. Takeuchi Hideo, *Tenmangū* (Tokyo: Yoshikawa Kōbunkan, 1968), 199. According to Takeuchi Hideo, "Kitano Kyōōdō ni tsuite," *Shiseki to kobijutsu* 19 (January 1937): 20, the marker was discovered and excavated at Kitano in 1936 when temporary structures were being built at Kitano Shrine.

24. Mizuno, *Nihon chōkokushi*, vol. 3, text vol., 197. For the *munafuda* (ridgepole plaque) inscriptions, see Kyōtofu, *Kokuhō*, 113–115, and Itō, *Senbon*, 186–188.

25. Photographs of interior of the hall were taken around 1951 before the restoration. See Kyōtofu, *Kokuhō*, 11, pl. 13. See Fowler, "Travels of the Daihōonji Six Kannon Sculptures," fig. 8, p. 185.

26. Itō, *Senbon*, 93, 137. See Fowler, "Travels of the Daihōonji Six Kannon Sculptures," fig. 9, p. 185.

27. The fact that the *issaikyō* (entire canon of sutras) formerly in the Kitano sutra hall was granted Important Cultural Property status in 1981 helped to inspire the construction of the new storehouse. Itō, *Senbon*, 168. A photograph in Murata, "The Main Hall," part 1, 83, from 1962 shows the tops of four of the Six Kannon outside the cabinets. For the exhibitions see Chūbu Nihon Shinbunsha, *Gunzō ni miru: Bukkyō bijutsu ten* (Nagoya: Chūbu Nihon Shinbunsha, 1963). The storehouse built in 1966 was converted into the reception area, where tickets, amulets, and souvenirs are purchased. Itō, *Senbon*, 169. See Nara Kokuritsu Hakubutsukan, *Kannon Bosatsu* (Nara: Nara Kokuritsu Hakubutsukan, 1977), 98–104. See also fig. 54, pp. 217, 429–430 in the deluxe edition of the catalogue published by Dōhōsha in Kyōto in 1981.

28. For more on *danzō*, see Christian Boehm, *The Concept of Danzō: 'Sandalwood Images' in Japanese Buddhist Sculpture of the 8th to 14th Centuries* (London: Saffron Books, 2012).

29. See Mizuno, *Nihon chōkokushi*, vol. 3, plate vol., 217, figs. 99-1–99-76. A significant article about this image was written not long after the inscription was discovered. See Nishikawa Kyōtarō, "Daihōonji Roku Kannon Juntei Kannon ryūzō," *Kokka* 800 (November 1958): 425–429. I would like to thank Michael Jamentz for pointing out that the "fourth day" in the inscription was written with two characters for the number two in a row. See Inscription 3.1 in the Appendix.

30. About the possible involvement of other sculptors with the set, see Miyama Takaaki, "Higo Jōkei no bosatsu zō ni tsuite," *Bukkyō geijutsu* 187 (November 1989): 108–109; Nakajima Junichi, "Busshi Higo bettō Jōkei kō," *Kanazawashi Monjokan kiyō* 4 (1981): 6–10; Nishikawa, "Daihōonji Roku Kannon," 426.

31. Shiozawa Hiroki, *Kamakura jidai zōzōron: Bakufu to busshi* (Tokyo: Yoshikawa Kōbunkan, 2009), 258.

32. For the images of Yuima (Skt. Vimalakīrti) and Monju made by the other sculptor named Jōkei from Nara, see *Nara rokudaiji taikan,* vol. 8 of *Kōfukuji* (Tokyo: Iwanami Shoten, 1970), 43–46.

33. Mizuno Keisaburō, "Kuramadera Shō Kannon zō ni tsuite," in *Kannon—sonzō to hensō: Kokusai kōryū bijutsushi kenkyūkai dai gokai shinpojiyamu,* ed. Kokusai Kōryū Bijutsushi Kenkyūkai (Osaka: Kokusai Kōryū Bijutsushi Kenkyūkai, 1986), 87–93; Miyama, "Higo Jōkei," 100–119; Mizuno Keisaburō, ed., *Nihon chōkokushi kiso shiryō shūsei: Kamakura jidai: zōzō meiki hen,* vol. 4 (Tokyo: Chūō Kōron Bijutsu Shuppan, 2006), text vol., 8–11; plate vol., 14–17, no. 150. The original location of this image is unknown, but it was transferred to Kuramadera in 1229 (Antei 3). See Mizuno, p. 9.

34. Yamaguchi Ryūsuke, "Jōkeiyō bosatsu zō no saikentō," *Bukkyō geijutsu* 299 (July 2008): 102. Oku Takeo, "Higo Jōkei wa sōfū ka," in *Yōshikiron: Sutairu to mōdo no bunseki,* ed. Hayashi On (Tokyo: Chikurinsha, 2012), 75–99. Oku found many other sources for the style.

35. See Okamoto Satoshi, "Higo Jōkei to Kōun," *Nara Daigakuin kenkyū nenpō* 15 (2010): 189–191, which is a synopsis of his master's thesis on this topic. Previously Mōri Hisashi and others had proposed that Kōun was the Jōkei who worked at Kōfukuji rather than Higo Jōkei. Hisashi Mōri, *Sculpture of the Kamakura Period* (New York: Weatherhill, 1974), 91. See also Miyake Hisao, "Kamakura jidai no chōkoku: Butsu to hito no aida," *Nihon no bijutsu* 459 (August 2004): 71, regarding the reference in *Kōzanji engi.*

36. Yamaguchi, "Jōkeiyō bosatsu zō," 95–96, fig. 5. Yunomae Board of Education now manages the Amida hall and its images, but because they were under the authority of Myōdōji previously they bear this location name in secondary literature.

37. Oku, "Higo Jōkei," 94; Kumamoto Kenritsu Bijutsukan, *Kannon Bosatsu to Jizō Bosatsu,* 10, 114–116. See also Nara Kokuritsu Hakubutsukan, *Kokuhō jūyō bunkazai Bukkyō bijutsu,* vol. 5: *Kyushu II* (Nara: Nara Kokuritsu Hakubutsukan, 1980), 74, 208–209, fig. 22. Along with the date, an inscription on the base of the Myōdōji Kannon image reads: "Nihon koku kōshō sō Jitsumyō" (Jitsumyō, monk and craftsperson of Japan). Jitsumyō is otherwise unknown, and the phrase "Nihon koku" (Japan) is atypical in an inscription. See also Takada Motoji, *Yunomae chōshi* (Yunomae-machi, 1968), 36–39, about the challenges of reading the inscription.

38. Shiozawa, *Kamakura jidai zōzōron,* 270–271. Nakajima Junichi proposed that Jōkei's geographic connection to Higo in Kyushu would have made it easier for him to access information about the Song style because of the region's proximity to China. See Nakajima, "Busshi Higo," 9. Prior to the twentieth century, the Myōdōji Amida hall was part of Jōshinji, which had also been referred to previously as Jōsenji. See Takada, *Yunomae chōshi,* 19 and "Jōshinji ato" in *Nihon rekishi chimei taikei* (accessed April 21, 2016).

39. Nakano Genzō, *Nihon no butsuzō, Kannon* (Kyoto: Tankōsha, 1982), 125. This oldest extant version of the scroll is known as the Jōkyūbon because it was made in the Jōkyū era (1219–1222).

40. Takeuchi, *Tenmangū*, 202. See *Meitokuki* in *Gunsho ruijū*, vol. 20 (Tokyo: Zoku Gunsho Ruijū Kanseikai, 1957), 300. The record was compiled circa 1396 and published in 1632 (Kanei 9).

41. *Tendai nanzan Mudōji konryū oshō den* in *Gunsho ruijū*, 5:551. The text is abbreviated as *Konryū oshō den*. See also M. W. de Visser, *Ancient Buddhism in Japan: Sūtras and Ceremonies in Use in the Seventh and Eighth Centuries A.D. and Their History in Later Times* (Leiden: Brill, 1935), 388.

42. See Mizuno, *Nihon chōkokushi 3*, text vol., 192. This text was written as a postscript to *Nyoirin darani* (full title: *Bussetsu kanjizai Bosatsu nyoishin darani jukyō*), which was found inside the sculpture.

43. See Mizuno, *Nihon chōkokushi*, vol. 3, text vol., 198. See also *Iemitsu kyōki* in *Rekidai zanketsu nikki*, ed. Kurokawa Harumura (Kyoto: Rinsen Shoten, 1969–1971), vol. 8, p. 24, which states that Mochihisa temporarily controlled Higo in 1221.

44. See Kyōtofu, *Kokuhō*, 3–4, 111–112; Mōri Hisashi, in Kikuiri, *Senbon Shakadō*, 2; Nakamura Masaaki, "Daihōonji," *Nihon no bijutsu kōgei* 503 (August 1980): 18. See also Itō, *Senbon*, 186.

45. Royall Tyler, trans., *The Tale of the Heike* (New York: Viking, 2012), 142–143; McCullough, *The Tale of the Heike*, 101–102; and Helen Craig McCullough, trans., *The Taiheiki: A Chronicle of Medieval Japan* (Rutland, Vt.: C. E. Tuttle, 1979), 12–13. See Chapter One of this book.

46. *Asabashō, TZ* 9: 224a.

47. *Asabashō, TZ* 9: 225a–226b.

48. Paintings elsewhere that show a *bonji* depicted on a moon disc sitting on a lotus base can help us imagine the desired contemplation. For an example, see the fourteenth-century example in Kanazawa Bunko, *Kanazawa Bunko no meihō* (Yokohama: Kanagawa Kenritsu Kanazawa Bunko, 1992), fig. 71, p. 86.

49. These are unpublished texts held in the Shōren'in archive. I am grateful to Donohashi Akio for helping me access photographs of these texts. Basic details about the texts are in Kissuizō Shōgyō Chōsadan, *Shōren'in monzeki kissuizō shōgyō mokuroku* (Tokyo: Kyūko Shoin, 1999), 387, 398, 483.

50. "Roku Kannon hōji," in *Keiran shūyōshū, T* 76:583c–587c.

51. *Roku Kannon gōgyōki* from Kyoto University Library, special collections.

52. *Roku Kannon gōgyōki*, in *Monyōki*, vol. 169 (dated Bunmei 6 [1474], ninth month, twenty-first day), *TZ* 12:551–552. Melissa McCormick identified the patrons as Ashikaga Yoshimasa (1435–1490), his wife Hino Tomiko (1440–1496), and son Yoshihisa (1465–1489) (personal communication, April 6, 2007).

53. For a general discussion of deposits placed inside images, see Kurata Bunsaku, "Zōnai nōnyūhin," *Nihon no bijutsu* 86 (July 1973); for the Daihōonji Six Kannon, see 67–70.

54. Note that the texts were taken out of the images and are now kept in a paulownia box in the temple storehouse. See Mizuno, *Nihon chōkokushi*, vol. 3, text vol., 192, n. 2 and 199. See also plate vol., 220, fig. 99–83.

55. See Chapter Four in this book on the Six-Syllable mandala.

56. According to Takeuchi, *Tenmangū*, 204, the old sutra hall was moved to Daihōonji in 1670 and another one was built just west of its old site at Kitano

in the Tenwa era (1681–1683), but it is more likely that parts of the building were reused for the Daihōonji main hall's reconstruction.

57. *Miyako meisho zue*, ed. Akisato Ritō (fl. 1780–1814) (Kyoto: Daihan Shorin, 1804). In an edition owned by the Spencer Museum of Art (1986.97ab), the author uses his alternate name, Akisato Shōseki. For a reproduction of the 1780 original, see Ikeda Yasaburō et al., *Nihon meisho fūzoku zue* (Tokyo: Kadokawa Shoten, 1979), vol. 8, 194. Note also that Daihōonji was also called Ikyōkeiji (or Yuikyōgyōji) during the Edo period. See Kikuiri, *Senbon Shukudō*, 1.

58. Itō, *Senbon*, 138. Itō argues that the two images date from 1438 (Eikyō 10) and were the main images of the sutra hall. If we accept this date, the images post-date the construction of the hall by thirty-seven years.

59. Among Daihōonji's treasures that formerly belonged to Kyōōdō is a wooden plaque, with the word "Kyōōdō" carved into it, which was made to hang on the outside of the hall. See "Daihōonji Hondō," in *Asahi hyakka Nihon no kokuhō*, 24. See also Itō, *Senbon*, 143. Daigoji Abbot Mansai (1378–1435) gives the date that the plaque was carved as 1425 (Ōei 32), tenth month, fifth day, in his diary, *Mansai jugō nikki, ZGR*, supplement 1a: 325.

60. Itō, *Senbon*, 144.

61. Richard Davis, *Lives of Indian Images* (Princeton, N.J.: Princeton University Press, 1997), 263.

62. Katharina Epprecht et al., *Kannon—Divine Compassion: Early Buddhist Art from Japan* (Zürich: Museum Rietberg, 2007), 170–171, cat. no. 28.

63. The characters used for Tōmyōji are "Lantern-Light-Temple" and "Eastern-Light-Temple." The former, which are used today, appear in documents from the eighteenth century. For a survey of the area's Buddhist art, see Kyoto Kokuritsu Hakubutsukan, *Minami Yamashiro no koji junrei* (Kyoto: Kyoto Kokuritsu Hakubutsukan, 2014). Tōmyōji works are not included, but p. 64 has a short outline of its history.

64. This section contains revised, updated, and abbreviated information from two previously published articles: Sherry Fowler, "Locating Tōmyōji and Its 'Six' Kannon in Japan," in *A Companion to Asian Art and Architecture*, eds. Rebecca Brown and Deborah Hutton (Malden, Mass.: Wiley-Blackwell, 2015), 580–603, and Sherry Fowler, "Locating Tōmyōji and Its 'Six' Kannon Sculptures" (Tōmyōji "Roku" Kannon zō o tadoru), in *Capturing the "Original": Archives for Cultural Properties* (Tokyo: National Research Institute for Cultural Properties, 2010), English: 56–74; Japanese: 157–181.

65. Tanaka Junichirō, "Kamo-chō kyū Tōmyōji zō den Nyoirin Kannon nōnyū monjo ni tsuite," *Yamashiro Kyōdo Shiryōkan hō* 4 (1986): 67–74. I did not have access to this article when I published on this topic in 2010–2011, and have updated this chapter accordingly. Kyoto Furitsu Yamashiro Kyōdo Shiryōkan, *Tōmyōji no bunkazai* (Yamashiro-chō: Kyoto Furitsu Yamashiro Kyōdo Shiryōkan, 1986), 9. Yamashiro Kyōdo Shiryōkan changed its name to Furusato Myūjiamu Yamashiro.

66. According to Nedachi Kensuke, the construction and rough finish of the sculpture are standard for the time period (personal communication, June 15, 2009). See also Kyoto Furitsu, *Tōmyōji no bunkazai,* 8.

67. Suzuki Yoshihiro, "Shukuin busshi," *Nihon no bijutsu* 487 (December 2006): dedicated issue; and Nara Kokuritsu Hakubutsukan, *Shukuin busshi: Sengoku jidai no Nara busshi* (Nara: Nara Kokuritsu Hakubutsukan, 2005).

68. See Kyōdoshi Kenkyū Kurabu, *Sōrakugun no jiin* (Kyoto: Kyoto Furitsu Kizu Kōtōgakkō, 1982), 42.

69. Tanaka, "Kamo-chō kyū Tōmyōji zō," 71–73. The year was omitted in one of the dated inscriptions.

70. Oku Takeo, "Ichinichi zōritsu butsu no saikentō," in *Ronshū tōyō nihon bijutsushi to genba: Mitsumeru, mamoru, tsutaeru,* ed. Tōyō Nihon Bijutsushi to Genba Henshū Iinkai (Tokyo: Chikurinsha, 2012), 243, 248.

71. Oku, "Ichinichi zōritsu," 246–247. *Asabashō, TZ* 9: 577b.

72. Oku, "Ichinichi zōritsu," 243–253, and Oku Takeo, "Seikōji Jūichimen Kannon zō to zōnai nōnyūhin," *Bukkyō geijutsu* 292 (May 2007): 20–22.

73. There are earlier, but more abbreviated sources for temple history. See Bunkazai Hozon Gijutsu Kyōkai, *Jūyō bunkazai Tōmyōji hondō shūri koji hōkokusho* (Tokyo: Sankeien Hoshōkai, 1987), 4–8.

74. See Kamo Chōshi Hensan to Iinkai, *Kamo chōshi* (Kamo-chō: Kamo Chōshi Hensan to Iinkai, 1988), vol. 4, 168–169, for *Tōmyōji engi.* Kasuga refers to sculptors who worked in the area of Nara. *Sanshū meisekishi* from 1711 (Shōtoku 1), *SKS* 15:34, states that the Seven Kannon from Shichi Kannon'in were also made by the Kasuga sculptors. See Chapter Five of the present book for discussion.

75. There are established groups of images of six and seven Kannon that do not look alike that are associated with pilgrimage routes in the Edo period (1615–1868). For an example of six, see Kyushu Rekishi Shiryōkan, *Tsushima Katsune Hōseiji Kannondō Fukuoka-ken* (Dazaifu-shi: Kyushu Rekishi Shiryōkan, 1992), 2, and for seven see Ōya Kuninori, *Tōno Shichi Kannon* (Tōno: Tōno Shiritsu Hakubutsukan, 1988), 14. And see discussion on Shichi Kannon'in in Chapter Five of the present book.

76. Kyoto Furitsu, *Tōmyōji no bunkazai,* 7.

77. Tanaka, "Kamo-chō kyū Tōmyōji zō," 70, 73.

78. In the case of the Daihōonji Six Kannon, there are two dedicatory inscriptions for the entire group. See Mizuno, *Nihon chōkokushi,* vol. 3, text vol., 191–192.

79. Kyoto Furitsu, *Tōmyōji no bunkazai,* 23.

80. See Kyoto Furitsu, *Tōmyōji no bunkazai,* 21.

81. See Kyoto Furitsu, *Tōmyōji no bunkazai,* 23, and Kamo Chōshi, vol. 2, 351. In regard to the possible arrangement of the Tōmyōji images in the past, Sogō Tairyū, "Tōmyōji no honzon," *Kamo bunka* 2 (April 1971): 3, claimed that he saw an "old record," presumably from the Edo period, which belonged to the Umoto family in nearby Funaya, that had a diagram with the images arranged in a square in the following way: Thousand-Armed Kannon in the center and clockwise from top right, Eleven-Headed (NE), Horse-Headed (SE), Shō (SW),

and Nyoirin (NW). If this is accurate, it shows that in this square configuration, the two larger Kannon would have been in the back and the two smaller images were in front. The Umoto family loaned several documents to the exhibition at Kyoto Furitsu Yamashiro Kyōdo Shiryōkan in 1986, but it is not clear from the catalogue if this document was included.

82. In 1996 Kyoto Furitsu Yamashiro Kyōdo Shiryōkan held an exhibition, "Minamiyamashiro sanjūsansho junrei" (Minamiyamashiro Thirty-Three Kannon Pilgrimage Route), that featured the history of the pilgrimage and material culture from temples along the route. See Kyoto Furitsu Yamashiro Kyōdo Shiryōkan, *Minamiyamashiro sanjūsansho junrei* (Yamashiro-chō: Kyoto Furitsu Yamashiro Kyōdo Shiryōkan, 1996).

83. About Jōkei at Kaijūsenji, see James L. Ford, *Jōkei and Buddhist Devotion in Early Medieval Japan* (New York: Oxford University Press, 2006), 25–27, 152–153.

84. The record was rewritten in 1756 in *Kaifuihen,* which is within a larger miscellany of Kaijūsenji records called *Kaijūsenji zakkiroku.* Kyoto Furitsu, *Minamiyamashiro,* 5, and Kamo Chōshi, vol. 2, 354. The actual measurement is of this image is 172 cm, but Johan may have mentally taken the base into account to arrive at six *shaku,* which totals 182 cm.

85. Kyoto Furitsu, *Minamiyamashiro,* 4, 15. Nine of the original wooden plaques still exist. Tōmyōji's plaque measures 44 × 56 cm. Yamashiro-chō Komonjo Saakuru Kisaragikai, *Edo jidai no Minamiyamashiro sanjūsansho o tazunete* (Yamashiro-chō: Yamashiro-chō Komonjo Saakuru Kisaragikai, 1996), 14.

86. Eight *chō* is approximately 872 meters. Jōnenji still exists as a neighboring temple that belongs to the Tendai Shinzei School.

87. The verse is written in the Japanese *kana* syllabary, so the name of the temple Tōmyōji "Eastern-Light-Temple" also means "shining in the east." I would like to thank John Carpenter for his help in translating this poem. He posits that *kusaba no tsuyu* (dew on the leaves of grasses) is a common metaphor for the evanescence of life and *wakeshi tama* means both "scattered jewels" and "departed souls" and thus imbues a poetic image with religious sentiment.

88. Kamo Chōshi, vol. 1, 52–53.

89. Bunkazai Hozon Gijutsu Kyōkai, *Jūyō bunkazai Tōmyōji,* 4.

90. For *Tōmyōji kakochō* see http://kawaizaidan.or.jp/bunakzai.html#04 (accessed April 21, 2016). See also Kyoto Furitsu, *Tōmyōji no bunkazai,* 20, and Bunkazai Hozon Gijutsu Kyōkai, *Jūyō bunkazai Tōmyōji,* 4. The text was added to in 1841 (Tenpō 12), but much of the historical information is repeated in other sources. The photographs of this text are blurry and I have not found the entire text reproduced.

91. A copy of *Daihannyagyō* (Skt. *Mahaprajna-paramita-sūtra*) donated by Genchō of Tōmyōji and copied by Shōen in 1225 is the earliest source for the name Tōmyōji. Kyoto Furitsu, *Tōmyōji no bunkazai,* 6. This sutra has been studied specifically as a precious example of early *kunten,* the marks for rendering Chinese into Japanese. See Utsunomiya Keigo, "Tōmyōji zō *Daihannya*

haramittakyō no kunten in tsuite," in *Kokugo mojishi no kenkyū,* vol. 7, ed. Maeda Tomiyoshi (Osaka: Izumi Shoin, 2003), 99–123.

92. Kyoto Furitsu, *Tōmyōji no bunkazai,* 11. An eighteenth-century copy of the lantern stands in front of the Tōmyōji storehouse today, while the original is now in the garden (south side of the guest hall) at Shinnyodō in Kyoto. See photograph of the copy at http://kawaizaidan.or.jp/bunakzai.html#03 (accessed June 1, 2015). For a detailed discussion of the movement and adaptation of the lantern see, Fowler, "Locating Tōmyōji and Its 'Six' Kannon in Japan," in *A Companion to Asian Art and Architecture*, 580–603.

93. *Kōfukuji kanmuchōso, DNBZ* 119:118, records that Shingyō founded Tōmyōji, which had five halls at the time.

94. There is a theory that the temple was reestablished in 1403 (Ōei 10) after it had fallen into ruin in the late fourteenth century. Bunkazai Hozon Gijutsu Kyōkai, *Jūyō bunkazai Tōmyōji,* 4, 134–135. *Tōmyōji engi* reports an imperial decree (*inzen*) in the same year. Another source for Tōmyōji history is an inscription found on the back of a Parinirvana painting that was offered to Kōhōin, a subtemple of Tōmyōji in 1463 (Kanshō 3); its inscription states that when Yamana Ujikiyo, Lord (*shugo*) of Yamashiro, was fighting in 1385 (Shitoku 2), Kōhōin fell into ruin, indicating that Tōmyōji may also have had problems. Kōhōin later merged with Jōnenji, which was founded in the Entoku era (1489–1492), which neighbors Tōmyōji. See Kyoto Furitsu, *Tōmyōji no bunkazai,* 15, and Kamo Chōshi, vol. 1, 289. For the Parinirvana painting, see Kyoto Kokuritsu Hakubutsukan, *Minami Yamashiro no koji junrei,* 60–61, 199, cat. no. 48.

95. Tōmyōji, the subject here, should not be confused with a temple of the same name located in the Satake-chō area of Kamigyōku, Kyoto. This Tōmyōji was a Nichiren School temple founded by Nichizō. See *Yōshūfushi* from 1684, *SKS* 22:298.

96. Higashi Shinji, "Tōdō Takatora kō no ohaka ga aru," *Kamo bunka* 13 (February 1985): 3–4. The Daimyo Tōdō Takatora (1556–1630) had five other memorial markers besides this one. Supposedly he stayed at neighboring temple Jōnenji in 1621 (Genna 7).

97. For photographs of the bell (137.5 cm), see Kyoto Furitsu, *Tōmyōji no bunkazai,* 22, and Bunkazai Hozon Gijutsu Kyōkai, *Jūyō bunkazai Tōmyōji,* 7, fig. 11. See also http://kawaizaidan.or.jp/bunakzai.html#02 (accessed May 30, 2015).

98. For a complete lineage chart, see Kyoto Furitsu, *Tōmyōji no bunkazai,* 17. The lineage was not continuous after 1889 as there were intermittent heads of the temple.

99. See Kyōdoshi, *Sōrakugun,* 42, and Kyoto Furitsu, *Tōmyōji no bunkazai,* 21. Both Tōmyōji and Saimyōji have legends that Gyōki founded their temples in the eighth century, and both were subtemples of Jōruriji in 1632 (Kan'ei 9). See Kamo Chōshi, vol. 1, 216–217 and vol. 2, 372.

100. Kyoto Furitsu, *Tōmyōji no bunkazai,* 17, and Kamo Chōshi, vol. 2, 377. The foundation's website says the date was recorded on a *munafuda* in the building.

101. *Shūi miyako meisho zue,* ed. Akisato Ritō (Kyoto: Yoshinoya Tamehachi, 1787). For reprint see Ikeda, *Nihon meisho fūzoku zue,* vol. 8, 382. See also http://www .nichibun.ac.jp/meisyozue/kyotosyui/jpg/5/km_02_05_071g.jpg (accessed January 28, 2014). A 1904 map shows about the same layout of buildings, but the main building is called a main hall (*hondō*). Kyoto Furitsu, *Tōmyōji no bunkazai,* 23. See also http://www.d1.dion.ne.jp/~s_minaga/n_16_Tōmyōji.htm (accessed June 2, 2015). Early twentieth-century photos of the pagoda and main hall have been published in Bunkazai Hozon Gijutsu Kyōkai, *Jūyō bunkazai Tōmyōji.* A nineteenth-century map titled *Honkōzan Tōmyōji keidaizu* (40.5 × 53.3 cm) calls the building a Kannondō, and the 1904 map titled *Tōmyōji keidaizu* (37.5 × 51.4 cm) calls it a Hondō. Photographs of the maps are also on the foundation website. See http://kawaizaidan.or.jp/bunakzai.html (accessed May 31, 2015).

102. Bunkazai Hozon Gijutsu Kyōkai, *Jūyō bunkazai Tōmyōji,* 8, n. 7. A very rough estimate of the value today can be calculated as ¥24,300,000 from the Bank of Japan website, http://www.boj.or.jp/oshiete/history/11100021.htm (accessed April 12, 2009). In my previous publications from 2010 and 2011, I gave different dates for Kawai's birth and death based on the information available at the time. The website appears to be carefully researched and trustworthy.

103. At this time Tōmyōji was also known as "Nichirenshū Nichiensan Tōmyōji" (Nichiren School, Mount Nichien, Tōmyōji). Note that Sengō and Kawai use the same characters with a different pronunciation and that the characters for the temple name were selected with that in mind.

104. See Bunkazai Hozon Gijutsu Kyōkai, *Jūyō bunkazai Tōmyōji,* 8. The organization was previously referred to as Nichirenshū Shōhō Goji Zaidan. Some details about Kawai's life can be found on a memorial stone located at Sengōji. I am grateful to Kawai Ryōichi for supplying information about his great-grandfather.

105. For a post-typhoon photograph see Bunkazai Hozon Gijutsu Kyōkai, *Jūyō bunkazai Tōmyōji,* pl. 36. See also p. 8 for text. And see Fowler, "Locating Tōmyōji."

106. Bunkazai Hozon Gijutsu Kyōkai, *Jūyō bunkazai Tōmyōji,* 5, and http:// kawaizaidan.or.jp/work_02.html (accessed January 28, 2014).

107. Bunkazai Hozon Gijutsu Kyōkai, *Jūyō bunkazai Tōmyōji,* 8.

108. The foundation became a general nonprofit in 2013 with the new name Ippan Zaidanhōjin Kawai Kyōto Bukkyō Bijutsu Zaidan (General foundation of Kawai Kyoto Buddhist art foundation). See http://kawaizaidan.or.jp/about.html (accessed May 31, 2015).

109. Christine Guth, "A Tale of Two Collectors: Hara Tomitarō and Charles Lang Freer," *Asian Art* (Fall 1991): 29–49. See also http://www.sankeien.or.jp/history /index.html (accessed April 20, 2016).

110. For photographs see Inoue Yasushi, *Nihon no teienbi Sankeien,* vol. 7 (Tokyo: Shūeisha, 1989). See also Sankeien Hoshōkai, *Sankeien hyakushūnen Hara Sankei no egaita fūkei* (Yokohama: Kanagawa Shinbunsha, 2006), 34, 83, 177.

111. Kyoto Kagaku in Fushimi ku, Kyoto (http://www.kyotokagaku.com/jp/), made the replica. The Art and Crafts department uses epoxy-acrylic resin to make medical simulators and replicas for museums. I would like to thank Mai Sarai for this information. According to Sankeien Hoshōkai, *Sankeien*, 83, the replica was installed in the *zushi* in July 1988, a year after the restoration of the main hall was completed.

112. Bunkazai Hozon Gijutsu Kyōkai, *Jūyō bunkazai Tōmyōji*, 68, 97–108, and plates 3, 18, 22, 23, 28, 68, 69, 132, 133. A prerestoration photograph in fig. 28 shows that the *zushi* previously housed the Thousand-Armed Kannon along with some smaller sculptures.

113. Bunkazai Hozon Gijutsu Kyōkai, *Jūyō bunkazai Tōmyōji*, 5–6. Figure 5 on p. 6 shows a photograph of the stone marker dated to 1751 (Kan'en 4) with an inscription that commemorates the repairs to the main hall as well as the *zushi*. There is a long description and discussion of the *zushi* and its modifications (97–108), in which the author compares it to other Kasuga-style *zushi* from the fourteenth and fifteenth centuries but never proposes a date.

114. "Tōmyōji" in Kyoto, Sōrakugun section of *Jiin jūki meisai chō*. Handwritten records of temple property compiled by the government and kept in special collections at Kyoto Furitsu Sōgō Shiryōkan (Kyoto Prefectural Library and Archives). This volume was compiled in 1888 (Meiji 21), but the entry was written in 1883 (Meiji 16). The three larger images actually measure closer to six *shaku* (181.8 cm). The Thousand-Armed Kannon is the shortest of the three at 172 cm. The two shorter images among the five measure about 110 cm, so they are between three and four *shaku*.

115. Inoue Kazutoshi, "Nyoirin Kannon zō, Batō Kannon zō," *Nihon no bijutsu* 312 (May 1992): 21–22. The eight-armed type appears in the twelfth- and thirteenth-century iconographic manuals. See *Zuzōsho, TZ* 3: fig. 62; *Asabashō, TZ* 9: fig. 31; and *Sho Kannon zuzō, TZ* 12. See twelfth-century copy in Nara Kokuritsu Hakubutsukan, *Nara Kokuritsu Hakubutsukan zōhin zuhan mokuroku, Bukkyō kaigahen* (Nara: Nara Kokuritsu Hakubutsukan, 2002), 90. According to Inoue, other than iconographic drawings there are no actual images. For the twelfth-century standing six-armed Nyoirin image from Nyoirinji see Inoue, "Nyoirin Kannon zō, Batō Kannon zō," fig. 53, p. 40.

116. Oku, "Ichinichi zōritsu," 246, and Tanaka, "Kamo-chō kyū Tōmyōji zō," 71.

117. See Hayami Takusu, *Kannon shinkō jiten* (Tokyo: Ebisu Kōshō Shuppan, 2000), 281–312. As an example, the fourteenth-century Tendai text *Keiran shūyōshū, T* 76:584c, notes that Tendai does not include Juntei in the group of Six Kannon because there is no Buddha in Juntei's crown and therefore Fukūkenjaku, who has a Buddha in the crown, should be included.

118. Asai Kazuharu, "Fukūkenjaku, Juntei Kannon zō," *Nihon no bijutsu* 382 (March 1998): 61–62. See Itō Shirō, "Fukūkenjaku Kannon zō no rokuhie," *Bigaku bijutsushi kenkyū ronshū* 1 (December 1996): 25–37.

119. See *T* 20:402a. The earlier text from which this was translated does not survive.

120. *T* 20:685a. See Asai Kazuharu, "Okayama Ōtsūji no Fukūkenjaku Bosatsu zazō," *Bukkyō geijutsu* 246 (1999): 80–81. Also Wong, "The Case of Amoghapāśa," 152, mentions a seventh-century Chinese description of the deity with a deerskin. See *Zan Guanshiyin pusa song* (J. *San Kanzeon Bosatsu ju*), *T* 20:67b. Itō, "Fukūkenjaku," 25, also lists other texts that refer to the deerskin.

121. The kami named Takemikazuchi, resident of the first shrine at Kasuga in Nara, is said to have traveled there on a deer. Kasuga and Kōfukuji are part of the same religious complex. See Richard Bowring, *The Religious Traditions of Japan, 500–1600* (Cambridge: Cambridge University Press, 2005), 180–182, 275.

122. See Kyoto Furitsu, *Tōmyōji no bunkazai*, 21.

123. Fowler, "Locating Tōmyōji;" Oku, "Ichinichi zōritsu," 246.

124. The sculpture by Kōkei replaced an earlier one, which was destroyed in a fire in 1180. See Susan Tyler, *The Cult of Kasuga Seen through Its Art* (Ann Arbor: Center for Japanese Studies, University of Michigan, 1992), 138. About the deerskin, see p. 91. According to temple records the main image of Fukūkenjaku was made in 746 (Tenpyō 8) and moved from the Kōdō at Kōfukuji to the earlier Nan'endō that was constructed in 813 (Kō'nin 4). See *Nara rokudaiji taikan*, vol. 8, *Kōfukuji*, 30–33.

125. For Bechie goshi and the On Matsuri see Allan Grapard, *The Protocol of the Gods* (Berkeley: University of California Press, 1992), 109, 143, 157. This festival is still held annually from December 15 through 18.

126. Oku, "Ichinichi zōritsu," 246.

127. See Tyler, *The Cult of Kasuga*, 177; Sherry Fowler, *Murōji: Rearranging Art and History at a Japanese Buddhist Temple* (Honolulu: University of Hawai'i Press, 2005), 194; and "Shion'in ato" in *Nihon rekishi chimei taikei* (accessed February 1, 2014).

128. *Kōfukuji kanmuchōso*, 118. Kōfukuji was a center for Hossō School teachings, but it had broad sectarian affiliations. As a later connection, a stone lantern from neighboring Goryō Jinja provides an inscription by Kōfukuji dated to 1806 (Bunka 3). See Bunkazai Hozon Gijutsu Kyōkai, *Jūyō bunkazai Tōmyōji*, 7, fig. 10.

129. *Kōfukuji ryaku nendaiki*, in *ZGR* 29, pt. 2:175. See Tanaka, "Kamo-chō kyū Tōmyōji zō," 71, and Oku, "Ichinichi zōritsu," 250. Oku discusses other examples of "One-Day Buddhas" mentioned at Kōfukuji.

Chapter Four: The Six-Syllable Sutra Ritual Mandala and the Six Kannon

1. *Kakuzenshō, TZ* 4:352a, 353.

2. Elizabeth ten Grotenhuis, *Japanese Mandalas: Representations of Sacred Geography* (Honolulu: University of Hawai'i Press, 1999), 96–100. See also pp. 2–3 for general comments on Japanese mandalas.

3. The examples are in the following texts: *Besson zakki* (4), *Kakuzenshō* (5), *Zuzōshō* (a.k.a. *Jikkanshō*) (1), *Atsuzōshi* (1), *Hizōkonpōshō*, (3), *Genpishō* (2), *Hishō mondō* (1), *Hishō* (2), *Denjushū* (1), *Shoson yōshō* (2), *Usuzōshi* (2), *Byakuhōkushō* (1), *Yonkashō*

zuzō (5), and *Besson yōki* (1). All of these texts, except for the last one, are in the Taishō canon. *Yonkashō zuzō* is in *TZ* 3:29–31 (nos. 37–41). See Nara Kokuritsu Hakubutsukan, *Saigoku sanjūsansho: Kannon reijō no inori to bi* (Nara: Nara Kokuritsu Hakubutsukan, 2008), fig. 21, pp. 39, 245, for a thirteenth- to fourteenth-century copy from Daigoji. I appreciate Michael Jamentz for showing me a photocopy of *Besson yōki,* which is kept at Kanazawa Bunko Library in Yokohama.

4. For excellent photographs see Shinbo Tōru, ed., *Besson mandara* (Tokyo: Mainichi Shinbunsha, 1985), 64–67. See also Sawa Ryūken, ed., *Daigoji,* vol. 8 of *Hihō* (Tokyo: Kōdansha, 1976), fig. 110, pp. 108, 334. This painting, along with the blue one from Hōonin, was exhibited in Germany in 2008. See Tomoe Steineck, ed., *Tempelschätze des heiligen Berges: Daigo-ji—der geheime Buddhismus in Japan* (München: Prestel, 2008), fig. 26, pp. 142–143.

5. Ishida Hisatoyo, *Japanese Esoteric Painting* (Tokyo: Kodansha International, 1987), 54. This deity is also known as Ichiji Kinrin (One-Syllable Golden Wheel). See Mimi Yiengpruksawan, "In My Image: The Ichiji Kinrin Statue at Chūsonji," *Monumenta Nipponica* 46, no. 3 (Autumn 1991): 333.

6. ten Grotenhuis, *Japanese Mandalas,* 100.

7. *Zuzōshō, TZ* 3:12, fig. 21, and *Besson zakki, TZ* 3:90.

8. *Sanmairyū kudenshū, T* 77:28ab.

9. *Byakuhōshō, TZ* 10:755b. *Byakuhōshō* (Pure treasures record) was compiled by Chōen (1218–1284?).

10. See *Hizōkonpōshō,* mid-twelfth century, *T* 78:339b; *Besson zakki, TZ* 3:90. *Atsuzōshi, T* 78:264b, says the name Jusojin came from an oral tradition.

11. See Hayashi On, "Chōjuji zō Shō Kannon mandara kō," *Bukkyō geijutsu* 197 (July 1991): 24, 27, n. 60. Hayashi found that *Byakuhōkushō TZ* 6:261b explains how the two Myōō were used together. Daiitoku wards off enemies and Fudō combats the four kinds of māra (demons). Daiitoku on his water buffalo might also have been a good choice to include because of the mandala's relationship to water.

12. About the relationship to six, see Daihōrinkaku Henshūbu, *Zukai butsuzō no miwakekata* (Tokyo: Daihōrinkaku, 2002), 74.

13. Two paintings with standing water buffalo are in the Museum of Fine Arts, Boston. One is the thirteenth-century painting of Daiitoku Myōō in the Fenollosa-Weld Collection (11.4037). See Julia Meech, "A Painting of Daiitoku from the Bigelow Collection," *Boston Museum Bulletin* 67, no. 347 (1969): 34, fig. 12; see also note 33 and Anne Nishimura Morse and Nobuo Tsuji, eds, *Japanese Art in the Museum of Fine Arts, Boston* (Boston: Museum of Fine Arts, 1998), vol. 1, p. 9, no. 37, and http://www.mfa.org/collections/object/daiitoku-my -the-wisdom-king-of-great-awe-inspiring-power-24539 (accessed June 26, 2015). The other is the museum's fourteenth-century painting of Daiitoku Myōō (08.82). See Morse, *Japanese Art in the Museum of Fine Arts, Boston,* vol. 1, p. 9, no. 38, and http://www.mfa.org/collections/object/daiitoku-myoo-the-wisdom -king-of-great-awe-inspiring-power-24373 (accessed June 26, 2015).

14. For the standing water buffalo, which might be a later replacement, see To-
kyo Kokuritsu Hakubutsukan, *Kokuhō Daigoji ten,* fig. 93, pp. 174–175. Daigoji
has other examples of Daiitoku upon seated water buffalo mounts, which is
the dominant form of the image. For paintings with seated water buffalo, see
figs. 4–5, pp. 39, 45.

15. Nishikawa Shinji et al., *Daigoji taikan,* vol. 2 (Tokyo: Iwanami Shoten: 2002), 25.

16. For high-resolution photographs, see http://www.kyohaku.go.jp/jp/syuzou
/index.html (accessed June 29, 2015). Use title in Japanese.

17. See also Nara Kokuritsu Hakubutsukan, *Nara Kokuritsu Hakubutsukan zōhin
zuhan mokuroku; Bukkyō kaigahen,* fig. 8, p. 17. See Nara National Museum data-
base, http://www.narahaku.go.jp/collection/1199–0.html (accessed June 10,
2015) for color photograph. According to Curator Kitazawa Natsuki, the mu-
seum acquired the painting in 1996 from a private collector, and its previous
provenance is unknown. I was able to view the painting on July 25, 2011.

18. Sawa, *Daigoji,* fig. 111, pp. 109, 334. Steineck, *Tempelschätze,* fig. 25, p. 142. Ni-
shikawa, *Daigoji taikan,* vol. 2, p. 25, mentions how the form of the water buf-
falo in these two paintings differs from most paintings of the Six-Syllable
mandala. See also See Sawa Ryūken, "Gohachi daiki," *Daigoji Bunkazai Kenkyūjo
kenkyū kiyō* 4 (March 1982): 21–23.

19. Nishikawa, *Daigoji taikan,* vol. 2, p. 25. See Sawa, "*Gohachi daiki,*" 47–48.

20. For information on Hōzōbō Kōyū, see http://shoukado-shojo.net/works/detail
/58 (accessed January 6, 2014).

21. Shiga Kenritsu Biwako Bunkakan, *Shinpi no moji: Bukkyō bijutsu ni awareta bonji*
(Ōtsu: Shiga Kenritsu Biwako Bunkakan, 2000), 79. This entry states that Kan-
zei consecrated the painting posthumously in 1660 (Manji 3), but since most
other sources indicate that Kanzei died in 1663 (Kanbun 3) he was likely alive
when this was consecrated and therefore this comment is a mistake. Gangōji
Bunkazai Kenkyūjo, *Buzan Hasedera shūi* (Sakurai: Sōhonzan Hasedera Bunka-
zai Tō Hozon Chōsa Iinkai, 1994), vol. 1, fig. 34, pp. 34, 256. The latter source
has more detailed information than the former.

22. Sawa Ryūken, ed., *Mikkyō jiten: Zen,* and *Mikkyō daijiten,* s.v. "Kanzei."

23. In 1658 (Manji 1) Tosa Hironobu executed the beautiful color painting *Shōten
himitsu mandara* (Secret mandala of Shōten), which features an elephant-
headed deity also known as Kangiten, in the collection of Kongōbuji on
Mount Kōya. See Osaka Shiritsu Bijutsukan, *Inori no michi: Yoshino, Kumano, Kōya
no meihō* (Tokyo: Mainichi Shinbunsha: Nihon Hōsō Kyōkai, 2004), 14, 114,
fig. 147. Although the artist is not given, the painting was also published in
Honolulu Academy of Arts, *Sacred Treasures of Mount Kōya: The Art of Japanese
Shingon Buddhism* (Honolulu: Koyasan Reihokan Museum, 2002), 68, 160, fig. 26.

24. Gangōji Bunkazai Kenkyūjo, *Buzan Hasedera shūi,* vol. 1, 256.

25. Kamakura Kokuhōkan, *Kamakura × mikkyō* (Kamakura: Kamakura Kokuhōkan,
2011), fig. 41, pp. 77, 117. See also Kamakura-shi Kyōiku Iinkai, ed., *Kamakura-
shi bunkazai sōgō mokuroku: Shoseki kaiga chōkoku kōgei hen* (Kyoto: Dōhōsha,

1986), 19. Hōkokuji stores most of its art works at the Kamakura Kokuhōkan (Kamakura treasure house).

26. See Furukawa Shōichi, "Rokuji mandara no seiritsu ni tsuite," *Yamato Bunka-kan bi no tayori* 160 (Fall 2007): n.p. Yamato Bunkakan curator Furukawa Shōichi kindly showed me the painting on July 31, 2008.

27. *Zuzōshō, TZ* 3: fig. 21, next to p. 12.

28. See Chibashi Fōramu Jikkō Iinkai, *Chibashi to sono jidai "zuroku"* (Chiba: Chibashi Fōramu Jikkō Iinkai, 2001), fig. 9, p. 16. See also pp. 6, 8.

29. https://www.facebook.com/media/set/?set=a.501490759910316.1073741826 .448673498525376&type=1 (accessed April 24, 2016). The photographs of the temple on the site were taken on April, 14, 2013. I am grateful to Maki Kaneko for calling the temple and asking about the painting on July 1, 2014. At the time, the head of the temple thought that the painting had been trans-ferred to the Fukushima Museum (Fukushima Kenritsu Hakubutsukan). On the returned image permission form, temple representative Ujiie Kōyo re-quested this publication to note that the painting is not publicly displayed (July 31, 2015).

30. Hayashi On, "Myōken Bosatsu to hoshi mandara," *Nihon no bijutsu* 377 (October 1997): 47. On the conflation of the two deities see Henrik Sørensen, "Concern-ing the Role and Iconography of the Astral Deity Sudṛṣṭi (Miaojian) in Esoteric Buddhism," in *China and Beyond in the Medieval Period: Cultural Crossings and Inter-Regional Connections,* eds. Dorothy Wong and Gustav Heldt (Amherst, N.Y.: Cambria Press, 2014), 412–414.

31. Chibashi Fōramu Jikkō Iinkai, *Chibashi to sono jidai,* 6, 8.

32. For the Six-Syllable mandala from Rokujizōji see http://www.city.mito.lg.jp /001373/001374/0/shiteibunkazai/siteibunkazai/rokujikyoumandara.html (accessed June 27, 2015). Tobita Hideyo, *Rokujizōji no rekishi to jihō* (Mito, Ibaraki: Rokujizōji, n.d.), 13.

33. ten Grotenhuis, *Japanese Mandalas,* 103–106.

34. Uchida Keiichi, "Kamata yonchōme no Kisshōin, Rokujikyō mandara to Kōbō Daishi zō no chōsa hōkoku," *Setagayaku bunkazai chōsa hōkokushū* 18 (2009): 1–12.

35. Tokyo Setagayaku Kyōiku Iinkai, *Setagayaku shaji shiryō,* vol. 3 (Tokyo Setagaya-ku Kyōiku Iinkai, 1984), 67–69, figs. 137–138. Uchida, "Kamata yonchōme," 4, dated the Kūkai painting to the early fifteenth century.

36. *Edo meisho zue,* ed. Saitō Chōshu (1737–1799) (Edo: Suharaya Mohē, 1836), vol. 3, p. 55, in Waseda Library database, http://archive.wul.waseda.ac.jp/kosho /ru04/ru04_05105/ru04_05105_0008/ru04_05105_0008_p0055.jpg (accessed January 3, 2014).

37. *Shinpen Musashi fudoki kō,* ed. Hayashi Jussai (1768–1841) (Tokyo: Rekishi To-shosha, 1969), vol. 5, p. 120. This substantial text was written 1830–1842 but first published in 1884.

38. Oyamada Tomokiyo (1783–1847), *Setagaya kikō* (Tokyo: Waseda Daigaku Shup-panbu, 1904), 12–13.

39. Uchida, "Kamata yonchōme no Kisshōin," 3–6. Uchida, p. 4, dates the Kūkai painting to the early fifteenth century based on the silk, so these paintings were not always together.

40. See http://www.denkoku-no-mori.yonezawa.yamagata.jp/040yukarino_bijutsu kogehin.htm (accessed June 28, 2015). In 2007 the painting was displayed in an exhibition on site titled "Yonezawa han yukari no bijutsu kōgeihin." Curator Sumiya Yumiko graciously sent me a small copy of the only photograph that the Museum has of the painting.

41. Kyoto Shiritsu Geijutsu Daigaku, *Bukkyo zuzō shūsei: Rokkakudō Nōmanin butsuga funpon* (Kyoto: Hōzōkan, 2004), vol. 1, pp. 76, 79, 309, nos. 1050, 1051.

42. Ibid., vol. 2, pp. 4–5.

43. *Genpishō,* compiled in the Hōgen era (1156–1159) by Jichiun (1105–1160), *T* 78:407a, gives a different reading. The other drawing (No. 1151) does not cite *Genpishō* and only gives the name Kibune for the Jusojin. According to *Byakuhōshō, TZ* 10:755b, Shifusen is one of the seven tall mountains in Nara. Shifusen might be an alternate reading for Mount Kinpu.

44. *Shoson yōshō, T* 78:307a. The text in the main section of the *Taishō* canon leaves this out. See footnote 2 in line 3 about the alternate reading in a variant text that refers to the use of red color for Horse-Headed Kannon.

45. I was able to view the painting on May 20, 2011. See Morse, *Japanese Art in the Museum of Fine Arts, Boston,* vol. 1, p. 38, no. 255, and http://www.mfa.org /collections/object/mandala-of-the-six-character-sutra-23465 (accessed January 1, 2015).

46. *Kakuzenshō, TZ* 4:360, fig. 113.

47. For an overview of the history of the department, see Hong-Eun Lee, "The History of Asiatic Department, Boston Museum of Fine Arts—Focused on the Far Eastern Arts," (MA thesis, Seton Hall University, 2000).

48. "Acquisitions July 17 to September 18, 1919," *Museum of Fine Arts Bulletin* 17, no. 103 (October 1919): 56.

49. Edward W. Forbes, "Report of the Fogg Art Museum, 1918–19," *Annual Report* (Fogg Art Museum), no. 1918/1919 (1918–1919): 1.

50. Fogg Art Museum, *Exhibition of Chinese, Japanese, and Korean Art: Bronze, Jade, Pottery, Sculpture, Together with Some Examples of Arabic Calligraphy and Persian Miniatures* (Cambridge, Mass.: Fogg Art Museum): n.d.

51. Patricia Graham, *Faith and Power in Japanese Buddhist Art 1600–2005* (Honolulu: University of Hawai'i Press, 2007), 208.

52. Victoria Weston, "Institutionalizing Talent and the Kano Legacy at the Tokyo School of Fine Arts, 1889–1893," in *Copying the Master and Stealing his Secrets,* eds. Brenda Jordan and Victoria Weston (Honolulu: University of Hawai'i Press, 2003), 163, 168.

53. *Sanmairyū kudenshū, T* 77:28ab.

54. See *Zuzōshō* (a.k.a. *Jikkanshō*), compiled by Ejū (d. 1135), *TZ* 3:11c. Also quoted in Hayami Tasuku, *Kannon shinkō jiten* (Tokyo: Ebisu Kōshō Shuppan, 2000), 302.

55. See Taiko Yamasaki et al., *Shingon Japanese Esoteric Buddhism* (Boston: Shambala, 1988), 37–38.

56. About the study of Siddham (J. *shittan*) in Japan, see Fabio Rambelli, "Secrecy in Japanese Esoteric Buddhism," in *The Culture of Secrecy in Japanese Religion,* ed. Bernhard Scheid (London: Routledge, 2006), 121–126. Siddham (also known as Siddhamātrkā) is a script used to write the form of Sanskrit used in the Buddhist world. Deriving from a script that in turn developed out of Brāhmī, it was introduced to Japan via China in the eighth century.

57. William Londo, "The Other Mountain: The Mount Kōya Temple Complex in the Heian Era," (Ph.D. diss., University of Michigan, 2004), 115–117, and Hase Hōshū, ed., *Kōbō Daishi den zenshū* (Kyoto: Rokudai Shinpōsha, 1934), vol. 1, p. 79.

58. See "Zuishin'in" in *Nihon rekishi chimei jiten* (accessed on November 22, 2007).

59. See Shirai Yūko, "Ame sōjō Ningai to Kūkai nyūjo densetsu," *Nihon Bukkyō* 41 (April 1977): 50–51, and Brian Ruppert, "Buddhist Rainmaking in Early Japan: The Dragon King and the Ritual Careers of Esoteric Monks," *History of Religions* 42, no. 2 (November 2002): 143–174.

60. Tsuda Tetusei, "Rokuji Myōō no shutsugen," *Museum* 533 (April 1998): 33. See *Ono ruihishō,* ed. Kanjin (1084–1153), in *Shingonshū zensho* (Mount Kōya: Shingonshū Zensho Kankōkai, 1933–1939), vol. 36, pt. 1, p. 39. See also Nakamura Teiri, "Rokujikyōhō to kitsune," *Ōsaki gakuhō* 156 (March 2000): 129. Ningai's methods for carrying out the ritual are recorded in the postscript, titled "Ningai jidai" of the *Six-Syllable sūtra* (*Rokujikyō*) section in the iconographic manual *Besson zakki, TZ* 3:98b–99b. See also Kamikawa Michio, "*Kakuzenshō* 'Rokujikyōhō' ni tsuite," *Aichi Kenritsu Daigaku bungakubu ronshū* 54 (March 2006): 30.

61. Tsuda, "Rokuji Myōō," 32–33, 52 n. 16, put this information together from three sources. *Asabashō, TZ* 9:169a, lists the ritual performed for Fujiwara no Tomoakira. Fujiwara no Tomoakira is mentioned in an entry (999.11.24) in *Shōyūki.* See *Shōyūki,* in *Dai Nihon kokiroku* 10, vol. 3, pt. 2, p. 73. Tsuda also found that *Taniajariden, ZGR,* vol. 8, pt. 2, p. 752, mentions Fujiwara no Tomoakira. The latter text is about Kōkei (a.k.a. Tani Ajari) and was written in 1254 (Kenchō 4). In addition, *Kakuzenshō, TZ* 4:351b, reports that Shinga (801–879), the head of Jōganji and Kūkai's disciple, performed the Six-Syllable ritual earlier, but this may be an overzealous attribution used to bolster the connection of the mandala to the Daigoji lineage. See Nakamura, "Rokujikyōhō to kitsune," 128.

62. Tsuda, "Rokuji Myōō," 33–35.

63. *Rokuji hōki,* in *Dai Nihon komonjo; Iewake; Daigoji monjo* (Tokyo: Tokyo Teikoku Daigaku, 1904–), vol. 19, pt. 11, no. 2538, pp. 190–212. See also the text about the Six-Syllable ritual titled *Rokujikyō genki* from 1290 (Shōō 3) in Abe Yasurō and Yamazaki Makoto, *Denki genkishū* (Kyoto: Rinsen Shoten, 2004), 659–660.

64. See Nakamura, "Rokujikyōhō to kitsune," 137–148. Nakamura cites the occasions in Mansai, *Mansai jugō nikki,* in *ZGR* supplement (*hoi*), vol. 1, pts. 1–2.

65. See Nishikawa, *Daigoji taikan,* vol. 2, p. 25, and Sawa, "*Gohachi daiki,*" 47–48. About Kenshun, see Mori Shigeaki, "Sanbōin Kenshun ni tsuite," in *Kyushu*

Daigaku Kokushigaku Kenkyūshitsu, Kodai chūseishi ronshū (Tokyo: Yoshikawa Kōbunkan, 1990), 421–422.

66. The Daigoji prelate Gien (1558–1626) noted in his diary that he performed the Six-Syllable ritual at Sanbōin in 1624 (Kan'ei 1), seventh month, twelfth day, for Tokugawa Kazuko, who later became Empress Tōfukumonin. See *Gien jugō nikki* (1624.7.12), available in Tokyo Daigaku shiryō hensanjo database: Kinsei hennen, http://wwwap.hi.u-tokyo.ac.jp/ships/shipscontroller (accessed July 30, 2015).

67. Benedetta Lomi, "Dharanis, Talismans, and Straw-Dolls: Ritual Choreographies and Healing Strategies of the 'Rokujikyōhō' in Medieval Japan," *Japanese Journal of Religious Studies* 41, no. 2 (2014): 255–304.

68. Shirai Yoshirō, "Rokuji karinhō no sekai," *Nihon bunka* 44 (July 1995): 80–83. Shirai refers to the reverse curse as *"juso kaeshi."*

69. *Bussetsu Rokuji juōkyō, T* 20:38a–39c, and *Bussetsu Rokuji jinjuōkyō, T* 20:39c–43c. Also *Mikkyō daijiten,* s.v. *"Rokuji jinjuōkyō"* gives an overview.

70. Kamikawa, *"Kakuzenshō,"* p. 24, gives the transliteration from *Kakuzenshō, TZ* 4:354c. Depending on the text, this can differ.

71. Lomi, "Dharanis, Talismans, and Straw-Dolls," 258–263.

72. For Rokuji Myōō, the six syllables are supposed to refer to "Om mani padme hum." See Kamikawa, *"Kakuzenshō,"* 24, 29. This is in *Atsuzōshi, T* 78:264c, and it differs from the six syllables in the *Six-Syllable sūtra.* Kamikawa says Ningai misquotes the six syllables in the sutra. The section on the "Shingon" (mantra) used in the ritual in *Kakuzenshō, TZ* 4:354c, says that the six syllables are taken from the *Rokujikyō.* The earliest manual, *Zuzōshō, TZ* 3:11b, lists the characters of the formula. *Kakuzenshō* says that the characters are different.

73. This discussion was aided by Kamikawa, *"Kakuzenshō,"* 22–24. The original text is in *Kakuzenshō, TZ* 4:351–366. Kakushin wrote this in 1125 (Tenji 2).

74. *Hizōkonpōshō, T* 78:340c.

75. *Shinzoku zakki mondōshō,* in *Shingonshū zenshū,* vol. 37, p. 436. See also Nakamura, "Rokujikyōhō to kitsune," 135. As a comparison, the Buddhist imagery of the Wheel of Life represents the three poisons as a bird (greed), snake (hatred), and pig (delusion) in the center. See Stephen Teiser, *Reinventing the Wheel* (Seattle: University of Washington Press, 2006), 11.

76. Nakamura, "Rokujikyōhō to kitsune," 136.

77. *Ono ruihishō,* in *Shingonshū zensho,* vol. 36, pt. 1, p. 39; Nakamura, "Rokujikyōhō to kitsune," 129.

78. For more speculation on the selection of foxes for the ritual, see Michel Strickmann, *Chinese Magical Medicine,* ed. Bernard Faure (Stanford, Calif.: Stanford University Press, 2002), 335, n. 90. See also Karen Smyers, *The Fox and the Jewel* (Honolulu: University of Hawai'i Press, 1999), 90. Smyers also explores the Buddhist origins of the relationship between the fox and Inari, 79–85. Michael Bathgate, *The Fox's Craft in Japanese Religion and Folklore* (New York: Routledge,

2004), 35–69. Bathgate discusses the appearance of foxes in the ninth-century collection of tales *Nihon ryōiki.*

79. *Mikkyō daijiten,* s.v. "Rokujikyōhō," and Kamikawa "*Kakuzenshō,*" 24.

80. There are numerous pictures of the variations of Six-Syllable ritual altars and the three forms (*sanruikei*). See *Hizōkonpōshō, T* 78:340a, 340c, for examples.

81. Tsuda, "Rokuji Myōō," 30–31.

82. *Zuzōshō, TZ* 3:11c, describes the five different types of mandala used as the *honzon* for this ritual. The same list is found in *Besson zakki, TZ* 3: 91c–92a, compiled during the Jōan era (1171–1175). Nakamura Teiri, "Rokujikyōhō no honzon ni tsuite," *Ōsaki gakuhō* 157 (March 2001): 104–107.

83. *Kakuzenshō, TZ* 4:353, fig. 111. There is also one in *Yonkashō zuzo, TZ* 3:29, fig. 37. (Note that the pages are not sequential in the entire *TZ* 4 volume.)

84. For information on the use of Shō Kannon as the main image, see Hayashi, "Chōjuji zō," 11–27. He discusses a painting of Shō Kannon flanked by Fudō and Daiitoku Myōō and proposes it is a Six-Syllable mandala. See Chapter Five.

85. *Gyōrinshō, T* 76:160c.

86. Tsuda, "Rokuji Myōō," 30.

87. Kyoto Kokuritsu Hakubutsukan, *Ōchō no butsuga to girei* (Kyoto: Kyoto Kokuritsu Hakubutsukan, 1998), fig. 64, pp. 134, 330.

88. Kyoto Shiritsu, *Bukkyō zuzō shūsei,* no. 1050, pp. 76, 309.

89. *Kakuzenshō,* TZ 4:362c, states that there is a hanging *honzon* (main image), but not specifically a Kannon, facing the altar and includes a diagram of the boat. Lomi, "Dharanis, Talismans, and Straw-Dolls," 276–279, gives a detailed account of the ritual and its variants.

90. *Rokuji karinhō, ZGR* 26, pt. 1:56. An illustration of the boat follows on p. 57. This text is copied with some variations in *Asabashō, TZ* 9:168–174. In the latter text, the two illustrations of the boat are on p. 174c and another labeled as illustration 26 without a sequential page number. *Besson zakki, TZ* 3:91, includes an illustration of the boat.

91. Tsuda, "Rokuji Myōō," 34 and Kamikawa, "*Kakuzenshō,*" 30.

92. See Ruppert, "Buddhist Rainmaking," 144–145.

93. See Kibune Shrine website, http://kifunejinja.jp/event.html (accessed January 4, 2014).

94. *Genpishō, T* 78:407a, and *Kakuzenshō, TZ* 4:362a. The transliterations of Suikazura vary. See Nakamura, "Rokujikyōhō to kitsune," 134.

95. *Byakuhōshō, TZ* 10:755bc; *Genpishō, T* 78:407a; *Hishō mondō, T* 79:412a. Raiyu, the author of the latter, mentioned that he disagreed with another master's opinion that the three unnamed Jusojin were foxes.

96. *Ryōjin hishō,* in *Kan'yaku Nihon no koten,* vol. 34 (Tokyo: Shōgakkan, 1988), 147. See poem number 252.

97. *Byakuhōshō, TZ* 10:755b.

98. See *Hishō mondō, T* 79:409a, 412ab. See Nakamura, "Rokujikyōhō to kitsune," 134.

Chapter Five: Painting the Six Kannon

1. http://bunka.nii.ac.jp/SearchDetail.do?heritageId=198956# (accessed December 28, 2012). The scroll was published in *TZ* 12:997–1045. Interestingly, two of the Thousand-Armed Kannon images have only two arms and two have four arms.

2. Nara Kokuritsu Hakubutsukan, *Nara Kokuritsu Hakubutsukan zōhin zuhan mokuroku: Bukkyō kaiga hen,* 89, 164. With the exception of two examples of Byakue that were omitted, the entire scroll is illustrated on pp. 87–90.

3. Katharina Epprecht et al., *Kannon—Divine Compassion: Early Buddhist Art from Japan* (Zürich: Museum Rietberg, 2007), 124–125. Miyajima Shin'ichi, "Tanaka bon 'Sho Kannon zuzō' ni tsuite," *Museum* 427 (October 1986): 20–21. Miyajima found that Jōshin did not become the head of Kiyomizudera until after 1085. See also Nara Kokuritsu Hakubutsukan, *Birei: Inseiki no kaiga* (Nara: Nara Kokuritsu Hakubutsukan, 2007), 181, 235, fig. 101 and also http://www.emuseum.jp/detail/100099 (accessed April 29, 2016).

4. Miyajima, "Tanaka bon," 21–22, 26. Jōshin seems to be quoting from a *Nyoirin darani.*

5. *Zuzōshō, TZ* 3:32ab and fig. 71, and *Besson zakki, TZ* 3:191b, fig. 75.

6. Although Izumi does not focus on Byakue's rope, he discusses early images of Byakue that hold a rosary in his article; Izumi Takeo, " 'Dōkō Kannon' gazō o megutte," in *Zuzōgaku I, Imēji no seiritsu to denshō,* ed. Tsuda Tetsuei (Tokyo: Chikurinsha, 2012), 87–90, 93–96.

7. *DNBZ* 27:936 and *T* 56:200b. Byakusho is the name used for Byakue in the Womb World Mandala.

8. See http://www.harvardartmuseums.org/art/201583 (accessed July 5, 2013). The scroll, listed as Gift of Philip Hofer, 1984.561, measures 29.2 × 410.2 cm. See also John Rosenfield, Fumiko Cranston, and Edwin Cranston, *The Courtly Tradition in Japanese Art and Literature* (Cambridge, Mass.: Fogg Art Museum, Harvard University, 1973), 86–87.

9. http://www.mfa.org/collections/object/iconographic-scroll-of-various-deities-25472 (accessed July 1, 2014). Anne Nishimura Morse and Nobuo Tsuji, eds., *Japanese Art in the Museum of Fine Arts, Boston* (Boston: Museum of Fine Arts, 1998), vol. 1, p. 6 and vol. 2, pp. 118–121. Miyajima, "Tanaka bon," p. 22. The museum website states there are seals of Kōzanji, but they are not visible in the published illustrations. Museum of Fine Arts, Boston, Tokyo Kokuritsu Hakubutsukan, and Kyoto Kokuritsu Hakubutsukan, *Bosuton Bijutsukan shozō Nihon kaiga meihinten* (Tokyo: Nihon Terebi Hōsōmō, 1983), fig. 17, p. 153, says more cautiously that the scroll has traditionally been given a Kōzanji provenance.

10. Morse, *Japanese Art in the Museum of Fine Arts, Boston,* vol. 1, p. 8 and vol. 2, p. 125. See the six images in the BMFA database, http://www.mfa.org/collections/mfa-images (accessed May 24, 2015).

11. See Nara Kokuritsu Hakubutsukan, *Busshari no shōgon* (Kyoto: Dōhōsha, 1983), figs. 81, 86, pp. 28, 126, 130, 327, 328, and Nara Kokuritsu Hakubutsukan, *Busshari*

to hōju: Shaka o shitau kokoro (Nara: Nara Kokuritsu Hakubutsukan, 2001), figs. 86, 109, pp. 111, 131, 219, 226.

12. For a thirteenth-century example (in a private collection) with six doors, see fig. 122, pp. 164–165, 338. Another possibility for the shape of the original *zushi* for the Kannon paintings is the *kyūden* (palace-style) form, which is rectangular with a flat-topped, gently sloping, four-sided roof. For several examples see Nara Kokuritsu Hakubutsukan, *Busshari no shōgon,* 138, 142, 147–152, 154–156.

13. See *Shoson zuzōshū,* from the twelfth to thirteenth century, in Morse, *Japanese Art in the Museum of Fine Arts, Boston,* vol. 1, p. 6 and vol. 2, pp. 118–121. Also, *Zuzōshō* from the twelfth century has both Juntei and Fukūkenjaku as examples of variations of Kannon. See *TZ* 3:27, 29–30.

14. http://www.narahaku.go.jp/collection/1110–0.html (accessed May 24, 2015). A photograph of Byakue is included.

15. See Nara Kokuritsu Hakubutsukan, *Busshari no shōgon,* fig. 106, pp. 148, 333. The tile pattern with the Boston Shō image only matches the pattern on the two wider images, so it would not have been paired with either of them.

16. Six Kannon images were enshrined with an Amida Buddha image in the Jōgyōdō at Miidera in Shiga prefecture in 1040. See Chapter One of this book.

17. *Zushi* from Nara National Museum and Cleveland Museum of Art both have similar twelfth-century black lacquer tabernacles that contained sutras, but in these cases, the images depicted on the inner doors are guardians. See Michael Cunningham, ed., *Buddhist Treasures from Nara* (Cleveland: Cleveland Museum of Art, 1998), fig. 75, pp. 202–205. A rectangular black-lacquer *zushi,* dated to 1226, that houses both the text of the *Lotus sūtra* and relics is discussed in Anne Nishimura Morse, ed., *Object as Insight: Japanese Buddhist Art & Ritual* (Katonah, N.Y.: Katonah Museum of Art, 1995), 76–77.

18. Maizawa Rei, "Hosomi Bijutsukan shozō roku Kannon zō kō," *Bijutsushi* 166 (March 2009): 324–239. For color pictures of all five paintings, see Chibashi Bijutsukan, *Shugyoku no Nihon bijutsu: Hosomi korekushon no zenbō to Bosuton, Kuriiburando, Sakkuraa no wadaisaku: Kaikan isshūnen kinen* (Chiba: Chibashi Bijutsukan, 1996), 38–39.

19. See entry by Yanagisawa Taka, in Mochizuki Shinjō, ed., *Nihon Bukkyō bijutsu hihō shoka aizō* (Tokyo: Sansaisha, 1973), 242.

20. Yanagisawa, in Mochizuki, ed., *Nihon Bukkyō,* 242, states the use of three vertical pieces of silk is a late fourteenth-century feature, but dates the paintings to the mid-fourteenth century. Maizawa, "Hosomi," 325.

21. Yanagisawa, in Mochizuki, ed., *Nihon Bukkyō,* 242.

22. Nara Kokuritsu Hakubutsukan, *Kannon Bosatsu,* expanded ed. (Kyoto: Dōhōsha, 1981), 437.

23. Jōrakuji Bijutsukan, *Sukui no hotoke Kannon to Jizō* (Ueda-shi, Nagano-ken, 1992), 18; Hosomi Bijutsukan, *Rinpa, Jakuchū to miyabi no sekai* (Kyoto: Seigensha, 2010), 114–117, 198.

24. Maizawa, "Hosomi," p. 327, states that she is not emphasizing stylistic analysis in the article.

25. See http://www.aisf.or.jp/~jaanus/deta/g/genzumandara.htm (accessed August 17, 2013).

26. Maizawa, "Hosomi," 328.

27. See Yamamoto Tsutomu, "Dainichi Nyorai zō," *Nihon no bijutsu* 374 (July 1997): 75; Asano Nagatake, ed., *Kōyasan*, vol. 7 of *Hihō* (Tokyo: Kōdansha, 1968), fig. 29, pp. 223–339. See also http://www.reihokan.or.jp/magazine/pdf /no-100.pdf (accessed August 12, 2013). This is the magazine of the Mount Kōya Treasure House, *Reihōkan dayori* 100 (2006), which is now online.

28. Maizawa, "Hosomi," 333. See Chapter Three of the present book for a discussion of the Song style in relation to sculpture.

29. See two examples in Sakata Munehiko, "Mikkyō hōgu," *Nihon no bijutsu* 282 (November 1989): figs. 56–57, p. 38. Sakata reports that the *warigokosho* is used by the Tachikawa School.

30. http://www.mfa.org/collections/object/iconographic-scroll-of-various -deities-25472 (accessed May 24, 2015). Morse, *Japanese Art in the Museum of Fine Arts, Boston*, vol. 1, p. 8 and vol. 2, pp. 118. Maizawa, "Hosomi," 331–332, noted this and included a photograph (fig. 15) of this Juntei detail in the Boston scroll.

31. I believe that Yanagisawa was the first to publish the reference. Yanagisawa, in Mochizuki, ed., *Nihon Bukkyō*, 242.

32. Yanagisawa, in Mochizuki, ed., *Nihon Bukkyō*, 242, and the entry in Jōrakuji Bijutsukan, *Sukui no hotoke Kannon to Jizō*, 18.

33. *Tōbōki*, compiled by the monk Gōhō (1306–1362), in *Zoku zoku gunsho ruijū*, vol. 12 (Tokyo: Zoku Gunsho Ruijū Kanseikai, 1970), 61.

34. Niimi Yasuko, ed., *Tōji hōmotsu no seiritsu katei no kenkyū* (Kyoto: Shibunkaku Shuppan, 2008).

35. Maizawa, "Hosomi," 335.

36. See chart in Niimi, *Tōji*, 554–555. Maizawa, "Hosomi," 335.

37. Maizawa, "Hosomi," 339, and Niimi, *Tōji*, 295, n. 73. Tōji Treasure House (Tōji Hōmotsukan) owns the former box.

38. Maizawa, "Hosomi," 335–336, proposes that the paintings were at Daigoji before arriving at Tōji.

39. *Zuzōshō*, TZ 3:11c, and *Besson zakki*, TZ 3:91c–92a.

40. See discussion in Chapter Four. See *Kakuzenshō*, TZ 4:353, fig. 111.

41. *Shinzoku zakki mondōshō*, in *Shingonshū zenshū*, vol. 37 (Mt. Kōya: Shingonshū Zensho Kankōkai, 1933–1939), 436.

42. Hayashi On, "Chōjuji zō Shō Kannon mandala kō," *Bukkyō geijutsu* 197 (July 1991): 22.

43. For examples see Takasaki Fujihiko, *Nihon Bukkyō kaigashi* (Tokyo: Kyūryūdō, 1966), 117–118, figs. 68–70.

44. See *Byakuhōshō*, TZ 10:755a, and *Shinzoku zakki mondōshō*, in *Shingonshū zenshū*, vol. 37, p. 436. Hayashi, "Chōjuji zō," 24, 27, n. 59–61. Maizawa, "Hosomi," 334.

45. See *Shiku, T* 78:841a.

46. Maizawa also ties some of the iconographic features of the Hosomi images to her theory that the paintings were produced at Daigoji before coming to Tōji. Maizawa, "Hosomi," 335–336.

47. *Roku Kannon gōgyōki,* in *Monyōki, TZ* 12:551b–c. With Shō in the center, the specific arrangement is asymmetrical; Thousand-Armed, Nyoirin, and Fukūkenjaku Kannon on the east side of Shō and Eleven-Headed and Horse-Headed to his west. This arrangement does not match known others.

48. The handwriting is difficult to read, so it is possible that Shō and Nyoirin are reversed. This unpublished record is held in the Shōrenin Kissui collection. I am grateful to Donohashi Akio for helping me access the text. Basic details about the text are in Kissuizō shōgyō chōsadan, *Shōrenin monzeki kissuizō shōgyō mokuroku* (Tokyo: Kyūko Shoin, 1999), 387.

49. *Asabashō, TZ* 9:224b.

50. *Kakuzenshō, TZ* 4:353, fig. 111.

51. Hayashi, "Chōjuji zō," 11–27. See also Shiga Kenritsu Biwako Bunkakan, *Kōga no shaji* (Ōtsu: Shiga Kenritsu Biwako Bunkakan, 1985), n.p., fig. 10 and color cover image, and Nara National Museum, *Kannon Bosatsu,* fig. 8, p. 139. The painting is color on silk and measures 114 × 85 cm.

52. Hayashi, "Chōjuji zō," 23–24. See *Hishō mondō, T* 79:408ac, and *Byakuhōshō, TZ* 10:792a.

53. *Roku Kannon gōgyōki,* in *Monyōki, TZ* 12:551b.

54. For a history of the temple see Inoue Yasushi, ed., *Ryōsenji* (Kyoto: Tankōsha, 1979), 78–92. See also http://www.ryosenji.jp/index.html (accessed May 24, 2015). I am grateful to the deputy abbot (Fukujūshoku) Tōyama Kōshū for showing me the painting on July 22, 2011.

55. Negishi Keiba Kinen Kōen and Baji Bunka Zaidan, *Batō Kannon shinkō no hirogari,* 26. The official Nara painting studios refer to Nanto edokoro.

56. Nara-shi Kyōiku Iinkai, *Nara-shi kaiga chōsa hōkokusho,* vol. 3 (Nara: Nara-shi Kyōiku Iinkai, 1989), fig. 725, p. 64; Nara Kokuritsu Hakubutsukan, *Yata kyūryō shūhen no bukkyō bijutsu* (Nara: Nara Kokuritsu Hakubutsukan, 1987), 28.

57. As one example of a related painting, Jōdoji in Hiroshima owns an attractive fourteenth-century painting featuring Thousand-Armed Kannon with his twenty-eight attendants that also has five other Kannon surrounding the mandorla above, to create a group of Six Kannon. Fukūkenjaku is included in the group. See Ryūkoku Daigaku Myūjiamu, *Gokuraku e no izanai: Nerikuyō o meguru bijutsu* (Kyoto: Ryūkoku Daigaku Ryūkoku Myūjiamu, 2013), 27, 184, cat. no. 15.

58. Nagahara Keiji, ed., *Zenyaku azumakagami* (Tokyo: Shin Jinbutsu Ōraisha, 1976–1979), vol. 3, p. 108.

59. Nagahara, *Zenyaku azumakagami,* vol. 5, p. 93.

60. Tanaka Kaori, "Sengokuki ni okeru 'shichi Kannon mōde,' 'shichinin mōde' ni tsuite," *Tezukayama Daigaku Daigakuin Jinbunkagaku Kenkyūka kiyō* 11 (February 2009): 13. The temples in the pilgrimages included Rokkakudō, Gyōganji (Kōdō),

Kiyomizudera, Rokuharamitsuji, Nakayamadera, Kawasakidera (Seiwa'in), and Chōrakuji.

61. *Roku Kannon Hachidai Kannon no koto* is included in *Kannon myōōshū* by Rentai (1663–1726), in ed. Kōbe Setsuwa Kenkyūkai, *Hōei hanpon Kannon myōōshū: Honbun to setsuwa mokuroku* (Osaka: Izumi Shoin, 2006), 12.

62. *Shinsen zōho Kyō ōezu* (Newly compiled and enlarged map of Kyoto) (Kyoto: Hayashi Yoshinaga, 1686), labeled this location as "Shichi Kannon." I would like to thank Matthew McKelway for alerting me to this map. Later copies of the map called *Kyō ōezu* from the eighteenth century also include it. A copy of the 1686 map, as well as two from the eighteenth century, are in the Library of Congress Geography and Map Reading Room collection.

63. See *Sanshū meisekishi*, *SKS* 15:34. Kyōgoku Nakagoryō is the location east of the palace. See *Yamashiro meishōshi*, *SKS* 14:209, and *Miyako meisho zue*, ed. Akisato Ritō (fl. 1780–1814), (first published in 1780), http://www.nichibun.ac.jp /meisyozue/kyoto/page7t/km_01_180.html (accessed May 22, 2015).

64. One section of the text *Kyō suzume* (Sparrow of the capital), from 1665 (Kanbun 5), describes the hall with Seven Kannon as previously relocated to Teramachi before moving in front of Kōdaiji in Yasaka in 1663. See *Kyō suzume*, *SKS* 1:201. Another entry in the same volume has a more complicated story that relates the Seven Kannon to Hyakumanben, *SKS* 1:185. In yet another entry, *SKS* 1:183, *Kyō suzume* explains that Teramachi Street refers to the former and previously mentioned Kyōgoku. The former area in Kyōgoku was also named Shichikannon-chō, *SKS* 1:201, but it changed. See also *Meirinshi*, ed. Meirin Jinjō Shōgakkō (Kyoto: Kyōtoshi Meirin Jinjō Shōgakkō, 1939), 156.

65. *Kyōhabutae*, *SKS* 2:80.

66. Mori Senzō and Kitagawa Hirokuni, eds., *Getsudō kenmonshū* in *Zoku Nihon zuihitsu taisei, bekkan*, vol. 3 (Tokyo: Yoshikawa Kōbunkan, 1982), 6, 24. There is a slight discrepancy since the passage on p. 6 says the opening took place in 1727, third month, third day to the fourth month, twentieth day, and the passage on p. 24 says it took place in the same year for sixty days, beginning on the second month, twenty-eighth day.

67. See Chapter Three for the claim in *Tōmyōji engi* that the Kannon images were made by the Kasuga sculptors.

68. "Shichi Kannon'in" in *Kyōtoshi jiin meisaichō* (Kyoto, 1884), n.p. This record is kept in special collections at Kyoto Furitsu Sōgō Shiryōkan (Kyoto Prefectural Library and Archives).

69. I refer to both editions as *Butsuzō zui*. See *Shoshū Butsuzō zui*, compiled by Gishin (n.p., 1690) and *Zōho shoshū Butsuzō zui*, ed. Ki no Shūshin (a.k.a. Tosa Hidenobu or Ki no Hidenobu), (Kyoto: Shorin, 1783). For reproductions of both 1690 and 1783 versions in the same volume, see Asakura Harahiko, ed., *Kinmō zui shūsei* (Tokyo: Ōzorasha, 1998), vol. 14. The drawings are different in the revised sections, but the iconography is almost the same. The Library of Congress has two copies of the first version, published in Hōreki 2 (1752), which

I used for reference. For the second version, I used the copy in the University of Pennsylvania Library, which was published in 1796 (Kansei 8).

70. Murakado Noriko, "Wiriamu Andaason to *Butsuzō zui*—'Nihon bijutsushi' kei-seiki ni okeru ōbun Nihon kenkyūsho no ichi," *Bijutsushi* 62/1 (2012): 56–57. The Worldcat and Webcat databases list different editions from 1783, 1787, 1792, 1794, 1796, 1831, 1886, 1876–1889, 1891, and 1900 from library collections around the world. Countless modern sources in several languages continue to reference this manual for image identification. For two examples, see Louis-Frédéric and Nissim Marshall, *Buddhism* (Paris: Flammarion, 1995); Kuno Takeshi, *Edo butsuzō zuten* (Tokyo: Tōkyōdō Shuppan, 1994). On the first page of the latter, Kuno writes that *Butsuzō zui* is the best source for Edo-period Buddhist images and includes its illustrations on almost every page of his book.

71. Mary Elizabeth Berry, *Japan in Print* (Berkeley: University of California Press, 2006), 19–20, 196. As one example from 1690 see Asakura Haruhiko, ed., *Jinrin kinmō zui* (Tokyo: Heibonsha, 1990), which classifies a vast number of jobs and positions in Japan. An exception that includes some pages with illustrations of religious images is *Zōho kashiragaki kinmō zui taisei,* but it does not have a picture of Kannon. Nakamura Tekisai (1629–1702), *Zōho kashiragaki kinmō zui taisei* (Kyoto: Kyūkōdō, 1789), vol. 10. See copy in Waseda Library. http://archive.wul.waseda.ac.jp/kosho/bunko06/bunko06_00027/bunko06_00027_0010/bunko06_00027_0010.html (accessed June 21, 2014).

72. See the twelve *Zuzō* volumes in *TZ*. For a twelfth-century example in the Nara National Museum see Miyajima, "Tanaka bon," 19–27.

73. Hidenobu, *Buddhist Iconography in the Butsuzōzui of Hidenobu,* ed. Anita Khanna (New Delhi: D. K. Printworld, 2010), 12. The prefaces, postscripts, and headings are translated, but the text that accompanies each image is not.

74. See Sherry Fowler, "Kannon Imagery in the Life of the Seventeenth-Century Manual *Butsuzō zui,*" in *Moving Signs and Shifting Discourses: Text Image Relations in East Asian Art,* eds. Jeong-hee Lee-Kalisch and Wibke Schrape (Weimar: VDG, forthcoming).

75. Hidenobu, *Buddhist Iconography in the Butsuzōzui of Hidenobu,* 14–15.

76. Murakado, "Wiriamu Andaason to *Butsuzō zui,*" 57.

77. Niizuma Hisao, *Shōwa shinsen Edo sanjūsansho Kannon junrei* (Osaka: Toki Shobō, 2005), 154–155. The lost sculptures, which were among Kōun's last works, were remade in the 1970s. See also "'Hofuraku Jizō:' Meisatsu Kōunji ni . . .," *Tokyo Asahi Shinbun* 17555 (March 4, 1935): G11 for an article on the images and photograph of the original group.

78. I was given permission to view The Field Museum's small tabernacle, measuring 20.1 cm in height, accession number 255110. I appreciate Yui Suzuki calling it to my attention.

79. *Mohe zhiguan* by Zhiyi (538–597), *T* 46:15ab.

80. Hattori Hōshō, "Nihon senjutsu gikyō to *Butsuzō zui,*" *Bukkyō bunka gakkai kiyō* 2 (1994): 92–93. Hattori noted *Butsuzō zui*'s section on Nyoirin Kannon mistakenly quotes an explanation for a Juntei Kannon from a different text.

81. *Butsuzō zui* (both 1690 and 1783 editions) lists eighty-six reference works, including *Mohe zhiguan.*

82. Ōtsu Kazuhirō, "Yoryū Kannon o haishita roku Kannon, shichi Kannon," *Nihon no sekibutsu* 124 (Winter 2007): 50–51. The article includes four other examples. When I photographed the image on May 25, 2014, I could not find the inscription with the date Ōtsu gives, but it looks like a nineteenth-century monument. The sculpture is located to the left of the front gate, and a more recent inscription on the stone base declares that it was moved in 1930 from the former graveyard.

83. See Museum für Ostasiatische Kunst der Stadt Köln, *Kerun Tōyō Bijutsukan Kaiga =Painting in the Museum of East Asian Art, Cologne* (Tokyo: Bunkazai Hozon Shūfuku Gakkai, 1999), 8, and Museum für Ostasiatische Kunst der Stadt Köln, *Buddhistische Kunst Ostasiens* (Köln: Wienand, 1968), 78.

84. Petra Rösch, curator of Asian art at Museum für Ostasiatische Kunst der Stadt Köln, explained that the painting entered the collection at the time the museum was founded in 1913. I would like to thank her for showing me the painting on June 20, 2013. For the history of the museum's Buddhist art collection see Sybille Girmond, "The Collection of Japanese Buddhist Painting and Sculpture in the Museum of East Asian Art in Cologne," *Orientations* 28, no. 1 (January 1997): 46–55.

85. Iida Michio, *Nichimachi, tsukimachi, kōshinmachi* (Kyoto: Jinbun Shoin, 1991), 7, 73–77. See also Nakayama Keishō, *Zenkoku sekibutsu ishigami daijiten* (Tokyo: Ritchi Maindo, 1990), 709.

86. See reprints of Edo-period illustrations in Iida, *Nichimachi,* 16–17. Originals are in *Tōto saijiki,* ed. Saitō Gesshin (Edo: Suharaya Mohē: Suharaya Ihachi, 1838), vol. 3, pp. 14–15. For the Takanawa festival in 1834, see *Edo meisho zue,* eds. Saitō Chōshu (1737–1799) et al. (Edo: Suharaya Mohē, 1836), vol. 3, p. 49, in Waseda Library database: http://archive.wul.waseda.ac.jp/kosho/ru04/ru04_00409 /ru04_00409_0003/ru04_00409_0003_p0049.jpg (accessed September 6, 2013). For another example see *Zenkōjimichi meisho zue,* ed. Toyota Toshitada (Edo: Suharaya Mohē, 1849), vol. 2, pp. 47–48.

87. Sakaguchi Kazuko, "Kinsei tsukimachi shinkō to nyoninkō no hitotsu kōsatsu," *Nihon no sekibutsu* 22 (August 1982): 4–15.

88. Ishikawa Hiroshi, "Shichiyamachitō zakki," *Nihon no sekibutsu* 22 (August 1982): 56–57, noted that he was unaware of any investigations of living Tsukimachi traditions. A related ritual is the all-night festival Nishiure Dengaku in Shizuoka, which includes a "Six Kannon" procession of people wearing bodhisattva masks.

89. The artist Hanabusa Itchō (1652–1724) made an impressive handscroll illustrating Himachi, called *Shiki himachi zukan,* circa 1700, which is in the Idemitsu Art Museum in Tokyo. http://www.idemitsu.co.jp/museum/collection /introduction/painting/ukiyoe/ukiyoe01.html (accessed June 16, 2014). See Miriam Wattles, *The Life and Afterlives of Hanabusa Itchō, Artist-Rebel of Edo* (Leiden: Brill, 2013), 78–85, fig. 32. Wattles refers to the painting as *Turning of the Seasons Ceremony* and describes its festive atmosphere.

90. About the Kōshin cult, see Livia Kohn, "Taoism in Japan: Positions and Evaluations," *Cahiers d'Extrême-Asie* 8 (1995): 389–412.

91. The Bernard Frank collection has an undated print of Seishi, twenty-third night, from Kongōsan Ban'naji in Tochigi prefecture. See http://ofuda.crcao .fr/consultation.php?mode=single&ofuda_ID=96&back=/home.php?coll=1 &rechcat=&catIDcoll=B&SscatIDcoll=B-02 (accessed May 24, 2015). Gaynor Sekimori located a twenty-third night Seishi print in the British Library collection (5-66) issued from Kongōin, a subtemple of Sensōji in Asakusa, Tokyo (personal communication, January 4, 2015). For two nineteenth-century Shichiyamachi Seishi prints mounted as hanging scrolls, see Mareile Flitsch, ed., *Tokens of the Path—Japanese Devotional and Pilgrimage Images: The Wilfried Spinner Collection (1854-1918)*, (Zürich: Ethnographic Museum at the University of Zurich, 2014), 202–205. One is a duplicate of the British Library print.

92. Ishikawa, "Shichiyamachitō zakki," 56. See also Iida, *Nichimachi*, p. 140.

93. *Tamon'in nikki*, originally compiled by Eishun (1518–1596), ed. Takeuchi Rizō, *Zōho zoku shiryō taisei* (Kyoto: Rinsen Shoten, 1978), vol. 1, pp. 437–438, 440–441, 445–446, 450, 453 and vol. 2, pp. 102–103, 108–109. Iida, *Nichimachi*, cites the *Tamon'in nikki* as a reference on pp. 26 and 139, but does not give the dates of the entries. The rituals were held during 1566–1569 (Eiroku 9–12).

94. Ishikawa, "Shichiyamachitō zakki," 56, takes information from *Mikkyō daijiten*, 979.

95. This text is found in a source called *Jikketsu shodaiji* (Many essentials of the ten fetters), which is also referred to as *Shodaiji jikketsu*. See Inaya Yūsen, *Shingon himitsu kaji shūsei* (Osaka: Tōhō Shuppan, 1998), 18–19. Inaya's book assembles the compilations, but provides no contextual information on its sources. Here the text is listed as *Shichiyamachi no daiji*. Information about the texts is in Ishii Yūshō, "*Shodaiji ruijū 'Jūshichitsūinjin' ni tsuite,*" *Shingonshū Buzanha sōgō kenkyūin kiyō* 9 (2004): 21–36.

96. This text is part of *Jūshichitsūinjin* (Seventeen letters of transmission) within the text *Shodaiji ruizō* (Collection of various essentials). Inaya, *Shingon himitsu*, 380–381, includes *Nanayamachi no daiji*, and the text is also in *Shugen shinpi gyōhō fujushū* 4, published in *Nihon daizōkyō* (Tokyo: Suzuki Gakujitsu Zaidan, 1976), vol. 94, p. 69. The entire text was republished in Nihon Daizōkyō Hensankai, *Shugen shinpi gyōhō fujushū* (Tokyo: Hachiman Shoten, 2010). Page 59 has the corresponding section. See Ishii, *Shodaiji ruijū*, 21–23. A few of the characters in the texts Ishii uses are alternates, suggesting he consulted different copies.

97. Ishii, *Shodaiji ruijū*, 23.

98. *Shichiyamachi sahō* in *Shugen shinpi gyōhō fujushū* 4, p. 69; *Nihon daizōkyō*, vol. 94, p. 69. The date is not given, but it is likely a seventeenth- or eighteenth-century record like the others in the volume.

99. The rectangular block base below the pillar gives the name of the patron as Yokoyama Jūzō, who belonged to a confraternity of thirty-two people. If the base is original, the monument doubled as a memorial as it has indentations

for offertory flowers and water. See Nihon Sekibutsu Kyōkai, *Nihon sekibutsu zuten* (Tokyo: Kokusho Kankōkai, 1986), 256.

100. http://www.city.nerima.tokyo.jp/annai/rekishiwoshiru/rekishibunkazai /bunkazai/bunkazaishosai/b014.html (accessed July 15, 2013). Seishi's flower looks somewhat like a willow branch, but the Sanskrit seed syllable is definitely *saku*, which is appropriate for Seishi but not for Willow Branch Kannon. The base has the four directions and the names of roads and areas in the corresponding directions. Ishikawa, "Shichiyamachitō zakki," 55–56, lists thirteen examples.

101. Daigo Hachirō, ed., *Nihon no sekibutsu: Minami Kantō hen*, vol. 7 (Tokyo: Kokusho Kankōkai, 1983), 22, figs. 1–8. In this case, the image that might have been Juntei was called a Fukūkenjaku Kannon (fig. 5). For Seven Kannon stone images, see Nakayama Keishō, *Zenkoku sekibutsu ishigami daijiten* (Tokyo: Ritchi Maindo, 1990), 417–418.

102. Ōtsu, "Yōryū Kannon o haishita roku Kannon," 50–51.

103. See Machida Shiritsu Hakubutsukan, *Shōmen kongō to kōshin shinkō* (Machida-shi: Machida Shiritsu Hakubutsukan, 1995).

104. Waseda University Library has a handscroll, measuring 40 × 24.5 centimeters, of a painted print of Seven Kannon, referred to as "Shichi Kannonzu." In it, a larger Shō Kannon in the center is surrounded by Nyoirin, Eleven-Headed, Thousand-Armed, Fukūkenjaku, Juntei, and Horse-Headed Kannon. Although no image of Seishi is present, the back of the scroll records that it is from a confraternity of the twenty-third night. This label indicates that either there was a later mistake in its identification or flexibility in the images used by the confraternity. Affixed to the scroll are a paper seal with picture and name of the former collector E. A. Gordon and the date of 1916.

105. The paintings may have been in Kōdaiji's possession for centuries, but the earliest record I found is the government survey of temple property that simply lists the paintings. See "Kōdaiji shūshū mokuroku" in *Homotsu torishirabe mokuroku* (Inventory of examined treasures), 1888 (Meiji 21), vol. 40, n.p. Handwritten records of temple property compiled by the government and kept in special collections at Kyoto Furitsu Sōgō Shiryōkan (Kyoto Prefectural Library and Archives).

106. As the paintings include Juntei and not Fukūkenjaku Kannon, they are in the Shingon School lineage. I was able to examine them on July 29, 2009.

107. Santori Bijutsukan et al., *Kōdaiji no meihō: Hideyoshi to Nene no tera* (Tokyo: Asahi Shinbunsha, 1995), 78–81, 168. Based on style, Izumi Takeo feels that they differ from works by the Kano School and other Chinese style works, but he believes that a professional Buddhist painter made the paintings in the early sixteenth century.

108. See http://www.youtube.com/watch?v=9mhMzY2gOW8 (accessed March 19, 2014). The paintings were displayed at the Shō Bijutsukan at Kōdaiji in 2009. See also the museum website, which shows one of the Thirty-Three Kannon paintings: http://www.kodaiji.com/museum/Treasure.html (accessed March 19, 2014). The painting shows a White-Robed Kannon with a Great General of Heaven (Tendaishōgunshin) preaching below. Two other paintings are

published in Kobori Taigan, *Kōdaiji, Shinpan koji junrei, Kyoto,* vol. 37 (Kyoto: Tankōsha, 2009), 46.

109. The first four examples of hungry ghosts are described in the tenth-century text *Ōjō yōshū,* but the fifth is mysterious. For an English translation of *Ōjō yōshū* see, A. K. Reischauer, "Genshin's Ojo Yoshu: Collected Essays on Birth into Paradise," *Transactions of the Asiatic Society of Japan,* 2nd series, vol. 7 (1930): 46–49. For comparisons to the thirteenth-century Shōjuraigōji scrolls, see Izumi Takeo, Kasuya Makoto, and Yamamoto Satomi, eds., *Kokuhō rokudōe* (Tokyo: Chūō Kōron Bijutsu Shuppan, 2007), 246, 287. For a Muromachi-period painting with a similar figure looking at a tree, which is not found in *Ōjō yōshū,* see Idemitsu Bijtsukan, *Nihon kaiga no miwaku* (Tokyo: Idemitsu Bijutsukan, 2014), 32, 163, cat. no. 6.

110. On the suffering of beasts in the animal path, see Barbara Ambros, *Bones of Contention: Animals and Religion in Contemporary Japan* (Honolulu: University of Hawai'i Press, 2012), 35–36.

111. Interestingly, scenes of the carnivorous food chain and driving an ox with a load uphill appear in scenes of the animal path in other *rokudoe* paintings, rather than the human path as seen here. See Izumi, *Kokuhō rokudōe,* 53, 247, 288–289.

112. About the *deva* path, see Reischauer, "Genshin's Ojo Yoshu," 57–59. The scene in the Kōdaiji painting is unusual.

113. See Izumi, *Kokuhō rokudōe,* 239–240.

114. Nara Kokuritsu Hakubutsukan, *Seichi Ninpō: Nihon Bukkyō 1300-nen no genryū* (Sacred Ningbo, gateway to 1300 years of Japanese Buddhism) (Nara: Nara Kokuritsu Hakubutsukan, 2009), 175–177, 313, and cat. no. 123. Although he does not specifically mention the use of six-path paintings in *shuilu* rites, for a discussion of the diversity of *shuilu* imagery see Daniel Stevenson, "Text, Image, and Transformation in the History of the *Shuilu fahui,* the Buddhist Rite for Deliverance of Creatures of Water and Land," in *Cultural Intersections in Later Chinese Buddhism,* ed. Marsha Weidner (Honolulu: University of Hawai'i Press, 2001), 40.

115. See Izumi, *Kokuhō rokudōe,* 62–71. Two related fourteenth-century paintings of the human and heavenly being paths, which were certainly part of a larger set in the past, are in the Freer Gallery of Art, Washington, D.C.; see pp. 172–173. See also Reischauer, "Genshin's Ojo Yoshu," 16–97.

Chapter Six: Bodies and Benefits

1. Eugene Y. Wang, *Shaping the Lotus Sūtra: Buddhist Visual Culture in Medieval China* (Seattle: University of Washington Press, 2005), 219, n. 12, p. 422; Willa Tanabe, *Paintings of the Lotus Sūtra* (New York: Weatherhill, 1988), xv, 5.

2. Burton Watson, trans., *The Lotus Sutra* (New York: Columbia University Press, 1993), 301–302, and *T* 9:56–58. See Hayami Takusu, *Kannon shinkō jiten* (Tokyo: Ebisu Kōshō Shuppan, 2000), 28–29.

3. See Chün-fang Yü, "Ambiguity of Avalokiteśvara and the Scriptural Sources for the Cult of Kuan-yin in China," *Zhonghua foxue xuebao* (Chung-Hwa Buddhist

Journal) 10 (1997): 424–425, and Gotō Daiyō, *Kanzeon Bosatsu no kenkyū* (Tokyo: Sankibō Busshorin, 1958), 168–169. *Śūraṅgama sūtra* is called the "Heroic Valor Sūtra" in English. See *The Śūraṅgama Sūtra*, translated by Upasaka Lu K'uan Yu (Charles Luk) at http://www.buddhanet.net/pdf_file/surangama.pdf (accessed June 24, 2015), 192–197. This translation was first published in 1966, but the web version is undated. See *Da foding shoulengyan jing*; J. *Dai butchō shuryōgon kyō, T* 19:128–129. For some unstated reason, this sutra leaves out Vajrāpani (J. Shūkongojin), who is included in the *Lotus sūtra* group.

4. http://www.haryana-online.com/ (accessed January 16, 2010).

5. See Hayami Takusu, *Bosatsu: Bukkyōgaku nyūmon* (Tokyo: Tokyo Bijutsu, 1982), 77–82; Mochizuki Shinkō, *Mochizuki Bukkyō daijiten* (1954–1958), s.v. "Sanjūsanshin," and Akira Sadakata, *Buddhist Cosmology: Philosophy and Origins* (Tokyo: Kosei Publishing, 1997), 57–61, 125.

6. Wang, *Shaping the Lotus*, 220–221, 287–288, figs. 4.20, 5.25–5.26. Wang's earliest example is a relief carving from Wanfosi in Chengdu dated to 425 CE that only exists as an ink rubbing. See Chün-fang Yü. *Kuan-yin: The Chinese Transformation of Avalokiteśvara* (New York: Columbia University Press, 2001), 76. For eighth-century images see Miyeko Murase, "Kuan-yin as Savior of Men: Illustration of the Twenty-Fifth Chapter of the Lotus Sūtra in Chinese Painting," *Artibus Asiae* 33, no. 1/2 (1971): 64–65.

7. Fujieda Akira, "S.6983 *Kannongyō*," *Bokubi* 177 (March 1968): 3–46. A wonderful digital reproduction of the entire booklet is available on the International Dunhuang Project database at the British Library. Search Or.8210/S.6983 in http://idp.bl.uk/pages/collections_en.a4d (accessed June 23, 2015). See also Murase, "Kuan-yin," 43–62. See also Roderick Whitfield, "An Art Treasury of China and Mankind: Some Recent Studies on the Dunhuang Caves," *Orientations* 20 (March 1989): 38–39.

8. Watson, *The Lotus Sutra*, 302.

9. Ibid., 302.

10. The extensive project was first completed in 1164 (Chōkan 2), but a fire destroyed most of the images in 1249 (Kenchō 1).

11. Mizuno Keizaburō, ed., *Nihon chōkokushi kiso shiryō shūsei: Kamakura jidai: Zōzō meiki hen* (Tokyo: Chūō Kōron Bijutsu Shuppan, 2010), vol. 8, pt. 1, 14–35; vol. 8, pt. 2, 6–20. This book has excellent photographs and the images are carefully described, but there is no attempt to identify each image. Although not all of the identities are obvious, this set seems to have fewer female images than others. Instead of names, numbers were carved on their backs, perhaps to make it easier to reattach them when necessary.

12. See Nara Kokuritsu Hakubutsukan, *Saigoku sanjūsansho: Kannon reijō no inori to bi* (Nara: Nara Kokuritsu Hakubutsukan, 2008), fig. 11, pp. 24, 243.

13. Yamane Yūzō, ed., *Emakimono*, vol. 2 of *Zaigai Nihon no shihō* (Tokyo: Mainichi Shinbunsha, 1979–1981), 148–149, figs. 54–60; Katharina Epprecht et al., *Kannon—Divine Compassion: Early Buddhist Art from Japan* (Zürich: Museum Rietberg, 2007), 114–121. Tanaka Ichimatsu, ed., *Kegon gojūgosho emaki; Hokekyō*

emaki; Kannonkyō emaki; Jūni'innen emaki, vol. 25 of *Shinshū Nihon emakimono zenshū* (Tokyo: Kadokawa Shoten, 1979), 40–49. See also http://www.metmuseum .org/TOAH/ho/07/eaj/ho_53.7.3.htm (accessed January 27, 2010).

14. Watson, *The Lotus Sutra,* 302.

15. Murase, "Kuan-yin," 68–70. I would like to thank Sinéad Kehoe for giving me the special privilege of viewing the scroll on February 5, 2010. For excellent digital images of the entire scroll, see the Metropolitan Museum of Art collection database, http://www.metmuseum.org/Collections/search-the-collections /60012552?rpp=20&pg=1&ft=kannon&pos=10 (accessed June 24, 2015).

16. Miya Tsugio, "Shussō *Kannongyō* no sho mondai," *Jissen joshidai bigaku bijutsu shigaku* 4 (1989): 82–101. For a discussion of style see also Julia Meech-Pekarik, "The Flying White Horse: Transmission of the Valāhassa Jātaka Imagery from India to Japan," *Artibus Asiae* 43, no. 1/2 (1981): 117–118.

17. See Gotō, *Kanzeon,* 346–399, for *Zuge Kannongyō* (Ch. *Tujie guanyinjing*), which was printed in 1433 (Xuande 8). This illustrated version of the *Kannon sūtra* mixes images of White-Robed Kannon with nine unidentified multiarmed images of Guanyin that float above scenes from the *Lotus sūtra.*

18. Uchida Keiichi, "Hasederashiki Jūichimen Kannon Bosatsu gazō ni tsuite," *Bukkyō geijutsu* 294 (September 2007): 26.

19. Nara Kokuritsu Hakubutsukan, *Saigoku,* cat. no. 115, p. 139, 271. See also Epprecht, *Kannon,* 144–145. The painting measures 116.6×58.8 cm.

20. A fifteenth-century painting now held by the Tokyo National Museum, known as *Kannon sanjūsan ōjin zu* (Thirty-Three Kannon transformation tableau), is a significant representation of the enumeration of the thirty-three guises. The central Eleven-Headed Kannon figure does not hold a monk's staff and so is not a representation of the Hasedera Kannon. Set against a dark blue ground, the central image is flanked by grids of smaller labeled images that match the *Kannon sūtra* guises. See Tokyo Kokuritsu Hakubutsukan, *Tokyo Kokuritsu Hakubutsukan zuhan mokuroku, Butsuga hen* (Tokyo: Tokyo Kokuritsu Hakubutsukan, 1987), 24, fig. 42, and Sherry Fowler, "Kannon Imagery in the Life of the Seventeenth-Century Manual *Butsuzō zui,*" forthcoming. This painting is on the Tokyo National Museum database, http://webarchives.tnm.jp/imgsearch / under image numbers C0035010, C0095269, E0024324 (accessed March 22, 2013). An earlier related source for Thirty-Three Kannon manifestations is found in a set of twenty-two large scrolls of *Lotus sūtra* paintings made in 1326–1328 from Honpōji in Tōyama City. The twentieth scroll in the set, which is dated to 1328 (Karyaku 3), illustrates the *Kannon sūtra.* The Thirty-Three Kannon guises are lined up in two rows with small, labeled cartouches above their heads. Below are scenes of the various perils from which Kannon can save beings. See Tanabe, *Paintings of the Lotus sūtra,* 117–122, fig. 46. Tanabe refers to them as "*Lotus sūtra hensō.*" Also see Nara Kokuritsu Hakubutsukan, *Saigoku,* cat. no. 106, pp. 128, 268.

21. Gangōji Bunkazai Kenkyūjo, *Buzan Hasedera shūi* (Sakurai: Sōhonzan Hasedera Bunkazai Tō Hozon Chōsa Iinkai, 1994), vol. 1, figs. 177–209, pp. 58–63. Each

painting on the wooden doors is about 104 × 40 cm. With the exception of two unidentified images the others are labeled. For an earlier group (dated Ōei 12 [1405]) of thirty-three guises of Kannon painted on wood boards from Kosuge Jinja in Mizuho, Nagano prefecture, see Nagano-ken, *Nagano kenshi: Bijutsu kenchiku shiryō hen; bijutsu kōgei* (Nagano-shi: Nagano Kenshi Kankōkai, 1992), 29–30. Although these paintings (each measuring approximately 60.2 × 26.9 cm) are very faint, they have significant inscriptions with date, location, donor names, and identification of the guises. See also Tokyo Bunkazai Kenkyūjo, *Nihon kuigashi nenki shiryō shūsei; Jūgo seiki* (Tokyo: Chuo Kōron Bijutsu Shuppan, 2011), 17–20.

22. Gangōji Bunkazai Kenkyūjo, *Buzan Hasedera shūi,* vol. 3, figs. 4–36, pp. 40–45.

23. See Nara Kokuritsu Hakubutsukan, *Ishiyamadera no bi* (Ōtsu: Daihonzan Ishiyamadera, 2008), 70–71, 193, cat. no. 8. See also Ōtsu Rekishi Hakubutsukan, *Ishiyamadera to konan no butsuzō* (Ōtsu: Ōtsu Rekishi Hakubutsukan, 2008), fig. 33, p. 37. Since Ishiyamadera's two-armed eleventh-century main image of Nyoirin Kannon is kept as a secret image, the thirty-three guises help to enhance the presence of a normally invisible Kannon icon within the context of the *Lotus sūtra*. For Kōmyōji, see Fujita Tsuneyo, "Kaname Kannondō no Kannon sanjūsanshin zō," *Hiratsukashi bunkazai chōsa hōkokusho* 8 (1968): 5–16. One of the sculptures (the young girl) has an inscription dated to 1498 (Meiō 7). See also http://www.city.hiratsuka.kanagawa.jp/rekisi/33ougen.htm (accessed January 25, 2010). In the photograph on this site, and in Honda Fujio, *Kannon Bosatsu* (Tokyo: Gakken, 2004), 98–99, the sculptures are displayed along with sculptures of the Seven Kannon. The latter are the same size, but I have not been able to determine when they were made. For the Kamakura Hasedera set see http://www.city.kamakura.kanagawa.jp/kokuhoukan/documents/27-04hasedera_list.pdf (accessed June 24, 2015). A variety of images are mixed in with the group.

24. Nara Kokuritsu Hakubutsukan, *Saigoku,* 271. See Nagai Yoshinori, ed., *Hasedera genki: Ihon* (Tokyo: Koten Bunko, 1953), 42–43.

25. Yamaguchi Kenritsu Bijutsukan, *Zendera no eshitachi: Minchō, Reisai, Sekkyakushi* (Yamaguchi: Yamaguchi Kenritsu Bijutsukan, 1998), 32–39, 137–139. Kōno Minoru et al., *Chūgoku shōkei: Nihon bijutsu no himitsu o sagure* (Machida-shi: Machida Shiritsu Kokusai Hanga Bijutsukan, 2007), 30–31, 191.

26. See Sakazaki Shizuka, ed., *Nihon garon taikan* (Tokyo: Arusu, 1927), vol. 2, pp. 924–925. About *Tansei jakubokushū* see Karen Gerhart, "Talent, Training, and Power: The Kano Workshop in the Seventeenth Century," in *Copying the Master and Stealing His Secrets: Talent and Training in Japanese Painting,* eds. Brenda Jordon and Victoria Weston (Honolulu: University of Hawai'i Press, 2002), 20, n. 43, p. 201.

27. For the Sansetsu paintings see Kyoto Bunka Hakubutsukan, *Miyako no eshi wa hyakka ryōran* (Kyoto: Kyoto Bunka Hakubutsukan, 1998), 42, fig. 0–1.

28. For two fifteenth–century printed Chinese versions of the sutra in the Harvard University Art Museums see Marsha Weidner, ed., *Latter Days of the Law:*

Images of Chinese Buddhism 850–1850 (Lawrence, Kans.: Spencer Museum of Art, 1994), 309–311, 313–314.

29. For a sixteenth-century album of Guanyin paintings, see Marsha Weidner et al., *Views from Jade Terrace: Chinese Women Artists, 1300–1912* (Indianapolis, Ind.: Indianapolis Museum of Art, 1988), 70–72. For others see Guoli gugong bowuyuan, *Guanyin tezhan* (Visions of Compassion: Images of Kuan-yin in Chinese art) (Taipei: Guoli gugong bowuyuan, 2000), 64–87, 90–93.

30. Igarashi Kōichi, "Tōfukuji zō sanjūsan Kannon zō," *Bijutsushi ronsō* 11 (March 1995): 199, and see 215–225 for comparisons between the Tōfukuji paintings and a set of prints from 1395 that are now in a private collection. See also Yamaguchi Kenritsu Bijutsukan, *Zendera*, 138 (Igarashi is the author of this entry). A set of Chinese paintings similar in iconography, painted in gold on blue paper and dated to 1451, is in the Anhui Museum. See Zhongguo gudai shuhua jianding zubian, *Zhongguo gudai shuhua tumu* (Illustrated catalogue of selected works of ancient Chinese painting and calligraphy), vol. 12 (Beijing: Wenwu chubanshe, 1986), 209–210, 374.

31. Kōno et al., *Chūgoku shōkei*, 28, 190–191.

32. Hata Yasunori, "Sesshū no Kannon hensōzu o megutte," in *Ronshū tōyō nihon bijutsushi to genba: Mitsumeru, mamoru, tsutaeru* (Collected essays of East Asian and Japanese art history and place: Looking, protecting, transmitting) (Tokyo: Chikurinsha, 2012), 100–101.

33. Tokyo Kokuritsu Hakubutsukan, *Kyoto Gozan Zen no bunka ten: Ashikaga Yoshimitsu roppyakunen goki kinen* (Tokyo: Nihon Keizai Shinbunsha, 2007), 219, 341. See also Yamaguchi Kenritsu Bijutsukan, *Sesshū Tōyō: Sesshū e no tabi ten kenkyū zuroku* (Tokyo: Chūō Kōron Bijutsu Shuppan, 2006), 54, 148. In the same year (1486) Sesshū went to China and also painted the famous "Long Landscape Scroll."

34. Tajima Shiichi, ed., *Sesshū gashū* (Tokyo: Shinbi Shoin, 1909), n.p. Jon Carter Covell, *Under the Seal of Sesshū* (New York: Hacker Art Books, 1975), 102–103, cat. 61, fig. 14a, notes that the painting's inscription at the top from the *Kannon sūtra* is in gold. She only includes a detail of the standing Kannon image. The painting (104.2×45.7 cm, ink and color on paper) is also cited in Mabuchi Miho, "Maruyama Ōkyo 'nanpuku zukan' to *Kannongyō*, Kannongyōe," *Bijutsu ronsō* 19 (February 2003): fig. 1, p. 103; Hata, "Sesshū no Kannon," 100–101. For translation see Watson, *The Lotus Sutra*, 299.

35. See similar example of the scene in a Chinese print made in 1433 in Gotō, *Kanzeon*, 353. The waves toss the buildings around more violently in the print.

36. Watson, *The Lotus Sutra*, 304.

37. This painting, which is now held by Kyushu National Museum, is ink and color on paper and measures 105.3×45.5 cm. See Tokyo Kokuritsu Hakubutsukan, *Kyoto Gozan Zen no bunka ten*, fig. 180, pp. 219, 341.

38. See example of the scene in a Chinese print made in 1433 in Gotō, *Kanzeon*, 392.

39. Tokyo Kokuritsu Hakubutsukan, *Sesshū: Botsugo 500-nen tokubetsuten* (Tokyo: Mainichi Shinbunsha, 2002), figs. 139–140, pp. 288–289.

40. Yamaguchi Kenritsu Bijutsukan, *Sesshū*, fig. 23, pp. 148–150. For photograph see Geijutsu Daigaku database: http://jmapps.ne.jp/geidai/det.html?data_id =16407 (accessed June 24, 2015). The painting measures 116.7 × 50.2 cm.

41. Bettina Klein and Kojima Kaoru, "Berurin tōyō bijutsukan zō shukuzu shochō '*Hitsuen itsuyō*,'" *Kokka* 1091 (February 1986): 43. The specific painting in the album is numbered 792, 40.

42. Watson, *The Lotus Sutra*, 304.

43. Tokyo Kokuritsu Hakubutsukan, *Sesshū*, fig. 110, pp. 166, 216, 277–278. The handscroll is ink and light color on paper and measures 26.7 × 879.8 cm. The author of the catalogue entry, p. 278, speculated that the paintings were made after the Early Modern (*kinsei*) period.

44. Kawasaki Chitora, "Takuhō hitsu sanjūsan Kannon ni tsuite," *Kokka* 135 (August 1901): 45–48; Kobe Shiritsu Hakubutsukan et al, *Ingen zenshi to Ōbakushū no kaigaten* (Kobe: Kobe-shi Supōtsu Kyōiku Kōsha, 1991), 103. Tokyo National Museum owns the paintings but does not list them under Takuhō's name, so there may be some question as to their authenticity.

45. Kakushū also went by the names Genkō and Sumiyoshi Hironatsu. Igarashi Kōichi, "Kakushū Reikō ni tsuite," *Kobijutsu* 105 (February 1993): 104–105. Igarashi discusses the possibilities for the different birth and death dates for Kakushū. The earliest set attributed to him, which formerly belonged to Kōchiji in Osaka (Settsu), was made in 1679 (Enpō 7) and is now in the Tokyo National Museum. Tokyo Kokuritsu Hakubutsukan, *Tokyo Kokuritsu Hakubutsukan zuhan mokuroku, Butsuga hen*, cat. nos. 43 and 44, pp. 25–35.

46. The Hōnenji paintings are in a 1692 (Genroku 5) set of folding screens. The Gokokuji set was made shortly afterward. See Patricia Graham, *Faith and Power in Japanese Buddhist Art, 1600–2005* (Honolulu: University of Hawai'i Press, 2007), 138–141. For the Gokokuji set, see Tajima Shiichi, ed., *Shinbi taikan* (Nihon Shinbi Kyōkai, 1902), vol. 7, unpaginated. See also Kobe Shiritsu Hakubutsukan, *Ingen zenshi*, 73, 76, 103–104; Takamatsushi Rekishi Shiryōkan, *Busshōzan Hōnenji no meihōten* (Takamatsu-shi: Takamatsushi Rekishi Shiryōkan, 1992), 26–32, 44–45; Namikawa Banri, *Sanuki no hihō* (Tokyo: Heibonsha, 1985), 318 and figs. 448–460, Igarashi, "Kakushū," 111. For one Hōnenji screen, see http://www .city.takamatsu.kagawa.jp/5778.html (accessed June 22, 2015).

47. Nakamura Kiyoshi, ed., *Kannon sanjūsanshin* (Kyoto: Ikkyū Shūonkai, 1985), 2–21; Kyoto Furitsu Sōgo Shiryōkan, ed., *Hara Zaichū to sono ryūha* (Kyoto: Kyoto Furitsu Sōgo Shiryōkan Tomo no Kai, 1976), n.p.; Yamaguchi Kenritsu Bijutsukan, *Zendera*, 139. See also Nagata Ken'ichi, "Harada Naojirō 'kiryū' Kannon (1890) ni okeru 'teikoku nihon' no gūi," *Bijutsushi* 167 (vol. 59, no. 1): fig. 5, p. 233 and figs. 2 and 4 for other examples.

48. Kyoto Kokuritsu Hakubutsukan, *Minami Yamashiro no koji junrei* (Kyoto: Kyoto Kokuritsu Hakubutsukan, 2014), 165–167, 216, cat. no. 131. According to inscriptions on the box lids, the paintings are by Zaichū, and Daiten, who was a patron and friend of the painter Itō Jakuchū, brushed the calligraphy for the sutra text on the paintings.

49. Igarashi, "Tōfukuji," 207. See also Yamato Bunkakan, *Sūkō naru sansui: Chūgoku Chōsen Rikakukei sansuiga no keifu tokubetsuten* (Nara: Yamato Bunkakan, 2008), fig. 34, pp. 74–75, 151–152, and Kang Soyon, "Chōsen zenki no Kannon Bosatsu no yōshikiteki henyō to sono ōshin myōhō no zuzō," *Bukkyō geijutsu* 276 (September 2004): 77–103, about an important Korean painting on silk, made in 1550 by the artist I Jasil (owned by Chionin in Kyoto), with a main Kannon image in the center, eight Buddhas above, and various scenes of the guises below.

50. Murano Shinsaku, "Den Shōkei hitsu 'Kannon zu' (Kenchōji shozō) sanjūni fuku no kenkyū," *Kajima bijutsu zaidan nenpō* 26 (2008): 482–491. See also http://www.tobunken.go.jp/materials/gahou/109254.html (accessed August 11, 2015). *Nihon bijutsu gahō,* vol. 3, no. 6 (November 1896), n.p.

51. The paintings were displayed in the exhibition "Kenchōji no Kannon zu~32 fuku zenbu misemasu yo!~" at Kamakura Kokuhōkan, June 10–July 11, 2010. For three of the paintings, see https://www.city.kamakura.kanagawa.jp/kokuhoukan/kaiga.html (accessed June 21, 2015). See also Tokyo Kokuritsu Hakubutsukan, *Kamakura, Zen no genryū: Kenchōji sōken 750-nen kinen tokubetsuten* (Tokyo: Nihon Keizai Shinbunsha, 2003), 174–179, 236, cat. no. 150.

52. Shibusawa Tatsuhiko et al., *Kenchōji* (Kyoto: Tankōsha, 1981), 143–144, figs. 43–44. For small black-and-white pictures of each painting, see Monbushō Bunkachō, ed., *Jūyō bunkazai 10, Kaiga* IV (Tōkyō: Mainichi Shinbunsha, 1972–1977), 62–63, fig. 128. Each painting measures approximately 128.5×51.8 cm. Murano, "Den Shōkei," 488. Yoshiaki Shimizu and Carolyn Wheelwright, eds., *Japanese Ink Paintings from American Collections: The Muromachi Period: An Exhibition in Honor of Shūjirō Shimada* (Princeton, N.J.: Princeton University Press, 1976), 50.

53. For details on the inscriptions see, Murano, "Den Shōkei," 482–484. For the complete record from 1670 (Kanbun 10), see Kamakura-shi Shishi Hensan Iinkai, *Kamakura shishi: Kinsei shiryō hen dai 2* (Tokyo: Yoshikawa Kōbunkan, 1987), 189–191.

54. Takahashi Shinsaku, "Den Shōkei hitsu 'Kannon zu' (sanjūni fuku) ni miru Kamakura chihō yōshiki to Kannon senpō," *Kokka* 1430 (May 2014): 18.

55. Helmut Brinker and Hiroshi Kanazawa, *Zen, Masters of Meditation in Images and Writings,* trans. Andreas Leisinger (Zürich: Artibus Asiae, 1996), 131; Gregory Levine and Yukio Lippit, *Awakenings: Zen Figure Painting in Medieval Japan* (New Haven, Conn.: Yale University Press, 2007), 39; Yü, *Kuan-yin,* 127.

56. Igarashi, "Tōfukuji," 198.

57. *Inryōken nichiroku* (Diary of the Inryōken cloister), written by Kikei Shinzui (d. 1469), includes entries about this from the second month, seventh to tenth days of Bunshō 1 (1466). See *DNBZ* 134:81–83. See also Igarashi, "Tōfukuji," 210, n. 2.

58. Tatehata Atsuko, "Tōfukuji zō Minchō hitsu sanjūsan Kannon zu ni kansuru ichikōsatsu," *De arute* 26 (2010): 57.

59. Takahashi, "Den Shōkei hitsu 'Kannon zu,'" 15–18.

60. Hata Yasunori, "Sesshū no Kannon hensōzu o megutte," in *Ronshū tōyō nihon bijutsushi to genba: Mitsumeru, mamoru, tsutaeru* (Tokyo: Chikurinsha, 2012), 104. Tatehata, "Tōfukuji zō Minchō," 56–57, determined that the inscriptions were not put on originally.

61. Quitman E. Phillips, "Narrating the Salvation of the Elite: The Jōfukuji Paintings of the Ten Kings," *Ars Orientalis* 33 (2003): 127; Karen Gerhart, *The Material Culture of Death in Japan* (Honolulu: University of Hawai'i Press, 2009), 155.

62. For images of the paintings and details about reading their postscript, see: http://www.itijyoin.or.jp/reading/33kannon/index.html (accessed May 3, 2016). See also Sakurai Megumu, *Kūkai no sekai: Kongōrei no hibiki* (Tōkyō: Amyūzu Bukkusu, 2000), 150–151.

63. The section on Ichijōin in the record *Kiizoku fudoki,* compiled 1839, corroborates the colophon by recording that the temple owns thirty-three paintings of Kannon made by Mu Qi that were donated by the nun Naoe (Osen). See *Zoku Shingonshū zensho* (Wakayama-ken, Ito-gun, Kōyasan: Zoku Shingonshū Zensho Kankōkai, 1975–1988), vol. 37, p. 316.

64. Yukio Lippit, *Colorful Realm: Japanese Bird-and-Flower Paintings by Itō Jakuchū* (Washington, D.C.: National Gallery of Art, 2012), 156–160. See also Kyoto Kokuritsu Hakubutsukan, *Minami Yamashiro no koji junrei,* 216, about Jakuchū's friend and patron Daiten, whose seal and signature are on the box for the Ikkyūji set.

65. See www.ikkyuji.org/gyouji/gyouji_8.html (accessed June 19, 2015) and http://www.ikkyuji.org/en/ (accessed June 19, 2015). See also Tanabe Sōichi, *Ikkyūji,* vol. 14 of *Kyō no koji kara* (Kyoto: Tankōsha, 1995), 89. As other temples have the custom of displaying paintings of the six paths (*rokudoe*) during Obon to help the dead and because Kannon can help the dead navigate the six paths, Ikkyūji's practice is not surprising.

66. Nakamura, *Kannon sanjūsanshin,* 3.

67. Lippit, *Colorful Realm,* 159.

68. For general sources on the pilgrimage see Nara Kokuritsu Hakubutsukan, *Saigoku sanjūsansho,* 214–227; http://sacredjapan.com/ (accessed June 24, 2015).

69. Ishikawa Tomohiko, "Sanjūsan Kannon mandara zu ni tsuite—Kegonji bon to Kannonshōji bon no zuzōteki shomondai," *Bukkyō geijutsu* 189 (March 1990): 34–60.

70. Nara Kokuritsu Hakubutsukan, *Saigoku,* 186, 189, 283–284. Ishikawa, "Sanjūsan," 35–36. The dates for the record are contested, and might be earlier, but most scholars agree that it is from the thirteenth century. Kevin Carr, *Plotting the Prince: Shōtoku Cults and the Mapping of Medieval Japanese Buddhism* (Honolulu: University of Hawai'i Press, 2012), 39–41, discusses another early pilgrimage mandala (fourteenth–fifteenth century) from Kannonshōji, which includes an image of Prince Shōtoku and thus demonstrates his connection with Kannon.

71. See Osaka Shiritsu Bijutsukan, *Saikoku sanjūsansho Kannon reijō no bijutsu* (Osaka: Osaka Shiritsu Bijutsukan, 1987), 212, figs. 220–222, and Tōbu Bijutsukan et al.,

Saigoku sanjūsansho: Kannon reijō no shinkō to bijutsu (Tokyo: Nihon Keizai Shinbunsha, 1995), 114–117, 156–157, figs. 74–77, for examples. Shiraki Toshiyuki, "Sanjūsansho Kannon zuzō ni tsuite," *Mikkyō zuzō* 10 (November 1991): 76–82, reports that the oldest extant example, fig. 74, dates from 1544 (Tenbu 13) and is from Nakayamadera. For other examples see Kanagawa Kenritsu Kanazawa Bunko, *Bukkyō hanga* (Yokohama: Kanagawa Kenritsu Kanazawa Bunko, 1993), 31, 58–59, figs. 81–84. See also Sherry Fowler, "Views of Japanese Temples and Shrines from Near and Far: Precinct Prints of the Eighteenth and Nineteenth Centuries," *Artibus Asiae* 68, no. 2 (2008): 247–285.

72. Fowler, "Views of Japanese Temples and Shrines from Near and Far," fig. 12, p. 261.

73. Katō Takeo, "Gifu Chūnō chihō no Saigoku sanjūsan Kannon," *Nihon no sekibutsu* 88 (December 1998): 55–57.

74. For a miniature Edo-period sculpture set, see Tōbu Bijutsukan et al., *Saigoku,* 134, 158, cat. no. 94.

75. Other than the Six Kannon, depictions of the Four Guardian Kings and apsaras can be found on bells. This section has been modified from my article, Sherry Fowler, "Saved by the Bell: Six Kannon and *Bonshō,*" in *China and Beyond in the Medieval Period: Cultural Crossings and Inter-Regional Connections,* eds. Dorothy Wong and Gustav Heldt (Amherst, N.Y.: Cambria Press, 2014), 329–350.

76. For the Chinese bell see Sugiyama Hiroshi, "Bonshō," *Nihon no bijutsu* 355 (December 1995): fig. 25, p. 15, and see fig. 2, p. 20, for the Myōshinji bell, which originally belonged to Jōkongōin in Saga, Kyoto, and is now housed in the Dharma Hall at Myōshinji. See also Tokyo Kokuritsu Hakubutsukan, *Myōshinji: Kaizan Musō Daishi 650-nen onki kinen* (Tokyo: Yomiuri Shinbunsha, 2009), fig. 148, pp. 237, 379. The *Tenjukoku shūchō* embroidery contains fragments from the seventh and thirteenth centuries. Its image of a monk ringing a bell dates from the thirteenth century, but according to Chari Pradel, it follows the design of the seventh-century original (personal communication, January 2, 2011). See Sugiyama, "Bonshō," fig. 32, p. 20. For some information on the Chinese and Korean prototypes for the temple bell, see Lothar von Falkenhausen, *Suspended Music: Chime-Bells in the Culture of Bronze Age China* (Berkeley: University of California Press, 1993), 76, 80, 139, 191.

77. Manabe Takashi, *Edo Tokyo bonshō meibunshū* (Tokyo: Bijinesu Kyōiku Shuppansha, 2001), 16–17.

78. I have taken much of this information from Nakada Junna, *Honsenji daibonshō monogatari* (Tokyo: Honsenji, 2011). This small publication, given to me by the temple, includes many excellent period photographs. The following websites are also very helpful and duplicate some information in the book. See http://www.evam.ne.jp/honsenji/history.html (accessed June 24, 2015) and http://www.geneve-shinagawa.ch/cloche.html (accessed June 22, 2015).

79. "Bell That Has Travelled," *Japan Times & Mail,* July 30, 1934, 8.

80. For information and controversy over using Buddhist bells as symbols of friendship, see Miriam Levering, "Are Friendship *Bonshō* Bells Buddhist

Symbols? The Case of Oak Ridge," *Pacific World: Journal of the Institute of Buddhist Studies,* 3rd series, no. 5 (Fall 2003): 163–178.

81. Niizuma, *Shōwa shinsen Edo sanjūsansho Kannon junrei* (Osaka: Toki Shobō, 2005), 202–203.

82. See Graham, *Faith and Power,* 99–101.

83. *Edo meisho zue,* eds. Saitō Chōshu (1737–1799) et al. (Edo: Suharaya Mohē, 1836), vol. 4, p. 28. See http://archive.wul.waseda.ac.jp/kosho/ru04/ru04_05105/ for image of volume held by Waseda Library (accessed April 29, 2016). For a reproduction, see Ikeda Yasaburo et al., *Nihon meisho fūzoku zue* (Tokyo: Kadokawa Shoten, 1979–1988), vol. 4, 98–99.

84. The Chichibu pilgrimage added an additional temple, so it has thirty-four stops.

85. Reader discusses the contemporary use of *osamefuda* for pilgrimage in Ian Reader and George Tanabe, *Practically Religious: Worldly Benefits and the Common Religion of Japan* (Honolulu: University of Hawai'i Press, 1998), 200–201.

86. Niizuma, *Shōwa shinsen,* 200–205.

87. While we should feel confident that the images represent the Six Kannon, there are some variations from the usual iconography in the number of arms; for example, Nyoirin has two arms and Thousand-Armed has only six arms. Both Yajima Yutaka, *Chichibu Kannon reijō kenkyū josetsu* (Tokyo: Hōshō Gakuen, 1966), 184, and Hirahata Yoshio, *Chichibu sanjūyonkasho* (Chiba-ken, Chōshi-shi: Fudasho Kenkyūkai, 1971), 126, claim one of the Kannon is a Fukūkenjaku with eight arms. No author has mentioned the possibility that this could be a Juntei image, although it is a possibility.

88. For a synopsis of the inscription see Yajima, *Chichibu,* 185–186.

89. Sumiko Enbutsu, *Chichibu: Japan's Hidden Treasure* (Rutland, Vt.: C. E. Tuttle, 1990), 71.

90. Ongakuji's bell is also famous for its role in calling the local farmers to revolt at the beginning of the Chichibu Rebellion in 1884. See Enbutsu, *Chichibu,* 195.

91. The website http://www.geocities.jp/koji_jyunrei/sub72.htm (accessed June 24, 2015) reports it as a standing image from the Muromachi period that measures 74.2 cm. See Saitama-ken Kyōiku Iinkai, ed., *Chichibu junreidō,* vol. 15 of *Rekishi no michi chōsa hōkokusho* (Saitama: Saitama Kenritsu Rekishi Shiryōkan, 1992), 104.

92. Most temples begin ringing the bell about 11:00 p.m. and pace it so that the one hundred and eighth strike is at midnight just as the new year begins. For the various theories as to why 108 is a sacred number, see Philip Nicoloff, *Sacred Kōyasan* (Albany: State University of New York Press, 2008), 158 and n. 73, pp. 311–312.

93. There is a possibility that the depiction of Six Kannon might have a relationship to the six hours of the day, but I have not been able to confirm this.

94. See Levering, "Are Friendship," 165, 167. Levering's article pointed me to the sources discussed below.

95. Yifa, *The Origins of Buddhist Monastic Codes in China: An Annotated Translation and Study of the Chanyuan qinggui* (Honolulu: University of Hawai'i Press, 2002), 26–27. See also *Shimen jiseng guidu tu jing* in Nakano Tekkei, *Nihon daizōkyō* (Tokyo: Nihon Daizōkyō Hensankai, 1914–1919), vol. 21, pp. 390–396.

96. Yifa, *The Rules of Purity of the Chan Monastery: An Annotated Translation and Study of the Chanyuan qinggui* (PhD diss., Yale University, 1996), 321 and n. 12, explains the eight difficulties, which are the (1) hell path; (2) hungry ghost path; (3) animal path; (4) heaven of longevity; (5) continent of Uttarakuru, where people are always happy; (6) state of blindness, deafness, or muteness; (7) state of worldly eloquent intellectuals; and (8) state of those born before or after the time of the Buddha.

97. Yifa, *The Rules*, p. 47 and n. 102, and *Fu fazang yinyuan zhuan* (J. *Fuhōzō innenden*), (Account of the causes and conditions of the Dharma-treasury transmission), *T* 50:315b–316. This translation has been traditionally attributed to the fifth-century monks Tanyao and Kiṃkārya (Ch. Jijiaye), but it may be a sixth-century text. Also in *Sifen lü shanfan buque xingshi chao, T* 40:6c, l. 21–24.

98. Yifa, *The Rules*, 275, and Yifa, *The Origins*, 169–170, 291–292, n. 50. See also *Xu Gaoseng zhuan, T* 50:695b–c. Makita Tairyō, "Zui chōan Dai Zenjōji Chikō ni tsuite," in *Chūgoku bukkyōshi kenkyū*, vol. 2 (Tokyo: Daitō Shuppansha, 1984), 16–27, discusses other extant versions of the story, which indicates it had widespread significance in China. Moreover, the Japanese monk Myōe (1173–1232) included Zhixing in his writings on the efficacy of bell ringing to help others. See Mark Unno, *Shingon Refractions: Myōe and the Mantra of Light* (Somerville, Mass.: Wisdom Publications, 2004), 135–136, 247–249.

99. The Zen master Dōgen (1200–1253) is one example of a significant teacher in Japan who imported and promoted the Chinese rules for monks, which included proper methods for ringing the bell. See Dōgen (1200–1253), *Dōgen's Pure Standards for the Zen Community: A Translation of the Eihei shingi*, trans. Taigen Daniel Leighton and Shohaku Okumura (Albany: State University of New York Press, 1995), 69. The description is mainly about when to hit the bells for time keeping. The meanings of striking the bells do not seem to be discussed in Japanese sources as often as in Chinese sources.

100. Ōtsuka Katsumi, "Chūsei ni okeru bonshō to hitobito no kurashi," *Suzaku Kyoto Bunka Hakubutsukan kenkyū kiyō* 2 (March 1989): 68. See Tsuboi Ryōhei, *Nihon koshōmei no shūsei* (Tokyo: Kadokawa Shoten, 1972), 234–235 and 201, respectively.

101. The custom of "*mukaegane*" (welcoming bell) is still observed, which can be seen in videos on YouTube: http://www.youtube.com/watch?v=xx9WvlokIUA (accessed June 24, 2015). This bell is located inside a closed bell tower.

102. Ōtsuka, "Chūsei," 66–67.

103. Koichi Shinohara, "The Moment of Death in Daoxuan's Vinaya Commentary," in *The Buddhist Dead*, eds. Bryan J. Cuevas and Jacqueline I. Stone (Honolulu: University of Hawai'i Press, 2007), 121. In Japan a *kei* is generally a small, flat, scalloped gong and very different in shape from a large temple bell.

104. Helen Craig McCullough, trans., *The Tale of the Heike* (Stanford, Calif.: Stanford University Press, 1988), 23.

105. Ibid., 436.

106. Yoshida Kenkō, *Essays in Idleness: The Tsurezuregusa of Kenkō,* trans. Donald Keene (New York: Columbia University Press, 1967), 18.

107. See Kan Ken'ei, *Richō no bi: Butsuga to bonshō* (Tokyo: Akashi Shoten, 2001), 57, 63–64. I am grateful to Maya Stiller for alerting me to this source.

108. Tokyo Kokuritsu Hakubutsukan, *Myōshinji,* fig. 150, pp. 239, 380.

109. About the Bandō pilgrimage see Mark MacWilliams, "Temple Myths and the Popularization of Kannon Pilgrimage in Japan: A Case Study of Ōya-ji on the Bandō Route," *Japanese Journal of Religious Studies,* 24, nos. 3–4 (1997): 375–411.

110. This information is in http://www.nichibun.ac.jp/graphicversion/dbase /reikenki/bando/reijo25.html (accessed June 24, 2015). The story of the bell may also be found in Shimizudani Zenshō, *Kannon no fudasho to densetsu* (Tokyo: Yūkōsha, 1940), 191. An original copy of the book, which was illustrated by Umedō Kunimasa (1848–1920), is in the Nichibunken library. See Hattori Ōga (a.k.a. Mantei Ōga [1818–1890]), *Bandō junrei sanjūsansho mokuroku,* n.p., n.d. According to Katō Mitsuo in Hayami, *Kannon shinkō jiten,* p. 181, Kunimasa's book was published in 1882 to coincide with the special openings of the main images at the Bandō temples. The book was also published as one volume in *Saigoku Bandō Chichibu: Hyakuban Kannon reigenki,* by Mantei Ōga (Tokyo: Kodama Yakichi, 1882). See National Diet Library Digital Collections database. http://kindai.ndl.go.jp/info:ndljp/pid/818856 (accessed May 4, 2016). For information on Tokuitsu, see Ryūichi Abe, *Weaving of Mantra* (New York: Columbia University Press, 1999), 204–214.

111. http://www.d1.dion.ne.jp/~s_minaga/sos_tukubasan.htm (accessed June 24, 2015).

112. *Bandō Saikoku Chichibu hyaku Kanzeon reijōki* (Tōkyō: Hakubunkan, 1903), 26. See also Shimizutani Kōshō, *Junrei to goeika Kannon shinkō e no hitotsu no dōhyō* (Osaka: Toki Shobō, 1992), 331–332. All the Kannon pilgrimage temples have accompanying verses.

113. See "Rokusho jinja ato" in *Nihon rekishi chimei taikei* (accessed July 5, 2010). The shrine was incorporated into Kogage Jinja in Kangōri, Tsukuba. See also Ibaraki Kenritsu Rekishikan, *Tsukubasan: Kami to hotoke no owasu yama* (Mito: Ibaraki Kenritsu Rekishikan, 2013), 28–29, about Rokusho Jinja's treasures, including a reference to a fifteenth-century bell and drawings of a Kannon *honji* mirror dedicated to the shrine in 1195 (Kenkyū 6).

114. One version of the story of the "Tide-Calling Bell" appears in the section on Ōmidō in *Sanjūsansho Bandō Kannon reijōki* (1771 [Meiwa 8]), n.p. See Kanezashi Shōzō, *Saigoku Bandō Kannon reijōki* (Tokyo: Seiabō, 1973), 325–326.

115. See Susan Blakely Kline, "When the Moon Strikes the Bell: Desire and Enlightenment in the Noh Play Dojoji," *Journal of Japanese Studies* 17, no. 2 (Summer 1991): 291–322. See also Ōtsuka, "Chūsei," 69.

116. The Asian Art Museum of San Francisco acquired a bell, h. 146.7 cm, dated to 1532 (Tenmon 1) that formerly belonged to Daienji in Tajima, which includes images of waves around the base, above which are dragons. In addition, one of its inscriptions is a dedication to Kannon, "Namu Kanzeon Bosatsu." The bell was given to the Fine Arts Museums in 1934 and transferred to the Asian Art Museum in 1984. Melissa Rinne, former assistant curator of Japanese art, Asian Art Museum of San Francisco, provided this information on October 14, 2009.

117. For a late-nineteenth-century foreigner's perspective of the area see, C. W. Lawrence, "Notes of a Journey in Hitachi and Shimosa," *Transactions of the Asiatic Society of Japan* 2 (1874): 177. "The meaning of the word Tsukuba is "a bank heaped up to resist the waves," and the gods and goddesses to whom the shrines are dedicated are said to have caused the sea to retire beyond what is now the island of Kashima. As the country is perfectly level up to the base of the mountain it is very probable that the sea has receded on this coast."

118. I am grateful to Yoshiko Kaneko for telephoning the temple on October 3, 2009, and asking if there were any images on the bell. The person who answered said no and seemed to find it a strange question.

119. See entry "Chichibu junrei michi" in *Nihon rekishi chimei taikei* (accessed June 17, 2009) about the addition of the thirty-fourth stop on the Chichibu pilgrimage route. According to this website, the concept of grouping the one hundred Kannon from the three pilgrimage routes occurred in the sixteenth century.

120. According to *Reijo no jiten* (Tokyo: Gakken, 1997), 176, there is also a seated image of the Eleven-Headed Kannon inside the hall.

121. Saitama-ken Kyōiku, *Chichibu,* 101. Yajima, *Chichibu,* 142, and Hirahata, *Chichibu sanjūyonkasho,* 92–93, describe the sculpture as dating from the late Kamakura period (1185–1333), which may be before the inscription was discovered. See picture of Jōrinji's main Kannon image in Hirahata, p. 94. The website "Fudasho mairi" gives the picture of a modern standing image, which is likely a *maedachi.* See http://www.geocities.jp/fudasyo34_jp/temple-17.htm (accessed June 24, 2015).

122. Kōno Zentarō, *Chichibu sanjūyon fudasho* (Urawa-shi: Saitama Shinbunsha, 1984), 83. *Shinpen Musashi fudoki kō,* ed. Hayashi Jussai (1768–1841) (Tokyo: Rekishi Toshosha, 1969), vol. 8, p. 550, repeated the information and added that the main image was made by the master sculptor Unkei (d. 1223).

123. In addition to the date, the name of the patron Shibata Shinemon of Kami Shinden, Ōsatogun, Musashi, and name of the bronze caster Shimizu Buzaemon Kiyonaga of Kami Koyōmura, Hikigun, Musashi, are cast into the Jōrinji bell.

124. Some variations of the story interpret the *osugata,* "honored form," to be a vision of Kannon.

125. Jōrinji is associated with helping children. Temple legend is that it was founded by a man who wanted to atone for causing harm to an abandoned child, who

was raised by the monks. See Enbutsu, *Chichibu,* 62–63; Yajima, *Chichibu,* 144–145; Hirahata, *Chichibu,* 94–95; and *Shinpen Musashi fudoki kō,* vol. 8, 550–551. There is a print featuring this episode within the series *Kanzeon reigenki* (Record of the miracles of Kannon), made in 1859 (Ansei 6) by Utagawa Kunisada I (Toyokuni III) (1786–1864) and Utagawa Hiroshige II (Shigenobu) (1826–1869). See http://www.nichibun.ac.jp/graphicversion/dbase/reikenki/chichibu/. The Nichibunken database has images of all the Kannon prints, with modern translations of the text and details. The Museum of Fine Arts, Boston, also owns a set.

126. The author of the poem chose the word *sadameshi* ("to settle") because it is the same character as the first in the name Jōrinji. The temple is more popularly known as Hayashidera (temple in the woods). For the poem, see Yajima, *Chichibu,* 144–145, and *Shinpen Musashi fudoki kō,* vol. 8, p. 551. I am grateful to John Carpenter for his assistance with the translation of this poem. See also Shimizutani, *Junrei to goeika,* 349.

127. See *Zōho shoshū Butsuzō zui,* vol. 2, pp. 13–17. For an English translation see Hidenobu, *Buddhist Iconography in the Butsuzōzui of Hidenobu,* ed. Anita Khanna (New Delhi: D. K. Printworld, 2010), 68–75. For a chart that compares *Butsuzō zui* images with the Tōfukuji paintings and the guises of Kannon in *Shōmugekyō* (Ch. *Shewuai jing*), see Yamaguchi Kenritsu Bijutsukan, *Zendera,* 127.

128. A general discussion on the images of the Thirty-Three Kannon in *Butsuzō zui* is in Epprecht, *Kannon,* 62; Tajima Sei, "Iroiro na Kannon sama 3—Sanjūsan Kannon," *Daihōrin* (June 2009): 86–89. For the Clamshell Kannon see Fujita Takuji, "Sanjūsan Kannon no monogatari—Kōri Kannon," *Zen bunka* 210 (2008): 81–87, and Yü, *Kuan-yin,* 187–188, 515, n. 16. See also Fujita Takuji, "Sanjūsan Kannon no monogatari—Ichiyō Kannon," *Zen bunka* 214 (2009): 33–40.

129. Yü, *Kuan-yin,* 6. See also Yuhang Li, "Gendered Materialization: An Investigation of Women's Artistic and Literary Reproductions of Guanyin in Late Imperial China" (PhD diss., University of Chicago, 2011).

130. Aoki Shigeru and Kobayashi Hiromitsu, *Chūgoku no yōfūga ten: Minmatsu kara shin jidai no kaiga, hanga, sashiebon* (Machida: Machida Shiritsu Kokusai Hanga Bijutsukan, 1995), 336–354, and Machida Shiritsu Kokusai Hanga Bijutsukan, *Sukui no hotoke: Kannon to Jizō no bijutsu* (Machida-shi: Machida Shiritsu Kokusai Hanga Bijutsukan, 2010), 114–115, 172. One known set of these prints is in the Machida Museum, and another is in the Shanghai Library. See Gao Ruizhe, "Qingchu Guanyin huapu cirong wushisan xianbanhua yanjiu" (A study of the woodcut paintings "Fifty-Three Presense [sic] of the Goddess of Mercy" in early Ching dynasty) (MA thesis, National Taiwan Normal University, 2006). I am grateful to Janet Chen for bringing this to my attention.

131. The small bird in flight appears in thirteen of the other prints in this series and is considered to be a connection between this world and paradise. The boy appears in twenty-four of the prints in this series. Aoki, *Chūgoku no yōfūga ten,* 340. For the story of the white parrot that accompanies Guanyin, see Chün-

fang Yü, "Guanyin: The Chinese Transformation of Avalokiteshvara," in *Latter Days of the Law: Images of Chinese Buddhism, 850–1850*, ed. Marsha Weidner (Lawrence, Kans.: Spencer Museum of Art, University of Kansas, 1994), 165–166, 178, n. 28. Yü, 361, states that the willow, boy, and parrot are standard iconography of the Guanyin of the South Seas.

132. Aoki, *Chūgoku no yōfūga ten*, 336.

133. For *Avataṃsaka sūtra* references to Sudana and the section on Avalokiteśvara, see Thomas Cleary, trans., *The Flower Ornament Scripture* (Boston: Shambhala, 1993), 45, 1275–1280, 1601–1602. For a discussion about the subject in painting see Jan Fontein, *The Pilgrimage of Sudhana: A Study of Gaṇḍavyūha Illustrations in China, Japan and Java* (The Hague: Mouton, 1967).

134. Shisendō in Kyoto has an iron sculpture of Wife of Mr. Ma made in the seventeenth century. For a black-and-white photograph, see Ishikawa Takudō, ed., *Shisendō* (Kyoto: Shisendō Jōzanji, 1971), 103. See also the temple website, http://www.kyoto- shisendo.com/temple.html (accessed June 24, 2015).

135. Patricia Fister, "Merōfu Kannon and Her Veneration in Zen and Imperial Circles in Seventeenth Century Japan," *Journal of Japanese Religious Studies* 34, no. 2 (2007): 419.

136. Fister, "Merōfu," 429–430. See also Chūsei Nihon Kenkyūjo, *Ama monzeki jiin no sekai: Kōjotachi no shinkō to gosho bunka* (Tokyo: Sankei Shinbunsha, 2009), 255, 266. See also Fujita Takuji, "Sanjūsan Kannon no monogatari—Merōfu Kannon to Gyoran Kannon," *Zen bunka* 209 (2008): 25–32.

137. Yü, *Kuan-yin*, 419–438, discusses the variations in the legends of the Fish-Basket Guanyin (Kannon).

138. Fister, "Merōfu," 423–424; Niizuma, *Shōwa shinsen*, 164–169.

139. For a color photograph of the original volume held by Waseda Library in Tokyo, see http://archive.wul.waseda.ac.jp/kosho/ru04/ru04_05105/ru04_05105_0003/ru04_05105_0003_p0043.jpg. See *Edo meisho zue*, 3:43.

140. See Levine, *Awakenings*, 194–198, for the Museum of Fine Arts, Boston, example and the fifteenth-century painting by the artist Bokkei in the George Gund III collection.

141. Miranda Shaw, *Buddhist Goddesses of India* (Princeton, N.J.: Princeton University Press, 2006), 318. Mallar Ghosh, *Development of Buddhist Iconography in Eastern India: A Study of Tārā, Prajñās of Five Tathāgatas and Bhṛikuṭī* (New Delhi: Munshiram Manoharlal, 1980), 40–46.

142. Shaw, *Buddhist Goddesses,* 307. Also Tajima, "Iroiro," 88.

143. Ghosh, *Development*, 23, fig. 3.

144. See Yü, *Kuan-yin*, 249–250, 413.

145. For example, Ch. *Ding lunwang damantuluo guanding yigui*, J. *Chōrinnō daimandara kanjō giki*, *T* 19:328a, names her "Tara Kannon."

146. In the iconographic manuals, the heading "Tara son" (Honored Tara) is used in *Kakuzenshō, TZ* 4:530-538, and "Tara Bosatsu" in both *Besson zakki, TZ* 3:229–232 and *Zuzōshō, TZ* 3:32. She is also called "Tarason Kannon." Mochizuki Shinkō, ed. *Mochizuki Bukkyō daijiten*, s.v. "Tara Bosatsu."

147. "Tara Bosatsu" in http://www.aisf.or.jp/~jaanus/deta/t/tarabosatsu.htm (accessed April 14, 2016). See also Sawa Ryūken, *Mikkyō jiten* (Kyoto: Hōzōkan, 1975), s.v. "Tara Bosatsu," and Sawa Ryūken, *Omuroban ryōbu mandara sonzōshū* (Kyoto: Hōzōkan, 1972), fig. 61, p. 46. See also Elizabeth ten Grotenhuis, *Japanese Mandalas: Representations of Sacred Geography* (Honolulu: University of Hawai'i Press, 1999), 62.

148. Tanabe, *Ikkyūji,* 36–37, 89.

149. Marushima Takaō, " 'Kanzeon Bosatsu sanjūsanshin mandara' ni egakareta sanjūsan Kannon ni tsuite," *Hiratsukashi bunkazai chōsa hōkokusho* 33 (1998): 27–34, 43. See also http://www.city.hiratsuka.kanagawa.jp/rekisi/mandara .htm (accessed June 24, 2015). In 1994 Fukui Eiichi donated the painting to Hiratsuka City Museum (Hiratsukashi Hakubutsukan).

150. For more on the Kanda Sōtei lineage of painters see Fujimoto Yūji, "Sensōji ni okeru Kanda Sōtei no gaji: Kaneiji goyō butsugashi no katsudō no hirogari to sono genkai," *Bukkyō geijutsu* 327 (March 2013): 35–73. Including the *Thirty-Three Kannon Bodhisattva Body Mandala*, the chart on pages 72–73 lists twelve of Yōshin's paintings but gives dates for him (1825–1874) that differ from Marushima's article. Yōshin is a possible pronunciation of the reading of the name, but I have not been able to confirm it.

151. Kyushu Rekishi Shiryōkan, *Chikuzen Wakamiya Seisuiji* (Dazaifu: Kyushu Rekishi Shiryōkan, 2006), n.p. The painting on paper measures 95.8 × 39 cm.

152. Sets of Thirty-Three Kannon paintings, such as those attributed to Minchō and Kakushū, include Kannon images standing on large sea creatures, which may also have served as inspirations for *Hokusai manga*. The Kakushū set from 1679 includes two sea creatures.

153. *Denshin kaishu Hokusai manga,* by Katsushika Hokusai (1760–1849) (Bishū Nagoya: Eirakuya Tōshirō; Edo: Dōdemise, 1834–1878), vol. 13, pp. 16–17. The fifteen volumes of the set were published from 1834 to 1878. Volume 13 was published posthumously in 1849. A sketch (63.5 × 36.2 cm) of the image, which Hokusai or someone in his atelier is considered to have made, is in the collection of the British Museum (registration number 1937,0710,0.296). See http://www.britishmuseum.org/research/collection_online/collection _object_details.aspx?objectId=783841&partId=1&searchText=kannon &page=1 (accessed June 22, 2015). And see Bernard Frank, *Le panthéon bouddhique au Japon: Collections d'Emile Guimet* (Paris: Editions de la Réunion des musées nationaux, 1991), 20–22, for a remarkable comparison between Hokusai's Inari image and one in *Butsuzō zui.*

154. Nihon Sekibutsu Kyōkai, *Nihon sekibutsu zuten* (Tokyo: Kokusho Kankōkai, 1986), 136–146.

155. Kajikawa Tatsuji, ed., *Meiji zōho shoshū Butsuzō zui* (Kyoto: Kajikawa Tatsuji, 1886), vol. 5. The Kannon images are arranged in order at the end of the text. Number 33 (Kegonji in Gifu) shares the final page with the publishing information for the book and another Kannon image from Nichienji in Kanbayashi, Tanba (now Ayabe). This temple is included in a different, local Thirty-Three Kan-

non pilgrimage route and it is unclear why this specific image of Shō Kannon was added.

156. Kajikawa, *Meiji zōho shoshū Butsuzō zui,* vol. 5.

157. This image appeared prior to *Meiji zōho shoshū Butsuzō zui.* See *Kannon reijōki zue* (Kyoto: Sakaiya Nihē, 1845), vol. 5, p. 2, in the UCLA Library. For a clear image see the Waseda Library database, http://archive.wul.waseda.ac.jp/kosho /ha04/ha04_01807/ha04_01807_0005/ha04_01807_0005_p0004.jpg (accessed August 11, 2016).

158. See print in Petzold collection, which is online in the Harvard University Library database http://hollis.harvard.edu/?q=nakayamadera (accessed April 17, 2013). The print measures 50.7 × 27.5 cm and is mounted as a hanging scroll that was likely made in the nineteenth century. For photographs of the main Kannon and one of the attendants, see Kuno Takeshi, *Kannon sōkan* (Tokyo: Shin Jinbutsu Ōraisha, 1986), figs. 281, 282, pp. 137, 265, and Ikawa Kazuko, "Hyōgo Nakayamadera no Jūichimen Kannon zō," *Bijutsu kenkyū* 303 (January 1976): 145–153. See also Donald McCallum, "The Evolution of the Buddha and Bodhisattva Figures in Japanese Sculpture of the Ninth and Tenth Centuries" (PhD diss., New York University, 1973), 338.

159. Ikawa, "Hyōgo Nakayamadera," 151. Washizuka Hiromitsu, "Nakayamadera to Sōōbuji no Jūichimen Kannon zō," *Museum* 248 (November 1971): 27. Inoue Tadashi, "Hyōgo, Nakayamadera Jūichimen Kannon ryūzō," *Nihon bijutsu kōgei* 604 (January 1989): 62. Ikawa and Washizuka do not give the basis for dating, but Inoue mentions that the base and mandorla were replaced when the image was repaired, and there is an inscription inside the lotus base that is dated to 1702.

160. The main secret image was shown after eighty-four years in 2009. From a small photograph it appears to be an Asuka-style bronze (approx. 40 cm), but as far as I am aware no assessment has been made. See http://www.mimurotoji.com /article.php?id=248 (accessed June 24, 2015).

161. Kajikawa, *Meiji zōho shoshū Butsuzō zui,* vol. 5. The mudra resembles the one used in the attendants in a Zenkōji Amida triad.

162. Itō Takemi, ed., *Zōho shoshū Butsuzō zui* (Tokyo: Yahata Shoten, 2005), 368.

163. Phillip Franz von Siebold, Johann J. Hoffman, and Yamabito Asiya, *Nippon: Archiv zur Beschreibung von Japan und dessen Neben- und Schutzländern: Jezo mit den südlichen Kurilen, Krafto, Kooraï und den Liukiu-Inseln, nach japanischen und europäischen Schriften und eigenen Beobachtungen bearbeitet* (Leyden: Siebold, 1832–1852). The pages in the volume owned by the Library of Congress are large, measuring 35 × 56 cm. The Kannon images are in volume 5. The Seven Kannon, along with the Nakayamadera Kannon, are in Tab. XIV, the Thirty-Three Kannon are in Tab. XV–XVII, and the Kannon pilgrimage images are in Tab. XXXIX. The German text refers to Thirty-Two Kannon.

164. For a discussion of the various translations see, Sueki F. [Fumihiko], "L'extraordinaire aventure du Butsuzō zui," http://www.lejapon.org/forum /content/721-L-extraordinaire-aventure-du-Butsuzo-zui (accessed June 24, 2015).

165. An example of a volume published in 1852 that is predominantly text may be found in the Spencer Research Library at the University of Kansas.

166. See the digital archives of Fukuoka Prefectural Library, http://www.lib.pref .fukuoka.jp/hp/gallery/nippon/nippon-top.html (accessed June 22, 2015).

167. See Frank, *Le panthéon*, 19–23, 52–53. For the Kannon images in the Guimet collection, see 108–121. See Murakado Noriko, "Wiriamu Andaason to *Butsuzō zui*—'Nihon bijutsushi' keiseiki ni okeru ōbun Nihon kenkyūsho no ichi," *Bijutsushi* 62/1 (2012): 59. About Guimet and his collection see Ellen Conant, "The French Connection: Emile Guimet's Mission to Japan, a Cultural Context for Japonisme," in *Japan in Transition: Thought and Action in the Meiji Era, 1868–1912*, eds. Hilary Conroy et al. (London: Associated University Presses, 1984), 113–146.

168. William Anderson, *Descriptive and Historical Catalogue of a Collection of Japanese and Chinese Paintings in the British Museum* (London: Longmans, 1886), 64–66. See Murakado, "Wiriamu Andaason to *Butsuzō zui*" article about Anderson's reading of *Butsuzō zui*.

169. Henri L. Joly, *Legend in Japanese Art* (London: J. Lane, 1908), 204–205. He refers to the manual as "*Butsu dzo dzui*."

170. Alice Getty, *The Gods of Northern Buddhism* (Oxford: Clarendon Press, 1914), 88.

Epilogue

1. The following three websites have good photographs of the images: http:// www.geocities.co.jp/SilkRoad/7460/nara-hora-buttouseki.htm, http://blog .goo.ne.jp/fineblue7966/e/6f38e0e384a4f8bedb39b8fe30985afd, and http://blog .goo.ne.jp/pzm4366/e/b2ac887e33d9dc180ff7f66a60d0adb5 (accessed May 5, 2016).

2. Chikatsu Asuka Museum in Osaka Prefecture has a collection of ink rubbings that include some of the Hora Head's Kannon mistakenly labeled as Korean. See http://www.osaka-archives.com/museum_cat_08.html (accessed April 29, 2016) for one. Searching the following database under Rokukannon will show more of them: http://search.dnparchives.com/ (accessed June 27, 2015). They came from the Niiro Collection, but there is no other information included.

3. See Kyoto National Museum website for a thirteenth-century painting held by the museum that is an excellent example of the figure that includes the hands and upper torso. See http://www.kyohaku.go.jp/eng/syuzou/meihin /butsuga/item03.html (accessed June 21, 2014). Although more rare, some fifteenth-century Yamagoshi raigō paintings only show Amida's head. See Ryūkoku Daigaku Myūjiamu, *Gokuraku e no izanai: Nerikuyō o meguru bijutsu* (Kyoto: Ryūkoku Daigaku Ryūkoku Myūjiamu, 2013), 53, 81, 158, figs. 80–81. The popular book Honda Fujio, ed., *Hen na butsuzō* (Tokyo: Gakken, 2012) has a few strange-looking disembodied Buddhist heads for comparison.

4. "Hora" in *Nihon rekishi chimei taikei* (accessed June 17, 2014). This entry has the most detailed information on the inscription. See also Kuno Takeshi, *Sekibutsu,*

vol. 36 of *Book of Books* (Tokyo: Shōgakkan, 1975), 212. Figure 101 is a photograph of rubbings of the six sides, which makes them somewhat easier to see. The beginning of the inscription has some missing characters, which are presumably part of the monk Kakuhen's title. See also Daigo Hachirō, ed., *Nihon no sekibutsu, Kinki hen* (Tokyo: Kokusho Kankōkai, 1983), 21, and other sources on stone images, such as Taniguchi Tetsuo, *Sekibutsu kikō* (Tokyo: Asahi Shinbunsha, 1966), 14–15; Nihon Sekibutsu Kyōkai, *Nihon sekibutsu zuten* (Tokyo: Kokusho Kankōkai, 1986), 330.

5. Nishimura Tei, *Nara no sekibutsu* (Osaka: Zenkoku Shobō, 1943), 143–147. A. K. Bhattacharyya, *Early and Buddhist Stone Sculpture of Japan* (New Delhi: Abhinav Publications, 2004), 16, fig. 12, claims the Hora Head was made by Enkū and does not mention Kakuhen.

6. James L. Ford, *Jōkei and Buddhist Devotion in Early Medieval Japan* (New York: Oxford University Press, 2006), 29, n. 79, p. 220. Tomimura Takafumi, "Jōkei no dōho to deshitachi," in *Shūkyō shakaishi kenkyū,* ed. Risshō Daigaku Shigakkai (Tokyo: Yūzankaku Shuppan, 1977), 203.

7. Nishimura, *Nara no sekibutsu,* 146.

8. Hank Glassman, *The Face of Jizō: Image and Cult in Medieval Japanese Buddhism* (Honolulu: University of Hawai'i Press, 2012), 157–159.

Character Glossary

ajari 阿闍梨

Ame no Sōjō 雨僧正

Annen 安然

Asabashō 阿娑縛抄

Ashikaga Yoshimasa 足利義政

Ashikaga Yoshimitsu 足利義満

Atsuhira 敦成

bakōin 馬口印

bakuryō 曝涼

Bandō 坂東

Bandō junrei sanjūsansho mokuroku 坂東巡禮三十三所目録

banjō 番匠

Banshū 播州

Basu sennin 婆藪仙人

Batō 馬頭

Batō konponin 馬口根本印

Batō Myōō 馬頭明王

Batō nenju, giki 馬頭念誦儀軌

Bechie goshi 別会五師

Benzaiten 弁財天

besson mandara 別尊曼荼羅

Besson zakki 別尊雑記

betsuin 別院

bettō 別当

Bikuchi 毘倶胝

Biro Jinja 枇榔神社 or 蒲葵神社

Birushana 毘盧遮那

Bishamonten 毘沙門天

bonji 梵字

bonnō 煩悩

bonshō 梵鐘

Bussanji 仏山寺

Butsuzō zui 仏像図彙

Buzaiin 豊財院

Byakue 白衣

Byakushi 白紫

Byakusho 白処

Chanyuan qinggui 禪苑清規

chi 乳

Chichibu 秩父

Chichibu engi reigenki entsūden 秩父縁起霊験円通伝

Chikatsu no Miya 近津宮

chiko 地狐

Chishakuin 智積院

Chisokuin Chūzenji 知足院中禅寺

Chōanji 長安寺

Chōen 長宴

Chōhōji 頂法寺

Chōja hōmu 長者法務

Chōjuji 長寿寺

Chōkyūji 長久寺

Chōmeiji 長命寺

Dai Busshi 大仏師

Daibonjin'on 大梵深遠

Daienji 大円寺

Daigoji 醍醐寺

Daihi 大悲

Daihōonji 大報恩寺

Daihōonji engiki 大報恩寺縁起記

Daihōonji ryō shōen denbaku tō mokuroku 大報恩寺領庄園田畠等目録

Daiitoku Myōō 大威徳明王

Daiji 大慈

Daijikaku 大慈閣

Daijizaiten 大自在天

Daikōfushō 大光普照

Dainichi sho 大日疏

Daiseishi 大勢至

Daisōzu Kakuhen Mokujiki, Eishō jūnana nen kōshin (konoetatsu) nigatsu nichi 大僧都覺遍木食、永正十七年庚辰二月日

Daiten Kenjō 大典顯常

danzō 檀像

Daoxuan 道宣

darani 陀羅尼

Dazai kannai shi 太宰管内志

Den Roku Kannon 伝六観音

Dengenji 殿原寺 or 殿源寺

Dō no sako magaibutsu 堂の迫磨崖仏

Dōganji 渡岸寺

dōji 童子

Dōjo 道所

Dōjōji 道成寺

Don'e 曇惠

Dōshokusaie 動植綵絵

dōtai 同体

Eiga 永雅 or Ei? 永[]

Eigenji 永源寺

Eison 栄尊 (sculptor of Yamakuchi mirrors from 1267)

Eison 永尊 (first generation of the Fumonji lineage)

Ejū 惠什

ekō 廻向

ema 絵馬

Enchin 円珍

En'en 延円

Engen 圓玄

Engi kazaritsuke furetsu hei kaichō chū shoki 縁起飾付列并開帳中諸記

Enkōin 円光院

Enkū 圓空

Enma 閻魔

Enmantokuka 焔曼徳迦

Ennin 円仁

Enryakuji gokoku engi 延暦寺護国縁起

Entsūji 円通寺

Fuchiwaki Anjun 渕脇安純 (there are variant characters for this name)

Fuchiwaki Nyūdō 渕脇入道

Fudō 不動

Fudōson saku jūkyū kan 不動尊作十九観

Fugen 普賢

fugūhō 不共法

Fūjin 風神

Fujiwara jidai Rokuji Kannon sonzō 藤原時代六字観音尊像

Fujiwara no Anshi 藤原安子

Fujiwara no Hidehira 藤原秀衛

Fujiwara no Junshi 藤原遵子

Fujiwara no Kaneie 藤原兼家

Fujiwara no Kintō 藤原公任

Fujiwara no Michinaga 藤原道長

Fujiwara no Mochihisa 藤原以久

Fujiwara no Morosuke 藤原師輔

Fujiwara no Morozane 藤原師実

Fujiwara no Mototsune 藤原基経

Fujiwara no Onshi 藤原穏子

Fujiwara no Sanetsuna 藤原実綱

Fujiwara no Saneyori 藤原実頼

Fujiwara no Tadahira 藤原忠平

Fujiwara no Tokinaga 藤原以利

Fujiwara no Tomoakira 藤原知章

fujoshin 婦女身

Fukūkenjaku 不空羂索

Fukuma magaibutsu 福真磨崖仏

Fumonbon 普門品

Fumonin 普門院

Fumonji 普門寺

Fumonji ryakki 普門寺畧記

funpon 粉本

Fuson 芙尊

Gakkō 月光

Ganjōji 願成寺

gasshōin 合掌印

Gekkan Gikō 月澗義光

Genemon no jō 源衛門尉

Gengorō 源五郎

Genji 源次

Genjitsu 源実

Genkō 元翯

Genkō shakusho 元亨釈書

Genpishō 玄祕抄

Genshin 源信

Genshirō 源四郎

Genzaburō 源三郎

Genzu mandara 現図曼荼羅

Getsudō kenmonshū 月堂見聞集

Gikai 義海

Gikū 義空

Gion Shōja 祇園精舎

Gizan 義山

Godai Myōō 五大明王

goeika 御詠歌

Gohachi daiki 五八代記

Gōhō 杲宝

Gojiin 護持院

Gokokuji 護国寺

Gomadan 護摩壇

Gonson 嚴尊

Goryō Jinja 御霊神社

goshinhō 護身法

Guanyin dashi wushisan xianxiang
　　觀音大士五十三現象

Guanyin gan ying zhuan 觀音感應傳

Guanzizai Ruyilun Guanyin pusa yuqie
　　fayao 觀自在如意輪觀音菩薩瑜伽法要

gyakushu 逆修

Gyōkai 行快

Gyōki 行基

gyokugan 玉眼

Gyokuyū 珏融

Gyoran Kannon 魚藍観音

Gyūba Kannon 牛馬観音

Hachiman 八幡

Hachimonjiya 八文字屋

hachinan 八難

hakama 袴

Hamatama-chō 浜玉町

Hana no Mine 花峰

Hantōkō 半陶薧

Hara Sankei 原三渓

Hara Tomitarō 原富太郎

Hara Zaichū 原在中

haraobi 腹帯

Hasedera genki 長谷寺験記

Hashimoto Kichijirō 橋本吉次良

Hasshūron Dainichi 八宗論大日

Hata 秦

Hayashidera 林寺

henchi'in 編知院

hibutsu 秘仏

Hidaka shibu Hideei 日高氏部秀永

Higashi Matsuura 東松浦

Higashi Matsuura gunshi 東松浦郡史

Higashi Naomasa 東直政

Higo Jōkei 肥後定慶

hijiri 聖

Hikohohodemi no mikoto 彦火火出見尊

Hikosan 彦山

Hikosan ruki 彦山流記

Himachi 日待

Himegami 比咩神 (also 比売神 or 姫神)

Hino Kannondō 日野観音堂

Hino Tomiko 日野富子

hinoki 桧

Hirosawa 広沢

Hishō mondō 秘鈔問答

hitogata 人形

Hizen 肥前

Hōen 芳縁 (daughter of Yoshihi)

Hōgen 法眼

Hōgonin 宝嚴院

Hōin 法印

Hōjō Masako 北条政子

Hōjōji 法成寺

Hōjuin 宝寿院

Hōkaiji 法界寺

hōkakechien kyōmyō 奉加結縁交名

Hokekyō 法華経

Hokkesan 法華山

Hokkyō 法橋

Hōkokuji 報国寺

hokuto shichisei 北斗七星

Hōmeiji 宝命寺

Hōmeiji keidai zenkei no zu
　　宝命寺境内全景之図

hōmyō 法名

Hōnenji 法然寺

honji 本地
honji-suijaku 本地垂迹
honjibutsu 本地仏
Honjidō 本地堂
Honjō no sekibutsu 本庄の石仏
Honkokuji 本圀寺
Honsenji 品川寺
honzei 本誓
honzon 本尊
Hōonin 報恩院
Hora no buttōseki 洞の仏頭石
Hōrengein mandokoro kudashibumi
 宝蓮花院政所下文
Hosshōji[a] 法性寺 (built by Fujiwara no
 Saneyori in the tenth century)
Hosshōji[b] 法勝寺 (built in the eleventh
 century as one of the six "superior-
 ity" temples)
Hōtō 法灯
hotoke wa 仏は
Hōzōbō Kōyū 豊蔵坊孝雄
hōzōnin Kakugi toshi nijūichi
 奉造人覺義歳二十一
Hyūgaki 日向記
Ichifusa Rokusha Dai Gongen
 市房六社大権現
Ichifusa Rokusho Gongen 市房六所権現
Ichijōin 一乗院
Ichijōji 一乗寺
ichinichi butsu 一日仏
ichinichi zō 一日造
Ichinichi zōritsu butsu 一日造立仏
Ide Tamamizu no Tachibana kō
 井手玉水の橘講
Iemitsu kyōki 家光卿記
Iguchi Bishin 井口美辰
Imafukuji 伊満福寺 or 今福寺
iwaya 岩屋
Ikyōkeiji 遺教経寺
Injōji 引接寺
Ishiyamadera 石山寺
issaikyō 一切経
Itō Jakuchū 伊藤若冲
Itō Yoshisuke 伊藤義祐

Iyo 伊予
Iwashimizu Hachiman 石清水八幡
Jakkōin 寂光院
Jichiun 実運
Jikidō 食堂
Jimoku taiseishō 除目大成抄
Jimon kōsōki 寺門高僧記
Jingū Kōgō 神功皇后
Jinja Keiōshū 神社慶応集
Jitsubo Jinja 鎮母神社
Jizō 地蔵
Jōchō 定朝
Jōganji 貞観寺
Jōgyō 浄行
Jōgyōdō 常行道
Johan 如範
Jōkei 定慶 (sculptor)
Jōkei 貞慶 (Hossō prelate)
Jōrinji 定林寺
jōroku 丈六
Jōshū 城州
joya no gane 除夜の鐘
ju 咒
Jūichimen 十一面
Jūichimen Kanzeon Bosatsu jinjukyō
 十一面観世音菩薩神呪経
Juntei 准提
Jusojin 呪咀神
Kagami Jingūji 鏡神宮寺
Kaigetsu 回月
Kaijūsenji 海住山寺
Kaikei 快慶
kakebotoke 懸仏
Kakuban 覚鑁
Kakugi 覚義
Kakunin 覚任
Kakushū Reikō 鶴州霊翯
Kakuzenshō 覚禅鈔
Kamechiyomaru 龜千代丸
Kamo 加茂
Kaname Kannondō 金目観音堂
Kanchiin 観智院
Kanda Sōtei Yōshin 神田宗庭要信
Kangiji 歓喜寺

Kangiten 歓喜天

Kanjin 寛信

Kanjizai Nyoirin Kannon Bosatsu yuga hōyō 観自在如意輪観音菩薩瑜伽法要

Kannon 観音

kannonbiraki tobira 観音開扉

Kannongyō 観音経

Kannonji 観音寺

Kano Eitoku 狩野永徳

Kano Ikkei 狩野一渓

Kano Sansetsu 狩野山雪

Kano Tanyū 狩野探幽

Kano Tsunenobu 狩野常信

Kanōya Yoheie 加能屋与兵衛

Kanshū 貫周

Kanshuku 観宿

Kanyō 寛陽

Kanzei 寛済

Kanzeon 観世音

Kanzeon Bosatsu sanjūsanshin mandara 観世音菩薩三十三身曼荼羅

Kashōji 嘉祥寺

Kasuga 春日

Kasuga Daimyōjin 春日大明神

Katsura 桂

Kawai Genmyō 川合玄妙

Kawai Yoshijirō 川合芳次郎

Kawai Yoshijirō Kinen Kyoto Bukkyō Bijutsu Hozon Zaidan 川合芳次郎記念京都仏教美術保存財団

Kawakami Jinja 川上神社 (also 河上神社)

Kawao 川尾

kaya 榧

kebori 毛彫

kebutsu 化仏

kechien 結縁

Kegonji 華厳寺

kei 慶

Keijirō 慶次郎

Keiran shūyōshū 渓嵐拾葉集

Keiryūji 慶龍寺

Keishoki 啓書記

Keishun 径舜 (54-year-old *ajari*)

Keishun 経舜 (fundraiser for bell)

Keishun 桂春 (lady in waiting for Tōfukumon'in)

keka 悔過

Kenbō 賢宝

Kenchōji 建長寺

kenjaku 羂索

Kenjun 憲淳

Kenreimon'in 建礼門院

Kenshun 賢俊

Ken'yū 賢雄

keribori 蹴彫

Kerinmitsuji 華林密寺

kesa 袈裟

keshin 化身

kessen 結線

Ki 紀

Ki no Hidenobu 紀秀信

Kibune 貴布祢

Kinpakuji 金柏寺

Kinpusen 金峰山

Kinsaku 金策

Kintaku sō Tōkai 近澤叟當海

kirikane 切金

Kirishima 霧島

Kirishima ryaku engi 霧島略縁起

Kirishimasan Rokusho Gongen 霧島山六所権現

Kisshōin 吉祥院

Kitano Ganjōjuji 北野願成就寺

Kitano tenjin engi 北野天神縁起

Kitao Rokusho Gongen 北尾六所権現

Kiyohara Yoritada 清原頼忠

Kiyomizu-mura 清水村

Kiyomizudera 清水寺

Kizu 木津

Kōbaiin 候梅院

Kobayashi Honkō 小林本弘

Kobayashi Kōjun 小林弘潤

Kōchiji 広智寺

Kōdaiji 高台寺

Kōfukuji 興福寺

Kōfukuji kanmuchōso 興福寺官務牒疏

Kōgenji 向源寺

Kogo shūi 古語拾遺

Koikebō 小池房

Kōju 宏寿

Kōkei 皇慶 (monk)

Kōkei 康慶 (sculptor)

Kokubunji 国分寺

Kokūzō Bosatsu 虚空蔵菩薩

komainu 狛犬

Kōmyōji 光明寺

Kōmyōsan 光明山

Konkaikōmyōji 金戒光明寺

Kōsai 康斉

Kōshin 庚申

Kōshū 光宗 (monk)

Kōshū 江州 (Shiga)

Kōson 弘尊

Kōun 康運 (Unkei's second son)

Kū Amida Butsu 空阿弥陀仏

Kūa 空阿

Kubotesan 求菩提山

Kudara 百済

kuden 口伝

Kugetsu 玖月

Kuma 球磨

Kumaezu 球磨絵図

Kūniin 救二院

Kunitama Jinja 国玉神社

Kunitomi-chō Tajiri 国富町田尻

Kuramadera 鞍馬寺

kuri 庫裏

Kurohiji-mura 黒肥地村

Kusano Shizunaga 草野鎮永

kya-chi-kya-chū-kya-bi-chi-kamu-shu-kamu-shu-ta-chi-ba-chi 伬知伬注伬毘知縅壽縅壽多知波知

Kyōhabutae 京羽二重

Kyōōdō 経王堂

Kyōtoshi jiin meisaichō 京都市寺院明細帳

machi 待

maedachi 前立

Makashikan 摩訶止観

Makizono-chō 牧園町

Manbukyōe 万部経会

mandara 曼荼羅

Mandaraji 曼荼羅寺

Mansai jugō nikki 満済准后日記

Manzokuji 満足寺

mappō 末法

Masahara 正原

matsuri 祭

Matsuura kojiki 松浦古事記

Mawaranyo 摩和羅女

Meiji zōho shoshū butsuzō zui 明治増補諸宗仏像図彙

Meitokuki 明徳期

Merōfu Kannon (Ch. Malangfu Guanyin) 馬郎婦観音

Miidera 三井寺

Miike 御池

mikkyō 密教

Mimurodoji 御室戸寺

Minamihokkeji 南法華寺

Minamiyamashiro sanjūsansho junrei 南山城三十三所順礼

Minamoto 源

Minchō 明兆

Miroku 弥勒

Mirokuji 弥勒寺

Misaki 御崎

misogi 御衣木

Misosogi Jinja 身濯神社

mizubachi 水鉢

Mizukami-mura 水上村

Mohe zhiguan 摩訶止観

Mokujiki 木喰

Monchūdosha narabi daidai senshi 門中堂社並代々先師

Monju 文殊

Monyōki 文葉記

motoyama 本山

Mudōji 無動寺

munafuda 棟札

Musashi-machi 武蔵町

mushiboshi 虫干

Mushin 武親

Mutsu 陸奥

Myōchin 妙珍

Myōdō 妙道

Myōdōji 明導寺
Myōen 明円
Myōken 妙見
Myōsen 明仙
nakayama 中山
Nakayamadera 中山寺
Nanayamachi no daiji 七々夜待ちの大事
　or 那々夜待大事
Nanendō 南円堂
Nantō manmenroku 南藤蔓綿録
Nanto no Busshi Gengorō kyōdai
　南都ノ仏師源五郎兄弟
Nanzōin 南蔵院
Naoe Kanetsugu 直江兼続
nenjibutsu 念持仏
Nichiben 日便
Nichien 日圓
Nichienji 日圓寺
Nichimachi 日待
Nichirin Kōbō Daishi 日輪弘法大師
nijūgou 二十五有
Nijūhachibushū 二十八部衆
Nikkan 日完 or Nichikan
Nikkō 日光
Ningai 仁海
Ningai chūshinmon 仁海注進文
Ningen 仁源
ninko 人狐
Ninmon 仁聞
Ninzen 忍禅
Nishiki-machi, Nishi-mura 錦町西村
Nissei 日誓
Nisshin 日進
nōkyō 納経
nōsatsuchō 納札帳
nyodai seshu 女大施主
nyogen sanmai 如幻三昧
Nyoirin 如意輪
*Nyūshingon monjū nyojitsuken kōen hokke
　ryakugi* 入真言門住如実見講演
　法華略儀
Obon お盆
ofuda お札
Ogata Daigaku 尾方大学

Ōgawa Tarōbee Tōshi Kanpū 大川太郎
　兵衛藤氏完封
Ogi 小城
Ogidera 小城寺
Ōi 大井
Ōiwaya 大岩屋
Ōjō yōshū 往生要集
Okadera 岡寺
ōke 応化
Okufuka 奥深
okurigane 送り鐘
Ōmidō 大御堂
Ōnakatomi 大中臣
Ongakuji 音楽寺
Ōnishi Gorōzaemon no jō
　Fujiwara Sonchō 大西五郎左衛門尉
　藤原村長
Onjōji 園城寺
Onki 隠岐
Ono no Ningai 小野仁海
Ono no Miyadono 小野宮殿
Ono ruihishō 小野類秘鈔
Ōrekiji 応暦寺
osamefuda 納札
Osen お船
oshie 押絵
osugata 御形
Ōsumi 大隅
Ōsuminokuni Kokubunji rokukannon
　sekizō mei 大隅国国分寺六観音
　石造銘
Ōta Dōkan 太田道灌
Oto 乙
Ōtomo 大友
Ōtsuka-mura 大塚村
Ōzawa Genzui 大沢玄瑞
Rago Ashura 羅睺阿修羅
Raijin 雷神
Raiyu 頼瑜
Rakuhoku Senbon Daihōonji engi 洛北千本
　大報恩寺縁起
Rekidai shisei dokushūran 歴代嗣誠独集覧
Renge'in Hyūga no kuni 蓮花院日向国
Richibō Gahon 理智房畫本

Rikuoku Daijō Tōshi Ietsugu
　陸奥大掾藤氏家次

rinnōza 輪王座

Rokkakudō 六角堂

Rokkakudō Nōmanin 六角堂能満院

Rokkannon no Miike 六観音御池

Roku Kannon gōgyō 六観音合行

Roku Kannon gōgyōki 六観音合行記

Roku Kannon gōgyō shiki 六観音合行私記

Roku Kannon Hachidai Kannon no koto
　六観音八大観音ノ事

Roku Kannon hōji 六観音法事

Roku Kannon zō roku ho 六観音像六鋪

Rokudō Chinkōji 六道珍皇寺

Rokudō no Tsuji 六道の辻

rokudōe 六道絵

Rokugō 六郷

Rokugō Manzan 六郷満山

Rokugōzan shogongyō tō mokuroku
　六郷山諸勤行等目録

rokuharamitsu 六波羅蜜

Rokuji 六字

Rokuji hōki 六字法記

Rokuji juōkyō 六字呪王経

Rokuji karinhō 六字河臨法

Rokuji Myōō 六字明王

Rokuji Tennō 六字天王

Rokujikyōhō 六字経法

Rokujikyōhō mandara 六字経法曼荼羅

rokujishōku darani 六字章句陀羅尼

Rokujizōji 六地蔵寺

Rokujō 六条

Rokusho Dai Gongen 六所大権現

Rokusho Gongen 六所権現

Rokusho Gongensha 六所権現社

Rokusho Jinja 六所神社

Rokusho Myōjin 六所明神

Rokusho no Miya 六所宮

Ryōgen 良源

Ryōgonji 楞厳寺

Ryōkei 良慶

Ryōsenji 霊山寺

Ryōshō 良紹

Ryōshōin Denshō kyū 龍生院傳昌求

Ryōyū 良祐

ryūjin 龍神

Ryūshin 隆信

Ryūyo 隆誉

Ryūzōji 龍造寺

Sagara 相良

Sagara Nagatsune 相良長毎

Sagara Yorisada 相良頼貞

Sagara Yoshihi 相良義陽

Saigoku 西国

*Saiin anchi honzon shōgyōtō tsuika
　mokuroku* 西院安置本尊聖教等追
　加目録

Saiin Mieidō naigejin gusoku mokurokuan
　西院御影堂内外陣具足目録案

Saimyōji 西明寺

Sairaian 西来庵

Saishōkōin 最勝光院

Saitō Kannondō 西塔観音堂

Saitō Tokiyori 斉藤時頼

Sanbao ganying yaolüelu 三寶感應要略録

Sanbōin 三宝院

sangaku 算額

Sangatsudō 三月堂

Sangoku meishō zue 三国名勝図会

Sanjō 三条

Sanjūsangendō 三十三間堂

sanjūsanshin 三十三身

Sanjūsantai Kannon 三十三体観音

Sankaiki 山槐記

Sankeien 三渓園

Sanmairyū kudenshū 三昧流口伝集

Sannō no Miya, Tarōtendō, Rokusho no
　Miya 山王宮 ・ 太郎天童 ・ 六所宮

sanruikei 三類形

Sanshū meisekishi 山州名跡志

Satomiya 里宮

segaki 施餓鬼

Seii 政意

Seison 成尊

Seisuiji 清水寺

Seiyo 盛誉

Seiyū 清融

sekidō 石幢

semuiin 施無畏印

Senbon Enmadō 千本閻魔堂

Senbon Shakadō 千本釈迦堂

sendatsu 先達

Sengōji 川合寺

Sen'i 遷意

senpō 懺法

Sentōji 千燈寺

Sesshū 攝州 (near Osaka in Hyōgo)

Sesshū Tōyō 雪舟等楊

sha 社

Shaka Kinrin 釈迦金輪

Shaka Nyorai 釈迦如来

shakujō 錫杖

Shibushi 志布志

Shichi Kannon'in 七観音院

Shichi Kannon mōde 七観音詣

*Shichibutsu hachibosatsu shosetsu dai
 darani jinjukyō* 七佛八菩薩所説大陀羅
 尼神呪経

Shichijō Bussho 七条仏所

Shichikannon-chō 七観音町

Shichikutei Butsumo 七倶胝仏母

Shichiyamachi 七夜待

Shichiyamachi kuyōtō 七夜待供養塔

Shichiyamachi no daiji 七夜待之大事

Shichiyamachi sahō 七夜待作法

Shiku 師口

Shimen jiseng guidu tu jing
 釋門集僧軌度圖經

Shinagawa 品川

Shinchion'in 新知恩院

Shinga 真雅

Shingon or *shingon* 真言

Shingūji 新宮寺

Shingūsō dayū chōsho 新宮荘大夫調書

Shingyō 真暁

Shinkai 真海

Shinmoedake 新燃岳

Shinō 真応

Shinpen Musashi fudoki kō
 新編武蔵風土記稿

shintai 神体

Shintan 真探

Shinzoku zakki mondōshō
 真俗雑記問答鈔

Shiō Gongen 四王権現

Shiō Ishiya 四王石屋

Shion'in 四恩院

Shioyobi no kane 汐呼鐘

Shiritsuki Iwaya 尻付岩屋

Shiroku 司録

Shishimui 師子無畏

shittan 悉曇

Shō 正 (correct or true)

Shō 聖 (noble)

sho 所 (place)

Shō Bijutsukan 掌美術館

Sho Kannon zuzō 諸観音図像

Shōchō 承澄

Shōfū 松風

shōgon 荘厳

Shōjuraigōji 聖衆来迎寺

Shōkei 祥啓

Shōkokuji 相国寺

Shōkū 性空

shōnin 上人

Shōnyo 勝如

Shōrengein 勝蓮華院

Shōrenin 青蓮院

Shoson zuzōshū 諸尊図像集

Shōtatsu 照辰

*Shōwa shinsen Edo sanjūsansho Kannon
 junrei* 昭和新選江戸三十三所観音順礼

Shuban 周鑁

shugenja 修験者

shuilu 水陸

Shukaku 守覚

Shukuin Busshi 宿院仏師

Shukuin-chō 宿院町

shukuzu 縮図

shumoku 撞木

Shūon'an Ikkyūji 酬恩庵一休寺

Shuryōgonkyō 首楞嚴經

sōfū 宋風

Sonjo 尊助

Sonshō mandala 尊勝曼荼羅

Sonshōji 尊勝寺

Sōō 相応

Sue 須恵

sueji 末寺

sueyama 末山

Sugawara no Mitsushige 菅原光重

Suhikazura 須比賀津良 (or Suikazura 吸葛)

Sumiyoshi Hironatsu 住吉広夏

Tachibanadera 橘寺

Tahō 多宝

Taigen 大玄

Taira no Shigemori 平重盛

Taira no Tokuko 平徳子

Taishakuten 帝釈天

Taitokuin 台徳院

Taiyuin 大猷院

Takachiho 高千穂

Takamura Kōun 高村光雲

Takemikazuchi 建御雷

Takuhō Dōshū 卓峯道秀

Tamatare 玉垂

Tamon'in 多聞院

Tanoura Yamamiya Jinja 田ノ浦山宮神社

Tansei jakubokushū 丹青若木集

Tara 多羅

Tarōten 太郎天

Tarōten Iwaya 太郎天岩屋

Tarōtendō 太郎天童

Tashirofumoto 田代麓

Tendai 天台

Tendai Myōhokkeshū Shakushi Gikū 天台妙法華宗釈氏義空

Tendai nanzan Mudōji konryū oshō den 天台南山無動寺健立和尚伝

tengu 天狗

tenko 天狐

Tenninjōfu 天人丈夫

Tenzui Dō'on 天瑞道恩

Tobihino 飛火野

Tōbōki 東宝記

Tōbokuin 東北院

Tōdaiji 東大寺

Tōfukumonin 東福門院

Tōkōji 東光寺

Tokuitsu 徳一

Tōmyōji 東明寺 (Eastern-Light temple)

Tōmyōji 燈明寺 (Lantern-Light temple)

Tōmyōji engi 東明寺縁起

Tōmyōji kakochō 東明寺過去帳

Tōnomine 多武峰

Tōriten 忉利天

Tosa Hironobu 土佐広信

Tōshōgū 東照宮

Toyouke Jinja 豊受神社

Tsubosakadera 壺阪寺

Tsuika mokuroku 追加目録

Tsukimachi 月待

tsukiza 撞座

Tsukuba Jinja 筑波神社

Tsūzei 通濟

Uchino 内野

Udo Jingū 鵜戸神宮

Uemura 上村

ufusuna ウフスナ (or *ubusuna* 産土)

Unagihime Jinja 宇奈岐日女神社

Unjōbō 雲浄坊

Unkei 運慶

Unmo 雲裳

urahaku 裏箔

urazaishiki 裏彩色

Usa Hachiman 宇佐八幡

wagesa 輪袈裟

Wakamiya Jinja 若宮神社

warihagi zukuri 割矧造

Wenshi 文侍

wuchang qing 無常磬

Xu Gaoseng zhuan 續高僧傳

Xuqu 徐曲

Ya 屋

yamabushi 山伏

Yamagoshi raigō 山越来迎

Yamakuchi Jinja 山口神社

Yamamiya Jinja 山宮神社

Yamamoto Shōgetsu 山本勝月

Yamana Ujikiyo 山名氏清

Yamao 山尾

Yasura Jinja 安楽神社
Yatadera 矢田寺
Yayama kankei nendaiki 屋山関係年代記
Yayamadera 屋山寺
yoganin 予願印
Yokawa Eshin'in 横川恵心院
Yoshida Kenkō 吉田兼好
Yoshihi 義陽
Yoshihisa 義尚
Yōzen 栄然
Yu 湯

Yufudake 由布岳
Yūgen 祐儼
Yunomae 湯前
Yunomae Furujō 湯前古城
za 座
Zaō Gongen 蔵王権現
Zhixing 智興
Zhiyi 智顗
Zuishinin 随心院
zushi 厨子
Zuzōshō 図像抄

Bibliography

Primary Sources

Asabashō. In *Taishō shinshu daizōkyō zuzō,* eds. Takakusu Junjirō, Watanabe Kaigyoku, et al., vol. 9. Tokyo: Taishō Issaikyō Kankōkai, 1934. Also in *Dai Nihon Bukkyō zensho,* vol. 38. Tokyo: Meicho Fukyūkai, 1978–1983.

Atsuzōshi. In *Taishō shinshu daizōkyō,* eds. Takakusu Junjirō, Watanabe Kaigyoku, et al., vol. 78, no. 2483. Tokyo: Taishō Issaikyō Kankōkai, 1934.

Bandō Saikoku Chichibu hyaku Kanzeon reijōki. Tokyo: Hakubunkan, 1903.

Banshū Shoshasan engi. In *Dai Nihon Bukkyō zensho,* vol. 117. Tokyo: Meicho Fukyūkai, 1978–1983.

Besson zakki. In *Taishō shinshu daizōkyō zuzō,* eds. Takakusu Junjirō, Watanabe Kaigyoku, et al., vol. 3. Tokyo: Taishō Issaikyō Kankōkai, 1934.

Buddhavacana Ekadaśamukha dhāraṇī sūtra (Ch. *Foshuo shiyimin guanshiyin shenzhou jing;* J. *Bussetsu Jūichimen Kanzeon jinjukyō*). In *Taishō shinshu daizōkyō,* eds. Takakusu Junjirō, Watanabe Kaigyoku, et al., vol. 46, no. 1070. Tokyo: Taishō Issaikyō Kankōkai, 1934.

Bukong juansuo zhou jing (J. *Fukūkenjaku jukyō*). In *Taishō shinshu daizōkyō,* eds. Takakusu Junjirō, Watanabe Kaigyoku, et al., vol. 20, no. 1093. Tokyo: Taishō Issaikyō Kankōkai, 1934.

Bungo kokushi: Tsuketari senshaku Bungo fudoki, ed. Karahashi Seisai (1736–1801). Tokyo: Hōbundō, 1975.

Bussetsu Rokuji jinjuōkyō. In *Taishō shinshu daizōkyō,* eds. Takakusu Junjirō, Watanabe Kaigyoku, et al., vol. 20, no. 1045. Tokyo: Taishō Issaikyō Kankōkai, 1934.

Bussetsu Rokuji juōkyō. In *Taishō shinshu daizōkyō,* eds. Takakusu Junjirō, Watanabe Kaigyoku, et al., vol. 20, no. 1044. Tokyo: Taishō Issaikyō Kankōkai, 1934.

Butsuzō zui. See *Shoshū Butsuzō zui* and *Zōho shoshū Butsuzō zui.*

Byakuhōkushō, by Ryōsen (1258–1341). In *Taishō shinshu daizōkyō zuzō,* eds. Takakusu Junjirō, Watanabe Kaigyoku, et al., vol. 6. Tokyo: Taishō Issaikyō Kankōkai, 1934.

Byakuhōshō. In *Taishō shinshu daizōkyō zuzō,* eds. Takakusu Junjirō, Watanabe Kaigyoku, et al., vol. 10. Tokyo: Taishō Issaikyō Kankōkai, 1934.

Chūyūki. In *Zōho shiryō taisei,* vols. 9–14. Kyoto: Rinsen Shoten, 1965.

Daihōonji engiki. In Kyōtofu Kyōikuchō Bunkazai Hogoka. *Kokuhō kenzōbutsu Daihōonji Hondō shūri koji hōkokusho.* Kyoto: Kyōtofu Kyōikuchō Bunkazai Hogoka, 1954. Also

in Itō Shirō, *Senbon Shakadō Daihōonji no bijutsu to rekishi.* Kyoto: Yanagihara Shuppan, 2008.

Dainichi sho (J. *Daibirushana jōbutsu kyō sho;* Ch. *Dapiiu zhena cheng fo jing su*). In *Taishō shinshu daizōkyō,* eds. Takakusu Junjirō, Watanabe Kaigyoku, et al., vol. 39, no. 1796. Tokyo: Taishō Issaikyō Kankōkai, 1934.

Dazai kannai shi, ed. Itō Tsunetaru (1774–1858). Tokyo: Bunken Shuppan, 1989.

Denshin kaishu Hokusai manga, by Katsushika Hokusai (1760–1849). Bishū Nagoya: Eirakuya Tōshirō; Edo: Dōdemise, 1834–1878.

Ding lunwang damantuluo guanding yigui (J. *Chōrinnō daimandara kanjō giki*). In *Taishō shinshu daizōkyō,* eds. Takakusu Junjirō, Watanabe Kaigyoku, et al., vol. 19, no. 959. Tokyo: Taishō Issaikyō Kankōkai, 1934.

Edo meisho zue, ed. Saitō Chōshu (1737–1799) et al. Edo: Suharaya Mohē 1834–1836.

Eiga monogatari, ed. Yamanaka Yutaka. Tokyo: Shōgakkan, 1995–1998.

Enryakuji gokoku engi. In *Dai Nihon Bukkyō zensho,* vol. 126. Tokyo: Meicho Fukyūkai, 1978–1983.

Foshuo chimingzang yujia dajiao zunna pusa daming chenjiu yiqui jing (J. *Bussetsu jimyōzō yugadaikyō sonna bosatsu daimyōjōju gikikyō*). In *Taishō shinshu daizōkyō,* eds. Takakusu Junjirō, Watanabe Kaigyoku, et al., vol. 20, no. 1169. Tokyo: Taishō Issaikyō Kankōkai, 1934.

Fu fazang yinyuan zhuan (J. *Fuhōzō innenden*). In *Taishō shinshu daizōkyō,* eds. Takakusu Junjirō, Watanabe Kaigyoku, et al., vol. 50, no. 2058. Tokyo: Taishō Issaikyō Kankōkai, 1934.

Fumonji daidai senshi. In Uemura Shigeji, *Kyushu Sagara no jiin shiryō.* Kumamoto: Seichōsha, 1968.

Fusō ryakki, by Kōen (d. 1169). In *Shintei zōho kokushi taikei,* vol. 12. Tokyo: Kokushi Taikei Kankōkai, 1965.

Genkō shakusho. In *Dai Nihon Bukkyō zensho,* vol. 101. Tokyo: Meicho Fukyūkai, 1978–1983.

Genpishō. In *Taishō shinshu daizōkyō,* eds. Takakusu Junjirō, Watanabe Kaigyoku, et al., vol. 78, no. 2486. Tokyo: Taishō Issaikyō Kankōkai, 1934.

Getsudō kenmonshū. In *Zoku Nihon zuihitsu taisei, bekkan,* eds. Mori Senzō and Kitagawa Hirokuni, vol. 3. Tokyo: Yoshikawa Kōbunkan, 1982.

Gyōrinshō, by Jōnen (fl. 1154). In *Taishō shinshu daizōkyō,* eds. Takakusu Junjirō, Watanabe Kaigyoku, et al., vol. 76, no. 2409. Tokyo: Taishō Issaikyō Kankōkai, 1934.

Hantōkō. In *Shinshū Kyōto sōsho,* vol. 18. Kyoto: Rinsen Shoten, 1976.

Hishō. In *Taishō shinshu daizōkyō,* eds. Takakusu Junjirō, Watanabe Kaigyoku, et al., vol. 78, no. 2489. Tokyo: Taishō Issaikyō Kankōkai, 1934.

Hishō mondō, by Raiyu (1226–1304). In *Taishō shinshu daizōkyō,* eds. Takakusu Junjirō, Watanabe Kaigyoku, et al., vol. 79, no. 2536. Tokyo: Taishō Issaikyō Kankōkai, 1934.

Hizōkonpōshō. In *Taishō shinshu daizōkyō,* eds. Takakusu Junjirō, Watanabe Kaigyoku, et al., vol. 78, no. 2458. Tokyo: Taishō Issaikyō Kankōkai, 1934.

Honchō bunshū. In *Shintei zōho kokushi taikei,* vol. 30. Tokyo: Yoshikawa Kōbunkan, 1964.

Iemitsu kyōki. In *Rekidai zanketsu nikki,* ed. Kurokawa Harumura, vol. 8. Kyoto: Rinsen Shoten, 1969–1971.

Inryōken nichiroku, by Kikei Shinzui (d. 1469). In *Dai Nihon Bukkyō zensho,* vol. 134. Tokyo: Meicho Fukyūkai, 1978–1983.

Jiin jūki meisai chō. Handwritten records of temple property compiled by the government and kept at special collections at Kyoto Furitsu Sōgō Shiryōkan (Kyoto Prefectural Library and Archives).

Jimoku taiseishō. In *Shintei zōho shiseki shūran,* vol. 1 (*bekkan*). Kyoto: Rinsen Shoten, 1973.

Kakuzenshō. In *Taishō shinshu daizōkyō zuzō,* eds. Takakusu Junjirō, Watanabe Kaigyoku, et al., vol. 4. Tokyo: Taishō Issaikyō Kankōkai, 1934.

Kanjizai Nyoirin Kannon Bosatsu yuga hōyō. In *Taishō shinshu daizōkyō,* eds. Takakusu Junjirō, Watanabe Kaigyoku, et al., vol. 20, no. 1087. Tokyo: Taishō Issaikyō Kankōkai, 1934.

Kannon reijōki zue. Kyoto: Sakaiya Nihē, 1845.

Keiran shūyōshū. In *Taishō shinshu daizōkyō,* eds. Takakusu Junjirō, Watanabe Kaigyoku, et al., vol. 76, no. 2410. Tokyo: Taishō Issaikyō Kankōkai, 1934.

Kiizoku fudoki. In *Zoku Shingonshū zensho,* vol. 37. Wakayama-ken, Ito-gun, Kōyasan: Zoku Shingonshū Zensho Kankōkai, 1975–1988.

Kirishima ryaku engi. In *Hizen, Higo, Hyūga, Satsuma, Ōsumi no kuni, Shintō taikei,* eds. Kudō Keiichi and Matsumoto Sumio, vol. 45. Tokyo: Shinto Taikei Henzankai, 1987.

"Kōdaiji shūshū mokuroku." In *Homotsu torishirabe mokuroku* (Inventory of examined treasures), vol. 40 (1888). Handwritten records of temple property compiled by the government and kept at special collections at Kyoto Furitsu Sōgō Shiryōkan (Kyoto Prefectural Library and Archives).

Kōfukuji kanmuchōso. In *Dai Nihon Bukkyō zensho,* vol. 119. Tokyo: Meicho Fukyūkai, 1978–1983.

Kōfukuji ryaku nendaiki. In *Zoku gunsho ruijū,* vol. 29, pt. 2. Tokyo: Zoku Gunsho Ruijū Kanseikai, 1959.

Kumagun jinjaki. In *Hizen, Higo, Hyūga, Satsuma, Ōsumi no kuni, Shintō taikei, jinja hen,* eds. Kudō Keiichi and Matsumoto Sumio, vol. 45. Tokyo: Shinto Taikei Henzankai, 1987.

Kumagun kyōdoshi, ed. Kumamoto-ken Kyōikukai Kumagunshikai. Kumagun Kumamoto-ken, 1916.

Kyō suzume. In *Shinshū Kyoto sōsho,* vo1. 1. Kyoto: Rinsen Shoten, 1976.

Kyōhabutae. In *Shinshū Kyoto sōsho,* vo1. 2. Kyoto: Rinsen Shoten, 1976.

Kyōtofū jishikō (Kyoto prefectural temple records) from 1892. Held at Kyoto Prefectural Library and Archives Special Collections.

Kyōtoshi jiin meisaichō. Kyoto, 1884.

Kyōuchi mairi. In *Shinshū Kyoto sōsho,* vol. 5. Kyoto: Rinsen Shoten, 1976.

Makura no sōshi, by Sei Shōnagon (ca. 967). In *Shinpen Nihon koten bungaku koten zenshū,* vol. 18. Tokyo: Shōgakkan, 1997.

Mansai jugō nikki. In *Zoku gunsho ruijū,* supplement (*hoi*), vol. 1, pts. 1–2. Tokyo: Zoku Gunsho Ruijū Kankōkai, 1957.

Meiji zōho shoshū butsuzō zui, ed. Kajikawa Tatsuji. Kyoto: Kajikawa Tatsuji, 1886.

Meirinshi, ed. Meirin Jinjō Shōgakkō. Kyoto: Kyōtoshi Meirin Jinjō Shōgakkō, 1939.

Meitokuki. In *Gunsho ruijū,* vol. 20. Tokyo: Zoku Gunsho Ruijū Kanseikai, 1957.

Miyako meisho zue, ed. Akisato Ritō (fl. 1780–1814). Kyoto: Daihan Shorin, 1804. First published in 1780 (An'ei 9).

Mohe zhiguan, by Zhiyi (538–597). In *Taishō shinshu daizōkyō,* eds. Takakusu Junjirō, Watanabe Kaigyoku, et al., vol. 46, no. 1911. Tokyo: Taishō Issaikyō Kankōkai, 1934.

Nanayamachi no daiji. In *Shingon himitsu kaji shūsei,* ed. Inaya Yūsen, no. 44. Osaka: Tōhō Shuppan, 1998. Also in *Shugen shinpi gyōhō fujushū* 4 in *Nihon daizōkyō,* vol. 94. Tokyo: Suzuki Gakujitsu Zaidan, 1977. Also in Nihon daizōkyō Hensankai, *Shugen shinpi gyōhō fujushū.* Tokyo: Hachiman Shoten, 2010.

Nantō manmenroku, ed. Umeyama Muikken (1755–1828). Kumamoto: Seichōsha, 1977.

Nihon kiryaku. In *Shintei zōho kokushi taikei,* vol. 11. Tokyo: Yoshikawa Kōbunkan, 1965.

Nihon sandai jitsuroku. In *Shintei zōho Kokushi taikei,* vol. 4. Tokyo: Yoshikawa Kōbunkan, 1964.

Nyūshingon monjū nyojitsuken kōen hokke ryakugi. In *Taishō shinshu daizōkyō,* eds. Takakusu Junjirō, Watanabe Kaigyoku, et al., vol. 56, no. 2192. Tokyo: Taishō Issaikyō Kankōkai, 1934. Also in *Dai Nihon Bukkyō zensho,* vol. 27. Tokyo: Meicho Fukyūkai, 1978–1983.

Onjōji denki. In *Dai Nihon Bukkyō zensho,* vol. 127. Tokyo: Meicho Fukyūkai, 1978–1983.

Ono ruihishō, ed. Kanjin (1084–1153). In *Shingonshū zensho,* vol. 36, pt. 1. Mt. Kōya: Shingonshū Zensho Kankōkai, 1933–1939.

Qianshou qianyan guanshiyin pusa dabeixin tuoluoni jing (J. *Senju sengen kanzeon Bosatsu daihishin daranikyō.*) In *Taishō shinshu daizōkyō,* eds. Takakusu Junjirō, Watanabe Kaigyoku, et al., vol. 20, no. 1060. Tokyo: Taishō Issaikyō Kankōkai, 1934.

Qifo bapusa suo shuo da tuoluoni shenzhou jing (J. *Shichibutsu hachibosatsu shosetsu dai darani jinjukyō*). In *Taishō shinshu daizōkyō,* eds. Takakusu Junjirō, Watanabe Kaigyoku, et al., vol. 21, no. 1332. Tokyo: Taishō Issaikyō Kankōkai, 1934.

Rekidai shisei dokushūran, by Umeyama Muikken (1755–1828). Kumamoto-ken, Kuma-gun, Sagara-mura, 1995.

Roku Kannon gōgyō. From *Asabashō.* In *Taishō shinshu daizōkyō zuzō,* eds. Takakusu Junjirō, Watanabe Kaigyoku, et al., vol. 9. Tokyo: Taishō Issaikyō Kankōkai, 1934.

Roku Kannon gōgyō shiki. Dated 1236 (Katei 2). In Shōrenin Kissui collection, Kyoto.

Roku Kannon gōgyōki. Dated 1474 (Bunmei 6). In Kyoto University Library, special collections.

Roku Kannon gōgyōki. From *Monyōki.* In *Taishō shinshu daizōkyō zuzō,* eds. Takakusu Junjirō, Watanabe Kaigyoku, et al., vol. 12, no. 169. Tokyo: Taishō Issaikyō Kankōkai, 1934.

Roku Kannon Hachidai Kannon no koto. From *Kannon myōōshū,* by Rentai (1663–1726). In *Hōei hanpon Kannon myōōshū: Honbun to setsuwa mokuroku,* ed. Kōbe Setsuwa Kenkyūkai. Osaka: Izumi Shoin, 2006.

Rokuji hōki. In *Dai Nihon komonjo; Iewake; Daigoji monjo,* vol. 19, pt. 11, no. 2538. Tokyo: Tokyo Teikoku Daigaku, 1904–.

Rokuji karinhō. In *Zoku gunsho ruijū,* vol. 26, pt. 1. Tokyo: Zoku Gunsho Ruijū Kankōkai, 1957.

Rokujikyō genki. In *Denki genkishū,* eds. Abe Yasurō and Yamazaki Makoto, Kyoto: Rinsen Shoten, 2004.

Saidaiji shizai rukichō. In *Zoku gunsho ruijū,* vol. 27, pt. 2. Tokyo: Zoku Gunsho Ruijū Kanseikai, 1984.

Saigoku Bandō Chichibu: Hyakuban Kannon reigenki, by Mantei Ōga. Tokyo: Kodama Yakichi, 1882.

Sanbao ganying yaolüelu, by Feizhuo (d. 1063). In *Taishō shinshu daizōkyō,* eds. Takakusu Junjirō, Watanabe Kaigyoku, et al., vol. 51, no. 2084. Tokyo: Taishō Issaikyō Kankōkai, 1934.

Sangoku meishō zue, eds. Godai Hidetaka and Hashiguchi Kenpei. Tokyo: Yamamoto Morihide, 1905. See also newer edition published by Seichōsha, 1982.

Sanjūsansho Bandō Kannon reijōki. n.p. 1766.

Sankaiki. In *Zōho shiryō taisei,* vol. 27. Kyoto: Rinsen Shoten, 1965.

Sanmairyū kudenshū. In *Taishō shinshu daizōkyō,* eds. Takakusu Junjirō, Watanabe Kaigyoku, et al., vol. 77, no. 2411. Tokyo: Taishō Issaikyō Kankōkai, 1934.

Sanmon dōshaki. In *Gunsho ruijū,* vol. 24. Tokyo: Gunsho Ruijū Kankōkai, 1960.

Sanshū meisekishi. In *Shinshū Kyoto sōsho,* vol. 15. Kyoto: Rinsen Shoten, 1976.

Shichiyamachi no daiji. In *Shingon himitsu kaji shūsei,* ed. Inaya Yūsen, no. 17. Osaka: Tōhō Shuppan, 1998.

Shichiyamachi sahō. In *Shingon himitsu kaji shūsei,* ed. Inaya Yūsen, no. 44. Osaka: Tōhō Shuppan, 1998. Also in *Shugen shinpi gyōhō fujushū* 4 in *Nihon daizōkyō,* vol. 94. Tokyo: Suzuki Gakujitsu Zaidan, 1977.

Shiku. In *Taishō shinshu daizōkyō,* eds. Takakusu Junjirō, Watanabe Kaigyoku, et al., vol. 78, no. 2501. Tokyo: Taishō Issaikyō Kankōkai, 1934.

Shimen jiseng guidu tu jing. In *Nihon daizōkyō,* ed. Nakano Takkei, vol. 21. Tokyo: Nihon Daizōkyō Hensankai, 1914–1919.

Shinpen Musashi fudoki kō, ed. Hayashi Jussai (1768–1841). Tokyo: Rekishi Toshosha, 1969.

Shinsen zōho Kyō ōezu. Kyoto: Hayashi Yoshinaga, 1686.

Shinzoku zakki mondōshō, by Raiyu (1226–1304). In *Shingonshū zenshū,* vol. 37. Mt. Kōya: Shingonshū Zensho Kankōkai, 1933–1939.

Sho Kannon zuzō. In *Taishō shinshu daizōkyō zuzō,* eds. Takakusu Junjirō, Watanabe Kaigyoku, et al., vol. 12. Tokyo: Taishō Issaikyō Kankōkai, 1934.

Shoku Nihon kōki. At http://www.j-texts.com/chuko/shokukouki.html (accessed January 19, 2014).

Shoshū Butsuzō zui, compiled by Gizan. n.p., 1690. Also in *Kinmō zui shūsei,* ed. Asakura Harahiko, vol. 14. Tokyo: Ōzorasha, 1998. See later edition: *Zōho shoshū Butsuzō zui.*

Shoson yōshō. In *Taishō shinshu daizōkyō,* eds. Takakusu Junjirō, Watanabe Kaigyoku, et al., vol. 78, no. 2484. Tokyo: Taishō Issaikyō Kankōkai, 1934.

Shōyūki, by Fujiwara no Sanesuke (957–1046). Tōkyō Daigaku Shiryō Hensanjo, ed. *Dai Nihon Kokiroku* 10. Tokyo: Iwanami Shoten, 1959–1986.

Shūi miyako meisho zue, ed. Akisato Ritō. Kyoto: Yoshinoya Tamehachi, 1787.

Sifen lü shanfan buque xingshi chao. In *Taishō shinshu daizōkyō,* eds. Takakusu Junjirō, Watanabe Kaigyoku, et al., vol. 40, no. 1804. Tokyo: Taishō Issaikyō Kankōkai, 1934.

Śūraṅgama sūtra (Ch. *Da foding shoulengyan jing;* J. *Dai butchō shuryōgon kyō*). In *Taishō shinshu daizōkyō,* eds. Takakusu Junjirō, Watanabe Kaigyoku, et al., vol. 19, no. 945. Tokyo: Taisho Issaikyo Kankōkai, 1934. And see *The Śūra ṅgama Sūtra,* translated by Upasaka Lu K'uan Yu (Charles Luk) at http://www.buddhanet.net/pdf _file/surangama.pdf (accessed May 27, 2010).

Taiheiki. In *Shinpen Nihon koten bungaku zenshū,* vol. 54. Tokyo: Shōgakkan, 1994.

Taizōkongō bodaishingi ryakumondō shō, by Annen (841–ca. 898). In *Taishō shinshu daizōkyō,* eds. Takakusu Junjirō, Watanabe Kaigyoku, et al., vol. 75, no. 2397. Tokyo: Taishō Issaikyō Kankōkai, 1934.

Tamon'in nikki, by Eishun (1518–1596). In *Zōho zoku shiryō taisei,* ed. Takeuchi Rizō, vols. 38–42. Kyoto: Rinsen Shoten, 1978.

Taniajariden. In *Zoku gunshō ruiju,* vol. 8, pt. 2. Tokyo: Zoku Gunshō Ruiju Kanseikai, 1957.

Tendai nanzan Mudōji konryū oshō den. In *Gunsho ruijū,* vol. 5. Tokyo: Gunsho Ruijū Kankōkai, 1960.

Tōbōki, compiled by Gōhō (1306–1362). In *Zoku zoku gunsho ruijū,* vol. 12. Tokyo: Zoku Gunsho Ruijū Kanseikai, 1970.

Tōto saijiki, ed. Saitō Gesshin, vol. 3. Edo: Suharaya Mohē: Suharaya Ihachi, 1838.

Xu Gaoseng zhuan (J. *Zoku kōsōden*). In *Taishō shinshu daizōkyō,* eds. Takakusu Junjirō, Watanabe Kaigyoku, et al., vol. 50, no. 2060. Tokyo: Taishō Issaikyō Kankōkai, 1934.

Yamashiro meishōshi. In *Shinshū Kyoto sōsho,* vol. 14. Kyoto: Rinsen Shoten, 1976.

Yayama kankei nendaiki. In Kyushu Rekishi Shiryōkan, *Kyushu Rekishi Shiryōkan kenkyū ronshū,* vol. 13. Dazaifu-machi [Fukuoka-ken]: Kyushu Rekishi Shiryōkan, 1988.

Yonkashō zuzō. In *Taishō shinshu daizōkyō zuzō,* eds. Takakusu Junjirō, Watanabe Kaigyoku, et al., vol. 3. Tokyo: Taishō Issaikyō Kankōkai, 1934.

Yōshūfushi. In *Shinshū Kyoto sōsho,* vol. 22. Kyoto: Rinsen Shoten, 1976.

Yōson dōjō kan. In *Taishō shinshu daizōkyō,* eds. Takakusu Junjirō, Watanabe Kaigyoku, et al., vol. 78, no. 2468. Tokyo: Taishō Issaikyō Kankōkai, 1934.

Zan Guanshiyin pusa song (J. *San Kanzeon Bosatsu ju*). In *Taishō shinshu daizōkyō,* eds. Takakusu Junjirō, Watanabe Kaigyoku, et al., vol. 20, no. 1052. Tokyo: Taishō Issaikyō Kankōkai, 1934.

Zenkōjimichi meisho zue, ed. Toyota Toshitada. Edo: Suharaya Mohē; Nagoya: Minoya Iroku, 1849.

Zenyaku azumakagami, ed. Nagahara Keiji. Tokyo: Shin Jinbutsu Ōraisha, 1976–1979.

Zōho kashiragaki kinmō zui taisei. Kyoto: Kyūkōdō, 1789.

Zōho shoshū Butsuzō zui, ed. Ki no Shūshin (a.k.a. Tosa Hidenobu or Ki no Hidenobu).
Kyoto: Shorin, 1783. Also in Asakura Harahiko, ed., *Kinmō zui shūsei,* vol. 14. Tokyo:
Ōzorasha, 1998. See earlier edition: *Shoshū Butsuzō zui.*

Zuzōshō (also called *Jikkanshō*). In *Taishō shinshu daizōkyō zuzō,* eds. Takakusu Junjirō,
Watanabe Kaigyoku, et al., vol. 3. Tokyo: Taishō Issaikyō Kankōkai, 1934.

Secondary Sources

Abe, Ryūichi. *The Weaving of Mantra.* New York: Columbia University Press, 1999.

"Acquisitions July 17 to September 18, 1919." *Museum of Fine Arts Bulletin* 17, no. 103
(October 1919): 55–56.

Aizu Yaichi. "Hōryūji rokutai butsu narabi ni byakudan Jizō zō no denrai o ronjitte
futatabi Shitennō zō no kondō inyū ni oyobu." *Tōyō bijutsu* 5 (1930): 1–19.

Ambros, Barbara. *Bones of Contention: Animals and Religion in Contemporary Japan.* Ho-
nolulu: University of Hawai'i Press, 2012.

Anderson, William. *Descriptive and Historical Catalogue of a Collection of Japanese and
Chinese Paintings in the British Museum.* London: Longmans, 1886.

Aoki Shigeru and Kobayashi Hiromitsu. *Chūgoku no yōfūga ten: Minmatsu kara shin
jidai no kaiga, hanga, sashiebon.* Machida: Machida Shiritsu Kokusai Hanga Biju-
tsukan, 1995.

Arakawa Hirokazu. "Aki no Buzaiin." *Museum* 130 (January 1962): 30–33.

Asai Kazuharu. "Fukūkenjaku, Juntei Kannon zō." *Nihon no bijutsu* 382 (March 1998).
Dedicated issue.

———. "Okayama Ōtsūji no Fukūkenjaku Bosatsu zazō." *Bukkyō geijutsu* 246 (1999):
69–85.

Asakura Haruhiko, ed. *Jinrin kinmō zui.* Tokyo: Heibonsha, 1990.

Asano Nagatake, ed. *Kōyasan.* Vol. 7 of *Hihō.* Tokyo: Kōdansha, 1968.

Asanuma Takashi. "Mokuzō Fukūkenjaku Kannon zazō, mokuzō Jūichimen Kan-
non zazō, Kyoto Konkaikōmyōji zō." *Gakusō* 29 (2007): 77–83.

Bathgate, Michael. *The Fox's Craft in Japanese Religion and Folklore.* New York: Routledge,
2004.

Baumann, Brian. *Divine Knowledge: Buddhist Mathematics According to the Anonymous
Manual of Mongolian Astrology and Divination.* Leiden: Brill, 2008.

Bellos, Alex. *The Grapes of Math: How Life Reflects Numbers and Numbers Reflect Life.* New
York: Simon & Schuster, 2014.

———. *Here's Looking at Euclid: A Surprising Excursion through the Astonishing World of
Math.* New York: Free Press, 2010.

Berry, Mary Elizabeth. *Hideyoshi.* Cambridge, Mass.: Harvard University Press, 1982.

———. *Japan in Print.* Berkeley: University of California Press, 2006.

Bhattacharyya, A. K. *Early and Buddhist Stone Sculpture of Japan.* New Delhi: Abhinav
Publications, 2004.

Blair, Heather. "Zaō Gongen: From Mountain Icon to National Treasure." *Monumenta
Nipponica* 66, no. 1 (2011): 1–47.

Bock, Felicia. *Engi-shiki: Procedures of the Engi Era.* Tokyo: Sophia University, 1970.

Boehm, Christian. *The Concept of Danzō: "Sandalwood Images" in Japanese Buddhist Sculpture of the 8th to 14th Centuries.* London: Saffron Books, 2012.

Bowring, Richard. *The Religious Traditions of Japan, 500–1600.* Cambridge: Cambridge University Press, 2005.

Brinker, Helmut, and Hiroshi Kanazawa. *Zen, Masters of Meditation in Images and Writings.* Andreas Leisinger, trans. Zürich: Artibus Asiae, 1996.

Bungo Takadashi shitsūshi. Ōita, Usa: Bungo Takadashi, 1998.

Bunkazai Hozon Gijutsu Kyokai. *Jūyō bunkazai Tōmyōji hondō shūri koji hōkokusho.* Tokyo: Sankeien Hoshōkai, 1987.

"Buzaiin kessho *Hanyashingyō.*" In *Hakui no mukashibanashi,* ed. Hakui no Mukashibanashi Chōsa Jikkō Iinkai, vol. 1, 66–68. Hakui: Hakui no Mukashibanashi Chōsa Jikkō Iinkai, 2006.

Carr, Kevin. *Plotting the Prince: Shōtoku Cults and the Mapping of Medieval Japanese Buddhism.* Honolulu: University of Hawai'i Press, 2012.

Chibashi Bijutsukan. *Shugyoku no Nihon bijutsu: Hosomi korekushon no zenbō to Bosuton, Kuriiburando, Sakkuraa no wadaisaku: kaikan isshūnen kinen.* Chiba: Chibashi Bijutsukan, 1996.

Chibashi Fōramu Jikkō Iinkai. *Chibashi to sono jidai "zuroku."* Chiba: Chibashi Fōramu Jikkō Iinkai, 2001.

Chikushi Yutaka. "Hikosan shinkō no bijutsu." *Bukkyō geijutsu* 81 (August 1971): 143–152.

Chūbu Nihon Shinbunsha. *Gunzō ni miru: Bukkyō bijutsu ten.* Nagoya: Chūbu Nihon Shinbunsha, 1963.

Chūsei Nihon Kenkyūjo. *Ama monzeki jiin no sekai: Kōjotachi no shinkō to gosho bunka.* Tokyo: Sankei Shinbunsha, 2009.

Cleary, Thomas, trans. *The Flower Ornament Scripture.* Boston: Shambhala, 1993.

Cobbing, Andrew. *Kyushu, Gateway to Japan.* Folkestone, UK: Global Oriental, 2009.

Conant, Ellen. "The French Connection: Emile Guimet's Mission to Japan, a Cultural Context for Japonisme." In *Japan in Transition: Thought and Action in the Meiji Era, 1868–1912,* ed. Hilary Conroy et al., 113–146. London: Associated University Presses, 1984.

Covell, Jon Carter. *Under the Seal of Sesshū.* New York: Hacker Art Books, 1975.

Cunningham, Michael, ed. *Buddhist Treasures from Nara.* Cleveland: Cleveland Museum of Art, 1998.

Daigo Hachirō, ed. *Nihon no sekibutsu.* Tokyo: Kokusho Kankōkai, 1983.

"Daihōonji Hondō." *Asahi hyakka Nihon no kokuhō* 7, no. 61 (1999): 22–25.

Daihōrinkaku Henshūbu. *Zukai butsuzō no miwakekata.* Tokyo: Daihōrinkaku, 2002.

Davis, Richard. *Lives of Indian Images.* Princeton, N.J.: Princeton University Press, 1997.

Dōgen (1200–1253). *Dōgen's Pure Standards for the Zen Community: A Translation of the Eihei shingi,* Taigen Daniel Leighton and Shohaku Okumura, trans. Albany, N.Y.: State University of New York Press, 1995.

Dohi Ken'ichirō. *Kumagun jinjaki.* Kamimura [Kumamoto-ken]: Kuma Sōsho Kankōkai, 1919.

Donner, Neal, and Daniel B. Stevenson. *The Great Calming and Contemplation.* Honolulu: University of Hawai'i Press, 1993.

Eigaku Kōichi. "Tenzui Dō'on no kenkyū." *Komazawa Daigaku gakuhō* 2 (1953): 31–40.

Embree, John F. *Suye Mura: A Japanese Village.* Chicago: University of Chicago Press, 1939.

Enbutsu, Sumiko. *Chichibu: Japan's Hidden Treasure.* Rutland, Vt.: C. E. Tuttle, 1990.

Epprecht, Katharina et al. *Kannon—Divine Compassion: Early Buddhist Art from Japan.* Zürich: Museum Rietberg, 2007.

von Falkenhausen, Lothar. *Suspended Music: Chime-Bells in the Culture of Bronze Age China.* Berkeley: University of California Press, 1993.

Fister, Patricia. "Merōfu Kannon and Her Veneration in Zen and Imperial Circles in Seventeenth Century Japan." *Journal of Japanese Religious Studies* 34, no. 2 (2007): 417–442.

Flitsch, Mareile, ed. *Tokens of the Path—Japanese Devotional and Pilgrimage Images: The Wilfried Spinner Collection (1854-1918).* Zürich: Arnoldsche Art Publishers and Ethnographic Museum at the University of Zurich, 2014.

Fogg Art Museum. *Exhibition of Chinese, Japanese, and Korean Art: Bronze, Jade, Pottery, Sculpture, Together with Some Examples of Arabic Calligraphy and Persian Miniatures.* Cambridge, Mass.: Fogg Art Museum, n.d.

Fontein, Jan. *The Pilgrimage of Sudhana: A Study of Gaṇḍavyūha Illustrations in China, Japan and Java.* The Hague: Mouton, 1967.

Forbes, Edward W. "Report of the Fogg Art Museum, 1918–19." *Annual Report* (Fogg Art Museum), no. 1918/1919 (1918–1919): 1–6.

Ford, James L. *Jōkei and Buddhist Devotion in Early Medieval Japan.* New York: Oxford University Press, 2006.

Fowler, Sherry. "Containers of Sacred Text and Image at Twelfth-Century Chōanji in Kyushu." *Artibus Asiae* 74, no. 1 (2014): 43–73.

———. "Kannon Imagery in the Life of the Seventeenth-Century Manual *Butsuzō zui.*" In *Moving Signs and Shifting Discourses: Text Image Relations in East Asian Art,* ed. Jeong-hee Lee-Kalisch and Wibke Schrape. Weimar: VDG, forthcoming.

———. "Locating Tōmyōji and Its 'Six' Kannon in Japan." In *A Companion to Asian Art and Architecture,* ed. Rebecca Brown and Deborah Hutton, 580–603. Malden, Mass.: Wiley-Blackwell, 2015.

———. "Locating Tōmyōji and Its 'Six' Kannon Sculptures" [Tōmyōji "Roku" Kannon zō o tadoru]. In *Capturing the "Original": Archives for Cultural Properties,* English: 56–74; Japanese: 157–181. Tokyo: National Research Institute for Cultural Properties, 2010.

———. *Murōji: Rearranging Art and History at a Japanese Buddhist Temple.* Honolulu: University of Hawai'i Press, 2005.

———. "Saved by the Bell: Six Kannon and *Bonshō.*" In *China and Beyond in the Medieval Period: Cultural Crossings and Inter-Regional Connections,* ed. Dorothy Wong and Gustav Heldt, 329–350. Amherst, N.Y.: Cambria Press, 2014.

———. "Travels of the Daihōonji Six Kannon Sculptures." *Ars Orientalis* 36 (2006): 178–214.

———. "Views of Japanese Temples and Shrines from Near and Far: Precinct Prints of the Eighteenth and Nineteenth Centuries." *Artibus Asiae* 68, no. 2 (2008): 247–285.

Frank, Bernard. *Le Panthéon Bouddhique Au Japon: Collections d'Emile Guimet.* Paris: Editions de la Réunion des musées nationaux, 1991.

Fuchū Shishi Hensan Iinkai, ed. *Fuchū shishi shiryōshū*, vol. 11. Fuchū [Tokyo]: Fuchū Shishi Hensan Iinkai, 1966.

Fujieda Akira. "S.6983 *Kannongyō.*" *Bokubi* 177 (March 1968): 3–46.

Fujimori Takeshi. *Nihon no kannon zō.* Tokyo: Shōgakukan, 2003.

Fujimoto Yūji. "Sensōji ni okeru Kanda Sōtei no gaji: Kaneiji goyō butsugashi no katsudō no hirogari to sono genkai." *Bukkyō geijutsu* 327 (March 2013): 35–73.

Fujita Takuji. "Sanjūsan Kannon no monogatari—Ichiyō Kannon." *Zen bunka* 214 (2009): 33–40.

———. "Sanjūsan Kannon no monogatari—Kōri Kannon." *Zen bunka* 210 (2008): 81–87.

———. "Sanjūsan Kannon no monogatari—Merōfu Kannon to Gyoran Kannon." *Zen bunka* 209 (2008): 25–32.

Fujita Tsuneyo. "Kaname Kannondō no Kannon sanjūsanshin zō." *Hiratsukashi bunkazai chōsa hōkokusho* 8 (1968): 5–16.

Fukagawa, Hidetoshi, and Tony Rothman. *Sacred Mathematics: Japanese Temple Geometry.* Princeton, N.J.: Princeton University Press, 2008.

Fukuoka-ken Kyōiku Iinkai. *Kyushu no bukkyō bijutsu ten.* Fukuoka-ken Bunka Kaikan, 1969.

Furukawa Shōichi. "Rokuji mandara no seiritsu ni tsuite." *Yamato Bunkakan bi no tayori* 160 (Fall 2007), n.p.

Gao Ruizhe. "Qingchu Guanyin huapu cirong wushisan xianbanhua yanjiu" [A Study of the Woodcut Paintings "Fifty-Three Presense [*sic*] of the Goddess of Mercy" in Early Ching Dynasty]. MA thesis, National Taiwan Normal University, 2006.

Gangōji Bunkazai Kenkyūjo. *Buzan Hasedera shūi.* Sakurai: Sōhonzan Hasedera Bunkazai Tō Hozon Chōsa Iinkai, 1994.

Gerhart, Karen. *The Material Culture of Death in Medieval Japan.* Honolulu: University of Hawai'i Press, 2009.

———. "Talent, Training, and Power: The Kano Workshop in the Seventeenth Century." In *Copying the Master and Stealing His Secrets: Talent and Training in Japanese Painting,* ed. Brenda Jordon and Victoria Weston, 189–194. Honolulu: University of Hawai'i Press, 2002.

Getty, Alice. *The Gods of Northern Buddhism.* Oxford: Clarendon Press, 1914.

Ghosh, Mallar. *Development of Buddhist Iconography in Eastern India: A Study of Tārā, Prajñās of Five Tathāgatas and Bhṛikuṭī.* New Delhi: Munshiram Manoharlal, 1980.

Gimello, Robert. "Icon and Incantation: The Goddess Zhunti and the Role of Images in the Occult Buddhism of China." In *Images in Asian Religions: Texts and Contexts,* ed. Phyllis Granoff, 225–256. Vancouver: University of British Columbia Press, 2004.

Girmond, Sybille. "The Collection of Japanese Buddhist Painting and Sculpture in the Museum of East Asian Art in Cologne." *Orientations* 28, no. 1 (January 1997): 46–55.

Glassman, Hank. *The Face of Jizō: Image and Cult in Medieval Japanese Buddhism.* Honolulu: University of Hawai'i Press, 2012.

Gotō Daiyō. *Kanzeon Bosatsu no kenkyū.* Suginami-chō, Tokyo: Hōshidō, 1928.

——. *Kanzeon Bosatsu no kenkyū.* Tokyo: Sankibō Busshorin, 1958.

——. *Zukai Kannonkyō tsuki Kanzeon Bosatsu no kenkyū.* Tokyo: Sankibō Shorin, 2005.

Gotō Osamu. "Kakureta chiiki no bunkazai isan: Kumamoto-ken Hitoyoshi, Kumagun no shaji kenchiku chōsa kara." *Gekkan bunkazai* 344 (May 1992): 4–12.

Graham, Patricia. *Faith and Power in Japanese Buddhist Art, 1600–2005.* Honolulu: University of Hawai'i Press, 2007.

Grapard, Allan. "Geotyping Sacred Space: The Case of Mt. Hiko in Japan." In *Sacred Space: Shrine, City, Land,* ed. Benjamin Z. Kedar and R. J. Zwi Werblowsky, 215–249. New York: New York University Press, 1998.

——. "Lotus in the Mountain, Mountain in the Lotus: Rokugō Kaizan Nimmon Daibosatsu Hongi." *Monumenta Nipponica* 41, no. 1 (Spring 1986): 21–50.

——. *The Protocol of the Gods.* Berkeley: University of California Press, 1992.

——. "The Textualized Mountain—Enmountained Text: The *Lotus Sutra* in Kunisaki." In *The Lotus Sutra in Japanese Culture,* ed. George J. Tanabe Jr. and Willa Jane Tanabe, 159–89. Honolulu: University of Hawai'i Press, 1989.

Groner, Paul. *Ryōgen and Mount Hiei Japanese Tendai in the Tenth Century.* Honolulu: University of Hawai'i Press, 2002.

Guoli gugong bowuyuan. *Guanyin tezhan* [Visions of Compassion: images of Kuanyin in Chinese art]. Taipei: Guoli gugong bowuyuan, 2000.

Guth, Christine. "The Divine Boy in Japanese Art." *Monumenta Nipponica* 42, no. 1 (Spring 1987): 1–23.

——. *Shinzō: Hachiman Imagery and Its Development.* Cambridge, Mass.: Harvard University Press, 1985.

——. "A Tale of Two Collectors: Hara Tomitarō and Charles Lang Freer." *Asian Art* (Fall 1991): 28–49.

Hakuishi Bunkazai Kyōiku Iinkai. *Hakuishi no bunkazai.* Hakui: Hakuishi Bunkazai Kyōiku Iinkai, 1968.

Hakuishi Shihensan Iinkai. *Hakuishishi: Chūsei shaji hen.* Hakuishi Shihensan Iinkai, 1975.

Hamatama-chō Kyōiku Iinkai. *Hamatama-chō no bunkazai.* Hamatama-chō: Hamatama-chō Kyōiku Iinkai, 1996.

——. *Hamatama chōshi,* vol. 1. Saga: Hamatama-chō Kyōiku Iinkai, 1989.

Haraguchi Shizuko. "Tōyama, Honpōji zō "Hokekyō mandara" no zuzō kaishaku to kanshin sō Jōshin." *Kyoto bigaku bijutsushigaku* 3 (2004): 27–66.

Haraguchi Torao. *Kagoshimaken no rekishi, Kenshi shirīzu,* vol. 46. Tokyo: Yamakawa Shuppansha, 1971.

Hase Hōshū, ed. *Kōbō Daishi den zenshū,* vol. 1. Kyoto: Rokudai Shinpōsha, 1934.

Hata Yasunori. "Sesshū no Kannon hensōzu o megutte." In *Ronshū tōyō nihon bijutsushi to genba: Mitsumeru, mamoru, tsutaeru,* 99–110. Tokyo: Chikurinsha, 2012.

Hattori Hōshō. "Nihon senjutsu gikyō to *Butsuzō zui." Bukkyō bunka gakkai kiyō* 2 (1994): 87–110.

Hayami Takusu. *Bosatsu: Bukkyōgaku nyūmon.* Tokyo: Tokyo Bijutsu, 1982.

———. *Jizō shinkō.* Tokyo: Hanawa Shobō, 1975.

———. *Kannon shinkō.* Tokyo: Hanawa Shobō, 1970.

———. *Kannon shinko jiten.* Tokyo: Ebisu Kōshō Shuppan, 2000.

Hayashi On. "Chōjuji zō Shō Kannon mandara kō." *Bukkyō geijutsu* 197 (July 1991): 11–27.

———. "Myōken Bosatsu to hoshi mandara." *Nihon no bijutsu* 377 (October 1997). Dedicated issue.

Hidenobu. *Buddhist Iconography in the Butsuzōzui of Hidenobu,* ed. Anita Khanna. New Delhi: D. K. Printworld, 2010.

Higashi Shinji. "Tōdō Takatora kō no ohaka ga aru." *Kamo bunka* 13 (February 1985): 3–4.

Hikonejō Hakubutsukan. *Bijutsu no naka no dōji.* Hikone: Hikone-shi Kyōiku Iinkai, 2000.

Hirabe Kyōnan (1815–1890). *Hyūga chishi.* Kumamoto: Seichōsha, 1976.

Hirahata Yoshio. *Chichibu sanjūyonkasho.* Chiba-ken, Chōshi-shi: Fudasho Kenkyūkai, 1971.

Hitoyoshi Shishi Hensan Kyōgikai. *Hitoyoshi shishi.* Hitoyoshi: Hitoyoshi-shi Kyōiku Iinkai, 1981.

"'Hofuraku Jizō': Meisatsu Kōunji ni. . . ." *Tokyo Asahi Shinbun* 17555 (March 4, 1935): G11.

Holm, Jean, ed. *Sacred Place.* London: Pinter Publishers, 1994.

Honda Fujio, ed. *Hen na butsuzō.* Tokyo: Gakken, 2012.

———. *Kannon Bosatsu.* Tokyo: Gakken, 2004.

Honolulu Academy of Arts. *Sacred Treasures of Mount Kōya: The Art of Japanese Shingon Buddhism.* Honolulu: Koyasan Reihokan Museum, 2002.

Hosomi Bijutsukan. *Rinpa, Jakuchū to miyabi no sekai.* Kyoto: Seigensha, 2010.

Howard, Angela F. *Summit of Treasures: Buddhist Cave Art of Dazu, China.* Trumbull, Conn.: Weatherhill, 2001.

Hsüan Hua, and Heng Yin. *The Dharani Sutra: The Sutra of the Vast, Great, Perfect, Full, Unimpeded Great Compassion Heart Dharani of the Thousand-Handed, Thousand-Eyed Bodhisattva Who Regards the World's Sounds.* San Francisco: The Society, 1976.

Ibaraki Kenritsu Rekishikan. *Tsukubasan: Kami to hotoke no owasu yama.* Mito: Ibaraki Kenritsu Rekishikan, 2013.

Ichiba Chōjirō. "Kubotesan dōbankyō zuzō shikō." *Kōkogaku zasshi* 40, no. 3 (1954): 12–24.

Idemitsu Bijtsukan. *Nihon kaiga no miwaku.* Tokyo: Idemitsu Bijtsukan, 2014.

Ifrah, Georges. *The Universal History of Numbers: From Prehistory to the Invention of the Computer,* David Bellos, trans. New York: J. Wiley, 2000.

Igarashi Kōichi. "Tōfukuji zō sanjūsan Kannon zō." *Bijutsushi ronsō* 11 (March 1995): 197–226.

Iida Michio. *Nichimachi, tsukimachi, kōshinmachi.* Kyoto: Jinbun Shoin, 1991.

Iinuma Kenji. "Bungo no kuni Rokugōsan *Dōkyōji monjo* no shōtai." *Ōita Kenritsu Usa Fudoki no Oka Rekishi Minzoku Shiryōkan kenkyū kiyō* 6 (1989): 45–68.

Ikawa Kazuko. "Hyōgo Nakayamadera no Jūichimen Kannon zō." *Bijutsu kenkyū* 303 (January 1976): 145–153.

——. "Kannon zō." *Nihon no bijutsu* 166 (March 1980). Dedicated issue.

Ikeda Yasaburō et al. *Nihon meisho fūzoku zue.* Tokyo: Kadokawa Shoten, 1979–1988.

Inaya Yūsen, ed. *Shingon himitsu kaji shūsei.* Osaka: Tōhō Shuppan, 1998.

Inoue Kazutoshi. "Nyoirin Kannon zō, Batō Kannon zō." *Nihon no bijutsu* 312 (May 1992). Dedicated issue.

Inoue Tadashi. "Hyōgo, Nakayamadera Jūichimen Kannon ryūzō." *Nihon bijutsu kōgei* 604 (January 1989): 60–65.

Inoue Yasushi. *Nihon no teienbi Sankeien,* vol. 7. Tokyo: Shūeisha, 1989.

——, ed. *Ryōsenji.* Kyoto: Tankōsha, 1979.

Ishida, Hisatoyo. *Japanese Esoteric Painting.* Tokyo: Kodansha International, 1987.

Ishii Yūshō. "*Shodaiji ruijū 'Jūshichitsūinjin'* ni tsuite." *Shingonshū Buzanha sōgō kenkyūin kiyō* 9 (2004): 21–36.

Ishikawa Hiroshi. "Shichiyamachitō zakki." *Nihon no sekibutsu* 22 (August 1982): 54–57.

Ishikawa Tomohiko. "Sanjūsan Kannon mandara zu ni tsuite–Kegonji bon to Kannonshōji bon no zuzōteki shomondai." *Bukkyō geijutsu* 189 (March 1990): 34–60.

Ishikawa Toshio. *Sūji de wakaru Bukkyō bunkazai no meishō.* Kyoto: Tankōsha, 2013.

Itō Shirō. "Fukūkenjaku Kannon zō no rokuhie." *Bigaku bijutsushi kenkyū ronshū* 1 (December 1996): 25–37.

——. *Senbon Shakadō Daihōonji no bijutsu to rekishi.* Kyoto: Yanagihara Shuppan, 2008.

Itō Takemi, ed. *Zōho shoshū butsuzō zui.* Tokyo: Yahata Shoten, 2005.

Iwai Taketoshi. *Nihon kokenchiku seika.* Tokyo: Benridō, 1919.

Iwata Shigeki. "Enkyōji Okunoin Kaizandō no Shōkū shonin zazō ni tsuite." *Rokuon zasshū* 11 (March 2009): 35–47.

Izumi Takeo. "'Dōkō Kannon' gazō o megutte." In *Zuzōgaku I, Imēji no seiritsu to denshō,* ed. Tsuda Tetsuei, 83–99. Tokyo: Chikurinsha, 2012.

Izumi Takeo, Kasuya Makoto, and Yamamoto Satomi, eds. *Kokuhō rokudōe.* Tokyo: Chūō Kōron Bijutsu Shuppan, 2007.

Japan Art Centre, ed. *Horses and Humanity in Japan.* Tokyo: Japan Association for International Horse Racing, 1999.

Joly, Henri L. *Legend in Japanese Art.* London: J. Lane, 1908.

Jōrakuji Bijutsukan. *Sukui no hotoke Kannon to Jizō.* Ueda-shi, Nagano-ken: 1992.

Kagoshima-ken Rekishi Shiryō Sentā Reimeikan. *Bukkyō bunka no denrai: Satsuma Kokubunji e no michi.* Kagoshima-shi: Kagoshima-ken Rekishi Shiryō Sentā Reimeikan, 1990.

——. *Inori no katachi: Chūsei Minami Kyushu no hotoke to kami.* Kagoshima-shi: Kagoshima-ken Rekishi Shiryō Sentā Reimeikan, 2005.

Kai Tsuneoki. "Shukuin busshi no shinshutsurei Chōkyūji no mokuzō Kokūzō Bo-satsu zazō ni tsuite." *Shiseki to bijutsu* 767 (August 2006): 274–278.

Kamikawa Michio. "*Kakuzenshō* 'Rokujikyōhō' ni tsuite." *Aichi Kenritsu Daigaku bun-gakubu ronshū* 54 (March 2006): 17–44.

Kamakura Kokuhōkan. *Kamakura × mikkyō.* Kamakura: Kamakura Kokuhōkan, 2011.

Kamakura-shi Kyōiku Iinkai, ed. *Kamakura-shi bunkazai sōgō mokuroku: Shoseki kaiga chōkoku kōgei hen.* Kyoto: Dōhōsha, 1986.

Kamakura-shi Shishi Hensan Iinkai. *Kamakura shishi: Kinsei shiryō hen dai 2.* Tokyo: Yoshikawa Kobunkan, 1987.

Kamo Chōshi Hensan to Iinkai. *Kamo chōshi.* Kamo-chō: Kamo Chōshi Hensan to Iinkai, 1988.

Kan Ken'ei. *Richō no bi: butsuga to bonshō.* Tokyo: Akashi Shoten, 2001.

Kanagawa Kenritsu Kanazawa Bunko. *Bukkyō hanga.* Yokohama: Kanagawa Kenritsu Kanazawa Bunko, 1993.

Kanazawa Bunko. *Kanazawa Bunko no meihō.* Yokohama: Kanagawa Kenritsu Kanazawa Bunko, 1992.

Kanezashi Shōzō. *Saigoku Bandō Kannon reijōki.* Tokyo: Seiabō, 1973.

Kang Soyon. Chōsen zenki no Kannon Bosatsu no yōshikiteki henyō to sono ōshin myōhō no zuzō." *Bukkyō geijutsu* 276 (September 2004): 77–103.

Katō Takeo. "Gifu Chūnō chihō no Saigoku sanjūsan Kannon." *Nihon no sekibutsu* 88 (December 1998): 54–57.

Kawasaki Chitora. "Takuhō hitsu sanjūsan Kannon ni tsuite." *Kokka* 135 (August 1901): 45–48.

Keene, Donald, trans. *Essays in Idleness: The Tsurezuregusa of Kenkō.* New York: Columbia University Press, 1967.

Kikuiri Tonnyo, ed. *Senbon Shakadō Daihōonji.* Kyoto: Benridō, 1956.

Kimura Takeshi. "Hakusekisan Buzaiin Notoshi ni okeru Sōtoshū to Ōbaku to no kakawari." *Ōbaku bunka* 121 (2000–2001): 182–186.

Kinki Nihon Tetsudō, ed. *Sōkan Hōryūji.* Kyoto: Kawahara Shoten, 1949.

Kissuizō Shōgyō Chōsadan. *Shōren'in monzeki kissuizō shōgyō mokuroku.* Tokyo: Kyūko Shoin, 1999.

Klein, Bettina, and Kojima Kaoru. "Berurin tōyō bijutsukan zō shukuzu shochō 'Hi-tsuen itsuyō.'" *Kokka* 1091 (February 1986): 29–45.

Kline, Susan Blakely. "When the Moon Strikes the Bell: Desire and Enlightenment in the Noh Play Dojoji." *Journal of Japanese Studies* 17, no. 2 (Summer 1991): 291–322.

Kobayashi Honkō. "Chōkyūji no kaiki to butsuzō." *Miyazaki hibi shinbun.* June 7, 1963.

Kobe Shiritsu Hakubutsukan. *Ingen zenshi to Ōbakushū no kaigaten.* Kobe: Kobe-shi Supōtsu Kyōiku Kōsha, 1991.

Kobori Taigan. *Kōdaiji, Shinpan koji junrei, Kyoto,* vol. 37. Kyoto: Tankōsha, 2009.

Kohn, Livia. "Taoism in Japan: Positions and Evaluations." *Cahiers d'Extrême-Asie* 8 (1995): 389–412.

Kokuritsu Rekishi Minzoku Hakubutsukan. *Shaji keidaizu shiryō shūsei.* Chiba-ken, Sakura-shi: Kokuritsu Rekishi Minzoku Hakubutsukan, 2001.

Kokushi Daijiten Henshū Iinkai hen. *Kokushi daijiten.* Tokyo: Yoshikawa Kōbunkan, 1979.

Kokuyaku issaikyō wakan senjutsu bu, shiden bu. Tokyo: Daitō Shuppansha, 1988.

Kondō Yuzuru. "Nyohōkyō shinkō to Ōita, Chōanji Tarōten zō." *Bukkyō Daigaku ajia shūkyō bunka jōhō kenkyūjo kenkyū kiyō* 3 (2007): 21–73.

Konkai Kōmyōji. *Daihonzan Kurotani Konkai Kōmyōji hōmotsu sōran.* Kyoto: Shibunkaku Shuppan, 2011.

Kōno Minoru et al. *Chūgoku shōkei: Nihon bijutsu no himitsu o sagure.* Machida-shi: Machida Shiritsu Kokusai Hanga Bijutsukan, 2007.

Kōno Zentarō. *Chichibu sanjūyon fudasho.* Urawa-shi: Saitama Shinbunsha, 1984.

Koyama Satoko. *Gohō dōji shinkō no kenkyū.* Kyoto: Jishōsha Shuppan, 2003.

Kumagun Kyōikushikai. *Kumagunshi.* Hitoyoshi-chō, Kumamoto-ken: 1941.

Kumamoto Kenritsu Bijutsukan. *Heian jidai no bijutsu: Kyushu no chōkoku o chūshin ni.* Kumamoto: Kumamoto Kenritsu Bijutsukan, 1999.

———. *Kannon Bosatsu to Jizō Bosatsu.* Kumamoto: Kumamoto Kenritsu Bijutsukan, 1997.

Kunimi Chōshi Henshū Iinkai. *Kunimi chōshi.* Ōita, Kunimi-chō, 1993.

Kunisaki chōshi. Ōita-ken: Kunisaki Chōshi Kankōkai, 1973.

Kuno Takeshi. *Edo butsuzō zuten.* Tokyo: Tōkyōdō Shuppan, 1994.

———. *Kannon sōkan.* Tokyo: Shin Jinbutsu Ōraisha, 1986.

———. *Sekibutsu.* Vol. 36 of *Book of Books.* Tokyo: Shōgakkan, 1975.

———. "Tachiki ni tsuite." *Bijutsu kenkyū* 217 (July 1961): 43–58.

Kurata Bunsaku. "Zōnai nōnyūhin." *Nihon no bijutsu* 86 (July 1973). Dedicated issue.

Kyōdoshi Kenkyū Kurabu. *Sōrakugun no jiin.* Kyoto: Kyoto Furitsu Kizu Kōtōgakkō, 1982.

Kyoto Bunka Hakubutsukan. *Miyako no eshi wa hyakka ryōran.* Kyoto: Kyoto Bunka Hakubutsukan, 1998.

Kyoto Furitsu Sōgo Shiryōkan, ed. *Hara Zaichū to sono ryūha.* Kyoto: Kyoto Furitsu Sōgo Shiryōkan Tomo no Kai, 1976.

Kyoto Furitsu Yamashiro Kyōdo Shiryōkan. *Minamiyamashiro sanjūsansho junrei.* Yamashiro-chō: Kyoto Furitsu Yamashiro Kyōdo Shiryōkan, 1996.

———. *Tōmyōji no bunkazai.* Yamashiro-chō: Kyoto Furitsu Yamashiro Kyōdo Shiryōkan, 1986.

Kyoto Kokuritsu Hakubutsukan. *Kyoto shaji chōsa hōkoku,* vol. 17. Kyoto: Dōhosha, 1996.

———. *Minami Yamashiro no koji junrei.* Kyoto: Kyoto Kokuritsu Hakubutsukan, 2014.

———. *Ōchō no butsuga to girei.* Kyoto: Kyoto Kokuritsu Hakubutsukan, 1998.

———. *Rakuchū rakugaizu.* Kyoto: Kokuritsu Hakubutsukan, 1997.

Kyoto Shiritsu Geijutsu Daigaku. *Bukkyō zuzō shūsei: Rokkakudō Nōmanin butsuga funpon.* Kyoto: Hōzōkan, 2004.

Kyoto Yamashiro jiin jinja daijiten. Tokyo: Heibonsha, 1997.

Kyōtofu Kyōikuchō Bunkazai Hogoka. *Kokuhō kenzōbutsu Daihōonji Hondō shūri koji hōkokusho.* Kyoto: Kyōtofu Kyōikuchō Bunkazai Hogoka, 1954.

Kyushu Rekishi Shiryōkan. *Bungo Kunisaki Chōanji.* Vol. 9 of *Kyushu no jisha shirizu.* Fukuoka-ken Dazaifu-shi: Kyushu Rekishi Shiryōkan, 1988.

——. *Chikuzen Wakamiya Seisuiji.* Dazaifu: Kyushu Rekishi Shiryōkan, 2006.

——. *Tsushima Katsune Hōseiji Kannondō Fukuoka-ken.* Dazaifu-shi: Kyushu Rekishi Shiryōkan, 1992.

Lachman, Charles. "Buddhism: Image as Icon, Image as Art." In *The Oxford Handbook of Religion and the Arts,* ed. Frank Burch Brown, 367–378. New York: Oxford University Press, 2014.

LaFleur, William. *The Karma of Words: Buddhism and the Literary Arts in Medieval Japan.* Berkeley: University of California Press, 1983.

Lawrence, C. W. "Notes of a Journey in Hitachi and Shimosa." *Transactions of the Asiatic Society of Japan* 2 (1874): 174–181.

Lee, Hong-Eun. "The History of Asiatic Department, Boston Museum of Fine Arts—Focused on the Far Eastern Arts." MA thesis, Seton Hall University, 2000.

Levering, Miriam. "Are Friendship *Bonshō* Bells Buddhist Symbols? The Case of Oak Ridge." *Pacific World: Journal of the Institute of Buddhist Studies,* 3rd series, no. 5 (Fall 2003): 163–178.

Levine, Gregory, and Yukio Lippit. *Awakenings: Zen Figure Painting in Medieval Japan.* New Haven, Conn.: Yale University Press, 2007.

Levy, Ian Hideo. *The Ten Thousand Leaves: A Translation of the Man'yōshū, Japan's Premier Anthology of Classical Poetry.* Princeton, N.J.: Princeton University Press, 1981.

Li, Yuhang. "Gendered Materialization: An Investigation of Women's Artistic and Literary Reproductions of Guanyin in Late Imperial China." PhD diss., University of Chicago, 2011.

Lindsey, William R. *Fertility and Pleasure: Ritual and Sexual Values in Tokugawa Japan.* Honolulu: University of Hawai'i Press, 2007.

Lippit, Yukio. *Colorful Realm: Japanese Bird-and-Flower Paintings by Itō Jakuchū.* Washington, D.C.: National Gallery of Art, 2012.

Lomi, Benedetta. "Dharanis, Talismans, and Straw-Dolls: Ritual Choreographies and Healing Strategies of the "Rokujikyōhō" in Medieval Japan." *Japanese Journal of Religious Studies* 41, no. 2 (2014): 255–304.

——. "The Iconography of Ritual Images, Texts and Beliefs in the Batō Kannon Fire Offering." In *Grammars and Morphologies of Ritual Practices in Asia,* ed. Axel Michaels et al., 568–569. Wiesbaden: Harrassowitz, 2010.

Londo, William. "The Other Mountain: The Mt. Kōya Temple Complex in the Heian Era." PhD diss., University of Michigan, 2004.

Louis-Frédéric, and Nissim Marshall. *Buddhism.* Paris: Flammarion, 1995.

Mabuchi Miho. "Maruyama Ōkyo 'nanpuku zukan' to *Kannongyō,* Kannongyōe." *Bijutsu ronsō* 19 (February 2003): 85–111.

Machida Shiritsu Hakubutsukan. *Shōmen kongō to kōshin shinkō.* Machida-shi: Machida Shiritsu Hakubutsukan, 1995.

Machida Shiritsu Kokusai Hanga Bijutsukan. *Sukui no hotoke: Kannon to Jizō no bijutsu.* Machida-shi: Machida Shiritsu Kokusai Hanga Bijutsukan, 2010.

Mack, Karen. "The Function and Context of Fudō Imagery from the Ninth to the Fourteenth Century in Japan." PhD diss., University of Kansas, 2006.

MacWilliams, Mark. "Temple Myths and the Popularization of Kannon Pilgrimage in Japan: A Case Study of Ōya-ji on the Bandō Route." *Japanese Journal of Religious Studies* 24, nos. 3–4 (1997): 375–411.

Maizawa Rei. "Hosomi Bijutsukan shozō roku Kannon zō kō." *Bijutsushi* 166 (March 2009): 324–339.

Makita Tairyō. "Zui chōan Dai Zenjōji Chikō ni tsuite." In *Chūgoku bukkyōshi kenkyū,* vol. 2, pp. 16–27. Tokyo: Daitō Shuppansha, 1984.

Manabe Takashi. *Edo Tokyo bonshō meibunshū.* Tokyo: Bijinesu Kyōiku Shuppansha, 2001.

Maruo Shōzaburō, ed. *Nihon chōkoku shi kiso shiryō shūsei: Heian jidai,* vol. 3. Tokyo: Chūō Kōron Bijutsu Shuppan, 1967.

Marushima Takaō. "'Kanzeon Bosatsu sanjūsanshin mandara' ni egakareta sanjūsan Kannon ni tsuite." *Hiratsukashi bunkazai chōsa hōkokusho* 33 (1998): 27–34, 43.

Masakama Tashiro et al. *Shin'yaku Kuma gaishi.* Kumamoto: Seichōsha, 1972.

Matsushima Ken. "Jizō Bosatsu zō." *Nihon no bijutsu* 239 (April 1986). Dedicated issue.

Matsushiro Matsutarō, ed. *Higashi Matsuuragunshi.* Higashimatsuura-gun: Kyōikukai Hakkō, 1915.

Matsuura Kiyoshi. "Ni ryūō ga rengeza o hōji suru Juntei Kannon ni tsuite." *Osaka Shiritsu Hakubutsukan kiyō* 22 (1990): 1–26.

McCallum, Donald. "The Evolution of the Buddha and Bodhisattva Figures in Japanese Sculpture of the Ninth and Tenth Centuries." PhD diss., New York University, 1973.

McCormick, Melissa. *Tosa Mitsunobu and the Small Scroll in Medieval Japan.* Seattle: University of Washington Press, 2009.

McCullough, Helen Craig, trans. *The Taiheiki: A Chronicle of Medieval Japan.* Rutland, Vt.: C. E. Tuttle, 1979.

——, trans. *A Tale of Flowering Fortunes: Annals of Japanese Aristocratic Life in the Heian Period.* Stanford, Calif.: Stanford University Press, 1980.

——, trans. *The Tale of the Heike.* Stanford, Calif.: Stanford University Press, 1988.

McKelway, Matthew P. *Capitalscapes: Folding Screens and Political Imagination in Late Medieval Kyoto.* Honolulu: University of Hawai'i Press, 2006.

——. "Kitano Kyōōdō to Suwa no shinji: Muromachi jidai senmen zu no ba to kioku" [Kitano Sūtra Hall and Archery at Suwa Shrine: Muromachi Fan Paintings and Shogunal Memory]. In *Fūzoku kaiga no bunkagaku: Toshi o utsusu media,* ed. Matsumoto Ikuyo, 78–96. Kyoto: Shibunkaku Shuppan, 2009.

Meech, Julia. "A Painting of Daiitoku from the Bigelow Collection." *Boston Museum Bulletin* 67, no. 347 (1969): 18–43.

Meech-Pekarik, Julia. "The Flying White Horse: Transmission of the Valāhassa Jātaka Imagery from India to Japan." *Artibus Asiae* 43, no. 1/2 (1981): 111–128.

Mikkyō daijiten. Kyoto: Hōzōkan, 1983.

Mitsumori Masashi. *Bukkyō bijutsu no kenkyū.* Kyoto: Jishōsha, 1999.

Miya Tsugio. "Shussō *Kannongyō* no sho mondai." *Jissen joshidai bigaku bijutsu shigaku* 4 (1989): 82–101.

Miyajima Shin'ichi. "Tanaka bon '*Sho Kannon zuzō*' ni tsuite." *Museum* 427 (October 1986): 19–27.

Miyake Hisao. "Kamakura jidai no chōkoku: Butsu to hito no aida." *Nihon no bijutsu* 459 (August 2004). Dedicated issue.

Miyama Takaaki. "Higo Jōkei no bosatsu zō ni tsuite." *Bukkyō geijutsu* 187 (November 1989): 100–119.

Miyazaki-ken. *Miyazaki-ken shiseki chōsa,* vol. 3. Miyazaki-ken, 1928.

———. *Miyazaki kenshi sōsho Hyūgaki.* Miyazaki-ken, 1999.

———. *Miyazaki kenshi tsūshihen.* Miyazaki-ken, 1998.

Miyazaki-ken Jinjachō. *Miyazaki-ken jinjashi.* Miyazaki-shi: Miyazaki-ken Jinjachō, 1988.

Mizuno Keisaburō. "Kuramadera Shō Kannon zō ni tsuite." In *Kannon—sonzō to hensō: Kokusai kōryū bijutsushi kenkyūkai dai gokai shinpojiyamu,* ed. Kokusai Kōryū Bijutsushi Kenkyūkai, 87–93. Osaka: Kokusai Kōryū Bijutsushi Kenkyūkai, 1986.

———, ed. *Nihon chōkokushi kiso shiryō shūsei: Kamakura jidai: Zōzō meiki hen.* Tokyo: Chūō Kōron Bijutsu Shuppan, 2003.

Mochizuki Shinjō. *Nihon Bukkyō bijutsu hihō: Shoka aizō.* Tokyo: Sansaisha, 1973.

Mochizuki Shinkō. *Mochizuki Bukkyō daijiten.* Tokyo: Sekai Seiten Kankō Kyōkai, 1954–1958.

Moerman, D. Max. "The Archeology of Anxiety: An Underground History of Heian Religion." In *Heian Japan, Centers and Peripheries,* ed. Mikael Adolphson, 245–271. Honolulu: University of Hawai'i Press, 2007.

Monbushō Bunkachō, ed. *Jūyō bunkazai 10, Kaiga* IV. Tokyo: Mainichi Shinbunsha, 1972–1977.

Mōri Hisashi. *Sculpture of the Kamakura Period.* New York: Weatherhill, 1974.

Mori Shigeaki. "Sanbōin Kenshun ni tsuite." In *Kodai chūseishi ronshū,* ed. Kyushu Daigaku Kokushigaku Kenkyūshitsu, 401–431. Tokyo: Yoshikawa Kōbunkan, 1990.

Morita Kiyomi. *Kakure nenbutsu to sukui: Nonosan no fushigi, Kirishima sanroku no minzoku no shugen.* Miyazaki: Kōmyakusha, 2008.

Morris, Ivan. *The Nobility of Failure: Tragic Heroes in the History of Japan.* Rutland, Vt.: Charles E. Tuttle, 1975.

Morse, Anne Nishimura, ed. *Object as Insight: Japanese Buddhist Art & Ritual.* Katonah, N.Y.: Katonah Museum of Art, 1995.

Morse, Anne Nishimura, and Nobuo Tsuji, eds. *Japanese Art in the Museum of Fine Arts, Boston.* Boston: Museum of Fine Arts, Boston, 1988.

Morse, Samuel C. "The Buddhist Transformation in the Ninth Century: The Case of Eleven-Headed Kannon." In *Heian Japan, Centers and Peripheries,* ed. Mikael Adolphson, 151–176. Honolulu: University of Hawai'i Press, 2007.

Mrázek, Jan, and Morgan Pitelka, eds. *What's the Use of Art?: Asian Visual and Material Culture in Context.* Honolulu: University of Hawai'i Press, 2008.

Murai Jun, ed. *Jōen-bon Tsurezuregusa kaishaku to kenkyū.* Tokyo: Ofūsha, 1967.

Murakado Noriko. "Wiriamu Andaason to *Butsuzō zui*—'Nihon bijutsushi' keiseiki ni okeru ōbun Nihon kenkyūsho no ichi." *Bijutsushi* 62, no. 1 (2012): 48–66.

Murano Shinsaku. "Den Shōkei hitsu "Kannon zu" (Kenchōji shozō) sanjūni fuku no kenkyū." *Kajima bijutsu zaidan nenpō* 26 (2008): 482–491.

Murase, Miyeko. "Kuan-yin as Savior of Men: Illustration of the Twenty-Fifth Chapter of the Lotus Sūtra in Chinese Painting." *Artibus Asiae* 33, no. 1–2 (1971): 39–74.

Murata, Jiro. "The Main Hall of the Daihoonji Temple." *Japan Architect* 37, pt. 1 (June 1962): 78–83 and pt. 2 (July 1962): 80–85.

Mus, Paul. *La lumière sur les six voies.* Paris: Institut d'ethnologie, 1939.

Museum für Ostasiatische Kunst der Stadt Köln. *Buddhistische Kunst Ostasiens.* Köln: Wienand, 1968.

———. *Kerun Tōyō Bijutsukan Kaiga = Painting in the Museum of East Asian Art, Cologne.* Tokyo: Bunkazai Hozon Shūfuku Gakkai, 1999.

Museum of Fine Arts, Boston, Tokyo Kokuritsu Hakubutsukan, and Kyoto Kokuritsu Hakubutsukan. *Bosuton Bijutsukan shozō Nihon kaiga meihinten.* Tokyo: Nihon Terebi Hōsōmō, 1983.

Nagai Yoshinori, ed. *Hasedera genki: Ihon.* Tokyo: Koten Bunko, 1953.

Nagano-ken. *Nagano kenshi: Bijutsu kenchiku shiryō hen; bijutsu kōgei.* Nagano-shi: Nagano Kenshi Kankōkai, 1992.

Nagata Ken'ichi. "Harada Naojirō 'kiryū' Kannon (1890) ni okeru 'teikoku nihon' no gūi." *Bijutsushi* 167 (vol. 59, no. 1): 232–249.

Nakada Junna. *Honsenji daibonshō monogatari.* Tokyo: Honsenji, 2011.

Nakajima Junichi. "Busshi Higo bettō Jōkei kō." *Kanazawashi Monjokan kiyō* 4 (1981): 1–25.

Nakamura Chishirō. *Kirishimayama.* Tokyo: Hōbundō, 1943.

Nakamura Kiyoshi, ed. *Kannon sanjūsanshin.* Kyoto: Ikkyū Shūonkai, 1985.

Nakamura Masaaki. "Daihōonji." *Nihon no bijutsu kōgei* 503 (August 1980): 15–21.

Nakamura Teiri. "Rokujikyōhō no honzon ni tsuite." *Ōsaki gakuhō* 157 (March 2001): 103–124.

———. "Rokujikyōhō to kitsune." *Ōsaki gakuhō* 156 (March 2000): 123–149.

Nakano Genzō. *Nihon no butsuzō, Kannon.* Kyoto: Tankōsha, 1982.

———. *Rokudōe no kenkyū.* Kyoto: Tankōsha, 1989.

Nakano Hatayoshi. *Hachiman shinkō shi no kenkyū.* Tokyo: Yoshikawa Kōbunkan, 1967.

Nakayama Keishō. *Zenkoku sekibutsu ishigami daijiten.* Tokyo: Ritchi Maindo, 1990.

Namikawa Banri. *Sanuki no hihō.* Tokyo: Heibonsha, 1985.

Naniwada Tōru. "Kyōzō to kakebotoke." *Nihon no bijutsu* 284 (January 1990). Dedicated Issue.

Nara-ken Kyōiku Iinkai. *Shukuin busshi.* Nara: Nara-ken Kyōiku Iinkai, 1998.

Nara Kokuritsu Hakubutsukan. *Birei: Inseiki no kaiga.* Nara: Nara Kokuritsu Hakubutsukan, 2007.

———. *Busshari no shōgon.* Kyoto: Dōhōsha, 1983.

———. *Ishiyamadera no bi.* Ōtsu: Daihonzan Ishiyamadera, 2008.

———. *Kannon Bosatsu.* Nara: Nara Kokuritsu Hakubutsukan, 1977.

———. *Kannon Bosatsu* [expanded edition]. Kyoto: Dōhōsha, 1981.

———. *Kokuhō jūyō bunkazai Bukkyō bijutsu,* vol. 5: *Kyushu* II. Nara: Nara Kokuritsu Hakubutsukan, 1980.

———. *Nara Kokuritsu Hakubutsukan zōhin zuhan mokuroku, Bukkyō kaigahen.* Nara: Nara Kokuritsu Hakubutsukan, 2002.

———. *Saigoku sanjūsansho: Kannon reijō no inori to bi.* Nara: Nara Kokuritsu Hakubutsukan, 2008.

———. *Seichi Ninpō: Nihon Bukkyō 1300-nen no genryū.* Nara: Nara Kokuritsu Hakubutsukan, 2009.

———. *Shukuin busshi: Sengoku jidai no Nara busshi.* Nara: Nara Kokuritsu Hakubutsukan, 2005.

———. *Yata kyūryō shūhen no Bukkyō bijutsu.* Nara: Nara Kokuritsu Hakubutsukan, 1987.

Nara rokudaiji taikan. Tokyo: Iwanami Shoten, 1970–.

Nara-shi Kyōiku Iinkai. *Nara-shi kaiga chōsa hōkokusho,* vol. 3. Nara: Nara-shi Kyōiku Iinkai 1989.

Nedachi Kensuke, ed. "Kamakura zenki chōkoku ni okeru Kyoto." *KURENAI* (2004). Dedicated issue. http://repository.kulib.kyoto-u.ac.jp/dspace/handle/2433 /85127 (accessed February 6, 2014).

Negishi Keiba Kinen Kōen, and Baji Bunka Zaidan. *Batō Kannon shinkō no hirogari: Shūki tokubetsuten.* Yokohama-shi: Baji Bunka Zaidan, 1992.

Neville, Tove. *Eleven-Headed Avalokiteśvara, Chenresigs, Kuan-yin or Kannon Bodhisattva: Its Origin and Development.* New Delhi: Munshiram Manoharlal Publishers, 1999.

Nhat Hanh, Thich. *Awakening of the Heart: Essential Buddhist Sutras and Commentaries.* Berkeley, Calif.: Parallax Press, 2012.

Nicoloff, Philip. *Sacred Kōyasan.* Albany: State University of New York Press, 2008.

Nihon rekishi chimei taikei. Accessible through JapanKnowledge, http://japan knowledge.com/en/contents/rekishi/index.html.

Nihon Sekibutsu Kyōkai. *Nihon sekibutsu zuten.* Tokyo: Kokusho Kankōkai, 1986.

Niimi Yasuko, ed. *Tōji hōmotsu no seiritsu katei no kenkyū.* Kyoto: Shibunkaku Shuppan, 2008.

Niizuma Hisao. *Shōwa shinsen Edo sanjūsansho Kannon junrei.* Osaka: Toki Shobō, 2005.

Nishikawa Kyōtarō. "Daihōonji Roku Kannon Juntei Kannon ryūzō." *Kokka* 800 (November 1958): 425–429.

Nishikawa Shinji. "Chōanji zō, Tarōten oyobi nidōji zō." *Bijutsushi* 12 (March 1963): 124–129.

Nishikawa Shinji et al. *Daigoji taikan,* vol. 2. Tokyo: Iwanami Shoten: 2002.

Nishimura Tei. *Nara no sekibutsu.* Osaka: Zenkoku Shobō, 1943.

Ōita-ken. *Ōita kenshi, Kodai hen,* vol. 2. Ōita: Ōita-ken, 1984.

Ōitaken Rekishi Hakubutsukan. *Rokugōsan jiin ikō kakunin chōsa hōkokusho,* vol. 9. Usa: Usa Fudoki no Oka Rekishi Minzoku Shiryōkan, 2001.

Okamoto Satoshi. "Higo Jōkei to Kōun." *Nara Daigakuin kenkyū nenpō* 15 (2010): 189–191.

Oku Takeo. "Garanjin no shōrai no juyō." In *Zuzō kaishakugaku: kenryoku to tasha,* ed. Kasuya Makoto, 365–375. Tokyo: Chikurinsha, 2013.

——. "Higo Jōkei wa sōfū ka." In *Yōshikiron: Sutairu to mōdo no bunseki,* ed. Hayashi On, 75–99. Tokyo: Chikurinsha, 2012.

——. "Ichinichi zōritsu butsu no saikentō." In *Ronshū tōyō nihon bijutsushi to genba: Mitsumeru, mamoru, tsutaeru,* ed. Tōyō Nihon Bijutsushi to Genba Henshū Iinkai, 243–253. Tokyo: Chikurinsha, 2012.

——."Seikōji Jūichimen Kannon zō to zōnai nōnyūhin." *Bukkyō geijutsu* 292 (May 2007): 13–28.

Orzech, Charles D., Henrik H. Sørensen, and Richard K. Payne, *Esoteric Buddhism and the Tantras in East Asia.* Leiden: Brill, 2011.

Osaka Shiritsu Bijutsukan. *Inori no michi: Yoshino, Kumano, Kōya no meihō.* Tokyo: Mainichi Shinbunsha: Nihon Hōsō Kyōkai, 2004.

——. *Saikoku sanjūsansho Kannon reijō no bijutsu.* Osaka: Osaka Shiritsu Bijutsukan, 1987.

Ōtsu Kazuhirō. "Yoryū Kannon o haishita roku Kannon, shichi Kannon." *Nihon no sekibutsu* 124 (Winter 2007): 50–51.

Ōtsu Rekishi Hakubutsukan. *Ishiyamadera to konan no butsuzō.* Ōtsu: Ōtsu Rekishi Hakubutsukan, 2008.

Ōtsuka Katsumi. "Chūsei ni okeru bonshō to hitobito no kurashi." *Suzaku Kyoto Bunka Hakubutsukan kenkyū kiyō* 2 (March 1989): 65–74.

Ōtsuki Mikio. *Ōbaku bunka jinmei jiten.* Kyoto: Shibunkaku Shuppan, 1988.

Ōya Kuninori. *Tōno Shichi Kannon.* Tōno: Tōno Shiritsu Hakubutsukan, 1988.

Oyamada Tomokiyo (1783–1847). *Setagaya kikō.* Tokyo: Waseda Daigaku Shuppanbu, 1904.

Phillips, Quitman E. "Narrating the Salvation of the Elite: The Jōfukuji Paintings of the Ten Kings." *Ars Orientalis* 33 (2003): 120–145.

Piggott, Joan R. et al. *Teishinkōki: The Year 939 in the Journal of Regent Fujiwara no Tadahira.* Ithaca, N.Y.: East Asia Program, Cornell University, 2008.

Rambelli, Fabio. *Buddhist Materiality: A Cultural History of Objects in Japanese Buddhism.* Stanford, Calif.: Stanford University Press, 2007.

——. "Secrecy in Japanese Esoteric Buddhism." In *The Culture of Secrecy in Japanese Religion,* ed. Bernhard Scheid, 107–129. London: Routledge, 2006.

Reader, Ian, and George Tanabe. *Practically Religious: Worldly Benefits and the Common Religion of Japan.* Honolulu: University of Hawai'i Press, 1998.

Reijo no jiten. Tokyo: Gakken, 1997.

Reischauer, A. K. "Genshin's Ojo Yoshu: Collected Essays on Birth into Paradise." *Transactions of the Asiatic Society of Japan,* 2nd series, vol. 7 (1930): 46–49.

"'Rōjaku danjo 244 nin ga sanka' Sagara sanjūsan Kannon uōkingu Hitoyoshi." *Hitoyoshi shinbun* (September 24, 2011). http://www.hitoyoshi-press.com (accessed September 26, 2011).

Rosenfield, John, Fumiko Cranston, and Edwin Cranston. *The Courtly Tradition in Japanese Art and Literature.* Cambridge, Mass.: Fogg Art Museum, Harvard University, 1973.

Ruppert, Brian. "Buddhist Rainmaking in Early Japan: The Dragon King and the Ritual Careers of Esoteric Monks." *History of Religions* 42, no. 2 (November 2002): 143–174.

Ryūkoku Daigaku Myūjiamu. *Gokuraku e no izanai: Nerikuyō o meguru bijutsu.* Kyoto: Ryūkoku Daigaku Ryūkoku Myūjiamu, 2013.

Sadakata, Akira. *Buddhist Cosmology: Philosophy and Origins.* Tokyo: Kosei Publishing, 1997.

Saeki Etatsu. *Haibutsu kishaku hyakunen: Shiitagerare tsuzuketa hotoketachi.* Miyazaki-shi: Kōmyakusha, 1988.

"Sagara sanjūsan Kannon." *Asahi shinbun, Kumamoto-ken* (March 22, 2008): 30.

Saitama-ken Kyōiku Iinkai, ed. *Chichibu junreidō.* Vol. 15 of *Rekishi no michi chōsa hōkokusho.* Saitama: Saitama Kenritsu Rekishi Shiryōkan, 1992.

Sakaguchi Kazuko. "Kinsei tsukimachi shinkō to nyoninkō no hitotsu kōsatsu." *Nihon no sekibutsu* 22 (August 1982): 4–15.

Sakai Tomizō. *Kunisaki hantō no Rokugō manzan.* Tokyo: Daiichi Hōki Shuppan, 1976.

Sakata Munehiko. "Mikkyō hōgu." *Nihon no bijutsu* 282 (November 1989). Dedicated issue.

Sakazaki Shizuka, ed. *Nihon garon taikan.* Tokyo: Arusu, 1927.

Sakurai Megumu. *Kūkai no sekai: Kongōrei no hibiki.* Tōkyō: Amyūzu Bukkusu, 2000.

Sankeien Hoshōkai. *Sankeien hyakushūnen Hara Sankei no egaita fūkei.* Yokohama: Kanagawa Shinbunsha, 2006.

Sano, Emily. "The Twenty-Eight Bushū of Sanjusangendō." PhD diss., Columbia University, 1983.

Santori Bijutsukan et al. *Kōdaiji no meihō: Hideyoshi to Nene no tera.* Tokyo: Asahi Shinbunsha, 1995.

Satō Sōtarō. *Sekibutsu no bi,* vol. 2. Tokyo: Mokujisha, 1968.

Sawa Ryūken, ed. *Daigoji.* Vol. 8 of *Hihō.* Tokyo: Kōdansha, 1976.

———. "Gohachi daiki." *Daigoji Bunkazai Kenkyūjo kenkyū kiyō* 4 (March 1982): 1–83.

———. *Mikkyō jiten.* Kyoto: Hōzōkan, 1975.

———. *Omuroban ryōbu mandara sonzōshū.* Kyoto: Hōzōkan, 1972.

Schmid, Neil. "Revisioning the Buddhist Cosmos: Shifting Paths of Rebirth in Medieval Chinese Buddhist Art." *Cahiers d'Extrême-Asie* 17 (2008): 293–325.

Seki Hideo. "Kyōzuka to sono ibutsu." *Nihon no bijutsu* 292 (September 1990). Dedicated issue.

Shaku Seitan. *Kannon no kenkyū.* Tokyo: Ōshima Seishindō, 1914.

———. "Roku Kannon to Rokuji shōku." *Kokka* 166 (March 1904): 207–218.

Shaw, Miranda. *Buddhist Goddesses of India.* Princeton, N.J.: Princeton University Press, 2006.

Shibusawa Tatsuhiko et al. *Kenchōji.* Kyoto: Tankōsha, 1981.

Shibushi-chō. *Shibushi chōshi.* Kagoshima: Shibushi-chō, 1972.

Shiga Kenritsu Biwako Bunkakan. *Kōga no shaji.* Ōtsu: Shiga Kenritsu Biwako Bunkakan, 1985.

———. *Shinpi no moji: Bukkyō bijutsu ni awareta bonji.* Ōtsu: Shiga Kenritsu Biwako Bunkakan, 2000.

Shigematsu Toshimi. "Kubotesan shinkō to bijutsu." *Bukkyō geijutsu* (August 1971): 133–142.

———. *Yamabushi mandara: Kubotesan shugen iseki ni miru.* Tokyo: Nihon Hōsō Shuppan Kyōkai, 1986.

Shimizu, Yoshiaki, and Carolyn Wheelwright, eds. *Japanese Ink Paintings from American Collections: The Muromachi Period: An Exhibition in Honor of Shūjirō Shimada.* Princeton, N.J.: Princeton University Press, 1976.

Shimizudani Zenshō. *Kannon no fudasho to densetsu.* Tokyo: Yūkōsha, 1940.

Shimizutani Kōshō. *Junrei to goeika Kannon shinkō e no hitotsu no dōhyō.* Osaka: Toki Shobō, 1992.

"Shimotetsuki (Imari-shi) Roku Kannon sekidō ni tsuite." *Matsuro no kuni* 167 (2006): 18–20.

Shinbi taikan. Nihon Shinbi Kyōkai, 1902.

Shinbo Tōru, ed. *Besson mandara.* Tokyo: Mainichi Shinbunsha, 1985.

Shinohara, Koichi. "The Moment of Death in Daoxuan's Vinaya Commentary." In *The Buddhist Dead,* ed. Bryan J. Cuevas and Jacqueline I. Stone, 105–133. Honolulu: University of Hawai'i Press, 2007.

Shiozawa Hiroki. *Kamakura jidai zōzōron: Bakufu to busshi.* Tokyo: Yoshikawa Kōbunkan, 2009.

Shirai Eiji, and Toki Masanori. *Jinja jiten.* Tokyo: Tōkyōdō Shuppan, 1979.

Shirai Yoshirō. "Rokuji karinhō no sekai." *Nihon bunka* 44 (July 1995): 78–88.

Shirai Yūko. "Ame sōjō Ningai to Kūkai nyūjo densetsu." *Nihon Bukkyō* 41 (April 1977): 50–68.

Shiraki Toshiyuki. "Sanjūsansho Kannon zuzō ni tsuite." *Mikkyō zuzō* 10 (November 1991): 73–83.

von Siebold, Phillip Franz, Johann J. Hoffman, and Yamabito Asiya. *Nippon: Archiv zur Beschreibung von Japan und dessen Neben- und Schutzländern: Jezo mit den südlichen Kurilen, Krafto, Kooraï und den Liukiu-Inseln, nach japanischen und europäischen Schriften und eigenen Beobachtungen bearbeitet.* Leyden: Siebold, 1832–1852.

Smyers, Karen. *The Fox and the Jewel.* Honolulu: University of Hawai'i Press, 1999.

Soejima Hiromichi. "Jūichimen Kannon zō, Senju Kannon zō." *Nihon no bijutsu* 311 (April 1992). Dedicated issue.

Sogō Tairyū. "Tōmyōji no honzon." *Kamo bunka* 2 (April 1971): 3–4.

Sørensen, Henrik. "Concerning the Role and Iconography of the Astral Deity Sudṛṣṭi (Miaojian) in Esoteric Buddhism." In *China and Beyond in the Medieval Period: Cultural Crossings and Inter-Regional Connections,* ed. Dorothy Wong and Gustav Heldt, 403–420. Amherst, N.Y.: Cambria Press, 2014.

Steineck, Tomoe, ed. *Tempelschätze des heiligen Berges: Daigo-ji—der geheime Buddhismus in Japan.* München: Prestel, 2008.

Stevenson, Daniel. "Text, Image, and Transformation in the History of the *Shuilu fahui,* the Buddhist Rite for Deliverance of Creatures of Water and Land." In *Cultural Intersections in Later Chinese Buddhism,* ed. Marsha Weidner, 30–70. Honolulu: University of Hawai'i Press, 2001.

Strickmann, Michel. *Chinese Magical Medicine,* ed. Bernard Faure. Stanford, Calif.: Stanford University Press, 2002.

Sueki F. [Fumihiko]. "L'extraordinaire aventure du Butsuzō zui." http://www.lejapon .org/forum/content/721-L-extraordinaire-aventure-du-Butsuzo-zui (accessed June 22, 2015).

Sugiyama Hiroshi. "Bonshō." *Nihon no bijutsu* 355 (December 1995). Dedicated issue.

Suzuki Yoshihiro. "Shukuin busshi." *Nihon no bijutsu* 487 (December 2006). Dedicated issue.

Suzuki, Yui. *Medicine Master Buddha: The Iconic Worship of Yakushi in Heian Japan.* Leiden: Brill, 2012.

Swanson, Paul L., trans. *The Great Cessation and Contemplation (Mo-ho chih-kuan),* compact disc. Tokyo: Kosei Publishing, provisional edition, 2004.

Taguchi Eiichi. "Dōban *Hokekyō,* tsuketari dō hakoita." *Kokka* 957 (May 1973): 44–52.

Tajima Sei. "Iroiro na Kannon sama 3—Sanjūsan Kannon." *Daihōrin* (June 2009): 86–89.

Tajima Shiichi, ed. *Sesshū gashū.* Tokyo: Shinbi Shoin, 1909.

Takada Motoji. *Sagara sanjūsan Kannon meguri.* Hitoyoshi: Hitoyoshi Kuma Bunkazai Hogo Kyōiku Iinkai, 1978.

———, ed. *Shinyaku Kuma gaishi.* Kumamoto: Seichōsha, 1972.

———. *Yunomae chōshi.* Yunomae-machi, 1968.

Takagaki, Cary Shinji. "The Rokushō-ji: The Six 'Superiority' Temples of Heian Japan." PhD diss., University of Toronto, 1999.

Takahashi Shinsaku. "Den Shōkei hitsu 'Kannon zu' (sanjūni fuku) ni miru Kamakura chihō yōshiki to Kannon senpō." *Kokka* 1430 (May 2014): 7–24.

Takaki, Nobuyuki. *A Comprehensive Guide to Hitoyoshi City and Kuma County.* Hitoyoshi: Hitoyoshi Tourist Club, 1977.

Takamatsushi Rekishi Shiryōkan. *Busshōzan Hōnenji no meihōten.* Takamatsu-shi: Takamatsushi Rekishi Shiryōkan, 1992.

Takasaki Fujihiko. *Nihon Bukkyō kaigashi.* Tokyo: Kyūryūdō, 1966.

Takeuchi Hideo. "Kitano Kyōōdō ni tsuite." *Shiseki to kobijutsu* 19 (January 1937): 19–26.

———. *Tenmangū.* Tokyo: Yoshikawa Kōbunkan, 1968. Tanabe Sōichi. *Ikkyūji.* Vol. 14 of *Kyō no koji kara.* Kyoto: Tankōsha, 1995.

Tanabe Takao. "Dengenji no Roku Kannon zō." *Nishi Nihon no bunka* 115 (1975): 16–21.

Tanabe, Willa. *Paintings of the Lotus Sūtra.* New York: Weatherhill, 1988.

Tanaka Ichimatsu, ed. *Kegon gojūgosho emaki; Hokekyō emaki; Kannonkyō emaki; Jūni'innen emaki.* Vol. 25 of *Shinshū Nihon emakimono zenshū.* Tokyo: Kadokawa Shoten, 1979.

———. "Ōita-ken hakken no dōban *Hokekyō* ni tsuite." *Kōkogaku zasshi* 18 (January 1928): 9–21.

Tanaka Junichirō. "Kamo-chō kyū Tōmyōji zō den Nyoirin Kannon nōnyū monjo ni tsuite." *Yamashiro Kyōdo Shiryōkan hō* 4 (1986): 67–74.

Tanaka Kaori. "Sengokuki ni okeru 'shichi Kannon mōde,' 'shichinin mōde' ni tsuite." *Tezukayama Daigaku Daigakuin Jinbunkagaku Kenkyūka kiyō* 11 (February 2009): 13–31.

Taniguchi Tetsuo. *Sekibutsu kikō.* Tokyo: Asahi Shinbunsha, 1966.

Tatehata Atsuko. "Tōfukuji zō Minchō hitsu sanjūsan Kannon zu ni kansuru ichikōsatsu." *De arute* 26 (2010): 41–70.

Teiser, Stephen F. *Reinventing the Wheel: Paintings of Rebirth in Medieval Buddhist Temples.* Seattle: University of Washington Press, 2006.

———. *The Scripture on the Ten Kings and the Making of Purgatory in Medieval Chinese Buddhism.* Honolulu: University of Hawai'i Press, 1994.

ten Grotenhuis, Elizabeth. *Japanese Mandalas: Representations of Sacred Geography.* Honolulu: University of Hawai'i Press, 1999.

Tobita Hideyo. *Rokujizōji no rekishi to jihō.* Mito, Ibaraki: Rokujizōji, n.d.

Tōbu Bijutsukan et al. *Saigoku sanjūsansho: Kannon reijō no shinkō to bijutsu.* Tokyo: Nihon Keizai Shinbunsha, 1995.

Toki Takeji. "*Makura no sōshi* 'subete Roku Kannon' no saiginmi." *Hanazono Daigaku kenkyū kiyō* 11 (March 1980): 1–25.

Tokyo Bunkazai Kenkyūjo. *Nihon kaigashi nenki shiryō shūsei; Jūgo seiki.* Tokyo: Chūō Kōron Bijutsu Shuppan, 2011.

Tokyo Daigaku Shiryō Hensanjo. *Dai Nihon komonjo; Iewake,* vol. 5, *Sagara-ke monjo,* pt. 2. Tokyo: Tokyo Teikoku Daigaku, 1917–1918.

Tokyo Kokuritsu Hakubutsukan. *Kamakura, Zen no genryū: Kenchōji sōken 750-nen kinen tokubetsuten.* Tokyo: Nihon Keizai Shinbunsha, 2003.

———. *Kokuhō Daigoji ten: Yama kara orita honzon.* Tokyo: Nihon Keizai Shinbunsha, 2001.

———. *Kyoto Gozan Zen no bunka ten: Ashikaga Yoshimitsu roppyakunen goki kinen.* Tokyo: Nihon Keizai Shinbunsha, 2007.

———. *Myōshinji: Kaizan Musō Daishi 650-nen onki kinen.* Tokyo: Yomiuri Shinbunsha, 2009.

———. *Sesshū: botsugo 500-nen tokubetsuten.* Tokyo: Mainichi Shinbunsha, 2002.

———. *Tokyo Kokuritsu Hakubutsukan zuhan mokuroku, Butsuga hen.* Tokyo: Tokyo Kokuritsu Hakubutsukan, 1987.

Tokyo Setagayaku Kyōiku Iinkai. *Setagayaku shaji shiryō,* vol. 3. Tokyo Setagayaku Kyōiku Iinkai, 1984.

Tomabechi Seiichi. "Heian jidai no roku Kannon zō to '*Makashikan:*' Roku Kannon shinkō no seiritsu o megutte (1)." In *Tada Kōshō hakushi koki kinen ronshū, Bukkyō to bunka,* ed. Tada Kōshō hakushi koki kinen ronshū kankōkai, 655–674. Tokyo: Sankibō Busshorin, 2008).

———. "Rokujikyōhō to mikkyō no roku Kannon: Roku Kannon shinkō no seiritsu o megutte (2)." In *Shingon mikkyō to nihon bunka: Katō Seiichi hakushi koki kinen ronbunshū,* 323–389. Tokyo: Nonburu, 2007.

Tomimura Takafumi. "Jōkei no dōki to deshitachi." In *Shūkyō shakaishi kenkyū,* ed. Risshō Daigaku Shigakkai, 193–208. Tokyo: Yūzankaku Shuppan, 1977.

Trede, Melanie, ed. *Arts of Japan: The John C. Weber Collection.* Berlin: Museum für Ostasiatische Kunst, Staatliche Museen zu Berlin, 2006.

Triplett, Katja. "Esoteric Buddhist Eye-healing Rituals in Japan and the Promotion of Benefits." In *Grammars and Morphologies of Ritual Practices in Asia,* ed. Axel Michaels et al., 485–499. Wiesbaden: Harrassowitz, 2010.

Tsuboi Ryōhei. *Nihon koshōmei no shūsei*. Tokyo: Kadokawa Shoten, 1972.

Tsuda Tetsuei. "Chūsei no dōjigyō." *Nihon no bijutsu* 442 (March 2003). Dedicated issue.

———. "Rokuji Myōō no shutsugen." *Museum* 533 (April 1998): 27–54.

Tyler, Royall, trans. *The Tale of the Heike*. New York: Viking, 2012.

Tyler, Susan. *The Cult of Kasuga Seen through Its Art*. Ann Arbor: Center for Japanese Studies, University of Michigan, 1992.

Uchida Keiichi. "Hasederashiki Jūichimen Kannon Bosatsu gazō ni tsuite." *Bukkyō geijutsu* 294 (September 2007): 13–31.

———. "Kamata yonchōme no Kisshōin, Rokujikyō mandara to Kōbō Daishi zō no chōsa hōkoku." *Setagayaku bunkazai chōsa hōkokushū* 18 (2009): 1–12.

Ueda Ensei, ed. *Ōita-ken shaji meishō zuroku*. Kumamoto: Seichōsha, 1983.

Uemura Shigeji. *Kyushu Sagara no jiin shiryō*. Kumamoto: Seichōsha, 1968.

Umezawa Akiko. "Muromachi jidai no Kitano Manbukyōe." *Nihon Joshi Daigakuin bungaku kenkyū kiyō* 8 (2002): 93–116.

Unno, Mark. *Shingon Refractions: Myōe and the Mantra of Light*. Somerville, Mass.: Wisdom Publications, 2004.

Unoki Eiji. *Higo no kuni Kumagun sonshi*. Kumamoto: Kumamoto Joshi Daigaku Rekishigaku Kenkyūbu, 1976.

Usa Fudoki no Oka Rekishi Minzoku Shiryōkan. *Rokugōsan jiin ikō kakunin chōsa hōkokusho*, vols. 2, 3, and 9. Usa: Usa Fudoki no Oka Rekishi Minzoku Shiryōkan, 1995.

Usui Nobuyoshi. "Kitanosha issaikyō to Kyōōdō." *Nihon Bukkyō* 3 (October 1959): 37–54.

Utsunomiya Keigo. "Tōmyōji zō *Daihannya haramittakyō* no kunten in tsuite." In *Kokugo mojishi no kenkyū*, vol. 7, ed. Maeda Tomiyoshi, 99–123. Osaka: Izumi Shoin, 2003.

Visser, M. W. de. *Ancient Buddhism in Japan: Sūtras and Ceremonies in Use in the Seventh and Eighth Centuries A.D. and Their History in Later Times*. Leiden: Brill, 1935.

Wakayama Kenritsu Hakubutsukan. *Idōsuru butsuzō: Aridagawa-chō no jūyō bunkazai o chūshin ni*. Wakayama-shi: Wakayama Kenritsu Hakubutsukan, 2010.

Wang, Eugene Y. *Shaping the Lotus Sūtra: Buddhist Visual Culture in Medieval China*. Seattle: University of Washington Press, 2005.

Wang-Toutain, Françoise. *Le bodhisattva Kṣitigarbha en Chine du Ve au XIIIe siècle*. Paris: Presses de l'École française d'Extrême-Orient, 1998.

Warner, Langdon. *Japanese Sculpture of the Suiko Period*. New Haven, Conn.: Yale University Press, 1923.

Washizuka Hiromitsu. "Nakayamadera to Sōōbuji no Jūichimen Kannon zō." *Museum* 248 (November 1971): 27–31.

Watanabe Katsumi. *Kunisaki koji junrei*. Ōita-shi: Sōrinsha, 1986.

———. *Kunisaki Rokugō Manzan reijō meguri*. Ōita: BookWay, 2012.

Watanabe Nobuyuki. *Kunisaki hantō no sekibutsu*. Tokyo: Mokujisha, 1971.

Watson, Burton, trans., *The Lotus Sutra*. New York: Columbia University Press, 1993.

Wattles, Miriam. *The Life and Afterlives of Hanabusa Itchō, Artist-Rebel of Edo*. Leiden: Brill, 2013.

Weidner, Marsha, ed. *Latter Days of the Law: Images of Chinese Buddhism 850–1850.* Lawrence, Kans.: Spencer Museum of Art, 1994.

—— et al. *Views from Jade Terrace: Chinese Women Artists, 1300–1912.* Indianapolis: Indianapolis Museum of Art, 1988.

Weston, Victoria. "Institutionalizing Talent and the Kano Legacy at the Tokyo School of Fine Arts, 1889–1893." In *Copying the Master and Stealing his Secrets,* ed. Brenda Jordan and Victoria Weston, 147–177. Honolulu: University of Hawai'i Press, 2003.

Whitfield, Roderick. "An Art Treasury of China and Mankind: Some Recent Studies on the Dunhuang Caves." *Orientations* 20 (March 1989): 34–40.

Whitfield, Roderick, and Anne Farrer. *Caves of the Thousand Buddhas: Chinese Art from the Silk Route.* London: British Museum, 1990.

Wong, Dorothy. "The Case of Amoghapāśa." *Journal of Inner Asian Art and Archaeology* 2 (2007): 151–158.

Wood, Donald A. "Eleven Faces of the Bodhisattva." PhD diss., University of Kansas, 1985.

Yajima Yutaka. *Chichibu Kannon reijō kenkyū josetsu.* Tokyo: Hōshō Gakuen, 1966.

Yamaguchi Kenritsu Bijutsukan. *Sesshū Tōyō: Sesshū e no tabi ten kenkyū zuroku.* Tokyo: Chūō Kōron Bijutsu Shuppan, 2006.

——. *Zendera no eshitachi: Minchō, Reisai, Sekkyakushi.* Yamaguchi: Yamaguchi Kenritsu Bijutsukan, 1998.

Yamaguchi Ryūsuke. "Jōkeiyō bosatsu zō no saikentō." *Bukkyō geijutsu* 299 (July 2008): 89–111.

Yamahata Toshihiro, ed. *Jinja Keiōshū.* Shibushi-chō: Shibushi-chō Kyōiku Iiinkai, 1998.

Yamamoto Tsutomu. "Dainichi Nyorai zō." *Nihon no bijutsu* 374 (July 1997). Dedicated issue.

Yamane Yūzō, ed. *Emakimono.* Vol. 2 of *Zaigai Nihon no shihō.* Tokyo: Mainichi Shinbunsha, 1979–1981.

Yamasaki, Taikō et al. *Shingon Japanese Esoteric Buddhism.* Boston: Shambhala, 1988.

Yamashiro-chō Komonjo Saakuru Kisaragikai. *Edo jidai no Minamiyamashiro sanjūsansho o tazunete.* Yamashiro-chō: Yamashiro-chō Komonjo Saakuru Kisaragikai, 1996.

Yamato Bunkakan. *Sūkō naru sansui: Chūgoku Chōsen Rikakukei sansuiga no keifu tokubetsuten.* Nara: Yamato Bunkakan, 2008.

Yiengpruksawan, Mimi. *Hiraizumi: Buddhist Art and Regional Politics in Twelfth-Century Japan.* Cambridge, Mass.: Harvard University Asia Center, 1998.

——. "In My Image: The Ichiji Kinrin Statue at Chūsonji." *Monumenta Nipponica* 46, no. 3 (Autumn 1991): 329–347.

Yifa. *The Origins of Buddhist Monastic Codes in China: An Annotated Translation and Study of the Chanyuan qinggui.* Honolulu: University of Hawai'i Press, 2002.

——. "The Rules of Purity of the Chan Monastery: An Annotated Translation and Study of the *Chanyuan qinggui.*" PhD diss., Yale University, 1996.

Yoshimura Shigesaburō. *Matsuura sōsho: Kyōdo shiryō.* Tokyo: Meicho Shuppan, 1974.

Yü, Chün-fang. "Ambiguity of Avalokiteśvara and the Scriptural Sources for the Cult of Kuan-yin in China." *Zhonghua foxue xuebao* [Chung-Hwa Buddhist Journal] 10 (1997): 409–464.

——. "Guanyin: The Chinese Transformation of Avalokiteshvara." In *Latter Days of the Law: Images of Chinese Buddhism, 850–1850,* ed. Marsha Weidner, 151–181. Lawrence, Kans.: Spencer Museum of Art, University of Kansas, 1994.

——. *Kuan-yin: The Chinese Transformation of Avalokiteśvara.* New York: Columbia University Press, 2001.

Yufuin-chō. *Choshi Yufuin.* Yufuin-chō, Ōita-ken: Yufuinchō-shi Kankō Kiseikai, 1989.

Zhongguo gudai shuhua jianding zubian. *Zhongguo gudai shuhua tumu* [Illustrated catalogue of selected works of ancient Chinese painting and calligraphy], vol. 12. Beijing: Wenwu chubanshe, 1986.

Bold page numbers refer to illustrations and page numbers followed by t refer to tables.

About the Author

SHERRY FOWLER is professor of Japanese art history at the University of Kansas. Her scholarly interests range from ninth-century Buddhist sculpture to nineteenth-century Japanese prints. She published *Murōji: Rearranging Art and History at a Japanese Buddhist Temple* in 2005.